MASTERPIECES OF PHOTOGRAPHY

MASTERPIECES of

From the George Eastman House

BY ROBERT A. SOBIESZEK

Masterpieces of photography from the George Eastman House Collections

PHOTOGRAPHY

Collections · Abbeville Press · Publishers · New York

Editor: Walton Rawls

Designer: James Wageman

Library of Congress Cataloging in Publication Data

International Museum of Photography
 at George Eastman House.
 Masterpieces of photography.

 Bibliography: p.
 Includes index.
 1. Photography—History. 2. International Museum
of Photography at George Eastman House—Photograph
collections. 1. Sobieszek, Robert A., 1943–
11. Title.
TR15.158 1985 770'.9 85-15704
ISBN 0-89659-586-2

CONTENTS

INTRODUCTION

EVERY PHOTOGRAPH is a moral emblem of human consciousness. Even at the seemingly least-mindful level of engagement, when the image portrayed is nothing more than the replication of an object's appearance or a document of prosaic fact, a photograph demonstrates a choice and by that choice it testifies to human value, for nothing has ever been photographed that did not mean something to the photographer or the person who requested the picture. The finest photographs, however, have been those images whose meanings, whether historical or for the present, have held and continue to hold a cultural significance far beyond personal considerations. Either through a powerful depiction of human sentiment or emotion, or through an aesthetic impact, such photographs obtain claim to artistic intelligence and attend to more profound levels of deciphering the complexities of the human condition.

Every photograph also contains a certain resonance with the entire cultural matrix in which it was created. No photograph is ever independent of the shared values of its societal and artistic context, whether a humble snapshot, the slickest advertising image, or a venture into art and personal expression. Like any other maker of pictures, the photographer has really only three choices in creating an image: to willfully subscribe to older and more traditional pictorial types and styles, to assume the limits of validated contemporary fashion, or to advance a set of choices beyond the expected and the ordained. Common to each is a dialogue with other (not necessarily photographic) pictures—a dialogue that assumes the form of acceptance, modification, or rejection of other images. Also, like any other picture-maker, the photographer is never an isolated agent fabricating images in a vacuum with utter disregard to the ideas and concerns that make up the world of received ideas. It would be quite exceptional to encounter a photograph that failed to reveal in one manner or other an attitude, a belief, a sensibility, or a mythology found in other forms of cultural expression. Behind the depiction of any object or scene, as well as the formulation of any interpretation or fantasy, there is a fabric of unstated correspondences that are often hidden or "encoded." In this sense, the photograph attests to far more than what it delineates and, as the French critic Roland Barthes suggested, by so doing "makes of an inert object a language and...transforms the unculture of a 'mechanical' art into the most social of institutions."[1]

Whether photographs are works of art or not is a rather immaterial question, and one that presupposes an already accepted idea as to the limits of art. Since 1839, there have been sufficient definitions of these limits to guarantee that one or another could prove the viability of the photograph as art. What really matters is that, since that same year, there have been innumerable creative talents using the camera and making images that, regardless of their characterization, have affected us emotionally, spiritually, and aesthetically. What is pertinent is that, as the art critic Philippe Burty wrote in 1859, "if photography is not a complete art, the photographer has always the right to be an artist."[2] By default, then, and not by polemics, there have been photographs (and some very great photographic images) that through their special affects and enduring qualities function as art. And this should be enough, actually. Photographs have also served at the same time to illustrate and enlighten, document and record, trace and map, entertain and inform. Frequently, this appears more than enough, considering the sheer volume of photographic images available to us.

Photography is essentially a modern form of both art and communication, and the various elements of its history are traceable as far back as the middle of the fourth century before our era. When Aristotle described images of sky and sun discovered on a forest floor, projected there by natural light streaming through small apertures formed by overlapping leaves in the trees, he was in fact pointing out photographic images—pictures written by light in the most literal of senses. That photographs as we now understand them were not invented until some 2200 years later, during the second quarter of the 19th century, was only in part due to the development of required chemistries and technologies. By the time William Henry Fox Talbot and Louis-Jacques-Mandé Daguerre first published their successful photographic processes in 1839, nearly all the chemical components of modern photography already had been discovered, such as silver nitrate for registering images made by light and hyposulphite of soda to make those images permanent. Likewise, a medieval scientific toy called the *camera obscura*, used to view images projected upon a ground glass, had been perfected enough by the 1830s to warrant being called simply a "camera" and adapted by early photographers for recording those images.

Photography's modernism is linked to two historical desires, to observe the world through synthetic optics and to reproduce what is observed by that vision. The conflation of these desires in the early 19th century contributed to the invention of photography more than any technical discoveries. Seventeenth-century Dutch advances in the design and application of optics generated a revolutionary approach to "picturing" the world. Nature—a far more expansive nature extending from the microscopic to the celestial—was a continuum that was viewable through a lens. With the lens, moreover, came the corollary notion of a field, a selection from the natural continuum encircled by the edge of the optics or framed by the edges of the

And the most difficult: beauty itself as perceived through the there and then.
—Vladimir Nabokov, *Ada,* 1969

picture. And fitted with optics that augmented as well as simulated human vision, the instruments of this synthetic vision also served as useful metaphors for human understanding. In 1604, Johannes Kepler equated human sight with a picture; around 1630 Constantijn Huygens viewed the images seen in a microscope or a *camera obscura* as pictures conveying knowledge; and by the end of the century the philosopher John Locke conceived of how the human mind functioned in terms of the images obtained in the *camera obscura*. Pictorially, the revolution in optics served to fashion and legitimize a new way of seeing the world as a seamless expanse of potential images whose portrayal emphasized the meaning of what the eye could take in. As one historian has remarked, "The concept of the mind as a place for storing visual images was of course a common one at the time. But it was in the north of Europe that artists *pictured* such a state of mind.... the tendency toward a descriptive approach to the representation of even elevated subject matter [is] due to this . . . practice...."[3] Observation was synonymous with knowledge, and the pictorial description of that observation was art.

When Huygens wished to picture images seen through a lens, he requested the aid of a friend who was a painter and whose skills at drawing proved adequate. When Daguerre, who was a painter, and Talbot, who was not, desired to capture optical images some two centuries later, they turned instead to mechanical and chemical alternatives and invented a medium that was able to render the lenticular images of nature with the utmost realism. Rather than produce these images by hand, they chose to reproduce them mechanically, thereby satisfying one of the principal demands of the capitalistic, industrialized cultures in which they lived—the reproduction of things (and people) on a mass scale. Machines and production techniques had been invented and were geared by the 1830s to decrease physical limitations such as time (the locomotive) and space (the telegraph) and to facilitate replication (stamping machines, the Jacquard loom, stereotypy). Economic philosophies, systems of capital exchange, and entire labor forces were based on principles that accommodated and encouraged greater numbers and increased work schedules. The unique and the hand-crafted evolved into especial commodities, and techniques were developed to replicate even works of art. According to the critic Jules Janin, upon seeing Daguerre's daguerreotypes for the first time:

We live in a singular epoque. We no longer dream nowadays of producing anything by ourselves, but, on the contrary, relentlessly search for ways of reproducing for us and in place of us.... the other day, another man of genius... invented a wheel with the aid of which he has

reproduced the *Venus de Milo* with admirable and unbelievable fidelity. Now, with a varnished copper plate, M. Daguerre replaces drawing and engraving. Allow it to continue and before long you will have machines that will dictate the comedies of Molière to you and make verses like the great Corneille: Amen.[4]

Thus, by 1839, the equation that brought forth the modern art of photography had been completed: picture and observation were equated, as were the functions of reproduction and modernity. All that was now necessary was the artist's choice of subject and viewpoint, for as L. Clément de Ris claimed in 1853, "whoever says art, says choice; whoever says choice says comparison, and supposes the idea of taste."[5]

Between Daguerre's invention of photography and the work of a contemporary photographer like Joel-Peter Witkin, a history of a medium has evolved along with most of modern art and culture, but Clément de Ris's comment continues to apply to the immeasurable number of photographs produced since 1839. By 1853, picture-makers who used a camera had selected subjects and created images that addressed every conceivable pictorial type then accepted and still viable today, from diagrammatic cartography to scenes of topography, from interpretive portraiture to the analysis of astronomical bodies, from picturesque still lifes to fabricated fictions, and from the most "neutral" documents to the most spiritual epiphanies. If Anthony Burgess could claim that "there are more novels published than the average reader can possibly realize,"[6] then the number of photographs made must truly defy the limits of even the largest electronic database. Even if we were to exclude the millions of repetitious and abjectly mundane snapshots made each year, the number of significant photographic images would remain incalculable and contain an overwhelming variety of approaches and intentions. There are those that are strictly artistic while others are merely reprographic; some are poetic excursions into essentially private arenas and others command our attention by the exactitude and strange elegance of the scientific record; a certain number are tours-de-force of technical perfection coolly articulated while others lack most of the basic requirements of craft but still evidence a profoundly moving human element; and some are domestically personal, others very public and commercial. The history of photography is defined by no single motivation or approach to making pictures with the camera, and its history cannot be evaluated except by attending to as many of its achievements with as wide a compass as possible.

The photographic collection of the International Museum of Photography at George Eastman House was conceived and has

been amassed along the lines of reflecting the general history of that mode of human expression called photography. The museum's mandate for nearly four decades has been to collect and preserve those images that best illustrate the medium's scientific, technical, artistic, and social histories; to bring together examples of every known process and method of producing as well as transforming photographic images; and to attempt a collection of the finest achievements of the current period. The collection is not precisely one of the art history of photography, unless one is excessively liberal in accepting all pictures as art, nor is it exactly a technical collection concerned solely with emulsions and papers. In a similar fashion, the museum's collection of more than a half-million images was not designed to be an iconographic archive of historic or contemporary subjects, nor was it ever seen as simply a repository of incunabula and antiquated experiments. It is not a gallery of unique exemplars of progressive expressionism, nor a mausoleum of industrial specimens.

Simply put, the photographic collection is all of these and, because of its exceptional lack of constraints, a great deal more. It is a research facility where the photomechanical can be compared to the photochemical, where untrimmed working sketches coexist with framed and signed exhibition prints, where tear-sheets from magazines are preserved along with original negatives, and where monuments of the medium's heritage are shelved along with minor gems of individual brilliance. It is a compendium of photographic history in which the journalistic is found alongside the allegorical, the exuberant along with the pathetic, the saccharin with the disturbing, and the beautiful in the same print case as the analytic. The benefits gained from such a collection of photographic pictures are many, not the least of which are the reverberations that transpire between individual images that ordinarily would not be considered in the same breadth—and the probability that these reverberations might illuminate an otherwise hidden quality or meaning. In short, the collection is as much about the history of the idea of the photographic image as about the artifacts that constitute photographic history.

Choosing two hundred images on the level of photographic "masterpieces" from a print collection of such dimensions and diversity has to be an act that is fundamentally personal and one dictated as much by a less than perfect understanding of the material's significance as it is by a set of idiosyncratic values and tastes. The intention was not to construct by these choices a narrative history of photography even though the selections are arranged in a roughly chronological fashion, and an attempt has been made to include as many historical processes, styles, nationalities, and pictorial types as possible while still warranting that the selection mirrors the collection with all of its admitted imperfections and idiosyncrasies. For the sake of structural convenience, the images chosen have been located within four episodic time frames, each roughly coincident with what may be considered four rather distinctive periods of photographic history.

"The First Generation and the Beginnings of a Medium" surveys the initial moment of photography, encompassing its origins within the entertainments of the Diorama by Daguerre and his partner Charles Marie Bouton during the 1820s and 1830s; the initial success of the daguerreotype; the early flourishing of the calotype; the first instances of interpretive portraiture, as in the work of David Octavius Hill and Robert Adamson; and the applications of the new medium to expeditionary photography and photographic publishing during the early part of the 1850s. It was a period, in short, of invention, experimentation, and intuition, and one during which the idea of the photographic image became firmly rooted in Western consciousness.

"Imperial Visions and Literary Tastes" traces what some have called "l'age d'or" of 19th-century photography, a period in which some of the most resplendent examples of photographic art were created. It was an era of monumentality and emotionalism, of broad effects and the anecdotal, of political engagement and positivism of spirit. It was a period that included the nobility and nationalism of an Edouard-Denis Baldus and the melodramatic fictions of a Henry Peach Robinson during the 1850s, the reformist sociologies of urban photography and the breathtaking expansiveness of Western American landscape imagery of the 1870s. In the current sense of the terms, both amateur and professional photographers became significant forces in defining the limits of the medium, incalculable amounts of pictorial knowledge and information were assembled, and the seeds for a future modern art were sown.

"Symbolism, Formalism, and the Problems of Style" posits a lengthy time span in which the imperatives of artistic expression flourished concurrently with those of technical innovation and the documentary style. It was an era of formulation and extravagance, beginning with Peter Henry Emerson's creation and sudden denunciation of photography as an art form and ending with the extremes of Surrealist advertising and the advent of World War II, stretching from the late-19th-century's first invention of color photography to color's second invention during the 1930s, and encompassing both the pictorialist penchant for metaphor and symbol and the constructivist devotion to clarity and the machine. New vocabularies and new forms of picturing with photographs were evolved, as were numerous vital and passionate

advancements for photography's place within the cultural matrices of affect and information. Most importantly, it was a time during which the photograph more or less ceased being invisible and became at once simply and complexly a picture manufactured by individual artistic vision, whether an "Equivalent" by Alfred Stieglitz, a photomontage by Lázsló Moholy-Nagy, or a straight document by Walker Evans.

Lastly, "A Dynamics of Pluralism: Matters of the Heart and Eye," glances back over the photographic accomplishments of the past forty or so years, a period as confusing and protean as it has been exciting and provocative. The larger issues of the medium's forms of expression had been formulated over the course of the previous century, leaving the much greater problem of addressing a hitherto unparalleled world audience that has been fractured into an inordinant diversity of both stylistic and moral "camps" and advocacies by the very history of the medium. To be taken seriously, the contemporary photograph can be a traditional example of journalistic or scientific documentation, an excursion into constructed formalism or fabricated pictorialism, a pictorial *haiku* as in the work of Minor White, or a picturesque pun as in John Pfahl's photographs; its tone can be harsh or elegant and its voice either antagonistic, tendentious, or seductive; but the real issue of contemporary photography has been to challenge, to understand, and to affect what we see and what we feel.

Regardless of size there is not a photographic collection known that does not contain certain lacunae in its representation of photographic history, but after more than thirty-five years of active acquisition no collection of the magnitude of the George Eastman House could fail equally to have specific strengths and characteristics endowed it by previous directors, curators, and the fortunes of availability. As far as it made sense, I have tried to draw on these strengths without, I hope, sacrificing a broad panoramic overview. Moreover, after years of exhibition and reproduction in countless publications, many of the collection's more important prints have become stereotypical "chestnuts" of photographic history, defying by their popular "aura" any deeper reexamination of the collection. A few of these well-known images have been chosen for inclusion here, partly because nothing else in the collection came close to them or partly due to my wish to confront them again after taking them for granted so long. Fortunately, however, the collection is so rich in variety that it was easy to make a selection with a modicum of familiar images. Whenever advantageous and when I felt it correct, I chose a print that had not been "neutralized" by being part of the standard repertoire of images found in photographic literature. Undoubtedly, there will be those who

will be disappointed not to encounter their favorite photograph by a specific master; but this is clearly offset by the fact that few photographers have made but a single great picture, and just as there are many unsung talents within photography's rather short history, there is also a wealth of unfamiliar, important images—even by the most renowned artists—worthy of meditation.

If this volume is not exactly a detailed narrative history of the technical or artistic evolution of photography, neither is it a general theory of photographic pictures. It is not at all convincing that any single, holistic set of aesthetic or critical formulations can account for a medium as protean, as transformable, and as polyvalent as photography. I am also of the opinion that while it is quite certain no further great masters of the art will be suddenly discovered in some European attic or American garage, the actual facts concerning the work of acknowledged masters are only now being pursued with any diligence and scholarly precision. And until this history is more adequately defined, it seems premature to rigidly apply a system of beliefs to the entire medium's history, or to try to construct any such system from a general collection of images. A comment made by the art historian John White pertains to some degree.

> It is only by close attention to historical detail, and the careful testing of each link in a chain of reasoning strictly based upon the visual and literary documents, that any advance seems to be possible. There is already a sufficiency of attractive but conflicting general theory. Until its foundations have been examined in detail there is little prospect of escaping from a Wimbledon of assertion and counter-assertion in which no game is ever won, and all the balls remain unchanged.[7]

If anything, two very different things have been attempted in this book, the first being to choose two hundred pictures from a general photographic collection on the simple basis of their intrinsic quality and significance. Second, each of these images has been responded to with a modest text utilizing a range of tones, voices, and critical postures that I am convinced must be used in addressing a general collection of historical and contemporary photographs not uniformly artistic, totally documentary, or at times even comparable except in their photochemistry. Each text has been designed as a form of extended "wall-label"—a gloss as it were to the exhibition of an individual photograph—meant to suggest as well as elucidate. I have tried to steer clear of becoming mired in the frequently esoteric and rather confining context of strict photographic history. While there is indeed a place and a need for such a "purist" approach, it has been more interesting to locate a number of great and

fascinating photographs within a broader context of cultural history and where appropriate to suggest parallels with other forms of expression contemporary to the picture. Thus, comments by poets, novelists, scientists, painters, and others not especially concerned with photography have been appropriated in addition to those by the photographers themselves or by critics of the medium. At worst, this design might serve to illustrate photography's involvement with the rest of a culture; at best, it may provide a dialogue through which some particular sense and quality of these "masterpieces" is enriched.

The idea of "masterpiece"—more a loose notion than an indisputable concept—is problematic in any discussion, but particularly in one concerning photography that may not be expressly artistic. Doubtless, no single photograph could be called a masterpiece in the sense that Raphael's *Transformation*, Bach's *Six Sonatas and Partitas for Solo Violin*, Tolstoy's *War and Peace*, or Picasso's *Guernica* stand as supreme monuments to human thought and creativity. A photograph simply cannot aspire to treat the human spirit with equivalent grandeur, breadth, and complexity. Yet towering magnitude need not be the overriding parameter of a masterpiece. Works of much smaller scope and more discrete measure can also rate—the pair of Mycenaean cups from Vapheio, Parmigianino's self-portrait drawing in a convex mirror, the "Mazeppa" from Liszt's *Transcendental Etudes*, Alain-Fournier's *Le Grand Meaulnes*, or Arshile Gorky's *The Liver Is the Cock's Comb* might be considered. And since "classic" is not synonymous with "masterpiece," we might with equal ease suggest John Fowles's *The Magus*, the Rolling Stones's *Satisfaction*, Sol LeWitt's *Cube Structures Based on Five Modules*, or Francis Ford Coppola's *Apocalypse Now*. Indeed, few today would, I suspect, argue against the inclusion of certain photographs in that company, such as Ansel Adam's *Moonrise—Hernandez*. As long as some meaningful human element is reflected by the work, and as long as that reflection is expressed or realized materially by a certain excellence of craft, idea, or imagination, a work of art can be nominated to be a masterpiece (its election, however, and its stay in office often depending on other matters) and considered for its unique and special value.

Historically, the term "masterpiece" has been inextricably linked to artistic achievement and theory, and while approaching photography from that point of view is frequently useful, it does chance certain pratfalls. If we take the term to mean a work or object that is judged to exhibit inordinate quality, or what Dr. Johnson called "chief excellence,"[8] then most anything at all that strikes us favorably might be said to be a masterpiece regardless of its human achievement or social significance: a sunset, a purple tulip, or a snapshot of someone's budgie. For the medieval artisan, the production of a *chef d'oeuvre* or masterpiece was a rite of passage from the position of apprentice or journeyman to that of master and a demonstration of skilled ability. In this sense, the word masterpiece could be and was applied to shoes, candlesticks, cabinets, and even a roast lamb as easily as to altarpieces, cathedral jamb figures, or a composition for a Requiem Mass; the only requirement was that it satisfy contemporary community standards of physical and visual quality. Works displaying radical individualism or unconventional historical styles were obviously excluded. Under these conditions and given the nature of today's corporate and popular tastes, both *Moonrise—Hernandez* and a *Playboy* centerfold might equally qualify as masterpieces, with little or no chance for that daguerreotype by Daguerre or allegory by Joel-Peter Witkin.

The most common, modern understanding of what a masterpiece is has been summarized by Sir Kenneth Clark, who wrote, "Although many meanings cluster round the word masterpiece, it is above all the work of an artist of genius who has been absorbed by the spirit of the time in a way that has made his individual experiences universal."[9] Following this definition, few would deny that Velázquez's *Las Meninas* is an unqualified masterpiece of painting, just as many would probably accept Alfred Stieglitz's *The Steerage* as a photographic masterpiece. Similarly, the same term could be applied with only a bit more difficulty to Rembrandt's *Self-Portrait* of 1658 in the Frick Collection and Etienne Carjat's portrait of Charles Baudelaire photographed around 1861. In each of these examples, the artist's intellectual grasp of the subject was combined with a pronounced technical skill and resulted in a pictorial masterpiece of lasting value. In each, also, the picture-maker was admittedly an artist, it mattering little, or not at all, if the individual picture was made for commercial or personal reasons. Rembrandt and Stieglitz both pursued their realization of artistic expression for ultimately private ends; Velázquez and Carjat were able to accomplish the same thing following the demands of commercial commissions. The point is that, as photographers, both Stieglitz and Carjat were also artists whose work could and still can be judged in artistic terms so long as these terms are recognized as being adamantly romantic and rather different from those that determined the classical ideal of artistic masterpieces.

Like much of Dutch painting of the 17th century, photography runs counter to the classical norm of art. Against the aesthetic doctrine of *invenzione*, which the 16th-century artist Vasari called the "mother" of all arts, photography poses the mechanical and the imitative. For centuries a work of art was viewed as essentially an image formed in the artist's mind—the *idea* or *disegno interno* ("inner design")—with the final picture, sculp-

ture, or whatever other form it took—the *disegno externo* ("outer design")—seen as merely a reflection of that mental image. For theologians like Thomas Aquinas and most art theorists from the Renaissance until the early 20th century, this *idea* demonstrated man's fundamental godlike nature.[10] The work of the individual artist, born as he was in the image of God, was an analogue to the original Creation, and as such needed nothing except the will to create from chaos and some materials to prove it. With parallels to divine ordination, the concept of a masterpiece of creative art and genius was secured, merging as it did the imagination, mind, and soul, and with it an image of the artist as sacred hero that has survived from Michelangelo to Jackson Pollock. Consequently, a painting by Velázquez or Rembrandt clearly would be eligible for masterpiece status, whereas a photograph by Stieglitz or Carjat would be just a photograph, despite numerous attempts over the years to create photographs that would stand the test of classical and early modern art.

External form was photography's *idea,* and for much of its history the photographer's invention was limited to the manipulation of concrete elements. The photographer's technical skills were not devoted to bringing a mental image into being; instead they were applied to a mechanical reflection of external nature. Obviously, this sort of picture-making proves incompatible with any traditional mode of critical assessment, for as one recent critic observed:

> How do you tell the good from the bad, especially when
> the factors of decision and intention do not merely
> operate differently from the way they do in painting, but
> may work *against* quality? Or how does one discriminate
> when the real source of interest is in subject matter or some
> equally circumstantial condition? No ready answers come to
> mind, and this perhaps causes the aesthetic situation in
> photography to be extremely fluid. Alarmingly but justi-
> fiably, anything goes. Photography from the beginning—
> and long before this fluidity was realized in art—posed
> the problem of a medium in which the artistic and the
> mechanical were ineffably mingled. Our current grow-
> ing sensitivity to the machinelike as a form of expression,
> and to the possibilities of the impersonal and chance-ridden,
> makes for a certain permissiveness toward the photograph.
> From this attitude we sanction those works in which
> the impersonal and random remain themselves and yet are
> eluded, works that inexplicably are thought to rise above an
> old convention or to establish a new one. The rest are
> painlessly and usefully forgotten in the mass of visual
> images that deluges society.[11]

Anonymity, the machinelike, and randomness are, it should be stressed, merely contemporary pictorial virtues, their currency bound to the modern era as distinctly as *disegno interno* was to the 16th century. And since it would be grossly ludicrous to address all contemporary photographs in terms of classical tradition (although some may demand it), it would also seem quite unfair to evaluate 19th-century photographs in light of either modern (or "post-modern") virtues and fashions (although at times it is tempting).

The virtues of modern criticism, however, have allowed us to take a backward glance across the last 150 years, and to view photography for the creative and expressive activity that it so frequently is, even when never intending to be art. Lacking divine ordination, pictures and other works of human manufacture might still speak to us with force and communicate with substance. Selection and choice are as potently spiritual as purely imaginative fabrications; machine forms and creative neutrality inspire and reveal hidden thoughts and emotions as do gestures of the hand or direct human contact; mathematics and information hold their own special beauty; unseen nature and the unsuspected inner dynamics of the seen world are as rich in potential human metaphor as ancient myths or classical literature, and, paradoxically, historicism is as vital as progressive innovation. Journalism and its forms are not that terribly different from fiction, nor is pure art any more removed from political engagement than social documentary. Images can connote and symbolize human ideologies and values as easily as they denote fact. In this climate, any photograph can become charged with significance, and in confronting the varied issues of quality and relative merit among pictures made in widely differing cultures and for more than a century and a half, it becomes equally obvious that photographers have created and continue to fashion images of lasting visual value that warrant being called "masterpieces."

Concluding his lectures on what constitutes the evaluation of quality in art, Jakob Rosenberg wrote:

> Should we despair because our investigation has resulted
> only in relative standards of considerable limitations
> and because little more than the reaffirmation of time-
> tested judgments has been achieved? I do not think so.
> After all, we set out to go only as far as we could with
> reasonable certainty, in the hope of strengthening the
> objective aspect of our judgment while recognizing that
> the subjective could not be eliminated. Besides, I feel it is
> hardly wasteful to have had practice in making discrimina-
> tions in a number of worthy works from various periods, while

attempting to avoid as far as possible the pitfalls that beset critics of the past....I believe that only a constant effort at proper discrimination can bring us progress, and that only in this way can the prejudices and the predilections which our own time forces upon us be counteracted and to a considerable extent corrected.[12]

Rosenberg's lucid analysis of various critical positions suggests a number of general approaches or guidelines to the discrimination of photographic quality, which have to some extent contributed to the pictorial choices and written commentaries in this volume. Simply stated, these have been to avoid the constraints of any current and dominant art or photographic theory (semiotics, deconstructivism, etc.), to attempt to appreciate the standards of excellence in place when and where the photograph was made (Victorian England, contemporary New Mexico, etc.), to avoid any mainstream notion of the limits of photography (thus photomontage, images sent from Voyager I, photomechanical prints, etc.), to apply whatever historical understanding of a piece is available to me (hence the numerous references and footnotes), and to respond to the salient formal qualities of the work wherever these seemed to reveal its import (e.g., Baldus, early modernism). Other than these, the choices, as mentioned above, were dictated by personal tastes, the particular complexion of the museum's collection, and, especially, a faith that the finest photographic images serve as emblems of human consciousness while they delight and inform.

All photographs are mementos of our profound singularity, moral reminders emblematically attesting to our limits and location, and, in spite of their often fragile characteristics and against all odds that they will soon fade, photographs were and are made to last—to serve as souvenirs of what came before or to endure as art. Whether of fact or imagination, photographs are records of times past and distant places, reflections of cultural aspirations as well as personal dreams, and memorials to visions and the experiences of what Joyce called the nightmare of history. While all photographs assist memory, the finest ones are testaments validating the more important facts and dreams of human achievement—the photograph as memorial. William Gass informs us that there is a common root to both memorial and memory, a word signified by the river Liffey at the end of *Finnegans Wake* where it sighs "Take. Bussoftlhee, mememormee!" "Mememormee" is, according to Gass, the motto of every monument and memorial whose purpose is "to return an idea to consciousness, to re-mind, and hence restore, a thought to life."[13] We might suggest a similar motive to every great photograph.

MASTERPIECES OF PHOTOGRAPHY

THE FIRST GENERATION AND THE BEGINNINGS OF A MEDIUM · 1839-1855

For, methinks, the understanding is not much unlike a closet wholly shut from light, with only some little openings left, to let in external visible resemblances, or ideas of things without: would the pictures coming into such a dark room but stay there, and lie so orderly as to be found upon occasion, it would very much resemble the understanding of a man, in reference to all objects of sight, and the ideas of them.

—John Locke, *Essay Concerning Human Understanding,* 1690

Nature has her artlessness, which must not be destroyed.

—Louis-Jacques-Mandé Daguerre, 1829

We have sufficient authority in the Dutch School of art for taking as subjects of representation scenes of daily and familiar occurrence. A painter's eye will often be arrested where ordinary people see nothing remarkable. A casual gleam of sunshine, or a shadow thrown across his path, a time-withered oak, or a moss-covered stone may awaken a train of thoughts and feelings, and picturesque imaginings.

—William Henry Fox Talbot, *The Pencil of Nature,* 1844

WITH THE SUDDENNESS that is a hallmark of the modern world, photography appeared in late 1839 as a fully mature pictorial art. Within months photographers were beginning to amass a pictorial record that has reverberated throughout our culture like no other medium. The first twenty years of photography were a period not only of invention and experimentation but also one in which the medium's broad potential for human expression and its varied alternatives were successfully explored. Practically every theme and motif valued in pictures was addressed by photography during this period, while certain photographers even sought, within the stylistic conventions of their time, to express the ineffable and spiritual that is customarily the province of art.

Louis-Jacques-Mandé Daguerre came to invent photography while searching for a tool that would help his painting achieve a greater accuracy of perspective and naturalistic detail. At nearly the same time, William Henry Fox Talbot arrived at a different process of photography. For him, the "magical" and furtive images found in the *camera obscura* were the final goal—an ideal with which no artist's hand could truly compete. From these two inventors came two distinctly different kinds of photography: the daguerreotype—a unique image on a small, highly polished, silver-plated piece of copper—and the Talbotype— more modern in that multiple paper prints could be generated from a single paper negative. For nearly two decades these two forms of photography vied with each other. Pigments were applied to daguerreotypes when color was needed, pairs of these silvered images were combined to create the illusion of spatial depth in stereo, and the daguerreotype plate was even chemically etched so its image could be printed in ink like an intaglio print. Calotypes or salted-paper prints (as Talbotypes came to be known) were painted, paired into stereos, waxed for greater transparency and luster, mass-produced and used in the first photographically illustrated books. The products of photography—its pictures—had even sparked substantial social and artistic criticism by the end of this period.

CHARLES-MARIE BOUTON

French · 1781–1853

Vaulted Gothic Ruin

ca. 1825 · Watercolor and graphite on paper · 22.2 × 32.3 cm.

A listing of paintings or sketches that the French painter and photographer Louis-Jacques-Mandé Daguerre might have done either as finished art or in preparation for the larger canvases of the Diorama would clearly indicate a penchant toward medieval ruins, gothic and romanesque architecture, abbeys and churches. Of twenty-six works catalogued, at least fourteen are of or include these subjects.[1] Clearly, such material was popular with the public attending Daguerre's Diorama during the 1820s and 1830s; as, indeed, it was for those viewing Charles-Marie Bouton's Dioramas in Paris and London during the same period. In a broadside published in 1825 for an exhibition of Bouton's paintings at the Louvre, twelve of the more than seventeen works are of ecclesiastical architecture or ruins.[2]

This charming sepia-colored watercolor by Bouton is undoubtedly connected to his work with the Diorama (a large pictorial entertainment and forerunner of today's cinema) which, according to most sources, he and Daguerre invented in the early 1820s. The French historian Gabriel Cromer, however, claimed that Bouton was only hired by Daguerre to assist in the laborious task of preparing the monumental canvases that exhibited a daylight effect when viewed by reflected light and a nighttime effect when illuminated from behind.[3] Bouton had studied painting with Jacques-Louis David and Jean-Victor Bertin, and he was a fairly capable painter of scenes and landscapes who won a gold medal in 1810, a "grand gold medal" in 1819 (although losing to Horace Vernet by only a single vote), and the *Légion d'Honneur* in 1824.[4] That Bouton was a master of perspective is fully demonstrated by such works as this watercolor sketch and by many of the pencil and ink drawings also in the George Eastman House collection [fig. 1].

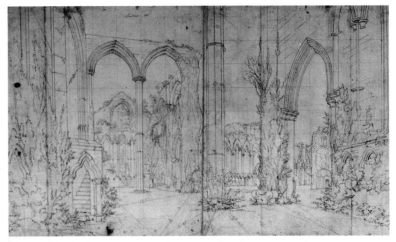

Fig. 1. Charles-Marie Bouton, (Interior of Diorama), pencil on paper, ca. 1830s. Unless otherwise specified, works illustrated as figures are from the George Eastman House collection.

Influenced by 18th-century architectural painters such as Pannini and Canaletto, Bouton's work falls squarely within the romantic interest in both medieval subjects and historical ruins fashionable in the decades immediately preceding the invention of photography. Paintings by the German Romantics Caspar David Friedrich and Karl Friedrich Schinkel are clear antecedants, just as Baron Taylor's and Charles Nodier's *Voyages pittoresques et romantiques en l'ancienne France*, which began publication in 1820, and Daguerre's *Ruins of Holyrood Chapel* of 1824 and *People Visiting a Romanesque Ruin* of 1826 are coeval examples of the cultural matrix in which Bouton worked.[5]

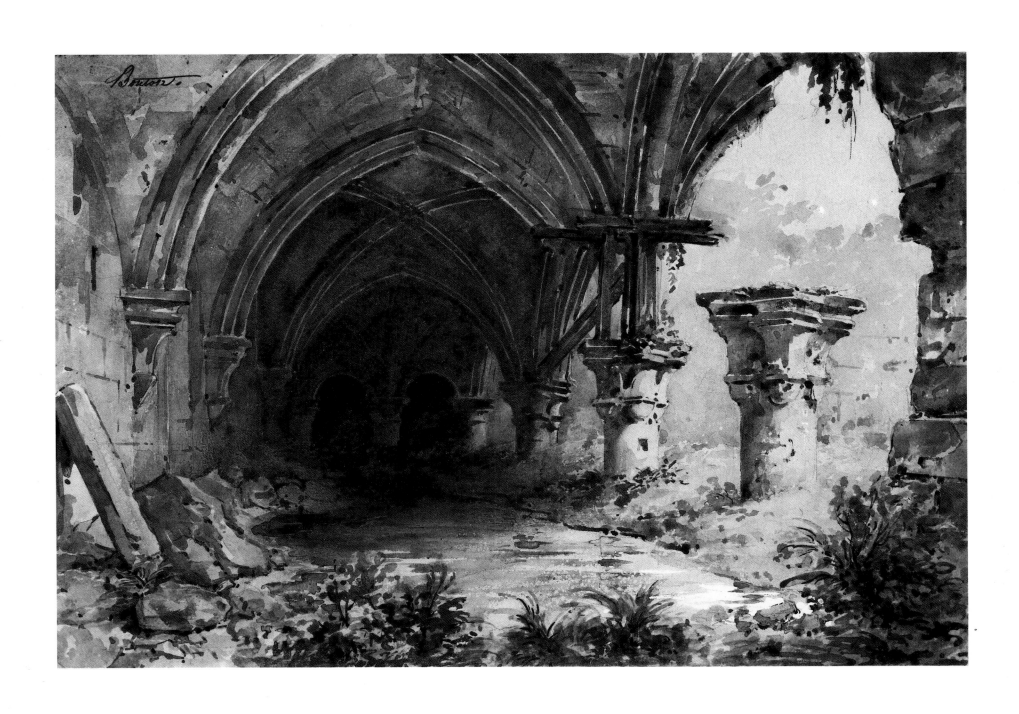

17

L. MARQUIER

French · active 1830s

The Notre-Dame Pumphouse

ca. 1839 · Lithograph, printed by Desportes · 20.2 × 14.0 cm. (image)

While not the very first lithograph copied from a daguerreotype plate, this is certainly one of the most striking of those made in the first few months following Daguerre's announcement of his invention in August, 1839. Marquier was the lithographer of at least four such images, beginning with an apsidal view of Notre-Dame de Paris itself, which was published in the journal *Le Lithographe* in October of that year.[1] The other three prints were published in what appears to have been either a small publication entitled *Le Daguerréo-Lithographe* or a series of lithographs with that title printed above the image. Besides the Notre-Dame pumphouse, Marquier lithographed *Le Pont-Neuf* from a daguerreotype provided by Noël-Marie Paymal Lerebours and *Le Panthéon* from a daguerreotype made by Soleil fils. All but this print clearly indicate that the lithographer was L. Marquier; here the artist is identified as "L. M. de V . . . after a Daguerr. print obtained from Lerebours." Thus, Marquier's authorship of this lithograph must at present remain an attribution, although a fairly comfortable one. It was perhaps the same L. Marquier who, in 1863, published a photolithograph of the façade of Notre-Dame.[2] All four of these lithographs from early daguerreotypes were printed by Desportes at the Royal Institute for the Deaf and Dumb; examples of each are in the museum's collection.

As for the authorship of the original daguerreotype, it is significant that in the view of the Panthéon Marquier indicated that it was taken from a daguerreotype "by" (*par*) Soleil fils, whereas, with both the view of the Pont-Neuf and this view, the lithographer used daguerreotypes "obtained from" (*obtenue par*) Lerebours. It would appear that Lerebours was already publishing printed copies from daguerreotypes prior- to his commissioning daguerreotypists to photograph international monuments and sites for his serial publication of lithographs and engravings, *Excursions daguerriennes: vues et monuments les plus remarquables du globe*, which appeared between 1840 and 1843 but was dated 1841 et seq. While the names of many of the daguerreian artists who worked for Lerebours on this project are recorded, the name of the photographer who took this view of the Notre-Dame pumphouse is unknown.

Two water pumps, one a suction pump and the other a force pump, had traditionally dominated the Notre-Dame Bridge. Originally built in 1676, they were strengthened in 1708 and rebuilt in 1777, despite their being a considerable obstacle to the flow of the Seine.[3] At first they pumped water to fountains

Fig. 2. Charles Meryon, *The Notre-Dame Pumphouse*, etching, 1852; from G. Geffroy, *Charles Meryon*, Paris, 1926, facing p. 124.

on both banks of the river, from which citizens could retrieve it; later, this single one pumped water for fighting fires. The pumps were permanently removed in 1861.

In 1852, the French artist Charles Meryon etched a view of the same subject showing the square tower of the pump atop two structures supported by crudely hewn timbers enclosing the pump's wheels [fig. 2]. Meryon's view, however, is from river level along the Left Bank, which allowed him to isolate the pumphouse and include the towers of Notre-Dame in the background.[4] In a letter to the critic Paul Mantz, Meryon confided that he exaggerated certain of the details in his picture.

> The Notre-Dame pumphouse is fairly close to an exact reproduction of that building which they say is soon to be destroyed. I feel I am, however, permitted some small changes in modifying the relationships of certain parts so as to raise the monument from its clumsy weight.[5]

The daguerreian artist who photographed the pumphouse in 1839 could not as easily modify his subject. He simply took the opposite view, from atop the quai and looking over to the houses of the 5th arrondissement. By choosing this point of view, he blended the architecture of the pumphouse in with the fabric of the Parisian backdrop and supported the entire cityscape with the pumphouse's timbers.

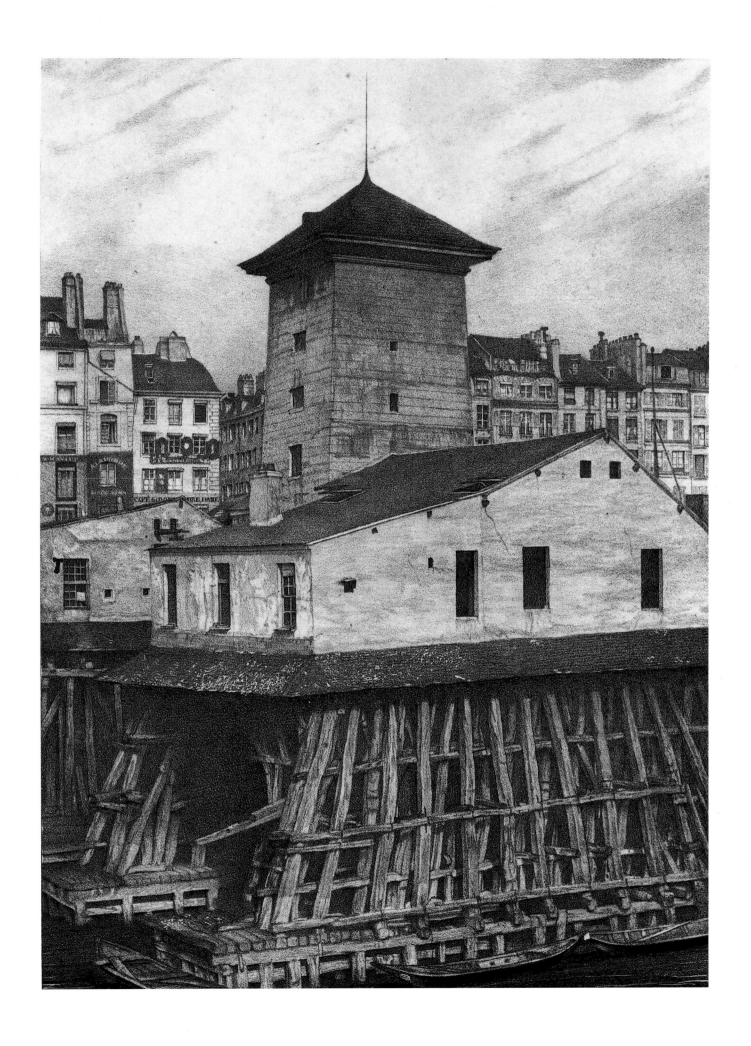

ARMAND-HIPPOLYTE-LOUIS FIZEAU

French · 1819–1896

House Elevation, Rue St. Georges, by M. Renaud

ca. 1842 · Photographic etching from daguerreotype · From: Nöel-Marie Paymal Lerebours, *Excursions daguerriennes: vues et monuments les plus remarquables du globe*, Paris, 1841–43, II, unnumbered plate · 14.2 × 19.1 cm. (image)

Despite the fact that no mention of this plate's title appears in the index to the French optician Lerebours's celebrated *Excursions daguerriennes...* of 1841–43,[1] this print originally was bound into a set of the two volumes presently in the museum's collection. Like the other engravings and etchings based on daguerreotype plates in the *Excursions daguerriennes...*, the print is mounted on a sheet bearing the same style of letterpress as the others, which states that the original daguerreotype was taken for Lerebours and that it was, like a few other plates in the publication, engraved by the Fizeau process.

Until Fizeau discovered a method of chemically etching the daguerreotype plate itself, any reproduction of the daguerreian image was a product of manual translation of the photograph to a steel engraving; in other words, an engraver had to copy the details of the daguerreotype onto a steel plate that could hold printing ink. This process accounted for the appearance of such publications as *Album du daguerréotype reproduit* (Paris, ca. 1840), Charles Philippon's *Paris et ses environs reproduits par le daguerréotype* (Paris, 1840), and the illustrations in John Lloyd Stephens's *Incidents of Travel in Yucatan* (New York, 1843). It was only toward the end of the publication of *Excursions daguerriennes...* that Fizeau came across a method of transforming the camera's vision into a printed one without the necessity of copying or tracing. Fizeau's breakthrough was signaled in a footnote in Lerebours's *Treatise* in 1843, indicating just how recent a discovery it was.

Mr. Fizeau, so well known for his admirable discoveries in photography, has just found out a process for engraving the Daguerreian plates, which is very superior to any hitherto known. We have seen some of the proofs struck off, without any particular care, by a workman of ordinary ability, and we can affirm that the most of these engravings, when seen through a magnifying-glass, showed the exact representation of the Daguerreian image, with its most minute details. Moreover, in the proofs which have been submitted to our examination, the dark parts of the picture were reproduced with a great degree of vigour, and, what is very remarkable, the white parts of the paper were perfectly pure. When one reflects on the future results of this discovery, one cannot be surprised that Mr. Fizeau should have wished to keep it secret. For our own part, it would be of immense utility to us for the publication of the *Daguerreian Excursions*; for, with its aid, we might immediately reproduce, at very small expense, the remarkable views which our correspondents are continually sending us; and, in order to avoid any greater or lesser alteration in the press, we should immediately reproduce several plates by the electrotype.[2]

Obviously Lerebours heeded his own advice and utilized Fizeau's patented process, since at least three of the plates in the *Excursions daguerriennes* are produced by the Fizeau process.

Later, Lerebours wrote that "in order to have a good engraving, it is first of all necessary to have an irreproachable daguerreotype plate, which is not common; but once that condition is fulfilled, one can be assured of finding all the details of the photographic print in the engraving."[3] Considering the detailing in this image, a similarly irreproachable plate must have been used by Fizeau for his photo-etching of this house by the architect Renaud.

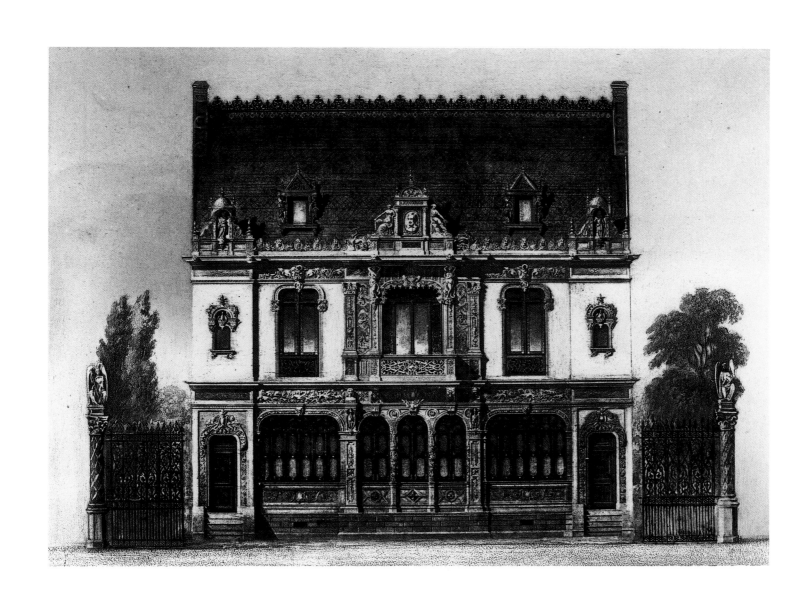

LOUIS-JACQUES-MANDE DAGUERRE

French · 1787–1851

Portrait of an Unidentified Painter

ca. 1842–43 · Daguerreotype · 10.5 × 8.3 cm., quarter plate

The principal reference to this artist lists only six known daguerreotypes made by L.-J.-M. Daguerre that are specifically portraits, and of these only three are extant: a portrait of the inventor's wife at the Science Museum in London, another of Mme. Daguerre's niece, Georgina Arrowsmith, in the collection of the *Société française de photographie* in Paris, and this portrait of a painter, whose identity only can be suggested.[1] Whereas a few of the known daguerreotypes by Daguerre have autographed inscriptions on the verso of the plates or frames attesting to their authorship, this portrait is the only one that bears his signature on the face of the plate.

The soundest speculation concerning the subject of this daguerreotype centers around his portrayal as a painter, sporting an artist's smock and holding a palette and brushes. Daguerre married Louise Georgina Smith (nee Arrowsmith), born in France of British parents and the older sister of Charles Arrowsmith, a painter living in Paris who was to become Daguerre's assistant at the Diorama. While there is no absolute evidence that the "artist" pictured here was Charles Arrowsmith, it is reasonable to suppose that a brother-in-law and business colleague would have been a convenient sitter for such an early daguerreian portrait. Daguerre never established a commercial portrait studio, even after the early 1840s when portraits could be confidently taken, but, like so many other pioneering photographers of the last century, he turned to his immediate family and associates when attempting portraiture.

Besides his wife and niece, Daguerre also photographed the family cook, in 1844,[2] and another painter who assisted on the Diorama, Louis-François-Nicholas Gosse, in 1843. The Gosse portrait was shown to the *Société française de photographie* in 1864 and it bore the inscription, "To my friend Gosse. Daguerre. Made in six seconds in hazy weather, in 1843," on the verso of the plate.[3] Were it not that Gosse would have been in his mid-fifties when this daguerreotype was taken, it would be tempting to suspect the portrait to be of him.

A few years after Daguerre made this portrait, the critic and poet Charles Baudelaire wrote a simple yet perfect definition of the portrait image.

> The first quality of a draughtsman is therefore a slow and sincere study of his model. Not only must the artist have a profound intuition of the character of his model; but further, he must generalize a little, he must deliberately exaggerate some of the details, in order to intensify a physiognomy and make its expression more clear.[4]

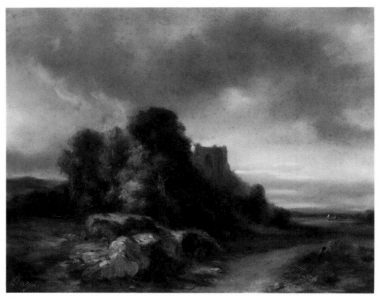

Fig. 3. Louis-Jacques-Mandé Daguerre, landscape with ruins, pastel, ca. 1820s.

It is obvious that, while never attaining the rank of one of the great portraitists of the last century, Daguerre consciously strove to render more than a prosaic likeness. His painter assumes the pose and *hauteur* of a dandy, dresses in the perquisite romantic smock (a studied disarray carefully attended to), and wears the face of thoughtfulness. Daguerre's photograph is more an image of the ideal artist than a portrait of a specific painter, and is much closer in sensibility to, say, Ingres's early romantically classical portraits such as that of François-Marius Granet of ca. 1807 or Charles-Joseph-Laurent Cordier of 1811 than to a more modern portrait of the 1840s such as Jean-François Millet's rendering of his brother-in-law Armand Ono of 1843 or Hippolyte Flandrin's *Portrait of Mme. Vinet* of 1840.[5] The presence of a painted landscape background behind the painter similarly recalls earlier 19th-century portraits where the sitter is depicted before a scenic, usually pastoral vista.

Each of the painters who worked on the Diorama was a capable draughtsman and many were landscapists. This is especially true of Charles-Marie Bouton, and more than likely both Arrowsmith and Gosse were also called upon to render the monumental landscape backgrounds at the Diorama. Daguerre himself was a fairly talented landscapist, as may be seen in the six drawings, one pastel, and one oil painting in the museum collection [fig. 3].

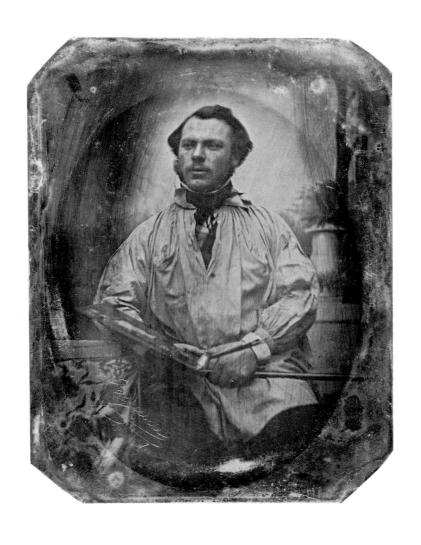

JEAN-BAPTISTE SABATIER-BLOT

French · 1801–1881

Mme. Sabatier

ca. 1844 · Daguerreotype · 10.7 × 8.3 cm., quarter plate

Jean-Baptiste Sabatier was born in Lassur (Ariège) in January, 1801. After leaving seminary training due to ill health, he followed his youthful penchant toward art and devoted himself to painting. As a miniaturist, he moved to Paris and first exhibited at the Salon of 1831, the same Salon at which Delacroix exhibited his revolutionary painting, *The 28th of July, Liberty Leading the People*. A year before Daguerre presented photography to the world, Sabatier married a Mlle. Blot, who bore him a child, Maria, in 1839; these two and the artist's mother-in-law, Mme. Blot, are the subjects of at least eight daguerreotypes in the museum's collections. Sabatier, who most frequently signed his name hyphenated with that of his wife, recognized the best qualities of the miniature portrait in the daguerreotype, and he became a student as well as a close friend of Daguerre himself. Sabatier's portrait of Daguerre is considered by Cromer to be the earliest daguerreotype portrait of the inventor[1] [fig. 4]. On the verso of the Daguerre portrait, Sabatier had written: "Daguerre. Ce portrait a été fait par Sabatier-Blot, son ami, en 1844" ("Daguerre. This portrait was made by Sabatier-Blot, his friend, in 1844"); Daguerre was fifty-seven years old at the time of the sitting.

Sabatier's final exhibition of painted miniatures was at the Salon of 1843; the following year he presented a collection of his daguerreotypes at the *Exposition des Produits de l'Industrie*, for which he received an honorable mention. In 1847, the daguerreotypist J. Thierry praised Sabatier for the perfection of his plates and considered the artist at the "summit of the art" of the daguerreotype.[2] In 1849, he again exhibited his daguerreotype portraits at that year's *Exposition des Produits de l'Industrie*, and in 1851 he was one of the founding members of the *Société française de photographie*, then called the *Société héliographique*. During the 1850s, Sabatier adopted the wet collodion process and specialized in carte-de-visite portraits, none of which was exceptional.

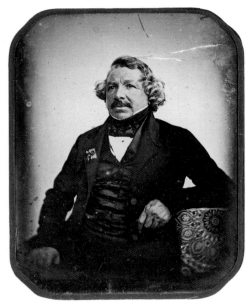

Fig. 4. J.-B. Sabatier-Blot, *Louis-Jacques-Mandé Daguerre*, daguerreotype, 1844.

Sabatier's likeness of his wife is an absolute classic of early French daguerreotype portraiture, and an absolute masterpiece of photographic syntax. A portrayal obtained with a complete lack of applied style or artifice, it is a document of a profound countenance and subtle gesture that is both resolute and tender. Mme. Sabatier-Blot, attired in plain, perhaps mourning, clothes, presents a simple, direct demeanor, and her presence is made even more forceful by the nearly incidental inclusion of a table corner and the strikingly material substance of her shadow. Only certain of Southworth and Hawes's daguerreotypes or Paul Strand's portrait of a blind woman come close to the iconic strength of this portrait.

ROBERT CORNELIUS

American · 1809–1893

Self Portrait with Laboratory Instruments

1843 · Daguerreotype · 8.3 × 7.7 cm., sixth plate

Originally thought to be a portrait of the Philadelphia chemist Hans Martin Boye (on the basis of an engraved copy of the hands and instruments found in Booth's *The Encyclopedia of Chemistry . . .* [1] [fig. 5]), the human subject of this eccentric image is now known to be the photographer himself, Robert Cornelius, one of America's photographic pioneers. Another Cornelius daguerreotype in the museum's collection does portray Boye, and with the same beakers, filter stand, and bottle [fig. 6]. Both images, as well as yet another in the museum's collection, were the result of the same sitting in December, 1843, and it is fascinating to conjecture whether Cornelius turned the camera's operation over to Boye for this exposure. Cornelius and Boye were friends, and both were conversant with physics and chemistry, two of the technical mainstays of photography. It would seem

Fig. 6. Robert Cornelius, *Hans Martin Boye with laboratory instruments*, daguerreotype, 1843.

Fig. 5. Anonymous engraver, illustration to Hans Martin Boye's article on "Analysis," from James Curtis Booth, *The Encyclopedia of Chemistry . . .*, Philadelphia, 1850, fig. 18.

that this sitting took place the year after Cornelius closed his photographic studio.

The ease and relative informality of the pose, its nearly surrealist irony, and its utter lack of any normative pictorial aesthetics (but perfectly photographic in its fashion) demonstrate a sense of play and casual facility seldom encountered in very early daguerreotypes—this from an artist who began daguerreotyping in 1839 and established this country's first photographic studio in Philadelphia. Most probably, this image was created as a model for a later engraver to copy for the illustrations to Boye's article, as was its companion piece; yet it remains a memorable icon to 19th-century science and one of the more fascinating so-called "occupational" daguerreotypes in which the subject is portrayed with the tools of his or her trade.

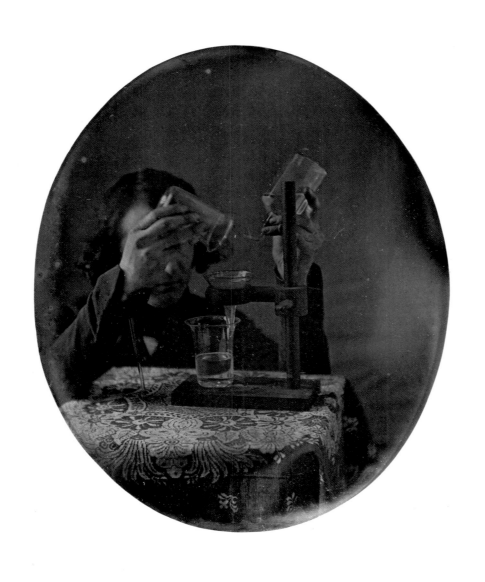

UNIDENTIFIED PHOTOGRAPHER

French · active 1840s

Man Seated in Front of Garden Wall

ca. 1845–50 · Daguerreotype · 16.5 × 21.7 cm., full plate

An enchanting and beautiful daguerreotype of a Frenchman dressed in Second Republic day-clothes and seated amid the trellising of a walled garden, this early photograph suggests a boundary between the posed formal portrait and the domestic garden scene so popular during the mid-19th century. A scene of middle-class realism, the subject was both comfortable and convenient, not only for painters but especially for photographers.

William Henry Fox Talbot in England and Hippolyte Bayard in France had each rendered similar subjects; and while Talbot vacillated between scenes of vacant gardens and those of simulated activity, Bayard practically duplicated this particular image many times in his paper prints.[1] In fact, the trellised gardens and straight-backed chairs are similar enough in Bayard's prints and in this anonymous daguerreotype that it is tempting to consider him the author of the work [fig. 7]. Such circumstantial evidence, however, no matter how attractive it may be, is not sufficient enough to make this attribution. Furthermore, while Bayard certainly was familiar with Daguerre's process, there is no indication that he ever applied it to making images on metallic plates.

Early photographers gravitated to the figured garden scene for the simple expedient of finding there a picturesque setting close to their studios and one that would also be saturated with daylight. Later in the century, even when glazed photographic studios allowed for portraiture indoors, photographers continued to take their equipment into the garden and depict their families

Fig. 7. Hippolyte Bayard, *The Arbor*, calotype, 1846-48, modern print from original negative, courtesy *Société française de photographie*, Paris.

and friends among bowers, flower beds, and leafy nooks. Photographers like Blanquart-Evrard, Humbert de Molard, Maxime Du Camp, and Alphonse Poitevin had each added to a photographic tradition that paralleled a similar trend in painting and that culminated in the effusion of peopled gardens as depicted by the French Impressionists.

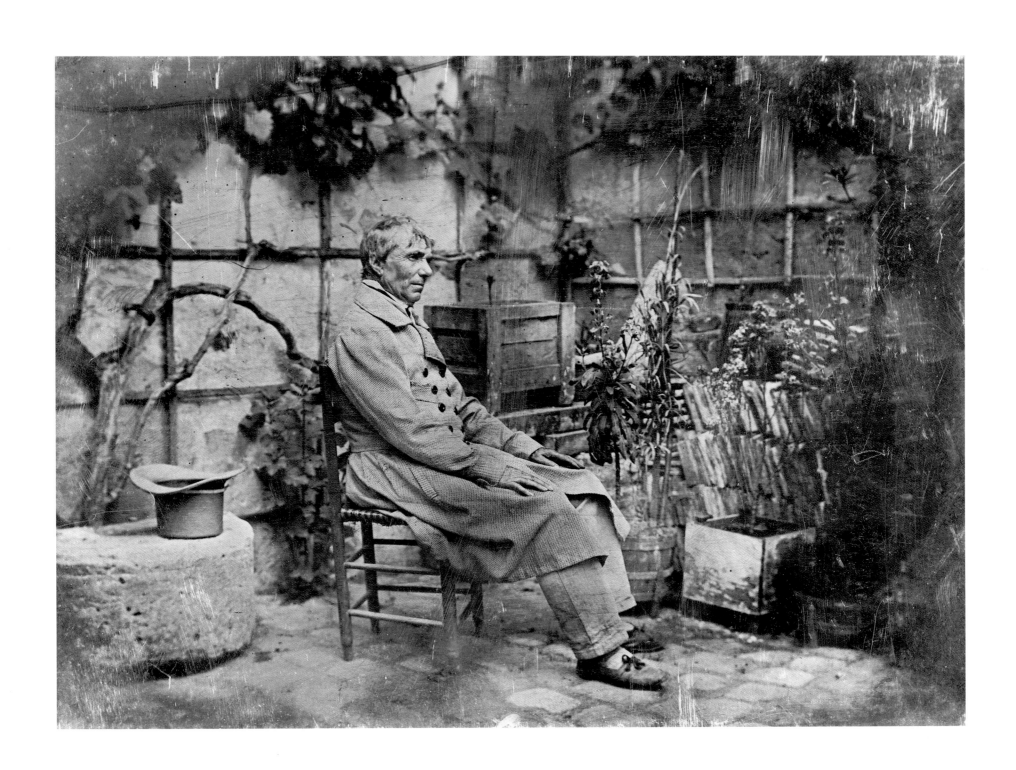

WILLIAM HENRY FOX TALBOT

British · 1800–1877

Lace

ca. 1845 · Salted paper print · 23.0 × 18.8 cm. (irregular)

Talbot was an etymologist, crystallographer, chemist, astrono-mer, physicist, mathematician, House of Commons member, and a specialist in Assyrian cuneiform inscriptions. He was also and incidentally the inventor of photography as we know it today; namely, the process of achieving multiple positive prints from a single negative image obtained by chemically developing out the latent image produced in the negative after exposure in a camera.[1] Like many photographic pioneers, both successful and not, Talbot was fascinated by the images he traced on the glass of a *camera obscura*, those "fairy pictures, creations of a moment, and destined as rapidly to fade away. . . . how charming it would be if it were possible to cause these natural images to imprint themselves durably, and remain fixed upon the paper!"[2]

The course of his scientific reasoning led him, around 1833, to frame the fundamental issue of photography with elegant economy.

> The picture . . . is but a succession or variety of stronger lights thrown upon one part of the paper, and of deeper shadows on another. Now Light, where it exists, can exert an action, and, in certain circumstances, does exert one sufficient to cause changes in material bodies. Suppose, then, such an action could be exerted on the paper; and suppose the paper could be visibly changed by it. In that case surely some effect must result having a general resemblance to the cause which produced it: so that the variegated scene of light and shade might leave its image or impression behind, stronger or weaker on different parts of the paper according to the strength or weakness of the light which had acted there.[3]

By experimentation at his home at Lacock Abbey, Wiltshire, Talbot was able to stabilize these "fairy images" by the autumn of 1834. By late 1839, the date of Daguerre's announcement of his process, Talbot had found how to more permanently fix his prints, and had published his paper "Some Account of the Art of Photogenic Drawing, or the Process by Which Natural Objects May be Made to Delineate Themselves Without the Aid of the Artist's Pencil." A year later, in 1840, he had discovered the latency of the image produced in the negative after a very brief exposure (invisible but susceptible to development with gal-lic acid) and had named the technique "calotype." By 1844, Talbot and his Dutch manservant Nicolaas Henneman had established a calotype printing studio in the industrial town of

Fig. 8. William Henry Fox Talbot, *Lace*, salted paper print, ca. 1844, pl. xx from *The Pencil of Nature*.

Reading and had supplied the photographic frontispiece to the very first printed publication illustrated by photography.[4] In June, 1844, the first fascicle of Talbot's masterpiece, *The Pencil of Nature*, appeared with four calotypes and accompanying texts; five further issues subsequently would be published between then and 1846.

Another *Lace*, the last plate in the fifth fascicle of *The Pencil of Nature*, is an anomaly in the book's illustrations [fig. 8]. First, it is not technically a photograph; since it was not produced by a negative but by directly laying a piece of lace atop sensitized paper and exposing it to light, it might be more properly called a "photogram." Second, as Talbot himself claimed in the text to this image, "it is called in the language of photography a *negative* image."[5] If this negative were to have been printed to form a positive image, Talbot explained, the lace would have appeared black against a white background—as it does here—and would not have been as clear since it would have been a second-generation image. It is instructive to realize that both photo-grams and negative printing, found to be so expressive by avant-garde photographers of the 1920s like Moholy-Nagy and Man Ray, were accepted as viable options from the very begin-ning of photography.

DAVID OCTAVIUS HILL and ROBERT ADAMSON

Scottish · 1802–1870 Scottish · 1821–1848

Professor James Miller

ca. 1846 · Salted paper print · 11.9 × 14.0 cm.

In the museum's collection of five calotype negatives and more than two-hundred salted paper prints by the Scottish team of Hill and Adamson, there is this rare portrait of James Miller (1812–1864), Professor of Surgery at Edinburgh University. Adamson, a young, consumptive calotypist, had opened his Edinburgh studio in 1843, and in July of that year the British physicist Sir David Brewster informed Fox Talbot that Adamson had "crowds every day at his studio."[1] On May 23 of that same year, nearly 500 ministers of the Church of Scotland resigned and established the Free Church of Scotland. D. O. Hill, a Scottish painter and member of the Royal Scottish Academy of Fine Arts, had been present at the signing of the Act of Separation and Deed of Demission on that date and shortly afterwards began work on a large, commemorative painting of the event, including portrait likenesses of each of the ministers [fig. 9]. Sir David Brewster, again, suggested that Hill would benefit by taking advantage of the new process of calotypy in rendering such a large number of portraits faithfully, and to that end Hill was introduced to Adamson. In a letter dated 3 July, Brewster wrote to Talbot:

> Mr. D. O. Hill the Painter is in the act of entering into partnership with Mr. Adamson, and proposes to apply the Calotype to many other general purposes of a very popular kind, and especially to the execution of large pictures representing diff. bodies & classes of individuals. I think you will find that we have, in Scotland, found out the value of your invention not before yourself, but before those to whom you have given the privilege of using it.[2]

Between 1843 and Adamson's death in 1848, the team produced hundreds of single and group portraits, some anecdotal stagings and views of Edinburgh, and a few landscapes. At first, they indicated that the pictures were "Executed by R. Adamson under the artistic direction of D. O. Hill" or ". . . designed and arranged by D. O. Hill and executed by R. Adamson."[3] Later, they simply claimed co-authorship of this impressive body of early photography and its unparalleled achievement in photographic portraiture. Clearly, theirs was a traditional portrait

Fig. 9. Thomas Annan, *"The Signing of the Act of Separation and the Deed of Demission 23 May 1843" by D. O. Hill*, albumen print, 1866, Museum purchase, Miller-Plummer Fund.

style. It customarily exhibited all the required factors of formal posing, Rembrandtesque lighting, physiognomic expression, and symbolic revelation found in academic portraiture, such as that by Sir Joshua Reynolds, Thomas Gainsborough, and Benjamin Robert Haydon. Periodically, however, the team would create a portrait that was out of keeping with academic tradition, or one that was surprisingly modern in its photographic vocabulary, such as a back view of the subject, but these were exceptions.

The portrait of Professor James Miller is a paradigm of the traditional portrait. Like so many saints of the Baroque era, Professor Miller is portrayed with the supreme symbolic artifact of his and humanity's mortality, which he roundly yet gently clasps as if disrupted from contemplation. Pictorially, the convention is that of the scholarly Saint Jerome in his study, the brooding Dane whose concentration is broken by approaching intrusion, or melancholia herself obsessed by the inevitable. Photographically, however, it is a portrait of a learned surgeon gently proferring the emblem of his profession, the human body reduced to its essential sign. Miller was one of the original members of the Free Church of Scotland, and Hill and Adamson made a number of other portraits of him, including one in which he posed with Hill in feigned distress after a night of drinking.[4] The many portraits of Master James Miller by Hill and Adamson are of the professor's son.

ANTOINE-SAMUEL ADAM-SALOMON

French · 1818–1881

Profile of a Woman

ca. 1848 · Daguerreotype · 8.3 × 6.9 cm., sixth plate

Relatively little has been written about Adam-Salomon, clearly one of the principal portrait photographers of the Second Empire, and one who shared a public esteem with the likes of Nadar, Carjat, and Pierre Petit. The tremendous fame this sculptor-turned-photographer enjoyed was signaled by a review of his very first exhibition of portraits in 1859, the same year Baudelaire published his famous attack on photography's pretensions to art. Writing in *La Lumière*, the noted French photographic critic Ernest Lacan wrote:

> The name of M. Adam Salomon [sic], the distinguished sculptor responsible for the very popular medallion of Charlotte Corday and the exceptionally accurate bust of Lamartine, figures for the first time in the catalogue of a photographic exhibition. When an artist of this stature enters our field, we all clap our hands and shout *Hosanna!* The debut of this new talent is a triumph and has to be reckoned with. His portraits have that magisterial character which comes from a profound study of art. Here, in the resolution of movement and beauty of line, one discovers the sculptor whose eye is fully accustomed to antique models. [1]

Comments as critically positive as these are fully understandable when confronting a paper print portrait by Adam-Salomon (Lacan was reviewing albumen prints in 1859) such as that of the architect Charles Garnier, published in woodburytype in *Galerie Contemporain*, 1877 [fig. 10].

Much less is known about Adam-Salomon's daguerreotype portraits, those images that were of such significance in impressing the French poet and statesman Alphonse de Lamartine and causing his complete change of heart about photographic art. In 1852, Lamartine wrote (*Entretien 36*) that photography was nothing more than "an optical plagiarism of nature"; soon afterward, apparently, he reversed his opinion and stated: "Since then we have admired the marvellous portraits taken in a radiance of light by Adam Salomon. . . . it is better than an art, it is a solar phenomenon where the artist collaborates with the sun." [2] In the same discourse (*Entretien 37*), Lamartine also exclaimed that "photography is the photographer."

More than likely, Lamartine was responding to Adam-Salomon's daguerreotype portraits, for the sculptor is known to have produced only daguerreotypes and albumen prints, and it is not likely that he was printing on albumen as early as Lamartine dates his encounter. The museum is fortunate in having eighteen of Adam-Salomon's daguerreotype portraits, including this rather striking profile of a woman. Adam-Salomon's skill at "Rembrandtesque" lighting and his suffusion of the model within an illumination that dramatically amplifies the volume

Fig. 10. A.-S. Adam-Salomon, *Charles Garnier,* woodburytype print from *Galerie contemporain, Littéraire, artistique,* 1877.

and relief of the subject are clearly evident in this image in spite of the abrasions suffered by the delicate surface. That the woman is recorded in strict profile may suggest that the photograph was taken with the idea of transforming it into a medallion sculpture, a practice frequently used by Adam-Salomon.

In the late 1860s, Adam-Salomon published certain of his thoughts on the art of photography. In them, he essentially posed a response to Lamartine's notion that the artist is what constitutes a medium.

> When the artist is interested in his work, and believes in his art, it becomes wonderfully plastic, and the materials wonderfully tractable in his hands, and he soon ceases to be concerned about his tools. For my own part, I lose sight of considerations as to the mechanical appliances, except so far as they require to be accommodated to the necessities of the picture. The rough instrument ceases to exist for me, absorbed as I am by the idea of reproducing my ideal. . . . In photography, as in art, when the sentiment is energetic, it can never be sterile. [3]

It should also be noted that later 19th-century photographers fully recognized Adam-Salomon's prominence as a portrait photographer. Peter Henry Emerson dedicated the first edition of his *Naturalistic Photography for Students of the Art* to "the first artist of acknowledged ability who was original enough to practise photography for its own sake, and who was brave enough to appear before a prejudiced art world as a photographer as well as a sculptor." [4] Henry Peach Robinson, a friend of Adam-Salomon, wrote that "It was at the Paris International Exhibition of 1867 that the works of Adam Salomon first became known to English photographers, and they at once created perhaps the greatest sensation that has ever occurred in our art . . . and immediately began to have an extraordinarily beneficial effect on the practice of professional portraiture." [5]

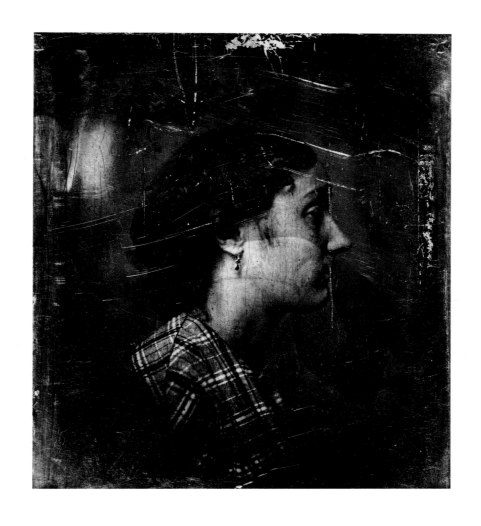

SAMUEL LEON WALKER

American · 1802–1874

The Artist's Daughter

ca. 1847–54 · Daguerreotype · 10.7 × 9.4 cm., quarter plate

Samuel Leon Walker was essentially little more than a local photographer, working most of his professional life in Poughkeepsie, New York; but he did manage to produce some rather sensitive and haunting daguerreotype images of his family, many of which are in the museum's collections.

Walker was a daguerreotypist, photographer, essayist, less-than-brilliant poet, journalist, editor, and a "devotee in the fullest sense to the doctrine of Life and Progress as taught by the Spiritual School."[1] He may have been an assistant to Samuel F. B. Morse in New York in 1839, and he may have been in partnership with another photographer named Gavit in Albany during the mid-1840s. He settled in Poughkeepsie in 1847, where he remained the rest of his life. He was a believer in the teachings of the "Psycho-Magnetic Physicians" Dr. and Mrs. J. R. Mettler of Hartford, Connecticut, was obsessed with the idea of death, and wrote his own obituary two years before he died.[2]

An obituary published *after* the artist's death characterized Walker as "a man of great artistic taste, and fervent love for his profession, withal possessing some eccentricities that made him a marked man."[3] Such a taunting set of references may be explained by the possibility of mercury poisoning, a risk suffered by many daguerreotypists and one that might explain Walker's disappearance from newspaper advertisements during the 1850s, or by exposure to potassium cyanide, a toxic chemical most likely used by Walker when he was involved with cleaning daguerreotypes during the 1860s.

This daguerreotype of Walker's daughter is quite special. Here Walker went beyond a mere prosaic rendering of the subject and unhesitatingly arranged the young girl in an attitude of winsome, narcissistic revery and eroticized daydreaming. A comparison between this image and a number of Lewis Carroll's depictions of young girls is difficult to avoid, but it would be superficial for the most part. Walker's daughter is alone; there is no response by her to an imagined or real viewer, as with Carroll's subjects. She is totally idealized, her nakedness as much promised as apparent, her body casually draped with a luxuriant carpet, and her long, corkscrew ringlets assuming an emphasis that is redolent of sensuality. Undoubtedly, this image was a private affair for the photographer/father, an image possibly fashioned by a semisweet realization of incipient blossoming.

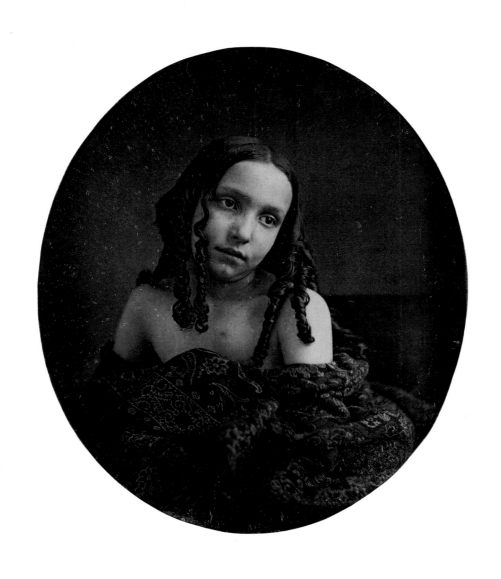

JEAN-GABRIEL EYNARD-LULLIN and JEAN RION

Swiss · 1775–1863 Swiss (?) · (dates unknown)

M. Eynard, Griselda, Felix

ca. 1843–52 · Daguerreotype · 16.9 × 21.1 cm., full plate

Eynard-Lullin was a banker, financial advisor to the queen of Etruria and the grand duke of Tuscany, and an attaché of the Geneva delegation to the Congress of Vienna in 1814. He devoted much of his life and fortune to Swiss independence and cantonal confederation. In Geneva, he built the Palais Eynard and the Atheneum. He also must have been one of Switzerland's first photographers of merit.

As early as 1843, N.-M. Paymal Lerebours wrote about the various techniques available for the polishing of daguerreotype plates, and advised against the then seemingly fashionable use of oil as part of the polishing process. "Amongst the most beautiful proofs we have ever seen," wrote Lerebours, "are those of a distinguished amateur, Mr. Eynard, who has entirely excluded the use of oil from his preparations."[1]

This positively charming portrait of Eynard, his horse Griselda, and a groom named simply Felix, all posed before a highly graphic diamond-patterned set of stable doors, presents a slight problem. If Eynard were the daguerreian artist, just who was responsible for taking the group portrait in this period before self-timers and remote shutter releases? Michel Auer, whose collection contains about 100 daguerreotypes by Eynard, found a comment on the verso of one of them that stated: "Jean Rion, servant at Eynard's home, who assisted him with his daguerreotypes."[2] It is all very probable that, like John Ruskin in England at about the same period, Eynard trained his servant in the craft of daguerreotypy; this would explain the relatively large number of plates that depict Eynard himself. Besides portraits, the Eynard daguerreotypes include many views of the gardens and facades of the Palais Eynard, and, in a sense, constitute one of the earliest, if not the first, amateur collection of domestic snapshots.

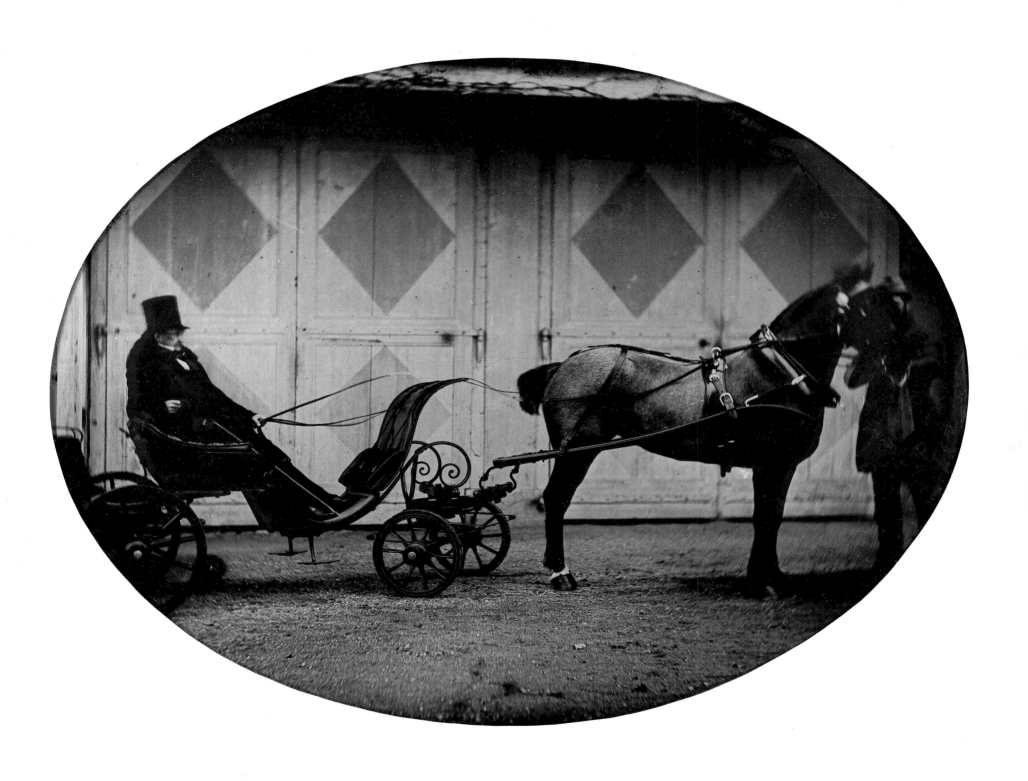

FREDERIC MARTENS

French · b. Germany · ca. 1809–1875

Panorama of Paris

ca. 1844–45 · Daguerreotype · 10.0 × 37.0 cm., panoramic plate

Frédéric Martens was a trained steel-engraver whose panoramic views of European cities were exhibited at the Paris Salon between 1834 and 1848. He was also the principal engraver of daguerreotypes for Lerebours's famed *Excursions daguerriennes...* of 1841–43, translating the daguerreian image into a hand-engraved plate suitable for letterpress printing. Following this experience, Martens developed a number of special daguerreotype cameras of his own design that allowed him to take exceptionally wide-angled views on a single silvered plate, views encompassing as wide a field as 150°.[1] One of these designs required that the daguerreotype plate be curved so that the lateral sides of the panorama were at the same focal distance from the lens as the center of the plate; the lens swung or turned on an axis, in essence projecting the image along the length of the plate. Mechanical drawings by Martens for these cameras and their optics, as well as later paper-print panoramas, are in the collections of the Smithsonian Institution, Washington, D. C. Martens was one of the earliest masters of the calotype process, and he continued to photograph well into the collodion era, working first with albumenized glass-plate negatives, and then printing Léon Méhédin's and Colonel Langlois's negatives of the Crimea during the mid-1850s. He probably also hand-painted the skyscapes in these same pictures. His own photography during the 1850s was concentrated primarily on scenic landscapes of Switzerland and of the French and Swiss Alps, for which he received numerous accolades in the Parisian press.

It appears that there are only two extant examples of Martens's daguerreotype panoramas, one in the *Société français de photographie* and this image. Martens positioned his camera atop one of the pavilions of the Louvre, presumably the *Cour carré*.[2] Across the Seine, the spires of Saint-Germain-des-Près and Saint-Sulpice rise above the rooftops; immediately opposite, the Institut de France is seen facing the Pont des Arts, and further in the distance is the cupola of the Panthéon. To the right and up-river is the Pont Neuf, the Ile de la Cité, and the scaffolded towers of Notre-Dame de Paris. Finally, at the very edge of the panorama, to the right, a portion of the Louvre's architectural decoration is barely glimpsed. Of course, the entire view is laterally reversed by the lens of the daguerreian camera; normally, seen from this position, the directions of right and left would be exchanged.

The modern panoramic vision was not an especially novel occurrence by the middle of the 1840s; its origins can be traced back to the late 18th century, and it is a direct antecedent to the Dioramas of Daguerre and Bouton.[3] In 1834, Balzac indicated the popularity of these entertainments in his novel *Le Père Goriot*: "The recent invention of the Diorama, which carries the optical illusion to a higher degree than in Panoramas, had, in certain painting studios, led to the pleasantry of speaking in *rama*." As a result, the art students coined such words as "soup-o-rama," "cold-o-rama," and "health-rama."[4] Whereas the painted panorama enjoyed such a scale as to literally engulf the spectator's entire field of vision, the smaller photographic panorama was able only to exhibit a miniaturization of an extreme wide angle that could be understood analytically but never entered, as it were. Nevertheless, there undoubtedly was and still remains something almost unnerving but fascinating in apprehending an image that compacts a physically encompassing spatial spread onto a flattened rectangle, which it does in defiance of a normal Renaissance perspective system.

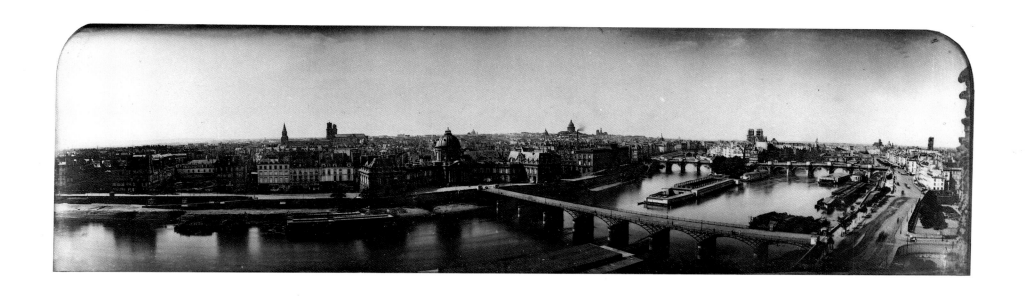

WILLIAM SOUTHGATE PORTER

American · 1822–1889

Fair Mount

1848 · Daguerreotypes · 36.7 × 99.8 cm., 8 half plates (trimmed)

Following the yellow fever epidemics of 1793 and 1798, Philadelphia built a pumping station at "Faire Mount" on the Schuylkill River immediately west of the city. In 1815, the city of Philadelphia's waterworks were officially transferred from Centre Square, where they had been powered by steam, to Fairmount and a far more cost-efficient water power. By 1822, a dam had been constructed as well as a neoclassical-style millhouse, designed by the architect Frederick Graff. The water of the Schuylkill River was pumped via the millhouse to a reservoir atop Fairmount Hill, from where it was distributed throughout the city. The reservoir was situated where the Philadelphia Museum of Art is presently located. In 1828, the city acquired twenty-four acres of land around the site of the waterworks to provide a picturesque natural retreat for the public called Fairmount Park, which currently extends to more than four-thousand acres. The park and its waterworks were to become a favorite attraction to many during the century, as attested to by its popular depictions on china and in engravings [fig. 11], and despite an initial lack of public enthusiasm for visiting the site.[1]

Porter's magnificent eight-plate daguerreian panorama of Fairmount Park and the waterworks was unquestionably the photographer's response to the famed glory of modern Philadelphia—a compendium of advanced engineering, Greco-Roman-style architecture, a vernal park, and nature's energy. Simply put, it is the most monumental and impressive early view of Philadelphia known, with plates so perfect and details so phenomenally exact that window mullions in a building a mile downstream are discernible.

While there is another view of the same subject by T. P. and D. C. Collins dating from around the same time and taken from nearly the same spot,[2] the Collins's six-part panorama fails to include one exceptional feature found in Porter's. As a gesture of complete assurance and photographic self-awareness, Porter finalized his seven-part view by documenting the "Point from

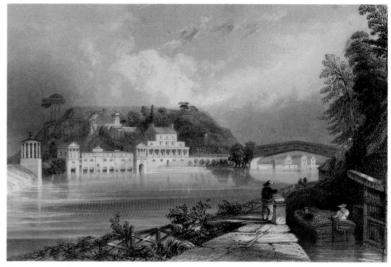

Fig. 11. William H. Bartlett, *Schuylkill Water Works*, steel-plate engraving by Armytage, 1839, collection of the author.

which this view was taken" on an eighth plate that he then mounted above the center of the panorama. This is perhaps the earliest example of a photographer directly challenging and visually defying the expectation that the camera's vision was merely a view out of a window, for by his eighth plate Porter unequivocally signals that the photograph is but an active human selection from a natural continuum.

It should be added that Porter made a second panoramic daguerreotype of the identical scene, presumably at the same time as this one, but it lacked the eighth plate showing the photographer's position.[3] In partnership with Charles Fontayne, Porter also documented the Cincinnati waterfront in the same year, 1848, in eight spectacular full-plate daguerreotypes. This panorama is presently in the collection of The Public Library of Cincinnati and Hamilton County, Cincinnati, Ohio.[4]

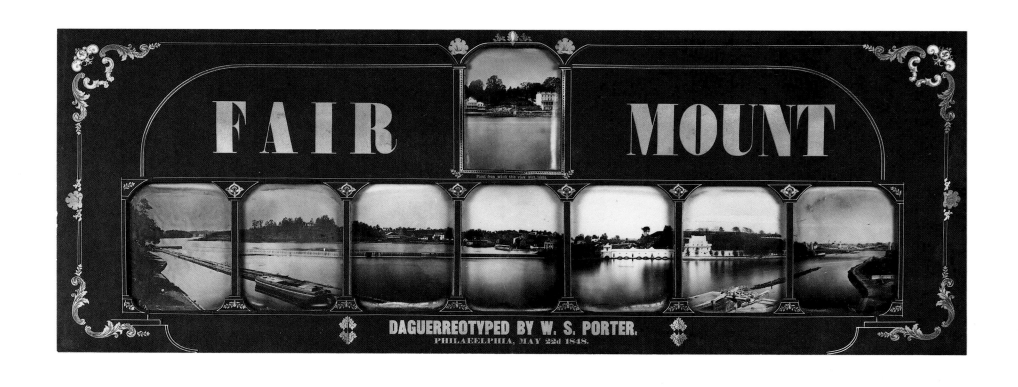

PLATT D. BABBITT

American · active, Niagara Falls, 1854–ca. 1870

Tourists Viewing Niagara Falls from Prospect Point

ca. 1855 · Daguerreotype, applied color · 16.5 × 21.6 cm., full plate

Platt D. Babbitt was highly acclaimed for his views of tourists overlooking the "American Falls" from Prospect Point, where he enjoyed a literal monopoly for photographing throughout his career. Not only daguerreotypes but ambrotypes as well as albumen print photographs of similar scenes are extant in sufficient numbers to suggest a rather successful undertaking for this photographer. Babbitt's daguerreotypes, however, are the most impressive and, in a way, most perfect realizations of the American reverence for and absorption in the natural landscape. The utter clarity and elegance of the American full-plate daguerreotype, polished as it was to a state of absolute visual smoothness and exposed with complete optical precision, make this and other Babbitt views of the same site (but with different figural groupings)[1] nothing less than pictorial validations of human determination in the face of an overwhelming nature "dreadful to look at . . . roaring noise, wild-looking islands . . . dreadful fall of water."[2]

The Falls at Niagara were an attraction to photographers from the earliest years of the medium. In the autumn of 1839, the French optician Nöel-Marie Paymal Lerebours enlisted the services of a number of camera operators, equipped them with daguerreian outfits, and sent them to capture many of the more famous sites in the known world on full-plate daguerreotypes. After the images were transferred onto engraving plates, they were published as a set of aquatint prints illustrating 110 culturally invested monuments, sites, and wonders.[3] The third plate in the collection is of Niagara Falls, taken by an amateur, H. L. Pattinson, who also wrote the accompanying text [fig. 12]. The Falls were repeatedly photographed throughout the 19th century, and even toward the end of the century the British photographer John Werge wrote that "No picture of language can possibly convey a just conception of the grandeur and vastness of these mighty cataracts. No poem has ever suggested a shadow of their majesty and sublimity."[4]

Babbitt's view is special. While most photographers, including Pattinson or at least Lerebours's engraver, included the human figure as a counterpoint to this sublime bit of nature,

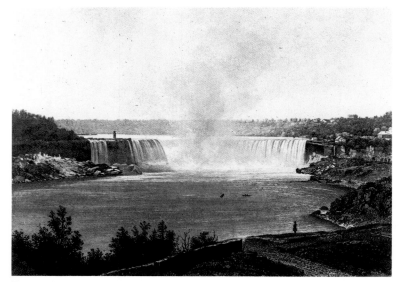

Fig. 12. N.-M. P. Lerebours, *Niagra* [sic], *Chute du fer à cheval*, engraving by Salathe from daguerreotype by H. L. Pattinson, 1841, from *Excursions daguerriennes . . .*, Paris, 1841-42, vol. 1, pl. 3.

Babbitt posed his tourists closer to both his camera and to what appears to be the very edge of the "dreadful fall of water." There is a *frisson* here suggested both by a sense of quietly approaching the group of awed spectators and by a recognition of their enjoying a flirtatious proximity to danger. Only in the archly romantic paintings of Caspar David Friedrich, painted some three decades earlier, do we find any similar treatment of human confrontation with nature's vast supremacy.

By the 1850s the land area around the Falls was hardly a preserve of bucolic nature; mills littered the water's edge as well as waste piles, and a power plant was constructed there as early as 1853. Charles Dickens had criticized the ugliness of the surrounding areas in 1843, and William Cullen Bryant wrote in the 1870s that the Falls were "a superb diamond set in lead."[5] Babbitt's ability, then, to render what looks like a thoroughly unsullied, untouched wilderness at awesome peace with man is merely a product of a creative selection of photographic vantage point.

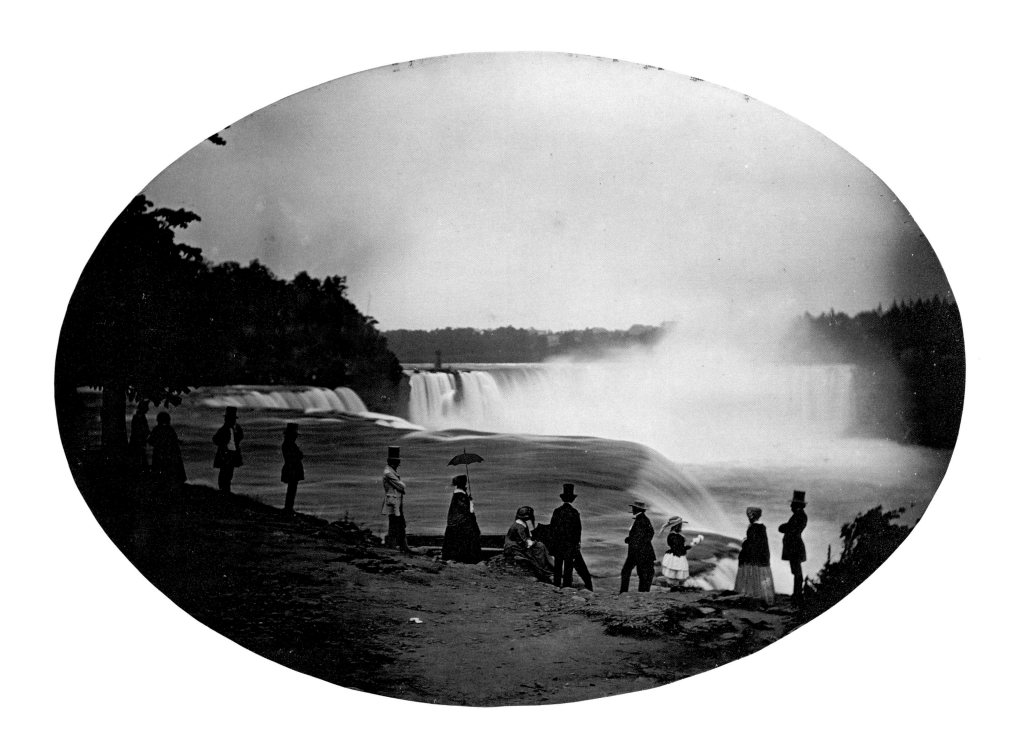

BARON JEAN-BAPTISTE-LOUIS GROS

French · 1793–1871

Monument of Lysicrates, Athens

1850 · Daguerreotype · 10.8 × 17.2 cm., half plate

Gros, a diplomat, senator, as well as a founding member of the *Société française de la photographie*, originally wrote his "Notes" on the daguerreotype process in January of 1850. In the following May, he traveled to Athens where he recorded many of the most famous monuments of that ancient city, including the Monument of Lysicrates. Upon returning to Paris, he was asked by his publisher, Roret, to write a new preface to the book that confirmed the empirical utility of his directions for photographing on metallic plates. Seemingly, both Roret and Gros were conscious of the ascendancy of paper photography and wished to gainsay the inadequacies of the daguerreotype. Thus, in July Gros wrote:

> Plates obtained by the processes that these notes describe have, in the words of the amateurs and artists to whom I have shown them, a strength and a richness which encourages me to recommend these same processes a second time at the request of M. Roret to those who are concerned with photography. [1]

Gros daguerreotyped in both half- and full-plate-sized formats, and his images, whether they are of Athenian monuments, the Louvre seen across the Seine (IMP/GEH), or Somerset House and St. Paul's dome seen from an embankment on the Thames (Bibliothèque Nationale), are uniformly some of the most detailed and most perfectly rendered European daguerreotypes to have been made.

Often mistakenly refered to as the Lantern of Demosthenes (legend had it that Demosthenes studied inside of it), the Choragic Monument of Lysicrates is preserved today not only for its grace and detailing but also because it is one of the earliest extant buildings in which the Corinthian order is exclusively used on the exterior. In Baron Gros's time, its attraction was as much literary and nationalistic as it was archaeological, since popular lore had it that Lord Byron, in the fashion of Demosthenes, used it while composing parts of *Childe Harold* in 1810–11. Any remnant of Greek antiquity found *in situ* could prompt reflections on what had happened to its monuments by time and foreign despoilers such as Lord Elgin and other antiquarians:

> Cold is the heart, fair Greece! that looks on thee,
> Nor feels as lovers o'er the dust they loved;
> Dull is the eye that will not weep to see
> Thy walls defaced, thy mouldering shrines removed
> By British hands, which it had best behoved to guard those relics ne'er to be restored.
> Curst be the hour when from their isle they roved,
> And once again thy hapless bosom gored,
> And snatch'd thy shrinking gods to northern climes abhorr'd! [2]

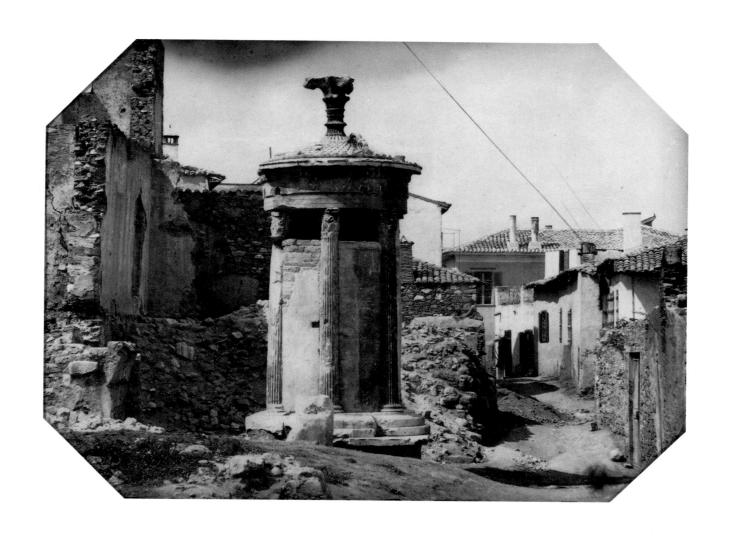

GEORGE N. BARNARD

American · 1819–1902

Fire in the Ames Mills, Oswego, New York

1853 · Daguerreotype, applied color · 7.0 × 8.3 cm., sixth plate

Before Barnard became famous for his documentary masterpiece, *Photographic Views of Sherman's Campaign*,[1] he was an accomplished and recognized daguerreian artist in upstate New York. A photographer by 1842, he was active in Oswego between 1851 and 1854, and opened his Syracuse studio in 1854. Barnard was one of the earliest American photographers to propose that photography needed an artistic theory, since by 1855 it had "passed the first blush of novelty, and has taken its rank among the necessary arts."[2] For Barnard, writing in the same essay:

> To be a true Daguerreotypist requires talents of no ordinary character—he should unite virtues and gifts, seldom attainable in their highest rank in the same person, he should be a skillful chemist, profound in natural philosophy, at least that portion embracing the laws of light and the theory of color, and last but not least he should be a cultivated artist.

Quoting John Ruskin, Barnard continued outlining what he felt were the eternal verities of art and beauty and how they were obtainable in photography.

> After distinctness or clearness the chief beauty of a picture depends upon the skilful arrangement of the drapery, the tasteful introduction of adjuncts, or the artistic disposition of the sitter, or the grouping. . . . Nor would I have an artist undervalue the amount of study necessary to this end. It requires as much patient investigation, study, and experience as the more fully developed laws of Chemistry or Natural Philosophy. Without the attainment of this knowledge the

Fig. 14. George N. Barnard, *Fire in the Ames Mills, Oswego, N.Y.*, daguerreotype, 1853.

Photographist is left to the guidance of his own uncultivated, or perhaps perverted ideas, or falls a victim to the Juggernaut of vitiated public taste.[3]

While there is no concrete evidence to link the two, it is tempting to speculate that the New York photographer was the same George Barnard who authored *The Theory and Practice of Landscape Painting in Water-colors*, a new and enlarged edition of which appeared in London in 1858.[4] In any case, Barnard's sensitivity to the 19th-century picturesque-landscape vision is fully attested to in his albumen prints that document the ravages of Sherman's campaign [fig. 13].

Between July 12 and August 1, 1853, the following advertisement appeared in the *Oswego Daily Times*:

> Daguerreotype Pictures of the late fire taken while burning may be obtained at Barnard's Daguerrean Rooms. These pictures are copied from large pictures, and are faithful representations of the different stages of the fire as it appeared on the 5th. Also views of the Ruins as they now appear. (Jy 12). [signed] Geo. N. Barnard.[5]

The present picture is without a doubt one of these daguerreotype copies of what was most likely a larger daguerreotype. The museum is fortunate also to have an uncolored view of what may be the post-fire scene mentioned in the advertisement [fig. 14]. The daguerreotype of the Ames Mills fire is a rare example of daguerreian journalism. An earlier view by Carl Ferdinand Stelzner of the aftermath of the great fire of Hamburg in May, 1842, lacked the immediacy of the moment and the spectacular coloring of the Barnard plate.[6] Despite the blurring of flames and smoke in Barnard's view, the sensitive application of colored pigments furnished his picture with a unique sense of the instantaneous.

Fig. 13. George N. Barnard, *Lu-La Lake Lookout Mountain*, albumen print, ca. 1864-65.

E. DESPLANQUES

Belgian (?) · active 1850s

The Grande Place at Oudenaarde

1854 · Salted paper print, printed by Blanquart-Evrard ·
From: L.-D. Blanquart-Evrard,
La Belgique, Lille, 1854, pl. 5. 34.3 × 44.8 cm.

Very few prints by this photographer have been discovered.
Besides the eight Belgian views found in Blanquart-Evrard's
album *La Belgique*, only three others have been clearly identified:
a reproductive photograph of Rubens's *The Raising of the Cross*
and two views of Antwerp. We cannot even say with certainty
that Desplanques was Belgian or French, nor do we know his first
name. Yet Blanquart-Evrard, the founder of Europe's foremost
photographic publishing house in the 1850s, included Desplan-
ques's images in one of his famed albums. Moreover, on the sim-
ple visual evidence of Desplanques's few photographs, we would
have to nominate him as one of the more talented 19th-century
urban and architectural photographers and, with this particular
print, one of the more original.

An important center of the textile industry in Eastern Flan-
ders, Oudenaarde was most noted for its imposing Town Hall,
which was built in 1525 in an exceptionally flamboyant, late-
Gothic style and dominated the central square of the town.
Desplanques made at least one other photograph of this
building, a more traditional document in which the Town Hall
is seen in three-quarter view nearly filling the picture's space.[1]
This view, however, is more than a portrayal of a single building,
it is a depiction of the heart of a provincial town seemingly unaf-
fected by contemporary progress. Desplanques did not isolate the
16th-century Town Hall here in order to stress its atemporal
remove from the 1850s, as was customarily done by photogra-
phers of historical architecture during this period. Instead, he
treated the fairly prosaic public square as a proscenium on which
the Town Hall does not dominate as much as accessorize the
daily activity of the public market and citizens in the square. It
is a miniaturized and nearly two-dimensional Town Hall that
merely forms a focus to a perspective set-piece.

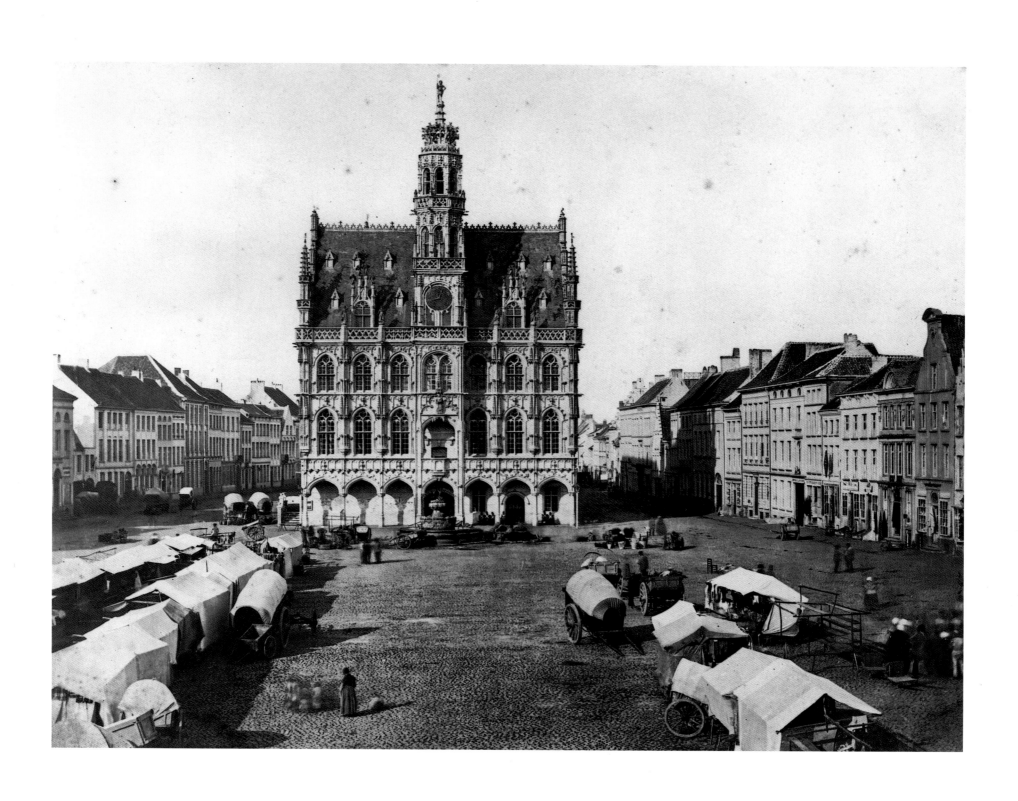

CHARLES NEGRE

French · 1820–1880

Arles: Porte des Châtaignes

1852 · Salted paper print · 23.3 × 32.0 cm.

In 1852, Charles Nègre journeyed to the South of France and documented the more significant views and architecture of such cities as Avignon, Arles, Gard, Marseille, Var, Fréjus, Cannes, Grasse, and Antibes. Like many other pioneering French photographers Nègre was a painter, and he applied the craft of photography to collecting images for study and copying onto canvas. Unlike many other painters, however, Nègre recognized that the camera's images could possess artistic qualities and even a visual poetics of the picturesque, which are more than readily apparent in his photographs of the Midi. Nègre's pictorial record of this trip remains probably his most inspired photographic achievement, one which the artist planned to publish in 1854 as a collection of some two-hundred prints. Unfortunately, the publication was never realized, but from the numerous remaining prints that are traceable to the project it is quite evident that Nègre brought a "sensuous and intellectual response to the subject, to its texture and atmosphere, and to the space it occupies."[1]

In an unpublished preface to the publication, *Le Midi de la France photographié*, Nègre outlined his artistic intent:

> In the reproduction of ancient and mediaeval monuments that I offer the public, I have attempted to join a picturesque aspect to the serious study of details sought after by archaeologists and by artist architects, sculptors and painters. Each of these categories of artists will find in this collection some motifs that will be useful to their own special fields without losing their artistic conditions.
>
> Thus, I have given to architects a general view of each monument by placing the line of the horizon directly in the center of the building's elevation and the vanishing point in the center. I have tried to avoid any perspective distortions and to give these images the look and precision of a geometric elevation. . . .
>
> After having addressed the architect, I believe I have satisfied the sculptor by reproducing the most interesting sculptural details in the largest possible scale.
>
> A painter myself, I have worked for painters by following my personal tastes. Wherever I have been able to dispense with architectural precision, I have been picturesque. Thus, I have sacrificed certain details in favor of an imposing effect necessary to give the monument its true character and to maintain the poetic charm that surrounds it.[2]

In this image, the city gate, ostensibly the subject of the picture, is centered and precisely frontal to the camera. By positioning his tripod some distance from the gate, however, Nègre included not only some of the more pictorially varied and interesting houses that lead to the gate but also a man and a woman resting on the retaining wall of the quai, the textured cobbled walk of the embankment, and a view up the Rhône river. While the subject of the picture was and is the *Porte des Châtaignes*, these secondary details furnish the subject with its artistic resonance. The photographic critic Henri de Lacretelle, commenting on Nègre's *Le Midi de la France photographié* portfolio, realized this when he prefaced his review by stating that "photography was nothing other than the indefinite prolongation of the glance."[3]

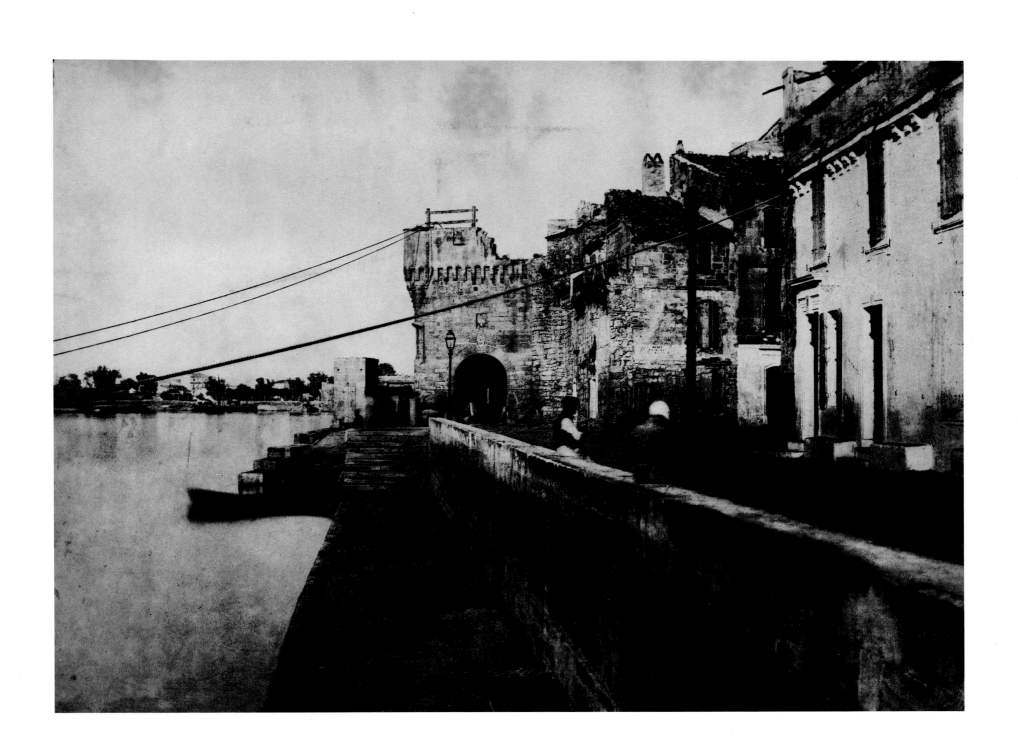

MARCUS AURELIUS ROOT

American · 1808–1888

Self Portrait

ca. 1850–55 · Daguerreotype · 11.8 × 8.8 cm. (sight), half plate, in vintage frame

Marcus Aurelius Root was to the city of Philadelphia what Southworth and Hawes were to Boston and Mathew Brady was to New York, namely, the premier portrait daguerreotypist. Root studied painting with Thomas Sully in the mid-1830s, but did not professionally pursue a career as a painter; instead, he taught penmanship in Philadelphia and learned the daguerreotype process from Robert Cornelius in 1843. In 1846, after having daguerreotyped in Mobile, New Orleans, and St. Louis, he purchased the studio of J. E. Mayall in Philadelphia. In 1849, he and his brother Samuel opened a photographic gallery in New York that lasted only until 1851. Root's Philadelphia studio took the portraits of such notables as Henry Clay, Franklin Pierce, Charlotte Cushman, and Dorothea Dix.

More than for his actual photography, Marcus Root is remembered as the author of *The Camera and the Pencil* . . . , published in 1864. No simple treatise on the techniques and processes of the medium, this was a complex, rambling, often tendentious, and impassioned essay on the artistic theory of photography, including also one of the earliest histories of photography published in America. For Root, photography, or what he chose to call "heliography," was much more than a craft or mechanical tool. It was a major, forceful art form that would democratize art and bring pictorial quality to the humblest of homes. Root's view of photography was both more elevated and more global than that of most writers of the period.

Why (I queried with myself) should not Heliography be placed beside Painting and Sculpture, and the Camera be held in like honor with the Pencil and the Chisel? Is that (methought) a low and vulgar art, which can bid defiance to time and space, and triumphantly look into the eye of the so-named "King of Terrors;" which grants me, at my own fireside, to behold the rocky heights once trodden by prophets

and apostles, and, more inspiring still, by Him who was the "brightness of the Father's glory," . . . to gaze on the immemorial pyramids and catacombs of Egypt, and the mystic caverns of Ipsamboul and Ellora?—which in a word, enables me, without crossing my threshold, to view the multitudinous populations of the total globe, past and present, with the monuments of beauty and grandeur, that immortalized their earth-existence? Finally, should that art be contemned, which is helping to train society, from its topmost to its nethermost stratum, to an appreciation of the beautiful? For, be it noted, the specimens, inferior as so many of them are, exhibited at the doors of the Heliographic Galleries, in numbers of our city streets, constitute a sort of artistic school for developing the idealistic capabilities of the masses that daily traverse those streets.[1]

If Root found photography to be a new and highly esteemed art, his aesthetic principles were still based on the writings of earlier art theorists, like Sir Joshua Reynolds, John Ruskin, Benjamin Haydon, and James Barry; and frequently he drew upon scientific theories, such as George Field's chromatics and chromatography and Sir Charles Bell's anatomy of expression, to support his observations. For Root, "expression" was essential to any artistic photograph, and especially to the photographic portrait.

For a portrait, so styled, however splendidly colored, and however skilfully finished its manifold accessories, is worse than worthless if the pictured face does not show the *soul* of the original,--that *individuality* or *selfhood*, which differences *him* from all beings, past, present, or future. The creative power never repeats itself; but in every successive performance presents somewhat varying from all existences that have been or are.[2]

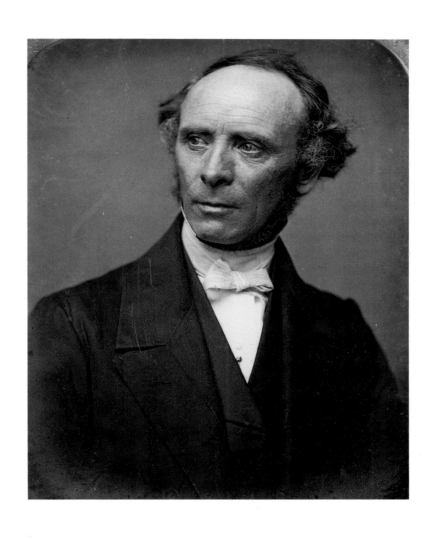

GABRIEL HARRISON

American · 1818–1902

The Infant Saviour Bearing the Cross

1853 · Daguerreotype · 16.5 × 14.2 cm. (sight), full plate

Gabriel Harrison was both an actor and a painter before he turned to photography, and his success at both acting and painting were such that in some biographies his photographic activity is barely mentioned.[1] In 1844, Harrison took up the daguerreotype process, which he learned from a Mr. Butler, the "head man" at John Plumbe's New York Gallery where Harrison worked for over three years. Harrison's portrait of Martin Van Buren and another of one of his sons clinging to a bust of George Washington won first prize at an exposition in Washington, D.C., in 1845. In 1849, he joined the studio of Martin M. Lawrence, also of New York, and in 1852 opened his own portrait and daguerreian studio. Harrison was famous for his mammoth plate daguerreotypes, measuring upwards of an impressive sixteen by twenty-two inches; and there is some evidence, although unsubstantiated, that he not only made a daguerreotype likeness of Edgar Allan Poe but also painted a portrait of the writer from that daguerreotype.[2]

For more than anything else in photography, Gabriel Harrison was known for his allegorical and symbolic tableaux. We are told by his first biographer that he studied the higher and more exclusive realms of pictorial art.

> Most of those engaged in the profession appear to have regarded it as merely a mechanical and chemical operation; seldom experimenting upon graceful position, bold folds in drapery or proper tone to pictures. Having paid much attention to these points, Mr. Harrison began at once to examine the choicest works on art, such as Alliston's and Reynolds's Lectures on Art, from which he derived immense advantage in his new pursuit.[3]

Harrison's attentions to the art theory of portraiture were not limited to fashionable portraiture; in addition, he pursued a much more literary form of picture making, and one that was rather exceptional for the age [fig. 15].

> Mr. Harrison is the first person who has produced *descriptive daguerreotypes*—that is—put poetry in types as well as in pictures. One of these specimens which is greatly admired, is styled, "Past, Present, and Future." Artists and poets have been lavish in the commendation of this exquisite picture, and so delighted have they been with his beautiful fancy sketches in daguerreotype, that he is now almost universally known as the *Poet Daguerrean*. Indeed the poets have taken him into their special favor.[4]

In 1853, Edward Anthony, a leading industrialist of photographic materials, initiated a competition designed to increase

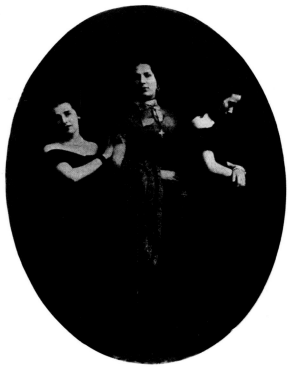

Fig. 15. Gabriel Harrison, *Past, Present, and Future*, crystallotype copy of daguerreotype in *The Photographic Art-Journal*, 1851.

the artistic quality of daguerreotypes in general. Harrison submitted this picture, entitled "The Infant Saviour Bearing the Cross," posed for by his son, George Washington Harrison, and with it he wrote: "I beg of you to place my name on the list of champions for the prize, earnestly do I enter the ranks, and most hard shall I try to be the victor, not so much for the value of the metal at stake, as to have it said on the occasion I took the best daguerreotype, 'simple' as the art may seem to many. . . ."[5] Besides this image and the allegory of *Past, Present, and Future*, Harrison also created such tableaux as *Young America*, *Mary Magdalene*, and *Helia, or the Genius of Daguerreotyping*. Of all of Harrison's allegorical or literary daguerreotypes, this daguerreotype appears to be the only extant one by perhaps the first American photographer to attempt the photography of fictive subjects; a photographer who, as early as 1851, challenged any photographer to say, "that we cannot have our representatives of Faith, Hope, and Charity, as well as *Sir J. Reynolds*; a *Holy Family* as well as Murillo; or the Infant Saviour, with cross and lamb, as well as Raphael."[6]

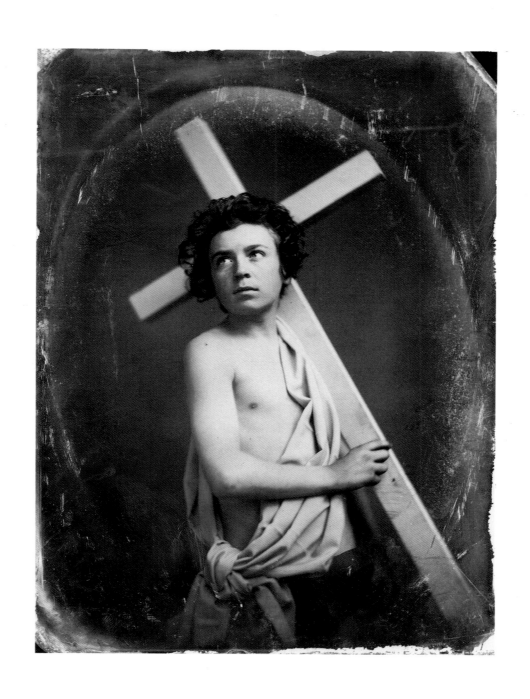

UNIDENTIFIED PHOTOGRAPHER

American · active 1850s

Quaker Sisters

1853 · Daguerreotype, applied color · 6.9 × 8.2 cm., oval, sixth plate

In the manuscript notebook to her collection of daguerreotypes, ambrotypes, and other examples of early American photography, the San Francisco collector Zelda Mackay wrote of this image: "1/6 dag. of 2 lovely Quaker sisters who married the Wharton Bros. of Phil. who became prominent financiers and aided in establishing the Wharton Graduate School at the Univ. of Pa. Daguer. made in 1853 (Scratched on edge)."[1]

At its very best, the daguerreotype was perfect for human aggrandizement in portraiture. With all the delicate feeling of a cameo portrait, this hauntingly beautiful double portrait commands a sense of monumentality that far exceeds its relatively small size. The total negation of any background or, rather, the impression that the two figures are pushed forward from a spaceless void is entirely daguerreotypical, achieved by photographing the two sitters against a dark background slightly beyond the focus of the camera's lens. The highly polished silvered background delineates nothing but the viewer's space—the locus not of what lies behind the sisters but of our position as spectator. This effect gained its fullest expression in American daguerreotypes or in those European daguerreotypes that were produced using the "American Process" of buffing the surface so finely that no abrasion scratches were visible or interfered with the mirrored surface.

For the most part, daguerreian portraitists in Europe, such as Sabatier-Blot, created more concrete and literal backdrops for their subjects, even after their polishing techniques could parallel those in the United States. The purely photographic and visually illogical void in which so many American portrait subjects are found in 19th-century daguerreotypes is a mark both of this country's fundamental discomfort with pictorial aesthetics and of its faith in material nominalism. Things and people simply were; they did not require a defining background or context to be understood.

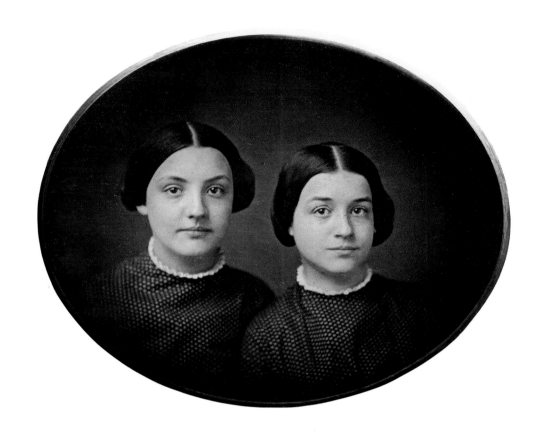

UNIDENTIFIED PHOTOGRAPHER

American · active 1850s

Portrait of a Male Hunter

ca. 1855–60 · Ambrotype · 8.3 × 6.9 cm., sixth plate

Vernacular photography, those pictures done mostly for and by ordinary citizens, is principally about the tokenism of possession. Since the earliest days of the medium, photography has captured people, events, objects of pride, and identities for the essential reasons of establishing their actuality and documenting their history. Susan Sontag expressed it succinctly when she wrote: "Memorializing the achievements of individuals considered as members of families (as well as other groups) is the earliest popular use of photography, [and] as photographs give people an imaginary possession of a past that is unreal, they also help people to take possession of space in which they are insecure."[1]

At only a single moment during the 1850s and only at a specific location (a certain photographer's studio) could this midwestern sportsman have realized himself and his life's particulars as seen here. The conflation of a particular trophy, a peculiarly self-conscious dog, a favorite musket, and certain articles of dress and appearance has been transformed from remembrance to memento.

The collector Zelda Mackay wrote in her notes to this ambrotype that it was found in an "unusual gutta percha 3 × 4 case with Robinson Crusoe in boat with sail on cover, Anchor on shield at base. Contains fine ambrotype of hunter in cap & jacket, with gun, dog, deer antlers, powder horn, etc."[2] Her succinct and descriptive reading of this striking ambrotype is also the image's most salient critique.

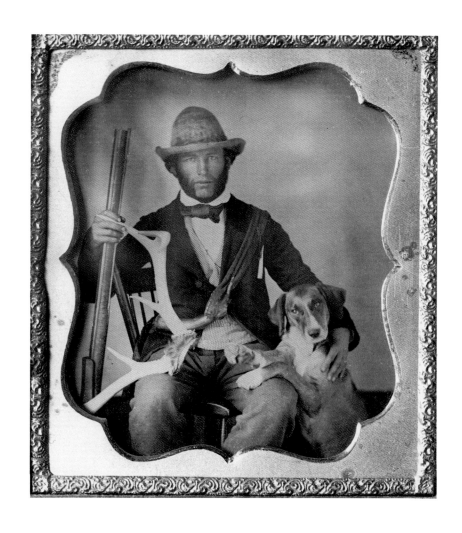

UNIDENTIFIED PHOTOGRAPHER

French · active 1850s

Street Flutists

ca. 1852 · Daguerreotype, applied color · 8.7 × 16.8 cm., stereograph

The street musician was a favorite subject for European artists and photographers during the 19th century. In painting and the graphic arts there are, of course, the famous examples of Honoré Daumier, Edouard Manet, and, later, Georges Seurat. Notable for their camera depictions of street musicians were Charles Nègre, whose calotypes of organ grinders are perhaps epitomes of French Realist photographic art, and, later, Eugène Atget, whose naturalistic studies of the same subject brought the tradition into the early 20th century. In its quiet and special way, this relatively unassuming stereographic daguerreotype is similarly an impressive and masterful image of public musicians, especially considering the perfection of the hand painting and the quality of monumentality given to images as small in scale as these.

The street flutist, or *pifferari*, from the Italian *piffero*, for fife, was a popular subject for Romantic painters, poets, and musicians during the first half of the century. The Swiss painters Leopold Robert and Charles Gleyre were both taken with these ambulatory players during their lengthy visits to Italy, as was the French composer Hector Berlioz, who wrote of his experiences in Rome in 1831.

> In Rome I was struck by one type of music only, and that (as I am inclined to think) a relic of antiquity: the folk music of the *pifferari*. These are strolling musicians who, towards Christmas, come down from the mountains in groups of four or five, armed with bagpipes and *pifferi* (a sort of oboe), to play in homage before the statues of the Madonna. They are generally dressed in large brown woollen coats and the pointed hats that brigands sport, and their whole appearance is instinct with a kind of mystic savagery that is most striking. . . . Close to [the music], it is overpoweringly loud, but at a certain distance the effect of this strange ensemble of instruments is haunting, and few are unmoved by it. [1]

Obviously, the romantic charm of this subject continued in effect beyond the first half of the last century, thereby influencing such photographic images as this. One is also reminded of the comparably composed rendition of trombonists and other horn musicians depicted by Seurat in his *Circus Parade* of 1887. [2] Although much more is symbolized and implied in the Seurat painting, a strange immobility of static performers arrayed in an absolutely direct and planal scheme figures in both images, made some thirty-five years apart.

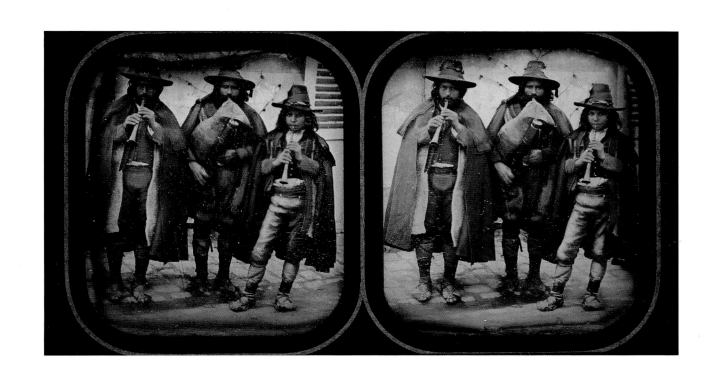

EUGENE PIOT

French · 1812–1891

The Acropolis of Athens, the Pandroseion

1852 · Salted paper print · 32.7 × 22.6 cm.

Eugene Piot was an antiquarian, archaeologist, art collector, and founder of the journal *Le Cabinet de l'amateur et de l'antiquaire*, which appeared in the 1840s and again in the 1860s. Piot accompanied Théophile Gautier on the latter's travels to Spain in 1840, and he may then have been introduced to photography since Gautier brought a daguerreotype outfit along on the trip. It was later in the decade, however, that Piot conceived of using paper photography for the encyclopedic documentation of antique monuments. Well before the *Commission des monuments historique* began systematically amassing photographs of French historical monuments, and well before Blanquart-Evrard began producing publications illustrated with actual photographs, Piot had commenced working on his first major achievement, *L'Italie monumentale*, which appeared in Paris in 1851. In the style of lithographic prints, Piot printed his images on China paper that was in turn mounted on vellum; the title of the image as well as the words "Piot, fecit et excudit," signaling that Piot both made and published this work, were printed in letterpress on the vellum. By using the traditional phrasing of prints, it would appear that Piot was equating his photographs with fine lithographs, thereby enabling him to attract a print collector audience. [1]

Reviewing the photographs at the *Exposition universelle* of 1855, Ernest Lacan wrote of Piot's views of Sicily and Greece.

> It is not without a certain sadness that one examines these views in which is discovered everything time has left for us of these flourishing cities that the poets have so often celebrated. . . . Everywhere ruins and always ruins. . . . the Pandroseion with its six female statues which time has respected, perhaps in memory of the unfortunate daughters of Cecrops. . . . M. Eugene Piot has accomplished a useful work here and one that few artists would have pursued with as much perseverance and talent. [2]

Other critics, however, were not as receptive to Piot's photography as Lacan; many criticized the coarse and brutal quality of his printing, its peculiar sepia tonality, and its lack of halftones or middle values. Piot's *Italie monumentale* failed as a commercial venture, as did his later projects, *Temples grecs* and *L'Acropole d'Athenes*, but he continued to exhibit throughout the 1850s.

Technically speaking, the Pandroseion was an area immediately to the west of the Porch of the Caryatids, in which, according to Herodotus, the "Sacred Olive of Athena" sprouted again after having been burnt down by the Persians. Piot's view simply does not include this area, which would be just to the left of the picture. Lacan's review of Piot's photographs, however, would indicate that the term was applied to the porch itself during the last century.

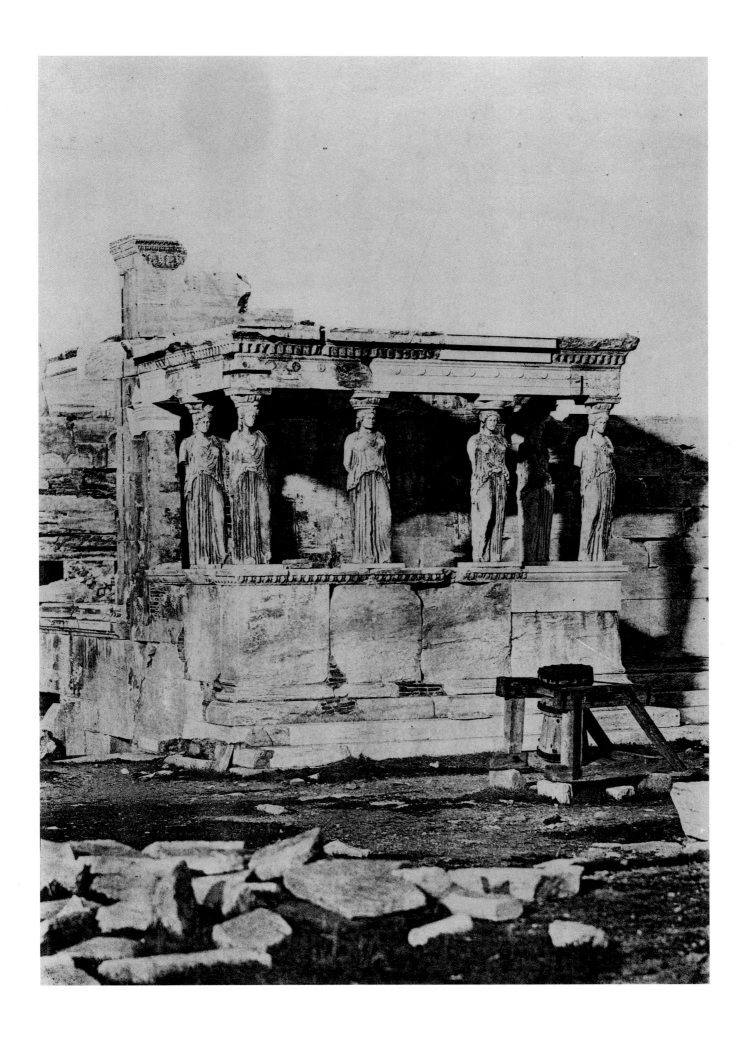

MAXIME DU CAMP

French · 1822–1894

Thebes, Gournah, Monolithic Colossus of Amenhotep III

1850/1852 · Salted paper print, printed by Blanquart-Evrard. · From: Maxime Du Camp, *Egypte, Nubie, Palestine et Syrie. Dessins photographiques recueillis pendant les années 1849, 1850 et 1851, accompagnés d'un texte explicatif et precédé d'une introduction par Maxime Du Camp, Chargé d'une mission archéologique par le Ministère de l'Instruction Publique*, Paris, 1852, pl. 56. 19.6 × 16.1 cm.

The desolation, majesty, and mystery of the ancient Near East are perfectly summarized in this calotype of a colossal figure on the west bank of the Nile at Thebes. Worn and weathered, broken and without its original crown, the statue dominates the pictorial landscape as it did its actual location when Du Camp photographed it. One of a pair of figures, each attaining a height of more than 60 feet, and both originally carved to represent Amenhotep (or Amenophis) III, the "Southern Colossus" is depicted alone here, isolated from its companion statue that could have been included if an oblique viewpoint were established by the camera's position—a view most often used in photographing these figures in the last century [fig. 16]. Ever since the Roman era, the figures were thought to be representations of Memnon, the slayer of Antilochus during the Trojan War, and although the original Egyptian identity of the colossi had long been recognized by the 1850s, Flaubert still referred to their Roman names in 1850 when he wrote "the colossi of Memnon are very big, but as far as being impressive is concerned, no. What a difference from the Sphinx!"[1]

In spite of Flaubert's lack of enthusiasm for these figures, they remained popular monuments throughout the century, due in part to their associations with Homeric mythology, the abundance of Greek and Latin inscriptions at their bases, and the legend of one of them emitting a "sweet and plaintive note" at dawn.[2] For romantic contemplation these colossi also presented a poetic specter of lonely, broken giants alienated from their past, a contemplation consisting of nostalgia for decayed ruin and a fascination with grandeur fallen into decay.[3] Du Camp's vision raises the deteriorated giant from an archaeological relic in a desert valley to the status of a melancholic icon.

Du Camp was a journalist, a world traveler, and a *flâneur* who obtained a government commission in 1849 to document the finest of Egyptian and Near Eastern monuments. He briefly studied photography with Gustave Le Gray, and spent nearly two years traveling the Orient with his novelist friend, Gustave Flaubert. In a letter to his mother in 1850, Flaubert described Du Camp at work: "Max's days are entirely absorbed and consumed by photography. He is doing well, but grows desperate whenever he spoils a picture or finds that a plate has been badly washed. Really, if he doesn't take things easier he'll crack up. But he has been getting some superb results, and in consequence his spirits have been better the last few days. The day before yesterday a kicking mule almost smashed the entire equipment."[4]

After the publication of his illustrated book on the Near East, Du Camp was awarded the *Croix de la Légion d'Honneur*, and his pictorial work was greeted by critical success. Even before actual

Fig. 16. Francis Frith, *The Statues of the Plain, Thebes,* albumen print, ca. 1858.

publication, Du Camp's calotypes were reviewed by Francis Wey, one of the first art and photography critics in France.

> Since passion is more energetic than cold interest, M. Du Camp has created an imposing collection in terms of the profusion and exquisite choice of subjects. . . . The least of these prints have the value of a faithful sketch, and these are few in number. The others, nearly three-quarters of the album, are exceptionally good prints, strongly printed, consistently clear, and regarding quality, we have noted about twenty-five which come close to the minutest detailing of glass plate negatives. M. Du Camp, who studied art, who possesses a certain and natural taste, and who is essentially a landscapist—as is easily seen from his style—has chosen his points of view with intelligence. His pictures are well composed, and he has been able to reconcile picturesque interest and charm with the exigencies of reality that are necessary to subjects of study. No one has given more than him to date, and assuredly, no one will do more.[5]

Du Camp was also the first major photographer to discuss the notion of a scale-reference figure, a common device in 19th-century photography and seen here in the figure standing between the colossus's legs:

> Every time I visited a monument I had my photographic apparatus carried along and took with me one of my sailors, Hadji Ismael, an extremely handsome Nubian, whom I had climb up on to the ruins I wanted to photograph. In this way I was always able to include a uniform scale of proportions. The great difficulty was to get Hadji Ismael to stand perfectly motionless while I performed my operations; and I finally succeeded by means of a trick whose success will convey the depth of naivete of these poor Arabs. I told him that the brass tube of the lens jutting from the camera was a cannon, which would vomit a hail of shot if he had the misfortune to move—a story which immobilized him completely, as can be seen from my plates.[6]

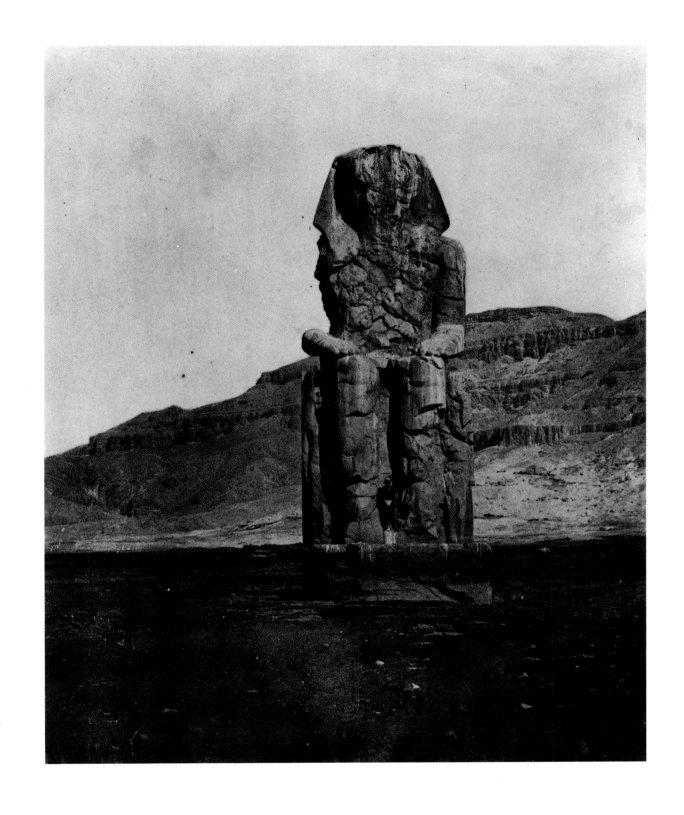

LINNEAUS TRIPE

British · 1822–1902

Approach to the Temple at Trivady

1856–57 · Salted paper print · From Linneaus Tripe, *Photographic Views in Tanjore and Trivady*, Madras, 1858, pl. 23. 29.0 × 37.5 cm.

The bloody uprisings in Lucknow, Cawnpore, and Delhi that took place in 1857-58, the results of which were photographed by Felice Beato, marked a turning point in the British hegemony of India. Called a "mutiny" by the British colonialists and the "First War of Independence" by later Indian nationalists, the hostilities led to the transfer of governmental power from the East India Company to the British Crown, Queen Victoria, through Parliament's "An Act for the Better Government of India" of 1858. In the same years, Captain Linneaus Tripe published from six to ten books of salted-paper-print photographs documenting the most important architectural and archaeological monuments in India's southern provinces, such sites as "Madurai, Tanjore and Trivady, Ryakotta, Seringham, Poodoocottah, and Trichinopoly."[1] This print issues from one of the albums, *Photographic Views in Tanjore and Trivady*, published in 1858.

Tripe was one of a handful of British photographers working in India during the 1850s and 1860s while in the service of the East India Company or the British Army. Among others, the names of Captain T. Biggs, Captain E. D. Lyon, and John Murray are perhaps the most noted; but none was as prolific as Tripe in terms of publishing or as steadfast in the use of what was by then the old-fashioned process of the calotype. In 1855, Tripe was hired by the British East India Company to document Indian antiquities, and in 1857 he published a series of views of upper Burma for the Madras Photographic Society, the first ever made in that region. His Burmese photographs (made while he was "Official Photographer" to the British Mission to the Court of Ava, Burma) were the result of only thirty-six days work due to inclement weather, but they did record one of the oldest Asian cities, Prome, before it was completely destroyed by fire in 1862. The formal commission to photograph important sites in the southern provinces was awarded Tripe in 1856, and in 1858 he returned to these areas to document the monuments with a stereoscopic camera. Like his Burmese prints, Tripe's Indian photographs reveal the most glaring limitations of the calotype process when utilized in warmer climates: graininess, black specks, and lack of definition. He apparently turned later to opaquing the skies in his negatives so that their effect in the final prints was completely white. In spite of these "defects," however, Tripe's images of Southern India are some of the most picturesque of the period, luminous and impressionistic, and remarkable for their viewpoint. Ordinarily, survey photographers of archaeological monuments would position their cameras as close to the site as possible, given the focal length of their lens and the format of the camera. Tripe customarily retreated from the subject in order to include the exotic flora of the region as well as the vernacular architecture that surrounded the ancient edifice, thereby rendering a broader and more sociological account of the site.

ALEXANDRE JEAN-PIERRE CLAUSEL

French · 1802–1884

Landscape, Probably Near Troyes

ca. 1855 · Daguerreotype · 17.0 × 21.3 cm., full plate

A unique and perfectly charming daguerreotype landscape taken on a relatively windless day in Northern France by an obscure French painter, the scene in this image is highly reminiscent of any number of landscapes painted throughout the mid-19th century. One thinks of Barbizon painters like Daubigny and Rousseau, or the atmospheric later landscapes of Corot, or of even more traditional painters like Edouard Cibot, whose *View at Bellevue, near Meudon* of 1852 is stylistically quite similar to Clausel's landscape.[1] The painter Jean-François Millet desired a camera so that he could take landscape sketches with it; while he valued the information in photographs, "he would, however, never paint from them, but would only use them as we use notes."[2] For most painters of the period, interpretation, sentiment and the artist's temperament were more important than sheer mechanical verisimilitude.[3]

That the season is late autumn or winter is obvious by the lack of foliation on the trees, and it is clear that the water is not stagnant since movement has blurred its surface into that ubiquitous milky substance seen so often in 19th-century photographs taken at moderate to long exposures. A figure wearing what appears to be a bicorne hat stands on the opposite bank surveying the photographer taking what would become in all likelihood a landscape study for future use in his painting.

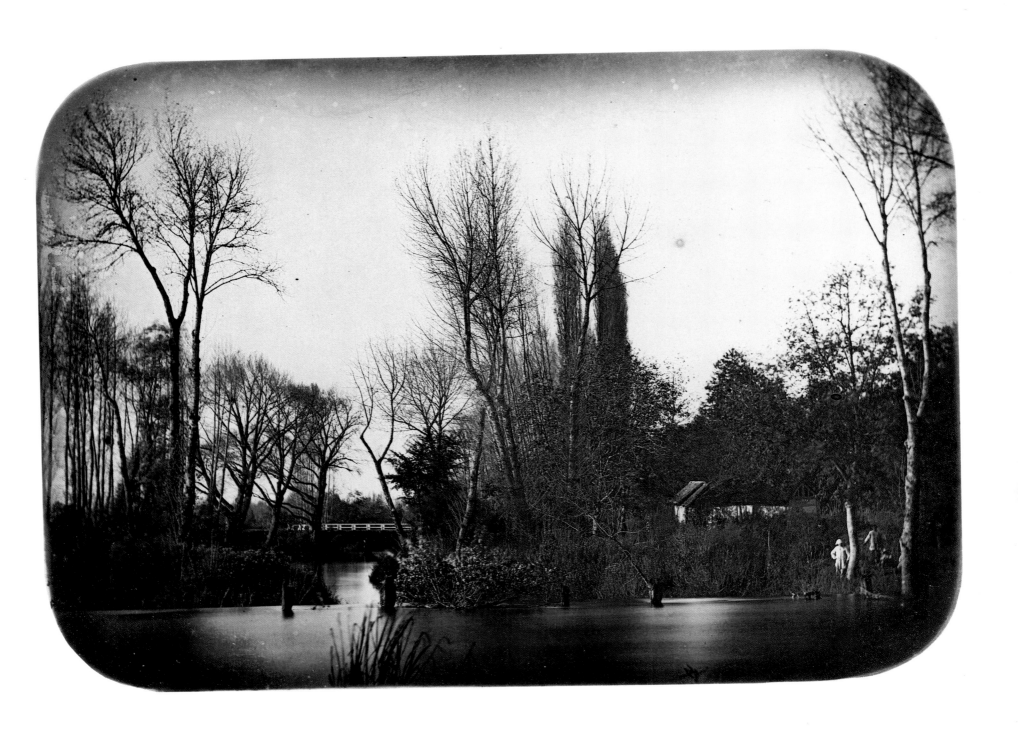

JEAN-LOUIS-HENRI LE SECQ DES TOURNELLES

French · 1818–1882

Farmyard Scene, Near St.-Leu-d'Esserent

ca. 1852 · Cyanotype print · 21.7 × 32.2 cm.

One of the principal figures of early French paper photography, Henri Le Secq was trained as a sculptor, and he became a rather uninteresting painter of genre subjects who nonetheless exhibited at the Salons throughout his life. He was an antiquarian, a collector of paintings, graphic arts, and ironworks, a friend of Charles Nègre, and a founding member of the *Société héliographique*. Like many other painters of his generation, Le Secq was drawn to the new art of photography by its potential for quick sketches and study material. He began photography, as the historian Eugenia Janis points out, following the "infectious wave of individual self-enrichment preceding the Revolution of 1848."[1] By 1851, he was one of the five photographers chosen by the *Commission des monuments historiques* to document antique and medieval architecture in France. During the 1850s, Le Secq photographed landscapes, still lifes, and architecture in Paris and in the provinces, which he printed in various processes including calotype, cyanotype, "*encre grasse*," and panotype.

The cyanotype process was invented as early as 1848 by Sir John Hershel and consisted of iron (rather than silver) salts in conjunction with cyanogen. The process was relatively easy to use, required no fixing, and produced paper prints of a deeply saturated blue or blue-green.[2] Apparently, the cyanotype process underwent numerous variations throughout the second part of the last century, and it is unclear whether Le Secq used either Testud de Beauregard's process or A. Marion's version.[3] Regardless of what exact process Le Secq chose or even modified for his own purposes, his cyanotype prints are coloristically vibrant still-life arrangements and scenes that project a sense of the irreal, the oneiric or dreamlike, and an alternative to the conventional browns of the calotype.

The farmyard scene was a popular theme during the Second Empire, treated by such photographers as Blanquart-Evrard, Victor Prevost, Bernabe, and André Giroux. Fraught with romantic and political overtones or subtexts, rural and rustic subjects were also frequently depicted by Barbizon painters, Realists, and Impressionists. As a photographic picture type, there is every reason to suspect that photographers like Le Secq were drawn to farmyards and views of barns and haystacks for reasons similar to those of the painters and lithographers. The rustic view was both picturesque and loaded with social implications. What is most striking about Le Secq's farmyard here is its absolutely progressive compositional structure. Everything is pushed to the edges, and the center is completely emptied of detail or meaning, a darkened void foreshadowing an Impressionist vision by two decades.

LOUIS-DESIRE BLANQUART-EVRARD

French · 1802–1872

Peasant Family at Rest in Front of a Thatched Shed

1853 · Salted paper print · From: Blanquart-Evrard, *Etudes photographiques*, Lille, 1853, 2nd. series, no. 204. 18.0 × 23.3 cm.

Louis-Désiré Blanquart-Evrard was to the decade of the 1850s what Alfred Stieglitz was to the 1900s. Both photographers, independent of their pictorial output, were responsible for publishing what they saw as the most significant photography in some of the most impressive publications attained in the history of the medium. While with *Camera Work* Stieglitz concentrated on the format of the periodical, illustrated by high-quality photogravure reproductions; Blanquart-Evrard specialized in printing actual silver prints from the calotype negatives of some of the most respected camera artists of the 1850s and issuing these prints in a series of portfolios. Through their passion for photography and commitment to their craft, both publisher-artists served the greater goal of disseminating and, thus, preserving some of the finest work of their respective periods. Both of them also, in a sense, defined the look and significance of photography for their times.

Blanquart-Evrard was educated as a chemist, a painter, a businessman, and, finally, spurred on by the disclosure of Daguerre's and Talbot's discoveries, a photographic researcher. Basing his studies on Talbot's initial successes with paper photography, Blanquart-Evrard announced his first modifications of the British process to the *Académie des Sciences* in 1847. His claim of photography's significance sounded much like Talbot's own words in his *The Pencil of Nature*.

> The ease of execution and reliability of the process and the reproduction of prints in large numbers are three factors which will soon give this branch of photography an important place in industry; for it not only provides man with living souvenirs of his travels and faithful images of the objects of his affection, but also gives scientists exact pictures from engineering, anatomy and natural history and provides historians, archaeologists and artists with landscapes and general and detail studies of classical and medieval works of art, drawings of which are rare and available to only a small number of persons. [1]

In 1847, however, the process of printing paper prints was still too slow and too costly to make it cost-effective for commercialization. By 1851, however, Blanquart-Evrard's experiments with photography had led him to discover that the paper positive could be chemically developed-out just as the calotype negative was. (In England, Talbot and Hennemann had persisted in physically printing-out the positive prints in direct sunlight.) As the historian Isabelle Jammes states, "The replacement of prolonged

exposure to strong sunlight by 'chemical action' was a considerable advantage. The exposure time was reduced to a few seconds. The gold toning and thorough washing of the paper gave these prints what for the period was an exceptional degree of permanence. Mass-produced, they could be sold more cheaply, thus partly meeting the needs of publishers." [2]

Blanquart-Evrard's printing establishment, *l'Imprimérie de Lille*, began in 1851 to supply prints to various Parisian publishers, such as Gide and Baudry, which then appeared in such landmark publications as Maxime Du Camp's *Egypte, Nubie, Palestine et Syrie* of 1852 and August Salzmann's *Jérusalem* of 1856. Between 1851 and 1855, Blanquart-Evrard and *l'Imprimérie de Lille* also published twenty-four portfolios of original prints carrying the firm's own imprint. The range and variety of subjects treated in these portfolios attested to the publisher's expressed claim for photography: reproductions of art works, noted monuments, foreign landscapes and cityscapes, as well as artistic studies of trees, portraits of animals, and rustic genre scenes. The list of known photographers that supplied negatives to these productions reads like a directory of the masters of French "primitive" photography, including, among others, Hippolyte Bayard, Victor Regnault, Charles Marville, Henri Le Secq, and Louis Robert. Possibly, Blanquart-Evrard might even have been the author of certain of the images, but this remains unclear.

While genre subjects are not completely unknown in daguerreotypes of the 1840s, their number is relatively small, and they are for the most part incidental. Genuine artistically motivated genre scenes appear in photography only early the next decade, perhaps due to greater conveniences in equipment and processing or to an increased respectability of the genre subject, especially the rustic variety, as a pictorial type. [3] These were, after all, the years that witnessed Gustave Courbet's monumentally realistic paintings of provincial scenes, Jean-François Millet's powerful renditions of peasant harvesters, and Jules Breton's theatrical treatment of impoverished gleaners. Romanticism had paid homage to the humble but noble peasant. Contemporary events, such as the changing demographics of the countryside and the debates over the rights of the gleaners, contributed to the artistic interest in agrarian themes. Thus, it is not surprising to find Blanquart-Evrard publishing a photograph like this in 1853. In fact, included in the same portfolio, *Etudes photographiques*, are five other images of thatched roof barns or sheds, two views of peasant labor, and seven photographs of farmyard scenes.

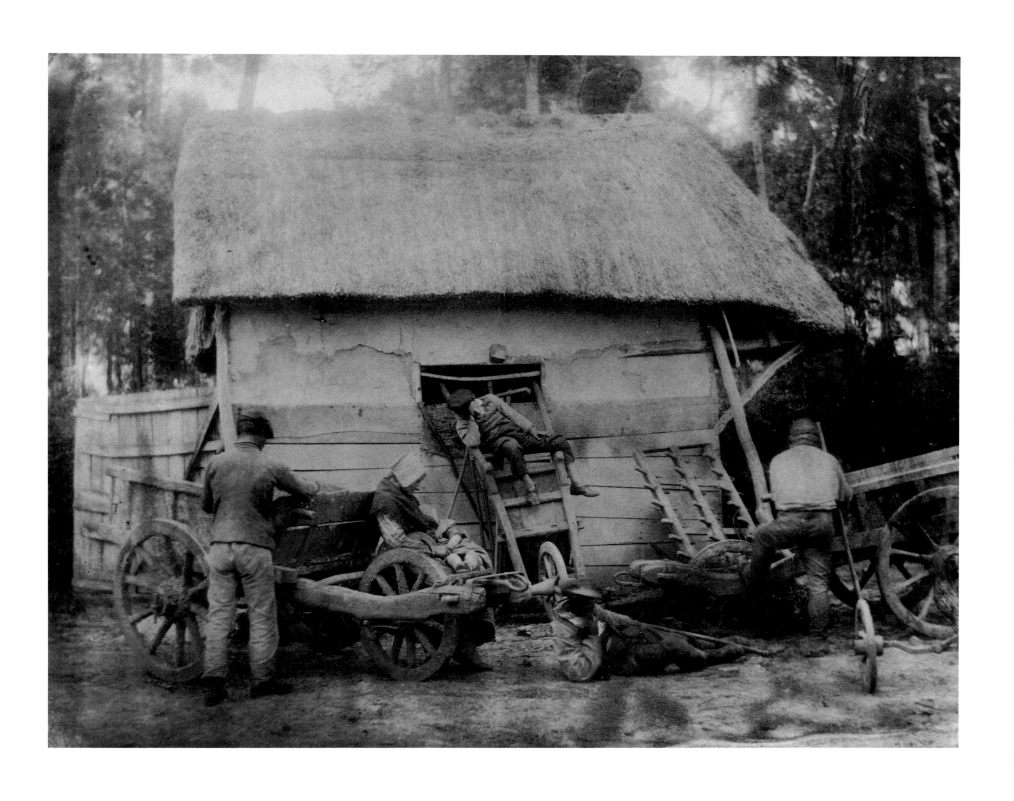

IMPERIAL VISIONS AND LITERARY TASTES 1855-1880

In a multiplicity of ways, Photography has already added and will increasingly tend to contribute, to the knowledge and happiness of mankind: by its means the aspect of our globe, from the tropics to the poles,—its inhabitants, from the dusky Nubian to the pale Esquimaux, its productions, animal and vegetable, the aspect of its cities, the outline of its mountains, are made familiar to us.
—Lake Price, *A Manual of Photographic Manipulation*, 1858

. . . all the gifts of science are aids in the process of levelling up; of removing the ignorant and baneful prejudices of nation against nation, . . . and class against class; of assuring that social order which is the foundation of progress.
—T. H. Huxley, *The Reign of Queen Victoria . . .* , 1887

None can pose limits nor state where [art] begins; it is as varied in its manifestations as thought, fantasy, human imagination. It exists in every single work which, speaking to both the spirit and the heart, excites in us a profound admiration that raises us beyond the material, which dominates it, and carries us towards the ideal. Whether this sentiment is born of beauty created by the artist or whether the beauty and truth of material reality awaken it in our souls matters little! Every work which gives rise to this sentiment is a work of art. Whether created by a chisel, a paint brush or a camera, this work is a conflation of spirit, reason and sentiment. This is a work of art.
—Alexandre Ken, *Dissertations . . . sur la Photographie*, 1864

ONCE THE PHOTOCHEMICAL PRINCIPLES of photography were understood well enough to be applied with some confidence and predictability, and once its pictorial and social options had been clearly outlined, photographers attained a level of brilliance and intelligent artistry that was both powerful and ingenuous. Photographers, professional and amateur, attended to the business of picturing and interpreting the world, of informing and entertaining a global audience that craved their images, and of establishing a set of traditions that spawned the modern art of photography.

Two factors, one technical, the other political, inform this period's great photographic achievement. The invention in 1851 by British photographer Frederick Scott Archer of the "wet collodion" process—a means by which photochemicals could be adhered to a sheet of glass—was nothing short of revolutionary. With this process, the negative gained in both clarity and brilliance over earlier paper negatives. Uniting wet collodion negatives with albumen-coated printing papers whose shell-like emulsion was equally capable of detailed precision, photography in the 1850s was pressed into the service of compiling a universal pictorial archive by which the world was appreciated, understood, and overseen.

Politically, the period coincided with the Victorian era and the farthest extension of the British Empire, with the Second Empire in France and its self-proclaimed Imperial stance, and with the dramatic conquest of the American West. The entire globe was appropriated and rendered through photography, from the grand, overwhelming views of foreign monuments and landscapes to the equally large pictorial celebrations of progressive engineering and domestic pride, from the face of every racial and national type to the portrait of every cultural hero, from the actualities of urban reform and the aftermath of warfare to the anxieties and melodramas of modern life. All of these images teach us about the past—its ideals, its aspirations, and its look; a fair number of them still move us by their visual eloquence and beauty.

GASPARD-FELIX TOURNACHON [called NADAR]

French · 1820–1910

The Nadar Pantheon

1854 · Lithographic print, printed by Lemercier, Paris · 72.0 × 94.5 cm. (image)

The artist's own "balloon-headed" caricature (*portrait-chargé*) of himself can be seen toward the upper right of the print, seated in the rocky landscape and seemingly oblivious to the serpentine procession of 269 of France's most noted poets, novelists, historians, publishers, and journalists, as well as a scattering of artists and musicians. In the lists of personalities represented that flank the image, Nadar occupies position number 203. A journalist, a cartoonist and caricaturist, an editor and publisher, a balloonist and photographer, Nadar remains the quintessential *flâneur* of the Second Empire. He is the observer, the reporter, and the outsider, whether figuratively behind the newspaper column or literally behind the camera, whether recording Paris from the lower depths of its sewers and catacombs or from the heights of his balloon *Le Géant*, whether satirically capturing the features of the famed with his lithographic crayon or poignantly revealing their characters with his collodion negative. Like Cham, Gavarni, and Daumier, Nadar held up French society, its customs and values, for observation through his hundreds of ironic and humorous cartoons. Unlike other caricaturists (Carjat is an exception), Nadar also bequeathed to posterity more than 6000 collodion negatives, of which the vast majority are portraits of French personalities. [1]

The figure of Nadar in the *Panthéon* sits behind a wooden sign that bears the print's dedication: "To the Gentleman whom I regret, obviously in advance, not knowing and who, on the 8th day of the 3rd moon of the year 3607, will flit like a lost dog from one auction to another trying to purchase with gold a copy of this print which will have become impossible to find and which he needs for his great work on the historical figures of the 19th century. Nadar." In March, 1854, when the long awaited print finally appeared after years spent obtaining permission for each subject's caricature, Nadar did not suspect that little more than just a century would elapse before collectors avidly pursued his photographic prints [fig. 17].

Heavily populated and monumental group portraits were not uncommon during the last century. David Octavius Hill and Robert Adamson had begun photographing in the 1840s in order to facilitate Hill's painting *The First General Assembly of the Free Church of Scotland*..., completed in 1866. Photographers like Notman in Montreal, Disdéri in Paris, and the Ashford Brothers in London found a ready market during the 1860s for photomontaged groupings of public personalities, in which the likenesses of hundreds of subjects were often photographically reduced to a carte-de-visite format. It was not, however, from any photographic convention that Nadar's *Panthéon* evolved but from the far more venerable tradition of constructing an edifice, either architectural or painted, that would honor a culture's gods or

Fig. 17.
Nadar, *Portrait of George Sand*, woodburytype print from *Galerie contemporaine, littéraire, artistique*, ca. 1865-77.

heroes. Thus, Nadar's graphic masterpiece was in essence a contemporary, ironic and popular answer to such models as Raphael's *School of Athens* or Ingres's *Apotheosis of Homer*, both of which Nadar would have known, at least, in the case of Raphael, through engravings. The cultural heroes of the modern world were no longer Olympian deities; instead, in the words of a critic of the time, Nadar presented:

> a type of museum of curiosities whose author wished to transform into a museum of grotesques, in virtue of the modern axiom: beauty is ugliness. They number two-hundred and fifty, pushing deformity as far as delirium, grotesquely bearing impossible heads, the elite confused with the crowd, and all as confident as Polyeucte marching towards an immortality that will end tomorrow. . . . Nadar turns the great words of Plato, that the spirit's beauty is read in the face, against his own time; mockery now is the soul used towards and against everyone. But this raillery is pleasant, and the observation that inspires it is so fine that the conceited, even those most outraged, will pardon Nadar his crayon marks and no longer see in them the marks of talons. [2]

The first printing of the *Panthéon* with only 249 figures had proved successful enough to warrant a second printing under contract with the newspaper *Le Figaro*, which in turn allowed for a slight change in title to *Prime du Figaro, Panthéon Nadar*, as well as the deletion and addition of certain figures. In the second printing, shown here, the original 249 figures were increased to 269, including more painters and musicians. Nadar had planned to devote three further *Panthéons* to dramatists, visual artists, and musicians, but apparently the first was so time consuming that the plan was abandoned, and they were simply added to the original procession.

PRIME DU FIGARO — PANTHÉON NADAR

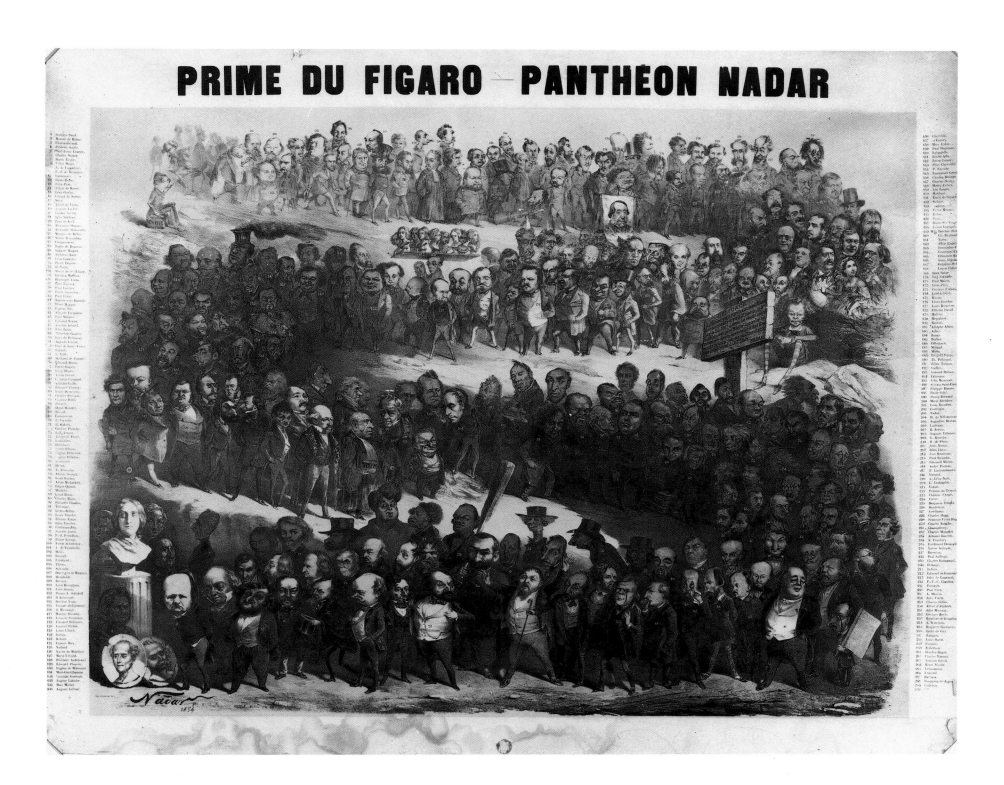

EDOUARD-DENIS BALDUS

French · b. Prussia · 1813–1882

Pavillon Turgot, Nouveau Louvre

ca. 1856 · Albumen print · 43.5 × 34.2 cm.

Baldus was born in Grunebach, Prussia, June 5, 1813. He settled in Paris around 1838 with the idea of furthering his art studies, but this was possibly after a sojourn to America where he was said to have been a portrait painter. In Paris, he exhibited portraits, genre scenes, and religious paintings at the Salons of 1847, 1848, and 1851. Apparently, he took up photography in 1848 and had his first success in 1849. In 1851 he was appointed to the first *Mission* organized by the *Commission des monuments historiques* to document in photographs the more important historical monuments and buildings in Burgundy, the Dauphiné, and Provence. The next year he was commissioned by the Ministry of the Interior to document Parisian monuments. In 1855, he began photographing the French railway lines for Baron James de Rothschild, which in turn led Baldus to produce at least three albums of albumen prints of trains, terminals, and roadbeds. Between 1856 and 1858, he photographed the inundations of the Rhône in the Midi and around Avignon, as well as the rebuilding of the "new" Louvre in Paris. Amid this activity, he became a naturalized Frenchman and was awarded the *Légion d'Honneur* in 1860. Baldus also developed a successful method of "waxing" calotype negatives with gelatin (ca. 1849), was one of the earliest to perfect a type of photogravure process (1852), photographed prize-winning animals (1854), and published a number of photogravure volumes of architectural details during the 1870s from negatives he made in the 1850s. Most likely he died in 1882.

It is little wonder that Baldus, among all the photographers of the 1850s, has been described as "achieving the greatest success with official organizations from which he received numerous commissions; this explains the importance of his productions, numbering in the hundreds—a very exceptional achievement in photography of that period."[1] But it was not solely Baldus's political savvy that accorded him such a stature during his lifetime and since. His photographs are among the most classically beautiful and consistently eloquent photographs made in the last century. According to one period source, writing about Baldus's use of gelatin, he "obtained by this substitution [for wax], prints that had a delicacy and remarkable beauty with extraordinary dimensions, prints that were and still are today a veritable triumph for photography on paper."[2] Similar accolades, for his print quality and his subjects, were widely bestowed on Baldus in the photographic press of the 1850s, most regularly in the pages of *La Lumière*.

Baldus formulated his aesthetic imperative from the very beginning of his involvement with architectural photography. The architecture is clear, lucid, and "grand"—no superfluous excrescences of everyday details, the absolute minimum of romanticizing light effects or chiaroscuro, and a rigid, formally direct confrontation with the edifice. Although the format of his prints was generally that of a full landscape plate, the subject consistently seems to extrude beyond the confines of the frame by its presence, symmetry, and the lack of any atmospheric effect. Baldus's architectural photography exudes a cool austerity consistent with scientific Positivism and Realism; chosen by refinement and sensitivity, his approach is one of pure photography, devoid of romanticism, sentimentality, and "style" in any artful sense. Unlike the lyricism of Henri Le Secq, another photographer of the *Mission historique*, Baldus's style is imperial.

Baldus's photography of the 1850s was a summation of the ideals of the Second Empire; the images portray grandeur, monumentality, philosophical disinterestedness, and official power. At the same time they represent the beginning of a completely inherent and modernist photographic style: straightforward, clear, nonpainterly, and unabashedly the product of the camera. Baldus's sense of conceptual enlargement, sensed by Ernest Lacan when he asked how "this artist was able to render so vast an expanse in so relatively restrained a space," is an accurate appraisal of this photographer's work.[3] Baldus's images are about things, the modern environment, and the largeness and power of the photographic image.

ROGER FENTON

British · 1819–1869

Chatsworth, The Palace of the Peak, The Italian Garden

ca. 1858–60 · Albumen print · 34.1 × 43.9 cm.

Known primarily for his views of the Crimean campaign in 1855 and for being thus one of the first photographic war journalists, along with Carol Papp de Szathmari, Léon Méhédin, and James Robertson, Roger Fenton was also one of the Victorian period's foremost photographic artists of landscapes and of architecture. According to one critic, writing three years after the photographer's return from the Crimea: "Of course, no one can touch Fenton in landscape: he seems to be to photography what Turner was to painting—our greatest landscape photographer. . . . There is such an artistic feeling about the whole of these pictures, the gradations of tint are so admirably given, that they cannot fail to strike the beholder as being something more than mere photographs."[1] Like so many French photographers of his generation, Fenton was trained as an artist. And like so many French photographers of the Second Empire, Fenton studied painting in Paris where, in the studio of Paul Delaroche, he most likely met Gustave Le Gray, Charles Nègre, and Henri Le Secq. Unlike most photographers of the period, he also trained as a solicitor, and it was to practice law that he gave up photography in 1862 after only a decade of intense and impassioned work.

It was Fenton's sophisticated eye for tones and textures and a structured pictorial composition that contributed to his inordinate success at creating superlative photographic pictures. While Robertson and Felice Beato focused to some degree on the carnage and suffering of the war, Fenton documented the officers of rank and distinction, the emptied landscapes, and the cityscapes and docks of Balaklava [fig. 18]. According to one reviewer of the period, Fenton's various photographs of Balaklava harbor were so well seen, "so truly are the textures realised, and so well do the objects compose, that many of them would paint extremely well."[2] By choice selection of view, then, and by composing that view with an eye toward variety of textures and tones, Fenton excelled at what was eminently the picturesque.

As applied to views of architecture, the picturesque was defined by the photographic art critic A. H. Wall in 1867.

I believe the great element of the picturesque is not mere "roughness," but variety. Grand Gothic cathedrals, whether new or old, are picturesque enough; but then they are so varied in their parts. . . . Classic architecture is less picturesque in the same condition of preservation only because it is more simply beautiful, more dependent upon symmetry and proportion, and less varied in its relative parts;

Fig. 18. Roger Fenton, *View of Balaklava Harbor*, albumen print, 1855.

and the formality of a modern garden, with its monotonous repetition of the same few forms, render it unpicturesque rather than its lack of roughness and disorder. The classic temple in ruin may be less grand and more picturesque than it was when new. . . . The cracks, breaks, and fissures, the various-coloured stains of time and vegetation, the differences between new and old fractures, the prostrate and variously dilapidated and displaced columns, the wild creeping plants, grasses, and weeds which have overgrown it— all serve to introduce that which I hold to be the life-blood of the picturesque, namely, variety. Therefore I urge photographers who may desire to render their works more interesting and attractive to the public to secure the picturesque, and to seek it in an increased variety of forms, light, shade, and tones, governed, of course, by the pictorial laws regulating breadth, relief, and atmospheric effect.[3]

Fenton's architectural photographs, whether they are of façades of cathedrals, medieval portals, stairways in gardens, cathedral naves, ruined abbeys, or ivy covered cottages, are all manifestly conceived as primarily picturesque images, images of unending visual fascination and variety.

J.-B. GUSTAVE LE GRAY

French · 1820–1882

Seascape

ca. 1857 · Albumen print, combination printing ·
34.8 × 41.5 cm.

Gustave Le Gray was unquestionably one of the foremost painter/photographers of the French Second Empire, and the present rather high opinion of his art was held as strongly then. His photographs have a breadth, a monumentality, and an authority that very few other camera artists ever achieved. Through his various publications, he also furthered the cause of formulating an aesthetic for the new art of photography, a theory asserting that the photographer ought to avoid the very details modern lenses were so capable of granting a picture. Like Sir William Newton in Great Britain during the early years of the 1850s, Le Gray found greater value in broader as opposed to more precise photographic effects: "In my opinion, the artistic beauty of a photographic print consists nearly always in the sacrifice of certain details; by varying the focus, the exposure time, the artist can make the most of one part or sacrifice another to produce powerful effects of light and shadow, or he can work for extreme softness or suavity, copying the same model or site, depending on how he feels."[1] General effects along with massings of planes and tonal areas and, thus, greater compositional vitality and harmony were, for Le Gray, the requisites of photographic art.

Nowhere are Le Gray's theories better applied than in the numerous marine subjects he made between about 1855 and 1857, the greatest of them being this particular image, popularly referred to as "The Great Wave" or "*La Grande vague*." A version of this print is in the *Société française de photographie*, and it has been suggested that this may have been the image exhibited in 1857 along with the inscription "View taken on the beach of Dieppe."[2] Le Gray's seascapes customarily have been associated with the prodigious marines of Gustave Courbet, but it must be recalled that the Realist painter only began doing seascapes in the middle 1860s and only realized his most famous one, *The Wave*, in 1869/70.[3] Certainly the depiction of boiling sea and skies filled with momentous clouds are similar in both artists' work, but it is more likely that they were both reacting to the same pictorial tradition that included the earlier marines of Paul Huet and Eugène Isabey. Although he did have a few followers, Le Gray's seascapes are unique to 19th-century photography, and only his prompted one critic to express: ". . . the event of the year was produced by the seascapes of M. Legray. M. Macaire had made some initial attempts at this subject, but M. Legray was perfect from the first. I say perfect, since the sky garnished with clouds, the moon silhouetted from afar, and the ships under way either by sail or steam leave nothing to be desired. Only the water is a bit black, but considering the grandeur of the prints, every unreasonable demand of nature must be silenced."[4]

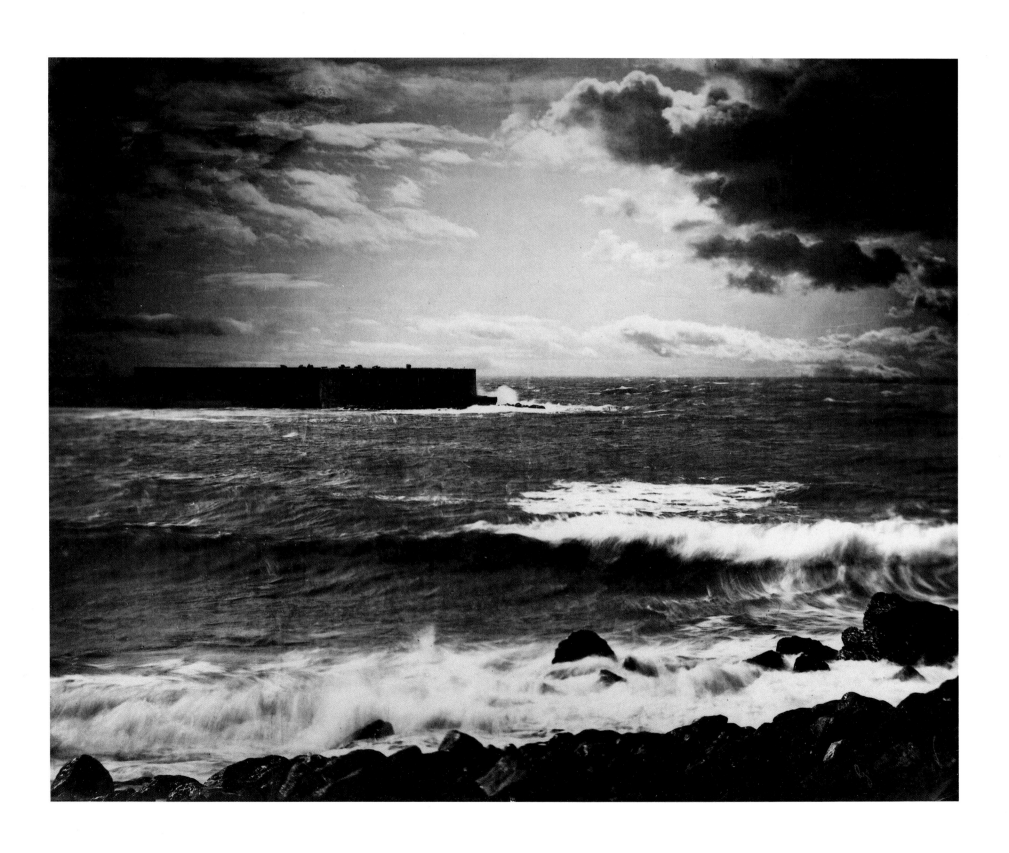

EDOUARD FIERLANTS

Belgian · 1819–1869

Hôpital St. Jean

ca. 1860–62 · Albumen print, varnished (?) · 27.0 × 36.3 cm.

Edouard Fierlants was most noted during the 1860s for his spectacular views of Antwerp and Brussels, especially his concentration on the picturesque architecture found in those cities. Fierlants's work is eminently comparable to that of the Ghémar Brothers of Brussels; both represent perhaps the finest urban photography in 19th-century Belgium, and it is only due to the Ghémars's continual appearance in the Parisian press that their photography was and remains more familiar. Fierlants began photography in the early 1850s and was the first in Belgium to photographically reproduce paintings; he worked for the city government of Antwerp early the next decade documenting that city's principal monuments; and about 1861 he founded the *Société Royale Belge de Photographie* in Elsene.

Fierlants may already have been aware of the Hôpital St. Jean in Bruges since it contained a number of particularly important works of early Netherlandish art, including five Hans Memlinc panels and the same artist's famous carved and painted Ursula Shrine of 1489. Fierlants does not show us a standardized or expected view of the medieval hospital. Instead, he positioned his camera alongside the building's chapel, aimed it downward so that the rooftops were cropped from view, and included the hospital's reflections in the adjacent canal. It is unclear whether Fierlants was recording a rather visible sign of flooding (since the water level at this angle seems rather high on the building) or whether he was specifically intent upon documenting the small porch of the hospital. In either case, the resulting print portrays a somewhat uncharacteristic closeup, a portion of a broader scene that suggests a stillness and gentle melancholy that anticipate the same elements in the work of another Bel-

Fig. 19. Fernand Khnopff, *Memories of Flanders. A Canal*, pencil, charcoal, and pastel on paper, 1904, Barry Friedman Ltd., New York.

gian artist, Fernand Khnopff, later in the century. In fact, this particular photograph by Fierlants is chillingly close in every detail to Khnopff's drawing from 1904 of the Green Canal as it passes the walls of Bruges's Chapel of the Holy Blood. Khnopff's comment that during his childhood Bruges was "a true *ville morte*, unknown to visitors," takes on special meaning here when one realizes that the years he spent in Bruges, 1859-64, coincide with the probable date of Fierlants's photograph[1] [fig. 19]. Khnopff's words also recall Baudelaire's reaction to the same city, which the French poet wrote in his notebooks between 1864 and 1866: "Phantom city, mummified city, a bit conserved. It smells of death, the middle ages, Venice, in black, routine spectres and tombs."[2]

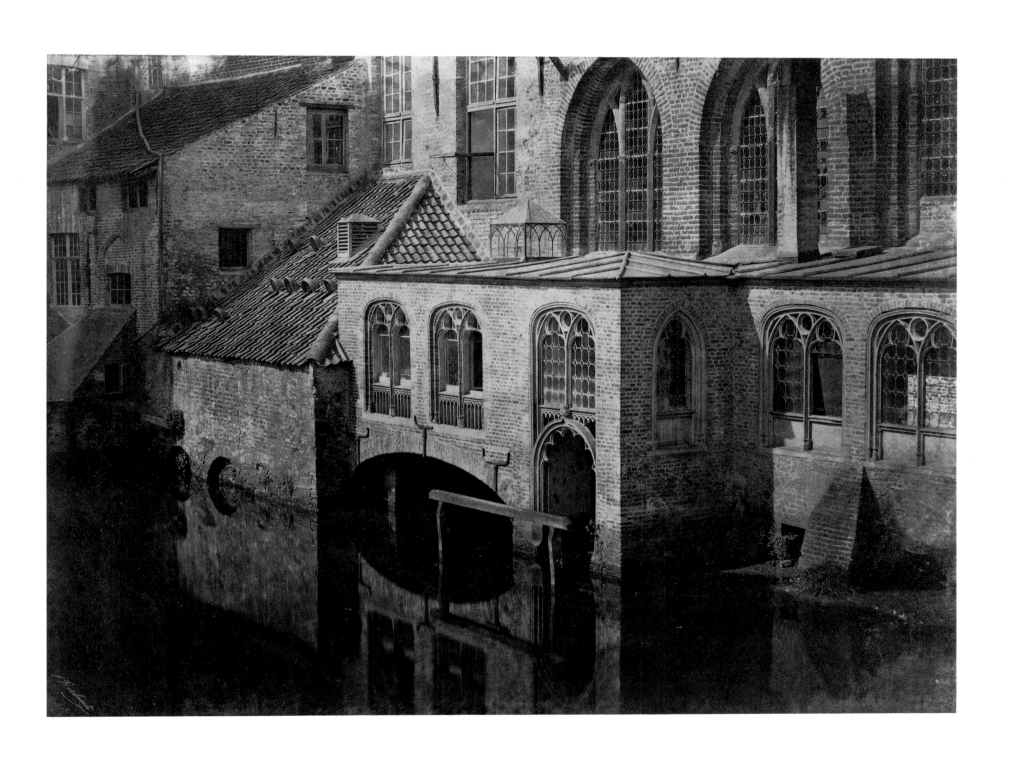

ADOLPHE BRAUN

French · 1812–1877

Still Life of Flowers

ca. 1854–56 · Albumen print · 43.8 × 46.7 cm., rounded corners

The name Adolphe Braun is synonymous with large, operatic carbon prints of the Tyrol and the Alps issued in the hundreds by his photographic printing firm, "Adolphe Braun et Cie.," located in Dornach near Mulhouse in northeastern France. What is not commonly known is that Braun began his artistic career as a designer and art director for a textile company in Mulhouse, later established his own design house specializing in creations for the textile and wallpaper industries, and only began working with a camera in 1853. By the end of 1854 he had produced an album of 300 albumen prints of floral arrangements, which gained him immediate recognition as a first-rate photographer by critics and academics of the period, as well as a gold medal at the *Exposition universelle* of 1855.

While a number of French photographers produced superb pictures of flowers during the 1860s (most notably A. Bolotte and Charles Aubry), in essence it was Braun who had created the genre at least a decade earlier. There is little reason to believe that Braun, when he assembled his 300 prints of floral still lifes in 1854 and promised hundreds more, was motivated by the singular ideal of making works of pure art. In fact, he is quite explicit that these were to be considered as works of *applied* art in the very title to his album: "Photographs of Flowers, for the use of manufacturers of painted fabrics, painted papers, silk stuffs, porcelains, etc." The prevalence of floral motifs in wallpapers and fabric design during the Second Empire is well documented in paintings of period interiors and in extant swatches and remnants. Perhaps the most famous is Edouard Muller's design for block-printed wallpaper for the manufacturer Jules Desfosse and illustrating "The Garden of Armida," in which the statue of Flora is nearly obliterated by an utter profusion of cascading roses, peonies, chrysanthemums, morning glories, and other varieties, all painted with perfect botanical exactitude. This three-part panoramic wallpaper, now in the collection of the Musée des Arts Dècoratifs in Paris, was printed in 1854, the same year as Braun's albumen prints, and also won a gold medal at the *Exposition universelle* of 1855.[1] It was to artists like Muller and manufacturers like Desfosse that Braun directed his photographs.

The photographic journal *La Lumière* immediately posited the social benefits gained from such a production, which Braun proposed to call a *Natural History of Flowers*: "The beautiful publication by M. Braun will be tremendously useful and will exert a significant influence on the progress of the art of design in its application to industry. . . . [for] it is thus in perfecting its beautiful products as much as possible that France will be able to maintain its superiority."[2] An uncited reviewer for the *Journal des débats* reported that "collodion is decidedly the photographic canvas par excellence, a fine and delicate canvas, on which the most frail productions of the vegetal kingdom have come to be fixed with an inexpressible grace." Braun's photographs were to this critic "so perfect and so seductive" that he found it difficult who most to praise—the photographer, the arranger of the floral compositions, or the collodion's sensitivity and precision, but he did conclude that "amateurs, botanists, horticulturists, artists— it is impossible that anyone who looks at this album will not sense an extreme pleasure."[3]

That these prints are now viewed as masterpieces of 19th-century photographic art instead of mere models for the use of other artists is a testimony to their exquisite beauty and the fluid parameters of what we declare to be art.

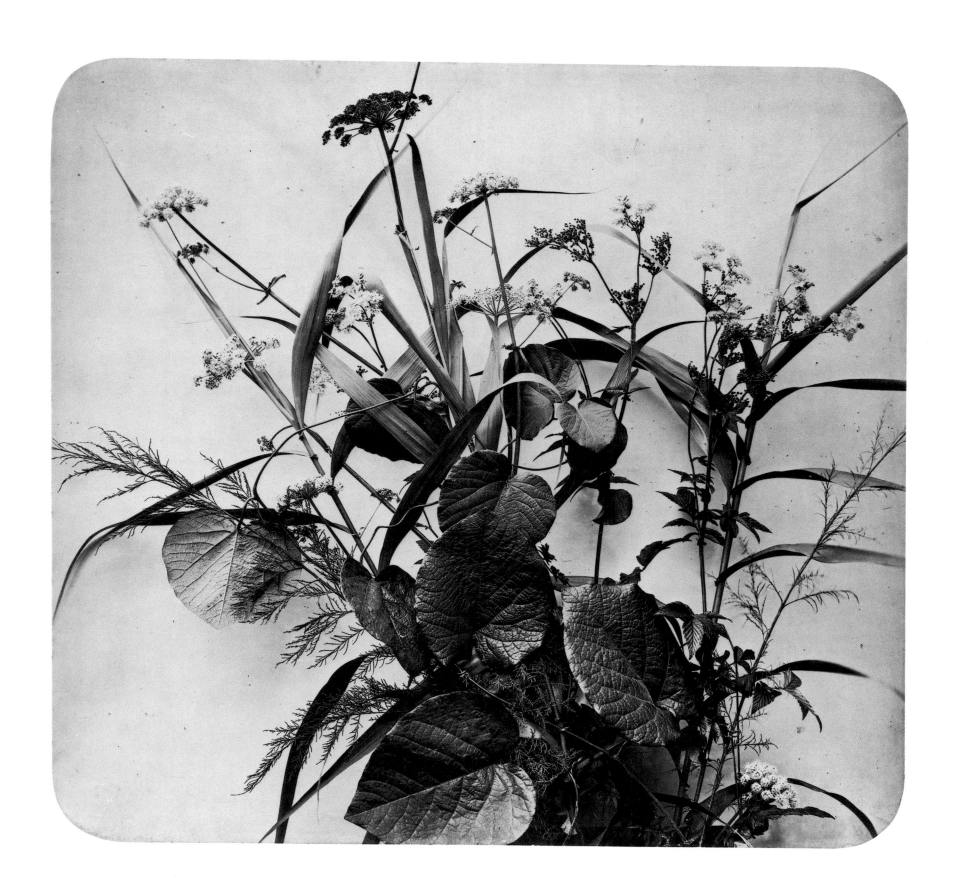

ADOLPHE BILORDEAUX

French · active 1850s–1860s

Still Life with Musket and Shell

ca. 1859 · Albumen print · 42.2 × 30.1 cm., domed

Throughout much of the 1850s, Bilordeaux, a lithographer and a student of Gustave Le Gray, concentrated on photographing plaster bas-reliefs, for which he was acclaimed. Toward the end of the decade, he earned a fashionable reputation for his elaborately posed and "accessorized" portraits. He exhibited a historical narrative entitled *The Alchemist from Life* in 1859,[1] thus placing him in a photographic tradition that included Oscar Gustave Rejlander and Henry Peach Robinson in Great Britain, and, later, Duchenne de Boulogne and De Charly in France.

The photographic still life in France during the Second Empire is generally a conflation of influences, consisting of elements from the Dutch 17th-century *vanitas*, French 18th-century Chardinesque still lifes, 19th-century paintings such as the "exotic masses of precious objects"[2] by the French romantic painter Blaise-Alexandre Desgoffe or the more contemporary floral pieces of Henri Fantin-Latour, and even including a short but prolific photographic tradition begun with the daguerreotypes of Daguerre and the paper positives of Bayard. Bilordeaux's albumen print still lifes, two of which are in the museum's collection, are exceptionally large, nearly baroque amassings of guns, swords, classical statuettes, sea shells, assorted *objets d'art*, and richly brocaded fabrics. Like the very earliest daguerreian still lifes [fig. 20], the objects are displayed atop a table and against a background foil that allows for the absolute minimum of spatial environment for the still life. In fact, there is an almost mannerist restriction of space that strikes an uncomfortable

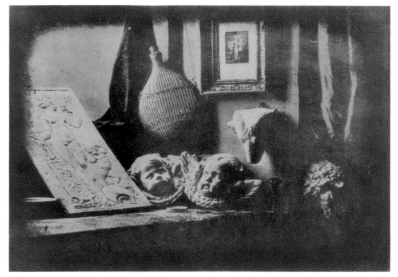

Fig. 20. Louis-Jacques-Mandé Daguerre, (Still life), daguerreotype, 1837, *Société française de photographie*.

chord of satiation. Reviewing Bilordeaux's portraiture in 1861, Ernest Lacan commented that the artist displayed, "a scholarly arrangement that masks its underlying research. They have character. They breathe, despite their restrained settings, and their three-dimensionality is striking. . . . In our opinion, the only reproach one might make is their lack of simplicity."[3] The same words could be used appropriately in describing this still life.

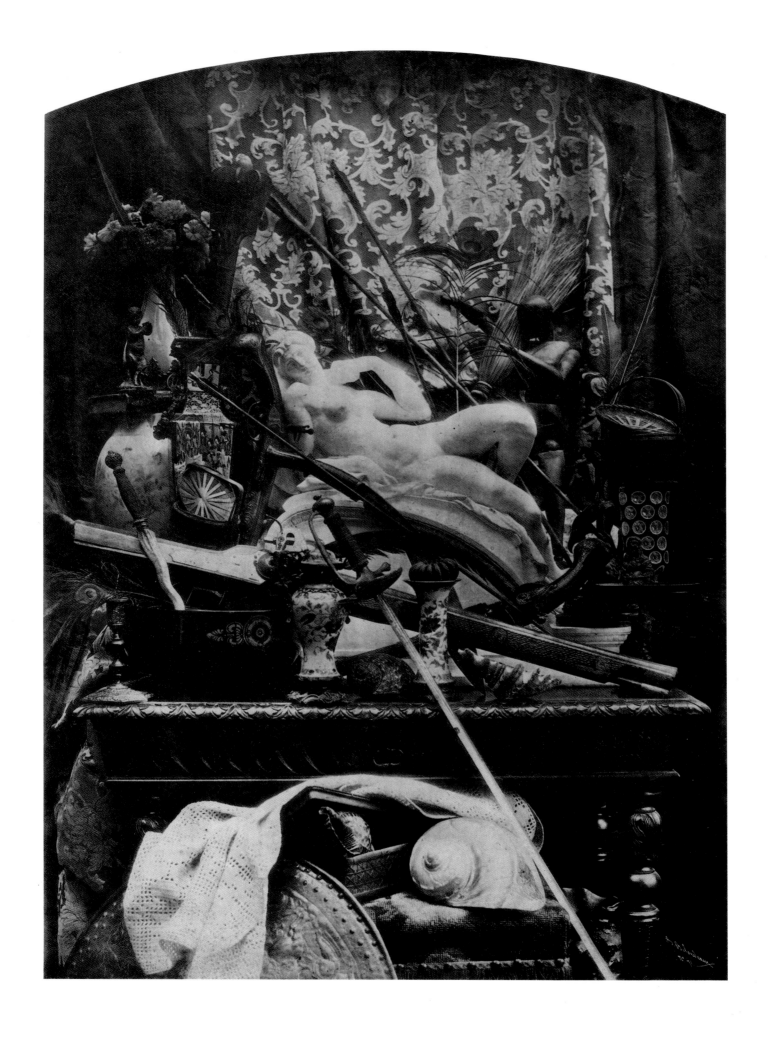

B. BRAQUEHAIS

French · active 1850–1874

Academic Study with "Venus de Milo"

ca. 1854 · Albumen print · 25.4 × 20.1 cm.

Along with Eugène Durieu and Julien Vallou de Villeneuve, B. Braquehais achieved some of the finest photographic nude studies, or *academies*, of the Second Empire. He began his career as a daguerreotypist, working with the Parisian photographer A. Gouin, whose daughter Braquehais married and whose studio he inherited in the 1860s. While he photographed portraits, monuments, and works of art in addition to nude studies, it is for his *academies* that he gained critical acclaim at the time.

Having already praised Braquehais for his portraits on waxed fabric earlier in the year,[1] Ernest Lacan devoted nearly an entire column to the photographer's studies of the nude and outlined the essential requirements of nude photography for use by artists and students.

The model, whether man or woman and no matter how beautiful, is always far from being perfect. The photographer, in order to achieve a fully resolved study, must emphasize the model's beautiful aspects as much as possible and minimize its imperfections—this supposes a sufficient knowledge of nature on the part of the photographer—and he must do this by observing the fixed rules of posing, the principal one of which being, in the language of the artist's studio, *movement*. Once these conditions are met, the model must be well lighted since the student must be able to find in works of this kind, the model's dignity and grace as well as muscular articulation and lines of contour. Composition is as important as execution. Clarity without aridity, full tonality, rigorous and exacting art-direction, and everything that helps avoid any deformation of line; these are the indispensable qualities needed by all these kinds of prints.[2]

Lacan's prescriptions are more than just a prologue to Braquehais's photographs, they read precisely like the rules governing figure painting at the *Ecole des Beaux-Arts*: obedience to anatomical correctness, idealized naturalism, and a unifying arrangement of darks and lights.

For Lacan, Braquehais completely satisfied these requirements, while at the same time elevating the figure's background to one of particular interest: "M. Braquehais has had the fortunate idea of arranging fairly dark curtains around his models which place the model into relief and which could themselves be used as studies. Our only regret is to see, in each of these prints, a plaster Venus which distracts the eye and singularly disturbs the general effect. With the exception of this useless accessory, his prints are the most beautiful and the most perfect we have ever seen of this genre."[3] In spite of Lacan's dissatisfaction with the plaster statue, its inclusion would seem to have certain benefits. First, the severe whiteness of the statuette completes the tonal scale of the picture that begins in the darks of the drapery. In between these two extremes, Braquehais recorded an extensive array of values and "half-tones," almost as if he were demonstrating an academic lesson in chiaroscuro and artistic effect, a lesson that in fact formed the basis of the curriculum at the *Ecole des Beaux-Arts* and was described by Ingres when he recalled: "To me, a plaster cast looked white when in the light and dark when in shadow; and it is a curious thing that the unpracticed eye does not perceive what we call 'modelling,' that is, the transition from light to shade by means of half-tones."[4] More importantly, with the greatest economy of means, Braquehais contrasted the ideal female form of art with its less than perfect living counterpart.

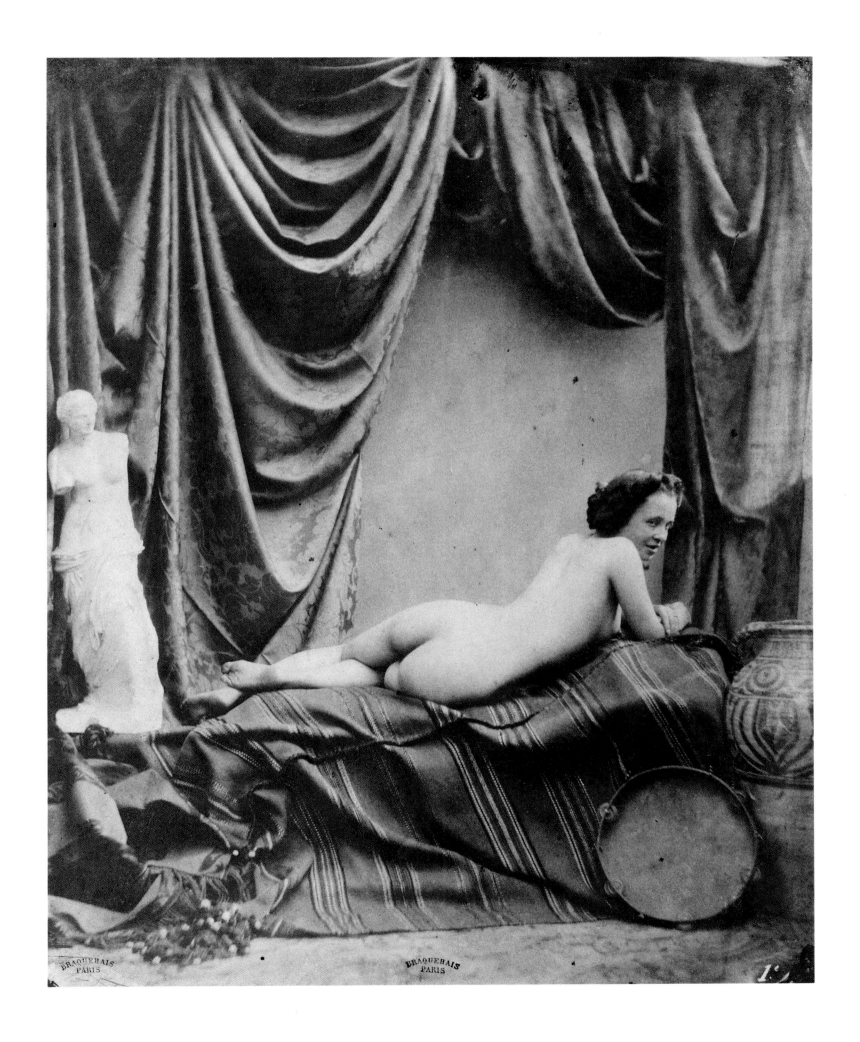

ADRIEN TOURNACHON

French · 1825–1903

Alphonse de Lamartine

1856 · Albumen print (?), applied color · 57.0 × 45.0 cm.

Adrien Tournachon was the younger brother of the more famous Second Empire French photographer, journalist, and caricaturist Gaspard-Félix Tournachon, called more simply Nadar. Adrien began photography in 1854 and signed his prints "Nadar jeune" (Nadar the younger), until his brother sought and received a legal injunction in 1856 against this use of his pseudonym. Adrien thereafter autographed his work as either "Adrien Tournachon, jne." or, more simply yet, "Tournachon jne." During the 1850s, Adrien's work was frequently mentioned along with Nadar's and critically adjudged to be the product of an equal talent. His portrait series of the famous French mime Charles Debureau posing as the character *Pierrot* was a striking success in 1855, as were his "portraits" of prize-winning bulls, cows, and horses done in the same year.[1] Working with Dr. Duchenne de Boulogne in 1859, Adrien photographed muscular gestures on the faces of the insane and of actors for a scientific study of physiognomic expression.[2]

The portrait of Lamartine is an exceptionally rare piece by Adrien Tournachon. For a time it was attributed to Nadar, the older brother, on the basis of the collector Gabriel Cromer's notes on the back of the print's mount:

First enlargement of portrait in 1861/(see "Moniteur de la Photographie" 1861 pages 18, etc.)/Solar enlarger by Liébert . . . 1864————/(see 1st ed. of Photo. en Amérique)/One of the first enlargements by Nadar/from his famous negative of Lamartine (1790-1869) taken about . . . /Enlargement made about 1865?/Same [indecipherable] as my grand mother Cromer/equally by Nadar/ . . . /by *Nadar*/ see l'Illustration/du 15 april/1933, page 436.

Cromer's reference to Liébert's *La Photographie en Amérique* does lead to a description of a solar enlarger, and the reference to portrait enlargements also proves fruitful.[3] This article only mentions the enlarged portraits made by Edouard Delessert, although it does discuss the sumptuous studios of Nadar, Adrien Tournachon, and Disdéri and their need to satisfy a public that demanded portraits made of themselves as well as their horses, their carriages, and their riding gear. The citation to *l'Illustration* proves to be inconclusive as to any verification of authorship.

Cromer's authority is customarily flawless, and the uncertain basis for his attribution of this portrait to Nadar remained problematic. A relatively obscure review of a Belgian exhibition, however, has provided the evidence necessary to attribute this portrait confidently to the younger Tournachon instead of to Nadar.

Writing in the autumn of 1856, the French photographic critic Ernest Lacan reported on an exhibition held in Brussels in that year. In his article, Lacan suggested certain thoughts about the role of art in photography as well as identifying this particular portrait.

Portraitists are few in number at the Brussels exhibition, but their prints are quite remarkable. Therefore, it is impossible to deny the intimate association of photography with art when one views the beautiful portraits (life-size) of Lamartine, of Jules Janin, of Meissonnier and of Dantan, which are exhibited by Messrs. Tournachon (Nadar jeune) and Company. The vigorous and spiritual pencil [*crayon*] of the painter, animating the photographic sketch [*ébauche*], creates a drawing in which, as only the great masters have been able to attain, one finds those two things which contribute to a masterpiece: truth allied with the ideal. If perfection in art consists of the exact reproduction of nature by making it immaterial, these are perfect works. Thus have these portraits caused a lively public sensation.[4]

Little more could be said of this portrait of Lamartine, which still elicits much the same sense of respect and awe it engendered in the 19th-century critic.

Author of *Méditations poétiques*, *Voyage en Orient*, and *Histoire de la Révolution de 1848*, among many other works, Lamartine was a member of the *Chambre des Députés* and singularly responsible for proclaiming the new republic of France after the social revolution of 1848. He also proclaimed that "photography was the photographer," a conclusion he reached after viewing the portrait daguerreotypes by Adam-Salomon. Lamartine figures as *portrait-chargé* No. 9 in Nadar's monumental lithograph, *Le Panthéon*, of 1854, immediately behind Victor Hugo and George Sand.

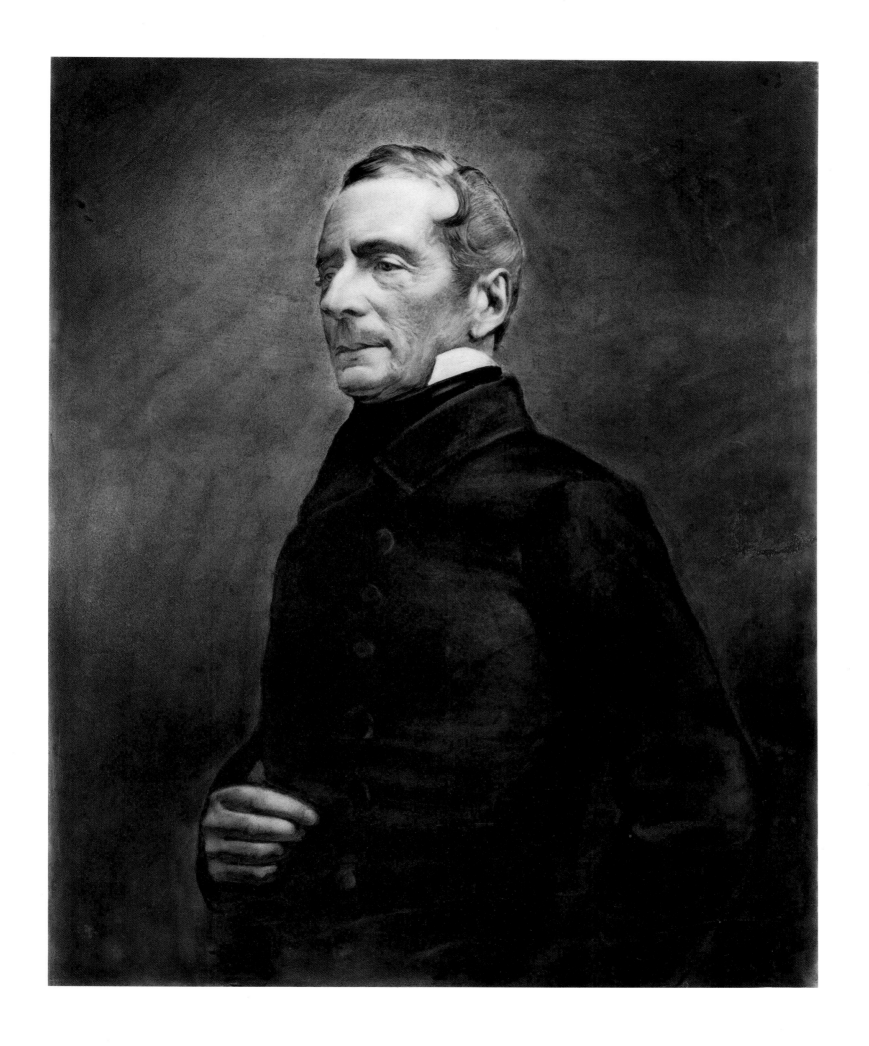

ALBERT SANDS SOUTHWORTH and JOSIAH JOHNSON HAWES

American · 1811–1894 American · 1808–1901

Group Portrait of Unidentified Women

ca. 1856 · Daguerreotype · 16.5 × 21.6 cm., full plate

In 1870, Albert Sands Southworth defined the artistic fundamentals of early American photography. These fundamentals were based on the physical manipulations of optics and chemistry and were vested with the responsibility of accuracy, fact, and truth. That given, there was also the art of the medium, and Southworth perceived it clearly in terms of American Transcendentalism.

> But the artist, even in photography, must go beyond discovery and the knowledge of facts; he must create and invent truths and produce new developments of facts. I would have him an artist in the highest and truest sense applicable to the production of views or pictures of any and every kind, or to statues and forms in nature, universally. I would have him able to wield at pleasure the power of drawing nature in all her forms, as represented to vision, with lights and shadows, and colors and forms, in all of nature's changes. . . . He should not only be familiar with nature and her philosophy, but he should be informed as to the principles which govern or influence human actions, and the causes which affect and mark human character. History and poetry should be to him mere *pastime*; observation of nature, cause and effect, should be his employment.[1]

For Southworth, there were simply few differences between photographer and painter or sculptor; all manipulated tools and materials, all required genius and intellect, all were artists. It was the mind of the artist that was most important, not the materials: "The mind must express the value and mark and impress resemblances and differences. It must be instructed and directed by impressions, at the time, emanating from the subject itself."[2]

These artistic ideals thoroughly permeated the daguerreotypes taken by the team of Southworth and Hawes between 1843 and 1862, unquestioningly this country's finest portraitists of the last century. Their Boston studio brilliantly captured the likenesses of such notables as Lola Montez, Daniel Webster, Justice Lemuel Shaw, Charles Sumner, Rufus Choate, Ralph Waldo Emerson, and Harriet Beecher Stowe. More often, however, their clients were not especially public personalities but fashionable citizens of Boston, pleased to pay the expense of having their portraits made by the city's most prestigious photographers. Again, Southworth summarized the requirements of an artistic portrait.

> What is to be done is obliged to be done quickly. The whole character of the sitter is to be read at first sight; the whole likeness, as it shall appear when finished, is to be seen at first, in each and all its details, and in their unity and

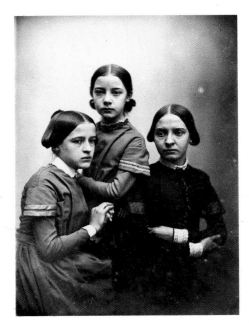

Fig. 21.
Southworth and Hawes,
*Group Portrait of
Unidentified Women*,
daguerreotype, ca. 1856.

combinations. Natural and accidental defects are to be separated from natural and possible perfections; these latter to obliterate or hide the former. Nature is not all to be represented as it is, but as it ought to be, and might possibly have been; and it is required of and should be the aim of the artist-photographer to produce in the likeness the best possible character and finest expression of which that particular face or figure could ever have been capable. But in the result there is to be no departure from truth in the delineation and representation of beauty, and expression, and character.[3]

This striking portrait of three young women loosely yet formally posed in the studio attests to Southworth and Hawes's preeminent command of those paramount factors of beauty, expression, and character. There is a second, vertical portrait of the same young women by Southworth and Hawes in the museum's collection, which accords the sitters the same degree of intuition, understanding, and revelation of individual character [fig. 21]. Despite the differences in feeling and composition, the psychological interpretation of the women is the same in both plates; one is shy and reclusive, another coyly assertive, and the last earnest and self-confident. Very few photographers of the time were as able delineators of the human personality and spirit as were Southworth and Hawes, nor were many able to render their sitter's character through subtleties of posture and composition so adroitly as in this horizontal plate.

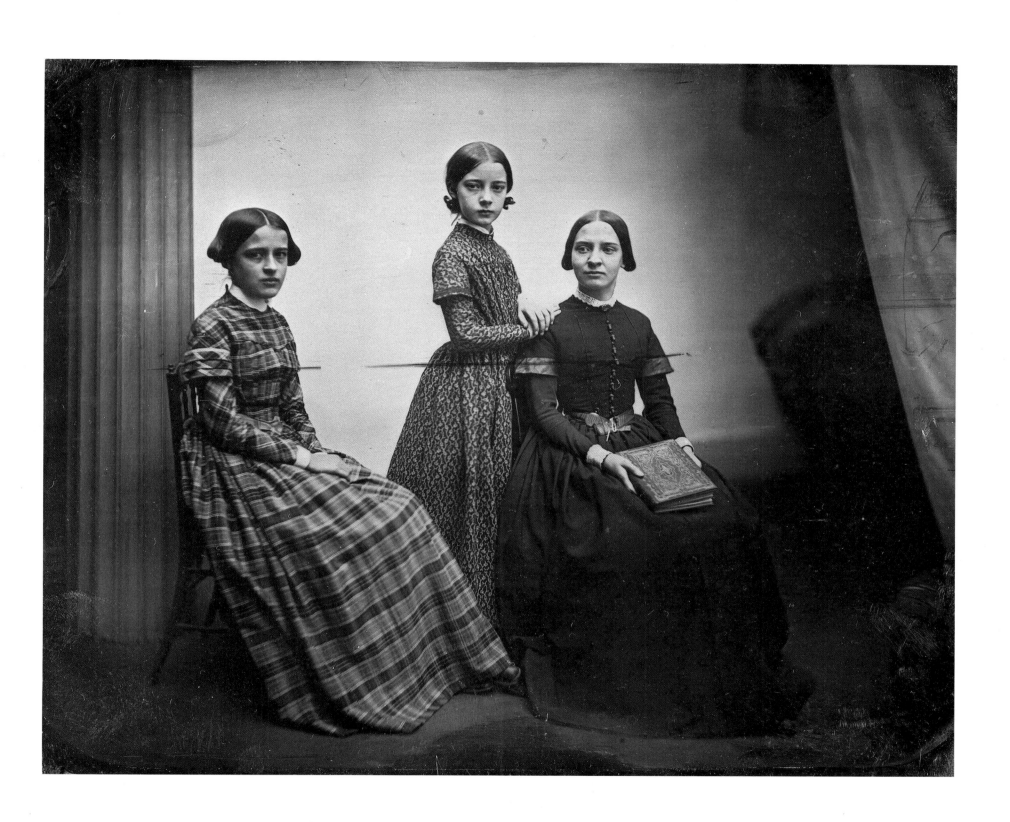

F. A. WENDEROTH

American · active 1860s

The Artist's Daughter

ca. 1855 · Ivorytype, applied color · 54.7 × 42.1 cm., domed

In all likelihood, this spectacular extant example of a rather eso-
teric 19th-century photographic process, and the largest in size,
is also the creation of the process's inventor. The subject, iden-
tified as Wenderoth's daughter by the artist's descendants and
family tradition, is a quintessential portrait of a Victorian Amer-
ican child.

The ivorytype process is little known and often misunder-
stood, complicated by its subtle variations and the lack of any
standardized nomenclature in photographic literature. Jones
described it as "an imitation of prints upon ivory,"[1] and he refers
the reader to a variation called "Eburneum Process." Woodbury
did not connect the process with any simulation of ivory-based
prints but did state that it is also known as "Hellenotype."[2] The
authoritative source for the process is, however, Root's classic
treatise of 1864 on American photography, wherein the author,
himself a noted photographer, distinguished between J. J. E.
Mayall's British "ivorytype," which was a photographic print
upon artificial ivory, and Wenderoth's "American ivorytype,"
which was a paper print annealed to glass and "finished so as to
resemble a miniature or portrait on ivory."[3]

Simply described, the American ivorytype was fabricated by
carefully painting over a "vigorous" print with permanent col-
ors, "much stronger [more saturated] than are commonly
employed on surface-painting." The colored print was then
pressed upon a sheet of glass that had been coated with pure
white, melted wax; when cooled the image was "permanently"
bonded to the glass and took on a richness and vibrancy unparal-
leled in other hand-colored photographic processes. Unfortu-
nately, wherever the print was not over-colored, such as the
daughter's face, or where the coloring was only applied to the
back of the print for a more muted effect, such as in the sky, the
oxidation of the wax over the years has resulted in a pronounced
yellowing. Despite these defects, however, the charm of this por-
trait is undiminished.

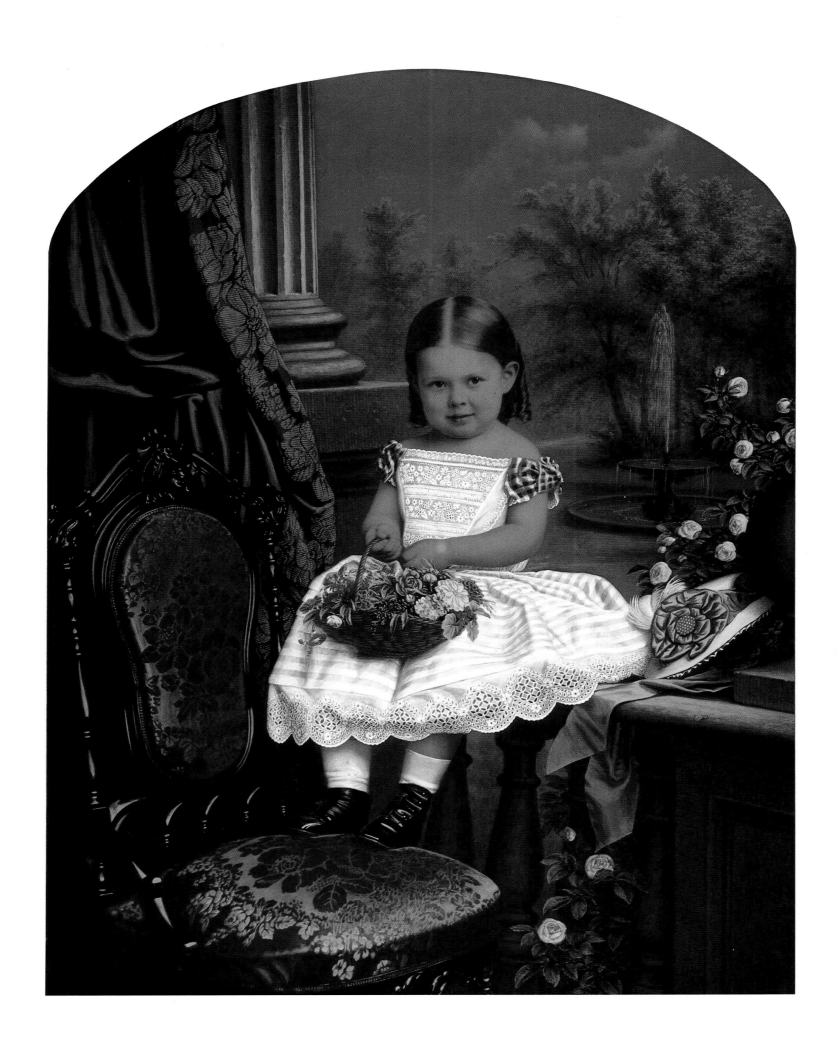

LEWIS CARROLL [REV. CHARLES LUTWIDGE DODGSON]

British · 1832–1898

Xie Kitchin with Violin

1876 · Albumen print · 14.8 × 10.4 cm., cabinet card

Next to Alice Liddell, the child who originally inspired the writing of *Alice in Wonderland* and *Through the Looking Glass*, Alexandra ("Xie") Kitchin was the most famous of Lewis Carroll's young models. Like the portraits of Alice, those of Xie portray the child in various costumes, with a variety of accoutrements, and often feigning some fictive character. Godchild of Queen Alexandra, Xie was the daughter of the Reverend George William Kitchin, Dean of Winchester and, later, Durham. Reverend Kitchin was the Censor of the unattached members of the University of Oxford for fifteen years, and thus Carroll, who taught mathematics and logic at Oxford, had frequent opportunity to photograph the cleric's daughter. Carroll depicted Xie in her winter furs, as "A Chinaman" dressed in *chinoiserie* and seated atop oriental boxes, as a sleeping odalisque reclining on a Victorian chaise, seated on a chair with its ornate back framing her, in a stroller with a paper umbrella, absurdly made up as Dolly Varden, and as the maiden along with her brothers in a dramatic skit of "St. George and the Dragon."[1]

Henry Holiday, from whose estate this and many other Carroll photographs come, was a sculptor and illustrator in addition to being Carroll's friend and an amateur photographer himself. Described by Carroll as a "most patient of artists," Holiday is most noted for his illustrations to Carroll's *The Hunting of the Snark*, published in 1876.[2] The publication of this poem coincided with the photograph. The earliest photographs of Xie Kitchin by Carroll appear to have been taken in the middle to late 1860s and the latest around the middle 1870s. A print from the entire negative used for this cabinet card, showing severe flaking of the collodion emulsion at the bottom and to the left, is in the Gernsheim Collection, University of Texas, Austin, and is dated there July 1, 1876 [fig. 22]. In August, 1875, Carroll wrote in his diary that dampness had ruined many of his best negatives; presumably he had not solved this problem by the

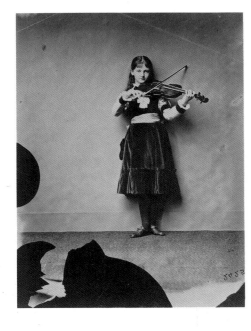

Fig. 22.
Lewis Carroll, *Xie Kitchin*, albumen print, 1876, Gernsheim Collection, Humanities Research Center, University of Texas, Austin.

following year. Choosing to print the negative on the much smaller cabinet format, however, permitted Carroll to avoid the damaged portions of the negative, but it also resulted in a far less spacious rendition of Xie with a violin. Much of the haunting effect of the small figure further diminished by the expanse of floor and wall is lost in the closer view of the cabinet, but the figure's poise and graceful elegance is certainly retained, reminiscent of some of James McNeill Whistler's portraits of the seventies and eighties.

On May 18, 1874, Carroll had inquired rhetorically of Reverend Kitchin if he knew how to guarantee excellence in a photograph. When Xie's father denied knowing, Carroll simply stated "All you have got to do is to get a lens and put Xie before it."[3]

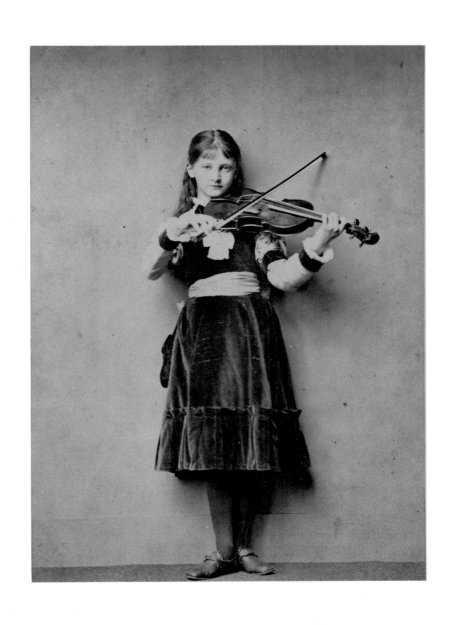

FRANZ HANFSTAENGL

German · 1804–1877

Carl August von Steinheil

ca. 1860 · Albumen print · 21.4 × 16.8 cm., octagonal

Franz Hanfstaengl was born in Beyernrain bei Tolz on March 1, 1804. He studied art at the Munich Academie der Künste, learned lithography quite early, around 1819, and by the mid-1820s was charming the Munich art world with portraits drawn directly on the printing stone. In 1826, he produced his lithographic masterpiece, the "Corpus Imaginum," a large series of celebrity likenesses. From 1835 to 1845 his Dresden studio produced over one hundred printed works, chiefly reproductions of paintings and drawings but also portraits of the likes of Richard Wagner, Gottfried Semper, and Franz Liszt. Hanfstaengl continued his lithographic career in Munich until the early 1850s, when the newer invention of collodion photography became popular. Earlier processes like the daguerreotype and calotype posed no serious threat to the other graphic arts, but the relative ease and perfection of glass plate negatives gave the artist the luxury of large format, detailed images—images that were popular and potentially limitless in edition. Hanfstaengl quickly turned to the new art and opened his "artistisch-photographischen Atelier" in Munich in 1853, abandoning the stone and printing press for the glass plate and studio view camera.

His fame as a portrait photographer was both pronounced and international. Within two years of beginning his new career as a photographer, Hanfstaengl secured a solid critical success at the Paris Exposition universelle of 1855, and no less a commentator than Ernest Lacan wrote:

> We do not know if this exhibitor is an amateur or professional photographer; but what is certain is that we have never seen prints as complete as his. They have a linear delicacy, a subtlety of modeling, a velvety richness in the shadows, highlights that are brilliant, and a total harmony which give these works an incomparable beauty. One first thinks that there is something faked about them, that these portraits are positive prints mounted on glass since their precision seems otherwise inexplicable; or that even an exceptionally skilled

hand had retouched them. . . . Then, one recognizes that these portraits were simply and admirably executed, and that all trickery rested only in the talent of the author.[1]

Hanfstaengl's principal photographic achievement was his "Album der Zeitgenossen," a series of mounted portraits of personalities that appeared in 1860. Helmut Gernsheim characterized this "Album" as "the first large format portfolio of its kind that we know of."[2] Whatever the accuracy of this statement, Hanfstaengl's photographic portraits place him on a par with Southworth and Hawes in Boston and Nadar in Paris, as one of the period's leading high art portraitists of celebrities. His likenesses of German statesmen, artists, architects, musicians, and scientists are powerful and aristocratic yet completely humane. They are academically posed, rigid and formal; at the same time, the subjects retain their individual personalities and characters. The sitters are customarily posed along with associative objects and emblematic accessories, but not the usual, thoughtless antique column or requisite open book. Instead, Hanfstaengl personalized these signs of prestige and identity, and it is not surprising to find a phrenological head next to a phrenologist, a modern globe of the world behind a female writer of travel literature, an antique shard in the hands of a neoclassical architect, or an esoteric piece of scientific instrumentation at the elbow of a physicist and optician, as in the portrait of Carl August von Steinheil (1801-1870).[3]

Steinheil first studied astronomy and later became a professor of physics and mathematics in Munich. He developed the first system of telegraphy in Vienna for the Austrian government in 1849, and did the same for Switzerland in 1851. In 1854, he established a firm in Munich that specialized in optics and astronomical instruments. He is considered to be the father of electromagnetic telegraphy and is said to have made the first daguerreotype in Germany,[4] as well as a prototype for a small-format camera in 1837 while working with Franz von Kobell.

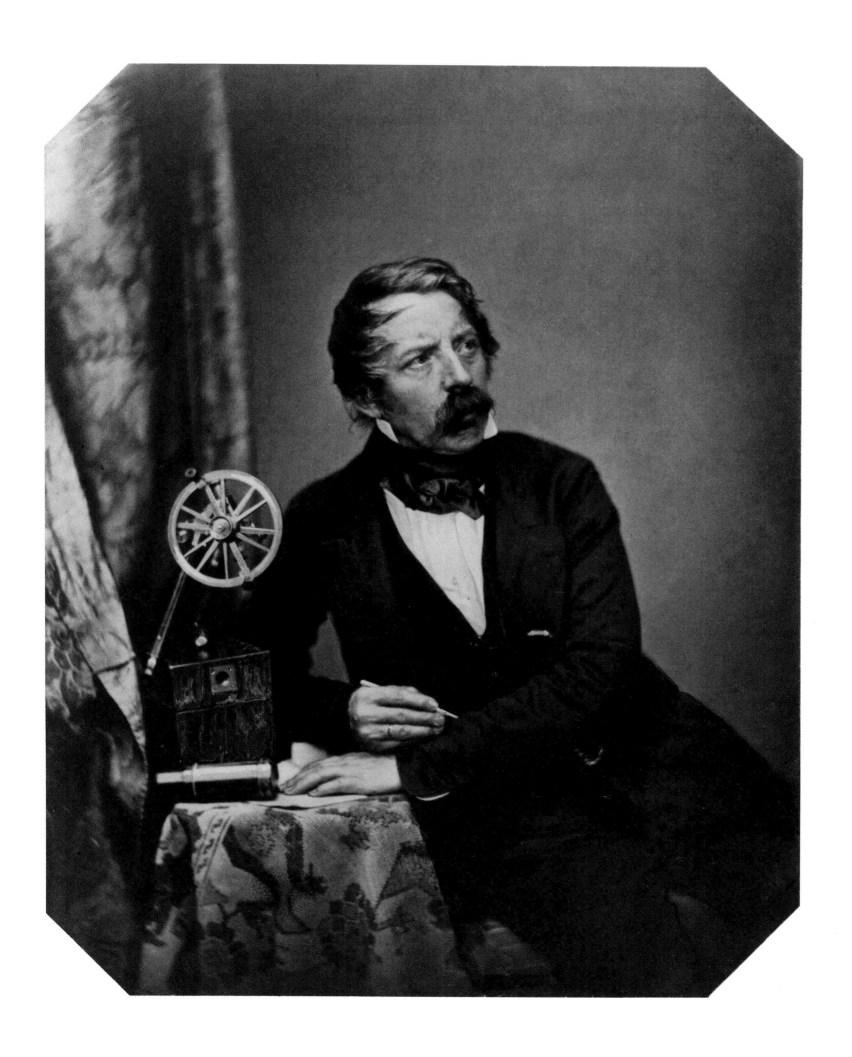

LEOPOLD ERNEST MAYER and PIERRE-LOUIS PIERSON

French · active 1855–1864 French · 1822–1913

Portrait of Napoleon III

ca. 1860 · Albumen print · 32.5 × 24.2 cm.

This is an absolutely first-rate "official" portrait photograph of the French emperor, exhibiting every feature of the prosaic commercial photographic style of the Second Empire—a type of picture that would cause Nadar to roundly criticize Mayer and Pierson later in the century but which accounted for the firm's tremendous fashionability in Paris during the fifties and sixties. "Paris and the provinces," wrote Nadar, "know of only a single studio: Mayer and Pierson; from every corner of the country they flock there. But the two otherwise intelligent men who founded that studio, because of their origins and previous occupations, have been found to be totally alien to any aesthetic."[1] With all the vacuity and static qualities of a carte-de-visite, this portrait is not one that attempts to interpret the inner character of the sitter; it has none of the expressive intensity and fullness of meaning found in portraits by Adam-Salomon, Carjat, or Nadar. It is about likeness and appearance, and depicts solely the public persona at the expense of any personality; a matter of trading expression and vigor for refinement and elegance.

Mayer and Pierson were not, however, without their own aesthetic posture, as revealed in their treatise on photography published in 1862 and in this portrait of Napoleon III. The photographer's "individuality, his personal cachet, is as profoundly engraved on the print that leaves his hands as is the individuality of the painter on the canvas which comes from his brush. His soul is entirely in his work; the breath of life that he imparts to it creates and animates his work."[2] For them, "photography is incapable of mannerism, and this is of an inestimable value to portraiture. . . . Photography alone is unmannered, it is truth."[3]

Throughout their discussion of portrait photography, the authors made frequent comparisons to fashionable portrait painters, naming some of the more obscure of the *juste milieu* or conventional portraitists of the period, including Charles-Lucien-Louis Muller whose "cold, correct talent was immedi-

Fig. 23.
Hippolyte-Jean Flandrin,
Napoleon III,
oil on canvas, ca. 1861-63,
Musée National
du Château, Versailles.

ately accepted by the public,"[4] Alexis Perignon, and Ingres, who they felt was the greatest painter of their era in spite of the fact that his portraits often lacked imagination. A full-length portrait of Napoleon III, painted by Ingres's student Hippolyte-Jean Flandrin and roughly contemporary to Mayer and Pierson's photograph, reveals a similar pose, identical lighting, and the same placement of the figure within the pictorial space [fig. 23]. The principal difference is that while Mayer and Pierson's emperor stands in the center of an empty studio, Flandrin surrounded Napoleon with imperial accessories and furnishings. Like Disdéri's, Mayer and Pierson's portraits were photographic adaptations of the conventional and fashionable portraiture of the Second Empire; and, with due regard to Nadar, theirs was an aesthetic.

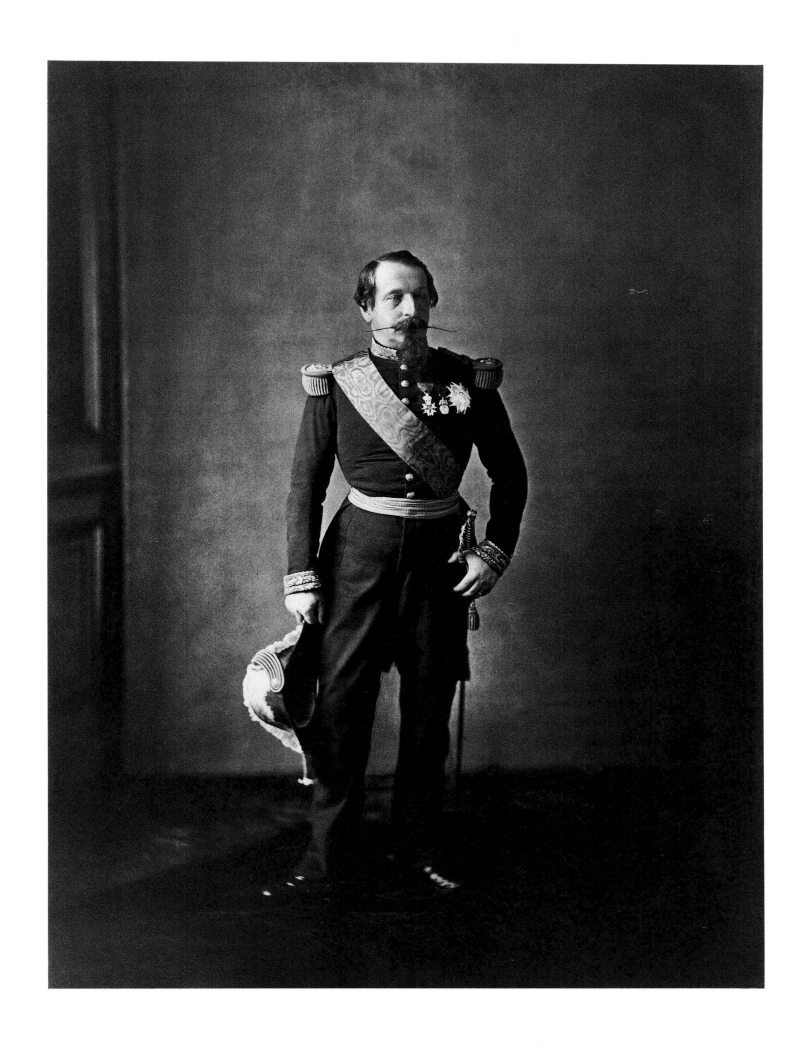

LOUIS-AUGUSTE and AUGUSTE-ROSALIE BISSON

French · 1814–1876 French · 1826–1900

The Locomotive, "La Vaux"

ca. 1859 · Albumen print · 31.5 × 43.6 cm.

Most noted and famed today for their impressive documentations of Parisian architecture and their pioneering reportage of Mont-Blanc in the French Alps in the late 1850s and early 1860s, the Bissons were acclaimed in their own day for a wide range of photographic types, including animal studies, reproductions of works of art (especially the graphic works of Rembrandt and Dürer), relief and planal cartography, and daguerreotype portraits. The museum is fortunate to have in its collections a rare example of a daguerreotype portrait of a woman by Louis-Auguste Bisson [fig. 24] as well as an album commemorating the ascent of Mont-Blanc by the emperor and empress [fig. 25].

This grand and fairly large "portrait" of a locomotive is formally in line with many Second Empire monumental documentations, images that not only record but imperialize the natural grandeur of the subject. Neutral lighting, an iconic composition, and a severity of viewpoint characterize this "style," which is repeatedly encountered in works by Le Gray, Braun, and especially Baldus. Here, the Bisson brothers direct this imperial vision onto a single industrial object, a token of growing French industrialism and a symbol of French modernism.

The railroad was a special subject in 19th-century photography, painting, and literature. Its tracks and trestles, its terminals and engines added a new element to the natural landscape, whether a subtle incursion in distant fields or a corollary to antique landscapes where Roman aqueducts are replaced by modern viaducts. Trains and their railbeds were extensively documented between 1854 and 1863 by such camera artists as Baldus, Collard, and V. Masse. Later, such French painters as Manet, Monet, Pissarro, Bernard, and Angrand, as well as Van Gogh, depicted this modern "Pegasus." Gustave Flaubert's character Frédéric Moreau planned to paint the image of Christ astride

Fig. 25. Louis-Auguste and Auguste-Rosalie Bisson, *Bourrasque au Mont-Blanc*, albumen print, ca. 1860, from Bisson frères, *Haute-Savoie. Le Mont-Blanc et ses glaciers, Souvenir du voyage de LL. MM. L'Empereur et L'Impératrice*, Paris, 1860.

a locomotive in *L'Education sentimental* (1869), and Emile Zola devoted an entire novel, *La Bête humaine* (1889-90), to railroads and conductors. Although Théophile Gautier wrote in 1830 that "the railroad cannot be seen except as a scientific curiosity, a type of industrial toy," he also believed that there was indeed a "poetry of the railroad," a poetry that would capture the imaginations of later generations of artists and writers. [1]

In an anonymous article published in 1854, the Bissons were applauded for their pioneering work in photographing empty parcels of land near the terrace of St. Germain and applying their images to posters advertising the sale of this real estate.

> Today a poster announcing the sale of these lands can be seen in every railway ticket office; the middle of the poster bearing a print by MM. Bisson. It is a new application of photography that we are proud to signal with the conviction that it will serve numerous purposes. This is not MM. Bisson's first attempt at this genre. Photography applied to industry, through the reproduction of models, clocks, *objets d'art*, machines, etc., has occupied an important role in the considerable work they undertake each day. In the future, we will again discuss the work of these skilled and industrious artists. [2]

No further articles along these promised lines have been located. The fact that the pristine locomotive, itself, bears the date "1858" suggests that it was perhaps on display at the *Exposition universelle* of 1859 for which the Bissons were at least semi-official photographers. [3]

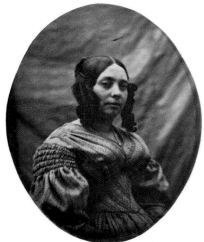

Fig. 24. Louis-Auguste Bisson, *Portrait of an Unidentified Woman*, daguerreotype, ca. 1850.

ROBERT HOWLETT

British · 1831–1858

Leviathan: View of the Bows

1857 · Albumen print · From: album "The Leviathan," London, n.d. [ca. 1858], unnumbered. 26.0 × 36.2 cm.

Christened *The Leviathan* on November 3, 1857, the *Great Eastern*, as it was officially registered, was one of the major achievements of Isambard Kingdom Brunel and one of the towering monuments of 19th-century British engineering. Constructed at Millwall on the Isle of Dogs in the Thames, the ship was the largest ever built and a popular symbol of technological progress. It is seen in this print as it appeared the day before its first and disastrously futile launch attempt; the grounds have been cleared and the hawsers readied for sliding the hull into the river. Between 1855 and the ship's successful launching in early 1858, a voyager on the Thames would have seen a nearly Wagnerian example of what capitalist enterprise could accomplish.

> At first a few enormous poles alone cut the sky-line and arrested his attention, then vast plates of iron, that seemed big enough to form shields for the Gods, reared themselves edgeways at great distances apart, and as months elapsed, a wall of metal slowly rose between him and the horizon. She is destined to carry eight hundred first class, two thousand second class and one thousand and two hundred third class passengers, with a ship's company making a total of four thousand and four hundred people.... From side to side of her hull, she measured 83 ft., the width of Pall Mall. She could just steam up Portland Place, with her paddles scraping the houses on each side.[1]

The ship's displacement was a staggering 32,000 tons, as compared to 3,618 tons and only 2,300 tons for her immediate predecessors, the *Great Britain* and the *Great Western*.

The *Great Eastern* was also invested with imperialistic pride. The first paragraph of "The Leviathan Number" of *The Illustrated Times* of London put it most adroitly.

> However great the scientific interest attached to the successful launch of a vessel like the *Leviathan*, its historical interest is even greater. It is the crowning achievement in ship-building of a nation renowned above all others for its power at sea. There is thus a certain fitness in such a work's proceeding from the Thames, which adds moral dignity to its material greatness. For if we do not take and keep the lead in everything that relates to nautical progress, we shall forfeit the best part of our traditional influence, and the surest guarantee for our national independence and honour.[2]

"The Leviathan Number" was illustrated by engraved views of the ship under construction, portraits of its engineers Scott Rus-

Fig. 26. Joseph Cundall, *The Leviathan During Its Construction*, albumen print, 21 September 1855.

sell, Robert Stephenson and Brunel, as well as diagrams of the ship's interiors. All but four of the engravings were copied from photographs by Robert Howlett; the other four, showing the ship in early stages of construction between May and November, 1855, were from photographs by Joseph Cundall, a partner of Howlett's at the Photographic Institution [fig. 26]. Apparently, Howlett's pictures were especially successful at the time, for the *Illustrated Times* commented that Howlett was "one of the most skilful photographers of the day," and that his pictures "form a portion of another extensively interesting series of photographic studies, in which the *Leviathan* plays the chief part, and which said studies are among the most attractive features of the printsellers' shop windows at the present moment."[3] An engraving by Loudan based on a Howlett photograph similar to this one appeared on page 64 of "The Leviathan Number." The two highly dramatic cables stretching across the foreground, however, were deleted by the engraver—an ironic omission since it was the *Great Eastern* that laid the first transatlantic cable between England and Newfoundland in her later years. The ship was sold piecemeal at auction in 1888.

AUGUSTE SALZMANN

French · 1824–1872

Temple Wall: Triple Roman Portal

1855/1856 · Salted paper print, printed by Blanquart-Evrard · From: August Salzmann, *Jérusalem. Etude et reproduction photo-graphique des monuments de la ville sainté, depuis l'époque judaïque jusqu'à nos jours*, Paris, 1856. 22.3 × 45.7 cm.

Salzmann's *Jérusalem*... focused on the various archaeological discoveries of the famed numismatist and antiquarian Louis-Félicien-Joseph Caignart de Saulcy (1807-1880). In 1850-51, de Saulcy, in the company of the photographer Edouard Delessert and also, perhaps, Salzmann, traveled to the Holy Land and concluded that much of the architecture and tomb sculpture in and about Jerusalem was not Greek or Roman in origin, as was then believed, but rather Israelite. De Saulcy's "radical" theories were met with derision by the other members of the Paris *Académie des Inscriptions et Belles-Lettres*, and the drawings and maps he published as proofs of his theories were labeled as products of his imagination and thus worthless.[1] To resolve this academic debate, Salzmann was commissioned by de Saulcy to authenticate his claims by photographic means. The basic premise of the undertaking was summarized in the journal *Cosmos*, which stated: "We can hardly accuse the *sun* of having an imagination."[2]

Writing in *Le Constitutionnel*, after Salzmann returned from the Near East with his negatives, de Saulcy exclaimed:

Concerning a remarkable publication, I would like to show how science can receive help from Photography when handled by an artist who, with a sense of the picturesque, can merge taste with studies of pure erudition. Mr. Auguste Salzmann is, in my opinion, the prototype of the intelligent photographer whose work must contribute to the distinct progress of the historic sciences. Above all he is a painter, a painter of distinction, which is hardly a detriment, who chooses the most picturesque way possible of rendering a site by using his artistic delicacy to show the most harmonious effects of line and lighting.... He brought with him a draughtsman who was highly skilled in truth, and whom it would be difficult to suspect of good intentions. In other words he brought with him the sun which does nothing else but reproduce what is.[3]

De Saulcy was correct to use the word "picturesque" in referring to Salzmann's work: the lighting, the textures, and the use of perspective nuance are traits more commonly associated with painting than with architectural photography. Often it would seem that Salzmann was so intently concerned with these effects that it mattered little if particular details of the subject were sacrificed.

In his preface to *Jérusalem*, Salzmann confided that "photographs are more than tales, they are facts endowed with convincing brute force."[4] Certainly Salzmann's photographs have a breadth and a monumentality of scale, a graphic quality and luminous impact seldom encountered in architectural photography of the last century. There is, moreover, something somewhat ironic in Salzmann's extreme artistry in the service of an exacting science; where a neutral aridity would seem to have been mandated, Salzmann fulfilled the requirements of factuality with an intelligent picturesqueness, which is fully apparent when his work is compared with the work of other European photographers of the same period.

FRATELLI ALINARI

Italian · firm est. 1854

Florence: Lower Section of the First Door of the Baptistry

ca. 1856 · Albumen print · 32.5 × 42.2 cm.

Photography and photographers are found in Italy from the very earliest years of the medium's existence. At first, it was principally a matter of French or British daguerreotypists, like Lerebours's operators, who traveled south in order to capture certain scenes for their audiences back home. It was even sometimes a matter of printing photographs from someone else's negative, as in the case of Talbot's use of Reverend Calvert Jones's calotypes. By the 1850s, however, either foreign or domestic photographers were establishing studios in each of the major urban centers of Italy. The views they produced (as opposed to their genre scenes) must in many ways be seen as a continuation of the older tradition of *vedute*, or view painting, represented by the works of Canaletto, Guardi, and Zocchi during the late 18th century. The new photographic views not only depicted the same or similar sites, but their greatest market still remained the foreign tourist.

The images produced by such Italian photographers as the Alinaris, Ponti, Altobelli, and Cuccioni are really much more than mere documents or records, although they are these as well. Their photographs, especially those made in large formats between 1855 and 1870, were as much infused with romantic poetics and historical classicizing as was the poetry of *Childe Harold*, the fiction of *The Marble Faun* and *Daisy Miller*, and the libretti of *Lélio* and *Harold in Italy*. In their "primitive" yet highly refined visions, these photographers repeatedly sought and managed to capture not only the look of Italy but a part of its myth as well in images that are often direct, evocative, and structurally surprising.

The photographs of Giuseppi (1836-1890 or 1892) and Leopoldo (?-1865) Alinari are perhaps the most familiar and most collected of all *vedute* photography. Like Thomas Annan in Glasgow, Charles Marville in Paris, and Charles Clifford in Madrid, much of the Alinaris' production was devoted to the reproduction of works of art. While often the very nature of the reproductive art photograph stops short of any sort of pictorial interest save its accuracy, at times it may transcend the mere tracing of another work of art and result in a picture of inordinate charm and beauty. Depending on the selection of point of view, the time of day, and the available lighting, an image seemingly as prosaic as that of the lower half of Lorenzo Ghiberti's famed bronze doors assumes a richness and monumentality of effect that is completely photographic and spectacular.

GIOACCHINO ALTOBELLI and POMPEO MOLINS

Italian · partnership active Rome, ca. 1857–1865

"Night" View of the Roman Colosseum

ca. 1860–65 · Albumen print, combination printing · 24.6 × 37.9 cm.

Only the most sketchy information is available about these two Italian masters of the last century. Altobelli shared a studio in Rome with Molins from around 1857 to about 1865, after which the two photographers followed separate careers. Altobelli was an official photographer to the Royal French Academy in Rome, and a photographer of works of art for the Roman railroad. His work was exhibited in 1861 at the *Esposizione Italiana* in Florence. He was also acclaimed during the 1860s for his moonlit effects, called "*chiari di luna*." Molins, born in 1827, continued to work after his association with Altobelli, first maintaining the studio of Enrico Verzaschi until 1875, and then recording ruins and monuments for the British archaeologist John Henry Parker until a fire destroyed his studio and negatives in 1893.

There is a natural suspicion that the view of the Colosseum as seen under moonlight was a product of Altobelli alone, since his was the reputation earned for the "*chiari di luna*" effects. Yet the supreme artistry of this image accords more with those prints known to be by both Altobelli and Molins than with those solely by Altobelli.

In the last century, moonlight visits to the famed Roman sites were a poetic fashion required of every sensitive tourist. Simply put, the antiquities would appear that much grander and less the detailed victims of time's erosion when bathed in the mysterious and none too brilliant illumination of the moon. Most Western European and American travelers carried with them lines from literature and poetry celebrating this experience, lines expressed by some of the major authors of the period, such as Goethe, Mme. de Stael, Poe, and others. Perhaps the most redolently evocative lines issue from Byron's "Childe Harold's Pilgrimage":

> Arches on arches! as it were that Rome,
> Collecting the chief trophies of her line,
> Would build up all her triumphs in one dome,
> Her Coliseum stands; the moon-beams shine
> As 't were its natural torches, for divine
> Should be the light which streams here to illume
> This long-explored but still exhaustless mine
> Of contemplation; and the azure gloom
> Of an Italian night, where the deep skies assume
>
> Hues which have words, and speak to ye of heaven,
> Floats o'er this vast and wondrous monument,
> And shadows forth its glory. . . .
>
> But when the rising moon begins to climb
> Its topmost arch, and gently pauses there;
> When the stars twinkle through the loops of time,
> And the low night-breeze waves along the air
> ·The garland-forest, which the gray walls wear,
> Like laurels on the bald first Caesar's head;
> When the light shines serene but doth not glare,
> Then in this magic circle raise the dead:
> Heroes have trod this spot—'t is on their dust ye tread. [1]

ROBERT MACPHERSON

Scottish · 1811–1872

Rome: Pines, Villa Pamphili-Doria

ca. 1856–65 · Albumen print · 40.0 × 30.1 cm.

A descendant of the infamous James Macpherson, author of the fabricated antique epic *Ossian*, Robert Macpherson was one of a number of British photographers who established studios in Rome and supplied large-scale albumen prints of famous monuments and views to tourists, educators, artists, and architects. Following the tradition of 18th-century Italian *vedutisti* painters, like Canaletto and Pannini, Macpherson's views of the antiquities, architecture, and landscapes in Rome and environs were precise and accurate records, designed for both study and souvenir. As photographs, his prints transcended the merely topographic; they are generally expansive and operatic, broadly conceived and dramatically lighted, iconic and dramatic.

Trees were not an especially unfamiliar subject for 19th-century photographers. Single trees, portraits of famous trees, trees associated with certain ideas were photographed by William Henry Fox Talbot, Sir William Newton, Gustave Le Gray, Carleton Watkins, and Eugène Atget early in this century. Customarily, however, the entire tree was portrayed, solidly rooted to the earth as a notable part of a landscape. Macpherson's image of the pines in the gardens of the Villa Pamphili-Doria are, thus, exceptional: it is a view looking upwards toward a canopy of trunks and crowns diagonally skewed and silhouetted against the blank background of the albumen print. The picture is more about the sense of being within this famous garden than it is a document of the trees themselves, and it elicits much the same feeling about this location as do popular 19th-century travel guides.

> The grand entrance, built like a triumphal arch, was constructed from the ruins of an older villa; through it we reach groves of oaks, of plane trees, of great spreading pines, long avenues, above which the branches of the trees are so thickly interlaced as to almost exclude the daylight. . . . to perspectives of verdure succeed perspectives of water, beside whose cool freshness and under the shadow of the lofty trees the grass gets a fineness and brightness which recalls the Alps; in the dawn of spring anemones, violets, periwinkles, primroses, and cyclamen display their mosaics on the turf beneath stately terraces crowned with camellias. Assuredly the gardens of Rome were like this in the time of Virgil and the poets of the Empire. [1]

FRANCIS FRITH

British · 1822–1898

The Pyramids of Sakkarah, from the North East

ca. 1858 · Albumen print · From: Francis Frith, *Egypt, Sinai and Jerusalem: A Series of Twenty Photographic Views by Francis Frith*, texts by Mrs. Poole and Reginald Stuart Poole, London, n.d. [ca. 1860], pl. 7. 38.2 × 47.5 cm.

Francis Frith was not the earliest photographer to visit and record the Near East—Frédéric Goupil-Fesquet, Maxime Du Camp, Félix Teynard, and J. B. Greene preceded him—but he was decidedly the very first to bring the grand vision of mammoth-plate collodion photography to the monuments and sites of the Orient. Frith also visited the area more often than his predecessors, making three different voyages between 1856 and 1859. His first trip to Egypt, from 1856 to July of 1857, resulted in the publication of stereographic cards, full-plate views measuring 8 × 10 inches, and mammoth-plate views of about 16 × 20 inches. Frith's second trip lasted from November, 1857, to May, 1858, and this expedition provided most of the 8 × 10 inch plates for his first photographic publication, *Egypt and Palestine Photographed and Described by Francis Frith* (London, 1858-60), consisting of seventy-six albumen prints that, when trimmed, measured approximately 8 3/4 × 6 1/2 inches (22.5 x 16.5 cm.). A third voyage, in the summer of 1859, had Frith travel up the Nile farther than any previous photographer, well into what was then Nubia and Ethiopia. Frith published eight separate photographically illustrated books between 1858 and 1862, containing more than four hundred images; and in 1862 he supplied prints to two different editions of the Bible, including the famed *The Queen's Bible*, published in Glasgow by W. Mackenzie and one of the most sumptuous products of Victorian book design.

The use of collodion in the desert caused problems not encountered by earlier photographers. When Goupil-Fesquet and Joly de Lotebinière daguerreotyped in Cairo in 1839, they simply returned to their hotel rooms to process their day's images.[1] Frith, traveling in a wickerwork carriage that was both home and darkroom, had to coat his negatives with the emulsion on location and process his large glass plate negatives immediately after exposure in the camera. The interior of his darkroom tent was filled with ether fumes and, at times, attained temperatures as high as 130 degrees: "Now in a smothering little tent, with my collodion fizzing—boiling up all over the glass the instant that it touched—and, again, pushing my way backwards, upon my hands and knees, into a damp, slimy rock-tomb to manipulate—it is truly marvelous that the results should be presentable at all."[2]

Part of the success of these prints was unquestionably the visual impact of their clarity and precision. Frith wrote in 1859:

Every stone, every little perfection, or dilapidation, the most minute detail, which, in an ordinary drawing, would merit no special attention, becomes, in a photograph, worthy of careful study. Very commonly, indeed, we have observed that these faithful pictures have conveyed to ourselves more copious and correct ideas of detail than the inspection of the subjects themselves had supplied; for there appears to be a greater aptitude in the mind for careful and minute study *from paper, and at intervals of leisure*, than when the mind is occupied with the general impressions suggested by a view of the objects themselves. . . .[3]

Its antiquity disputed at the time, the Third Dynasty stepped pyramid of Saqqara (modern spelling) is revealed by Frith in all its regal silence and melancholy grandeur.

CLAUDE-JOSEPH-DESIRE CHARNAY

French · 1828–1915

Chichén-Itzà: Main façade of the Nun's Palace

1857–61 · Albumen print · From: Désiré Charnay, untitled album, (prototype [?] for *Cités et ruines américaines...*, Paris, 1862–63), Paris, n.d. (ca. 1861). 34.4 × 43.5 cm.

Désiré Charnay was a paradigm of the photographer-traveler of the last century whose sole purpose was to contribute to the photographic *musée imaginaire* of the entire globe. While he is most known today for his images of Central America, especially of the great Mayan ruins of southern Mexico and the Yucatán, he also photographed Madagascar in 1863, Chile and Java in 1878, and Yemen in 1897. The greater part of his extant work reveals not only an untiring desire to record the monuments, landscapes, and the people of the areas he visited but also a vision that was purely and unaffectedly photographic. Charnay consistently delineated his subjects with little regard for conventional, artful "treatment." His images are neither picturesque in the strictest sense nor exactly classical; rather, they are powerfully confrontational and vested in immediacy, romantically suggestive yet unidealized, thorough and direct. His studies of native types in costume are anthropologically clinical, addressed in a photographic aesthetic that would reach its full force only in the next century in the work of August Sander. His views of temple ruins in Chichén-Itzà, in spite of their archaeological exactitude, transcend most 19th-century depictions of ruins by their eccentric compositions, unexpected perspectives, and particularly by the emphasis Charnay placed on the intrusive vegetation that engulfed this exotic architecture.[1] The motivation may have been scientific; the result is melancholy and nearly surreal.

Writing in Paris in October, 1861, the critic of *Le Moniteur de la photographie*, Ernest Lacan, reported on Charnay's Mexican photographs.

> The author must have possessed a strong willpower in order to visit, amidst forests and solitude, the unknown or forgotten ruins which he wanted to rescue from oblivion. The question must be asked: How could he transport, on these dangerous trips, the photographic equipment necessary to take such pictures? The archaeologists, architects, and painters who have seen this collection praise it highly. Photography covers the world, searching and finding everywhere beautiful objects for the study of artists and scholars. Soon there will not be a corner of the world which has not been explored by photographers.[2]

Charnay, himself, wrote about his work in Yucatán between 1857 and 1861, and summarized it succinctly: "When I was in the presence of the [ruins] I felt myself crushed by the grandeur of the work...."[3]

JAMES ROBERTSON

British · active 1852–1865

Interior of the Redan after the Assault (The Barracks Battery)

1855 · Albumenized salted paper print [?] · From James Robertson, *Athenes-Constantinople-Sebastopol*, Constantinople [?], ca. 1855, unn. 23.8 × 30.2 cm.

During the first months of 1854, the British press published numerous articles and letters subscribing to the necessity for and advantages of having photographers document the conflict in the Crimea: "Hitherto Photography has flourished as one of the arts of peace, lending its aid to the direct advancement of civilization in various ways. It seems not unlikely that it may be pressed now into the service of war, and thus have to exert its influence rather indirectly, that is, in arresting the destructive efforts of the 'barbarians.' "[1] Of British photographers, Roger Fenton was the first to travel to the Crimea, document the event (albeit selectively by today's standards), and return with more than 360 prints. His departure from the war zone was in part determined by illness, causing him to leave after the first, abortive French and British offensive against Sebastopol and its Russian forts. The photographing of the war for the British was left to James Robertson and Felice Beato, who were there to record the aftermath of the allies' taking of the Redan and Sebastopol.

Where Fenton had portrayed empty battlefields, shot-broken buildings and soldiers and officers at recreation, Robertson and Beato documented the battle-scarred remnants of the conflict. They were at Sebastopol the day after its abandonment by the Russians, and the desolation they portrayed, as seen in this print, was completely new to the world of photography. On September 8, 1855, the battle of Sebastopol took place, singularly one of the worst of the military campaign in the Crimea.

According to Fenton's brother-in-law:

I was scarcely mounted on the top of the parapet myself, before my face was covered with blood and brains spurting from a poor fellow of another regiment who was shot close to me. Such a sight as I must have been for the 2½ hours we remained up there, men falling in every direction and at times almost knocking one over as they fell. . . . One object was in view: if possible, to drive the Russians away from behind their parapet, and in endeavouring to accomplish this, dead and dying were alike forgotten and trampled under foot. . . . it seemed a providential thing that I did not effect an entrance into the Redan, as we have since learnt that the Russians intended to have blown us all up if we had. That same night after they had evacuated it themselves they blew it mostly to pieces.[2]

Following the removal of the Russians, Robertson and Beato were able to capture sights the likes of which Fenton never attempted. They photographed the ruins of the Malakoff, which had been taken earlier by the French, the Russian generals' bomb-proof shelter in the Redan, views of the interior of the Redan, and the Barracks Battery. This last view, this print, is perhaps one of the more unnerving, claustrophobic, and striking of all 19th-century war images.

FELICE BEATO

British · b. Italy · active 1855–ca. 1867

The Capture of Fort Taku in North China

1860 · Albumen print · 24.2 × 31.5 cm.

The biography of this famed 19th-century war photographer, as well as that of his presumed brother Antonio, remains for the most part a skeletal listing of brief facts and very little substantive understanding. Apparently, Beato, a naturalized Britisher, met the photographer James Robertson on Malta in 1850, and four or five years later they together photographed the Crimean landscape during the war. In 1857-58, Beato, whether with or without Robertson remains conjectural, was in Lucknow, the capital city of Oudh in India, where he documented the results of the Bengal-Sepoy Mutiny as it spread from Delhi to that city [fig. 27]. The next instance we hear of Beato is in Northern China in the spring of 1860, where again his subject was the effects of war and combat during the last Opium War. Following China, Beato established a photographic studio in Yokohama, Japan, in 1862, the very year that Renjo Shimooka opened the first Japanese studio in the same city.[1] Presumably Beato was in partnership with Charles Wirgman, another British photographer on the islands, until about 1867.

General Garnet Joseph Wolseley, who was active with the British army in the Crimea, at Lucknow, and in China at precisely the same time as Beato, became a first viscount following his actions at Khartoum in the Sudan in 1884-85. This fact is worth noting since, in 1886, "Signor Felice Beatto" displayed albumen prints he made while accompanying Wolseley in the Sudan, along with his earlier post-battle scenes of the Crimea, India, and China. At a meeting of the London and Provincial Photographic Association, Beato not only discussed his various photojournalistic campaigns but also stated that "in 1867 he gave up photography altogether, and had since been working at it only as an amateur."[2] Few "amateur" photographers, it might be noted, have accompanied generals into battle zones.

The Chinese Opium Wars of 1839-42, 1856-58, and 1859-60 were waged as a result of China's wish to restrict the importation of Indian opium into their country by the British, who, in their turn, saw the trade of this opiate as one of their principal economic imperatives in the Far East. In each of these "wars," China never was able ultimately to withstand Western armaments and subsequently lost to further foreign influence and even "occupation." The British victory at Fort Taku in late September, 1860, was one of the bloodiest and most symbolic battles of the last offensive since the fort guarded the important port of Tientsin. After its fall, China was forced into even greater restrictions through the Peking Conventions of 1860.

Fig. 27. Felice Beato, *The Baille Guard Gateway...*, albumen print, 1857-58.

Beato's pictures of the aftermath of the Fort Taku battle are historically significant, since they are most likely the earliest images that depicted the human cost of war. Every earlier war photographer, whether Robertson, Roger Fenton, Szathmari, or Léon Méhédin, avoided focusing on human carnage, and Timothy O'Sullivan's photographs of the aftermath of Gettysburg and Alexander Gardner's of a dead rebel sharpshooter were taken only in 1863. The impact such images made at the time is attested to by a comment published in 1862:

> At Mr. Hering's, Regent Street, may be seen a large collection of photographic views and panoramas taken by Signor Beato during the Indian Mutiny and the Chinese War. . . . The Chinese forts of Pehtung and Tangkoo, with the North Fort [Taku], expand one's notions of the importance of the difficulties overcome in their capture. . . . Believing that men are more interesting subjects of study than buildings however remarkable, or landscapes however famous and beautiful, we should like to see more of the human element added to this collection than it yet contains.[3]

It is, of course, unclear whether the writer was considering the British victors or the Chinese victims when asking for more of the "human element."

ANDREW JOSEPH RUSSELL

American · 1830–1902

Rebel Caisson Destroyed by Federal Shells

1863 · Albumen print · 24.4 × 33.2 cm.

A. J. Russell is well known for his views of Western American scenery and for his documentation of the building of the Union Pacific railway, especially the famous view of the joining of the rails at Promontory Point, Utah Territory, in 1869. During the Civil War, however, and before he traveled west, Russell was a Union captain attached to the U.S. Military Railroad Construction Corps commanded by General A. Haupt. The largest collections of this photographer's Civil War images are in the National Archives and in the Prints and Photographs Division of the Library of Congress, Washington.

In *Drum Taps,* Walt Whitman wrote:

With its cloud of skirmishers in advance,
With now the sound of a single shot snapping like a whip,
 and now an irregular volley,
The swarming ranks press on and on, the dense brigades
 press on,
Glittering dimly, toiling under the sun—the dust-cover'd
 men,
In columns rise and fall to the undulations of the ground,
With artillery interspers'd—the wheels rumble, the horses
 sweat,
As the army corps advances. [1]

Unless, of course, hit by artillery fire, as was this Confederate caisson and its brace of eight horses killed at Fredericksburg on May 3, 1863.

In reviewing an illustrated edition of Whitman's *Specimen Days,* Leo Marx commented on the direct and casual tone of Whitman's prose, a straightforward voice that is also very present in his poetry:

Although they give rise to similar feelings, it is not easy to find what the photograph and the prose have in common. The actual subjects are quite different, and while the picture is manifestly artful, the prose seems wholly casual, not to say careless. Yet they both manage to convey a feeling of absolute directness and honesty. No sham, no tricks, nothing hidden from view, not even—and perhaps this is the crucial factor— the art back of the seeming artlessness. Both the photographer and the writer unequivocally locate themselves, allow us to know exactly where they are and what they are doing. The common feature is the artist's direct address to his subject. [2]

Russell's view of the shelled caisson and fallen horses witnessed by Union soldiers presents a specific event; it is not the shelling that is recorded but the witnessing of its result, a witnessing that is in turn documented by the camera, with no artifice or artistry, just a profound re-presentation.

ALEXANDER HESLER

American · b. Canada · 1823–1895

Portrait of Abraham Lincoln

1860/1881 · Albumen print, printed by George B. Ayres · 19.0 × 14.0 cm.

Alexander Hesler first photographed Lincoln in February, 1857, the second recorded photographic portrait of the then Illinois senator and the one that has become known as the "tousled hair" portrait. On June 3, 1860, Lincoln again sat for Hesler in Springfield, resulting in four of his most famous early portraits, including this likeness that, along with one other, sold over 10,000 prints at the time. The photographs were to be used as official campaign portraits since Lincoln was by then the Republican candidate for President of the United States, having been nominated at the Republican convention in Chicago on May 16th. In 1866, the photographer George B. Ayres acquired Hesler's Chicago studio along with the Lincoln negatives. In 1881, Ayres made prints from these plates and also produced a set of glass plate copy negatives. Hesler's original negatives were badly damaged in 1933, and their cracked remains are now in the Smithsonian Institution. In 1952 Ayres's copy negatives were rediscovered and used to produce modern prints.

In a letter to Ayres written shortly before his death, Hesler commented on his portraits of Lincoln: "Mr. Lincoln was a man that did not care for pictures especially of his own. He said he could not see what any one wanted a picture of his ugly face for, but he would sit to please them if they wanted them. When he saw the pictures I had, he said Well that looks better, and expresses me better than any I have seen, if it pleases the people I am satisfied. . . ."[1]

While Lincoln may have been rather disinterested in his own portraits, according to Hesler, portraits of this president were exceptionally popular and subjected to a variety of physiognomic, phrenological, and idolizing interpretations during the last century. William Henry Herndon, law partner and biographer of Lincoln, briefly analyzed this particular portrait with some attention to physiognomic detailing when he wrote, "There is the peculiar curve of the lower lip, the lone mole on the right cheek, and a pose of the head so essentially Lincolnian; no other artist has ever caught it."[2] Describing an engraving from an early photograph of Lincoln with a beard, a popular American text on physiognomy stated, "This photograph of 1860 shows, not the face of a great man, but one whose elements were so molded that stormy and eventful times might easily stamp him with the seal of greatness."[3] And in a Currier & Ives lithograph issued for the campaign of 1860, where Louis Maurer depicted the unbearded Presidential candidate being carried into a "Lunatic Asylum" by Horace Greeley and followed by a crowd of liberal and social extremists, a woman at the head of the crowd says, "Oh! what a beautiful man he is, I feel a 'passionate attraction' every time I see his lovely face."[4]

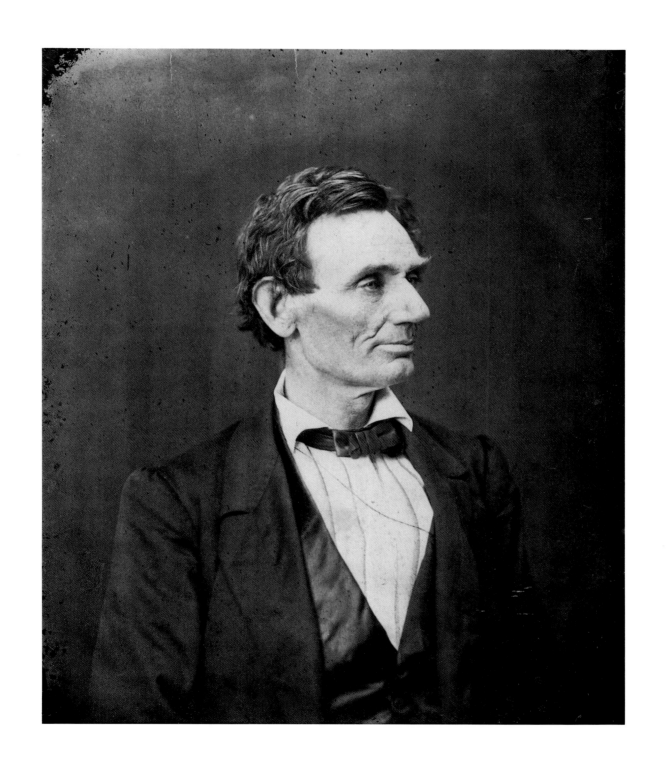

ALEXANDER GARDNER

American · b. Scotland · 1821–1882

"*Lewis Payne* [sic] *Powell, Alias Lewis Payne, Who Attacked Hon. W. H. Seward*"

1865 · Albumen print · From album *The Lincoln Conspiracy*, Boston, 1865, folio number 2082. 22.0 × 16.5 cm.

Alexander Gardner is best known for *Gardner's Photographic Sketchbook of the War*, the most extensive documentation of the American Civil War to have been published with actual photographic prints. For this two-volume set, published by Philip & Solomons of Washington in 1866, Gardner had assembled some of the finest photographic talents of the period, including his brother James, Timothy O'Sullivan, Wood and Gibson, John Reekie, and others. Gardner himself was responsible for a number of the more memorable images of the set, most notably *A Sharpshooter's Last Sleep* and *The Home of Rebel Sharpshooter, Gettysburg*. Following the war, in 1867, Gardner recorded the construction of the Kansas Pacific Railroad along the route following the 35th Parallel from Kansas City to Los Angeles.

Between the war and his work in Kansas, Gardner documented an event unprecedented in American history: the final episodes of the trial and execution of those who conspired with John Wilkes Booth to assassinate President Abraham Lincoln on Good Friday, April 14, 1865. Following their arrests and the death of Booth, Gardner gained permission to record the prisoners while they were held aboard the ironclad *U.S.S. Montauk* anchored in the Potomac River in late April. In the album assembled after the war by retired Union Colonel Arnold A. Rand, an early collector of Civil War photography, are some of the most powerful human likenesses captured by the 19th-century camera. Of the eight prisoners he photographed in hand restraints against the rough-forged iron plating and its massive rivets there are portraits of the carriage painter George Atzerodt; Booth's friend Samuel B. Arnold; Edmund Spangler, a stagehand at Ford's Theatre; David E. Herold, a drugstore clerk with a mental age of about eleven; Michael O'Laughlin, a Confederate deserter; and Thomas Jones, who hid Booth in Maryland. There is another portrait by Gardner of an unidentified prisoner who may have been the doctor Samuel Mudd. The last of the eight prisoners was Lewis Paine, the son of a Baptist minister whose temperament was diagnosed by one doctor as warranting a "suspicion of insanity," most likely because he exclaimed "I'm mad! I'm mad!" as he fled the house of Secretary of State William H. Seward after having unsuccessfully tried to stab him to death the

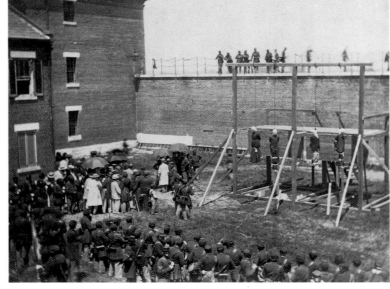

Fig. 28: Alexander Gardner, [*The Execution of the Conspirators*], albumen print, 1865.

same night Lincoln was shot.[1] Gardner made a series of exposures of Paine, without hand restraints and standing before a plain canvas cloth; in one, Gardner even included the Union guard with his bayoneted rifle.[2]

Neither John H. Surratt, who had escaped the country, nor his mother Mary, who owned the boarding house in Washington where the others had met and who was imprisoned elsewhere, were photographed by Gardner on this occasion. Gardner did photograph Mary Surratt, along with Paine, Herold, and Atzerodt, when the four were executed by hanging on July 7, 1865, in the yard of Washington's Old Penitentiary [fig. 36]. Although there was no clear evidence against Mrs. Surratt, she became the first woman to be hanged for a crime in this country. Paine, believing in her innocence, told the executioner, "If I had two lives to give, I'd give one gladly to save Mrs. Surratt. I know she is innocent. . . . she knew nothing about the conspiracy at all."[3]

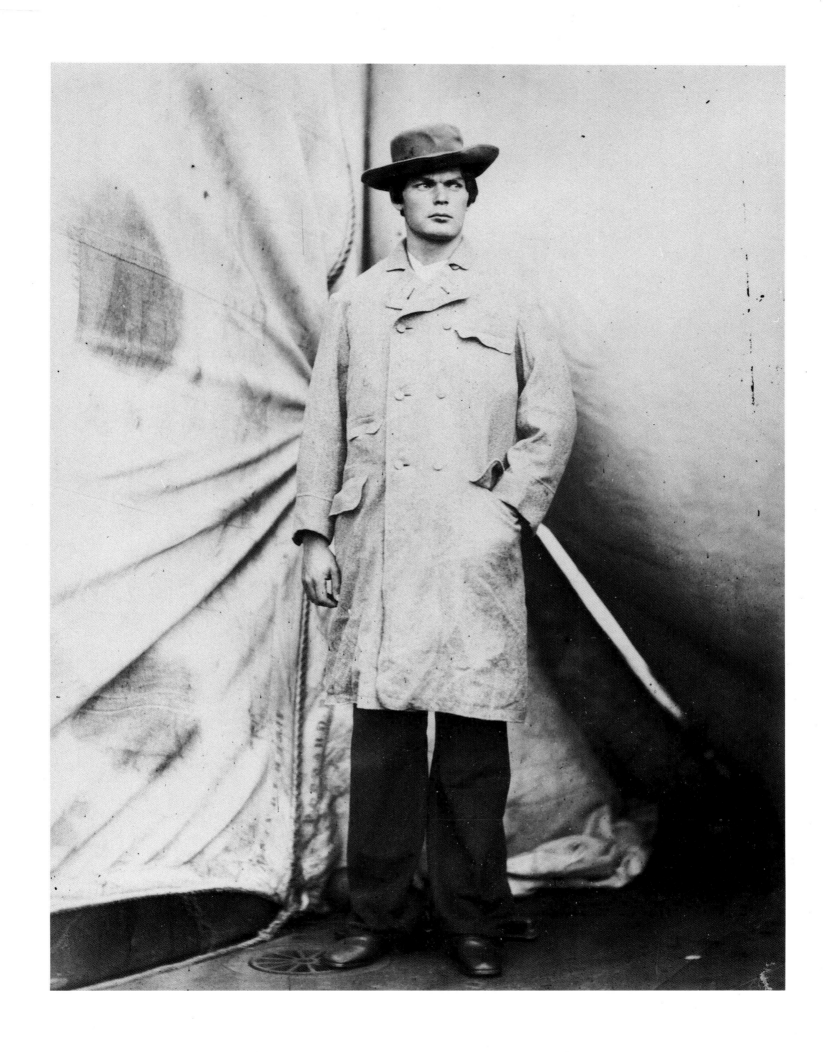

ANDRE-ADOLPHE-EUGENE DISDERI

French · 1819–1889

Portrait of Unidentified Woman

ca. 1860–65 · Albumen print · 19.8 × 23.7 cm., sheet of uncut cartes-de-visite

The carte-de-visite portrait—small, collectible, economical, fashionable, and of universal appeal—rarely, if ever, attained the degree of expressive characterization or emotive forcefulness that a high art portrait by Etienne Carjat or Nadar achieved. Its stylish vernacular was of a different sort and aimed at a much broader audience. More than any other photographer, Disdéri has been singularly cited for the popularization, if not actual invention, of the carte-de-visite, and subsequently the demise of serious photographic portraiture in mid-19th-century France. In his memoirs, Nadar wrote that Disdéri, "created a veritable fad which immediately infatuated the entire world. Moreover, he turned around the economic proportion that until then had been established; that is, by giving infinitely more for infinitely less, he definitively popularized photography."[1] To be certain, Disdéri was adept at other forms of photography: daguerreotype and ambrotype, narrative tableaus and rustic genre subjects, architectural interiors and war reportage, and the techniques of montage and life-size enlargements. Mme. Disdéri was also a talented photographer who documented the sites and landscapes around Brest, while the couple's studio was located in that town prior to their moving to Paris. Yet Eugène Disdéri became the most successful and most frequented portraitist of the 1860s simply because of the carte-de-visite. In fact, he was the only photographer of the period to have had numerous caricatures drawn of him [fig. 29] as well as a short story based on his career.[2]

The carte-de-visite and all that it meant was not without its own artistry and aesthetics. It was vested in a portrait style that well suited the bourgeois clientele who found in it those tokens of tradition and conventional respectability they desired. Like the painted portraits of Hippolyte Flandrin and Charles Muller or the grand-styled photographs of Mayer and Pierson, the success of the carte-de-visite portrait was predicated on a perfected

Fig. 29. Van den Anker, "N'Bougeons plus!," *Journal amusant,* (9 February 1860).

formula of accessible decorum and taste. By specific choices of pose, background, accessories, lighting, and costume, Disdéri claimed, the photographer "would capture that most important aspect which results from the subject's stature through which he is immediately recognized by the general forms presented and independent of those details of features, physiognomy, pose and apparel."[3] This was not a type of portrait that examined the countenance for every nuance or suggestion of inner personality—its small size prohibited that—but one that manufactured up to eight public likenesses on a single sheet of printing paper before trimming and mounting for mass consumption.

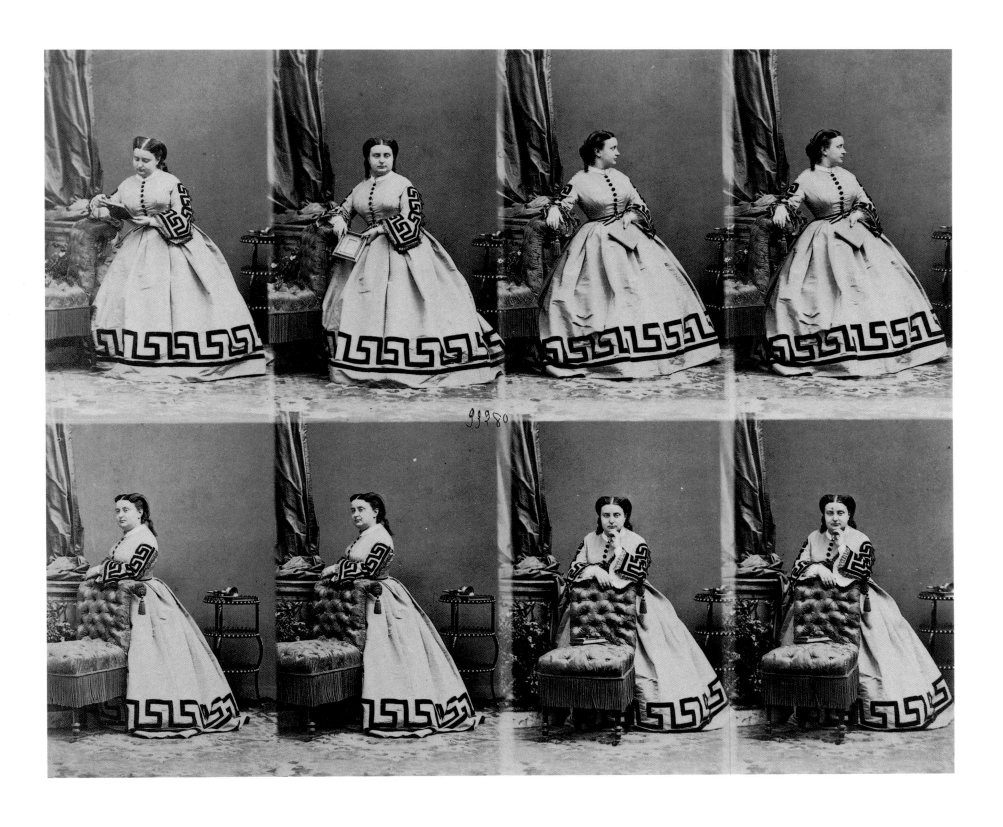

ANTOINE FRANCOIS JEAN CLAUDET

British · b. France · 1797–1867

Mrs. Antoine Claudet

ca. 1860 · Albumen print · 25.5 × 20.0 cm.

His career begun as a banker and businessman, Antoine Claudet learned the daguerreotype process soon after it was announced in 1839 and acquired a license from Daguerre to practice it in Great Britain. Claudet specialized in fashionable and expensive daguerreotype portraits and (what he has come to be known for) sweet domestic genre interior scenes on stereographic daguerreotypes, depicting such subjects as quiet conversations, chess games, geography and music lessons [fig. 30]. Claudet was a friend of William Henry Fox Talbot with whom he frequently corresponded, and the author of more than fifty articles and letters in the international photographic and art press. In 1851, Claudet opened his "Temple to Photography" on Regent Street, a combination of photographic shrine and portrait studio, which he maintained until his death. It was also at this studio that Claudet began working with calotype and collodion portraiture, in which his aesthetics of softened and selected focus are most apparent.

Like the British photographers Sir William Newton before him and David Wilkie Wynfield and Julia Margaret Cameron at approximately the same time, Claudet was firmly convinced that the route to any photographic artistry remained vested in the quality of the image's focus.

> Excessive minuteness is the greatest reproach which has been made by artists to the best photographic portraiture, and, in order to obviate it, some have gone so far as to suggest that it would be desirable that photographers should take their portraits *a little out of focus*. But these artists, forgetting certain laws of optics failed to observe that it was impossible to represent the whole of the figure *in the same degree* out of focus.
>
> Convinced myself of the advantage which, in an artistic point of view, would result from photographic portraits being taken in such a manner that they should as much as possible resemble a work of art, in which all the features are marked by light touches of the brush or pencil, softly blending from light to shade, such an important subject has for a long time occupied my attention. My precise object has been to discover a method of removing, if possible, from photographic portraiture that mechanical harshness which is due to the action of the most perfect lenses. [1]

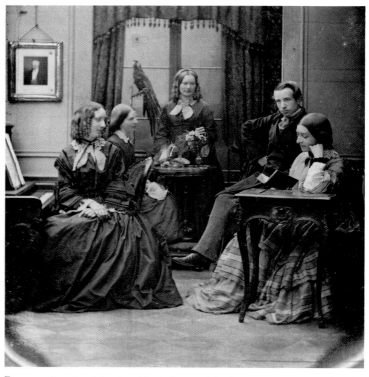

Fig. 30. Antoine Claudet, *Music Lesson* (?), daguerreotype, ca. 1855-60.

Claudet defended the manipulation of photographic prints for artistic purposes, including moving the lens in and out of focus during exposure and retouching either negative or print as in this portrait of his wife.

> Call it a *heresy* or a *dodge* if you like, but look at the result, and if it be good what matters the name given to it? When a dodge is capable of improving any production in art or anything else, is it not very ridiculous to condemn it and to refuse to adopt it because it is only a dodge? . . . Therefore let us hear no more of dodge and heresy, unmeaning expressions, conveying with them no argumentative reasoning; but let us employ all the means we can, whether they are empirical or scientific, simple or clever, and whatever be their nature, provided we can by their use improve what we do imperfectly. [2]

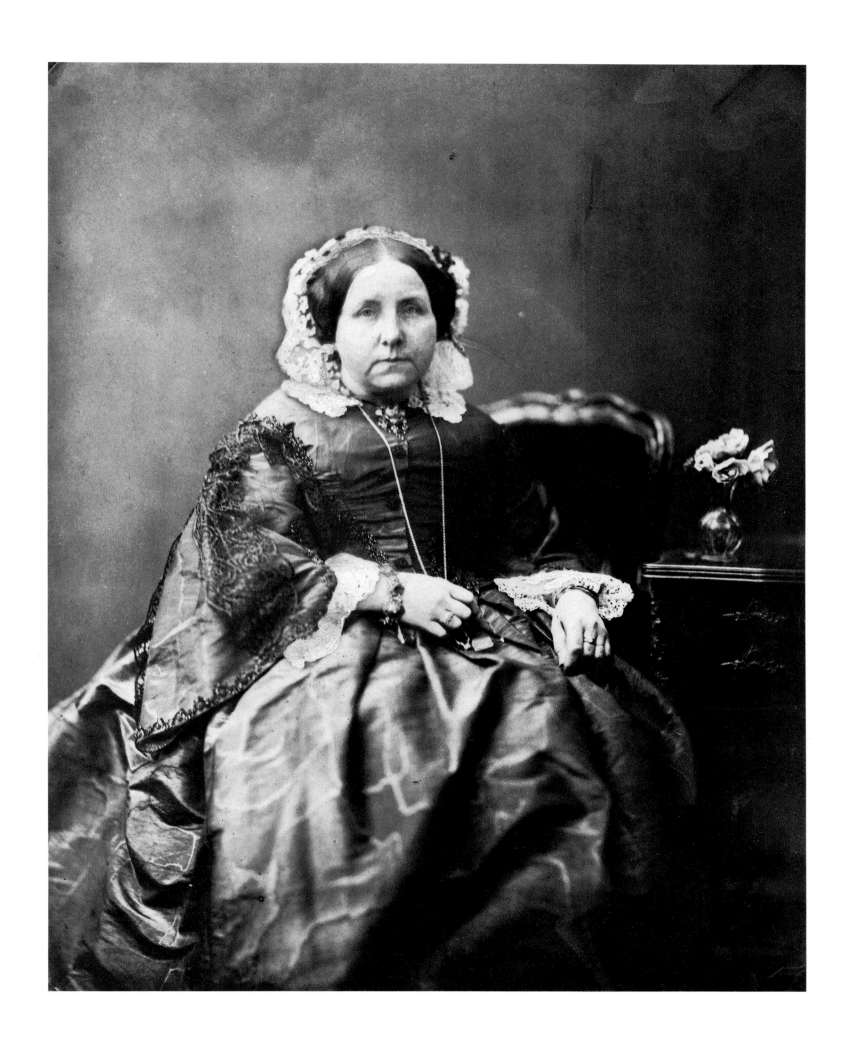

FRANÇOIS WILLÈME

French · 1830–1905

The Artist's Brother

ca. 1859–61 · Bronze relief · 9.0 × 6.0 × 1.4 cm., on base 10.9 × 8.9 cm.

Just because photography was one of the pictorial arts did not prevent photographers from attempting to simulate volume nor even to duplicate it photographically. The "relievo" ambrotype and the more popular device of laminating prints inside convex glass domes were attempts at suggesting spatial volume. Photosculpture, on the other hand, was a technique or process by which the subject's three dimensions could be indirectly transcribed into a variety of materials by photography. In 1859, François Willème conceived the idea of what he called "mechanical sculpture," a form of photographically derived sculpture with only minimal need for handwork. The process was an outgrowth of the idea that the sum of a form's profiles equals the entire volumetric figure. Within two years, Willème developed his ideas for "photosculpture" proper, and he took out patents for it in 1860 and 1861.

There were two distinct yet similar processes involved in Willème's photosculpture: "mechanical sculpture," sometimes called "automatic sculpture," and "photosculpture" itself. Both were fabricated by sequentially photographing the subject, either circularly or progressively focused on serial planes in a linear progression. The individual images were then developed and their outlines transferred to the desired material, such as wood. The material would then be shaped following the single outlines and the shapes combined around a central axis, with the result being a rough stepped portrait in three dimensions. One example in the museum's collection of this technique is a small wooden bust of a woman, her various profiles held together by twine [fig. 31]. The bronze profile of Willème's brother is a unique example of Willème's technique of assembling the profiles derived from photographs focused on multiple planes of the subject's head, from front to back. The leaves of more than fifty individual half-profile shapes as well as the flat background were bolted together to form a finished bas-relief. As a mechanical tour-de-force, there is little with which it competes in 19th-century photography or photographically derived art.

Photosculpture proper was a system of pantographically translating these various profiles onto a clay form from which, in turn, a mold would be fashioned, and the entire process ended by casting the figure and finishing the details. In this process, the customer would have a choice of any material that could be cast: terra-cotta, biscuit, and bronze were options as was metal-plating. The extant examples of Willème's photosculpture would seem to indicate, however, that the material most often used was

Fig. 31. François Willème, untitled mechanically produced bust, oak and twine, ca. 1859-61.

Fig. 32. François Willème, *Self portrait*, plaster photosculpture, ca. 1863.

plaster of Paris, as in the artist's own full-length self-portrait, also in the museum's collection [fig. 32].

The primary attraction of photosculpture was precisely in the miniaturization of dimensional likeness and its facility at rendering the most subtle details and surfaces. Its claim to art was nonetheless challenged by critics of the time, even by its most ardent supporters, such as Théophile Gautier who felt that Willème's invention was no more than a very sophisticated tool for the artist: "Art must see both photosculpture and photography as only docile slaves which take notes for the artist's use, prepare the work for him, do the boring labor, and remove all material obstacles from the realm of the ideal."[1] For many critics, it was the artist who gave the mechanical sculpture its "life of the soul" and its interpretation in the finishing touches put on by hand. The highest praise Gautier could give to Willème's art was simply: "If this is not a masterpiece, it is at least a marvel."

ETIENNE CARJAT

French · 1828–1906

Charles Baudelaire

1861–62/1877 · Woodburytype print · From: *Galerie contemporaine, littéraire, artistique*, sem. 1, series 1 (1878), unp. 23.0 × 18.1 cm.

Charles Baudelaire has secured a place in the history of photography as the principal critic of the medium's aspirations to the ranks of art. Writing in 1859, the poet vehemently argued that photography's materialism could never achieve the ideal of art.

> During this lamentable period, a new industry arose which contributed not a little to confirm stupidity in its faith and to ruin whatever might remain of the divine in the French mind. The idolatrous mob demanded an ideal worthy of itself and appropriate to its nature—that is perfectly understood. In matters of painting and sculpture, the present-day *Credo* of the sophisticated, above all in France (and I do not think that anyone at all would dare to state the contrary), is this: "I believe in Nature, and I believe only in Nature (there are good reasons for that). I believe that Art is, and cannot be other than, the exact reproduction of Nature (a timid and dissident sect would wish to exclude the more repellent objects of nature, such as skeletons or chamber-pots). Thus an industry that could give us a result identical to Nature would be the absolute of art." A revengeful God has given ear to the prayers of this multitude. Daguerre was his Messiah. And now the faithful says to himself: "Since Photography gives us every guarantee of exactitude that we could desire (they really believe that, the mad fools!), then Photography and Art are the same thing." From that moment our squalid society rushed, Narcissus to a man, to gaze at its trivial image on a scrap of metal. [1]

Baudelaire concluded that photography was best left to tourists, astronomers, naturalists, and librarians, and that it had nothing whatsoever to do with impalpable and imaginary realms of art.

Baudelaire was also one of the most photographed writers of the Second Empire. His likeness was taken five times by Nadar and repeatedly caricatured by the same artist; twice by Charles Neyt, friend to Félicien Rops and claimed by the *La Petite Revue* of 1865 to "enjoy the same public renown in Bruxelles as Carjat had in Paris"[2]; and five times by Carjat. The author of the *Flowers of Evil* and *The Spleen of Paris* also dedicated certain of his poems to photographers, most notably to Nadar and Maxime Du Camp. Numerous paintings, lithographs, and etchings of the poet's portrait were copied from photographs during his lifetime, including Manet's famous etching of 1865–68.

Baudelaire sat for Carjat at the commencement of the photographer's career in 1861 and, again, at the very end of the poet's life in 1866.[3] Where the last photograph clearly shows the ravages of severe illness and a personality completely withdrawn and isolated, this earlier print bears pictorial witness to Baudelaire's abject passion, his sardonic intensity, and his melancholic ardor.

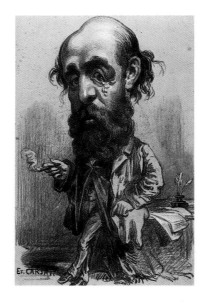

Fig. 33: Etienne Carjat, *Portrait chargé of an unidentified writer*, pen and ink with color, ca. 1860s.

The traces of illness are already there: the balding, the flaccidity, the fatigue; but still present is the look of the driven, creative, and visionary genius. As a character portrait or a portrait intimating the soul of the sitter, Carjat's *Baudelaire* of 1861–62 is one of the clear masterpieces of 19th-century interpretive photography, easily comparable to the best work by Nadar or Julia Margaret Cameron.

Like Eugène Atget decades later, Carjat came to photography from acting and painting. Like Nadar, he continued to make caricatures and lithographs throughout his career, several of which are in the museum's collection [fig. 33]. Around 1876, Carjat gave up photography, disillusioned and with little money, but only after he wrote his *Lamento du photographe* the previous year.

> If for a lucrative business
> You wish to abandon painting,
> Do not select the camera:
> It is an instrument of torture.
> Its two lenses of crystal
> Enclosed in a long copper tube
> Will lead their owner to the hospital,
> And I forbid you to follow me there.
>
> Become a Quaker; become a Mormon,
> Even become a Bonapartist,
> But never a photographer! Oh no.
> The fate of the galley-slave is less sad.[4]

A number of watercolors and etchings of Baudelaire were made from Carjat's photographic portraits of the poet.[5]

HENRY PEACH ROBINSON

British · 1830–1901

Fading Away

1858 · Albumen print, combination print from 5 negatives · 24.2 × 39.2 cm.

Robinson was unquestionably the most noted and famed "literary" photographer of the Victorian era. A steadfast champion of photography as a fine art, he wrote in 1869 that the photographer could "so render his interpretation . . . as to give evident indication of what is called feeling in art, and which almost rises to poetry.[1] The picture that brought him nearly immediate success was *Fading Away*, the most famous "combination" photograph (printed from multiple negatives) of the century next to Oscar Gustave Rejlander's *Two Ways of Life* of the previous year. In addition to making pictures, which he continued to do and exhibit until his death, Robinson was a prolific writer. His books and articles stand as the first complete photographic art theory in the English language. At his death, one British critic wrote that "in England and on the continent, for nearly half a century (1857-1900) no single influence has been greater than his in shaping the progress of pictorial work."[2]

This wonderfully sentimental image of a young maiden's last moments of life is an eloquent testimony to the romantic Victorian fascination with death and dying. The dying girl is attended to by her mother, a sister or a friend, and a male figure lost in melancholy revery at the window who was identified by critics of the period as the heroine's fiancé. Robinson appended six lines of poetry from Percy Bysshe Shelley's *Queen Mab*, privately printed in 1813 but more readily available in part in the 1839 edition of the poet's works. The lines read:

> Must then that peerless form
> Which love and admiration cannot view
> Without a beating heart, those azure veins
> Which steal like streams along a field of snow,
> That lovely outline, which is fair
> As breathing marble, perish?

The theme of the dying consumptive was quite popular in the arts of the last century. We have only to recall Mimi in *La Bohème*, Marguerite Gautier in *La Dame aux camelias*, Little Eva in *Uncle Tom's Cabin*, and Smike in *Nicholas Nickleby*.[3] That

Fig. 34. Henry Peach Robinson, *A Study*, albumen print, 1858.

Robinson's central figure belongs to that group is attested to by "those azure veins . . . along a field of snow"—a certain translucency of the skin being a late symptom of tuberculosis. In his study for *Fading Away* [fig. 34], Robinson posed his single model "in order to see how near death she could be made to look."[4] Again, the idea of consumption from within is pictorially rendered and emphasized by an associated text, this time from Shakespeare;[5]

> She never told her love
> But let concealment, like a worm i' the bud,
> Feed on her damask cheek.

Engravings of *Fading Away* were published in such popular magazines as *Harper's Weekly* (New York) and *Le Journal illustré* (Paris) in 1858.

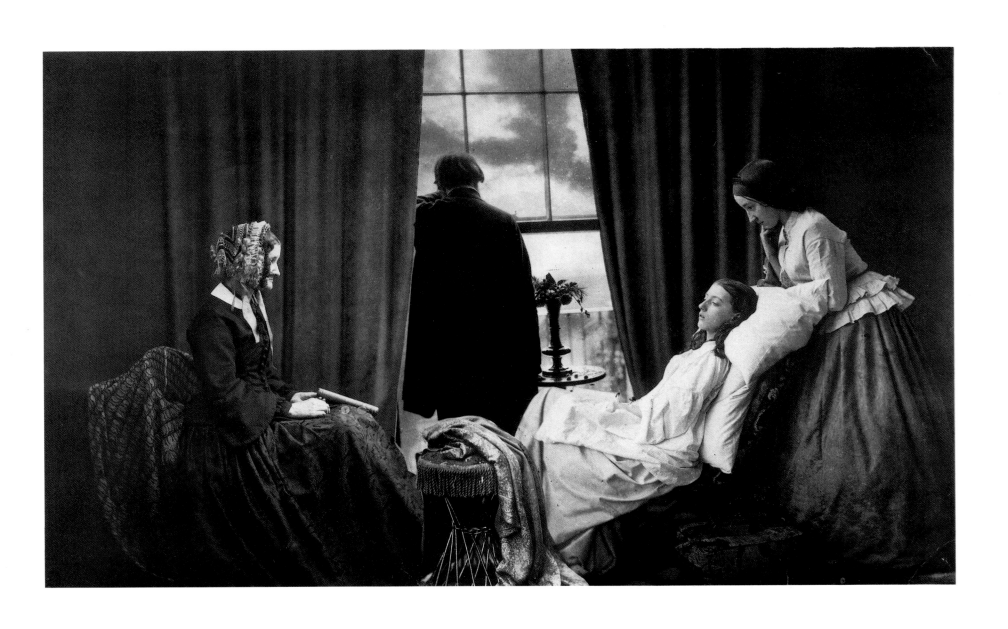

DAVID WILKIE WYNFIELD

British · 1837–1887

Self Portrait in Renaissance Costume

ca. 1860–65 · Albumen print · 21.0 × 16.0 cm.

In a letter to William Michael Rossetti in 1866, Julia Margaret Cameron added a postscript in which she expressed her debt to another photographer: "...I urge you to see at Colnaghi's my late large pictures. Mr. Wynfield too never went! and that surprised me. My Book there held the one great fact that to my feeling about his beautiful Photography, I owed *all* my attempts and indeed consequently all my success."[1] Superficially there are certain resemblances between Cameron's photography and Wynfield's. Both were interested in expressively rendering the likenesses of friends and acquaintances who were prominent figures in British arts and letters, and both eschewed the idea of naturalistic or objective photography in a technical sense as well as thematically. Neither photographer was especially enamored of the clinical sharpness possible from modern camera optics; rather, theirs was an aesthetic choice of soft effusion and impression.

Their subjects, too, were often posed in "fancy dress" or period costumes, whether Arthurian, medieval, or early Renaissance. By the time Cameron portrayed her friend Tennyson as a medieval monk, poet laureate Henry Taylor as an Elizabethan bard, and her husband as King Arthur, Wynfield had already depicted the painter Frederic Leighton as a Renaissance poet, the pre-Raphaelite John Everett Millais as Dante, the illustrator Charles S. Keene as a 17th-century cavalier, and book illustrator Frederick Walker as a Florentine painter. In his own portrait, Wynfield is presented as a Tudor man of letters, pensively engrossed in a small volume of what may well be poems.

The notion of portraying real individuals in some sort of fictive mode or historical costume was not especially an invention of Wynfield's. In 17th-century Dutch art, the "so-called historiating portrait" enjoyed a fair popularity, with even Rembrandt transforming a portrait of a contemporary couple into a history painting, *The Jewish Bride*.[2] The history of this kind of portrait, one in which there is an active dissembling of the subject for metaphoric or symbolic reasons, is certainly irregular, but it again won a degree of fashionability during the later 19th century. In 1863, Dante Gabriel Rossetti completed his master-

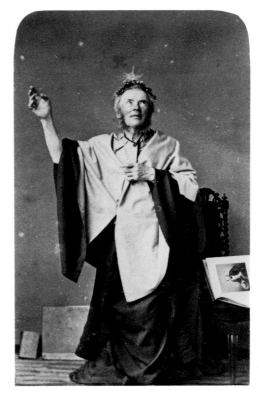

Fig. 35.
Richard Cockle Lucas,
As the Poet of Hope,
albumen print, 1865.

piece *Beata Beatrix*, in which the earlier Dante's famed lover Beatrice is hauntingly rendered in the likeness of Rossetti's late wife Elizabeth Siddal. The French photographer Hippolyte Bayard portrayed himself as the dead Marat about 1847; Gabriel Harrison, the American daguerreotypist, photographed his son as the young Christ carrying the Cross; and in 1865 the British sculptor Richard Cockle Lucas filled an entire carte-de-visite album with forty-nine self-portraits illustrating various literary themes or historic characters [fig. 35]. Again, in recent times, such artists as Lucas Samaras, Robert Mapplethorpe, and Cindy Sherman have all portrayed themselves as both self and other.

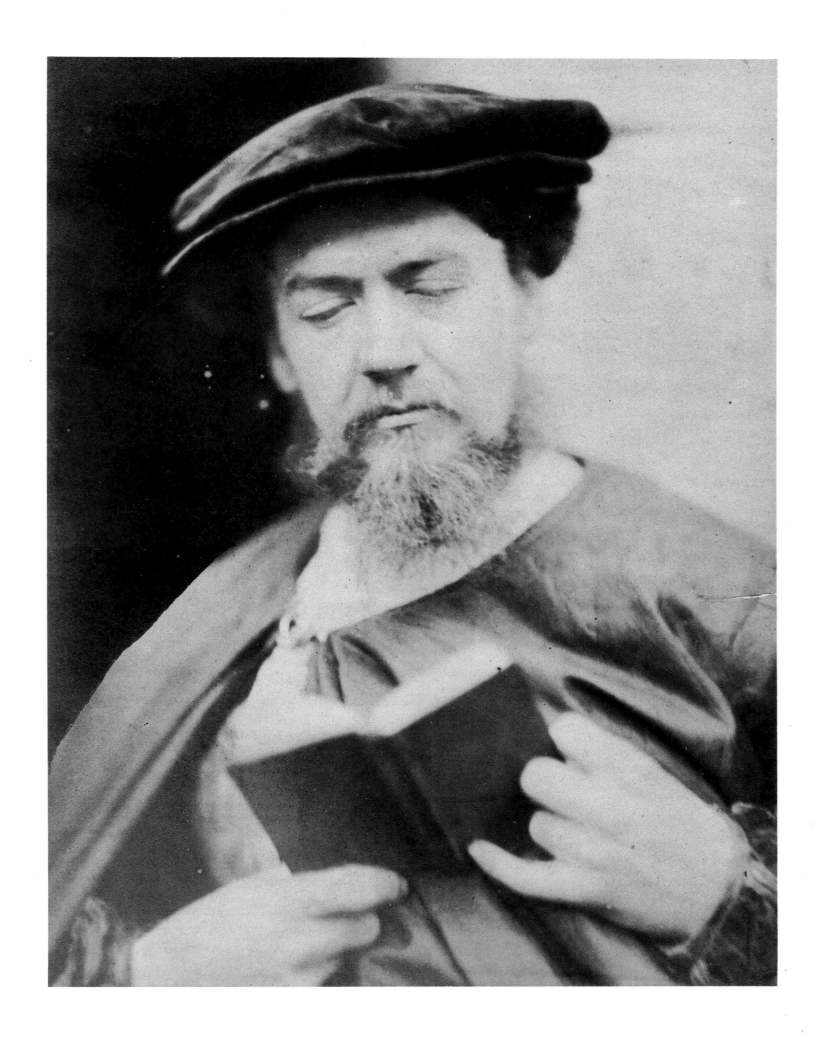

143

JULIA MARGARET CAMERON

British · b. India · 1815–1879

Mrs. Herbert Duckworth

1867 · Albumen print · 27.6 × 23.8 cm.

Just possibly the most spectacularly iconic portrait of the last century, Cameron's *Mrs. Herbert Duckworth* is also one of the simplest and most evocative of her work. Two variants of this pose, one entitled *Stella*[1] and another without title,[2] were probably taken at the same sitting. The more famous patrician profile of the same subject, Julia Jackson, the photographer's niece, was also taken the same year.[3]

The source for such a striking frontal composition most likely comes from Cameron's friend and spiritual mentor the painter George Frederick Watts, who had begun two portraits of Alfred Lord Tennyson in 1863, both of which depicted the poet laureate in just as severe and strong a fashion.[4] In turn, the ultimate source probably rested in 16th-century Italian Renaissance portraiture, such as that by Tintoretto, Palma Vecchio, and Raphael. Nevertheless, Cameron transformed her young niece into one of her most perfect sibylline "impersonations"—secularly spiritual, mysterious, and portentous.

In 1875, Cameron composed her poem "On a Portrait," which nearly reads as a verbal reprise of this photograph.

Oh, mystery of Beauty! who can tell
　　Thy mighty influence? who can best descry
How secret, swift, and subtle is the spell
　　Wherein the music of thy voice doth lie?

Here we have eyes so full of fervent love,
　　That but for lids behind which sorrow's touch
Doth press and linger, one could almost prove
　　That Earth had loved her favourite over much.

A mouth where silence seems to gather strength
　　From lips so gently closed, that almost say,
'Ask not my story, lest you hear at length
　　Of sorrows where sweet hope has lost its way.'

And yet the head is borne so proudly high,
　　The soft round cheek, so splendid in its bloom,
True courage rises thro' the brilliant eye,
　　And great resolve comes flashing thro' the gloom.

Oh noble painter! more than genius goes
　　To search the key-note of those melodies
To find the depths of all those tragic woes,
　　Tune thy song right and paint rare harmonies.

Genius and love have each fulfilled their part,
　　And both unite with force and equal grace,
Whilst all that we love best in classic art
　　Is stamped for ever on the immortal face.[5]

In 1858, when Tennyson sat for an earlier portrait by Watts, the poet asked him what he thought about when painting a portrait, and upon Watts's response Tennyson based a passage in his *The Idylls of the King*. This passage from "Elaine," would have been known by Cameron and, in brief, summarized her attitude toward portraiture.

And all night long his face before her lived,
As when a painter, poring on a face,
Divinely thro' all hindrance finds the man
Behind it, and so paints him that his face,
The shape and colour of a mind and life,
Lives for his children, ever at its best
And fullest;...[6]

Later, Cameron wrote to Sir John Herschel and, in words similar to Tennyson's and Watts's "shape and colour of a mind and life," confessed her intention to render photographically the "roundness and fulness of force and feature" of her subjects.[7]

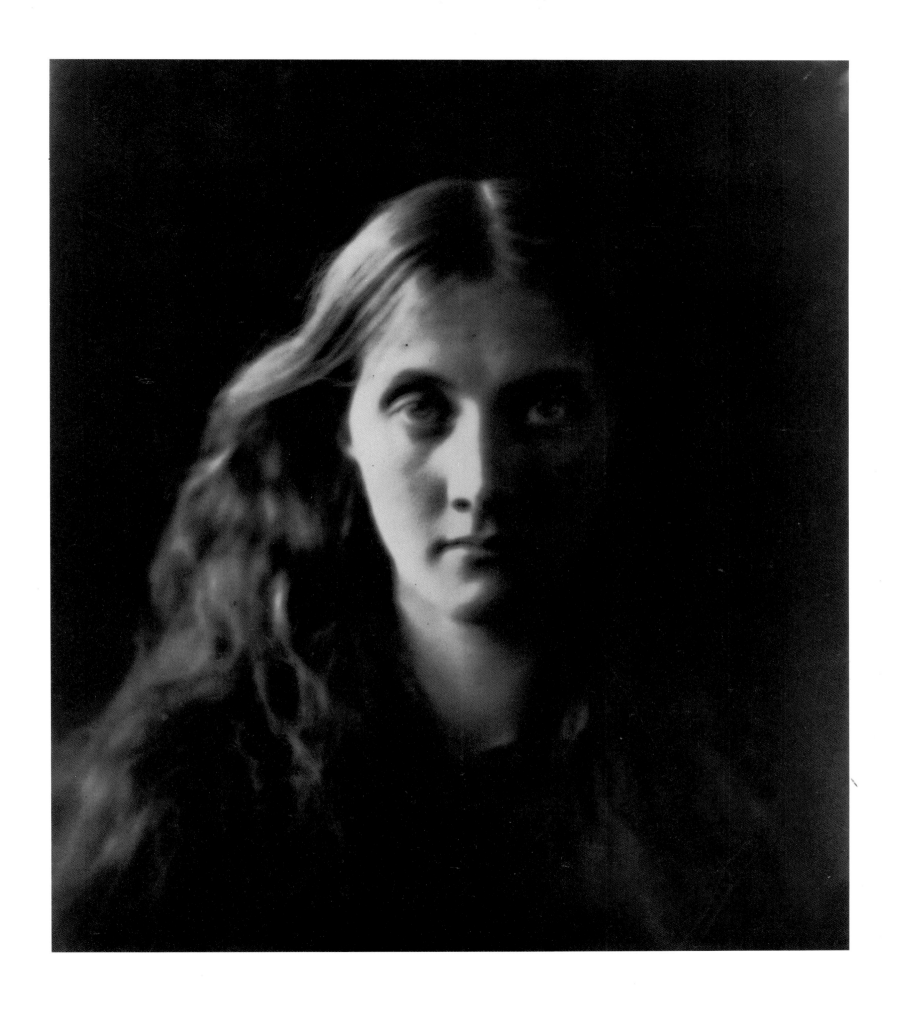

FRANCIS EDMOND CURREY

British · 1814–1886

The Heron

ca. 1865 · Albumen print · 20.3 × 14.5 cm.

It would be difficult to underestimate the popularity of animals in 19th-century British art. Whether depicted live or "after the hunt," animals (including birds) provided artists with the perfect subject on which to exercise their virtuosity in rendering the most minute natural detailing, through which to comment on human behavior and social issues, and with which to invest political reproach in allegory and symbolism. From George Stubbs's anatomical studies and Thomas Bewick's compendia of bird types to William Cruikshank's precisely drawn watercolors of dead birds and their nests and Sir Edwin Landseer's dying stags and dead game, animal themes had proven to have significant enough historical weight by mid-century to attract Victorian photographers in search of meaningful subject matter. This was especially the case with portrayals of dead game and birds, with the obvious connections these subjects had to traditional still life painting and "sporting prints," as well as their associations with conservation and mortality.

The 19th-century French critic and art theorist Hippolyte Taine summarized the role of the animal in British art of the time: "The English painter does not love the animal for its own sake, as a living creature nor yet on account of its form standing out in relief, or of its coloured shape harmonising with the surroundings; he looks deeper, he has meditated, and he refines. He humanises his animals; he has philosophic, moral, and sentimental ends in view. He desires to suggest a reflection; he acts the part of a fabulist. His painted scene is a species of enigma, of which the key is written below."[1] As such, then, the various paintings and photographs of dead game so popular during the Victorian era would have to be seen as icons—images meant to suggest themes as diverse as man's misuse of natural resources, beauty of nature despoiled by the hunter, or death itself.

Currey's The Heron is remarkable for its austere simplicity: a single bird, elegant and graceful in its form, its feet tied and nailed to a plain wooden wall. Most earlier photographs of the same subject were complicated by groupings of birds, as in Currey's many other game pictures and William Lake Price's The First of September of 1855,[2] or by including the dead bird or rabbit in a more expansive still life of vases, flowers, baskets, powder horns, and shoes as in Hugh W. Diamond's Still Life of around 1856.[3] Similar subjects occur in French photography, most notably in the work of Adolphe Braun, Charles Philippe-Auguste Carey, and Louise Laffon, ranging from the mid-fifties to the early seventies;[4] but seldom does a heron figure in these compositions, since it was not strictly speaking a game bird.

While the stately and delicate proportions of the heron are frequently found in decorative arts of the period, this bird is seldom encountered in the pictorial arts. The earlier photographer J. D. Llewelyn, for example, included a stuffed heron in the shallows of a pond in his Piscator No. 2 of around 1857.[5] Unquestionably, however, the most famous late 19th-century appearance of the heron in art, and the one that serves most to underscore the poignancy of Currey's photograph, occurs in literature the following decade. Thomas Hardy's Return of the Native of 1874–78 contains a scene in which the character Mrs. Yeobright, depressed and exhausted, sights one of these majestic creatures at sunset: "He had come dripping wet from some pool in the valleys, and as he flew the edges and linings of his wings, his thighs, and his breast were so caught by the bright sunbeams that he appeared as if formed of burnished silver. Up in the zenith where he was seemed a free and happy place, away from all contact with the earthly ball to which she was pinioned; and she wished that she could arise uncrushed from its surface and fly as he flew then."[6] The heron, the agent of Mrs. Yeobright's epiphanic vision, is a naturalist symbol of lightness and freedom; as an icon in Currey's photograph, it is just the opposite: bound, dead, and nailed to the wall.

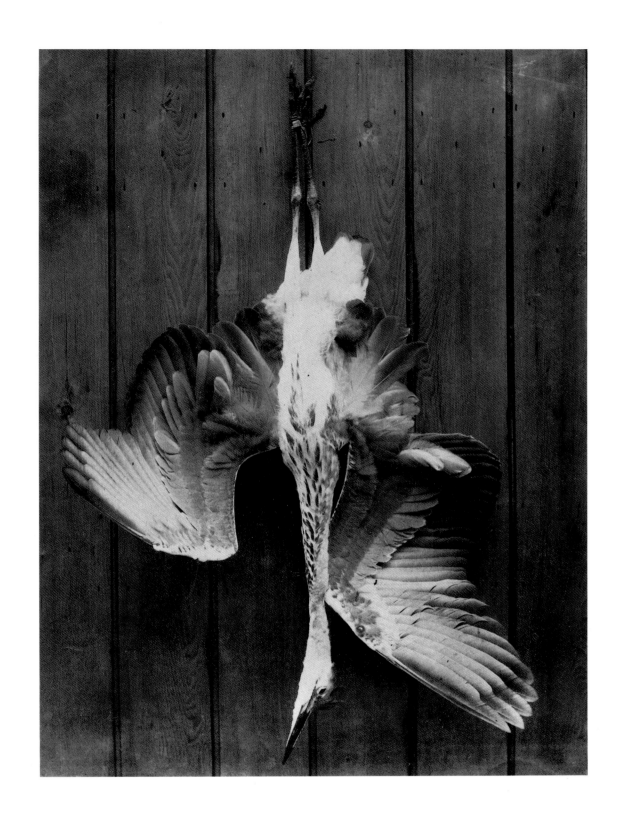

COUNT DE MONTIZON

French · active England, 1850s

The Hippopotamus at the Zoological Gardens, Regent's Park

ca. 1854 · Albumen (or albumenized salt) print · From: *Photographic Album for the Year 1855. Contributions from the Members of the Photographic Club.*, London, 1855. 11.1 × 12.7 cm.

The text that accompanied this image in the *Photographic Album for the Year 1855* detailed this rather unusual subject: "This animal was captured in August 1849, when quite young, on the banks of the White Nile; and was sent over to England by the Pasha of Egypt as a present to Queen Victoria. He arrived at Southampton on May 25, 1850; and on the evening of the same day was safely housed in the apartment prepared for him at the Zoological Gardens, where he has ever since been an object of great attraction. Taken on Collodion with a double Lens, by instantaneous exposure."[1] This is a rather lifeless description of one of the more fascinating prints of the last century, made by a photographer about whom little is known except that he also documented a dromedary, a giraffe, a stork, and a live pickerel in an aquarium; prints of each of these subjects are in the museum's collection.

Today the zoological garden has become a conflation of scientific research center, educational institution, museum, and amusement park. In contrast, the first modern zoos, established in the late-eighteenth and early-nineteenth centuries were as much signs of national prestige as they were instruments of learning and entertainment.

> When they were founded . . . they brought considerable prestige to the national capitals. The prestige was not so different from that which had accrued to the private royal menageries. These menageries . . . had been demonstrations of an emperor's or king's power and wealth. Likewise in the 19th century, public zoos were an endorsement of modern colonial power. The capturing of the animals was a symbolic representation of the conquest of all distant and exotic lands. 'Explorers' proved their patriotism by sending home a tiger or an elephant. The gift of an exotic animal to the metropolitan zoo became a token in subservient diplomatic relations.[2]

To be able to see polar bears, kangaroos, elephants, and lions at any of the zoos in London, Liverpool, Leeds, Bristol, Cheltenham, Dublin, and Edinburgh meant that the public did not have to travel far, or expensively, from their suburban cottages or manors. The wilderness was accessible within easy commute, and it was only in that "gloomy forest" that the sublime could be experienced, according to Edmund Burke, "in the form of the lion, the tiger, the panther, or rhinoceros."[3] With all due respect to Burke, little of the sublime seems to have been invested in this aspect of a dormant hippopotamus.

Animal photography existed in some force during the 1850s in Europe. Achille Devéria and Louis Rousseau published their *Zoological Photography, or Representations of Rare Animals in the Collections of the Museum of Natural History* in 1853; Adrien Tournachon photographed cows for Emile Baudement's *Bovine Breeds From the Universal Agricultural Competition in 1856: Zootechnical Studies*, published in 1869; and Camille Silvy apparently recorded sheep in farmyards as early as 1859. De Montizon may well have been the earliest zoological photographer in England; most other British photographers of the period either capitalized on the popularity of dead game still lifes, like F. E. Currey, or posed stuffed animals in real landscapes or dioramas, as Alfred Rosling and J. D. Llewelyn did.

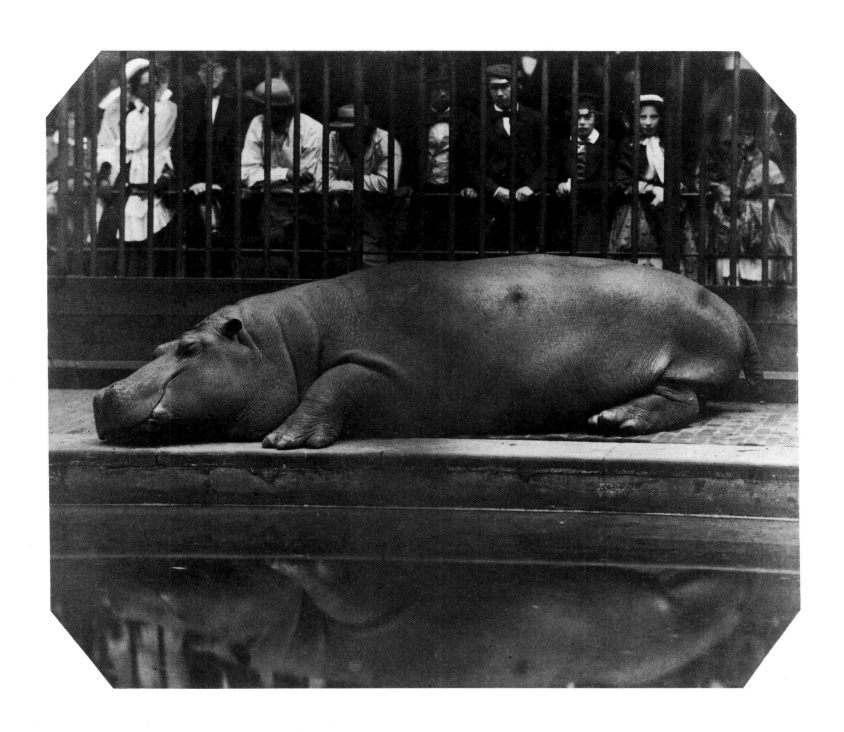

UNIDENTIFIED PHOTOGRAPHER

British (?) · active 1870s

"Col. Michael, Military Secretary to Government, with Bones of the Leg of the Australian Dinornis."

ca. 1872 · Albumen print · From: album *Indian Photographs*, Madras, n.d. [ca. 1872]. 22.9 × 17.3 cm.

In the wake of Linnaeus's and Buffon's systems of natural classification, the aftermath of Darwin's theories of evolution, and the ascents and descents of species, the science of paleontology took on special significance for the Victorian. Not only were fossils and bones to be collected, catalogued, and compared to one another, they were also very real tokens of a very disquieting and uncertain distant past. As Darwin courageously stated in 1860:

> Analogy would lead me one step further, namely, to the belief that ALL ANIMALS AND PLANTS have descended from some one prototype. But analogy may be a deceitful guide. Nevertheless, all living things have much in common in their chemical composition, their germinal vesicles, their cellular structure, and their laws of growth and reproduction. . . . Therefore I should infer from analogy that probably all the organic beings which have ever lived on this earth have descended from some one primordial form into which life was first breathed by the Creator. [1]

And as a critic for the *Quarterly Review* summarized Darwin's fundamental thought: "Man, beast, creeping thing, and plant of the earth, are all the lineal and direct descendants of some one individual *ens*, whose various progeny have been simply modified by the action of natural and ascertainable conditions into the multiform aspect of life which we see around us." [2]

Photographs of prehistoric bones were not uncommon to the late-19th century—Roger Fenton had photographed the British Museum's "Dinornis Elephantopus" about 1853 [3]—but those in which the human figure is utilized as a scale reference to what was only the leg are exceptional. Smartly dressed, Col. Michael presents us with a specimen, which was for him, most likely, also a question of relationship.

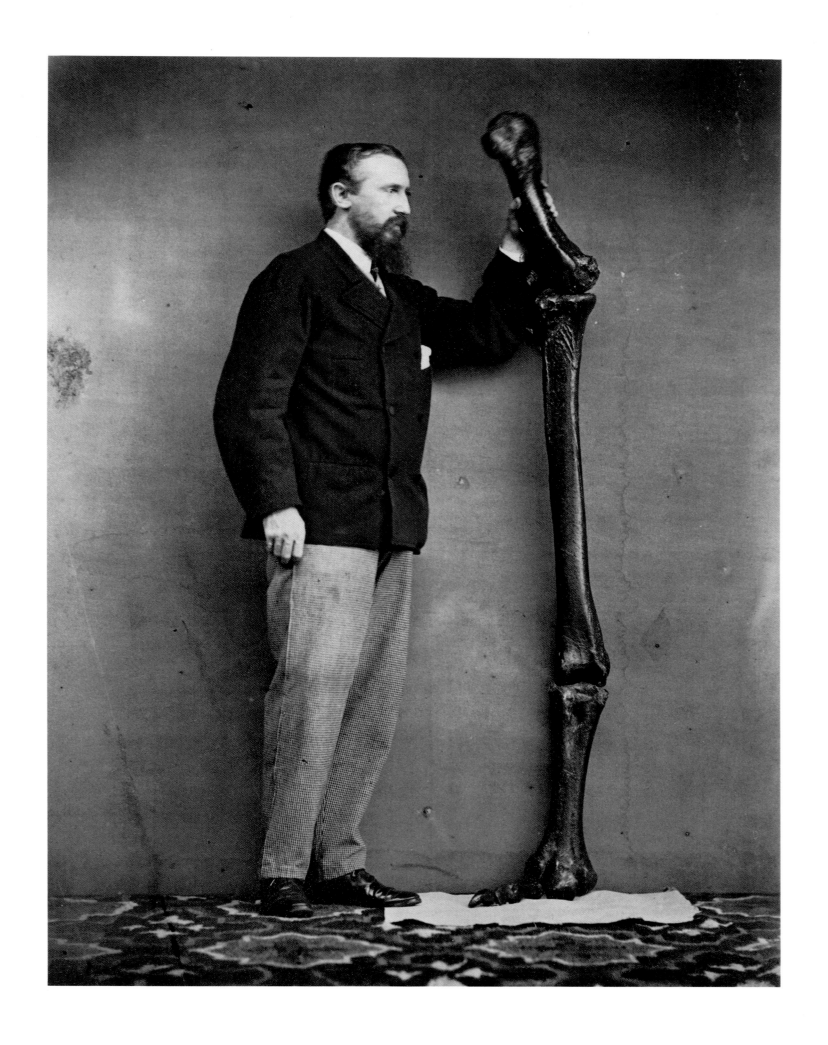

UNIDENTIFIED PHOTOGRAPHER

British · active 1860s (?)

Japanese Samurai

ca. late 1860s · Albumen print · 19.4 × 13.3 cm.

As is frequent with photographic images, the lack of historical or even factual context lends them a certain power to evoke. This is such an image, about which so little is known that it might as well be a hieroglyph found in the wilderness. The subject is apparently a samurai warrior, or at least an Oriental male dressed as such; it is unclear whether the image depicts an actual historical figure or a bit of stagecraft. There is some suspicion that the origins of the print are British, simply because of other pictures grouped with it in the museum's collection; but it is uncertain whether the photograph was taken in the Far East or in some Western European photographer's studio. Is it a portrait, or more accurately a costume piece aimed at an audience interested in simple exoticism or in foreign arms and armor? Is it ethnographic, anthropological, exploitative, or honorific in its documentary purpose? The photograph, unfortunately, refuses to yield any suggestions or answers.

Superficially, a Japanese poses in a studio in full samurai regalia, standing in near profile with arms pridefully akimbo, or at least the pride in such a gesture is one read by a Western viewer. Banner, sword, and knife are fully displayed, as is the man's aggressive grimace—which may also be a Western reading of the physiognomy—and behind him is the warrior's helmet or headgear, displayed frontally atop an obviously mid-Victorian, wooden tripod stand. Still more incongruous is the presence of the cast-iron floor stand, barely discernible behind the figure's feet, suspiciously like the base of an accessory found in a British photographer's studio. Most likely, these European incursions into an otherwise strict document of exotic culture were invisible to the Victorian viewer—the figure and helmet were alone admitted to conscious visualization. Without the explanation of context or intent, however, it is impossible to more fully appreciate the image's content. It becomes purely an image, partly non-referential and in part metaphoric, allowing meaning to be applied to it without regard to any literal reality of past or present. As in literature, "images" in photography "can also function as markers of fiction, indices to a representation of the unreal, or rather to a non-representational, non-mimetic type of discourse."[1] Since it is not of the present and has no tangible past, its details and features become simply a pictorial system from which whatever "samurai" we may imagine is invented.[2] Which may in turn be exactly what the photograph meant for the viewers of the last century.

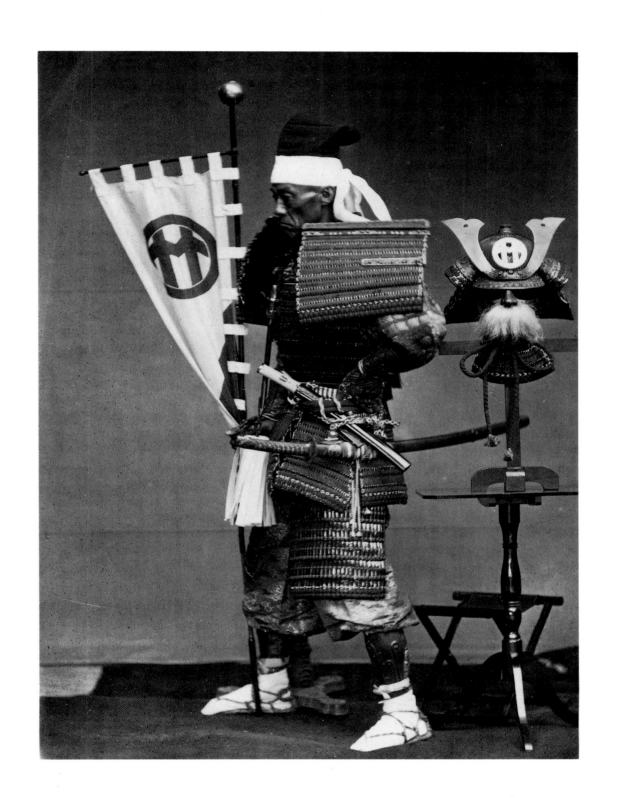

ERNEST EDWARDS

British · 1837–1903

"Cleft in the Rock—Anchor Church, Derby"

ca. 1860–65 · Albumen print · 22.6 × 18.6 cm.

Ernest Edwards is not especially well known, but his was a rather typical example of the Victorian photographer. Not exactly an amateur, although he was a member of the purely nonprofessional Amateur Photographic Association, he manufactured one of the earliest pocket-sized folding cameras, was instrumental in introducing the heliotype process into London, and made portraits of distinguished public figures. Nor was Edwards strictly speaking a professional photographer, despite his traveling to the Bernese Oberland with naturalist H. B. George and supplying prints to illustrate their joint publication, *The Oberland and Its Glaciers Explored and Illustrated with Ice Axe and Camera* (London, 1866), and despite his maintaining a photographic studio in the center of London. His portraiture was customarily of famous personalities such as the historian J. A. Froude, the anatomist Sir Richard Owen, and the explorer and writer Captain Richard Burton; his landscape work, on the other hand, appears to have been mostly of isolated scenes and retiring corners of nature. Besides his book on the Oberland, there is no evidence that Edwards applied his nonportrait work to any commercial end.

In volume four of *Modern Painters*, containing the section entitled "Of Mountain Beauty," John Ruskin wrote that mountainous landscapes are:

> calculated for the delight, the advantage, or the teaching of men; prepared, it seems so as to contain, alike in fortitude or feebleness, in kindliness or in terror, some beneficence of gift, or profoundness of counsel. We have found that where at first all seemed disturbed and accidental, the most tender laws were appointed to produce forms of perpetual beauty; and that where to the careless or cold observer all seemed severe or purposeless, the well-being of man has been chiefly consulted, and his rightly directed powers, and sincerely awakened intelligence, may find wealth in every falling rock, and wisdom in every talking wave. [1]

It was certainly with such words in mind, or at least given to a comparable sensibility, that Edwards photographed the Grindelwald Glacier and the surrounding areas of the Oberland. It was also likely that Edwards came to the varied and picturesque landscape of Derbyshire with some amount of Ruskinian naturalism. Anchor Church in Derby was a piece of architecture seemingly carved out of the limestone cliffs and hills making up the landscape. Its origins and date are uncertain. Nearby, presumably, Edwards trained his camera onto a vine-covered rocky formation whose very structure had decidedly organic, if not erotic, overtones. Either the result of erosion into the soft stone, or a mark left in the earth by centuries-old lead mining, the somber, foliated cleft was a paradigm of the picturesque. Ruskin discussed at length the various ways vegetation grew in relation to the stones and rocks of the landscape, and even had similar scenes of natural grandeur and beauty daguerreotyped. [2]

UNIDENTIFIED PHOTOGRAPHER

British · active 1860s (?)

Windsor Park—Virginia Waters

ca. 1865 · Albumen print · 21.2 × 25.6 cm. (oval)

Any number of British photographers may have been the author of this rather elegant suburban park scene. Given the picture's size, its lyrical tone, the pastoral subject, and the exceptionally beautiful quality of the albumen printing, the names of Henry White, Philip Henry Delamotte, Edward Fox, Francis Frith, and Roger Fenton come immediately to mind; but little evidence, either within the photograph or external to it, would recommend any particular photographer. It is safe, however, to suggest that, whoever the artist was, he or she had talent far and away above the average camera operator.

This is hardly a dramatic landscape filled with romantic *Sturm und Drang*, nor is it Ruskinian and devoted to untrammeled, sublime nature. Rather, it is a landscape of calm, serenity, and control, a park scene in which fashionably dressed folk can sketch and amble upon well-kempt lawns and savor good conversation, just twenty miles up the Thames from London. For its date, it is not a very modern landscape rendition; its formal conventions are much more in line with Constable's paintings, such as *Malvern Hall, Warwickshire* of 1821 or *Wivenhoe Park, Essex* of 1816, than with the naturalist paintings of the Pre-Raphaelites John Everett Millais or William Dyce. More to the point, the carefully constructed landscape composition recalls one of photographer William Lake Price's lessons on composition published in 1860 and illustrated with a wood-engraving reproduction of a Dutch 17th-century landscape with figures by Jan Both [fig. 36]. Tall trees standing to one side, hills shrouded in atmospheric perspective in the distance, clearly structured diagonal elements, and a rich play of darks and lights are common to both images. Lake Price's comments, as well, may be favorably applied to this photograph.

> As photography progresses we shall doubtless see brilliant *effects of sun-light* rendered in the landscape with more power,

Fig. 36. Engraving after Jan Both, *The Photographic News*, 27 April 1860.

> the great error now being that the mass of photographers do not aim at them. The parrot cry of "sharp, sharp," which the ignorant in art raise, seems the main point aimed at, the result being, in the majority of cases, the production of painfully elaborated details, instead of broad *effects* of light glancing through the landscape, which are qualities of an infinitely higher standard, and which, when produced, are sure to supercede the other in the estimation of the spectator.[1]

The balance maintained between those "elaborated details" and "broad effects" is precisely what makes this photograph so special.

VICTOR PREVOST

French · 1820–1881

Part of the Lion Bridge on Equestrian Road, August 17th

1862 · Albumen print · From Presentation portfolio,
("To A. H. Green Esq." from V. Prevost), *Central Park*,
New York, 1862, pl. 5. 13.5 × 13.5 cm.

Prevost, following a similar path taken by many other early
French photographers, had begun his career as a painter who
studied in the studio of Paul Delaroche and exhibited a number
of paintings in the Salons of the 1840s. When the California
gold rush of 1849 materialized, Prevost relocated himself to San
Francisco where he painted topographic views of that city. Two
years later, in 1851, he was in New York where he apparently
learned the calotype process. In 1853, he was back in France,
and it was most likely at this time that he learned the waxed
paper process from Gustave Le Gray. He photographed the forest
at Compiègne, and returned to the United States the same year.
In New York, he entered into partnership with another French-
man, P. C. Duchochois, and he made large-scale calotype nega-
tives, measuring upwards of 18 by 22 inches. From then on, it
would appear that Prevost worked both at various galleries,
including that of C. D. Fredericks, and free-lanced as a photog-
rapher until completing his career as a teacher and principal in
Upstate New York schools.

Apparently, Prevost, one of the finest photographers working
in America in the 1850s, was granted permission to document
Frederick Law Olmsted's Central Park in New York during its
construction between 1856 and 1862, the date of most of the
prints in this presentation portfolio. It is interesting to note that
Prevost, whose monumental calotype negatives have compelled
some critics to rank him with Marville, Le Secq, and Le Gray,
was by the early 1860s using collodion negatives and printing
out albumen prints of a rather diminished size. [1] Yet in his photo-
graphic record of various sites under construction within the
park, Prevost clearly brought to his admittedly modest-sized
images a sense of the monumental and the grandiose that few
other photographers were capable of. His was a pictorial enco-
mium to the landscape architect's vision, situating the cast-iron
and concrete creations of man within the natural terrain of the
meadows and hills, as if the Victorian decorative bridges and
monuments were part of the very nature they were adorning.
Furthermore, his scale references, like the young boy posing
beneath the Iron Bridge, are customarily accommodated to the
subject at hand in a rather graphic manner; here the figure
stands at the precise culmination of man-made curve and natural
shadow. There is a quiet finesse to Prevost's late images that is
both rare and wonderful.

GEORGE WASHINGTON WILSON

Scottish · 1823–1893

Abbotsford, from the Tweed [3 Views]

ca. 1856–ca. 1863 (and after ?) · Albumen prints (3 pairs) · 7.6 × 6.9 (l.) and 7.5 × 6.7 (r.); 7.7 × 7.8 (l.) and 7.7 × 7.1 (r.); 7.9 × 7.4 (l.) and 8.0 × 7.3 (r.) cm.; stereographs.

The stereoscope was based on the simple proposition that with binocular vision a greater degree of spatial depth is perceived than with monocular sight. In 1859, the American Oliver Wendell Holmes understood this principle perfectly and how it related to photographic stereography.

We see something with the second eye which we did not see with the first; in other words, the two eyes see different pictures of the same thing, for the obvious reason that they look from points two or three inches apart. By means of these two different views of an object, the mind, as it were, *feels round it* and gets an idea of its solidity. We clasp an object with our eyes. . . . [Though] the two eyes look on two different pictures, we perceive but one picture. The two have run together and become blended into a third, which shows us everything we see in each.[1]

Beginning with the daguerreotype, photographers have produced pairs of camera images that, when viewed through a lenticular or optical viewer, blended into one and gave the illusion of spatial depth. During the 19th century, stereoscopic card photographs were manufactured in the hundreds of thousands and documented nearly every known site and event of even moderate interest.

One of the largest producers of stereoscopic views in the Victorian era was the Scottish painter turned photographer G. W. Wilson of Aberdeen. His first catalogue of stereographic images appeared in 1856, numbering forty-four different subjects. If only a conservative 100 stereographs were printed of each subject, it would have required approximately 45,000 separate production steps or operations.[2] In 1863, Wilson published a second cata-

logue of stereographic views, this time numbering an impressive 264 entries, of which No. 103 is listed as *Abbotsford, from the Tweed*.[3] At once, this view encapsulates those pictorial qualities that earned Wilson his renown and success: generally shot toward the sun, picturesque in composition, and featuring figures in small boats, reflections in water, and popular architectural landmarks. A reviewer in 1872 wrote: "Mr. Wilson's views, in all respects, prove that he is an artist. In points of selection he is exceedingly careful and particular; he studies the lighting of the landscape he intends to photograph, as a portrait operator studies the lighting of the sitter's face, and if the light does not suit him, he will wait until it is *favorable*. He is not satisfied with a negative unless it is *perfect*."[4]

At first, it would appear that these three stereographs (all bearing the same title and photographer's number), each including what would casually seem to be the same figure and boat, were taken at the same time. Closer examination indicates, however, that they are literally years apart; the figures are dressed differently in each, the boat's anchor post is missing from its bow in one picture, the trees on the opposite bank are in different stages of growth, and the fence has been changed in one view. Whether over a period of time Wilson needed to replace the negative of a rather popular image, or whether, as his technique and processes evolved, he felt he could obtain a better negative is uncertain. Wilson made yet another version of this view in the monocular imperial format, including the same boat without, however, the figure.[5] Since the imperial view, which measured 7 by 10 inches, only appeared in 1875, and since the natural details are again different, it would appear that Wilson made at least four trips to Abbotsford and the Tweed for this image.

160

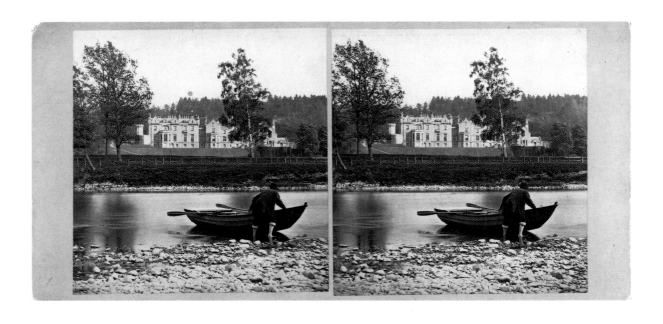

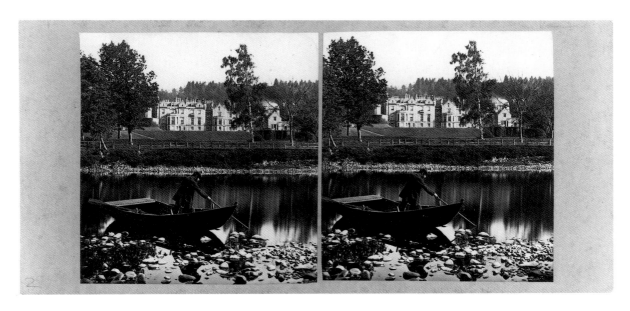

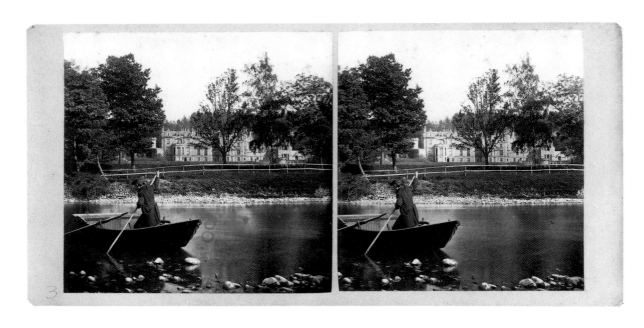

XAVIER MERIEUX

French · active 1860s

Photographic Trade Card

ca. 1865 · Albumen print · 8.8 × 5.7 cm., carte-de-visite

No mention of Xavier Merieux appears readily in the literature of photographic history. Apparently he was a commercial photographer in Paris during the Second Empire, and, from the style of his sole carte-de-visite in the museum's collection, it would seem that he was at least active during the height of the carte-de-visite fashion.

Like many commercial photographers of the period, Merieux advertised his studio wares by issuing photographic caprices designed to capture the viewer's attention as well as attest to the skill of the artist. In Merieux's trade card the artist's studio becomes a veritable cornucopia of prints, symbolizing the riotous proliferation of the photographic image during its first golden period of mass commercialization. The human figure, a young boy, is nearly lost amid the technological equipment and cascade of photographs. The abject sense of *production* that this picture signifies easily calls to mind the painter Paul Klee's comment that "Photography was invented at the right moment as a warning against materialistic vision."[1] Merieux, however, seems to have reveled in photography's inordinate ability to reproduce and produce.

DELMAET and (EDOUARD?) DURANDELLE

French · partnership active 1866–1888

Men on the Roof of the Paris Opera Construction

ca. 1866–70 · Albumen print · 27.0 × 38.3 cm.

Little is known about either of these two photographers, and their association as a team seems to be centered on their documentation of the construction of Charles Garnier's architectural masterpiece, the Paris Opéra—that monument described by the poet Théophile Gautier as the "secular cathedral of civilization."[1] The partnership specialized in documenting construction sites in Paris such as those on the Ile de la Cité, Hôtel de Ville, Hôtel-Dieu, and Sacré Coeur.[2] In 1876, Durandelle published a portfolio of albumen prints entitled *Le Nouvel Opéra de Paris: Sculpture ornementale* that surveyed the sculptural decorations of this Beaux-Arts building. Of the two Paris Opéra projects—the construction and the sculptural decoration—the museum has forty-three prints and another five that appear to be related works.

This rooftop view is not so much about the specifics of building as it is about faith in modernity, progress, and the new. It is an image that would not have been painted by any artist of the period; the closest approximation being Gustave Caillebotte's portrayal of Parisians on *Le Pont de l'Europe*, strolling or watching the trains beneath them, captured within the dynamic geometries and perspectives of modern iron construction [fig. 37]. Yet those perspectives, as complex and disturbing as they may have been, are still rooted in traditional pictorial traditions. Delmaet and Durandelle's photograph, on the other hand, is utterly modern. Here, any stable reference to the earth or landscape is completely dismissed; it is a new landscape with its own system of skewed perspective careening upwards toward a synthetic horizon beyond which lies nothing but a void of blank, albumen sky. The modern laborers balance and teeter precariously atop iron beams; perched like acrobats, nearly all of them stop work and pose for the photographer's camera, while one figure in the foreground, moving during the exposure, evaporates into a ghostly presence. Two figures in the distance hold wooden shafts as if they were positioning a set of uncertain surveying standards for the cameraman to focus on and establish the bearings of this new landscape.

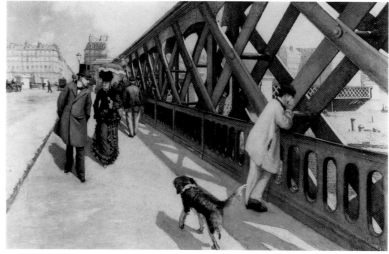

Fig. 37. Gustave Caillebotte, *Le Pont de l'Europe*, oil on canvas, 1876, Musee du Petit Palais, Geneva.

A passage from Marx's *Communist Manifesto* (1848) describes the modern industrial society in a manner that seems strangely pertinent to this image: "Constant revolutionizing of production, uninterrupted disturbance of all social relations, everlasting uncertainty and agitation, distinguish the bourgeois epoch from all earlier times. All fixed, fast-frozen relationships, with their train of venerable ideas and opinions, are swept away, all new-formed ones become obsolete before they can ossify. All that is solid melts into air, all that is holy is profaned, and men at last are forced to face with sober senses the real conditions of their lives and their relations with their fellow men."[3] The normal and expected relationships of man to landscape, ground to horizon, substance to appearance, and worker to task are defied in this photograph—one of the first to provoke an entirely new and modern kind of vision.

PIALLAT

French · active 1860s (?)

Warehouse of Edmond Ganneron, Specialist in Agricultural Equipment

ca. 1865–70 · Photolithographic print, plate by Rodier, printed by Bertauts · 35.4 × 46.2 cm.

Although considerable experimentation with photomechanical processes resulted from the competition established in 1856 by the duke of Luynes to develop the most permanent photographic process, many fundamental forms of transferring the photographic image onto printing plates already had been discovered, including photolithography. As early as 1853, the team of Lemercier, Lerebours, Barreswil, and Davanne had submitted a *cahier* to the Académie des Sciences that was published the following year; in it were directions for photographically sensitizing the lithographic stone and printing impressions from it.[1] No longer were artists required to copy, tediously and painstakingly, the photographic image onto the printing stone as L. Marquier had done from daguerreotypes in 1839. Now, the camera's image could be directly recorded upon the printing surface and multiple impressions printed. Similarly, both photogravure and photoetching also had been developed prior to the mid-fifties.

The printing firm of Bertauts, which actually produced this image, was a fairly well-known establishment in Paris during the 1860s; the names of the photolithographer, Rodier, and that of the original photographer of this image, Piallat, are not readily discoverable in the literature. Piallat may perhaps be the Parisian photographer "Pialat" mentioned in the press of the 1860s in connection with a fifteen-lensed camera for the production of gem-sized photographs, even smaller than those traditionally used on the carte-de-visite.[2]

Industrial subjects, except where some product of industrialization was exhibited at a fair or exposition, were not especially popular themes for artists or photographers during the 1860s. Few painters found anything truly picturesque or ennobling about factories or factory labor—neither could be invested with the kind of romanticism found in rural, peasant labor or the dynamics of urban life found on the boulevards of Paris. The first principal photographic documentation of factory interiors was that of Edouard Durandelle's recording of steel foundries in the Pas-de-Calais region of France toward the end of the 1870s. Piallat's view of the interior of Ganneron's warehouse was thus one

Fig. 38. François Bonhommé, *Workshop with Mechanical Sieves at the Factory of La Vieille Montagne*, watercolor, ca. 1859, Conservatoire National des Arts et Métiers, Musée National des Techniques.

of the earliest monumental depictions of this modern subject. Save that it shows no workers, it is not too dissimilar in effect from the watercolors made by François Bonhommé in 1859 in which there is a complete engagement with the visual recording and celebration of contemporary industrial interiors [fig. 38]. Bonhommé's watercolor of a factory interior with mechanical sieves portrays the same close, rough-wooded space and the same kind of carefully arranged disorder as does Piallat's photolithograph. We know from one of Bonhommé's letters that he felt it was just as important to glorify a foreman or engineer as it was a military leader, that his pictures were inspired by Napoleon III's theory of industrial progress and were meant to recognize the "aspirations of industry for the betterment of mankind."[3] In much the same way, Piallat's photolithograph of a warehouse scene would seem to imply a motivation not unlike Bonhommé's insofar as it seriously treats its progressive subject matter in an exceptionally grand, large-scaled manner.

167

EDOUARD(?) DURANDELLE

French · active 1860s–1880s

School for Infants

ca. 1875–80 · Albumen print · From series, *Eschger Ghesquière & Cie. Fondaries & Laminoirs de Biache St. Vaast (Pas-de-Calais)*. 41.7 × 53.2 cm.

Of the photographic team of Delmaet and Durandelle, Durandelle was the only one who clearly continued working in architectural and industrial photography beyond the reaches of the French capital. He is known to have photographed the Abbey of Mont-Saint-Michel as well as the construction of the Théâtre de Monte Carlo.[1] Only recently have some of his photographs documenting the operations and interiors of a French iron foundry in the north come to light; they are now in the collections of this museum and the Canadian Centre for Architecture, Montreal.

The majority of Durandelle's photographs of the foundry of *Eschger Ghesquière & Cie.* in Biache St. Vaast depict the machinery and interiors of the factory. Many of them appear to have been taken with a wider angled lens than was customary and, thus, portray a space and a perspective that is dynamic and fundamentally photographic, not too unlike certain of the interior photographs taken of the Paris Opera construction [fig. 39]. More than likely, the series of pictures of the *Eschger Ghesquière & Cie.* foundry was taken for publicity as well as strict record-making; therefore, a number of photographs of the factory's exterior, workers' housing, and this print of a children's day school were also included. It can only be suspected that this school was built for the workers' children, which would suggest that the workers' wives were also engaged at the foundry and that this particular industry was somewhat more paternalistic in providing necessary services to its employees than was the norm.[2] Since the area of Pas-de-Calais was industrialized rather late in the century, any industry in that department—especially in the wake of the Commune uprising of 1871 and with major labor unions forming in Belgium—might well have wanted to document their concern for labor.[3] Of course, beyond any possible social meaning behind this picture, there is still the very real

Fig. 39. Edouard(?) Durandelle, *Extrusion Benches*, albumen print, ca. 1875-80.

charm of a schoolyard scene captured in late afternoon, autumnal light during recess. Three groups of students, each with an attendant priest, either join hands in a circle or listen attentively to one of their teachers. An isolated group of six children stands against the schoolhouse wall. Looming in the foreground, however (in perfect anticipation of Lee Friedlander's self-portraits of the 1960s), is the ominous shadow of Durandelle's view camera, the photographer himself, and two other figures. This rather surprising and graphic feature lends an almost snapshot informality to an otherwise monumental architectural photograph.

FELIX BONFILS

French · 1831–1885

Palmyra: A Sculptured Capital, Syria

ca. 1867–1876 · Albumen print · 23.2 × 28.4 cm.

There is ample security in attributing this image to the hand of Félix Bonfils, even though a large number of prints depicting the scenes and costumes of the Near East and bearing the inscription "Bonfils" may have been the creation of Félix's wife Marie Lydie Cabannis, his son Paul-Félix-Adrien, or even his successor Abraham Guiragossian. The title of this print is listed in Bonfils's first catalogue, published in 1876, and is still included in Guiragossian's later edition of the Bonfils catalogue.[1] Secondly, the style of the photograph would strongly suggest the work of Félix, who, it would seem, frequently posed his models (for scale reference) in humorous or pictorially comic positions while at the same time fully documenting the principal subject. Where many photographers would simply have introduced a measured rule or a figure seated or standing beside the subject, Bonfils here has a young Syrian boy feigning a midday nap atop the ancient carved capital. It was most likely an unconscious motivation on the part of the photographer, but the pose of this boy and its suggestion of inactivity accorded well with the 19th-century European view of the Oriental, or Near Easterner, as nonrationalistic, sensual, lazy, and unprogressive, a view which formed the ethical foundations of colonialism or what Anwar Abdel Malek called "the hegemonism of possessing minorities."[2]

Bonfils was certainly not the first photographer to record the Orient; in fact he followed in the footsteps of Du Camp by nearly two decades and Frith by a decade. Yet Bonfils, and his heirs and successors, succeeded most in influencing how the West saw the Orient by the sheer proliferation of photographic images and albums directed to a mass market of tourists and scholars. Bonfils's masterpiece is unquestionably his *Souvenirs d'Orient: Album pittoresque des sites, villes et ruines les plus remarquables de l'Egypte et de la Nubie (de la Palestine, de la Syrie et de la Grèce)*, published in four folio volumes in 1877–78. In the introduction to these albums, G. Charvet wrote of the photographs:

> The Orient whose remains, superior in beauty to all the world's ruins, ceaselessly excite admiration, is revealed with its parade of splendors. Lofty conceptions of the pharaohs, places made famous by the prophets, Christ and his apostles; colossal structures of Baalbek, vast horizons of Palmyra; such is the immense field where the [photographer] of so many marvels takes our vision. The sculptor, painter, sketcher, architect, archaeologist, historian, Christian—all will find here majestic inspirations and incomparable souvenirs.[3]

LALA DEEN DAYAL [RAJA]

Indian · 1844–1910

Gold and Silver Guns—Baroda

ca. 1880s · Albumen print · 19.4 × 26.9 cm.

Court photographer to the sixth nizam of Hyderabad, Raja Lala Deen Dayal was perhaps the preeminent native-born photographer of 19th-century India. Originally trained as an architectural draftsman, he began to photograph the archaeological heritage of India in 1874, and in 1875–76, as he later wrote, "having found that the public greatly appreciated my views and a consequent demand for them having arisen, I took [a] furlough for two years in order to complete my series."[1] In 1884 he was appointed court photographer to the nizam, the then richest prince in India, who characterized Dayal as "Raja Musavir Jung," the approximate meaning of which is "bold photographic warrior."[2] By 1896, he and his sons had opened the largest photographic studio in Bombay and a "zenana studio for female photography" in the nizam's capital, Secunderabad, which was directed by Mrs. Kenny-Levick, the wife of a British journalist. The term "zenana" referred to the apartments in which both Muslim and Hindu women were secluded.

By 1890, Dayal's stock of images included archaeological sites, portraits of British colonials and Indian royalty, scenes from the aftermath of the Indian Mutiny of 1857 (obviously not made by him and possibly copies of photographs by Felice Beato), the growing Indian railway system, industrial scenes, native types, and countless photographs of army maneuvers and camp exercises. Among Dayal's pictures there are numerous documents of the lavish wealth of the Indian maharajas and nobility: elaborate dinner parties, ornate festivities, fleets of European automobiles such as the thirty owned by the nizam, hunting expeditions and their resulting displays of tiger and leopard pelts. While most of Dayal's photographs of Indian nobility were taken around Hyderabad and Secunderabad, a few were taken at Baroda, a city in the state of Gujarat in West Central India, including a portrait of Fateh Singh Rao, the eldest son of the Gaekwar of Baroda, dated 1891,[3] and this image of gold and silver (plated ?) cannon.

CARLETON E. WATKINS

American · 1829–1916

Cape Horn, Columbia River, Oregon

1867 · Albumen print, combination printing · 52.3 × 40.4 cm.

Two years after C. L. Weed took the first photographs of Yosemite, using a stereographic camera, Carleton E. Watkins carried a mammoth-plate camera into the same valley and inaugurated what was to become the premier school, or style, of American landscape photography of the 19th century [fig. 40]. Using collodion on glass plate negatives measuring on average some 18 by 21 inches, and printing their landscape views on albumen printing-out paper, photographers like Watkins, followed later by Weed, Eadweard J. Muybridge, and William Henry Jackson, recorded the essentially unexplored landscapes of the American West on a scale that was impressively monumental. Whereas European photographers such as Francis Frith and Gustave Le Gray had been making large photographs since the middle 1850s, this was a new format in American photography, and one that was as much the result as the cause of a landscape vision of the land's awesome grandeur and sublime power. Views of this wilderness demanded monumental photographs to justly convey its scope and impact; at the same time, mammoth-plate photographs commanded a breadth of pictorial effect that was stunningly operatic and entirely unsuited to picturesque intimacy. Thus, even in smaller full-plate or imperial-plate prints created in the later 1860s and 1870s by A. J. Russell, William Bell, or Timothy O'Sullivan, we see the same monumental vision expressed—a vision that in part shared certain sensibilities with period landscape painting such as that by Frederick Church, Albert Bierstadt, and Thomas Moran.

Reviewing Bierstadt's panoramic painting *Rocky Mountains* in 1867, one critic commented on its subject and style: "Representing the sublime range which guards the remote West, its subject is eminently national, and the spirit in which it is executed is at once patient and comprehensive—patient in the careful reproduction of the tints and traits which make up and identify its local character, and comprehensive in the breadth, elevation, and grandeur of the composition."[1] Nearly the same words could be applied to Watkins's Yosemite photographs or to many of the mammoth-plate views he made on his 1867 trip up the Columbia River in Oregon.

Watkins's vision of Cape Horn on the Columbia River cer-

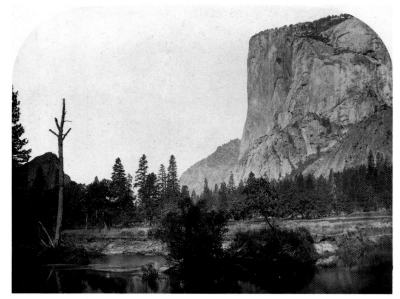

Fig. 40: Carleton E. Watkins, *Tu-Toch-Anula, or El Capitan, 3,600 Ft. High, Yosemite*, albumen print, 1861.

tainly incorporated the exactitude of natural details in the subject required by geologist Josiah Dwight Whitney, a friend and professional client of the photographer[2]—those tones and traits identifying the local characteristics of the land. Watkins was also one of the period's foremost masters of photographic composition, arranging his pictures with an eye toward conveying the scene's breadth, elevation, and grandeur. And where the limits to his chosen medium failed him at capturing the full range of the landscape's expressive impact, he felt no compulsion in manipulating the print to his desired effect. There is another version of this image in which the background sky is customarily blank, a result of the negative's sensitivity to blue and its inability to render both sky and landscape on the same plate.[3] Here, however, Watkins felt it necessary to double print a cloudscape view in order to complete the composition and to add a dramatic resonance to the image, contrasting the swirl of cumulus clouds to the frozen stillness of the Columbia River.

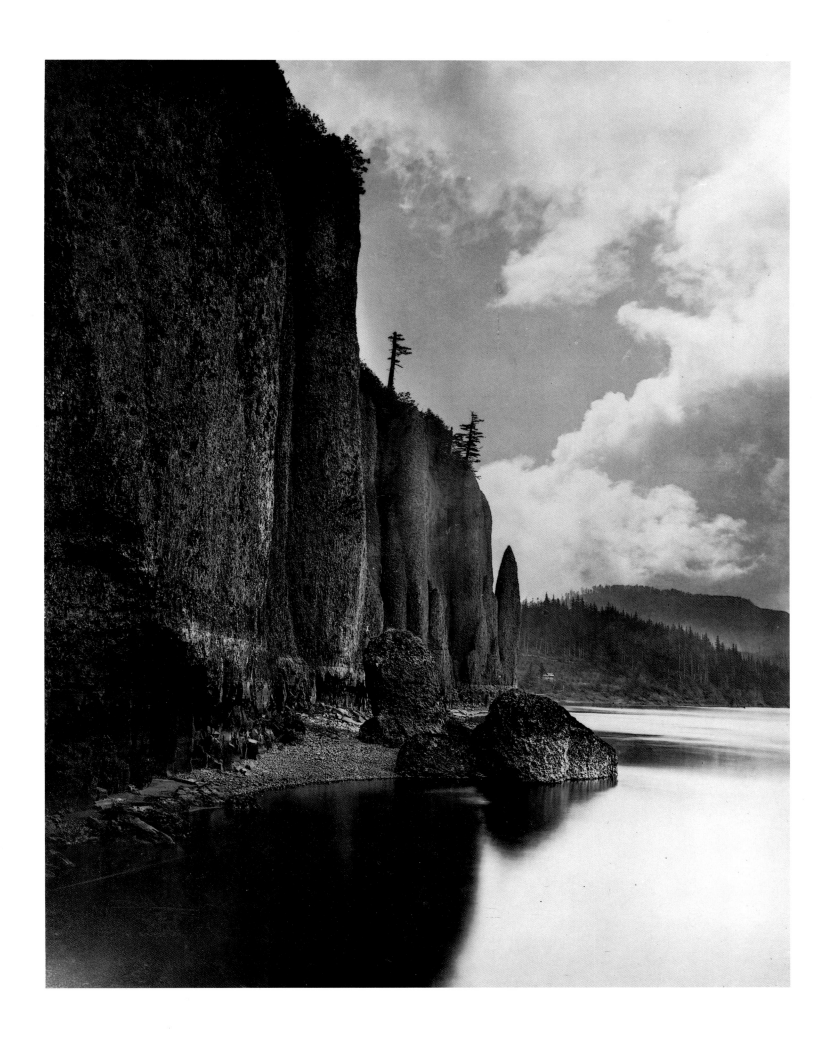

TIMOTHY H. O'SULLIVAN

American · b. Ireland (?) · ca. 1840–1882

Wall in the Grand Cañon, Colorado River

1871 · Albumen print · From: U. S. Army, Corps of Engineers, *Photographs Showing Landscapes, Geological and other Features, of Portions of the Western Territory of the United States, Obtained in Connection with Geographical and Geological Explorations and Surveys West of the 100th Meridian, Seasons of 1871, 1872 and 1873. 1st Lieut. Geo. M. Wheeler, Corps of Engineers, U. S. Army, In Charge*, n.p. [Washington], n.d. [ca. 1875], pl. 11. 27.6 × 20.3 cm.

The photographs O'Sullivan made after the great battle of Gettysburg in 1863 are some of the most gut-wrenching and powerful images captured from that conflict. These were not the first American views of Civil War dead—Alexander Gardner, with whom O'Sullivan worked, had recorded the corpses after the battle of Antietam the previous year—but at least one of O'Sullivan's images captured the expansiveness of death to such a degree that it was given a metaphoric title: *A Harvest of Death* [fig. 41]. Here, the bloated, grotesque human carnage of war extended as far as could be seen or focused, documented by the camera with an unswerving directness and in pictorial terms that are abidingly photographic. [1]

Exactly the same sense of uncompromisingly direct vision was carried over by O'Sullivan to his views of the American West. If Carleton Watkins and William Henry Jackson were committed to the poetics of aggrandizement in their photographs of the West, O'Sullivan maintained an ingenuous rhetoric. Very often his landscape photographs fail to fit with any mode of conventional representation. Engineered for the sake of the record, O'Sullivan's pictures often ignore or even spurn the picturesque; yet there is a sophistication to their organization and a nearly abstract quality that runs counter to their historical context. Most of O'Sullivan's work in the West was done in conjunction with government-sponsored geological surveys; thus, most of what he pictured was not intended to be pictorially beautiful, only clear and informative. While working with Clarence King's Geological Explorations of the Fortieth Parallel between 1867 and 1869, O'Sullivan did produce some images that seem picturesque; but for every spectacular view of the Shoshone Falls in Idaho, there were many more that recorded bizarre tufa rocks, odd volcanic ridges, eccentrically shaped stone formations, and unearthly fissure vents. Later, with the Wheeler surveys, O'Sullivan trained his camera on canyon walls, waterfalls, and river valleys with the same persistent motivation.

About mountains and cliffs, John Ruskin had written:

It can hardly be necessary to point out how these natural ordinances seem intended to teach us the great truths which are the basis of all political science; how the polishing friction which separates, the affection that binds, and the affliction that fuses and confirms, are accurately symbolized

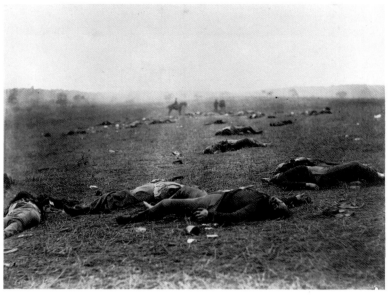

Fig. 41. Timothy H. O'Sullivan, *A Harvest of Death, Gettysburg, July, 1863*, albumen print, 1863, from Alexander Gardner, *Gardner's Photographic Sketch Book of the War*, Washington, 1866, 1, pl. 36.

by the processes to which the several ranks of hills appear to owe their present aspect. . . . the problem to be solved in every mountain range appears to be, that . . . the cliffs and peaks may be raised as high, and thrown into as noble forms, as is possible, consistently with an effective, though not perfect permanence, and a general, though not absolute security. . . . mountains were to be destructible and frail; to melt under the soft lambency of the streamlet; to shiver before the subtle wedge of the frost; to wither with untraceable decay in their own substance; and yet, under all these conditions of destruction, to be maintained in magnificent eminence before the eyes of men. [2]

For the 19th century, nearly all essential truths accessible to man were to be discovered in the natural landscape either physically, symbolically, or metaphorically. The science of geology and, indirectly, geological photographs were important tools for these discoveries. That O'Sullivan's landscape images are some of the finest of the 19th century was incidental at the time.

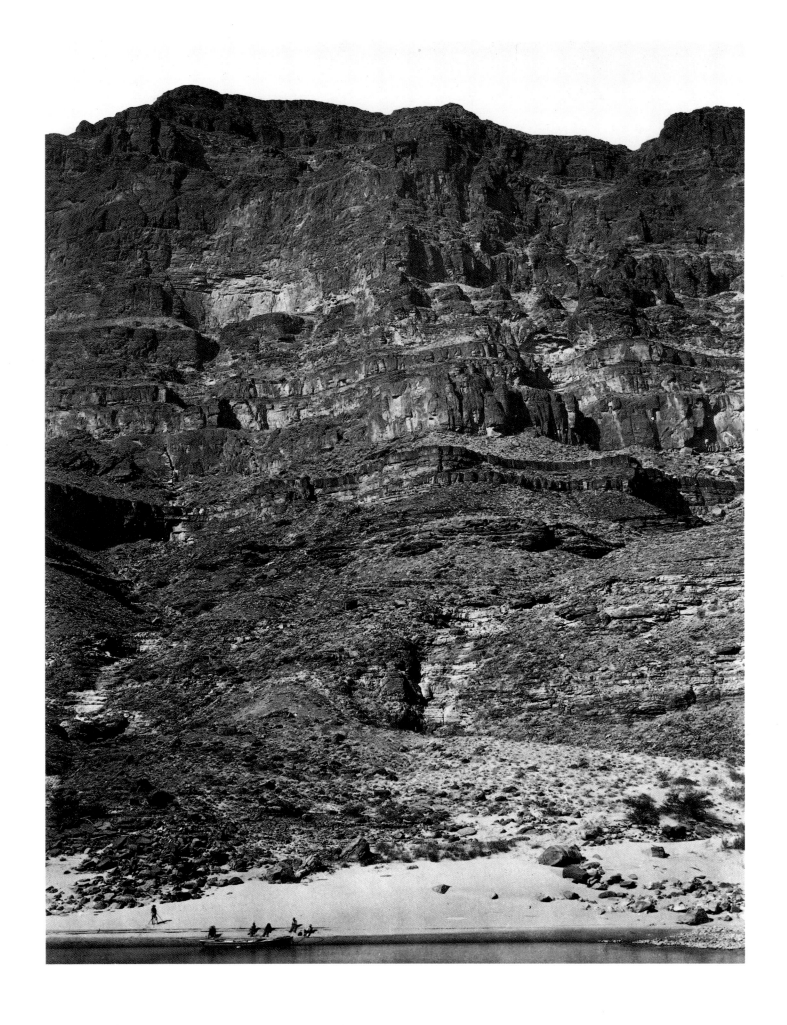

EADWEARD J. MUYBRIDGE

American · b. England · 1830–1904

Mount Hoffmann, Sierra Nevada Mountain, from Lake Tenaya

1872 · Albumen print, combination printing · 43.2 × 55.1 cm.

Muybridge, who was to become internationally famous for his chronophotographic studies of *Animal Locomotion* and who became infamous for murdering his wife's lover, was not the first photographer of the 19th century to document Yosemite Valley; Charles L. Weed, Carleton E. Watkins, and W. Harris preceded his first trip there in 1867. Of them all, however, Muybridge's photographs were the most consciously artistic and resolutely sublime. In a brochure he published in 1868, we read: "I am now preparing for publication twenty views of our world-renowned Yo-Semite Valley, photographed last year by 'Helios.' For artistic effect, and careful manipulation, they are pronounced by all the best landscape painters and photographers in the city to be the most exquisite photographic views ever produced on this coast, and are marvelous examples of the perfection to which photography can attain in the delineation of sublime and beautiful scenery, as exemplified in our wonderful valley."[1] Not only did Muybridge select the key words necessary to place his work within the grand landscape tradition in painting—words such as "sublime" and "beautiful"—but he consciously chose the classicism "Helios" as a pseudonym. Dissatisfied with the artless, empty sky left by the collodion negative, he fabricated a "Sky Shade" with which he could block out the upper part of his negative and thus later print in a more aesthetically complete backdrop of appropriate clouds. As early as 1868, a San Francisco critic commented that "in some of the series we have just such cloud effects as we see in nature or oil painting."[2]

For the series of views he took in 1867, Muybridge used a full-plate negative that yielded 6 × 8 inch prints when trimmed. In 1872, he returned to the Yosemite, but this time his camera took mammoth-plate negatives, measuring 20 × 24 inches, for prints about 18 × 22 inches. According to the *Alta California* of April 7, 1872:

> [Muybridge] waited several days in a neighborhood to get the proper conditions of atmosphere for some of his views; he has cut down trees by the score that interfered with the cameras from the best point of sight; he had himself lowered by ropes down precipices to establish his instruments in places where the full beauty of the object to be photographed could be transferred to the negative; he has gone to points where his packers refused to follow him, and he has carried the

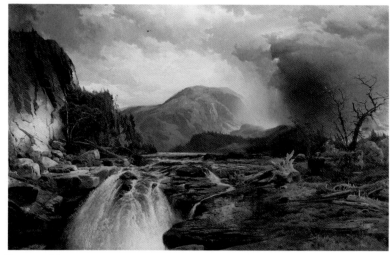

Fig. 42. Thomas Moran, *Western Landscape*, oil on canvas, 1864, The New Britain Museum of American Art, Charles F. Smith Fund.

apparatus himself rather than to forego the picture on which he has set his mind.[3]

The same article suggested that these photographs probably would be used as subjects for paintings by Albert Bierstadt who "made several suggestions to Mr. Muybridge, while in the Valley, and . . . is, in fact, a patron and adviser."

Muybridge pursued the notion of artful sublimity in his views of Yosemite to such an extent that, but for their lack of color, they may well have been medium-sized paintings in the operatic tradition of, say, Bierstadt or Thomas Moran [fig. 42]. Like many Western American landscape painters, Muybridge periodically balanced the scene's sublime grandeur by inserting more romantic details such as storm-tossed broken limbs and roots, a visual excursis of sorts on nature's careless strength. The final aim, however, was to achieve the controlled recording of absolute natural beauty. To the extent that he was able, Muybridge manipulated whatever he could to facilitate this expression, even going so far, as in this print, to adroitly insert a large boulder at the right edge of the water for compositional harmony. Only upon close examination of the lighting on the rocks and of its "reflection" is Muybridge's artifice revealed.

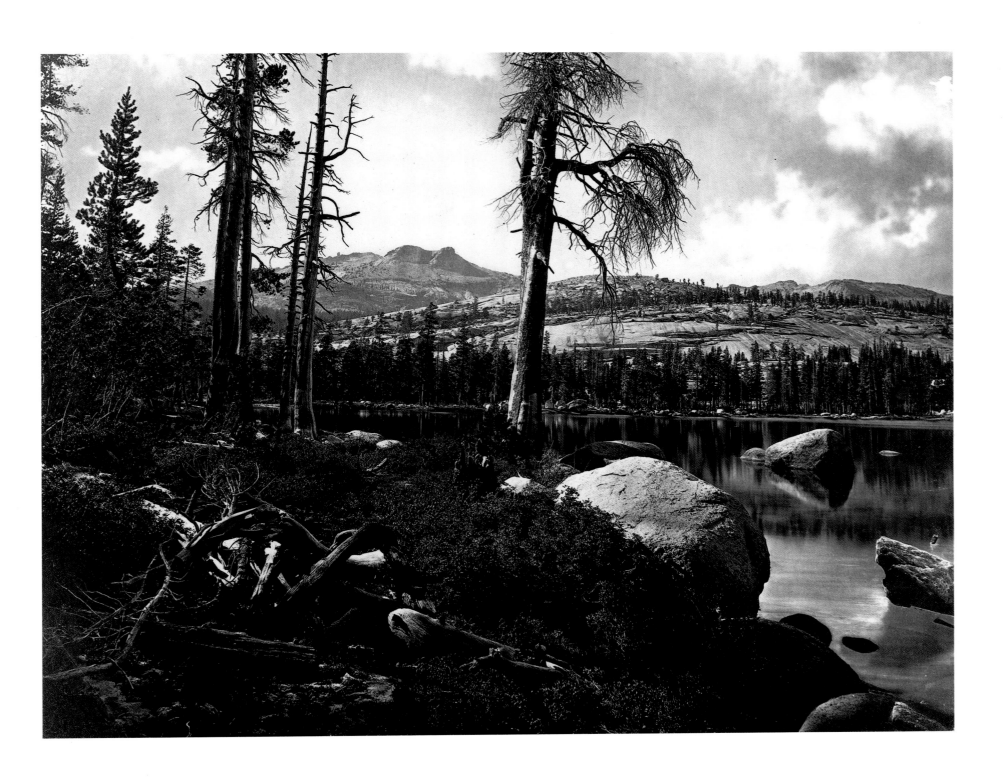

WILLIAM HENRY JACKSON

American · 1843–1942

Mt. Sopris, From Junction of Rock Creek and Roaring Fork

After 1880 · Albumen print, combination printing · From: series "Colorado Midland Ry./Pike's Peak Route." 54.3 × 44.3 cm.

Writing his life's story some four decades into the 20th century, Jackson recalled his earlier days as a pioneering photographer of the American West.

> But this hurly-burly era of thievery and abuse was for me the most rewarding time of my whole life. While everybody else stewed and sweated I lived mostly in the open country, weeks removed from any news, good or bad. I was exploring the Yellowstone (whose very existence was still doubted in some quarters); or wandering over the unmapped Rockies of Colorado; or helping to uncover the cliff dwellings of Mesa Verde. And if any work that I have done should have value beyond my own lifetime, I believe it will be the happy labors of the decade 1869–1878.[1]

Jackson had spent the majority of that decade photographing for F. V. Hayden's U. S. Geological and Geographical Survey of the Territories, which, in 1879, developed into the United States Geological Survey. In 1872, Jackson documented the principal features of the Yellowstone, and purportedly these images were so instrumental in depicting the area's grandeurs to the U. S. Congress that it was declared a national park in that year.

In 1879, Jackson established the Jackson Photographic Company in Denver, and during the early 1880s was frequently commissioned by Western railroad companies to record the scenic wonders along various routes through the Rocky Mountains. A notable feature of this later work is the supreme artfulness of the images. Where his work for the surveys was topographically direct and literal, the photographs he made for the railroads—including those he made for Eastern companies such as the Baltimore and Ohio Railway—were increasingly organized along the lines of traditional landscape paintings and the rules established for delineating vast spaces ever since the Renaissance.[2] Jackson's pictures are far less the mechanical vision of the land portrayed without human reference or purchase; they purposely frame an immediate and understandable foreground, showing clearly where the photographer placed the tripod and from where the spectator perceives the grandeur of nature. Perhaps simply a tuft of land, or a rock ledge shows just slightly at the bottom, often a stretch of rail sufficed, as here, and sometimes a figure depicted from the back shares in the pictorial experience. Jackson's railroad photographs are more than statements of fact, they are attempts to express something about the landscape and man's place in it. They are heroic visions, solemn and operatic, emotional and humanized.

There is something of the "technological sublime" in this picture, in which traces of man's intrusion into the landscape are merged with nature, recalling the stern determinism of Melville's Captain Ahab: "Swerve me? ye cannot swerve me, else ye swerve yourselves! Man has ye there. Swerve me? The path to my fixed purpose is laid with iron rails, whereon my soul is grooved to run. Over unsounded gorges, through the rifled hearts of mountains, under torrents' beds, unerringly I rush! Naught's an obstacle, naught's an angle to the iron way!"[3] Jackson's was a landscape view that accommodated the determinism of modern progress far more readily than would later 20th-century romantic landscape photographers such as Ansel Adams.

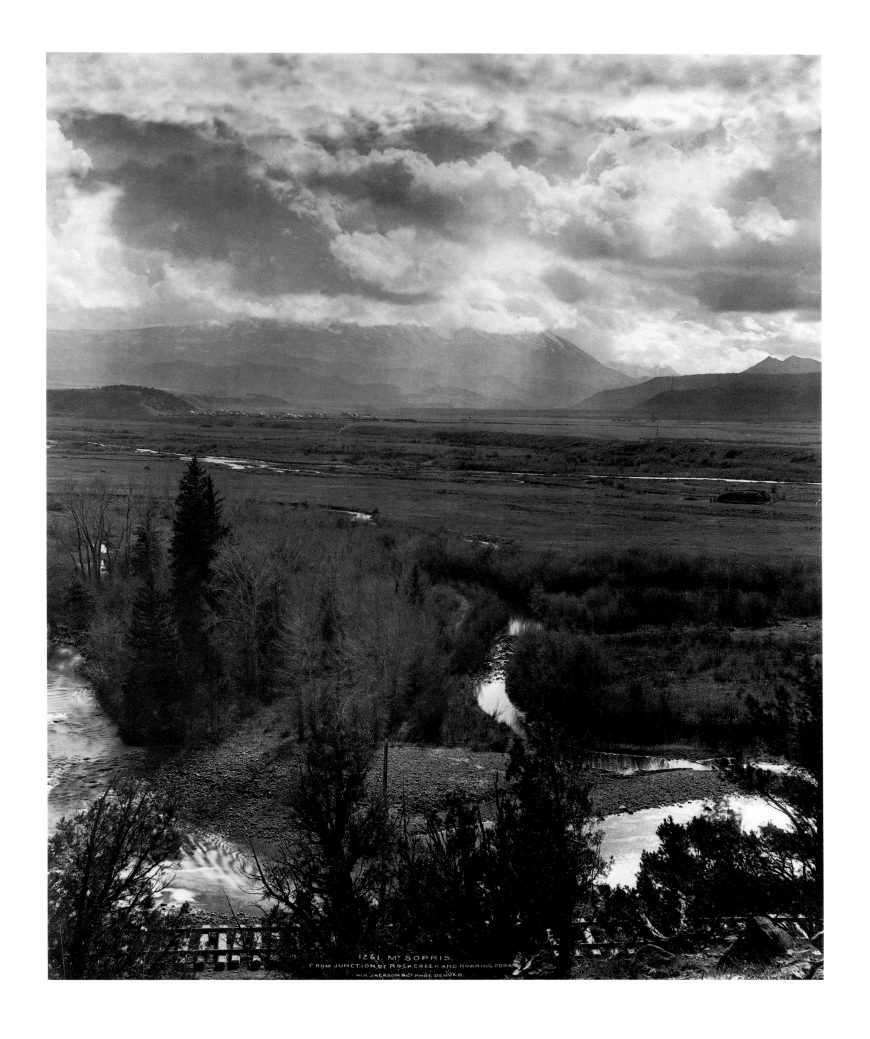

1261. MT. SOPRIS.
FROM JUNCTION OF ROCK CREEK AND ROARING FORK.
W.H. JACKSON & CO. PHOT. DENVER.

OSCAR GUSTAVE REJLANDER

British · b. Sweden · 1813–1875

Poor Jo

ca. 1860 · Albumen print · 20.2 × 14.9 cm.

If Oscar Gustave Rejlander is known today, it is undoubtedly due to his largest and most infamous photograph, *The Two Paths of Life* of 1857. With its extreme theatricality, its attempt to fabricate allegory with photography, and its early use of combination printing or photomontage, *The Two Paths of Life* was Rejlander's masterpiece, but not by any means his only one. During a prolific career lasting more than two decades, Rejlander created numerous photographic tableaus and narrative subjects: domestic scenes, character studies, examinations of facial expression, and themes from popular fiction. He depicted the decapitated head of St. John the Baptist, the goddess Nicotina, "Ginx's Baby," and St. Sebastian, as well as family dramas reminiscent of the paintings of David Wilkie and William Mulready, and certain enigmatic personal dramas bordering on the pathological or the surreal [fig. 43]. But by far his favorite themes were those that illustrated poverty, its types and its customs.

Ragged schoolboys, chimney sweeps, jobless carpenters, blind street violinists, Italian organ-grinders, destitute beggars—in short the nearly hopeless and helpless of Victorian England fascinated Rejlander and, apparently, his audience, already prepared for such subjects by Dickens and social reformers. The poor of Great Britain, particularly those in London and especially children, were the focus of ever-increasing social analysis throughout the Victorian era. Henry Mayhew's *London Labour and the London Poor* appeared in 1851; Charles Dickens's socially realistic *Bleak House* appeared between 1851 and 1853 and was followed by *Hard Times* in 1854; Charles Kingsley published *The Water Babies* in 1863; and, in 1864, Lord Shaftesbury's Chimney Sweepers Regulation Act legislated against the employ of children under sixteen in that occupation.[1] Bowman Stephenson began The Children's Home in 1869, and Dr. Thomas John Barnardo established his first Boys' Home in 1874. It is little wonder that a photographer in such a climate would find obvious pictorial value and apparent commercial interest in subjects of poverty and street urchins, especially a photographer like Rejlander who took "undoubted precedence in the higher regions of the picturesque, such as are due to thought and conception, or to the expression of varying and even complicated feelings and sentiments.[2]

Poor Jo, Rejlander's most famous picture after *The Two Paths of Life*, was probably made in 1860 and was first exhibited in 1861.[3] This particular picture has been variously entitled by separate sources as *Homeless* or *A Night in Town*. In an article by a friend of Rejlander's, A. H. Wall, the critic claimed that his illustration, entitled *Homeless*, was "another photograph of

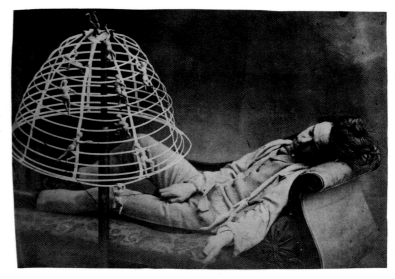

Fig. 43. Oscar Gustave Rejlander, *The Dream*, albumen print, ca. 1860.

Rejlander's, which was widely popular . . . of a little outcast of the street, another 'Poor Joe' asleep in a doorway. . . . In this specimen the weary and ragged 'Homeless' boy is partially lighted by a disc of light from the lantern of some stern mover-on, and all the rest of the picture is dimly obscure."[4] Whatever Rejlander's original title was for this picture, its subject was associated with the character of the crossing sweep, Poor Jo, in Dickens's *Bleak House* nearly from the start.

> Name, Jo. Nothing else that he knows on. Don't know that everybody has two names. Never heerd of sich a think. Don't know that Jo is short for a longer name. Thinks it long enough for *him*. *He* don't find no fault with it. Spell it? No. *He* can't spell it. No father, no mother, no friends. Never been to school. What's home? Knows a broom's a broom, and knows it's wicked to tell a lie. Don't recollect who told him about the broom, or about the lie, but knows both. . . . That one cold winter night, when he, the boy, was shivering in a doorway near his crossing, the man turned to look at him, and came back, and, having questioned him and found that he had not a friend in the world, said, "Neither have I. Not one!"[5]

Engravings and photographic copies from this photograph continue to be used by the Shaftesbury Society and other homes for neglected children in England.

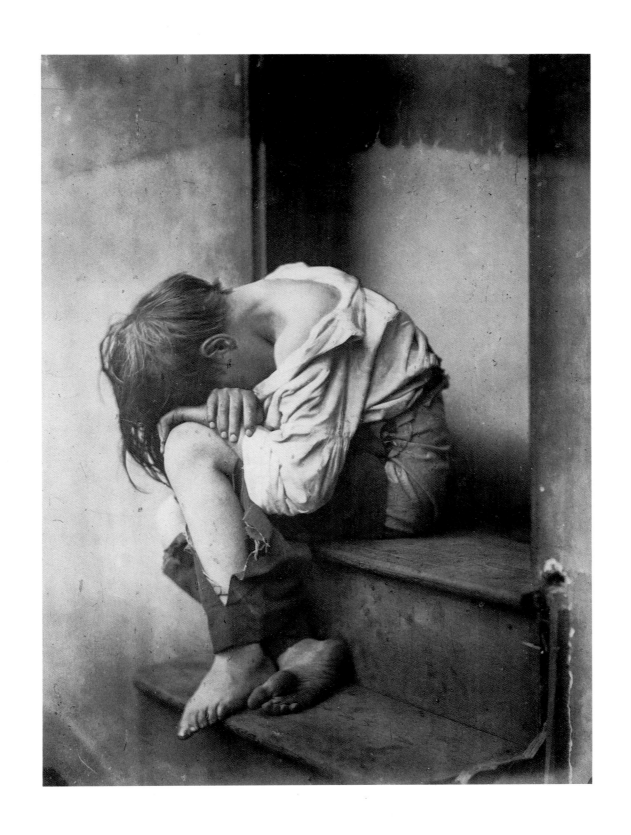

JOHN THOMSON

British · 1837–1921

London Nomades

ca. 1876 · Woodburytype print · From: John Thomson and Adolphe Smith, *Street Life in London*, London, 1877–78, pl. 1. 11.0 × 8.6 cm.

"The camera should be a power in this age of instruction for the instruction of age," wrote John Thomson in 1875.[1] Two years later he and Adolphe Smith (a pseudonym for Adolphe Smith Headingly) a journalist and union activist, began issuing the first sociological text whose "case histories" were acccompanied by photographic illustrations. *Street Life in London* lies precisely between the pioneering "human science" work of Henry Mayhew, whose large-scaled *London Labour and London Poor* appeared between 1851 and 1862, and the monumental seventeen-volume *Life and Labours of the People in London* by Charles Booth, which was published between 1889 and 1903. Thomson's and Smith's book was more modest than either of these others. A single volume of thirty-six brief, descriptive texts each illustrated by a single woodburytype print (one plate being two images), it nevertheless sought to depict a broad survey of social street types and to validate Smith's written descriptions by Thomson's photography. In their preface to *Street Life in London*, the authors fully credited Mayhew's earlier efforts as well as other published "sketches of low life"; but they firmly believed that one could not be "too frequently reminded of the poverty that nevertheless still exists in our midst. . . . And now we also have sought to portray these harder phases of life, bringing to bear the precision of photography in illustration of our subject. The unquestionable accuracy of this testimony will enable us to present true types of the London Poor and shield us from the accusation of either underrating or exaggerating individual peculiarities of appearance."[2]

While most of the types in *Street Life in London* are lower-class tradespeople—chimney sweeps, fish merchants, boot-blacks, locksmiths, disinfectors, and street doctors—the authors began their survey with one of the most abjectly romantic of 19th-century social types, a type that was essentially asocial and "who would rather not be trammelled by the usages that regulate settled labour, or by the laws that bind together communities."[3]

The class of Nomades with which I propose to deal makes some show of industry. These people attend fairs, markets, and hawk cheap ornaments or useful wares from door to door. At other seasons its members migrate to the provinces, to engage in harvesting, hop-picking, or to attend fairs. . . . Their movements, however, are so uncertain and erratic, as to render them generally unable to name a day when they will shift their camp to a new neighbourhood. Changes of locality with them, are partly caused by caprice, partly by necessity. . . . As a rule, they are improvident, and, like most Nomades, unable to follow any intelligent plan of life. To

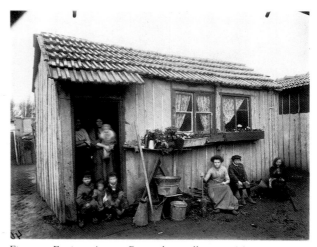

Fig. 44. Eugène Atget, *Rag-pickers*, albumen (?) print, 1910.

them the future is almost as uncertain, and as far beyond their control, as the changes of wind and weather.[4]

There were a wide variety of these nomadic tribes at the time: Romany gypsies or gleaners in the country, *chiffonniers* or rag-pickers in the city. In London, these were the ultimate street people, addressless and migratory, in part the antecedents of the "hobo" of the 1930s or the modern urban "box man" of Tokyo and bag-lady of New York.

Honoré Daumier and Gustave Doré had both drawn and printed these types frequently before 1876, as had many other artists. Nor was this an especially new theme for photographers. As early as 1851, Charles Nègre had photographed a number of young rag-pickers, and by 1854 had also depicted street organists, *pifferari*, chimney sweeps, and ambulatory merchants found on the streets of Paris. In England, Oscar Gustave Rejlander photographed his famous *Poor Jo* around 1860, as well as numerous other literary scenerios about impoverished urban children and destitute adults. Later, in the following century, Eugène Atget took at least fifty-nine photographs of rag-pickers, gypsies, their hovels and wagons [fig. 44]. With the accompaniment of Smith's text, however, Thomson's photograph presented a far more humanized depiction of these nomads, one that not only showed them picturesquely posed on some vacant land at Battersea, but with their particular individuality preserved. The man in the center, Smith wrote, was a certain William Hampton, "fair-spoken, honest gentleman," and the woman on the steps was Mary Pradd, who was murdered some weeks after this photograph was taken; and while there were suspects, the jury lacked sufficient evidence to indict anyone.

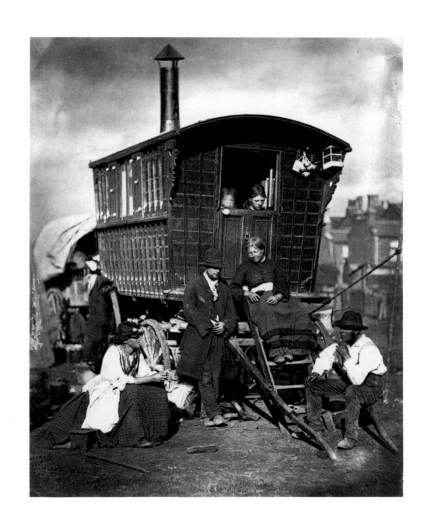

THOMAS ANNAN

Scottish · 1829–1887

Close No. 118, High Street

ca. 1868–77 · Carbon print, combination printing or retouched negative · From Thomas Annan, *Photographs of the Old Closes, Streets, Etc., Taken 1868-1877*, Glasgow, 1878, pl. 6. 27.3 × 21.9 cm.

Were it not for the Alinari Brothers in Florence, the firm begun by Thomas Annan in Glasgow in 1855, and presently under the fifth generation of direct family proprietorship, would be the longest-lived photographic establishment in the world. Primarily concerned with the reproduction of art works in Scottish museums and with the sale of paintings and prints, Annan began photographing the landscape and people around Glasgow during the 1860s. His portraits—while to some degree comparable to those of his contemporaries Camille Silvy and Southwell—never arrived at that synthesis of form and expression that infused the portraits created by Annan's friend David Octavius Hill some two decades earlier.

Annan's architectural photography, however, and his topographic rendering of Glasgow and its neighborhoods, are unquestionably this Scottish cameraman's major contribution to photographic history, and clearly the subject with which he was most comfortable and adept. His principal work began in 1868, when the City of Glasgow Improvement Trust commissioned him to document the slums and older sections of the city immediately surrounding the "Cross" that were slated to be demolished. Much like Charles Marville's photographs of old Paris prior to Baron Haussmann's massive urban renewal project of the 1850s, Annan's photographic survey, issued in 1878 as a portfolio of carbon prints made by the Swann Process, is not only a record of official urban blight and decay but a romantic paean to a vision of a metropolis's past. According to William Young's introductory text to the photogravure version of *The Old Closes and Streets of Glasgow*, published in 1900:

> The value of the plates . . . consist[s] in their true
> presentation of the seamy side of the City's life; in their
> depicting, with absolute faithfulness, the gloom and squalor
> of the slums. The City Improvement Trust acquired . . . in
> 1866 the right to alter and reconstruct several of the more
> densely built areas of the City, and these operations, it was
> foreseen, would remove many old and interesting
> landmarks. . . . These pictures should prove of exceptional
> interest. Little now remains of what may strictly be regarded
> as old Glasgow. [1]

The sociological impact of pictures such as these on more economically advantaged viewers can only be surmised. While the existence of the underprivileged within society was hardly denied by Victorian humanitarians—the lower classes were cer-

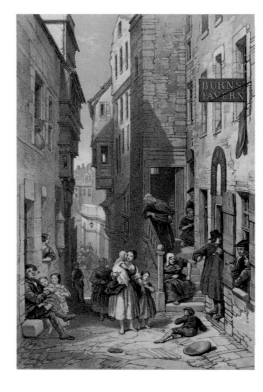

Fig. 45. G. Cattermole, *Libberton's Wynd, Edinburgh*, lithograph by T. Picken, printed by Day & Son, London and R. Griffin & Co., Glasgow, ca. 1830s, the author's collection.

tainly a consistent staple of British literature and art during the early 19th century and the Victorian era—the actual look and sense of the living conditions were seldom, if ever, encountered in such a factual and clinically detached fashion. Even in the most sentimentally distressful subjects painted by William Mulready or David Wilkie, or in the journalistic narrative descriptions of Dickens's *Bleak House*, there is a sense of the picturesque, one in which the human spirit rises above life's station, or at least inhabits the environment with individual life. The utter vacuity of the scenes Annan photographed, an emptiness made even more potent by the periodic inclusion of a human being's blurred trace or an untailored wash hung out to dry in damp alleys, reveals its realistic charge fully when compared to an earlier lithograph of a similar scene of an Edinburgh street, published in the 1830s [fig. 45]. Where the earlier print is filled with people gossiping, strolling, and playing with children, Annan's print posits a lone child barely discernible in its fugitive isolation atop a flight of stairs. Here we have the real beginnings of a documentary tradition that culminated with the photographs of Jacob Riis and Lewis Hine in this century.

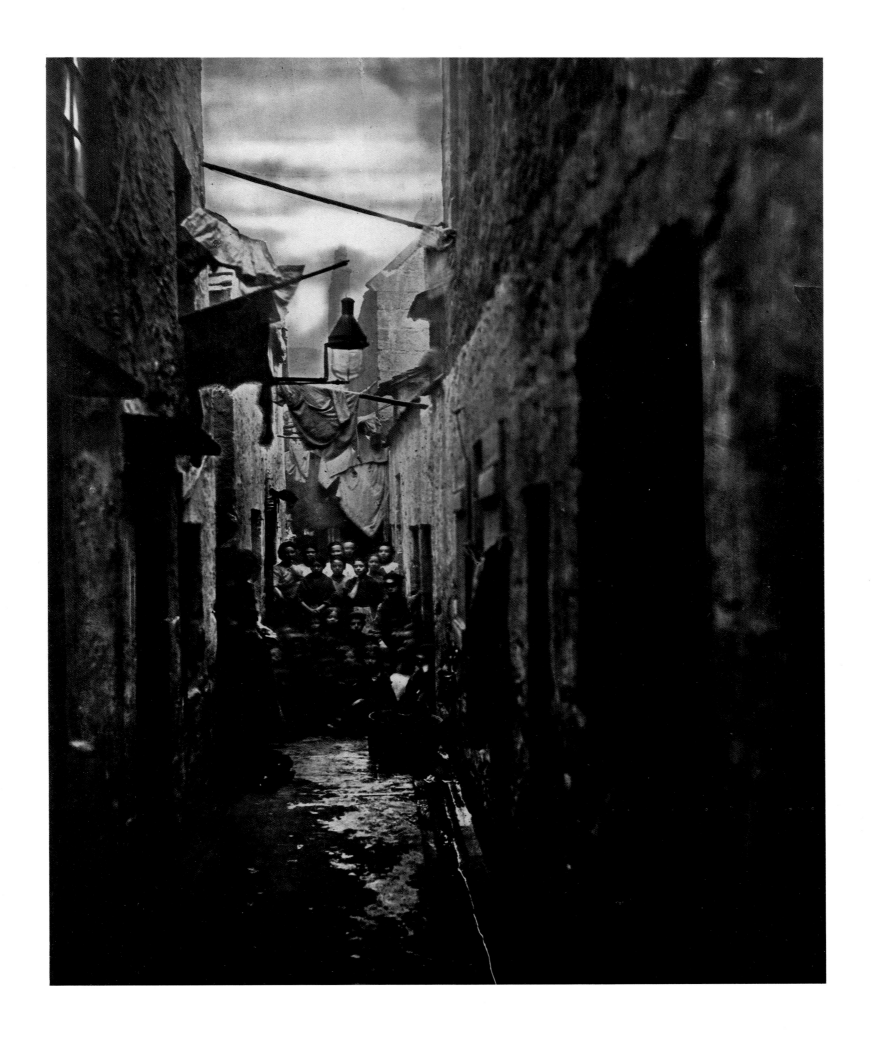

HENRY DIXON

British · 1820–1893 ·

Little Dean's Yard, Westminster

1882 · Carbon print · From: Society for Photographing Relics of Old London, · *Photographic Relics of Old London*, London, 1886, pl. 61.
18.0 × 22.5 cm

In 1855, Reverend F. A. S. Marshall observed the moral and educational value of photographing significant artifacts of the past: "Let this age of Science then, preserve for Posterity, records, truthful as Photography portrays them, of all those precious Relics which yet remain to us, precious alike for their Historical and Artistic interest, but which must succumb beneath the wave of Time."[1] Twenty years later, in 1875, the Society for Photographing Relics of Old London was specifically established for documenting historic architecture in London threatened by urban development and renewal. Similar motivations lay behind the decision in 1868 by the Glasgow City Improvement Trust to commission Thomas Annan for a photographic record of that city's slums. But where Annan was attempting to depict a portion of the city that was slated for demolition, the photographers who worked for the Society for Photographing Relics of Old London were invested with the responsibility of picturing buildings and sites worthy to be preserved as well as those in danger of being destroyed. Thus, rather than documenting a single urban area or district, the photographs made for the Society record individual houses, inns, and streets located throughout London. Between 1881 and 1886, the Society published a total of 120 consecutively numbered carbon print photographs, forming a pictorial index to the nonmonumental architecture of London.

Four photographers worked on the project in various capacities. The team of Alfred and John Bool photographed and printed the first eighteen plates of the numbered series of prints. Numbers 19 through 24 were photographed by the Bools but printed by Henry Dixon and his son, T. J. Dixon. The Dixons both photographed and printed the remainder of the set, except for number 69, which was photographed by William Strudwick and printed by the Dixons. In this print, number 61, the Dixons positioned their camera in the middle of Little Dean's Yard, an interior court immediately to the south of Westminster Abbey's Cloisters, in such a way as to locate pictorially the mélange of various buildings in the shadow, as it were, of the Abbey. The

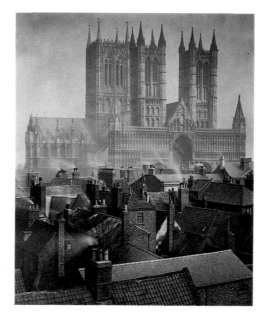

Fig. 46.
Frederick H. Evans,
*Lincoln Cathedral:
From the Castle,*
platinum print, ca. 1898.

top of the Abbey's south transept and its spires, and the cross atop the Chapter House rise in atmospheric haze above the roofs of the more secular architecture in the foreground. By this viewpoint, the photographers brought a visual cacophony of pinnacles, spires, tiled chimneys, and dormers, and a rich play of volumes, planes, textures, and shadows into a structured composition that graphically reveals the dense heterogeneity of central London building left to its own momentum over the years.

Dixon's *Little Dean's Yard* anticipates, in a fashion, the much more heroically scaled and poetic *Lincoln Cathedral: From the Castle* by Frederick H. Evans made later in the century [fig. 46]. Yet for all of its earnest simplicity of approach and means, this earlier photograph suggests an essential poetics of camera vision based not on the stylistic imperatives of its age but on discovery, encounter, and selection, and a poetics of the yard instead of the castle.

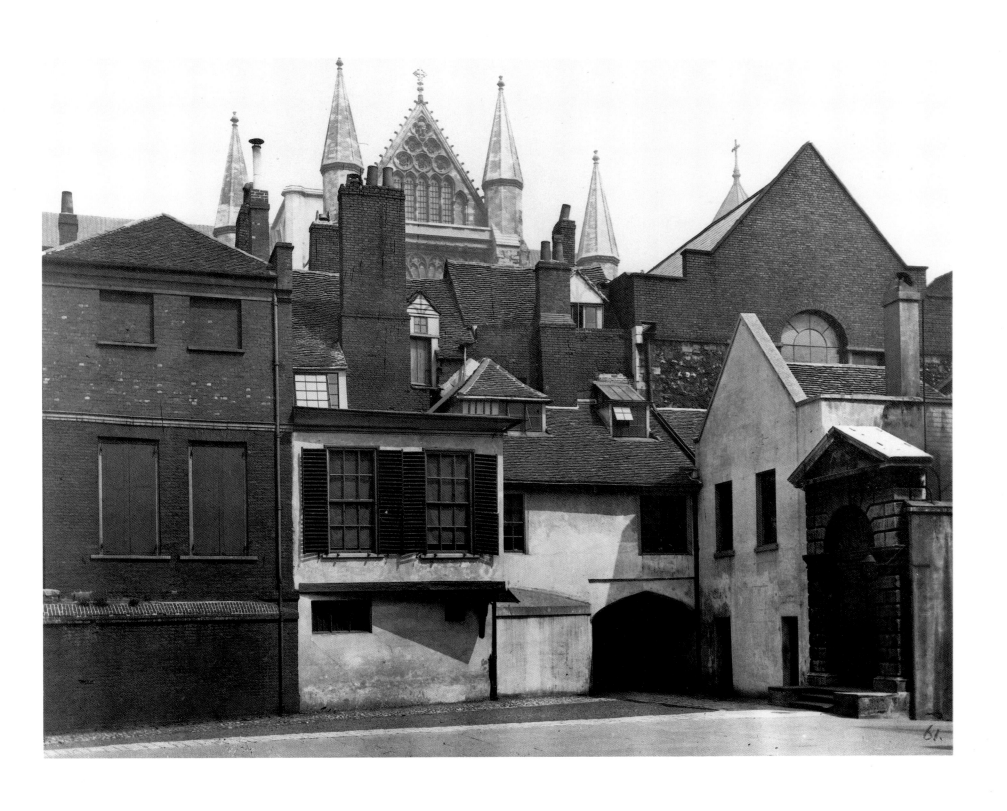

189

SYMBOLISM, FORMALISM, AND THE PROBLEMS OF STYLE 1880-1940

To you, then, who seek an explanation for my conduct, Art . . . *is not* nature—is not necessarily the reproduction or translation of it—much, so very much, that is good art, some of the very best—is not nature at all, nor even based upon it. . . .

— P. H. Emerson, *The Death of Naturalistic Photography*, 1890

. . . right photographing is a difficult thing to accomplish. That is if an emotion—a feeling generated by, born of, intense experience—is to be put into form by photographic means—that is in photography. In short, to make the medium do what one feels, to be able to do that, one must actually *feel* something *intellectually*, in part at least,—and the metier, photography in this case, must become an inherent part of oneself.

— Alfred Stieglitz, Letter to R. Child Bayley, 1919

Very soon, it was discovered that the dreams invented by writers stand in the same relation to analysis as do genuine dreams. The conception of the unconscious psychic activity enabled us to get the first glimpse into the nature of the poetic creativeness. The valuation of the emotional feelings, which we were forced to recognize while studying the neuroses, enabled us to recognize the sources of artistic productions and brought up the problem as to how the artist reacts to those stimuli and with what means he disguises his reactions.

— Sigmund Freud, *The History of the Psychoanalytic Movement*, 1938

. . . that which withers in the age of mechanical reproduction is the aura of the work of art . . . the technique of reproduction detaches the reproduced object from the domain of tradition. By making many reproductions it substitutes a plurality of copies for a unique existence. And in permitting the reproduction to meet the beholder or listener in his own particular situation, it reactivates the object reproduced.

— Walter Benjamin, "The Work of Art in the Age of Mechanical Reproduction," 1936

UNLIKE PHOTOGRAPHY'S FIRST HALF-CENTURY, when only a handful of major technical processes were available, the medium's second fifty or more years was a period of intense experimentation and redefinition. Faster and more efficient negatives became available along with smaller, hand-held cameras. Amateurism became a real force in photography, and the medium industrialized on an unprecedented, global scale. Color found its place within the list of photographic options, from the first demonstrably successful attempts by Louis Ducos du Hauron at the end of the 1860s to color carbro prints and Kodachromes in the mid-1930s. Through advances in photomechanical printing, images produced by the camera reached a larger public than ever before. Photographs in newspapers during the 1890s and those in picture magazines of the 1920s and 1930s, gave rise to a new kind of photographer: the photojournalist. The same factors also produced a greatly expanded vehicle for the most traditional form of camera art, the documentary, and for a newer form of pictorial discourse, the photo-essay. By the end of the period, photography was decidedly the language of the modern era.

Printing processes and darkroom techniques were adapted during the last decade of the 19th century to emphasize the photograph's nature as a printed surface on which an artist's expression, a pure design, or an emotional experience could be revealed. Gum-bichromate printing, oil transfer processes, glycerine prints, and various combinations of techniques were drafted into the service of photographic art. In this century, abstraction and its rigors entered the vocabulary of photography: from kaleidoscopic "vortographs" to cameraless photograms, solarizations, and photomontage. Even the pure, unadulterated photograph could transcend mere fact and excel at a modern sense of form and meaning when fashioned by the hand of a creative vision. Like other art forms, photography easily engaged with contemporary symbolism, poetic metaphors, avant-garde formalism, and the narration of dreams and fantasies.

LOUIS DUCOS DU HAURON

French · 1837–1920

Still Life with Rooster

ca. 1869–79 · Tricolor carbro print · 20.8 × 21.7 cm. (irregular)

Early in 1869, Charles Cros, the French poet and inventor of the phonograph, published an article in *Les Mondes* that began with a sentence that responded to a dream as old as the invention of photography itself: "I have found a general method for registering, fixing and reproducing all the visible phenomena integrally; that is, in the two orders of their primordial characteristics: figure and color."[1] Cros's theories were presented to the *Société français de photographie* on May 7, 1869, the very same day that Louis Ducos du Hauron presented his report on tricolor photography. Like the simultaneity of Talbot and Daguerre before them, these two photographers coincided perfectly in discovering the first practical method of photographing in color. In a letter to Cros the same year, Du Hauron wrote: "If it is true that in science the first idea counts for much, only the research and discovery of its practical application is yours, Monsieur: the first idea is shared by both of us. Such is my sentiment, and such is the formula by which we can bring to a close that honorable debate, which you have felt it necessary to raise."[2]

The breakthrough in color photography, shared by both Du Hauron and Cros, was not in striving to impress the colors of nature directly onto a photographic plate but to achieve these colors indirectly. Many attempts previously had been made along the lines of direct color photography: Levi Hill, Nièpce de St. Victor, Edmund Becquerel, and Alphonse Louis Poitevin had all researched this possibility to varying degrees of partial and irregular success. Only Léon Vidal, in 1873, had come close to Du Hauron's and Cros's methods with his *photochromie* process. Du Hauron reasoned that since only the daguerreotype was a direct photographic process and that every other process was based on first creating a negative and then indirectly printing a positive print, the same "indirect" approach might be the surest way of creating natural colors in the photographic print. Du Hauron summarized his working hypothesis: "If I take a picture given to us by nature, which appears singular, but which is in reality triple in terms of color, and disassemble it onto three distinct pic-

Fig. 47. Louis Ducos du Hauron, *Self Portrait Deformation*, albumen print, ca. 1888.

tures, one red, one yellow and one blue; and if I obtain a separate photographic image of each of these three pictures which reproduces its particular color; it will be sufficient to join the three resulting images into a single image in order to possess the exact representation of nature, color and modeling all together."[3]

Du Hauron's process worked, and one result is this studio still life of a stuffed rooster and budgie (or parakeet). What is wonderfully charming about this image is that the photographer has recorded a fictive nature, a diorama of sorts, with stones and vegetation added for verisimilitude. Du Hauron exceeded the simple need for choosing a multicolored subject and created an artifice that not only demonstrated his three-color process but did so whimsically. A similar humor is also found in the series of distortions or "transformations" Du Hauron fabricated in 1888 and 1889, in which the artist's self-portrait is the object of various deformations obtained by a slit diaphragm [fig. 47].[4]

3623

PETER HENRY EMERSON

British · b. Cuba, 1856–1936

A Stiff Pull, Suffolk

1886 · Photogravure print · From: Peter Henry Emerson, *Pictures of East Anglian Life*, London, 1888, pl. 4. 20.7 × 28.6 cm.

A champion of naturalistic photography based in very large part on modern theories of physiological optics, Emerson was the first photographer to apply scientific principles to the development of a purely photographic art. His aesthetic program for art photography was expounded at length in the first edition of his *Naturalistic Photography . . .* (1889) and greeted as utterly outrageous. Emerson's significance, however, rests securely in his provocative and sensitive depiction of late-Victorian rustic life. Like his contemporary Thomas Hardy, Emerson discovered a vital landscape in which a profound human life took place. His were the same heavy, sodden, and unyielding landscapes, the commonplace and unfashionable agrarian backdrops that are found in the pages of *Far from the Madding Crowd* of 1874 or *Tess of the d'Urbervilles* of 1891. Topographically, Emerson's Norfolk and Suffolk are not exactly Hardy's fictional Wessex—for one they are far too marshy and aquatic—but certainly the characters that inhabit them all share equivalent labors, costumes, and prideful demeanors. The same interest in peasant or rustic subjects was increasingly encountered at the London Salon, in such paintings as George Clausen's *Labourers after Dinner* of 1883–84 or Henry Herbert La Thangue's *The Return of the Reapers* of 1886. Also in 1886, Emerson published his platinotype-illustrated *Life and Landscape on the Norfolk Broads*, and through his co-author T. F. Goodall he was acquainted with both Clausen and La Thangue. [1]

Although *A Stiff Pull, Suffolk* appears in Emerson's *Pictures of East Anglian Life* in 1888, he had already exhibited an albumen print version of the same picture two years earlier [fig. 48]. [2] It is interesting to note in the photogravure print of 1888, that Emerson deleted the treetop at the upper right of the image and added a darkly threatening cloudscape. The theme of the ploughman struggling uphill enjoyed a particular vogue in 19th-century art. It was depicted by Jean-François Millet, Rosa Bonheur, Léon Lhermitte, and Sir Edward Landseer, among others, and as rendered by Camille Pissarro this subject appeared on the cover of Peter Kropotkin's anarchistic *Les Temps nouveaux* in 1896. [3] For some, this subject was only an exercise in picturesque rural genre, as summarized by the French writer André Theuriet

Fig. 48. Peter Henry Emerson, *A Stiff Pull*, albumen print, 1886.

in 1887: "Everywhere people and animals are at work; rustic life is wide awake. Here they are already harrowing; farther on the ploughshare is beginning to lift the shining clods. The horses pull with outstretched necks, the whips crack, the men urge them on with their voices,—Hue! dia! ohe! Their shouts sound clearly through the sonorous air." [4]

Emerson's description of this image is quite different and verges on the socialistic: "Our plate shows us a stiff pull, such as is life for many. Like the horses and the ploughman in the plate, they must look neither to the right nor to the left, but straight before them, putting all their strength into their work. Slowly, they climb the steep ascent of years, and finally, when they have reached the top, they sink down exhausted under the disappointments of life's imperfections." [5]

ALFRED STIEGLITZ

American · 1864–1946

The Terminal (New York)

1893/(?) · Gelatin silver on glass (lantern slide) · 6.5 × 7.5 cm. (image), on glass 8.2 × 8.1 cm.

The artist who was to become the single most influential force in the development of modern photography, the photographer who defined for generations the possibilities of serious artistic photography, the gallery owner who first exhibited the art of Picasso, Matisse, and Rodin in this country, the editor of one of most impressive journals published in this century—this one person, Alfred Stieglitz, photographed this simple street scene in 1893 at the age of twenty-nine. Depressed following his return from Germany where he had studied photography under Hermann Vogel, Stieglitz felt displaced from the cultural richness he experienced in Europe and alone in his own country which to him seemed empty and materialistic. After he attended an emotional performance of Eleanora Duse in *Camille*, Stieglitz's optimism about his own role as an artist in America began to surface. As he told Dorothy Norman:

> It was a few days later that I photographed *The Car Horses* at the *Terminal*, opposite the old *Astor House.* . . . There was snow on the ground. A driver in a rubber coat was watering his steaming horses. There seemed to be something closely related to my deepest feeling in what I saw, and I decided to photograph what was within me. The steaming horses, and their driver watering them on a cold winter day; my feeling of aloneness in my own country, amongst my own people, seemed, somehow, related to the experience I had had when seeing Duse in *Camille.* . . . I felt how fortunate the horses were to have at least a human being to give them the water they needed. What made me see the watering of the horses as I did was my own loneliness.[1]

The specific subject matter of this image—which exists as a platinum print, a photogravure print, a gelatin silver print, as well as this lantern slide—is essentially a scene of modern urban life, a picturesque theme of colorful daily experience, a spectacle of common occurence. Similar subjects are readily found in late-19th-century naturalist art, in the novels of Jack London and Emile Zola or in the paintings of René Choquet and Emil Jacque.[2] But seldom if ever were such subjects treated as significant epiphanic moments, those spiritual, artistic correspondences that signify far more than their objective nature. In this picture, Stieglitz had anticipated the ideas of Joyce's Stephen Hero, who saw in an "epiphany" that "sudden spiritual manifestation, whether in the vulgarity of speech or of gesture or in a

Fig. 49.
Alfred Stieglitz, *Equivalent*, gelatin silver print, ca. 1925, gift of Georgia O'Keeffe.

memorable phase of the mind itself . . . the most delicate and evanescent of moments . . . [by which] we recognize that it is *that* thing which it is. Its soul, its whatness, leaps to us from the vestment of its appearance. The soul of the commonest object, the structure of which is so adjusted, seems to us radiant. The object achieves its epiphany."[3]

By the mid-1920s, Stieglitz had further pared his images down to their bare essence of visual significance and entitled them "Equivalents" [fig. 49]. Almost with theosophical rigor, Stieglitz fashioned his most extreme case for "idea photography," in which the thing or nature photographed was not the subject of the picture as much as it was an "equivalent" of a state of mind or experience.

What Stieglitz encountered in front of the Astor House, however, was the first step toward an "idea photography," and one that established the singularity of modern photography as a mode of artistic expression. As he is reported to have said around 1900, "The arts equally have distinct departments, and unless photography has its own possibilities of expression, separate from those of the other arts, it is merely a process, not an art; but granted that it is an art, reliance should be placed unreservedly upon those possibilities, that they may be made to yield the fullest results."[4]

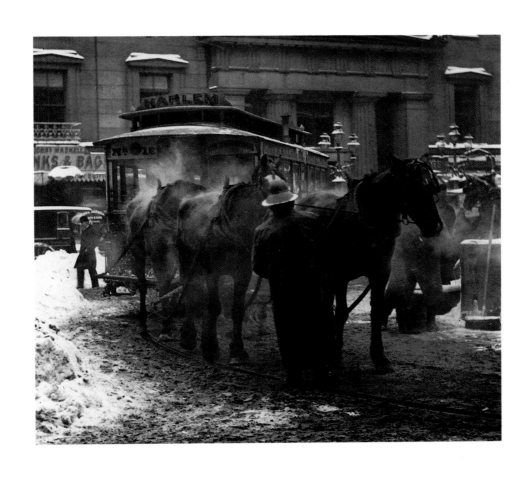

HILAIRE GERMAIN EDGAR DEGAS

French · 1834–1917

Portrait of Emile Verhaeren

ca. 1895 · Gelatin silver print · 11.0 × 7.9 cm. (irregular)

Toward the middle of the 1890s, the French painter of modern life Edgar Degas became fascinated with photography and afflicted many of his friends and acquaintances with having their portraits made by him. The painter's close friend poet Paul Valéry wrote of a portrait of Stephen Mallarmé by Degas that had been given him: "It shows Mallarmé leaning against the wall, close by a mirror, with Renoir sitting opposite on a divan. In the mirror you can just make out, like phantoms, Degas and the camera, Mme and Mlle Mallarmé. This masterpiece of its kind involved the use of nine oil lamps . . . and a fearful quarter-hour of immobility for the subjects. It has the finest likeness of Mallarmé I have ever seen, apart from Whistler's admirable lithograph. . . ."[1] Historian and biographer Daniel Halévy witnessed one of Degas's notorious photographic sessions.

He had seated Uncle Jules, Mathilde, and Henriette on the little sofa in front of the piano. He went back and forth in front of them running from one side of the room to the other with an expression of infinite happiness. He moved lamps, changed the reflectors, tried to light the legs by putting a lamp on the floor—to light Uncle Jules's legs. . . . "And you, Mademoiselle Henriette, bend your head—more—still more. Really bend it. Rest it on your neighbor's shoulder." And when she didn't follow his orders to suit him he caught her by the nape of the neck and posed her as he wished. He seized hold of Mathilde and turned her face towards her uncle. Then he stepped back and exclaimed happily, "That does it." The pose was held for two minutes—and then repeated. We shall see the photographs tonight or tomorrow morning, I think. He will display them here looking happy—and really at moments like that he is happy.[2]

Degas possibly was attracted to the medium once instanta-neous photography was proved feasible by Eadweard Muybridge's chronophotographs of racehorses shown in Paris in 1881. Since a number of sources mention his enlargements, Degas must have used a small-format camera, and one fictional remark suggested that he colored over these enlarged photographs with pastels.[3] Degas also was interested in night photography; in one of his letters to a photographic dealer he wrote, "What I suggested yesterday seems to me absurd. I am trying to photograph almost the night. Have you any tips on this?"[4] Degas's earlier fascination with painting scenes of Parisian night life, its *café-concerts* and nocturnal urban types, may very well have accounted for this interest. Seemingly, he also photographed nudes and landscapes, but it was portraits of his friends for which Degas most used the camera.

Poet and art critic Emile Verhaeren was, along with Maurice Maeterlinck, one of the foremost writers of the Belgian Symbolist movement. Considering Degas's own personal and artistic sensibilities, he would have been quite sympathetic to the poet who had written that, "Modern imagination is strongly drawn toward the past, [undertaking] an enormous scientific inquiry into unfamiliar passions over a vague and as yet unidentified supernatural, which has urged us to reincarnate our dreams and even our fear and trembling before the new unknown of this strange Symbolism which interprets the contemporary soul. . . . But it is not our faith and our beliefs that we put forward; on the contrary, it is our doubts, our anxiety, our problems, our vices, our despair and probably our agony."[5] This is far more than a simple snapshot of a great artist's friend. Given Degas's method of photographing, Verhaeren's intensity of expression and unswerving stare are undoubtedly purposeful, as are the nearly irreal illumination and resolutely mysterious shadows out of which the poet's face projects.

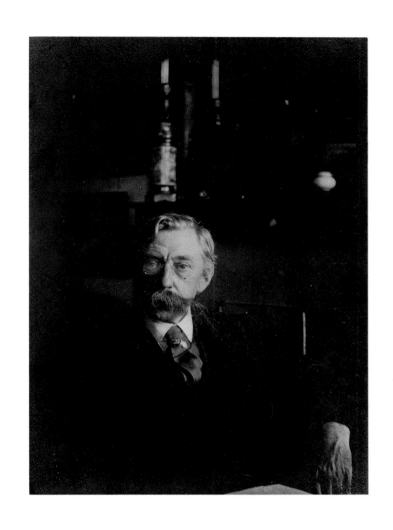

JOSEF MARIA EDER and EDUARD VALENTA

Austrian · 1855–1944 Austrian · 1857–after 1929

Aesculapius Snake

1896 · Photogravure print from stereoscopic negatives · From Josef Maria Eder and Eduard Valenta, *Versuche über Photographie mittelst der* RONTGEN*schen*, Vienna, 1896, pl. 15. 27.0 × 21.7 cm.

Wilhelm Conrad Roentgen (1845–1923), the German physicist and Nobel laureate (1901), discovered both the existence of those light rays named after him (also called "X-rays") and "X-ray" or Roentgen photography in 1895. A year later, Professor Ernst Mach (1838–1916) visited Eder's and Valenta's research facility at the Graphische Lehr- und Versuchsanstalt in Vienna, where those two were experimenting with Roentgen photography, and he suggested that the customarily flat images then obtained might be made to reveal greater stereoscopic effects by a different arrangement of the Roentgen tubes. Together, all three scientists invented stereoscopic "X-ray" photography, which was published later the same year by Eder and Valenta as the *Versuche über Photographie mittelst der* RONTGEN*schen* (*Experiments in Photography with Roentgen Rays*).

The images obtained in the manner described by the aid of Roentgen rays, are silhouettes, which show . . . a certain degree of apparent relief, because the varying degrees of transparency of the layers are expressed in the picture. In order to attain completely this relief effect we experimented with stereoscopic exposures, employing Roentgen rays according to Dr. E. Mach's advice. For this purpose the object, a mouse, was placed on a piece of mica stretched over two strips of wood on a table, and the plate, wrapped in black paper, was slid under it, until it touched the mica, but enabled the plate to be exchanged without moving the object lying on the mica. . . . The light source, about 30 cm. above the object, was placed at first so that its center registered with

one of [two] marks on the table; then its axis was turned toward the object, and an exposure taken. The plate under the object was now changed, and the light was moved so that its center registered with the other mark, and the procedure was repeated. The two pictures, viewed as diapositives in a mirror stereoscope, showed a stereoscopic picture in astonishing relief of the skeleton of the mouse. This method of photography may find approval after some improvements in the apparatus are made, in particular when dealing with objects of natural history.[1]

Even in this single-image photogravure print, a certain sense of density and volume is retained.

In their *Technical Manifesto* of 1910, the Italian Futurists exclaimed: "Who can still believe in the opacity of bodies, since our sharpened and multiplied sensitiveness has already penetrated the obscure manifestations of the medium? Why should we forget in our creations the doubled power of our sight, capable of giving results analogous to those of the X-rays?"[2] Three decades later, the Hungarian artist, László Moholy-Nagy cited the Futurists' reference to Roentgen photography and expanded on its meaning: "The X-ray pictures, about which the Futurists spoke, are among the most outstanding space-time examples on the static plane. They give a transparent view of an opaque solid, the outside and inside of the structure. The passion for transparencies is one of the most spectacular features of our time. We might say, with pardonable enthusiasm, that structure becomes transparency and transparency manifests structure."[3]

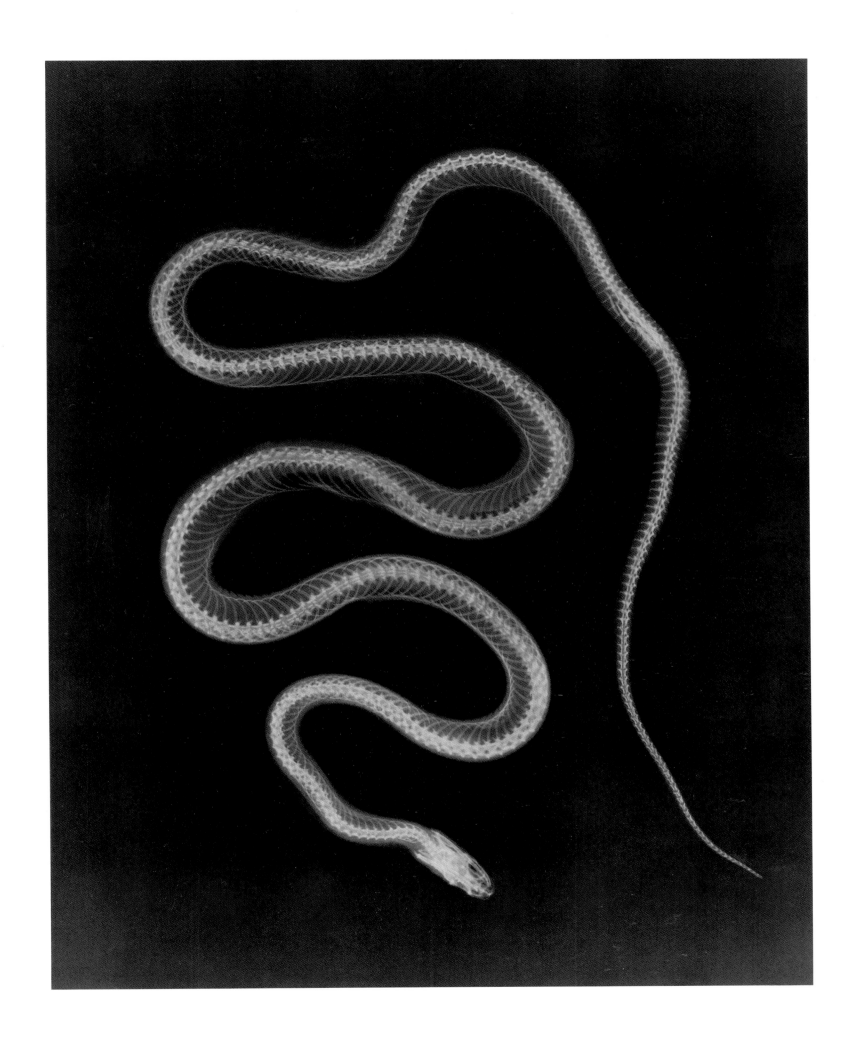

ALFRED HORSLEY HINTON

British · 1863–1906

Day's Awakening

1896 · Platinum print, toned (?) · 49.8 × 29.2 cm.

Writing of Hinton's work in *The Studio* of 1905, the critic Clive Holland stated: "Of all landscape pictorialists, we are inclined to think, Mr. Horsley Hinton provides the most useful lessons in the value of the foreground, the importance of clouds and sky both from a pictorial point of view and as an element of poetry, and the undeniable advantage of a painter-like scheme of chiaroscuro. His work, too, refutes the contentions of those who plead the artistic claims of much diffused focus, whilst at the same time it shows that a sharp all-over picture does not give either the most pictorial nor even the truest idea of natural scenes."[1] Like other Pictorialists of the period, such as Alexander Keighley, Hinton was encouraged as an artist-photographer by the persistent example of Henry Peach Robinson, Britain's leading exponent of Pictorialist photography. Unlike Keighley and others, Hinton knew Robinson and even worked for his son Ralph at the latter's Guildford Studios. During the 1890s, Hinton was a member of The Linked Ring; he was editor of the *Photographic Art Journal* and of the highly influential *Amateur Photographer*, for which he wrote extensively on the aesthetics of pictorial photography.

In an article on individuality in photographic expression, Hinton cautioned against the lure of adapting one's work to a celebrated model, a model that sounds much like Hinton himself.

> Again it has become notorious that some gained some successes in rendering nature in sombre guise, enveloped in mist, at evening and at dawn, and found, to them, pleasing subjects in the empty places of the earth amidst marsh and river estuary, many, very many others followed until now one would think that further evidence is needless of photography's capability of rendering hazy, misty effects, but because some sought inspiration in dreary marshland and were led to seek expression of the prevailing moods of Nature as there encountered, it is not to be supposed that these pioneer workers would have us believe that Nature elsewhere and under different conditions is less beautiful, less expressive, or less capable of artistic rendering.[2]

Three years earlier, Hinton created this image of *Day's Awakening* along with a companion picture, *Day's Decline* [fig. 50]. Seemingly, the strength of his images found resonance in his followers.

Hinton had little sympathy for the scientifically based naturalism of Peter Henry Emerson and vigorously argued against what he saw as the hegemony of realism in photographic art.

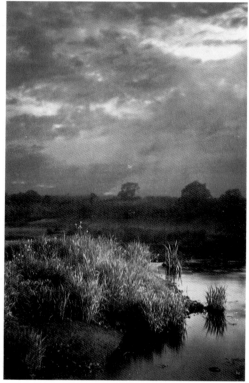

Fig. 50. A. Horsley Hinton, *Day's Decline*, platinum print, toned (?), 1896.

The artist, by reason of his artistic temperament, *feels* nature more readily than another who examines the hidden mechanism of her various organisms, or than he who is too engrossed with the affairs of city or state. By constant, reverent study of her exterior, he becomes so that, as a tightly drawn wire or a hollow glass globe will resonate if a particular note is struck, so he quickly responds to an effect in nature, and by his art, his artifice and craft produces something which will make others feel or imagine something that perhaps had no actual physical existence, but was the offspring of visible nature and his own particular temperament.[3]

Basing his ideas partially on Zola's notion of art's being nature seen through the temperament of the artist, Hinton applied a fundamentally British Arts and Crafts sensibility to the free expression of the artist at the expense of any positive reference to reality. Photography for Hinton was synonymous with a species of aesthetic poetry.

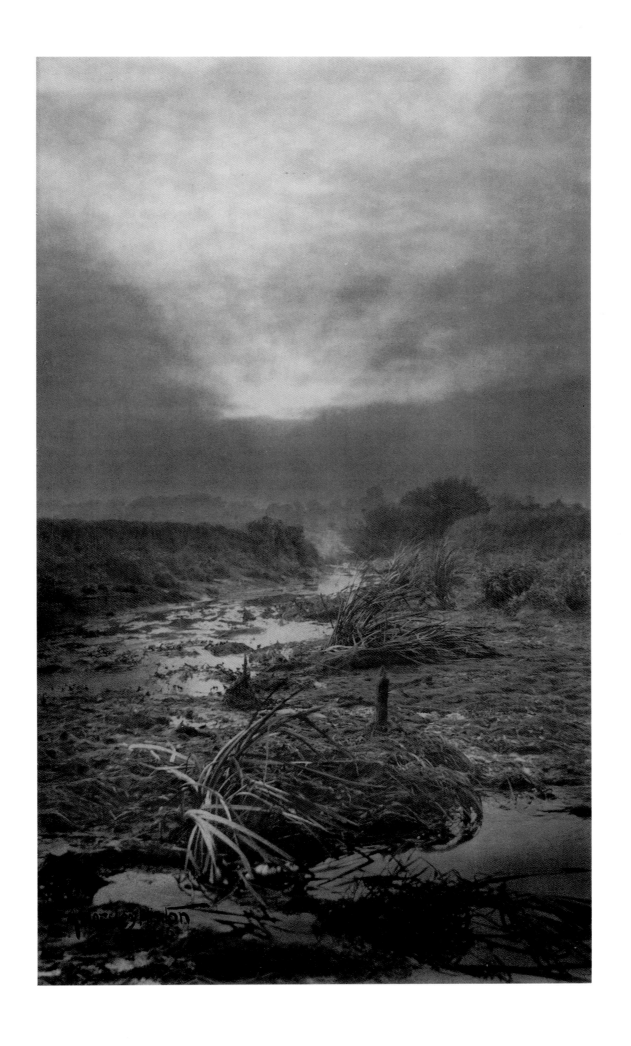

ALEXANDER KEIGHLEY

British · 1861–1947

Gathering the Flock

1897 · Carbon print, manipulated · 31.6 × 49.1 cm.

Trained in science and by vocation a businessman, Alexander Keighley was one of a large number of amateur photographers during the last decade of the 19th century who successfully pursued the avocation of art photography. A director until 1932 of Sugden Keighley & Co., a worsted-wool manufacturer in Yorkshire, Keighley began photographing in 1880 following the precepts and example of Henry Peach Robinson, then the foremost pictorialist photographer in Great Britain. His initial photographic submission to a competition in 1887 secured him a first prize. His earliest works were principally of genre subjects, and these were printed on silver bromide paper. Between 1896 and 1897, he worked with platinum papers, and in 1897, "he discovered his ideal printing medium in the carbon process, and from then onwards until the end he used no other. In practice he adhered to a shade of brown from which he rarely departed, so that a Keighley print was almost as readily identified by its color as by its individual treatment. Precise definition and the modern ideas of the sharpness of image had no attractions for him. His handling was often very loose and his textures 'woolly,' but the treatment was always broad and painterlike."[1]

In 1892, The Linked Ring was organized in London, a society whose "express object would be the complete emancipation of pictorial photography, properly so called, from the retarding and nanizing bondage of that which was purely scientific or technical, with which its identity had been confused too long; its development as an independent art; and its advancement along such lines as to them seemed the proper tracks of progress into what, as the perspective of logical possibilities opened itself to their mental visions, appeared to be its promised land."[2]

There is conflicting evidence as to whether Keighley was a founding member of The Linked Ring in 1892, or if he only joined the brotherhood in 1900. Nevertheless, such prints as *Gathering the Flock*, one of his earliest carbon prints, are perfect examples of British Pictorialism, comparable in their diffuse softness and dramatic light effects to the best work by J. Craig Annan, A. Horsley Hinton, or Alfred Maskell. "He was quite unashamedly a romantic, and romance and poetry are the distinguishing features of his pictures."[3] Keighley exhibited his pastoral imagery—with titles like *The Shepherdess*, *The Rest Is Silence*, and *A Spring Idyll*—well into the 1940s, influencing succeeding generations of lingering pictorialists.

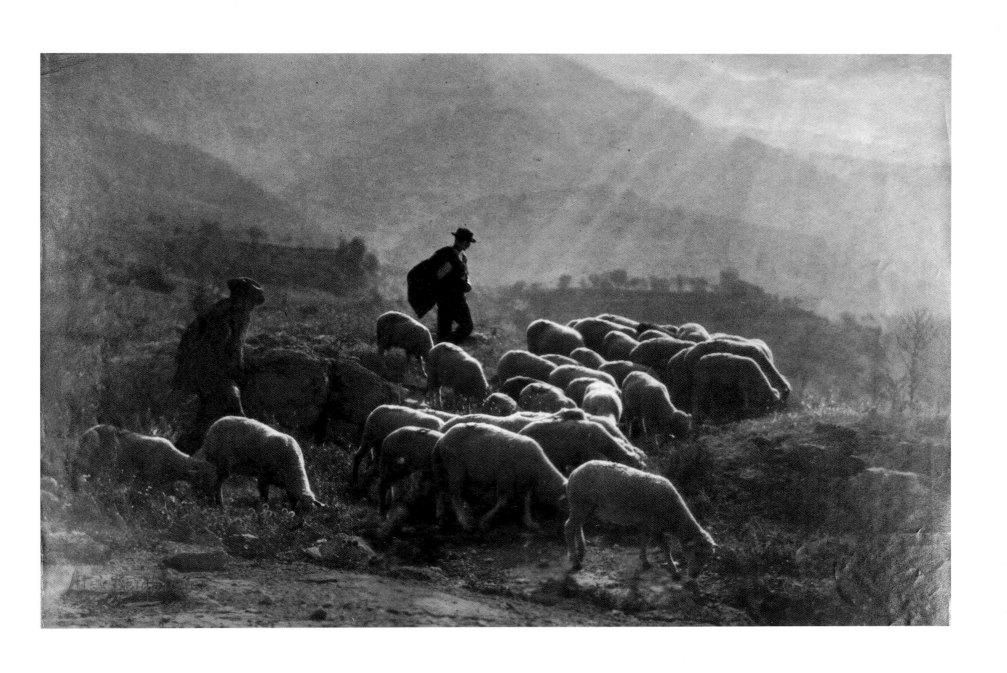

F. HOLLAND DAY

American · 1864–1933

The Seven Last Words. I. *"Father, forgive them, they know not what they do."* II. *"To—day thou shalt be with Me in Paradise."* III. *"Woman, behold thy son; son, thy mother."* IV. *"My God! my God! why hast Thou forsaken me?"* V. *"I thirst."* VI. *"Into Thy hands I commend my spirit."* VII. *"It is finished."*

1898/1912 · Platinum prints (7), printed by Frederick Evans from copy negatives · 19.9 × 15.1, 20.0 × 15.2, 20.2 × 15.2, 20.1 × 15.3, 20.1 × 15.1, 20.2 × 15.1, 20.1 × 15.2 cm. (respectively, nos. 1–7)

F. Holland Day spent the summer of 1898 at his home outside Norwood, Massachusetts, creating as many as 250 negatives portraying scenes from the Life of Christ, including the Baptism, Raising of Lazarus, Betrayal, Crucifixion, Descent from the Cross, Entombment, and Resurrection.[1] The singularly most ambitious of these christophanic subjects was a series of seven close-up portraits of the head of Christ as he uttered the famed "Seven Last Words." As in the Crucifixions and others, Day himself posed as Christ in front of the camera, purportedly after going into seclusion, letting his hair grow, and starving himself for months.[2] According to notes by Frederick H. Evans that accompany these later prints, Day had "a mirror attached to the camera so that he could see his expression at the time of exposure; he made the exposure himself, so the whole effort was a purely personal one. . . . It was a unique effort, inspired by the utmost reverence and carried out with extraordinary success."[3] Day's original prints were processed by the glycerine process which allowed the eradication of much of the obdurate detailing and gave the final prints their sketchlike, vignetted appearance and softened grace.

In November, 1898, Day mounted a small exhibition of his "sacred subjects" at his residence in Boston. On the printed invitation, the photographer included the following text: "Mr. Day is the first to undertake the character of work represented by these studies, and as some controversy has arisen regarding the legitimate use of the camera in this field, your opinion for or against exhibition is sought."[4] While Day was perfectly correct about the controversial reaction these works provoked and would continue to cause, he clearly was not the first photographer to attempt such hallowed subjects with the camera. In 1853, the American daguerreotypist Gabriel Harrison photographed his son in the guise of the Infant Christ carrying a cross. During the latter decades of the century, Christian and other sacred themes were especially popular in painting and literature, as well as in photography. In 1896, Belgian photographer Léon Bouvier exhibited a print illustrating the dead Christ in the tomb [fig. 51], and a year later the American Pictorialist John

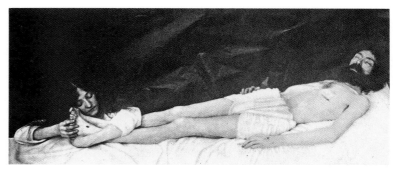

Fig. 51. Léon Bouvier, *The Entombment of Christ*, photogravure print from Photo-Club de Paris, *Troisième exposition d'art photographique*, Paris, 1896, pl. 3.

E. Dumont fashioned a reprise of this same subject.[5] Day most likely never saw Harrison's daguerreotype, but it is quite probable that he was familiar with either Bouvier's or Dumont's images, or both.

In Day's article, "Sacred Art and the Camera," he defended the propriety of pictorially interpreting religious subjects, and suggested that if there were a problem with photographing instead of painting them it was only due to the inexperience of the young medium. "To consider the application of this new medium to *any* form of pictorial art other than in the round, as impossible or even dangerous, is to write the condemner down, ignorant of the causes and effects he condemns. From the experience of nearly a decade and a half, I fear not to declare that we are as yet only at the outskirts of the approaching path leading to the highway wherein lie the possibilities of the photographic medium of expression."[6] Evans considered that the intense condemnations of Day's *The Seven Last Words* might have been occasioned by the artist's self-portrayal as Christ, and suggested that if another actor were chosen, the denunciations would not have been as fierce.[7] Yet it may indeed be Day's self-dissemblance and role-playing that lends these images their inordinate passion and substance.

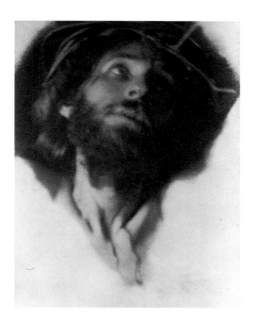
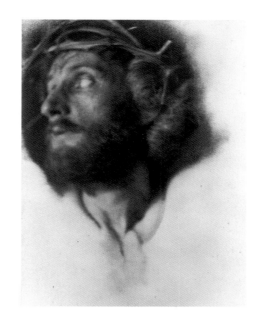
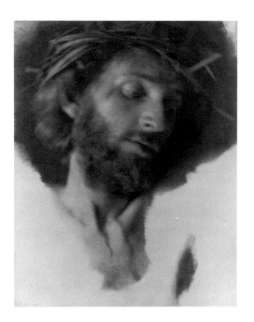
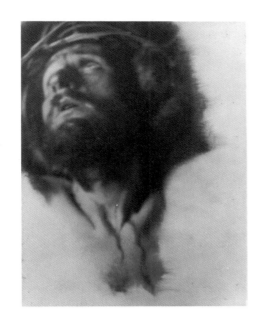
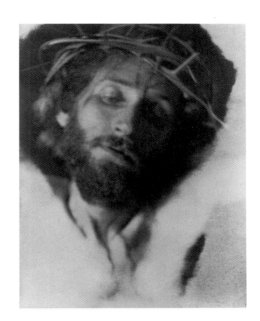
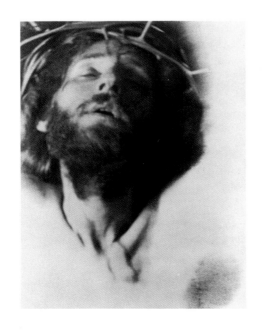
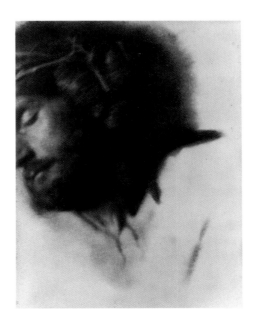

EMILE JOACHIM CONSTANT PUYO

French · 1857–1933

Gorgon's Head

ca. 1898 · Brown gum bichromate print · 20.3 × 15.2 cm.

"One of the defects of photography—considered as an art-process," observed Constant Puyo in 1899, "consists in the excess of details, which, uniformly spread on all the picture, produces a general confusion injurious to the effect."[1] He went on to say: "The treatment of the surroundings of the principal motive being thus too minute and too much hurried, the harassed eye is not immediately conducted toward the aesthetical center of the picture; the art impression is sensibly diminished." According to Puyo, there were two distinct opportunities for the artist-photographer to artistically modulate the amount of super-fluous detail in the photograph: at the time of composition and when the print is "manufactured." In composing, lighting could be carefully manipulated to create broad, dark shadows and dramatic highlights that would in turn diminish mid-tone detailing. Discussing his *Gorgon's Head*, Puyo wrote: "As example of localized lighting, . . . (the model's head was stuck through a rough paper). I wanted to have the orbits plunged in shade, the forehead and nose well lighted, and altogether a strong light making the osseous frame stick out. A lamp enclosed in a screen and placed at a distance of fifty centimeters above the forehead produced the effect; the dominant lights are well placed on the frontal bone and on the bridge of the nose. Try to obtain the same effect with only daylight."[2]

Even famed critic of the period Robert de la Sizeranne commented on Puyo's use of specialized lighting in this print, and quoted the artist at length on the subject. More significantly, however, Sizeranne concluded his short essay on photographic art by describing the photographers of the *Photo-Club de Paris*, the principal forum of Parisian Pictorialism.

Thoroughly gentle and quite silently, these men, armed with a machine, conspire towards the classic ideal of earlier times. They have not issued heated manifestos, nor proclaimed the deposition of any art. Their poster represented only a woman dropping the pale petals of a sunflower. . . . They have sought only pleasure; and pleasure, we must recall, has contributed to more beautiful works of art than has ambition. . . . These artists are not at all mysterious . . . it is not their papers and their chemical ingredients, their screens and their magnesium lamps that give them any superiority—it is their aesthetic education and their taste.[3]

Puyo's aesthetic taste led him to photograph sweetly rococo interiors, domesticated genre scenes of young women painting and knitting, young maidens in meadows, and voluptuous nudes. He summarized his entire aesthetic with the words, "Happy are the simple subjects! For their's is the Kingdom of the Aesthetic!"[4]

Yet for so many artists of the *fin-de-siècle*, and for many photographers of the period, the gently romantic and decorous were found to have decided correlatives in the grotesque and satanic, the chimeric and the macabre, the sexual and the hallucinatory. Sharing in the "decadent imagination" of the 1890s, Puyo frequently gravitated to themes of Salome, the *femme fatale*, vampirism, and the Gorgon, or Medusa, the sight of whose head signaled sudden death. In his taste for these themes, Puyo is very much akin to such artists as Gustave Moreau, Odilon Redon, Jean Delville, Luc Olivier Merson, and Fernand Khnopff, and to such poets as Baudelaire or Jean Lorrain, who fashioned his own medusa:

Hanging at the foot of the bed, the head with painted lips,
Calm and pale let drip its heavy clots of blood
Above a bowl of dazzling copper
Filled to the brim with lilies and hyacinths.[5]

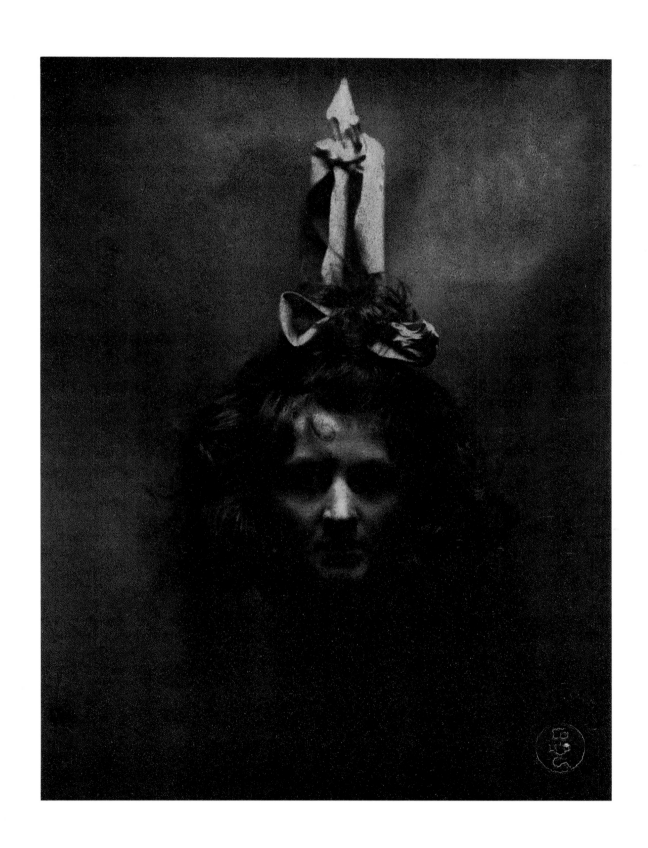

GUIDO REY

Italian · active 1890s–1920s

Woman with Lilies

ca. 1899 · Platinum print · 14.6 × 18.7 cm.

In the October, 1908, issue of *Camera Work*, the editors published two gravures by a relatively little known Italian Pictorialist photographer, Guido Rey, entitled *The Letter* and *A Flemish Interior*. They seem nearly as out of place in that publication's pages as the earlier inclusion of A. Radclyffe Dugmore's *A Study in Natural History*, a picture of a branch holding four young fledglings, which appeared in the magazine's first issue, April, 1903. Instead of the customarily dark and brooding symbolism or the graphic experimentation with printing techniques that had characterized *Camera Work*'s choices of imagery in its first years, Rey's pictures are sentimental history pieces, in the style and with all the trappings of a Dutch 17th-century interior scene as painted by Vermeer or Gabriel Metsu; in fact, Rey's *The Letter* [fig. 52] is nearly a direct reprise of Metsu's *Man Writing a Letter* from the collection of Sir Alfred Beit, and *A Flemish Interior* is not unlike Pieter de Hooch's *The Card Players* in Buckingham Palace. Of course, Rey stresses the supposed erotic sub-texts of these Dutch genre scenes, filled as they were with afternoon encounters, presentations of bouquets, and the writings of love letters. Besides the art of 17th-century Holland, Rey also appropriated tastes for 18th-century French scenes of intimate repasts and young maidens strolling through vernal glades, as well as for subjects from classical antiquity reminiscent of certain history painters of the 19th century, such as the Italian Federico Faruffini or the British Sir Lawrence Alma-Tadema, whose studies of young Roman women leaning over impossibly high ramparts were of probable influence on Rey's works.

Nearly all of Rey's costume or period photography is concerned with the wistful delectation of quiet sensibilities, charming and intimate moods, and serene reflections—all fashioned with near archaeological exactitude. The French Pictorialist photographer E. J. C. Puyo, in an article nominally on the work of Guido Rey, cautioned against the too strict dependence on past masters and against the too facile mimicry of past styles, but he praised, however, Rey's mastery of photographic historicism,

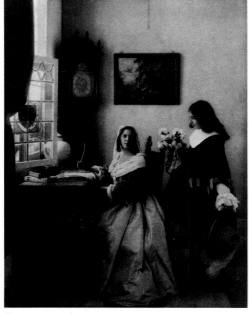

Fig. 52. Guido Rey, *The Letter*, (ca. 1900), photogravure print from *Camera Work*, 24 (October 1908), p. 41.

a dangerous terrain where many others had failed. Puyo concluded that the most attenuated extremes of photography at the time were represented by the work of Guido Rey and Eduard Steichen: ". . . one classic, focusing his effort on the very composition of the subject; the other, penetrated by modernism and composing above all in line with an ulterior interpretation. Placed side by side on the same wall, their works would speak eloquently, it seems to me, in favor of the process we cultivate [photography]; and we would doubtless only have to show the brilliant variety of their work—the power of the one and the delicate charm of the other—to those who would misunderstand that the last ten years of thankless labor have given us freedom."[1]

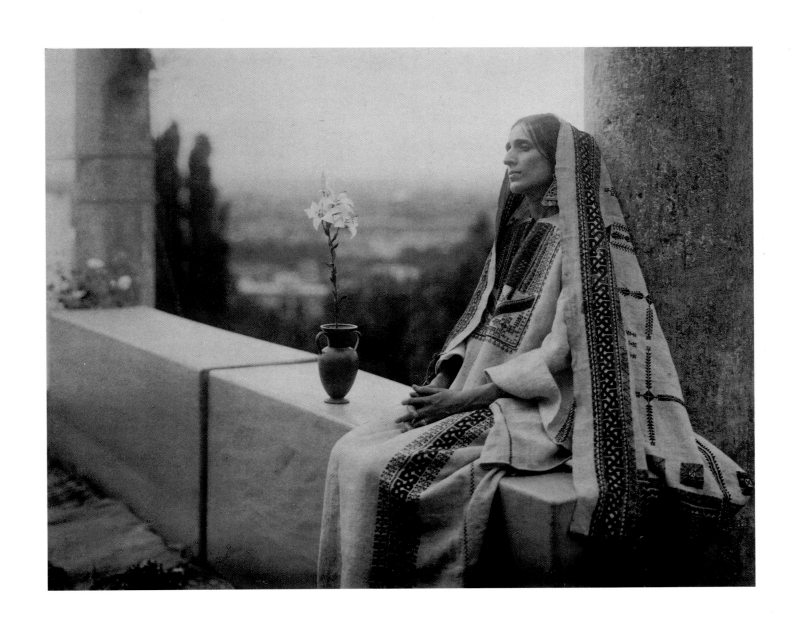

LEON ROBERT DEMACHY

French · 1859–1936

The Young Votaress

ca. 1905 · Oil transfer print · 15.1 × 8.9 cm.

"We have slipped into the Temple of Art by a back door," wrote the French photographer Robert Demachy in 1899, "and found ourselves amongst the crowd of adepts—alone and uninitiated. Let us frankly discard our primitive errors—and learn."[1] "We" referred to modern, Pictorialist photographers, convinced that the photographic print could attain the same levels of expression as other works of pictorial art, and the "crowd of adepts" were simply nonphotographic artists, painters, etchers, lithographers, and engravers. For Demachy, modern photography was engaged in a crusade, a battle of art versus the mechanical and the prosaic in photography. What the artist-photographer had to learn were the rules governing pictorial form: composition, lighting, values, textures, tones, and medium. The silver print was fine for topographics and portraits of actresses, but it was not satisfactory for the production of an art work. Platinotype or Artigue papers and gum-bichromate or oil transfer processes were far more beautiful and far more adaptable to the creation of artistic form. "We cannot do better," he declared, "than to take as a guide the effects of etching and water colors, freshness, strength, boldness and delicacy combined."[2] While Demachy found fault with artist-photographers who tended to work in the styles of Rembrandt, Van Dyck, Théodore Rousseau, or Millet, he repeatedly advocated looking to the masters of painting and printmaking for ideas and guidance. "We will continue to study artists like Rembrandt or Rops rather than photographers like X. . . . The effects of the former are certainly worth more than those of the latter."[3]

Art for Demachy was indeed a temple, a sacristy in which there were inspiration, high ideals, metaphysics, and symbolism. His voluminous writings on artistic photography are filled with the passionate convictions of a true believer. For the most part, too, his pictures of the 1890s and early 20th century are, if not religiously motivated, at least spiritually informed and symbolically charged. In a 1902 editorial, we read:

> In his pictures M. Demachy apparently endeavours to convey an idea that by some method disengages itself from reality; rather than reality itself; or, more tersely, he idealises and gives us a mental conception of reality. Thus his "portraits" are not, strictly speaking, portraits, but artistic ideals of the personages. A critical inspection of the pictures will show how he has modified the original, by means of brushwork upon the prints, in order to convey his ideal. Herein lies the artist's work, in which the border lines of art and nature merge and becomes [sic] fused.[4]

Demachy's artistic modernism was not in line with the formalism of Post-Impressionism; his sympathies rested much more with the literary and evocative romanticism of *fin-de-siècle* aestheticism and Symbolist art in general.

Religious themes were an integral part of Symbolist art at the end of the last century. The French art critic Camille Mauclair commented at the time that, "The Salons bulged with Holy Women at the Sepulchre, Seas of Galilee, crucifixions, roads to Emmaus, pardons, and benedictions, all executed in the same leached-out tones and with the same magic lantern lighting effects. . . . An appalling and unending plethora of missals, chasubles, monstrances, and lilies. . . . All the external signs of faith were dragged in, and only faith itself was left out."[5] Like painters and poets of the Symbolist epoque, photographers also found Christian themes or Mystic subjects of significance. As quiet and unassuming as it is, Demachy's *Young Votaress*, with its "leached-out tones" and inspirational lighting, is a masterpiece of Symbolist photography.

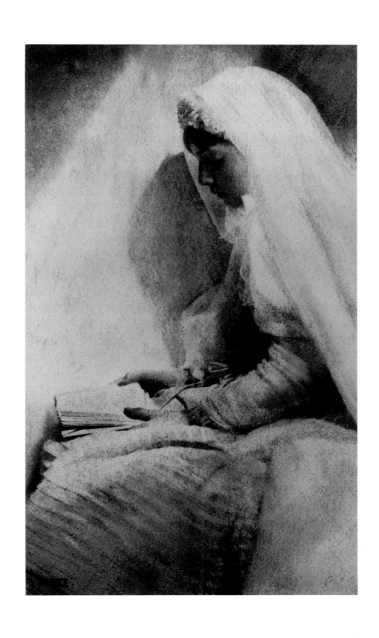

GERTRUDE STANTON KASEBIER

American · 1852–1934

Portrait (Miss N.)

ca. 1898 · Platinum print · 20.4 × 15.5 cm.

No less an American painter than Arthur Wesley Dow wrote in 1899 about Käsebier's portrait studies.

> Mrs. Käsebier is answering the question whether the camera can be substituted for the palette. She looks for some special evidence of personality in her sitter, some line, some silhouette, some expression or movement; she searches for character and for beauty in the sitter. Then she endeavors to give the best presentation by the pose, the lighting, the focusing, the developing, the printing—all the processes and manipulations of her art which she knows so well. She is not dependent upon an elaborate outfit, but gets her effects with a common tripod camera, in a plain room with ordinary light and quiet furnishings. Art always shows itself in doing much with few and simple things.[1]

Some few pages later, the American photographer Joseph T. Keiley spoke of Käsebier's work in terms of "notan," Dow's adoption of a Japanese term signifying harmonious arrangements of dark and light masses in a pictorial composition. "The manner in which [the] modern dress was handled, subordinated, and made to play its proper part in the composition of these pictures, evidenced great artistic feeling and readiness of device, while the arrangement of the light and shade of the different pictures displayed a keen appreciation of the refinements of notan."[2] And no less a master of American photography than Alfred Stieglitz commenced the publication of his prestigious *Camera Work* in 1903 by selecting Käsebier's photographs for its very first portfolio of gravure prints, including this particular image.

The subject for Käsebier's *Portrait (Miss N.)* was the actress Evelyn Nesbit, wife of Harry K. Thaw and mistress of the architect Stanford White, who was shot to death by Thaw in 1906. Nesbit is portrayed by Käsebier with all the delicate and proffered sensuality of an *ancien regime* voluptuary. Implying more than a portrait, Käsebier captured Nesbit in the near classic pose of a languid young maiden reminiscent of certain paintings by Greuze even so far as the inclusion of a suggestively empty pitcher. Everything about this image conforms to its sensuous mood— the sitter's posture, her upturned chin and languorous eyelids, the bare shoulders and boudoir garb, and even the plush, elegantly curved settee. It is a sophisticated reprise of any number

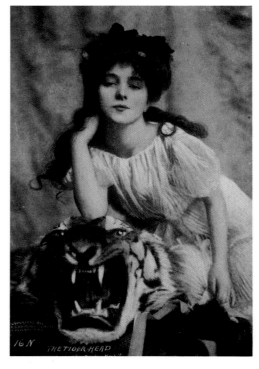

Fig. 53.
A. S. Cambell Art Co.,
The Tiger Head, Posed by Evelyn Nesbit, photomechanically printed post card, 1902.

of 18th-century depictions of "Psyche," "Innocence," or "Hope," one in which the popular vamp is fashionably interpreted as an idealized *femme-fatale*. A similar treatment of the same model was effected by a New Jersey post card company in 1902, when a series of mass-produced and utterly conventional images of Nesbit were circulated [fig. 53]. While they attest to the commercial viability of Nesbit as a public personality, these post cards validate at once the artistry of Käsebier, who without the tawdry and obvious symbolism of stuffed wild beasts, amply revealed more than mere likeness. Or, in Käsebier's own words, recalling similar words by Julia Margaret Cameron: "I have longed unceasingly to make pictures of people, not maps of faces, but pictures of real men and women as they know themselves, to make likenesses that are biographies, to bring out in each photograph the essential personality that is variously called temperament, soul, humanity."[3]

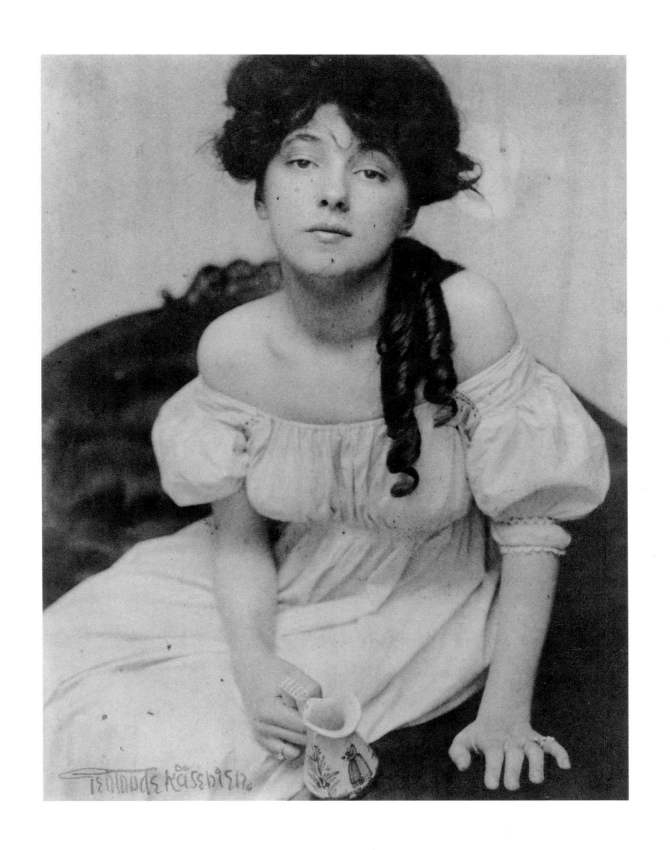

CLARENCE HUDSON WHITE

American · 1871–1925

The Ring Toss

1899 · Platinum print · 19.9 × 15.2 cm.

Where other photographers of the Pictorialist movement during the last decade of the 19th century stressed an assault on photography's fundamental realism by broadened, painterly effects and manipulative printing techniques, a number of American photographers maintained an essentially realistic vision of everyday life while advancing the aestheticism of soft focus and progressive composition. Writing in *Camera Work* in 1917, the photographer Paul Strand, who along with Alfred Stieglitz and Charles Sheeler was championing a more relentlessly direct style of photographic art, praised the "subtle feeling . . . the quiet simplicity of life in the American small town, so sensitively suggested in the early work of Clarence White."[1] A paradigm of the inspired amateur of the period, White was a self-taught photographer involved for the most part with a local (Newark, Ohio) camera club and regional competitions. In 1898, five years after he began photographing, White traveled to New York where he met Stieglitz, F. Holland Day, and Gertrude Käsebier, and by 1901, when he opened his studio in Newark, he was fully active in the international Pictorialist movement, a member of the Camera Club in New York and the Linked Ring in London.

White's photography was a panegyric to the calm and orderly life of the American middle class and to a refinement of outward behavior that was leisurely, studious, and joyously suburban. This was not merely a pleasant rendering of games and quiet moments with a hand camera, as encountered in photographs by Samuel Castner or the majority of amateur camera buffs. White's was a serious monument to a certain style of life, a testimonial to grace and virtue, and an abstraction of ideal beauty objectively expressed by the camera's lens. White continued a tradition of European naturalism that sought to ennoble and memorialize simple domestic scenes and the poetry of serene romanticism. Thirty years the junior of the British painter Albert Moore, who specialized in depicting wan, classically gowned feminine figures asleep or absorbed in contemplation of flowers or shuttlecocks, White followed suit, and his young women, in modern rather than Roman dress, are customarily

Fig. 54.
Clarence H. White,
Spring—A Triptych,
platinum prints, 1898.
Courtesy of the
Library of Congress,
Washington, D.C.

captured in languid reflection, either in a stilled corner of a room or amid the arcadian splendor of an orchard [fig. 54].[2]

In this print of 1899, White portrayed three young girls not so much playing a ring toss game as whiling away a comfortable, listless afternoon. Like the American expatriate painter John Singer Sargent, whose portrait of *The Daughters of Edward Darley Boit* of 1882, one of the masterpieces of 19th-century portraiture, shows children arranged in silent and complex relationship to one another and to the interior space of their apartment,[3] White emphasized the figures' solitary isolation despite their joint activity. The high-keyed, light-saturated interior intensifies the mood of displacement and the nearly dreamlike removal of the figures from the action of the picture and from each other. And even the placement of the game's implements in the immediate foreground serves visually to exaggerate the perspective of the flooring and distance the girls from their game.

SAMUEL J. CASTNER

American · 1843–1929

Children on Lawn

ca. 1910–12 · Platinum print · 19.7 × 22.7 cm.

An informal, prosaic style, endemic to the hand-held camera, is here raised to the scale of a tableau, frozen in the softened grisaille of platinum tones. A poignant moment captured for a souvenir of memory's desires recalls Santayana's comments on the function of photography.

> The eye has only one retina, the brain a limited capacity for storage; but the camera can receive any number of plates, and the new need never blur nor crowd out the old. Here is a new and accurate visual memory, a perfect record of what the brain must necessarily forget or confuse. Here is an art that truly imitates the given nature, in the proper meaning of this much-abused phrase—an art that carries on in the spirit of nature, but with another organ, functions which the given nature imperfectly performs. Photography imitates memory, so that its product, the photograph, carries out the function imperfectly fulfilled by the mental image. The virtue of photography is to preserve the visible semblance of interesting things so that the memory of them may be fixed or accurately restored. [1]

UNIDENTIFIED PHOTOGRAPHER

Russian (?) · active late 19th century

View of Moscow

ca. late 19th century · Albumen print, applied color · 20.5 × 26.5 cm.

This is a rather standard photograph of an urban center during the later 19th century, except for two features: the city is Moscow, which was photographed far less than, say, Paris or London, and it is over-painted with a masterful delicacy and precision prompting the simile of a Fabergé jewel. Significantly, the Kremlin's walls and a myriad of 15th-century cathedral towers, including those of St. Basil's, are only minor but vibrant details of the background. The substantial content of the image is really the empty expanse of the square, dominated by the massive commemorative statue and inhabited by a few shadowy figures in the distance and a single vendor and carriage beneath a lamppost. But it is not modern Russia that was recorded in this image, with its broad urban "prospects" and boulevards designed to bring its cities into line with progressive Western European centers. While the Nevsky Prospect of St. Petersburg was customarily awash with jostling crowds at all hours, the central square of Moscow is seen as nearly deserted.

The 19th-century Russian, if one were to trust that period's literature, found the nexus of modern life and excitement on the avenue or boulevard. From Pushkin and Gogol in the 1830s through Dostoevsky and Chernyshevsky in the 1860s and up to Andrei Biely and Osip Mandelstam after the turn of the century, the urban street was a principal metaphor as well as a scene. As early as 1835, Gogol wrote about the principal artery of St. Petersburg and exclaimed, "Omniscient Nevsky Prospect! . . . How swift the phantasmagoria that develops here in the course of a single day! How many metamorphoses it goes through within twenty-four hours!"[1] Moscow's advance into urban progressivism, however, would not occur during the 19th century, as this late-19th-century photograph would seem to document exquisitely.

FREDERICK H. EVANS

British · 1853–1943

Wells Cathedral: Stairway to Chapter House [A Sea of Steps]

1903 · Gelatin silver print · 23.1 × 19.2 cm.

The architectural photography of Frederick H. Evans, bookseller, bibliophile, and writer on photography, is the most poetic and the most interpretively lyrical in the entire history of the medium. A friend of George Bernard Shaw, Audrey Beardsley, and publisher J. M. Dent, Evans was perhaps the most literate of photographers at the turn of the century. His membership in The Linked Ring society in the 1890s and the publication of his articles in *Amateur Photographer* and *Camera Work* brought him into contact with the foremost artistic photographers of the time, including Alvin Langdon Coburn, F. Holland Day, and Alfred Stieglitz. He was a more than capable portraitist of his friends, and he delighted in the pictorial abstractions he found in photomicrographs of natural objects, such as the spine of a sea urchin. But it was in architecture, especially that of medieval châteaux and cathedrals, that Evans found his most personally gratifying subject. Lecturing in 1900, Evans stated:

> And there are no more abiding memories of peace, deep joy, and satisfaction, of a calm realization of an order of beauty that is so new to us as to be a real revelation, than those given by a prolonged stay in a cathedral vicinity. The sense of withdrawal, an apartness from the rush of life surging up to the very doors of the wonderful building, is so refreshing and recreating to the spirit as surely to be worth any effort of attaining. When one comes to be past the fatigues of traveling, and has to rely on old memories, these old visits to glorious cathedral-piles will be found, I think, to be among the richest remembrances one has stored up. [1]

A bit Proustian, perhaps, but it is essentially an expression of the same sentiment that pervaded the 19th century's adoration of the romantic Gothic, beginning with Gothic revivalist Viollet-le-Duc's comment before the Cathedral at Chartres: "All of this makes my heart vibrate and plunges me into thoughts inexpressibly serene." [2]

Writing of this picture in 1903, Evans explained that he used a nineteen-inch lens on an 8 × 10 inch camera and "succeeded in getting a negative that has contented me more than I thought possible." [3] In the same article, Evans continued by saying, "The

Fig. 55. Katsushika Hokusai, *Waves*, woodcut, 1815, from *Manga*, Edo, 1814-78, vol. 2. Courtesy of Art Department, Newark Public Library, Newark, NJ.

beautiful curve of the steps on the right is for all the world like the surge of a great wave that will presently break and subside into smaller ones like those at the top of the picture. It is one of the most imaginative lines it has been my good fortune to try and depict, this superb mounting of the steps."

It is interesting to speculate whether Evans's poetic title to this print and, in fact, its entire composition are not somehow indebted to the impact of Japanese prints on late-19th-century art. Sir Rutherford Alcock had brought a collection of Japanese prints to London in 1862, and later artists like Whistler and Tissot personally collected *ukiyo-e* prints and incorporated certain formal elements from them into their paintings. It is also known that photographers, like Coburn, absorbed a sense of *japonisme* from the art theories of Arthur Wesley Dow and others. Katsushika Hokusai's fifteen-volume set of woodcuts, the *Manga*, or at least parts thereof, was in Holland and Paris by the 1850s, and one double-page spread in particular shares a certain structural resonance with Evans's *The Sea of Steps—Wells Cathedral* [fig. 55]. [4]

CARL CHRISTIAN HEINRICH KUHN

Austrian · 1866–1944

Hans Kühn and His Tutor

1902 · Gum-bichromate print (brown) · 73.3 × 55.0 cm.

Commenting on the Austrian and German school of Pictorialist photography in 1905, British photographer and critic A. Horsley Hinton wrote that, "It needs no demonstration that in the faithful delineation of physical facts photography as a method is paramount, but that the purpose of the more aspiring photographer is not to thus record Nature must be obvious. He would appear to have at least learnt the principle that Nature and Art are distinct, and that whilst the mere subject of a picture may be of some interest, it is secondary in importance to what that picture *is* and the personal impression which it expresses."[1] Earlier in the same article, Hinton pointed out that, "it is to the work first shown in Vienna . . . by Dr. Hugo Henneberg, Heinrich Kühn, and the late Professor Hans Watzek, that the Austro-German movement is due."[2] Of these three artist-photographers, known as the "Trifolium," Kühn is perhaps best known in this country on account of his early friendship with Alfred Stieglitz and the collection of correspondence between the two that remains.[3]

In their attempts to fashion photography into an accepted mode of pictorial expression, photographers during the 1890s on both sides of the Atlantic shunned the merely reproductive look of the photographic print. They adopted "simple, painterly effects and [a] variety of interpretations, expressions, and conceptions of technique and impression."[4] In particular, it was an antiquated process, gum-bichromate printing, that granted many photographers the opportunity of rendering broad effects, selected or diminished details, and choices of color. As the German critic F. Matthies-Masuren, commenting on the work of the "Trifolium," phrased it toward the end of the decade, ". . . the gum bichromate process has provided photography with a technique which at last makes possible both greater decorative effects and the faithful reproduction of tonal relationships. Photography is thus now capable of providing a representation which is not merely a 'colorless mirror image of nature, produced by purely mechanical and physical means' . . . but rather images which are 'intellectual reworkings of nature.' "[5] For Kühn, a prolific writer on the theory of art photography himself, the photographer,

. . . must control nature. For it is now entirely within his power to translate colors into their monochromatic values; and if the negative should show any discord, the gum process enables him at will to attune the discordant elements in the print. . . . on the one hand, he can subdue or entirely suppress anything too prominent in the less important parts of the picture, while, on the other, he can emphasize all the subtleties where they are interesting and of importance for a pictorial effect. . . . The apparatus, the soulless machine, must be subservient, the personality and its demands must dominate. The craftsman becomes an artist.[6]

This nearly absolute separation of the photographic art print from the restrictions of optical realism customarily associated with photographs throughout the 19th century accorded well with the motto of the Vienna Secession, carved on the massive lintel of Josef Olbrich's Secession House in 1898: "To the Age its Art/To Art its Freedom."[7]

ANNE W. BRIGMAN

American · 1869–1950

Invictus

ca. 1907–11 · Gelatin silver print · 24.5 × 18.8 cm.

Late 19th-century Pictorialist photographers, in an almost universal attempt to elevate their medium to an elaborated tradition of fine arts, couched much of the language of their medium in terms that not only suggested a continuity with classical antiquity and tradition but literally transformed the history of art into modern photographic reprises. In this context, the work of Anne Brigman appears as no great surprise, and, like many of her contemporaries, she turned to historical themes that would transform the photographic subject beyond a base, everyday reality. Well received by the early Photo-Secession, of which she was a member, her work was described by Joseph T. Keiley in 1911: "Annie W. Brigman . . . seems to have sought to grasp the very soul of nature, and her entire collection is rhythmic with the poetry of nature, its bigness, its grandeur, its mystery. It is reminiscent of the Ovidean metamorphoses, and the 'Midsummer Night's Dream'—pervaded with a certain bigness of feeling that the splendor of our Western nature seems to infuse into the soul."[1]

Brigman's imagery is a concerted invocation to the theme of Apollo and Daphne, with the notable exclusion of Apollo. The suggestion, however, that the human spirit is one with nature and that the living forms of land and trees are mere transmutations of the human spirit and thus both divinely inspired are the same in both classical myth and modern photograph. According to a critic of the period, Brigman's prints were clearly anthropomorphic in meaning. "The figure, in its outline and the poise of the hand, has its own interest, while it gives a sense of mystery and poetry to a scene that would otherwise be quite uninteresting. The way in which the line of the figure blends into the light-tipped line of the first plane, helps the idea that here is

the genius of the mountain welcoming the dawn, an idea intensified by the heroic scale of the figure in comparison with the landscape setting."[2] Despite the fact that the vast majority of trees with which Brigman's nudes couple in symbiosis were cypress, the allusion intended could only have been to Daphne's transformation into a laurel to defy Apollo's amorous pursuit of her: ". . . a stiffness seized all her limbs; her bosom began to be enclosed in a tender bark; her hair became leaves; her arms became branches[;] her foot stuck fast in the ground, as a root; her face became a tree-top, retaining nothing of its former self but its beauty."[3] The sense of symbolic pantheism this myth satisfied also served the theme of universalism espoused by one of the Pictorialist's favorite authors, Maurice Maeterlinck, who wrote in his *The Intelligence of Flowers* of 1906 that flowers:

allow us to presume with greater confidence that the spirit which animates all things or emanates from them is of the same essence as that which animates our bodies. If this spirit resembles us, if we thus resemble it, if all that it contains is contained also within ourselves, if it employs our methods, if it has our habits, our preoccupations, our tendencies, our desires for better things, is it illogical for us to hope all that we do hope, instinctively, invincibly, seeing that it is almost certain that it hopes the same? Is it probable, when we find scattered through life so great a sum total of intelligence, that this life should make no work of intelligence, that is to say, should not pursue an aim of happiness, of perfection, of victory over that which we call evil, death, darkness, annihilation, which is probably only the shadow of its face or its own sleep?[4]

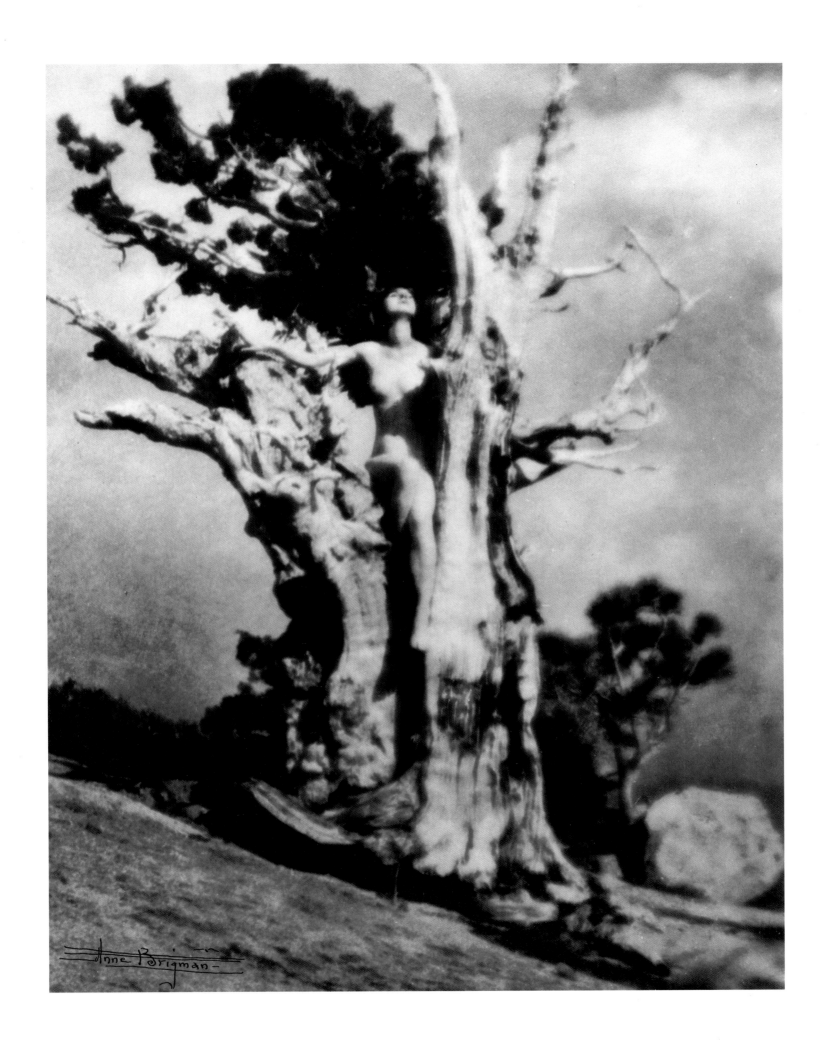

WILHELM VON GLOEDEN

German · 1856–1931

A Boy and a Child with Vases of Roses

1913 · Albumen print · 39.8 × 29.1 cm.

Classical antiquity (or at least a fiction of that antiquity) and the male nude (or at least a certain kind of fey, attenuated version of that nude) were appropriated and conjoined by a number of photographers at the close of the last century. Among many others, Gugliemo Fluschow, Baron Corso, F. Holland Day, and Count von Gloeden are the most remembered for their celebrations of male sensuality and homo-eroticism raised to high photographic art. Homosexuality in modern art, thinly disguised in the writings of Théophile Gautier and Charles Baudelaire and apparent in the poems of Walt Whitman, turned fully overt in the literature of Oscar Wilde, Jean Lorrain, and, slightly later, Marcel Proust; and one of the principal tactics for homosexual description or pictorialization was to clothe the subject in the theater of the antique. The Parnassian poems of Lorrain, for example, evoked equally the female types of Salome and Helen of Troy as they did the charms of youthful Greek heroes such as Hylas and Narcissus. Painting and sculpture of the last two decades of the century were similarly invested with masculine ideals of beauty, found repeatedly in the work of such artists as Frederick Leighton, Hans van Marees, and William Bouguereau and most frequently in the form of Greek gods, athletes, and satyrs. "Thus, breaking with varying degrees of openness and brutality through the embargoes hitherto placed by convention and decorum on subject of a sexual nature, the decadent imagination found in eroticism new ways to abandon itself to prohibited or seductive reveries, ways along which it was tempted to venture even further by the fact that it was ultimately only playing a purely cerebral and inward game: a revenge of the imagination against the steadily hardening constraints of bourgeois respectability in fin-de-siècle France and late Victorian England alike."[1]

Vested as they were in Christian legend, the martyred St. Sebastians and crucified Christs posed and photographed by F. Holland Day during the 1890s were only slightly risky. The antique visions of young boys and male children photographed in Taormina, Sicily, by Wilhelm von Gloeden are by contrast without any narrative validation save their vague allusions to classical garb and pose, but that was seemingly sufficient to accord them acceptability and immense popularity. According to one critic of the period, "Count von Gloeden, who has perhaps made a greater success of the nude in photography than any one else, has for his backgrounds the antique and classic scenery of his Sicilian hills. There, amid the ruins of amphitheatres, fountains, and terraces, overlooking an exquisite bay, with an old town on the hills sloping to the water, his young figures, whether draped or undraped, for the most part look as natural as if in a painting of the classic age. They suggest pictures by Jerome [sic] or Alma Tadema. . . ."[2]

A confirmed homosexual, Von Gloeden established his modern "Hellas" in Taormina, a somewhat isolated town in the 1880s that had recently been "discovered" by a friend, the German painter Otto Geleng. From around 1889 to the start of the first World War, Von Gloeden photographed native boys and young men, sometimes draped with quasi-antique robes but most often completely nude, with such sensual passion as to create a pictorial world "at the same time real and unreal, realistic and immensely false, an anti-oneiric world, the maddest of dreams."[3] Prints from his thousands of negatives were widely distributed to European and American collections, and visitors to his studio included Edward VII of England, Richard Strauss, Oscar Wilde, Eleanora Duse, Gabriele d'Annunzio, Anatole France, and Friedrich Alfred Krupp. A number of his street scenes and portraits of Sicilian "types" were even published in *The National Geographic Magazine* in 1916, lent to that periodical by Mrs. Alexander Graham Bell.

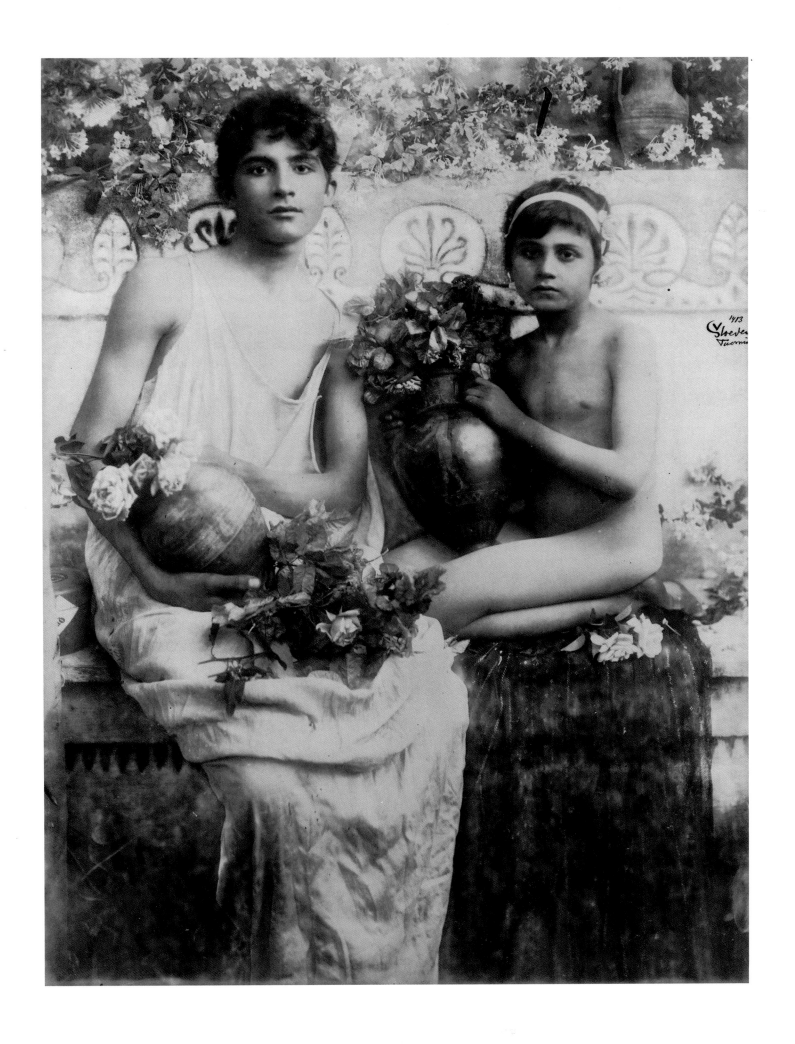

PAUL LEWIS ANDERSON

American · 1880–1956

Branch Brook Park

1911 · Platinum print · 20.1 × 14.8 cm.

Recognizing that composition was the only portal through which the new candidate for art recognition could gain an entrance into the circle of Art, the single effort of the past photographer, viz.; the striving for detail and sharpness of line, has been relegated to its reasonable place. A comprehension of composition was found to demand the knowledge of a score of things which then by necessity were rapidly discovered, applied and installed. Composition means sacrifice, gradation, concentration, accent, obliteration, replacement, construction of things the plate does not have, destruction of what it should not have. Supplied with such a magician's wand no effect was denied: all things seemed possible. [1]

The keynote to Pictorialist photography, as expressed by the art critic Henry Poore, was simply the construction of the picture, the visual composition of pictorial effect as prescribed by taste and the rules of harmony and balance, symmetry and dynamics. Following the earlier art writings of John Burnet, Henry Peach Robinson, and Arthur Wesley Dow, Poore outlined the formal basis for photographic pictorialism in the early 20th century.

Paul L. Anderson adopted Poore's theory of composition and developed it into a strictly photographic program, explained in his numerous books and articles and demonstrated in his widely acclaimed and popular photographs. Because ordinary or "straight" photography was tightly restricted in what it could express, Anderson believed that it "must be classed as the lowest of the fine arts, if, indeed, it can claim admission to their com-

pany at all." [2] For Anderson, artistic photography was both intellectual and emotional, nearly limitless in what it could achieve or express, and fully able to contend with the two elements of advanced art, mystery and suggestion. "It is impossible to place any definite limit to the emotions expressible by photography, for they include practically if not absolutely all that can be expressed by any graphic medium." [3] Like Poore, Anderson saw composition as the foundation of pictorial art. Like Poore and other Pictorialist photographers of the period, such as Gertrude Käsebier, Alvin Langdon Coburn, and Joseph T. Keiley, Anderson found significance in Arthur Wesley Dow's adaptation of the Japanese aesthetic of "notan." Flattened perspectives, contrasts of dark and light, equal weight given both positive and negative areas, and graceful orchestrations of sinuous lines all contributed to the picture's suggestiveness and sense of mystery.

Without suggestion and mystery, the picture was, for Anderson, too literal, too prosaic, and too devoid of meaningful association: ". . . mystery consists in affording an opportunity for the exercise of the imagination, whereas suggestion involves stimulating the imagination by direct or indirect means. Suggestion, if successful, is always to be preferred to delineation, simply because the spectator, grasping the artist's unexpressed idea, experiences a glow of self-satisfaction." [4] *Branch Brook Park* is not a record of any specific location as much as it is an evocation of a dreamscape. It is a romantic landscape, suggestive of tension and anticipation, an unsettling vision in which distance is more vertical than deep, and a hauntingly isolated figure casts an equally solid shadow recalling certain Surrealist paintings.

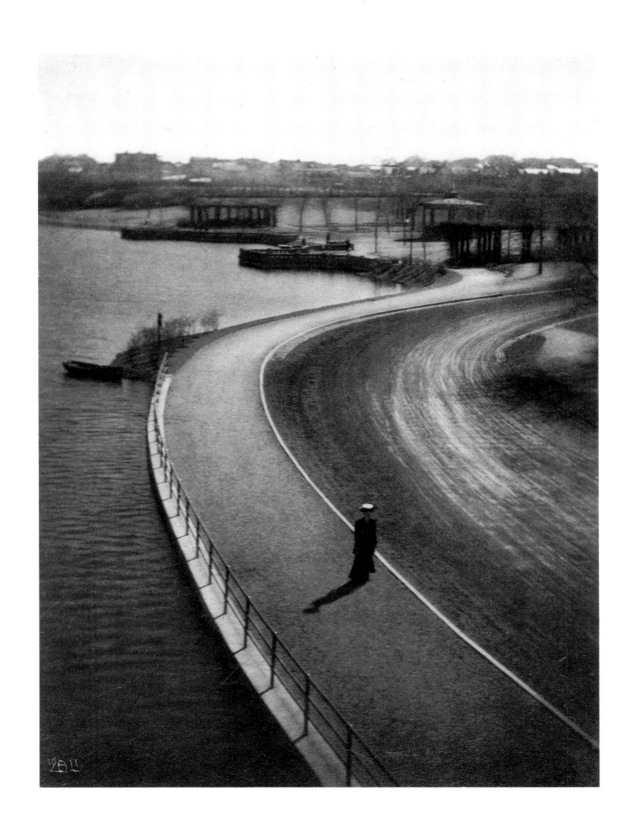

CHARLES SHEELER

American · 1883–1965

Bucks County House, Interior Detail

ca. 1914–17 · Gelatin silver print · 24.2 × 16.2 cm.

Although a photographer since 1912, Charles Sheeler wrote as late as 1923 that the persistent question was still in evidence: "how long before photography shall be accorded an importance not less worthy than painting and music as a vehicle for the transmission of ideas?"[1] A painter by inclination, Sheeler studied at the Pennsylvania Academy of the Fine Arts under the direction of artist William Merritt Chase. About 1912, in order to earn a living, he took up photography and specialized in architectural subjects and the documenting of artworks for galleries and artists. From his student days, Sheeler was a close friend of another painter-photographer, Morton Schamberg, with whom he traveled to Paris and Italy and shared studio space in Philadelphia. Around 1910–11, the two artists began sharing a small frame house in Doylestown, Pennsylvania; it was this house that Sheeler photographed on a number of occasions and in differing aspects until he exhibited these prints at Marius de Zayas's Modern Gallery in New York in 1917. By that date, Sheeler had already exhibited a number of paintings at the infamous Armory Show in 1913, had met Alfred Stieglitz, and was a part of the circle of avant-garde artists that formed around Walter and Louise Arensberg, including such European artists as Marcel Duchamp and Francis Picabia.

Throughout Sheeler's career as an artist, painting and photography functioned separately but symbiotically; and while many of his photographs were distinctly commercial images, many others were relentlessly personal, both in terms of their expressive qualities as well as their use as traditional *aides-mémoire* for the artist's paintings, which often were transformations of the photographic image into the medium of paint. Sheeler's favored photographic subject was architecture, and his photographs of architectural form are compressed, carefully studied orchestrations of textures, geometries, and flattened pictorial spaces. Drawn to an essentially Cubist formalism in his painting, as was his friend Schamberg, Sheeler selected his architectural subjects as much for their purely visual characteristics as for their content.[2] Whether the side of a Pennsylvania barn, the simple interior of his weekend house in Doylestown, the medieval buttressing of Chartres Cathedral, or the mechanomorphic shapes of modern industry or steamship machinery—Sheeler's studies were a blend of nearly Shaker austerity and streamlined precisionism.

There is reason to suspect that Sheeler's later fascination with mechanical and industrial forms was in part due to the earlier example of Picabia, whose mechanomorphic "portraits," including those of Stieglitz and de Zayas, were published in the journal

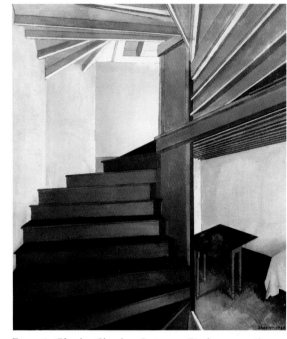

Fig. 56. Charles Sheeler, *Staircase, Doylestown*, oil on canvas, 1925, Hirshhorn Museum and Sculpture Garden, Smithsonian Institution.

291 in 1915. And it may well be that Sheeler's numerous photographs and many later paintings of staircases were prompted by one of the most controversial paintings of the decade: Duchamp's *Nude Descending a Staircase* of around 1913 that was exhibited at the Armory Show. Not only Sheeler [fig. 56] but other American artists of the teens and twenties, such as painter Charles Demuth and photographer Tina Modotti, also discovered the staircase's choice potential for exploration of Cubist form.[3] The very shape of a staircase, seen either head-on, from above, or from beneath, automatically presented a Cubist arrangement of interrelated planes and shadows where positive and negative forms suffered a dynamic ambivalence and where space was more signified than represented. The poet William Carlos Williams later wrote, "Driving down for illumination into the local, Sheeler has had his Welsh blood to set him on. . . . the Shakers express the same feeling in maple, pine and birch, pieces which Sheeler out of admiration for what they could do with those materials keeps about him. . . . for the artist, for Sheeler as an artist, it is in the shape of the thing that the essence lies."[4]

MORTON LIVINGSTON SCHAMBERG

American · 1881–1918

City Rooftops

1916 · Gelatin silver print · 22.8 × 15.2 cm.

Photography, by the very nature of the process, has lent itself to a number of themes and subjects that seem to have been, if not unique within the history of pictures, at least rather special. One of these themes, the rooftop view, is among the the most hallowed and one of the oldest. Nièpce's earliest extant experiment in photography is of this subject, as are certain early pictures by Daguerre, Hippolyte Bayard, and Fox Talbot. Commenting on his view of the rooftops of Paris in 1844, Fox Talbot stated: "A whole forest of chimneys borders the horizon; for, the instrument chronicles whatever it sees, and certainly would delineate a chimney-pot or a chimney-sweeper with the same impartiality as it would the Apollo of Belvedere."[1] Simple elevated views of the tops of buildings continued to appear in the work of Edouard-Denis Baldus, Samuel Bourne, and Frederick Evans until early in this century, when such views assumed the prominence of artistic innovation in the photographs of Alvin Langdon Coburn and of a poetic naturalism in prints made by Alfred Stieglitz and the photographers who were associated with him and his gallery.

For Stieglitz, the view out of the window, looking out or down, was a confirmation that the artist's vision could find significance in the most ordinary and simplest of subjects. The American writer Harold Clurman later wrote of these images.

> This picture of New York is simply the landscape that Stieglitz photographs by focusing his camera outside the window at Madison Avenue and Fifty-third Street. And since Stieglitz is the kind of artist who finds all his subjective intuitions embodied objectively in his immediate surroundings, so that we are never quite sure whether his photographs are "merely" factual records or entirely personal interpretations, we may justifiably conclude that these photographs represent what Stieglitz feels as he looks out from An American Place as well as what actually exists.[2]

Very much the same could be said for this photograph Philadelphia-born painter and photographer Morton Schamberg made four years after Coburn's *The House of a Thousand Windows* and less than a year after Stieglitz began his series of photographs entitled *From the Back Window, "291."*

Fig. 57. Paul Strand, *Photograph—New York [City Backyards]*, photogravure print, 1916, from *Camera Work*, 48 (October 1916), pl. IV.

Working out of tradition that was as much indebted to Dada as to Cubism, Schamberg used his camera as an instrument in the investigation of seeing and the sense of form. This image is not a documentary view out of a rear window; frankly, in terms of content, the most important element may be the sleeping cat atop the porch roof, the rest mere backdrop. In fact, however, the cat is incidental and the content of the print need not be invoked in order to appreciate what is pictorially achieved, for what is signified is vision at the expense of subject and understanding of the emotional organization of seeing. Schamberg, like Paul Strand at the same time [fig. 57], was demonstrating what Marius de Zayas had said in 1915 concerning pure photography: "If modern plastic expression has made us conceive the possiblity of creating new forms to express new sentiments, photography . . . has succeeded in determining the objectivity of form, that is to say, in obtaining the initial condition of the phenomena of form, phenomena, which under the domain of human thought give birth to emotions, sensations, and ideas."[3]

ALVIN LANGDON COBURN

American · 1882–1966

Vortograph of Ezra Pound

ca. 1917 · Gelatin silver print · 20.2 × 15.5 cm.

The photography of Alvin Langdon Coburn is integrally linked to the ideas of modernism. A second cousin to the American Pictorialist F. Holland Day, Coburn traveled to London and Paris at the turn of the century where he met Eduard Steichen and Robert Demachy. He was a member of The Linked Ring in Great Britain and the Photo-Secession in New York, and friends with Clarence White, Gertrude Käsebier, and Alfred Stieglitz. He experimented with platinum and gum-bichromate printing, and often combined both for rich tonal effects. In 1904, his first portfolio of gravures appeared in *Camera Work*, and, later that year, he began photographing literary notables in London, a project that would eventually result in the publication of thirty-three portraits as *Men of Mark* in 1913. Before that date, however, Coburn had illustrated the complete works of Henry James (1908), H. G. Wells's *The Door in the Wall, and Other Stories* of 1911, and had issued two volumes of original photogravures, *London* in 1909 and *New York* in 1910. Anticipating the Russian Constructivists such as Alexander Rodchenko by some years, Coburn photographed near-abstract views of New York from greatly elevated positions in 1912; and anticipating Stieglitz's "Equivalents" of the early 1920s, he contributed six original platinotype prints of cloud studies for a limited edition publication of Shelley's *The Cloud* in 1912. His work was praised by the likes of George Bernard Shaw and art critic Charles Caffin, and in 1917 by the poet Ezra Pound.

Anonymously contributing the preface to a catalogue of Coburn's paintings and new photographs, Pound wrote that from then on, "the camera is freed from reality . . . Vorticism has reawakened our sense of form, a sense long dead in occidental artists. . . . [Vortography] stands infinitely above photography in that the vortographer combines his forms *at will*."[1] Pound christened Coburn's new abstractions "vortographs" and the triangular arrangement of three facing mirrors, whose multiple, fractured, and patterned reflections were captured by the photographer, a "vortescope." Both Pound and Coburn were connected to the British "Vorticists," an avant-garde art group centered on the artist Wyndham Lewis that attempted to merge the principles of Italian Futurism and Cubism into a new style. Breaking ranks with traditional Pictorialism in 1916, Coburn pointed to the examples of Matisse, Stravinsky, and Gertrude Stein and declared:

> why should not the camera also throw off the shackles of conventional representation and attempt something fresh and untried? Why should not its subtle rapidity be utilised to study movement? Why not repeated successive exposures of

Fig. 58. Alvin Langdon Coburn, *Vortograph of Ezra Pound*, gelatin silver print, ca. 1917. Bequest of Alvin Langdon Coburn.

an object in motion on the same plate? Why should not perspective be studied from angles hitherto neglected or unobserved? Why, I ask you earnestly, need we go on making commonplace little exposures of subjects that may be sorted into groups of landscapes, portraits, and figure studies? Think of the joy of doing something which it would be impossible to classify, or to tell which was the top and which the bottom![2]

Although Pound championed Coburn's vortography over ordinary photography, he felt that it stood below the other "vorticist arts" since it was made only by the eye of the artist and not his eye and hand together. In a letter dated the same year, Pound wrote that "the vortescope isn't a cinema. It is an attachment to enable a photographer to do sham Picassos. That sarcastic definition probably covers the ground."[3] Still, Pound posed for at least eight different vortographs before Coburn abandoned this form of abstract photography [fig. 58] and was the only human subject Coburn "vortographed."

FRANTISEK DRTIKOL

Czechoslovakian · 1883–1961

Portrait of an Unidentified Woman

1922 · Gelatin silver print · 26.8 × 16.1 cm.

Best known for his spectacularly theatrical studies of the female nude [fig. 59], Drtikol was also an accomplished photographer of landscapes, still lifes, and portraits. Having studied photography at the Munich Lehr- und Versuchsanstalt für Photographie in 1901,[1] he had fully formed his poetic sense within the context of *fin-de-siècle* Secessionism, a blending of Art-Nouveau decorativeness, psychosexual symbolism, and expressionism. The photographic climate in which he developed was that of Northern European Pictorialism, and undoubtedly he was familiar with the work of such masters as Heinrich Kühn, Robert Demachy, and Constant Puyo. In 1910 he and his companion Augustin Škarda established a portrait gallery in Prague; soon after, successful and quite fashionable, he began exhibiting his artistic photography internationally. Following three years in the Hungarian army during World War I, he returned to Prague and photography. During the 1920s, he patented a process of semitone photolithography, married the dancer Ervína Kopferová, and gained critical acclaim in Paris through exhibitions and the publication of his portfolio of photogravure prints *Les nus de Drtikol*. According to a Parisian journal of the period, Drtikol was "one of the greatest artists of our time."[2] In 1935, he gave up photography for philosophy.

Throughout Drtikol's work, photographic Pictorialism is evolved through the fashions of style—from the early tableaux of wan, pensive, and vaguely allegorical females to the later photographs of nudes cavorting amidst large geometric forms and sharply defined, elemental shadows. Just as Art Deco architecture was essentially no different from Beaux-Arts buildings except in its decorative veneer, Drtikol's later nudes were fundamentally the same as the nudes photographed by Puyo or René Le Bègue during the 1890s except in the mathematical rigidity of the sets and lighting. They still remain pictorial pin-ups of ideal, feminine beauty, as seen by a male artist, decorative and suggestive of a wide variety of meanings, ranging from maternal purity and vestal virginity on the one hand to erotic fantasy and vampirism on the other.

In Drtikol's portraits, however, the figure is frequently treated in a far more profound manner. The gesture and pose of the

Fig. 59. František Drtikol, *Nude Study*, gelatin silver print, ca. 1929. Gift of Mrs. Alexander Leventon, Rochester, NY.

subject, its carefully adjusted details, how it is dominated by the often strident, dramatic light, and just how it controls the photographic space—everything is manipulated toward a single end: a formal likeness that is at once pictorially expressionistic and psychologically charged. Stylishly attired in a Vienna Werkstätte-designed or inspired dress, the subject of this portrait is revealed as a controlled, mediated intelligence of regal elegance and bearing, merging warmth and charm with an independent otherness. What is new in this kind of portrait is the positioning of the sitter within such a vast, empty space. The full darkness of the background assumes a ponderous and substantial weight under which the refinement of the woman seems somewhat mysterious and haunting. We are reminded of the Surrealist poet André Breton's comment, made at a conference in Prague in 1935, that, "Prague, adorned by legendary seductions, is in effect one of those sites which electively fixes poetic thought, always more or less adrift in space. . . . the magical capital of old Europe."[3]

EDWARD HENRY WESTON

American · 1886–1958

Ruth Shaw

1922 · Gelatin silver print · 18.8 × 24.0 cm.

It would be difficult to deny that the work of Edward Weston has had the single most influential effect on the course of 20th-century photography. Stieglitz may have set the tone and established the ideological foundations of modern photography, and Man Ray may very well have moved the frontiers of experimental photography forward, but it was Weston, through the example of his photographic prints, who commanded that the absolute perfection of photographic beauty be attended to as it served the ideals of natural form and classical expression. For Weston, photography could only be tied to obdurate fact and material form, whether man-made, as in the towers of a steel factory or toilet bowl, or a part of nature, as in a nude, a chambered nautilus, or a rocky landscape at Point Lobos, California. Artistic expression resulted directly from an inordinate technical mastery of unadulterated process, and was an indirect result of personal vision and emotional, sensuous passion. "*One must feel definitely, fully, before the exposure,*" he wrote in 1930.[1] But, for Weston, these expansive feelings were to be tempered by a far greater understanding of nature; for, as he wrote in 1932, "*Fortunately, it is difficult to see too personally with the very impersonal lens-eye: through it one is prone to approach nature with desire to learn from rather than impose upon, so that a photograph, done in this spirit, is not an interpretation, a biased opinion of what nature should be, but a revelation,—an absolute, impersonal recognition of the significance of facts.*"[2]

Prior to Weston's complete advocacy of a photography that was "direct, honest, uncompromising,"[3] and before he turned exclusively to printing on glossy and relentlessly photographic papers, he was a commercial portraitist partially indebted to Pictorialism who, while not disposed to painterly effects or technical manipulations, favored the softer tonalities and surface qualities of platinum and chlorobromide papers. His portrait of the concert pianist Ruth Shaw was made in Glendale, California, the year before Weston temporarily expatriated to Mexico City, and, according to Ben Maddow, only a few weeks before he traveled east where he photographed his now famous views of the plant and stacks of the American Rolling Mill Co., "Armco," a series that marked the turning point of Weston's career from pictorialism to a more objectified modernism.[4]

Even in this early print, however, Weston's particular strengths as a photographic artist are apparent. Much more than a portrait, *Ruth Shaw* is a concise and expressive study of form and a

Fig. 60. Edward Weston, *Guadalupe Marín de Rivera*, gelatin silver print, 1924.

thoroughly cubist analysis of graphic dynamics. Two years later, in Mexico, Weston photographed Nahui Olín, Guadalupe Marín de Rivera [fig. 60], and Tina Modotti, and while these portraits are quite different in feeling from that of Ruth Shaw, they all share Weston's penetrating vision of abstract form and the visualization of dramatic effect anticipated by the earlier picture. Nearly unique to Weston's work in its eccentric composition, *Ruth Shaw* is a transition work. For a moment during the early 1920s, Weston abandoned the obvious sentimentality of Pictorialism for a more energetic and precise articulation of the picture's formal properties. In a number of prints, which he called his "attic series," the model was subordinated to an overwhelmingly powerful background, positioned at the very edge of the picture or, as here, severely edited by the picture's frame. Here, also, the boldness of the graphic chevron at the top and the cutting off of the subject's head may have been occasioned by Weston's apparent hatred of Shaw, who had told his wife of his adultery.[5] Weston's mature work would bear slight resemblance to this print, and not until later in the decade, with German photographers like Lotte Jacobi and Max Burchartz, would such closely cropped, "modern" portraiture again appear.

PAUL EVERARD OUTERBRIDGE, JR.

American · 1896–1958

Piano

1924 · Platinum print · 11.5 × 8.9 cm.

Paul Outerbridge had studied at the Art Students League and the Clarence H. White school, and had only met Alfred Stieglitz before moving to Paris and the center of the artistic avant-garde during the late 1920s; yet these encounters with modern art seemed to have merely validated his already sophisticated vision and urged him toward a more openly estranged eroticism. Prior to his European trip, Outerbridge's experiences in working for *Vogue*, *Vanity Fair*, *Harper's Bazaar*, and other commercial accounts were the professional basis for his development as one of the finest precisionist photographers of this country. Undoubtedly influenced by the acutely formalist photographs of Paul Strand and Morton Schamberg and the ideas of Alfred Stieglitz concerning straight photography, and more than likely responding to the incursion of European art into America since the Armory show of 1913, Outerbridge eschewed the overwhelming mainstream of Pictorialist photography, such as was championed by White and Paul L. Anderson, for a modernist look based on geometric severity, clarity of forms, and an elegant organizational purity. About one of his early prints from the 1920s, one depicting a simple cracker box [fig. 61], Outerbridge wrote: "This abstraction created for aesthetic appreciation of line against line and tone against tone without any sentimental associations, utilizes a tin Saltine box, so lighted that the shadow and reflections from its highly polished surface produced this result. Note especially the gradation on the top of the box." [1] The uncompromisingly Cubist display of fractured space and faceted planes produced by the box and its shadows testifies to an exceptional imagination of control and order.

Similarly, Outerbridge approached an upright piano in as controlled and ordered a manner, not to record its essential form but to render an abstract harmony of reflected light and cast shadow. An oblique view, reduced to exquisitely subtle gradations of tones and only two dimensions, a flattened prospect as synthetically indicative of space as any Cubist painting of the

Fig. 61. Paul Outerbridge, Jr., *Saltine Box*, platinum print, 1922. Museum of Modern Art, New York, Gift of David H. McAlpin.

same era, it represented the piano, but only incidentally. Just as the Saltine box was only an excuse for pictorial form, the piano is also divested of any specific qualities of a musical instrument. What Marcel Duchamp had accomplished with a coffee grinder in 1911, Francis Picabia with a spark-plug in 1915, Schamberg with a mitre box and plumbing trap in 1918, and Paul Strand with a machine lathe in 1923, Outerbridge had now achieved with a piano—compelled the object to be seen in an utter singularity of abstracted pattern and form. As William Carlos Williams had written in his prologue to *Kora in Hell*, "The true value is that peculiarity which gives an object a character by itself. The associational or sentimental value is the false." [2]

JEAN-EUGENE-AUGUSTE ATGET

French · 1857–1927

Coiffeur—Avenue Observatoire

ca. 1926 · Gelatin silver print, toned · 18.0 × 22.4 cm.

The example of Eugène Atget's photography is momentous if not exactly understood. He may have been merely an industrious and tireless documentarian of Paris and its environs from around 1900 until his death in 1927, much as Charles Marville had been during the Second Empire, or it may be "that though Atget was a genius he took a good many dull pictures."[1] He may have been the culmination of everything photography aspired to in the 19th century, a one-man *Mission des monuments historiques*, or he may have been, as Ansel Adams once wrote, the first truly modern photographic artist whose pictures provoked, ". . . a point of view which we are pleased to call 'modern' and which is essentially timeless. His work is a simple revelation of the simplest aspects of his environment. There is no superimposed symbolic motive, no tortured application of design, no intellectual ax to grind. The Atget prints are direct and emotionally clean records of a rare and subtle perception, and represent perhaps the earliest expression of true photographic art."[2] To some, Atget was a careful chronicler of old and new Paris, who studiously, and without interpretation, classified its history by his photographs. To others, "the demeanor of his work—its air of rectitude and seriousness—and the quality in it of wonder and deep affection persuade us of Atget's untroubled faith in the coherence and logic of the real world. Poetic intuition was the means by which he served the large, impersonal truth of history."[3] Whatever the case, Atget, one of the most taciturn of recorded photographers whose most elaborated statement about his prints was that "they are only documents,"[4] quietly and with passionate deliberation created some of the most memorable images ever made by the camera, images of unquestioned truth and a perfect eloquence of vision.

Where Marville had documented the romantic Paris of cobbled, medieval street scenes, the Paris of Victor Hugo's novels, Atget recorded all of Paris: the romantically picturesque and the aristocratically elegant, its bourgeois shops and street peddlers, its melancholy parks and ephemeral entertainments, its courtyards and its doors, the landscape of its *banlieue*, and its most fashionable urban shops. It was as much the Paris of the Goncourts and Baudelaire as it was of Proust and Breton. In 1925, after nearly three decades of selling his photographs to artists, architects, and publishers, Atget was more revealed than discovered by his neighbor Man Ray who brought Atget's imagery to the attention of the French Surrealists and whose assistant Berenice Abbott was most responsible for the preservation of Atget's *oeuvre* after the artist's death. With probable misinterpretation of the meaning of his pictures, the Surrealists appropriated Atget's views of Paris and reproduced four of his prints in the June 15 and December 1, 1926, issues of André Breton's periodical *La Révolution Surréaliste*. As in this image, Breton found in Atget a profound sense of what Mallarmé had called the *irréal*, that sense of displacement and uncertainty often contained within the most commonplace of scenes or objects, and that sense of immateriality commemorated that same year by the poet Paul Eluard in his "The Mirror of a Moment."

> It disperses the day,
> It shows us the subtle images of appearance,
> It raises for us the possibility of being distracted.
> It is as hard as stone,
> The stone informs,
> The stone of movement and vision,
> And its brilliance is such that every weapon, every mask
> is corrupted.
> That which the hand has seized, disdains to even take the
> form of the hand,
> What has been understood no longer exists,
> The bird is confused with the wind,
> The sky with its truth,
> Man with his reality.[5]

244

EDWARD SHERIFF CURTIS

American · 1868–1952

Placating the Spirit of a Slain Eagle—Assiniboin

1926 · Photogravure print, printed by John Andrew & Son, Boston · From Edward S. Curtis, *The North American Indian, Being a Series of Volumes Picturing and Describing the Indians of the United States and Alaska*, Cambridge (Mass.), 1907–1930, XVIII, pl. 634. 39.5 × 29.2 cm. (image)

Edward Curtis's monumental documentation of the native tribes of North America cannot be viewed without consideration of two factors. First, that by the end of the last century it had become clear that American Indian culture was fast becoming homogenized with that of the continent's predominantly European population. Reviewing the first volume of Curtis's work to appear in 1907, the critic Sadakichi Hartmann wrote: "Walt Whitman, in his prose writings, expressed more than once his regret at the ultimate fate and extinction of this wild and beautiful race. . . . I perfectly agree that Mr. Curtis' undertaking is one that can not easily be repeated. The red savage Indian is fast changing into a mere ordinary, uninteresting copy of the white race."[1] Second, by 1898, the year Curtis began his massive project, the separate study of primitive art and material culture had been added to ethnography and anthropology. After initial attempts by historians of design during the 1860s, such as Gottfried Semper and Owen Jones, Franz Boas published his classic *Primitive Art* in 1927, the result of intensive field work with native American cultures begun well before 1900. Increased scientific interest in the arts of primitive peoples in general, and specifically those of the American Indian in this country, also had an effect on contemporary artists and photographers during the 1890s, both as formal models and as subject matter. Elias Goldensky, the Philadelphia Pictorialist, photographed Indians, and, in 1898, both Gertrude Käsebier and Joseph T. Keiley portrayed Sioux Indians from the Pine Ridge Indian Agency, not so much for documentary reasons as for their exotic features and pictorial value as primitive subjects [fig. 62].

Out of this context, Edward Curtis assembled the largest photographic documentation of the North American Indian ever achieved. Between 1898 and 1930, he produced a forty-volume work, comprised of twenty text volumes, including small gravure prints, and twenty portfolios of larger gravure prints. In all, 2,228 prints went into each set, of which 723 were folio gravures; and of the projected edition of 500, about half were finally issued at a price of $3,000. The project was initiated with the blessings of President Theodore Roosevelt and the financial sup-

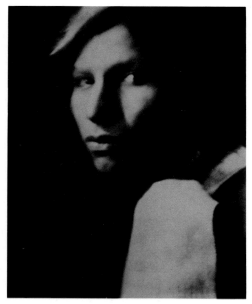

Fig. 62. Joseph T. Keiley, *Philip Standing Soldier*, cyanotype print, 1898.

port of J. Pierpont Morgan. In more than thirty years, Curtis photographed nearly every tribe and nation on the continent, ranging from the southern United States to Alaska and Canada. While his images documented the appearance of the Indian and his culture, architecture, and customs, Curtis's pictures are seldom neutral or candid. In nearly all, there is a sense of pictorial interpretation and staging that reflects the artist's wish to ennoble and dramatize, to capture the dignity and, most frequently, the picturesque quality of the primitive. The caption that accompanied this print of an Assiniboin Indian of Saskatchewan holding a dead eagle and a rattle reads:

For their feathers, which were used in many ways as ornaments and as fetishes, eagles were caught by a hunter concealed in a brush-covered pit. A rather elaborate ceremony took place over the bodies of the slain birds for the purpose of placating the eagle spirits.[2]

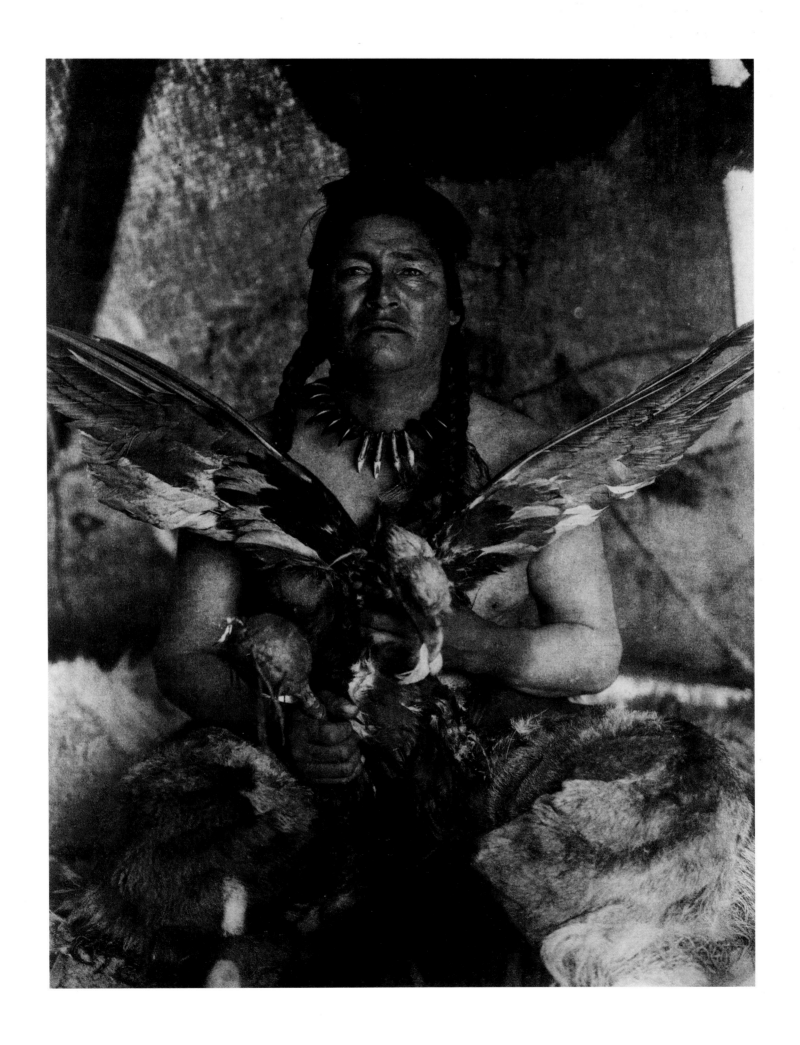

LASZLO MOHOLY-NAGY

Hungarian · 1895–1946

The Structure of the World

1927 · Photomechanical offset, rotogravure, pencil · 64.9 × 49.2 cm.

By the end of the 1920s, the aesthetics of photomontage had advanced so significantly as an art that certain critics could describe its formal evolution. With the Dadaists there had been a desire to compress as much pictorial material into the montage as possible in order to achieve virtual chaos and the idea of non-structure within the picture. With later artists such as Moholy-Nagy a greater expressive clarity was assumed. The art critic Franz Roh commented in 1929 that photomontage:

> ...took rise from futurism and dadaism, and has gradually been clarified and simplified. Photomontage, formerly a demolishment of form, a chaotic whirl of blown up total appearance, now shows systematic construction and an almost classic moderation and calm. How flexible, transparent and delicate is the play of forms in "Leda".... the fanciful of this whole species is not factorial fantasticality, as was a certain stage of cubism, where the simple world of objects was dissected into complicating structure, but an **object**-fantasticality in which from simple fragments of reality a more complex unit is piled up.[1]

The "Leda" Roh mentioned was Moholy-Nagy's *Leda and the Swan* of around 1925 [fig. 63], which was sub-captioned by Moholy-Nagy as "the myth inverted"[2] and in which an athletic woman is found swan-diving downward while beneath her the ruminating swan, quite unlike any alter-ego of Zeus, lies in wait.

In his Bauhaus book of 1925, Moholy-Nagy used the term *"fotoplastik"* instead of the more traditional "photomontage" so as to differentiate his own from earlier productions. "The cutting out, juxtaposing, careful arranging of photographic prints as it is done today is a more advanced form (photoplastic...) than the early glued photographic compositions (photomontage) of the Dadaists.... But not until they have been mechanically improved and their development boldly carried forward will the wonderful potentialities inherent in photography and film be realized."[3] It would be difficult to imagine just how simple mechanics could "improve" upon such large constructions as Moholy-Nagy's *Leda and the Swan* or *The Structure of the World* of a few years later, where the montaging of photographic elements was placed fully in the service of psychology and art. Later, in 1947, he wrote: "Photomontage—like superimposition—also attempts to develop a technique for the recordings of

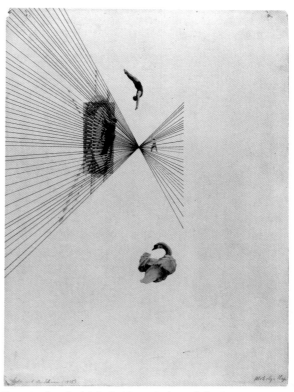

Fig. 63. László Moholy-Nagy, *Leda and the Swan*, "fotoplastik," ca. 1925.

events occurring on the threshold between dream and consciousness; a tumultuous collision of whimsical detail from which hidden meanings flash; visual poetry with bitter jests and sometimes with blasphemy.... The photomontage can be dramatic, lyrical; it can be naturalistic, abstract, etc. Here is a satirical montage making fun of the fright of the monkey and the quack-clacking super-geese (pelicans) who discovered the simplicity of the world constructed as a leg show."[4] There is some evidence that the incredulous "structure" of the world, as witnessed by the pelicans, is just as much a political and social statement as any of the montages of the Dadaists, and that, like John Heartfield, Moholy-Nagy was conscious of the use of photographic montage for other than purely visual effects. Unlike the Dadaists and Heartfield, however, Moholy-Nagy's rhetoric and meaning seem almost more poetic than revolutionary, more metaphoric than polemical.

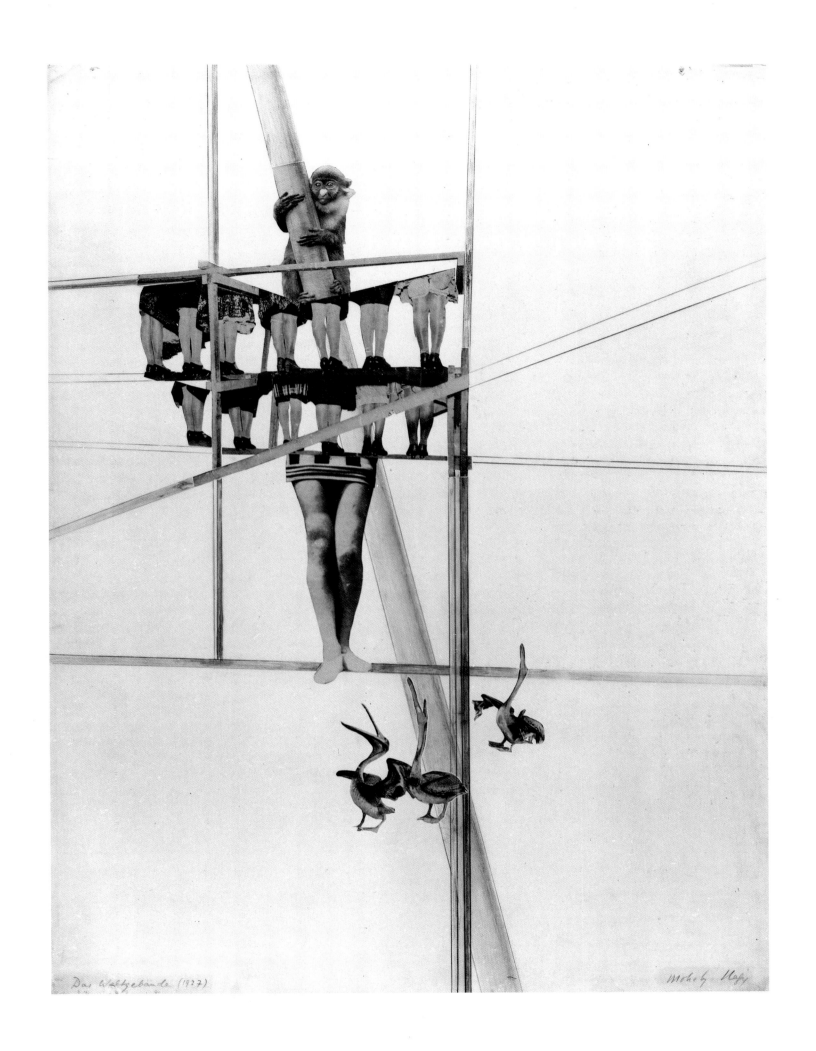

Das Waltzebande (1927) Moholy-Nagy

ALEXANDER MIKHAILOVICH RODCHENKO

Russian · 1891–1956

Portrait of the Writer Nicolai Asseev

1927 · Gelatin silver print · 15.6 × 22.5 cm.

Painter, sculptor, typographer, graphic artist, designer, photographer, and photomontagist, Alexander Rodchenko integrated nearly all of the visual arts into his productions. Photography and its service to the technique of montage was simply another tool, a utilitarian instrument for the fabrication of an explicitly modern vision, a vision as challenging and as optimistic as the new Soviet state. His paintings of the second decade of the century were explosive, dynamic, and vibrantly coloristic, and owed much to the pioneering nonobjective paintings and writings of Kasimir Malevich and Wassily Kandinsky. But while Kandinsky continued to refine and extend the limits of his painting at the Bauhaus and Malevich returned to figurative painting in the 1930s, Rodchenko was fully committed to the idea of the engineer/art-worker, which led him, in 1921, to a rejection of painting and sculpture in favor of industrial design, post-revolutionary graphics, worker's uniforms, and photography.[1]

Ossip Brik, an editor of the journal *LEF* (*Left Front of Art*), wrote about this new photographer:

> . . . some artists and painters do exist who have
> abandoned painting in favor of photography; people
> who already understand that photography has its mission,
> its aims, its own development. . . . What is needed is
> that these people somehow exchange their views, tell each
> other of their experiences, unite their powers in a common
> effort, a common battle against the painterly element in
> photography and towards a new theory of the art of
> photography which is independent of the laws of
> painting. . . . One of them is A. M. Rodchenko, once a
> brilliant painter, today a committed photographer. . . . His
> main task is to move away from the principles of painterly
> composition of photographs and to find other, specifically
> photographic laws for their making and composition.
> And this must after all interest everybody who does not
> see photography as a pitiable craft but as a subject of enormous
> social relevance, called upon to silence painting's chatter
> about representing life artistically.[2]

Rodchenko's answer to this task was to fashion a new language of photography, much as László Moholy-Nagy was doing in Germany at the same time. Exaggerations, distortions, vertiginous viewpoints, double exposures, disconcerting close-ups, dynamic tiltings of the camera, and bizarre perspectives were all adapted as the principal vocabulary of this progressive language [fig. 64].

Author of *The Steel Nightingale*, Nicolai Asseev was a poet and critic of the Russian avant-garde, and a friend of the futurist

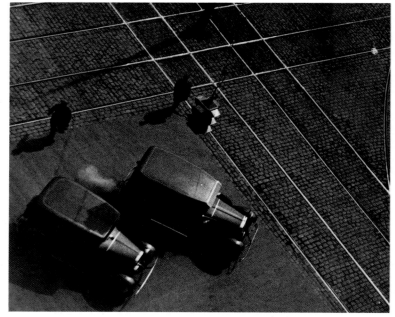

Fig. 64. Alexander Rodchenko, *City Street, Moscow*, gelatin silver print, ca. 1927-30.

poet Vladimir Mayakovsky who had founded the revolutionary journal *LEF* in 1923. In 1928, Mayakovsky, along with Asseev, Rodchenko, the artist Varvara Stepanova who was married to Rodchenko, and Ossip Brik, founded *REF* (*Revolutionary Front of Art*), in order to continue the ideological battles begun by *LEF*. This portrait of Asseev was taken then, at about the time of this artistic reorganization. Seemingly, Asseev's own work would have appealed to Rodchenko, for like him Asseev had discovered a new innovative language for poetry. As Ossip Mandelstam described him:

> He had created the vocabulary of a qualified technician.
> This is a poet-engineer, a specialist, a labor
> organizer. . . . What characterizes Asseev is that the
> machine, as an appropriated engine, forms the
> foundation of these verses which in no way speak of the
> machine. The lyrical current, sometimes divided, sometimes
> disconnected, gives the impression of a rapid combustion
> and powerful emotional shock. . . . He never poetizes,
> being content to turn on the lyrical current, like a good
> electrician who uses adequate materials.[3]

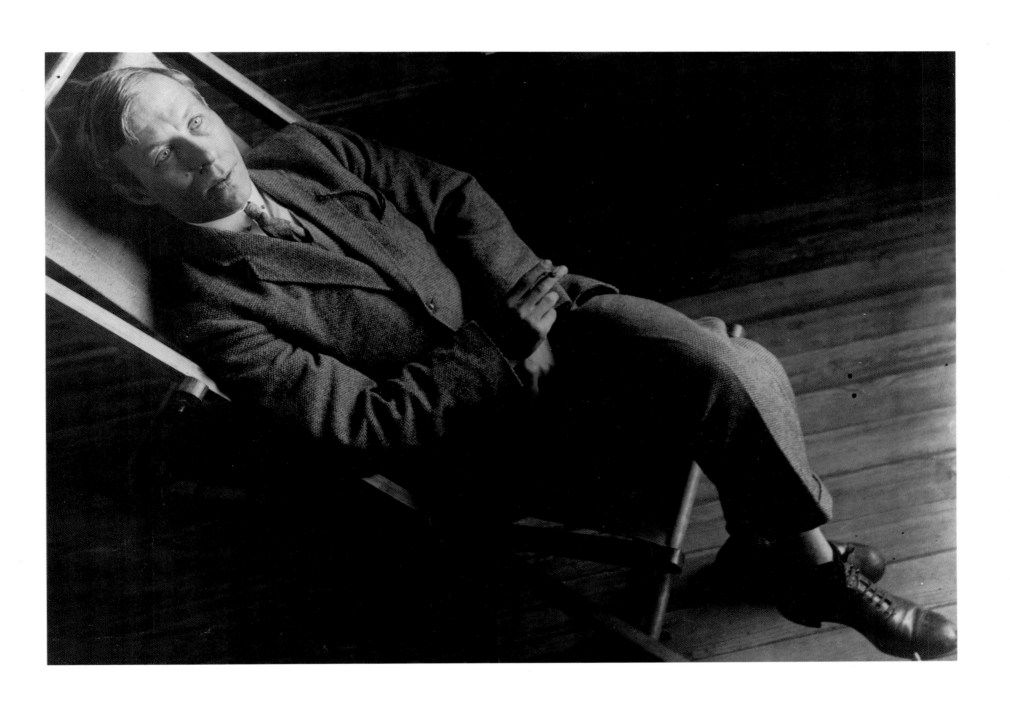

AUGUST SANDER

German · 1876–1964

Young Sport Pilot

1925 · Gelatin silver print · 20.5 × 14.6 cm.

Introducing the first published collection of Sander's photographs in 1929, Alfred Döblin, the author of the epic German novel of the common man *Berlin Alexanderplatz*, commented on the two great levelers of human faces: death and societal structures. For Döblin, there were as well three types of photographic portraits: the pictorial work of art, the individual likeness, and the sociological type-portrait. About the collection of Sander's pictures, he wrote:

> You have in front of you a kind of cultural history, better, sociology of the last 30 years. How to write sociology without writing, but presenting photographs instead, photographs of faces and not national costumes, this is what the photographer accomplished with his eyes, his mind, his observation, his knowledge and last but not least his considerable photographic ability. . . . this photographer has practised comparative photography and therefore found a scientific point of view beyond the conventional photographer. It is up to us to read the various interpretations of his photographs; on the whole the photographs are superb material for the cultural, class and economic history of the last 30 years. [1]

Döblin continued with an examination of the groupings of Sander's prints and concluded that since "men are shaped by their livelihood, the air and light they move in, the work they do or do not do, and moreover, the special ideology of their class," then photography not of particular individuals but of large numbers of social types contained a vast storehouse of information, and "he who knows how to look will be enlightened more effectively than through lectures and theories." [2]

When Helmar Lerski photographed the heads of ordinary people, he depicted his street sweepers, washerwomen, housemaids, beggars, and the unemployed as theatrically lighted, depersonalized monoliths expressive of fundamental human strength and passion. Sander, on the other hand, recorded many of the same types of people, but with an earnest deliberation of clinical disinterestedness that defied any traditional sense of the pictorial. Where Lerski could easily be seen in conjunction with early-20th-century Expressionism, Sander in part could be compared to that frame of 1920s modernism called *Die neue Sachlichkeit*, or the New Objectivity, to painters like Otto Dix and Christian Schad, and to other photographers like Albert Renger-Patzsch whose book *Die Welt ist schön* (*The World is Beautiful*) appeared a year before Sander's. With an impressively severe neutrality, Sander recorded the German society and its types in hundreds of photographs, arranged into groups designated by station or occupation, and constructed the first photographic taxonomy of a culture over the course of four decades.

Far more than simply picturing the world with optical clarity and mechanical precision, Sander graphed that world, charted the varieties of types within social groups, and created a pictorial structure of those types that reflected a demographic picture of social classes. During the 1920s, Sander was allied to the avant-garde circle of Cologne artists, the *Gruppe progressiver Künstler* (Progressive Artists Group), which included the artists Gerd Arntz and Franz Wilhelm Seiwert, who demanded an art of "collective informational signs." [3] Not only was the idea of a highly organized, schematic, and informational art shared by both Sander and this Marxist group of artists, but Sander's title to his first publication, *Antlitz der Zeit* (*Face of the Time*) appears to have been directly based on Seiwert's series of drawings *Sieben Antlitze der Zeit* (Seven Faces of the Time) of 1921, which also depicted workers, teachers, union leaders, soldiers, capitalists, and other social types. Sander's corpus of images was an abstraction more than a documentation, but an abstraction founded on the chilling realism of the camera's vision, and one that would later influence such dissimilar photographers as Diane Arbus and Bernhard and Hilla Becher.

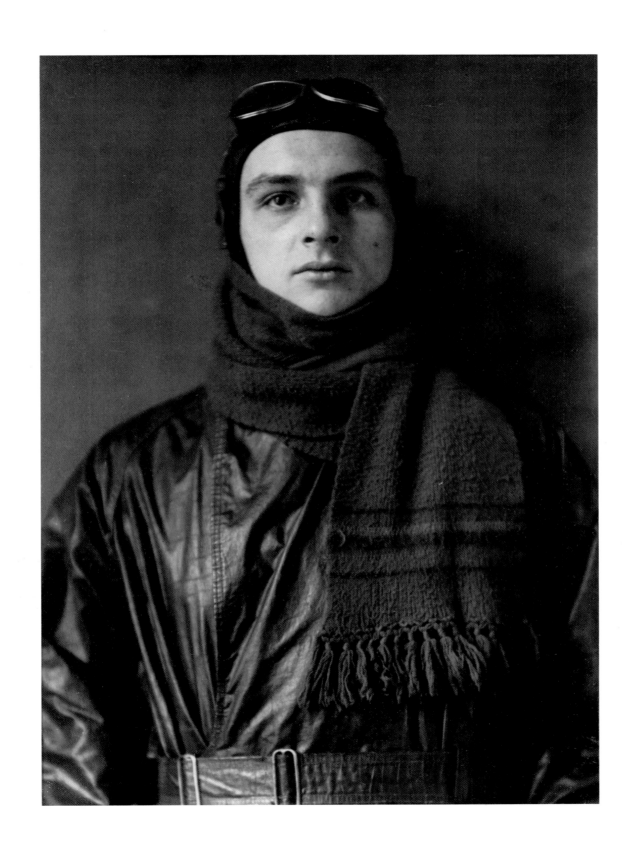

EDUARD [EDWARD] JEAN STEICHEN

American · b. Luxembourg · 1879–1973

Greta Garbo, Hollywood

1928 · Gelatin silver print · 42.2 × 33.9 cm.

Edward Steichen has had the most profound influence upon American photography of this century; and, more than that of any other modern photographic artist, his impact was not limited to a single style or application of the medium. A pioneering Pictorialist photographer at the turn of the century, Steichen was also a painter in Paris, a champion of the work of Brancusi, Matisse, Picasso, and Rodin, an advisor on contemporary art to Alfred Stieglitz, and one of the founders of the Photo-Secession. His straight photography of the 1910s was securely rooted in abstract formalism, as was that of Paul Strand and Charles Sheeler during the same years, and it was his advocacy of the formal beauties of the silver print that brought him in the following decade to the forefront of a photography that was eloquently direct and spectacularly seductive, a fundamental photography of human vision and monumental vigor. Working for publisher Condé Nast in the 1920s and 1930s, he singularly established modern advertising and fashion photography in New York; the latest in Parisian fashions were photographed by him for the pages of *Vanity Fair* and, later, *Vogue*, as were portraits of the most celebrated stars of Broadway, Hollywood, the literary and visual arts, politics, and society. He created the first serious streamline moderne or "art deco" photography in this country with his designs for printed fabrics during the mid-twenties, and brought a new kind of dramatic humanism to war documentation during the second World War. After the war, he was responsible for the creation of the Department of Photography at the Museum of Modern Art in New York, where between 1952 and 1955 he curated *The Family of Man* exhibition, the most attended and most persistent photographic exhibition in history.

Steichen took this portrait of Greta Garbo in Hollywood while the actress was on the set of the film *The Green Hat* in 1928. An improvised portrait studio was assembled next to the set and included as scenery and props only a wooden kitchen chair and Steichen's focusing cloth. During a ten-minute break from the film, Garbo quite unself-consciously straddled the chair backward and rested her arms on its back. Only her hair, styled for the film, bothered Steichen. "It was curled and fluffy and hung down over her forehead. I said, 'It's too bad we're doing this with that movie hairdo.' At that, she put her hands up to her forehead and pushed every strand of hair back away from her face, saying, 'Oh, this terrible hair.' At that moment, the *woman* came out, like the sun coming out from behind dark clouds. The full beauty of her magnificent face was revealed."[1]

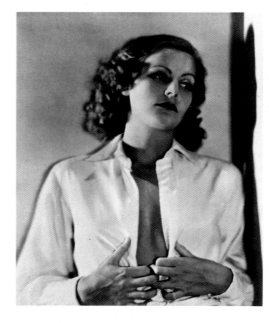

Fig. 65. Nickolas Muray, *Greta Garbo*, gelatin silver print, ca. 1929. Gift of Mrs. Nickolas Muray.

And at that moment one of the great iconic portraits of the 20th century was made, a portrait of tense perfection and passionate severity, revealing as much the unattainable ideal of this actress as her likeness. Few portrait photographs in history—some of Julia Margaret Cameron's or Alfred Stieglitz's come to mind—even approach the strength of engagement and human character captured here. Just how supremely simple and effective was the economy of Steichen's eye can be seen in comparison with a much more obviously studied, although sensitive, publicity shot of the same actress taken by Nickolas Muray at about the same time [fig. 65].

Alexander Liberman wrote of Steichen's art three decades after this image was taken: "To paraphrase Cezanne, a photographic law would be: 'When light is at its most revealing intensity, the subject should be seen at its most meaningful aspect.' This is not a question of the amount of light, but is truly a matter of revelation to the photographer. When does a smile catch the right amount of light—not so much that the smile becomes a grimace, not too little to lose its mystery? This balance of light and substance creates what may be called mood. In Steichen's case, mood is not a pictorial word; it means respect for the subject."[2]

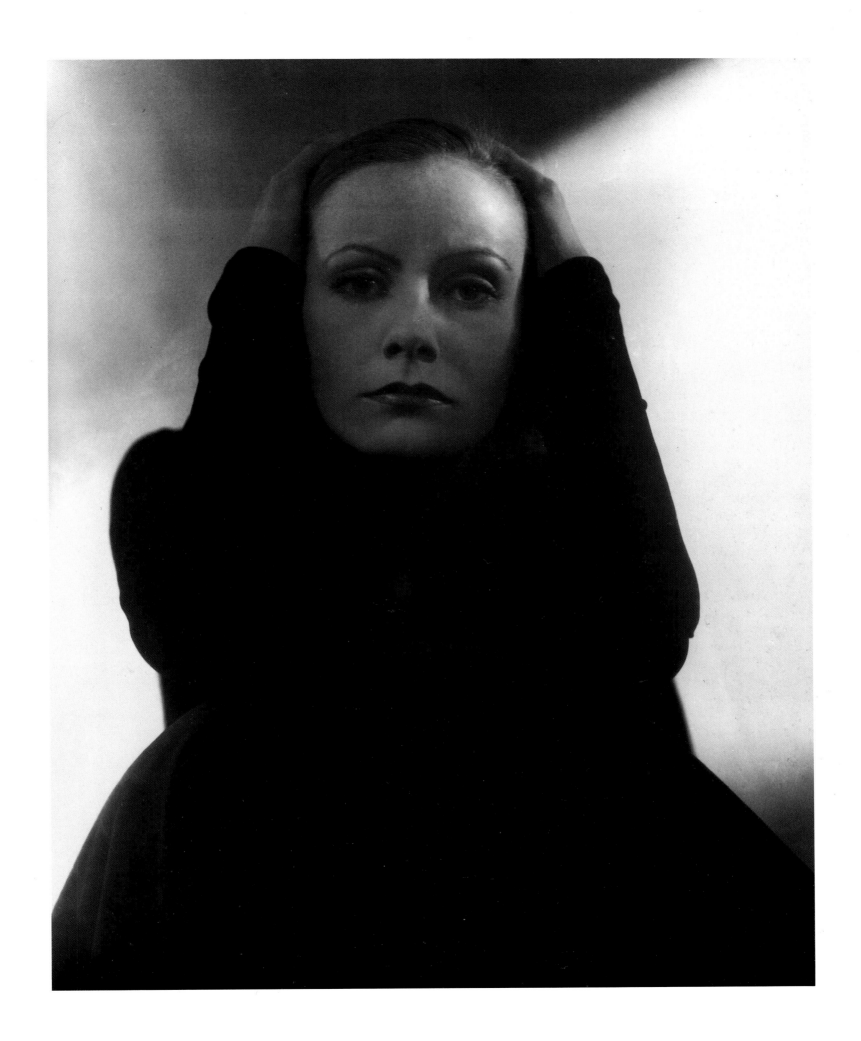

HELMAR LERSKI [ISRAEL SCHMUKLERSKI]

German · 1871–1956

German Housekeeper

ca. 1928–31 · Gelatin silver print · 28.6 × 23.1 cm.

Lerski's portraiture is essentially that of the stilled cinematic close-up of the 1920s. There are a number of filmic instances from that decade in which the human face assumes the proportions of the screen and is transformed into what comes close to landscape. The old woman on the Odessa steps in Eisenstein's *Potemkin* of 1926, the strike-breakers in Pudovkin's *Mother* of the same year, and especially the faces of Antonin Artaud and Maria Falconetti in Carl Dreyer's *The Passion of Joan of Arc* from 1929 are some more notable examples. And then there are the less familiar German films of the late teens and twenties, films by William Wauer, Robert Reinert, and Paul Leni, with their striking use of expressionistic lighting and facial close-up—films in which the cameraman achieved a "perfection in living portraiture . . . through his artistically and technically new usage and placement of light sources, which allow him to capture the human soul as reflected in the living reality of the face,"[1]—films that were photographed by Helmar Lerski. In his photographic portraits, Lerski even exceeded the formal conventions of the motion picture; the theatrical lighting, the framing and cropping of the face, and the forceful angularities defined an entirely new portraiture for still photography.

Lerski moved to Chicago in 1893, where he worked in various German-language theater companies there as well as in Milwaukee and New York. Disappointed with his career as an actor, he took up photography and, along with his first wife, opened a portrait studio in Milwaukee in 1910. His early work displayed a decidedly histrionic look, similar to the celebrity portrait styles of Pirie MacDonald and Elias Goldensky in the same years. Differing from others, however, Lerski was already placing his camera closer to the sitter's face, set against an utterly black background and modeled by severe raking light. Returning to Europe in 1915, Lerski worked for German filmmakers until 1928, when he again turned to portrait photography, photographing Berlin artists, intellectuals, actors, and politicians much as Hugo Erfurth had been doing in Dresden, but with a charged cinematic style.

Between 1928 and 1931, Lerski worked on a series of portraits, not of known personalities but of common German types: metalworkers, weavers, booksellers, cleaning women, revolutionaries, and the unemployed. Like August Sander, at precisely the same time, Lerski abandoned the personality for the human or social type. As Curt Glaser wrote in the introduction to Lerski's *Köpfe des Alltags* (*Heads of Everyday*): "People whom no one knows and who do not know themselves are the best subjects for this new, special type of photography. Those who play a significant part in life or on the stage, what are nowadays called 'personalities,' wear a mask when they come before the camera. . . . so Lerski uses as models people encountered in the street or hired from the labour exchange—believing as he does that everyone has a face, only one must make the effort to see it."[2] Lerski's portraits are those of Everyman, raised to monumental effect, not unlike what Alfred Döblin had done with the character of Franz Biberkopf in the novel *Berlin Alexanderplatz* of 1929.

Another critic of the period, Kenneth Macpherson, wrote of these portraits: "There is something that arrests in the so examinable detail of these heads, something almost telescopic, nearness that seems to be about to topple on you. They tell their own tale, there is stress without bias. Helmar Lerski . . . has made observation sensitive and illuminated, leaving finally, through the wilful drama of lighting and tonal quality, the faces to find, like water, their own level of expression."[3] Lerski's ultimate leveling of expression occurred in 1936, when he began a new series of photographs in Tel Aviv that consisted of 175 portraits of the same Jewish worker.

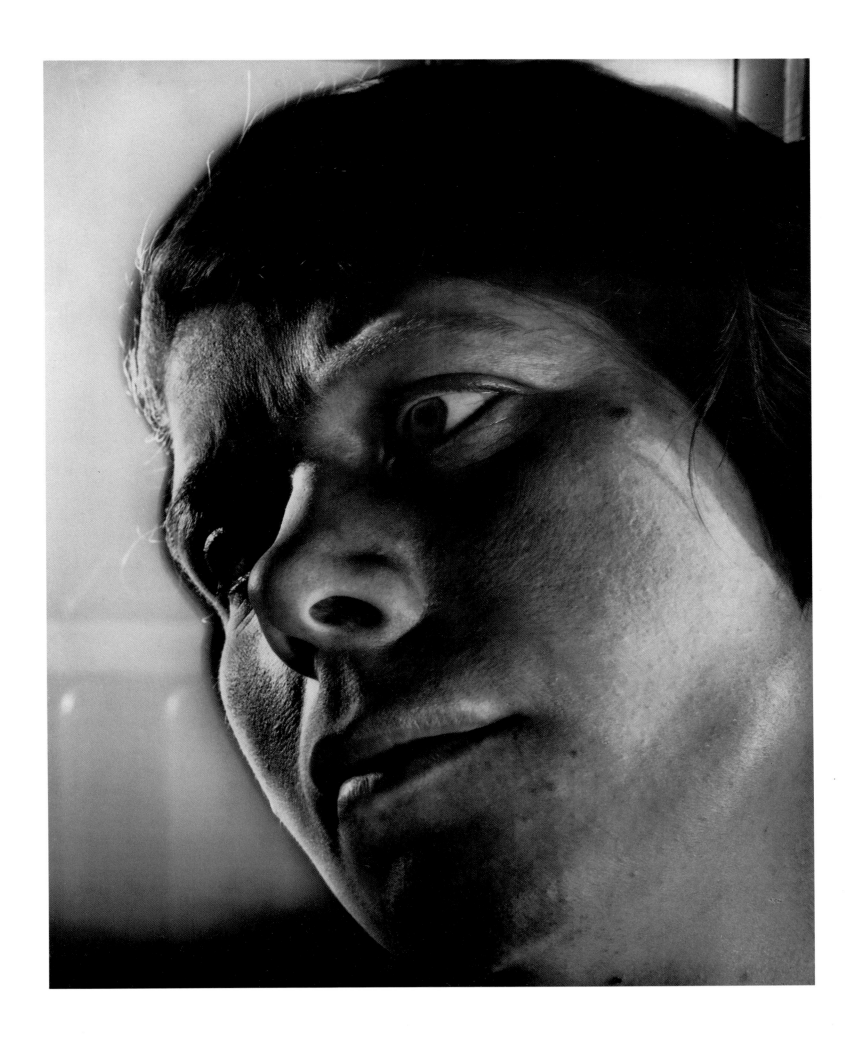

IMOGEN CUNNINGHAM

American · 1883–1976

Calla

1929 · Gelatin silver print · From series *Pflanzenformen*. 28.0 × 24.2 cm.

Although known primarily as one of the finest portrait photographers of this century, Imogen Cunningham photographed both natural and inanimate things throughout her career, and customarily invested these subjects with the same concentration and expressive interpretation of character she devoted to the human form and personality. Raised in Portland, Oregon, and Seattle, Washington, Cunningham began photographing at about the age of eighteen, worked for the portrait studio of Edward S. Curtis while attending the University of Washington, studied technical photography in Dresden in 1909, met Alfred Stieglitz and Alvin Langdon Coburn, and opened her own studio in Seattle the following year. By the end of the twenties, she had exhibited widely in the United States and had had ten prints shown at the famous Stuttgart exhibition *Film und Foto* of 1929, where her work was displayed along with that of Edward Weston, Charles Sheeler, Edward Steichen, and Berenice Abbott. Number 166 of that exhibition's catalogue, entitled *Calla*, may very well have been this particular image.[1] In 1932, she joined with Ansel Adams, John Paul Edwards, Sonya Noskowiak, Henry Swift, Willard Van Dyke, and Weston to form Group f.64, and shared with them the belief that the "greatest aesthetic beauty, the fullest power of expression, the real worth of the medium lies in its pure form rather than in its superficial modifications."[2] In an early statement of her artistic position, Cunningham wrote: "Photography began for me with people and no matter what interest I have given plant life, I have never totally deserted the bigger significance in human life. As a document or record of personality I feel that photography isn't surpassed by any other graphic medium."[3]

It would be as difficult to avoid the near-human associations and ultimate sensuality found in her portraits of calla lilies as it would to ignore the role played by plant forms in artistic photography during the 1920s. Edward Steichen had already photographed waterlilies in 1915, and had continued with floral forms during the following decade, intimately depicting sunflower blossoms, begonias, and foxgloves. In 1928, Albert Renger-Patzsch published his *Die Welt ist schön* (*The World is Beautiful*), in which numerous plant studies were pictured with a hygienic precision that emphasized the strictly formal values of subject and image

Fig. 66.
Albert Renger-Patzsch,
Heterotrichum Macrodum,
gelatin silver print, 1922.
San Francisco Museum
of Modern Art,
The Helen Crocker
Russell and William H.
and Ethel Crocker
Family Funds Purchase.

through sharply focused macrophotography [fig. 66]. In the same year, Karl Blossfeldt's *Urformen der Kunst* (published in London as *Art Forms in Nature*) appeared, in which the camera was used to reveal the almost microscopic shapes and designs of natural plant forms, which were then compared to various historical styles of art. At the *Film und Foto* exhibition, Weston had exhibited a number of eloquent studies of cypress and juniper tree trunks, and another Carmel photographer, Roger Sturlevant, had shown a print entitled *Plant Form with Glass*. In the preface to Renger-Patzsch's book, the writer asks: "...like the botanist—the photographer isolates the characteristic fragment from the multiplicity of the whole, underlines the essential elements and eliminates that which could lead to a deconcentration into the complexity of the whole. He captures the observer's attention and directs it to the strange beauty of organic growth."[4] Cunningham's *Pflanzenformen* of the late 1920s shared much the same motivation and interest in the "strange beauty of organic growth."

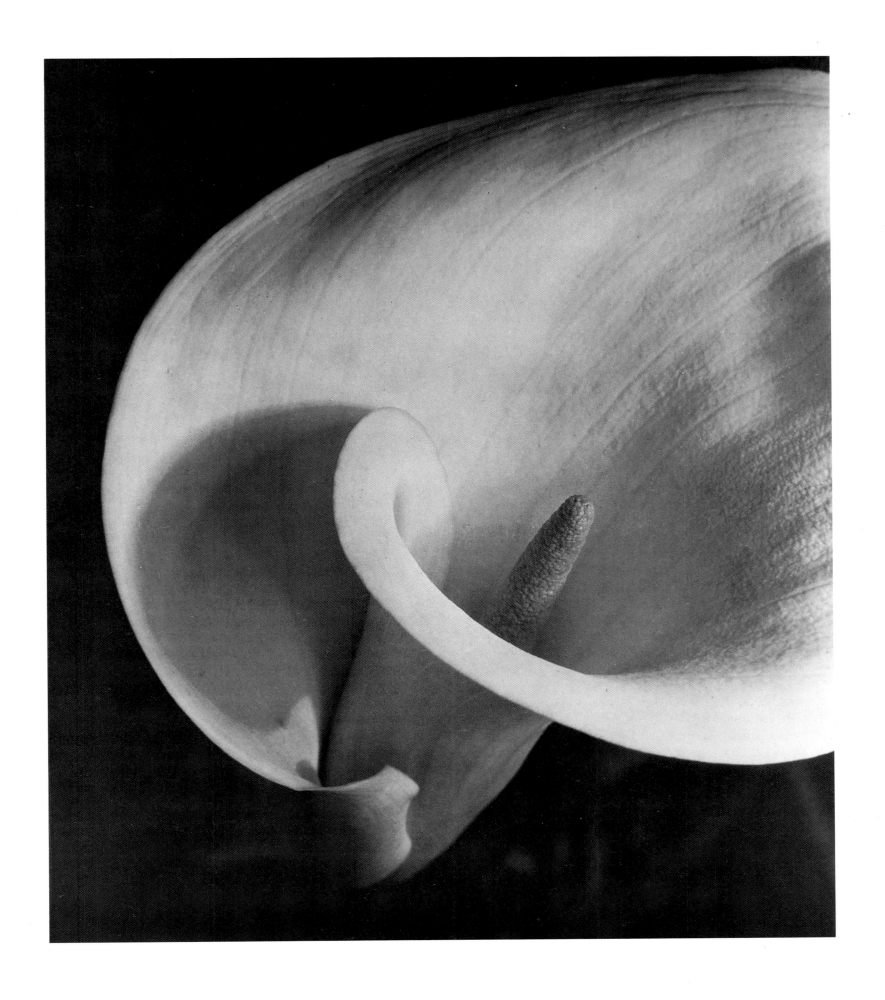

ERICH SALOMON

German · 1886–1944

Balcony, League of Nations, Geneva

1930/ca. 1958 · Gelatin silver print · 19.2 × 24.5 cm.

A lawyer and mechanical engineer, Dr. Erich Salomon was also one of the earliest of a new kind of photographer that appeared toward the last years of the 1920s—the photojournalist, not with a large 4 × 5 inch camera and intrusive flashgun but with a miniature apparatus, frequently hidden from view, and using only available light. What provided Salomon the opportunity for this new vision was twofold. First, Oskar Barnack's Leica camera and the Ermanox camera produced by the Dresden firm of Ernemann were marketed in 1924, one a roll-film camera and the other a miniature plate camera. These cameras and their remarkably fast lenses permitted the photographer to merge with his surroundings and assume a practical inconspicuousness. Salomon, as well as another pioneer of the miniature news camera, Felix H. Man, used his Ermanox on a tripod at first; still, the photographer remained discrete because of the camera's small size. Second, both the *Münchner Illustrierte Presse* and the *Berliner Illustrierte Zeitung* were modernized in 1928, and in addition to new editorial policies they both incorporated a greater number of press photographs into their formats than had ever been used in news magazines. These two journals were the beginning of what later would culminate in Stephan Lorant's *Weekly Illustrated* and *Picture Post* in Britain, as well as Henry Luce's *Life* and the Cowles' *Look* in America.

The new cameras gave the photographer a new vision, a vision of immediacy and involvement coupled with an unparalleled authenticity of presence; the news magazines accounted for the commercial viability and justification of these images, as well as an increased demand for photographs. As Salomon wrote, "The work of a photojournalist who wants to be more than a mere craftsman is a constant battle, a battle for the picture, and as in hunting, he gets his game only if he has an obsession for the chase."[1] In addition, it was no longer the principal news event or the principles of that event that were necessarily the subject of the picture, a sense of significance was also granted the incidental, the secondary, or simply the background of that subject. The image did not necessarily carry with it its own identification, prompting the need for printed captions beneath the photographs when published. Sensing this paramount requirement, the German critic Walter Benjamin wrote in 1931: "The camera is getting smaller and smaller, ever readier to capture fleeting and secret moments whose images paralyze the associative mechanisms in the beholder. This is where the caption comes in, whereby photography turns all life's relationships into literature, and without which all constructivist photography must remain arrested in the approximate. . . . Will not the caption become the most important part of the photograph?"[2]

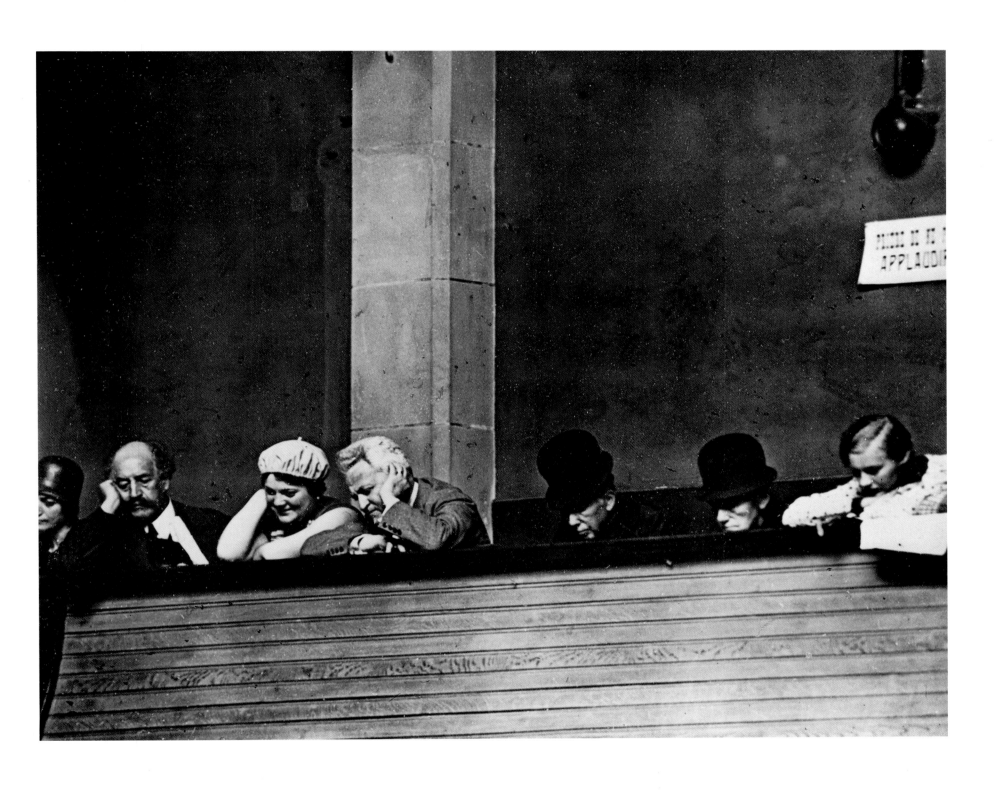

ROBERT CAPA [ANDREI FRIEDMANN]

American · b. Hungary · 1913–1954

Leon Trotsky, Copenhagen

1932 · Gelatin silver print · 22.6 × 34.1 cm.

Robert Capa was only eighteen years of age when he took this photograph, his first published work.[1] Born in Budapest, Capa studied in Berlin where the Bauhaus photographer Gyorgy Kepes gave him a Voigtländer camera, with which he presumably made this picture. In 1933, Capa settled in Paris where, along with David Seymour (Chim) and Henri Cartier-Bresson, he assisted in the founding of Magnum Photos, the international photographic agency. In 1936, he documented the Spanish Civil War and took what has become his most famous picture, *Death of a Loyalist Soldier* [fig. 67]. After Spain, he was in China during the Japanese invasion of 1938, on the beaches of Normandy in June, 1944, in Israel in 1948, and in Indo-China in 1954, where he covered the French war in Vietnam and was killed by a landmine.

Capa's style was redolently immediate, gutsy, and actively pictorial. His most famous statement was that, "If your pictures aren't good enough, you aren't close enough."[2] In his pictures, soldiers are shot, wounded dive for cover, widows mourn at graveside, collaborators are run out of town, and infantrymen crawl through the surf seeking highground. Often the speed of the action Capa shot was slightly faster than his camera's shutter, lending the picture an even greater impact of spontaneous authenticity through its blurred, grainy appearance and the sense that the captured moment was too brief for even the most modern equipment to render clearly. His images have that kind of direct, honest form and abbreviation of statement that certain prose writers, like Ernest Hemingway, cultivated when describing conflict. And, it was a style of photography that Capa assumed from the very beginning, as in this picture of Leon Trotsky speaking in Copenhagen in the early 1930s.

Menshevik politician and writer of such works as *Literature and Revolution*, *The History of the Russian Revolution*, and *1905*, Leon Trotsky (his real name was Lev Davýdovich Bronstein) was one of the singularly most impassioned orators of that period in Russian history. Edmund Wilson characterized Trotsky's public speaking style:

> He could handle the grim Marxist logic with a freer and
> more sweeping hand so as to make it an instrument
> for persuasion and wield the knife of the Marxist irony for

Fig. 67. Robert Capa, *Death of a Loyalist Soldier*, gelatin silver print, 1936. Gift of Magnum Photos, Inc., New York.

purposes of public exhibition, when he would flay the officials alive and, turning their skins inside out, display the ignominious carcasses concealed by their assurances and promises; he could dip down and raise a laugh from the peasant at the core of every Russian proletarian by hitting off something with a proverb or fable from that Ukrainian countryside of his youth; he could point epigrams with a swiftness and a cleanness that woke the wonder of the cleverest intellectuals; and he could throw wide the horizons of the mind to a vision of that dignity and liberty that every man among them there should enjoy. Between the vision and the horrible carcasses that stood in the way of their attaining it, the audience would be lashed to fury.[3]

And Robert Capa, standing not too distant from this volatile speaker and through an intuitive, assaultive camera technique was able to arrest Trotsky at an instant of passionate expressiveness.

LEWIS WICKES HINE

American · 1874–1940

Icarus Atop Empire State Building

1931 · Gelatin silver print · 18.8 × 6.3 cm.

As Elizabeth McCausland characterized him, ". . . one would say that Hine exemplifies the self-conscious, aware artist. He is above all, a folk artist, a primitive, whose instincts functioned as an extra sense to take the place of those highly efficient cameras, lenses and flash apparatus he did not have."[1] Yet this "folk artist" defined the parameters of documentary photography for much of this century, while at the same time clarifying the role of the recording artist. His was hardly a mechanical process of recording, for Hine completely understood the responsibility of the selective eye and compassionate intelligence in documenting the world with a camera. Coming from a small town in Wisconsin, studying sociology at Columbia University in New York, and at sympathy with the Ethical Culture Society, Hine found a vast subject in need of portrayal—the common American. For more than three decades, Hine recorded the laboring classes, both men and women as well as children, the orphaned, the starving, the refugeed, and the immigrant [fig. 68]. That he did so in such a sensitive and compelling manner attested to his fundamental humanism; that his pictures are some of the most poignant and telling attested to his conviction that in order to document one had to interpret.

When Hine began to photograph seriously in 1908, he immediately entered into a long tradition of social photography that began with the use of Richard Beard's daguerreotypes to illustrate Henry Mayhew's *London Labour and the London Poor* of 1851–62 and proceeded through John Thomson's *Street Life in London* of 1876 and Jacob Riis's photographic coverage of the slums of New York during the 1880s. Like many of his predecessors, Hine realized that the photograph could educate and inform about the poor and the abused of society. Unlike earlier photographers, however, he understood and formulated a very basic difference between documentation and reportage, and he did this well in anticipation of later documentary filmmakers and photographers like John Grierson and Edward Steichen who redefined the term "documentary" so as to include both fact and feeling.[2] "With a picture," Hine stated in 1909, "thus sympathetically interpreted, what a lever we have for the social uplift."[3]

Hine also believed that, "Whether it be a painting or a photograph, the picture is a symbol that brings one immediately into close touch with reality. It speaks a language learned early in the race and in the individual. . . . In fact, it is often more effective than the reality would have been, because, in the picture, the non-essential and conflicting interests have been eliminated."[4]

Fig 68. Lewis Wickes Hine, *Young Girl Holding a Pot*, gelatin silver print, ca. 1910. The Lewis W. Hine Collection, gift of the the Photo League, New York.

In 1930-31, Hine documented the building of Shreve, Lamb & Harmon's Empire State Building on Fifth Avenue in New York, but this was not an architectural documentation as much as it was the interpretive record of the construction workers, confidently progressive at the beginning of the Great Depression and bravely scaling the heights of the world's tallest structure. In this subject, Hine found that he could incorporate multiple themes of labor, progress, economics, optimism, pride, and human achievement. "I have always avoided dare-devil exploits, and do not consider these experiences as going quite that far," Hine wrote later, "—but they have given a new zest . . . and perhaps, a different note in my interpretation of Industry."[5]

It was the same zest and dynamics that infused the new spirit of "tall buildings" in the modern metropolis. In 1930, the architectural critic Sheldon Cheney wrote, "What figure the poet might employ to describe the skyscraper, dwarfing the church, outpointing the cathedral spire, I do not know. There is an epic implication in man's defiance of the laws of gravity, and beauty in the naked lift of uprising steel and concrete. But the purpose of the skyscraper is not poetic."[6] Hine would seem to have agreed, for he vested his poetic interpretation fully in the human spirit at labor, even granting that spirit a mythological pedigree by his title to this picture.

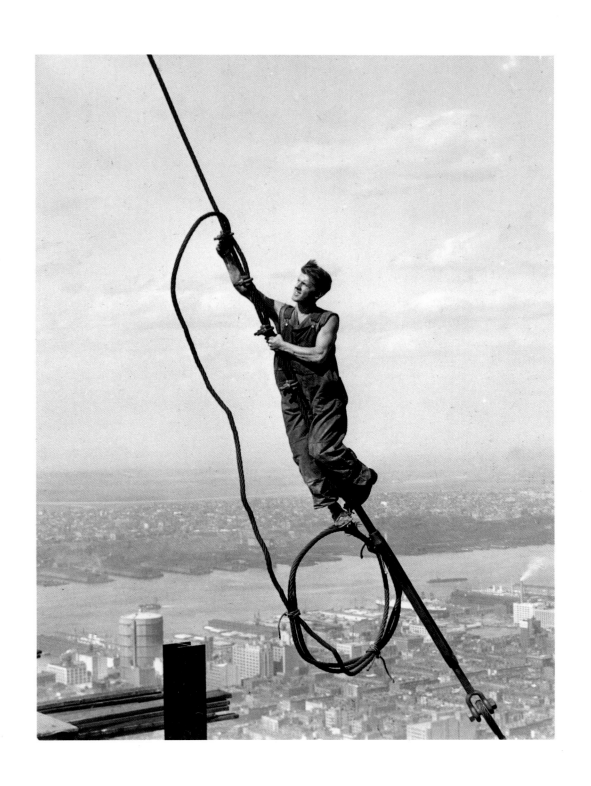

BERENICE ABBOTT

American · 1898–

Horse Fountain, Lincoln Square

1929 · Gelatin silver print · 16.2 × 22.3 cm.

A lost part of old New York (where Broadway crosses Sixty-fifth Street and where from present street-level the view is dominated by the massive auditoria of Lincoln Center), captured from an equally forgotten "El" platform, this print exploits one of the characteristic viewpoints of modernist photography of the 1920s and 1930s in order to render a moment of pure chance and implied integration. "The story told in dramatic contrast of old and new, of beauty and decay, is part of the function of this documentation. Scenes which were here two years ago and are gone today, and changes which are taking place are recorded in their relationship to the environment which remains. A truthful, sometimes humorous and often bitter commentary ensues."[1] These words were used by the Regional Director of the Federal Art Project in 1939 to describe Berenice Abbott's principal photographic achievement, the documentation of New York City in hundreds of photographs. Her book, *Changing New York*, was the culmination of nearly four years of photographing America's largest city for the Works Progress Administration. Officially beginning the project in 1935, Abbott already had been training her 8 × 10 inch camera on New York buildings and street scenes since 1929, the year she returned from Paris after working for Man Ray, photographing avant-garde artists and writers, and helping to preserve, along with Julien Levy, what remained of Eugène Atget's life's work after his death. From Atget, it would appear, she learned the passion of seeing the dense complexity of a large city; but she also never lost that sense of serious play and new vision in her photography that was so much the part of Parisian modernism.

When Elizabeth McCausland wrote of Abbott's work in 1935, she pointed out an obvious factor in this kind of photography: ". . . she is more than ever hungry to set down in the imperishable fabric of the photographic print that ultimate truth which is art's contribution to the history, the artist's perception of the moment translated into terms which definitively capture the spirit of his age and which by this very quality of being supremely topical achieve timelessness."[2] Abbott's photographs of Bowery hardware stores, Gramercy Park row houses or "Irishtown" shanties, of Rockefeller Center or the Flatiron Building, of Brooklyn Bridge or the Greyhound Bus Terminal are at once a record of the past while being removed from that past by the simple operation of being printed.

Abbott's art is one of relationships—serious relationships of appearance to character, of humans to an urban environment, of contemporary architecture flanking vintage buildings, of activity to stasis, and, especially in her later photographs of scientific principles, dynamics to inertia. McCausland characterized her work as the "desire to take myriad unrelated elements in life and make order from them," but then she cautioned, "If this seems to suggest that Berenice Abbott's emphasis is too sociological, it must be added at once that her art is not lacking in humor and in a spontaneous pleasure in the human comedy. . . . [Hers] is a range into which a tender and creative love enters. These things are amusing and quaint and significant in an historical way; they can also be loved for themselves, for their materials and shapes and textures and uses or for their sheer lack of meaning and their grotesquerie."[3]

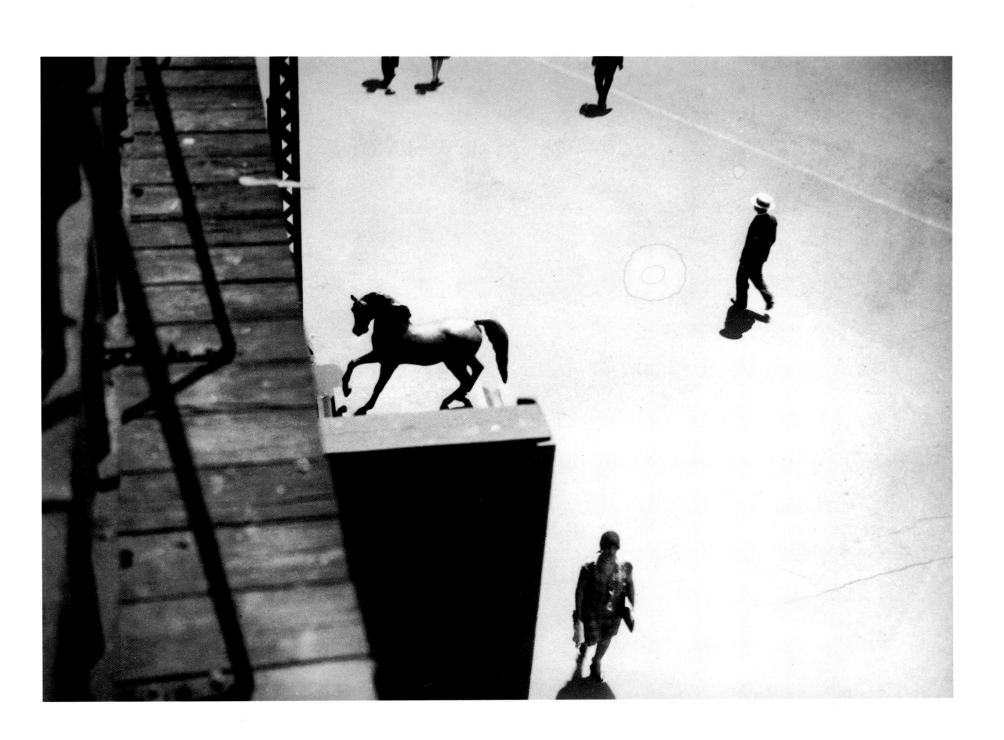

HENRI CARTIER-BRESSON

French · 1908–

Hyères, France

1932 · Gelatin silver print · 33.9 × 50.4 cm.

Far more than any photographer of this century, Cartier-Bresson has proven the value of time and the hand-camera in the service of artistic vision. In 1932, only a few years after Erich Salomon and other photographers began using Ermanoxes and Leicas as serious tools of documentation and journalism, Cartier-Bresson defined a modernist aesthetic of photography that is still to a large degree a standard. The aesthetic was one of selection, only it went further than any 19th-century idea of the artist's choice of subject matter and angle of view to also encompass the selection of that specific fraction of a second when the constant fluidity of the temporal scene arranged itself at its most descriptive. Recognition of a subject's vitality and meaning was as important as the ability of the photographer to precisely anticipate the 1/125 of a second when every element of the natural flux would be visibly balanced for the most revealing relationship.

> In photography there is a new kind of plasticity, product of the instantaneous lines made by movements of the subject. We work in unison with movement as though it were a presentiment of the way in which life itself unfolds. But inside movement there is one moment at which the elements in motion are in balance. Photography must seize upon this moment and hold immobile the equilibrium of it.
>
> The photographer's eye is perpetually evaluating. . . . he composes a picture in very nearly the same amount of time it takes to click the shutter, at the speed of a reflex action.
>
> Sometimes it happens that you stall, delay, wait for something to happen. Sometimes you have the feeling that here are all the makings of a picture—except for just one thing that seems to be missing. But what one thing? Perhaps someone suddenly walks into your range of view. You follow his progress through the view-finder. You wait and wait, and then finally you press the button. . . . if the shutter was released at the decisive moment, you have instinctively fixed a geometric pattern without which the photograph would have been both formless and lifeless.[1]

While not including this picture of a speeding bicyclist seen in one of the small streets of Hyères, Cartier-Bresson's classic *The Decisive Moment* included photographs made in and since 1932, large-format images that were grainy, stark, spontaneous, and pared to an essential photographic vocabulary. These images eschewed the accepted standards of the "fine print" for a striking immediacy of effect and bold assertion of material honesty—an ethics of image-making not unlike that suggested by such artists as Jean Dubuffet, Karel Appel, and Alberto Burri or the architects Peter and Alison Smithson whose idea of "image" in building was viewed by one critic in 1955 as antithetical to classical beauty: "Where Thomas Aquinas supposed beauty to be *quod visum placet* (that which seen, pleases), image may be defined as *quod visum perturbat*—that which seen, affects the emotions, a situation which could subsume the pleasure caused by beauty, but is not normally taken to do so. . . ."[2] Well before the fifties, Cartier-Bresson had already developed a style of photography that was similarly direct and expressive, but it was in that decade that this style gained its fullest effect. Engendered by an acceptance of the efficiency of the hand-held camera and the coarse graininess of newer, fast films, and maintained by an assumed moral obligation to portray the world as it was from a nonintrusive position, his example became the very foundations of much later photography. Without Cartier-Bresson, it would be difficult to imagine the work of Robert Frank,[3] William Klein, or even, indirectly, that of Lee Friedlander and Garry Winogrand.

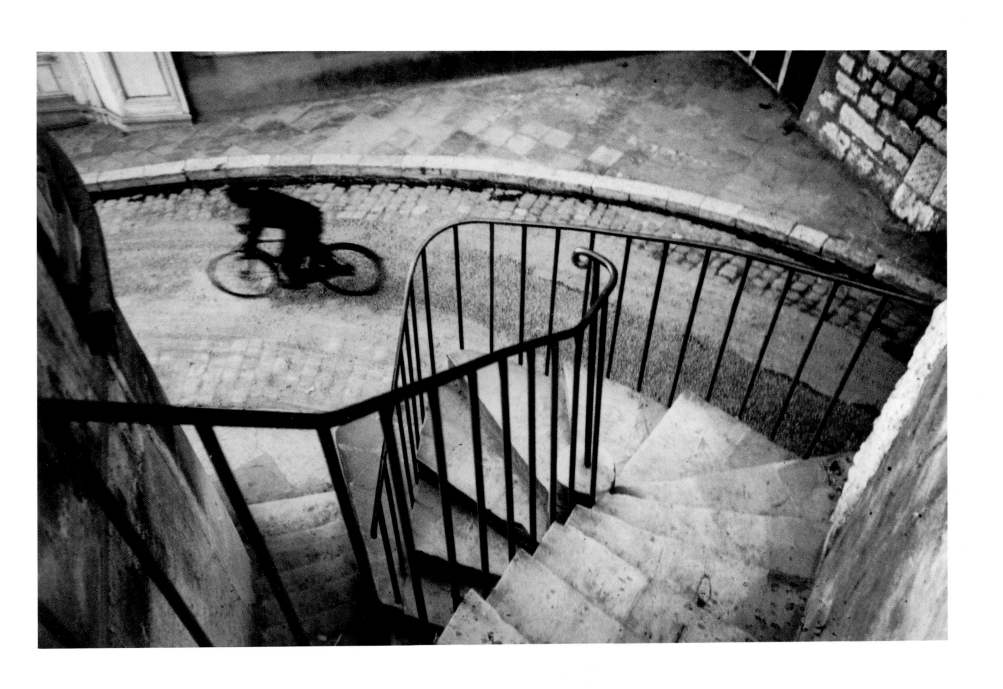

BRASSAI [GYULA HALASZ]

Hungarian · 1899–1984

Couple at the Bal des Quatre Saisons, Rue de Lappe

ca. 1932 · Gelatin silver print · 49.4 × 40.3 cm.

"I don't bother myself with psychology," said Brassaï during a radio interview, "I photograph everything—one doesn't need psychology. . . . When I do a picture of someone I like to render the immobility of the face—of the person thrown back on his own inner solitude. The mobility of the face is always an accident. . . . But I hunt for what is permanent."[1] Elsewhere, this photographer of Parisian night scenes of the 1930s and of Picasso stated:

> For me the photograph must suggest rather than insist or explain; just as a novelist offers his readers only a part of his creation—in leaving certain aspects unexpressed—so I think the photograph shouldn't provide superfluous explanations of its subject. . . . The photograph has a double destiny. . . . It is the daughter of the world of externals, of the living second, and as such will always keep something of the historic or scientific document about it; but it is also the daughter of the rectangle, a child of the *beaux-arts*, which requires one to fill up the space agreeably or harmoniously with black-and-white spots or colors. In this sense the photograph will always have one foot in the camp of the graphic arts, and will never be able to escape the fact.[2]

Much of the world of externals Brassaï photographed during the 1930s centered on the nocturnal activities of Parisians—the streetwalkers, the young toughs, the clochards, the ragpickers, and the groups and couples seated at bistros, cafes, and bars. Brassaï celebrated the urban soul as it is revealed by its citizens only at night, dissected it with honesty and severity—and one suspects, detachment—and recorded what remained. If out-of-doors, the subject was bathed in saturated black the richness of which, printed on the photographer's favored glossy paper, appeared even harder and denser than it was. If inside a bistro, a mirror often reflected the subject, multiplying a feature or face and emphasizing its solitary uniqueness. Mostly, Brassaï's pictures, like those by his friend André Kertész of that period, were concerned with human isolation and alienation, whether in a crowd or standing on a darkened street corner, reveling in gaiety or sleeping along the quais.

The cafe at night, the cafe-concert and its customers was a traditional theme for French artists since the mid-19th century. Both Manet and Degas rendered drinkers and merrymakers in cafes, as did Daumier and, later, Van Gogh and Toulouse-

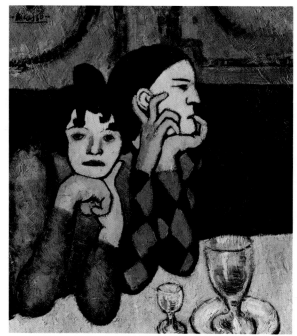

Fig. 69. Pablo Picasso, *The Two Saltimbanques* (*Harlequin and His Companion*), oil on canvas, 1901. The Pushkin State Museum of Fine Arts, Moscow.

Lautrec. The hero of Joris-Karl Huysmans's novel *A rebours* discerned the meaning of the cafe scene in 1884: "The true significance of all these cafes [was] that they corresponded to the state of mind of an entire generation. . . . They offered him a synthesis of the age."[3] In the first years of this century, Brassaï's friend Picasso depicted a number of scenes in which the figures of Harlequin and Columbine or of saltimbanques were portrayed in solemn isolation standing at bars or seated in cafes [fig. 69]. Similarly, in this print, Brassaï has captured a couple seated on a banquette in a bistro, engrossed in playful conversation and oblivious to the rest of the cafe. That their self-absorption extended to not registering the photographer's presence is very unlikely, but the semblance of candidness is part of the print's charm. Here, as elsewhere, Brassaï made use of the ubiquitous mirrored walls in Parisian cafes and bistros in order to fracture and multiply the drinkers' features as well as suggest more disconnected, psychological relationships between them.

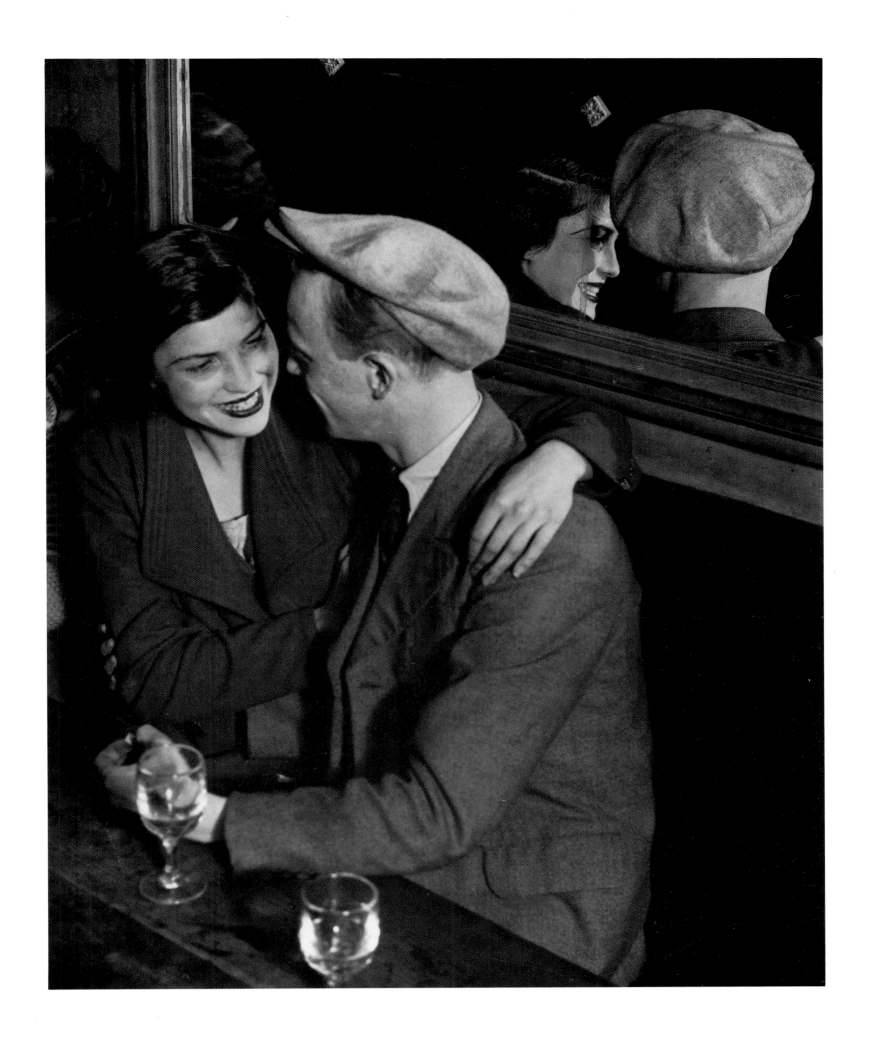

CECIL WALTER HARDY BEATON

British · 1904–1980

Paula Gellibrand, Countess de Maury

ca. 1930/printed later · Gelatin silver print · 44.9 × 35.4 cm.

Throughout photographic history there has been a certain kind of photographer that has endured simply because of the glamor surrounding his images. Disdéri and the firm of Mayer and Pierson were *the* fashionable photographers of royalty and the elite during the French Second Empire, and Pierson's series of mock-comedic portraits of the Comtesse de Castiglione marks a high point of chic and allure for that period. Napoleon Sarony's portraits of celebrities of the dramatic stage, like those of the "Divine" Miss Sarah Bernhardt languishing in opulence [fig. 70], were similarly inclined toward *panache*, vamping, affluence, and the pictorial validation of the ineffably chic. Much the same could be said about many other photographers, including Camille Silvy, E. O. Hoppé, Alice Hughes, Miss Compton Collier, Baron Adolf de Meyer, George Hoyningen-Huene, and, periodically, Edward Steichen, all of whom were influences on perhaps the greatest of all 20th-century glamor photographers, Sir Cecil Beaton.[1]

According to a recent critic:

> Beaton was born into a wealthy British family, and his pictures are as much a reflection of his social milieu as the society magazines he read, the costume balls he attended, or the early Victorian shell flower decorations, beadwork chairs, and mother-of-pearl tables he collected. . . .
> Beaton was a nineteenth century photographer working in the twentieth century, exhibiting through his work [during the thirties] an ornate Victorian taste.
> His style was then concerned with surface ornamentation and opulent effects. Even in the works he labeled surreal, there is an overtone of nineteenth century sentimentality and the surface buzzes with decorative fussiness.[2]

His was a style that perfectly exemplified an "extravagant and over-ripe artifice,"[3] and his interest was not only fashion but

Fig. 70. Napoleon Sarony, *Sarah Bernhardt*, albumen print, 1880.

fashionability itself. "Fashion is a mass phenomenon, but it feeds on the individual. The true representatives of fashion are often those whose surprising originality leads them to a very private outward expression of themselves. In some given decade they appear somewhat outre, they may border on exhibitionism, or even eccentricity, but their means of self-expression curiously corresponds to a need in others who, in a modified way, copy them. Thus they create taste."[4] Beaton's work may be uneven and inconsistent, but then fashion itself is so utterly ephemeral and changing. At his best, as in this portrait of Paula Gellibrand whom he transformed into a *moderne* female Narcissus, Beaton's pictures satisfy because he was exactly synchronous with his highly stylized subjects.

MAN RAY [EMMANUEL RUDNITSKY (?)]

French · b. United States · 1890–1976

Nude

1931 · Gelatin silver print, solarized · 23.0 × 29.7 cm.

Man Ray was a Dadaist, Surrealist, modernist artist; he was technically a painter, a sculptor, an *assembleur*, and a photographer. He was born in Philadelphia and lived for most of his adult life in Paris; Man Ray was only an assumed name. While he may or may not have invented the modern photogram (William Henry Fox Talbot actually made the first such cameraless photographic image in the 1830s), he did invent the "Rayogram" around 1921, which was roughly the same thing, and used it to explore constructivist abstractions [fig. 71]. He wrapped and tied a sewing-machine in cloth so that its identity could not be discerned, and entitled the work *The Enigma of Isidore Ducasse* (1920). He wrote a book entitled *Photography Is Not an Art* (1937) and an article entitled "Photography Can Be Art" (undated). His photographs were published in *Vogue* during the twenties, and during the same period he worked on avant-garde films with Marcel Duchamp and Fernand Léger, and in 1944–46 he co-starred in Hans Richter's film *Dreams That Money Can Buy*. In 1947 he photographed an extended narrative featuring the erotic adventures of two wooden lay figures, which he published in 1970 as *Mr. and Mrs. Woodman*. He practiced straight photography, solarized photographic printing, and color photography. He collected hundreds of photographs of found, assembled, mysterious objects that he called "Objects of My Affection"; and he, along with Berenice Abbott, was most responsible for the preservation of the photographs and negatives of Eugène Atget following that artist's death in 1927.

One of Man Ray's more famous statements was, "A certain amount of contempt for the material employed to express an idea is indispensable to the purest realization of this idea."[1] At another time he wrote, concerning his own work: "In whatever form it is finally presented, by a drawing, by a painting, by a photograph or by the object itself in its original material and dimensions, it is designed to amuse, bewilder, annoy or to inspire reflection, but not to arouse admiration for any technical excellence usually sought for in works of art. The streets are full of admirable craftsmen, but so few practical dreamers."[2] Nevertheless, his photographs are masterpieces testifying to that special amalgam of tastes, styles, and sensibilities that made up this artist.

As one of the texts included in James Thrall Soby's classic publication of Man Ray's photographs, the poet Paul Eluard contributed a short poem that prefaced the section of the book containing this image.

The storm of a robe which falls
Then a simple body without clouds
So come and tell me all your charms

Fig. 71. Man Ray, *Rayogram*, gelatin silver print, ca. 1926.

You who have had your share of happiness
And who often bewails the dismal fate of the one who made you
 so happy
You who have no desire to reason
You who knew not how to create a man
Without loving another

In the ebb and flow of a body which undresses
Akin to the breast of twilight
The eye forms in line on the neglected dunes
Where the fountains hold naked hands within their claws
Vestiges of bare forehead pale cheeks beneath the eyelashes
 of the horizon
A rocket-like tear betrothed to the past
To know that light was fertile
Childish swallows mistake the earth for the sky

The dark room where the stones of cold are bare
Do not say you have no fear
Your look is level with my shoulder
You are too lovely to preach chastity

In the dark room where even the wheat
Is born of greediness

Remain unmoving
And you are alone[3]

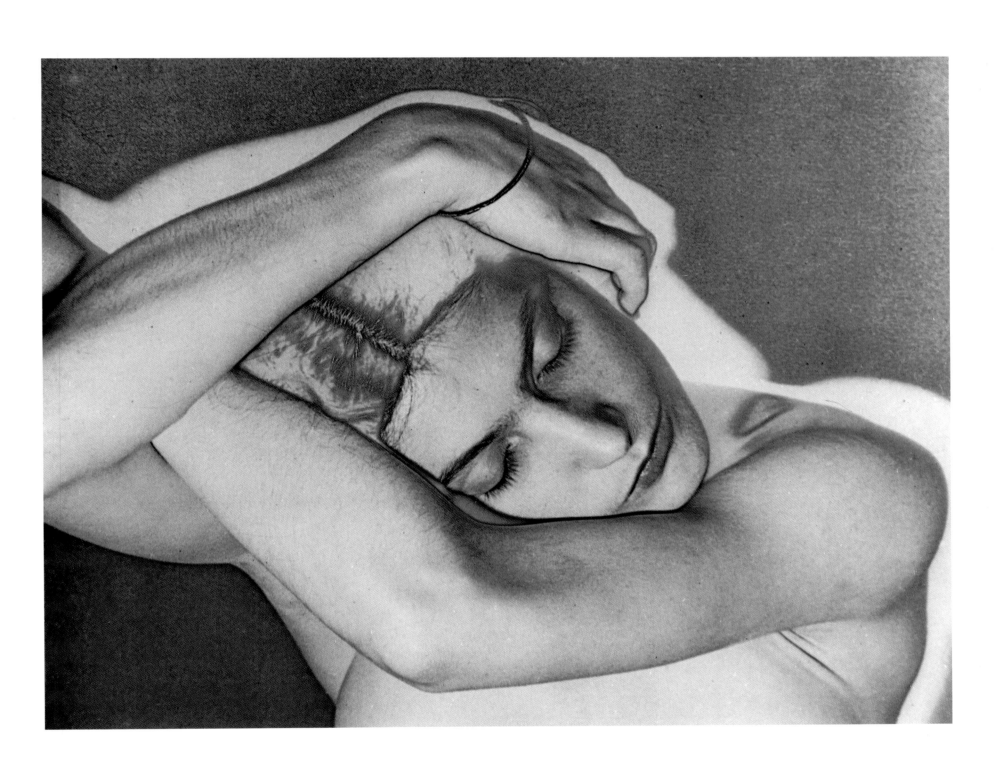

FLORENCE HENRI

German · b. United States · 1895–1982

Composition No. 12

ca. 1930–32 · Gelatin silver print · 24.0 × 37.8 cm.

From the teachings of her two principal mentors, Florence Henri developed a personal aesthetic of photography that blended the substantiality of absolutely pure geometric form with the dematerialized energy of reflections and refractions. Her images, especially those made in the late 1920s and early 1930s, were cool, streamlined, distinctly modernistic in spirit, and able to sustain a "nonobjective" affect in spite of the real objects photographed. From Fernand Léger, she respected the idea that in modern art, "geometric form is dominant," and that the art object was, "its value rigorous in itself, made out of concentration and intensity, antidecorative, the opposite of a wall. The coordination of all possible plastic means, the grouping of contrasting elements, the multiplication of variety, radiance, light, brought into focus, life force, the whole united, isolated, and embodied in a frame."[1] More than likely Henri was also familiar with the dazzling effects of fragmentation, multiplication, and distortion of an image created by light and mirrors, as used by Léger in his film *Les Ballets mécaniques* of 1923–24.

At the Bauhaus, at which she later studied with László Moholy-Nagy, Henri was again exposed to the dynamics of modernist machine aesthetics and the abstract materiality of light. As Moholy-Nagy wrote, the investigation of light was crucial to the curriculum.

> One of the aims was to create a new space, which was to be produced through the relations of the elemental material of visual expression—a new space created with light directly. . . . These actual reflections and mirrorings bring the surroundings into the picture, attaining through this a pliability of surface which has been striven for ever since the first days of impressionism. The surface becomes a part of the atmosphere, of the atmospheric background; it sucks up light phenomena produced outside itself—a vivid contrast to the classical conception of the picture, the illusion of an open window. . . . it represents the mastery of the surface, not for atmospheric, but for plastic, spatial ends.[2]

During the 1920s, theorists and critics like Moholy-Nagy and Franz Roh offered lists of the various types or categories of photography by which it could qualify as a "new vision." Henri's constructivist compositions or still lifes with mirrors were clearly the products of "abstract photography"—a concept that enjoyed a certain vogue in 1930, the year she first published her mirror pieces. Writing in the first issue of *Arts et métiers graphiques* devoted to photography, Waldemar George defined this new style.

> "Abstract" photography. Alteration and decomposition of form by shadow and light which attack its corporeal essence. Objects rendered unknowable. Foreshortened effects. Perforation of dense and opaque bodys. Transgression, violation of gravity's laws. Mirages, will-o'-the-wisps, tonal seas. Magical lines, planes, and values. White, grey and black waves. Visual polyphonics more eloquent than palpable images, more active than veristic scenes. Phantoms of waves that dance, of clouds that unthread, of smoke clusters that escape toward the sky. There, where the pure painter, that utopian, ran aground following the endeavors of Wassily Kandinsky, heliography wins an ephemeral but magnificent victory.[3]

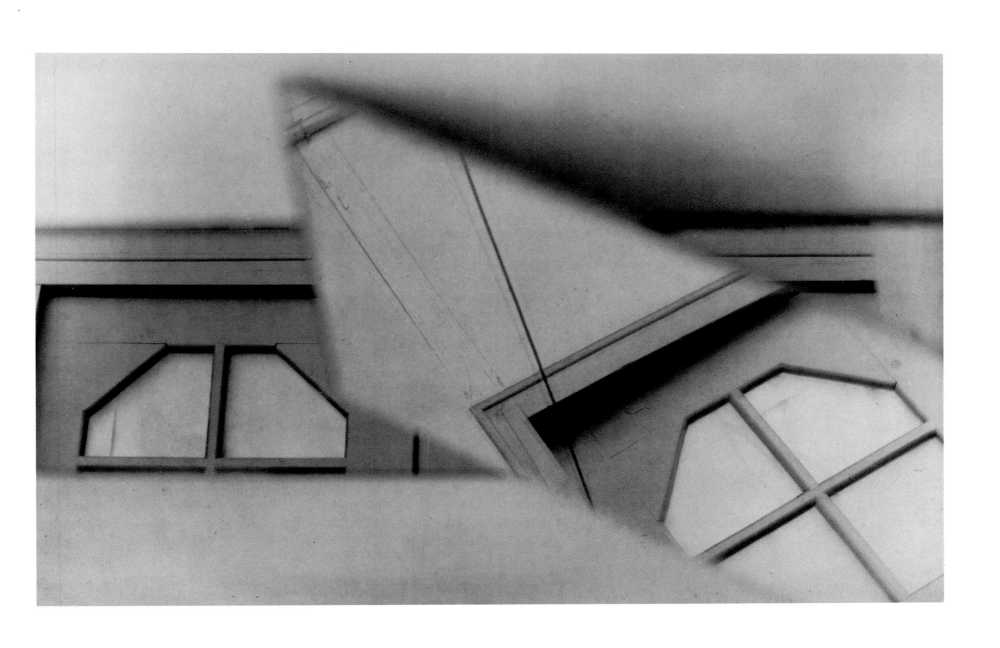

PAUL STRAND

American · 1890–1976

Women of Santa Ana, Michocan, Mexico

1933 · Gelatin silver print · 19.3 × 24.2 cm.

The critic Susan Sontag was probably more or less correct when she wrote, "I suppose that Paul Strand is the greatest American photographer. . . . Strand is simply the biggest, widest, most commanding talent in the history of American photography."[1] Strand came to photography by way of two other towering giants of the medium, Lewis W. Hine, with whom he began to photograph in 1907, and Alfred Stieglitz, who canonized Strand in 1917 by saying, "His work is rooted in the best traditions of photography. His vision is potential. His work is pure. It is direct. It does not rely upon tricks of process. In whatever he does there is applied intelligence. In the history of photography there are but few photographers who, from the point of view of expression, have really done work of any importance. And by importance we mean work that has some relatively lasting quality, that element which gives all art its real significance."[2] Thus, from Hine's affirmative documentation of human values and Stieglitz's faith in the camera's ability to achieve levels of supreme artistic expression, Strand evolved a photography that was at once passionate and serene, formal yet humanistic, realistic and noble.

Strand's aesthetic was founded on the simple and elegant belief that pictures of profound expressive value could be attained through an almost complete neutrality of affect or manipulation. In the finest sense of the Realist artist, Strand is always absent from his pictures, his presence behind the camera totally nonintrusive. His subjects are more honored than interpreted, as it were, by the very act of their portrayal. Strand is the epitome of the ideal artist described by Flaubert a century earlier: "The artist ought to be in his work like God in creation, invisible and omnipotent. He should be felt everywhere but not seen. Art ought, moreover, to rise above personal feelings and nervous susceptibilities! It is time to give it the precision of the physical sciences, by means of a pitiless method!"[3] As Strand wrote in 1973, "Almost all the things of the world have their own character. . . . I think that what exists outside the artist is much more important than his imagination."[4]

Strand's photographs always have a certain monumentality. Whether the subject is a blind woman in 1916, a detail of a machine lathe in 1923, a group of Mexican women photographed in the early 1930s, or a family portrait done in Italy in 1953 [fig. 72], the result is the same—the world quietly seen

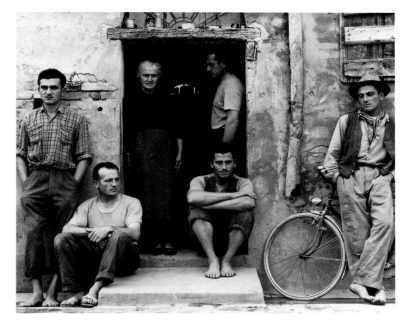

Fig. 72. Paul Strand, *The Family, Luzzara, Italy*, gelatin silver print, 1953.

and impressed with a scale that far belies the image's modest size. Like the Renaissance fresco painter Piero della Francesca, with whom he felt an abiding rapport, Strand commemorated the heroism of common things and common people. According to Milton Brown, with whom he visited Piero's frescos, Strand responded to "Piero's serene grandeur, the peasant robustness transformed into patrician dignity, the real transmuted into the ideal, the ordinary in man and the transitory in nature converted into eternal symbols. . . ."[5] Here, four Michocan women are caught in the matrix of the background wall in varying poses and expressions. Strand probably made use of a reflecting prism on his lens, thereby appearing to photograph in another direction—a stratagem quite opposite from that used with his Italian family, but one that would explain the women's casual indifference to their roles as subjects. Nonetheless, there is a magnificence about these women, positioned as they are within a rigorous arrangement of taut, physical geometries and emotional tensions, statuesquely testifying to their elemental natures in remote silence.

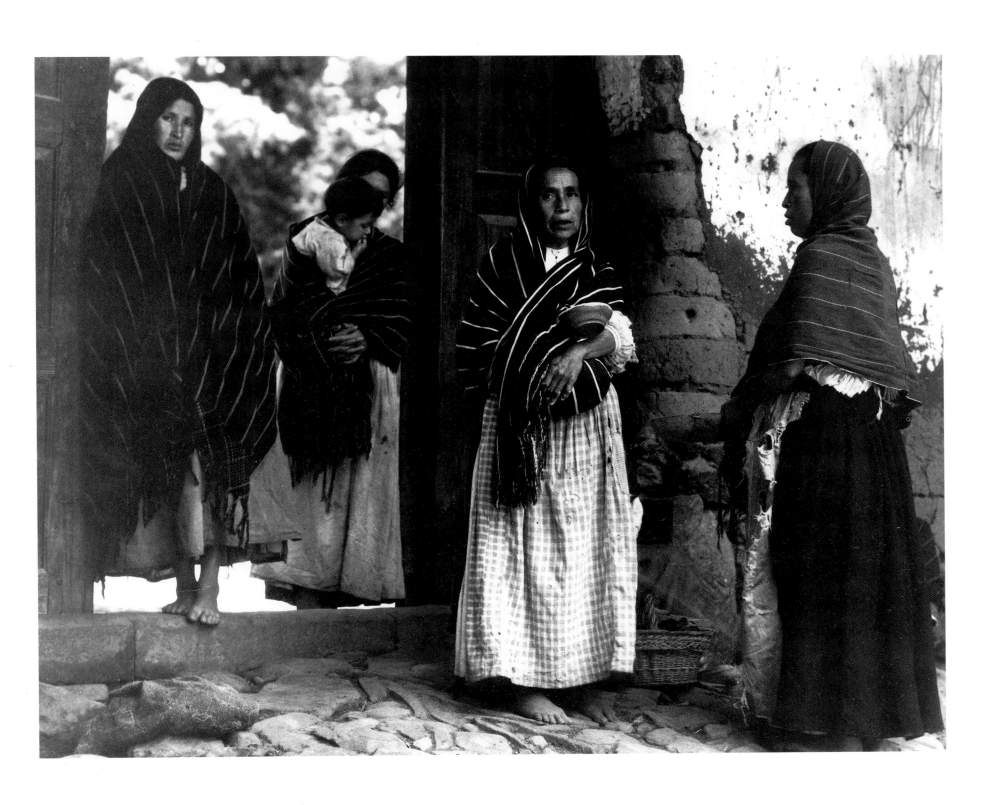

VINICIO PALADINI

Italian · b. Russia · 1902–1971

Olympic Games

ca. 1933–34 · Gelatin silver print, watercolor, construction paper on board · From series *Olympic Games* · 30.0 × 19.0 cm.

Although he spent less than a year in Russia after his birth in Moscow, Paladini later developed and maintained a strong attraction to the art of the Soviet avant-garde. During the 1920s and early 1930s, he made frequent trips to Moscow, published a book on Soviet art that contained the first critical analysis of Malevitch's Suprematism to appear in Italy, and was the author of numerous publications on revolutionary art and on Communism and art.[1] His "Imaginist" photomontages of the late 1920s displayed a marked debt to the montage style of the Russian avant-gardist Alexander Rodchenko; and, like the Russian Constructivists, he valued the forms, iconography, and idea of machine art. Unlike his counterparts in Moscow, however, Paladini also flirted with Dadaistic montages, Giacomo Balla's style of Futurist "Plastic Dynamism," Giorgio De Chirico's *L'Arte metafisica*, and the French *L'Esprit nouveau*. He conceived and staged a *Ballet mécanique* in the early 1920s, and a play more in the style of Italian Rationalism at the end of the decade. For imagery, he drew from sports and fashion photography, nude photographs and those of race cars, the chronophotography of Eadweard Muybridge and classical Greek statuary. His themes ranged from eroticism to velocity, and from jazz dancing to athletic competitions.

Constructed in a style that is strongly reminiscent of advertising graphics during the late 1920s, especially the kind that can be linked to Purism or *L'Esprit nouveau*, Paladini's tribute to the games of ancient Greece are not intended to depict programmatically every Olympian sporting event. Rather, they are a set of decorative montages suggesting in part a historic and physiological perfection of the athletic body. The athlete as the embodiment of strength and energy had been a mildly popular theme in European art of the decades following World War I; but where most artists, like Rodchenko, Léger, or Willi Baumeister, modernized the body's form, often bringing it into a mechanical streamlined shape or photographing it from new perspectives,[2] Paladini here rejected modernity in favor of a classic reference. In this montage, a youthful male athlete, vaguely similar to Polyclitus's Doryphoros of around 440 B.C., has been trimmed at knee height and positioned over a relief of ecstatic Maenads dancing in rhythmical poses and diaphanous drapery. Paladini

Fig. 73. Vinicio Paladini, *Photomontage*, gelatin silver print, watercolor, construction paper on board, ca. 1933-34. Museum purchase, Alvin Langdon Coburn Memorial Fund.

had clearly revealed his interest in erotic or Freudian themes in other work done around the same time, such as his grainy montage about sexual absorption and interruption, *Hommage à Dada*, and his graphic incursion into the pathologies of frustration, anxiety, and sexual jealousy, *Freudiana*—both of 1933. Whether there is a similar, although subordinate association in his series on the Olympics is unclear, since others in the group portray the athlete in front of classic reliefs depicting chaotic battle scenes [fig. 73]. Yet in his dialogues between broken statues of ancient athletes and scenes of carnage or abandonment, it would seem that the artist was attempting more than a mere homage to antiquity.

JOHN PAUL PENNEBAKER

American · active 1930s

Chicago World's Fair

1933/34 · Fresson prints, composite triptych · 34.1 × 56.9 cm.
(ensemble)

Little information beyond this print has been located about the photographer and his relationship with the Chicago World's Fair of 1933–34, *A Century of Progress*. The fair was photographed officially by the firm of Kaufmann-Fabry of Chicago, who were responsible for most of the images found on post cards, in the various guidebooks, and in the albums of actual photographs given the officers, trustees, and founding members of the fair's commission. In addition to Kaufmann-Fabry, Ken Hedrich of the firm of Hedrich-Blessing also documented the fair, as did countless amateur photographers who visited the exposition grounds along Lake Michigan.

Many of the official photographs of the fair adapted their images to the spirit of the fair and its sense of futuristic, technical progress; in fact much of the fair's architecture gave many of the scenes an automatically modernistic look. The exposition was this country's largest concentration of the European Art Deco building style, more appropriately called on this side of the Atlantic Depression Modern or Streamline Modern, and many pavilions were associated with dramatic and highly stylized fountain and searchlight effects. None of the more documentary photographs of the Chicago World's Fair, however, come close to this melange of vertiginously exploding details in suggesting how the fair must have been perceived by both its planners and the public. *A Century of Progress* was at its time the most daring and utterly unprecedented public extravaganza in this country. In the depths of the Great Depression it promised a solvent future, new and startling building types, grand engineering designs, and new modes of transportation, such as Buckminster Fuller's Dymaxion car and the famous Sky Ride, which transported 3,600 people per hour at a height of more than 200 feet, suspended from twin towers each more than 620 feet high, and across a span of 1,850 feet. The many guidebooks to the fair are filled with optimistic comments: "The whole Exposition is a demonstration of man's advancing control over the forces of nature. . . . Beauty of the new architecture is peculiar to itself. It is a dynamic, stimulating expression of the living age. . . . The theme of the Exposition is the dependence of industrial advancement upon the pure sciences. . . . [and] The Fourth Dimension is another subject rendered intelligible by object lessons."[1] It was this fervent excitement of technological progress symbolized by the fair that Pennebaker strove to convey in a triptych that is singularly more cinematic than photographic in feeling.

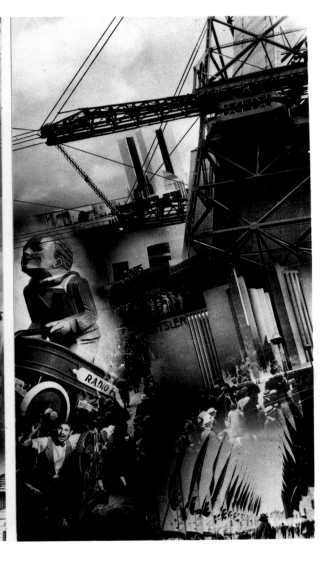

HANS BELLMER

German · 1902–1975

The Doll

ca. 1934 · Gelatin silver print · From Hans Bellmer, *Die Puppe*, Carlsruhe, 1934. 11.6 × 7.8 cm.

Among other notable objects, Surrealists of the 1930s cherished the image of the mannequin: from Alberto Giacometti's sculpture of that name in 1932 to adulterated actual mannequins in such works as André Masson's *Mannequin* and Salvador Dali's *Rainy Taxi* of 1938. The mannequin was a fetish effigy of sexual desire, a doll to be manipulated and customized according to the fantasy and desires of the artist—the image of a female, entirely submissive and purely erotic. Her feet are found extending from Victrola horns into which she had been forced; snails crawl over her face; gagged and flowered and caged, she still offers her image to control and domination. Serious photographers, like Brassaï, documented her in store vitrines, novelists such as Georges Bataille recounted her fortunes and perils, and living fashion models assumed her breathless guise by the late 1930s. And, as late as the mid-sixties, the French novelist Alain Robbe-Grillet would still liken the photographer's model to a mannequin, a doll, a *poupée*, since she was completely compliant to the demands of the photographer whose manifest aim was to freeze her, "in a pose which is not the model at all, but the image born in the imagination of her male partner."[1]

In an article published in Paris in 1936, the German artist Hans Bellmer discussed a recurring dream image of his in which nothing compared to:

. . . the richness of that enchanted garden whose distant fragrance had so rapidly depreciated my powers to enchant. Was it not necessary to suppose that the fabulous distance where the dolls were was an essential factor of that exceptional sweetness which wasted away as their inaccessibility lessened? In spite of her doctrine of limitless accommodation, was it not the doll herself who was gathered in hopeless reserve; and could not imagination find what it sought in joy, exaltation and fear in the very reality of the doll? Was this not the ultimate triumph over large-eyed adolescents who, yes, turned away under the conscious stare pillaging their charms—the aggressive fingers assailing the plastic form and slowly constructing, member by member, what the senses and the mind felt were appropriate.[2]

During the first years of Nazi-controlled Germany, Bellmer, along with his wife, his young cousin Ursula, and his brother, an engineer, fabricated a doll, a nearly life-size figure of movable parts that were variously interchangeable. According to him, "I wish to construct a girl who will be both artificial, but complete in all anatomical possibilities, and capable of being able to physiologically alter the giddinesses of her passions unto the point of creating an entirely new level of desires."[3] The doll, with its swollen breasts and pronounced *mons*, was assembled and reassembled in countless permutations, and photographed by Bellmer in various contexts. Mostly, the photographs are of a Surrealist object, an abstraction of inordinate sexuality; at best, as in this print, there is a moving, terrifying sense of human complicity and proclivities.

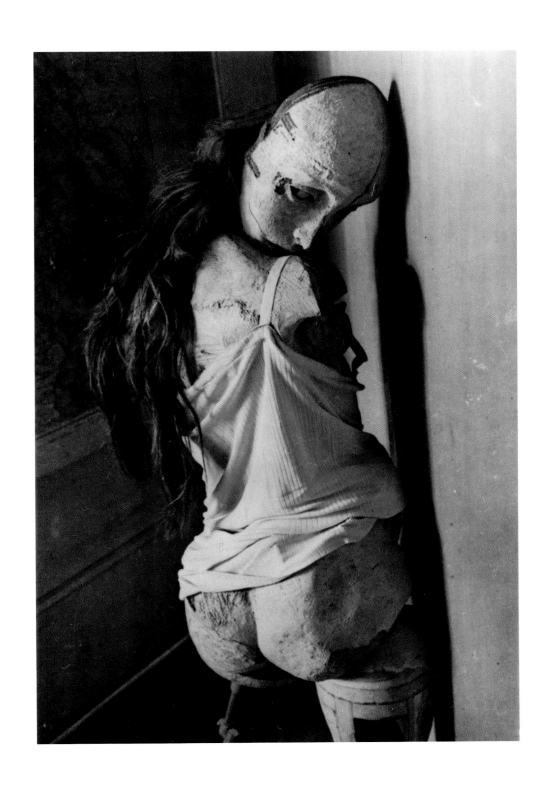

JOHN HEARTFIELD [HELMUT HERZFELD]

German · 1891–1968

What the Angels of Christmas Have Become

["*O du fröhliche, O du selige, gnadenbringende Zeit*"] 1935 · Rotogravure print, rephotographed montage with typography · From *AIZ*, 26 December 1935, p. 831. 38.3 × 26.6 cm.

Political photomontage during the turbulent decades of the 1930s is dominated by the example of John Heartfield. There were others, of course, such as Karl Vanek in Germany, Alexander Rodchenko in Russia, Mieczyslaw Berman in Poland, and, to some degree, Georges Hugnet in France; yet none of these attained the lasting impact and uniquely obsessive commitment to political montage as had Heartfield; nor had any other artist persisted so passionately in using this idiom as a form of sociopolitical expression. A revolutionary artist connected to the Berlin Dada group just after World War I, Heartfield along with George Grosz may actually have "invented" the modern mode of photomontage as early as 1916. According to Grosz in 1928, "When John Heartfield and I invented photomontage in my South End studio at five o'clock on a May morning in 1916, neither of us had any inkling of its great possibilities, nor of the thorny yet successful road it was to take. As so often happens in life, we had stumbled across a vein of gold without knowing it."[1]

During the twenties, Heartfield worked as a designer of book covers and posters for Malik Verlag, the left-wing publishing firm owned by his brother Wieland Herzfelde, whose authors included Upton Sinclair, Maxim Gorky, and Ilya Ehrenburg. Throughout the later twenties and the following decade, Heartfield produced photomontages for the KPD, the German Communist Party, and for its periodical *Arbeiter-Illustrierte-Zeitung* (*Worker's Illustrated News*). Heartfield was also a close friend of the playwright Bertolt Brecht, and, living through the deteriorating political and economic situation of the Weimar period and the injustices of Nazi hegemony, Heartfield "consciously placed photography in the service of political agitation."[2]

The forced withdrawal of Heartfield's montaged posters from a Prague art exhibition in 1934 prompted his first one-man show in Paris in 1935, which was sponsored by the Neo-Impressionist painter Paul Signac and the *Independents*. For the French magazine *Commune*, the Dada author and poet Louis Aragon wrote an extensive article about the exhibition of Heartfield's photomontage and in it claimed:

John Heartfield *today knows how to salute beauty*. He knows how to create those images which are the very beauty of our age since they represent the cry of the people and the translation of the people's struggle against the brown hangman with his craw crammed with pieces of gold. He knows how to make these realistic images of our life and struggle arresting and gripping for the millions, these images which are a part of that life and that struggle. His art is art in Lenin's sense for it is a weapon in the revolutionary struggle of the proletariat. John Heartfield *today knows how to salute beauty*. Because he speaks for the countless oppressed people throughout the world, without depreciating for a moment the magnificent tone of his voice and without humiliating the majestic poetry of his colossal imagination. *Without diminishing the quality of his work.* Master of a technique entirely of his own invention, never bridling the expression of his thought, having as a palette every aspect of the real world, willfully blending its appearances, he has no other guide but dialectical materialism, only the reality of the historic process which he, with the anger of battle, translated into black and white.[3]

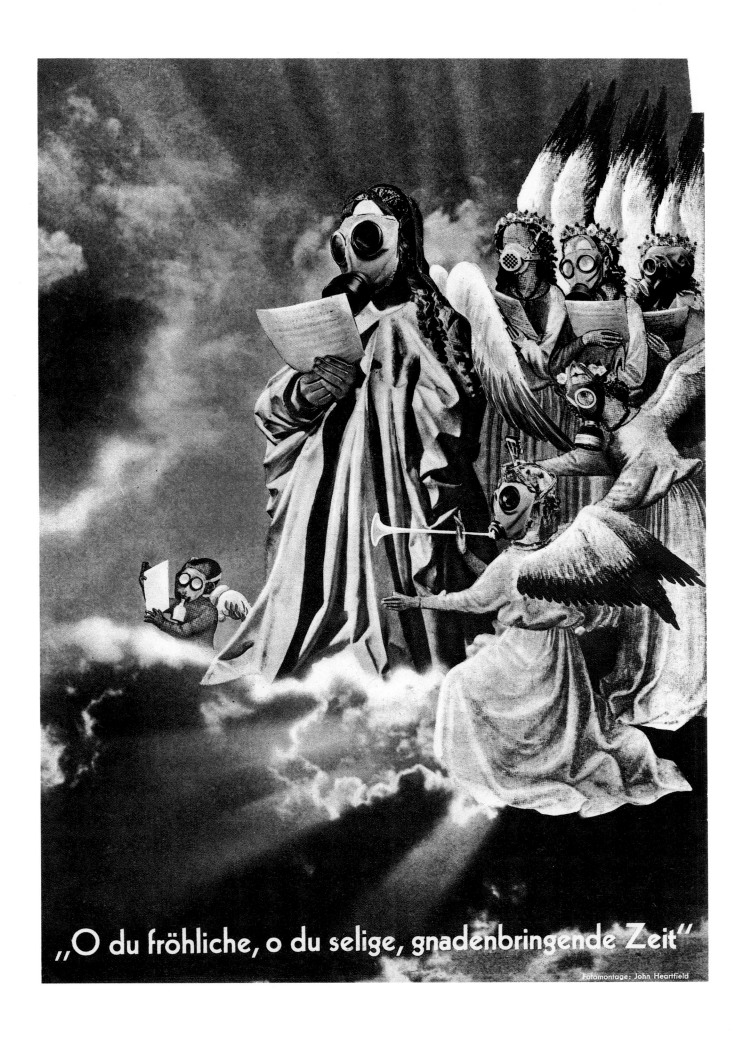

„O du fröhliche, o du selige, gnadenbringende Zeit"

Fotomontage: John Heartfield

287

LEJAREN A HILLER

American · 1880–1969

Etienne Gourmelen

ca. 1927–38 · Gelatin silver print, toned · From series "Surgery Through the Ages." 45.6 × 37.5 cm.

Lejaren à Hiller was a magazine illustrator and advertising photographer working in New York from around 1903 to 1949. He was characterized in 1929 as the inventor of "creative photographic illustration," and his work was seen as a continuous contradiction of the camera's truthfulness: ". . . Hiller has been busy with camera, models, brushes, paints, and modeling clay, turning out 'creative photographs' for calendars, posters, booklets, and other advertising material. The subjects of his 'photos' range from Commodore Peary discovering the North Pole and the pioneers of '49 crossing the desert in covered wagons, to Santa Claus making a triumphal entry in his reindeer sled on the asphalt of Fifth Avenue."[1] Hiller is perhaps best remembered for his series of staged, narrative photographs depicting key moments of surgical history, or at least those episodes in which some pioneering surgeon discovered a new cure or technique that revolutionized the history of human medicine. Hiller's series, begun around 1927 and most likely not completed until the late 1930s or early 1940s, was done for the American firm of Davis & Geck, which specialized in the production of surgical sutures. Included in the series were such subjects as Aspasia, "the first woman physician and surgeon," the Italian anatomist Gabriello Fallopius who discovered the tubes named after him, and more obscure figures such as Giovanni Andrea della Croce and François Rousset. Over two hundred of these historic events were photographed, apparently, many of them used for advertising by the firm during the 1930s and a selection made for Hiller's book *Surgery Through the Ages . . .* of 1944.[2]

Seldom since Oscar Gustave Rejlander's *Two Ways of Life* of 1857 has photography been placed so successfully in the service of grand historical subjects. Next to Hiller's work, the tableaux of even the most famous photographic fabulist of the 1930s, William Mortensen, seem devoid of breadth and rather predictable [fig. 74]. Whether culturally determined or a product of Hiller's idiosyncratic mind, what distinguishes his pictorial historicizing from that of Rejlander, say, is the degree to which he can be charged with a relentless sexism unsuited to the historical demands of his program. Throughout the entire span of his rehabilitation of surgical history, the only figures portrayed as ill, distressed, or dying *and* naked are attractive, very well endowed, young women. By the very poses and staged action of these models, Hiller stresses a prurient eroticism that is thoroughly incidental to the subject and thus salacious. Nonetheless, in the midst of progressive photographic purism, exemplified by the work of Edward Weston and Imogen Cunningham, and following

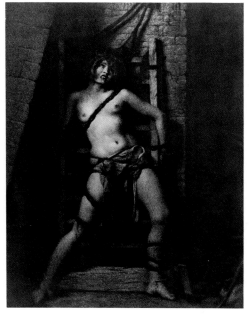

Fig. 74. William Mortensen, *The Heretic*, from *Monsters and Madonnas*, San Francisco, 1936. Gift of Dr. C. E. Kenneth Mees, Rochester, NY.

in the wake of effusively sentimental pictorialism, as seen in the photography of Paul L. Anderson and Adolf Fassbender, Hiller maintained a creative belief in the ability of photography to illustrate historical events and narrate grand schemes equally as well as it could render natural form or evoke poetic emotions.

Etienne Gourmelen (ca. 1540–1595) was a French surgeon, author of several medical treatises, and a teacher, whose historical fame stemmed from his treatment of plague victims. "Gourmelen was dean of the faculty when the terrible plague of 1580 swept Paris and the death carts rattled through the cobbled streets picking up victims of the dread epidemic which, presumably, was bubonic plague. During these dark days Gourmelen was everywhere in the city giving his services to the stricken, aiding the fearful and showing such unusual zeal and philanthropy that he became one of the best loved men in Paris."[3] This is the scene, then, that Hiller attempted to reproduce by actors and painted backdrops, which resulted in a picture that mediates between the expressionism of Robert Wiene's film *The Cabinet of Dr. Caligari* of 1921 and the psychosexual photographic theatrics of Les Krims or Helmut Newton during the late 1970s.

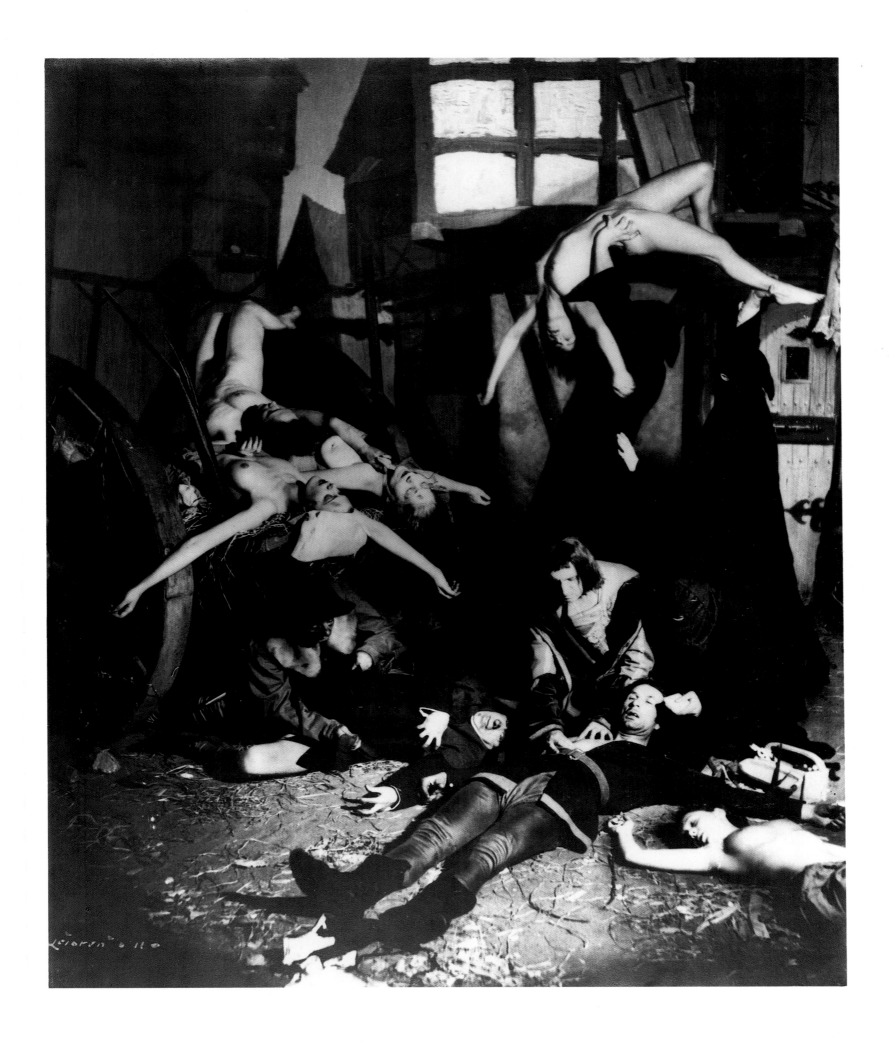

GEORGES HUGNET

French · 1906–1974

"The Double Life . . ."

1936 · Photomechanical offset, rotogravure, typography · From Georges Hugnet, *La septième face du dé, Poèmes—découpages*, Paris, 1936, insert to special edition. 28.7 × 21.0 cm.

La septième face du dé is a pictorially extended serial narrative in which there is a complete merging of texts and images, words and pictures combined in such a manner as to suggest if not tell a story. As such it is a masterpiece of 20th-century art, one in which its author, the Dada and Surrealist poet Georges Hugnet, complicated the modern artistic investigation of psychosexual pathologies by the concrete realism of photography and photomontage. A small volume of ninety unnumbered pages, the work is divided into twenty chapters, each made up of a single page of "poetry" eccentrically arranged and in differing typefaces, facing a page of pictorial and typographic montage reproduced by offset printing [fig. 75]. The deluxe edition of the publication, limited to twenty copies, came bound in a special cover by Marcel Duchamp, and included an original montage, like this one, signed by Hugnet. The story of the "novel" involves the internal voyage of either one or two young girls through episodes of sexual initiation, deflowering, submission, confinement, and violence. Both the literary and the pictorial contents are filled with motifs of strange perfumes, exotic insects, and luxurious splendors that are, in turn, countered by other metaphors of fire, phallic reptiles, and sacrificial lambs. The montages are replete with discernible images of semi-nude women coyly hiding behind their gloved arms, languishing females in overstuffed armchairs, and nudes in ecstasy, as well as women chained to boxes or kneeling in purposely ambiguous positions signaling either pious reverence or abject subjugation.

Hugnet was not the first modern artist to attempt a serious modification of the traditional book format, but he went well beyond his antecedents in working with photographic and photomechanical found imagery and with lengthy, and at times audacious, passages of discovered texts. *La septième face du dé* can be compared to André Breton's and Philippe Soupault's pioneering Surrealist work *Les champs magnétiques* of 1921 or to any of Max Ernst's pictorial novels, such as *Rêve d'une petite fille qui voulut entrer au Carmel* of 1930 or *Une semaine de bonté* of 1934. While Hugnet's publication is rooted in Dada and Surrealism, his montages are structurally closer to the "*fotoplastiks*" by Moholy-Nagy; instead of explosively disintegrated like many of the Dada montages, they are more clearly orchestrated literal and narrative images, although rather confusing as to what exactly is being narrrated.

The Dadaist Tristan Tzara described the functions of ordinary collage:

A form plucked from a newspaper and introduced in a
drawing or picture incorporates a morsel of everyday reality

Fig. 75. Georges Hugnet, Chapter 10, double-page spread from *La septième face du dé*, Paris, 1936.

into another reality constructed by the spirit. The contrast between materials which the eye is capable of transposing almost into a tactile sensation, gives a new dimension to the picture in which the object's weight, set down with mathematical precision by symbols, volume and density, its very taste on the tongue, its consistency
brings before us a unique reality in a world created by the force of the spirit and the dream. [1]

For the Surrealist André Breton, the juxtaposition of mere objects, capable of eliciting complex and unexpected meanings, along with a written text, resulted in what that artist called "*objets-poèmes*": "The object-poem is a composition which combines the resources of poetry and plastic art, and thus speculates on the capacity of these two elements to excite each other mutually." [2] Hugnet openly credited Breton as a source for his "novel": "André Breton attempted to intimately blend writing and visual representation, poetry and chance in his poem-objects. In *La septième face du dé*, I myself, by means of *poèmes-découpages*, made like experiments by suppressing metaphor for the sole advantage of the image." [3] In many ways, the origins of much later montaged eroticism, such as that found in the work of Robert Heinecken, may be indirectly traced to Hugnet's example.

SECRETE

mutilée

La double vie

RISQUAIT DE PERDRE

ROBOT MAGIQUE

Un buste

se laisse
mourir
de désespoir

Votre destin

n'est que de l'herbe

Mai 1936 GH

MANUEL ALVAREZ BRAVO

Mexican · 1902–

Murdered Worker, Tehuantepec, Chiapas

1934 · Gelatin silver print · 19.3 × 23.8 cm.

The Surrealist poet and artist André Breton began his essay on Mexico in 1939 with the juxtaposition of two photographs by Alvarez Bravo, one an image of a variety of agave planted atop a grave, and the other this image of a dead worker in Tehuantepec, then entitled *After the Strike*. The first words of the text were, "Red earth, virgin earth, completely impregnated with the most generous blood, earth where there is no price to a man's life."[1] Breton continued:

> Mexico, only slightly awakened from its mythological past, continues to evolve under the protection of Xochipilli, god of flowers and lyric poetry, and of Coatlicue, goddess of the earth and violent death, whose effigies dominate all others in their pathos and intensity.... This power of conciliation between life and death is without any doubt the principal enticement to which Mexico is disposed. In this respect, it opens an inexhaustible register of sensations, from the most benign to the most insidious. The great art of Manuel Alvarez Bravo permits us... to discover these extreme polarities.[2]

One simply cannot address the work of this photographer without confronting the symbolism, the metaphors, the emblems, and the reality of death, whether it is the flowering plant in the cemetery, the child's coffin mounted on a wall above a Victrola, a young girl smiling while holding a candy skull on the forehead of which is the word "*Amor*," or an assassinated striker. Even where death is not the nominal theme of the picture, Alvarez Bravo customarily prints with such deep shadows and density that its presence is none too far. As one critic wrote in 1971:

> Death is omnipresent in Alvarez Bravo's... prints.... [he] is not obsessed with death, but simply surrounded by it to such an extent that his consciousness of it, in all its manifestations, necessarily imbues his work.[3]

It is the land, as in Malcolm Lowry's novel *Under the Volcano*, begun in Mexico in 1938, where "effortlessly, beautifully, in the blue sky above them, floated, the vultures—xopilotes, who wait only for the ratification of death."[4]

This print is not journalism in any strict sense; it is a work of artistic vision, consistent with a body of such work, whose subject is not as portentous as it is abjectly, expressively moving. It is an image as graphically powerful as an Aztec carving of "Death Monsters," Diego Rivera's murals, or Posada's revolutionary prints.

WEEGEE [ARTHUR FELLIG]

American · b. Austria–Hungary · 1899–1968

"Booked on Suspicion of Killing a Policeman"

1939 · Gelatin silver print · 34.5 × 27.1 cm.

The image of Weegee is that of the quintessential news photographer: clad in trenchcoat and beaten fedora, persistently attached to his 4 × 5 inch Speed Graphic and flashgun, chewing on a large cigar, sarcastic, gruff, and more than a bit impatient. Were he to carry a revolver instead of a camera, his image could easily be one of a private cop straight out of a period *film noir* detective thriller. And like Sam Spade or the later Mike Hammer, his world was littered with corpses, hoodlums, hookers, precinct houses, tenements and nightclubs, suspects and entertainers. Of course, Weegee also photographed openings at the Metropolitan Opera, the crowd at Coney Island, Emmett Kelly at the circus, and children playing in the street; but these are not his more remembered images. It is for scenes at Sammy's-on-the-Bowery that one turns to Weegee, not the Metropolitan; for New York street people at night, not bathers on the beach at noon; for grief-stricken residents watching their tenement burn, not the fashionable elite at a reception. From 1936 to 1945, he was a free-lance journalist. His pictures appeared in numerous newspapers, such as the *Herald Tribune*, *Daily News*, *PM*, and *Post*, and were syndicated through Associated Press Photos, World Wide Photos, and Acme Newspictures, which later became United Press International Photos.

The eruption of mob wars and organized murders during the late 1930s and 1940s furnished Weegee with ample subject matter for the tabloids, and, like his pictures, his recollections of the period were written in the same neutral, direct tone used by a Dashiell Hammett or Mickey Spillane.

I started getting a lot of murders. . . . When the murder happened at night, it was very difficult to photograph a black car. So, believe it or not, I sent word back to the boys at Murder, Inc., that the next time they did a job, to steal (now, when they're going to do a job, they don't call up a carrier limousine service) a car, don't get a black limousine—it's very hard to photograph at night, especially a rainy one. Get a light-colored one—light gray, and watch the interior decor—have it in good taste.[1]

Like his predecessor Brassaï, Weegee made his best pictures at night. But where Brassaï, often using a tripod, carefully composed his images of nocturnal Paris into complex, subtle arrangements, Weegee reacted spontaneously to the scene's central issue, igniting his subject matter with the harsh light of his flash.[2] Any compositional niceties were gotten to later by Weegee or an editor; it did not matter who cropped the image as long as it was focused on the subject and preserved the facts. The original negative from which this image is printed was photographed horizontally. At the left appeared the looming arm of the police photographer preparing his camera for the mug shot. The final print, with Weegee's stamp on the verso, is only concerned with the image of the psychopathic cop killer, beaten and abject, being lead by two seemingly ponderous detectives to the height indicator against the wall.[3] In a way, the final image is that of a modern, secular *Ecce Homo*, victimized and presented to the masses through newsprint before his execution.

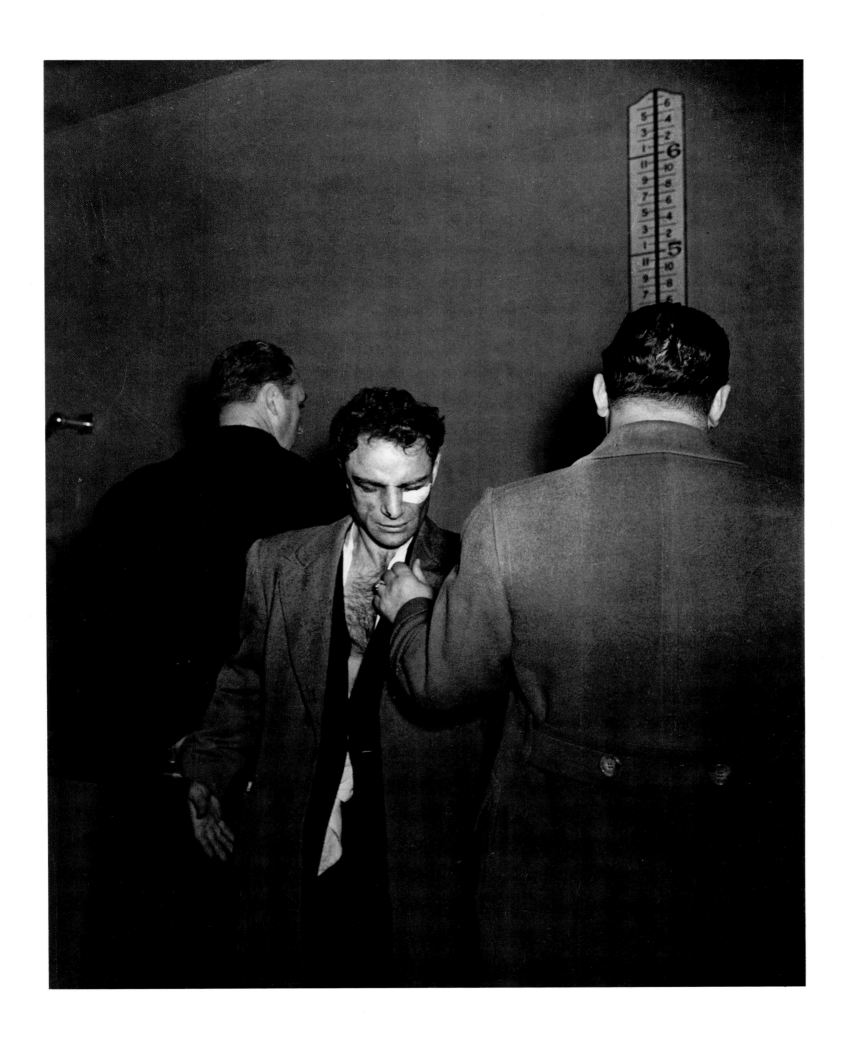

ARTHUR ROTHSTEIN

American · 1915–

Dust Storm, Cimarron County, Oklahoma

1936/printed later · Gelatin silver print · 19.1 × 19.2 cm.

On April 30, 1935, President Franklin Delano Roosevelt signed Executive Order 7027, thus creating the Resettlement Administration, an independent agency established to assist the growing numbers of American rural poor displaced from their tenant farms during the Depression. In July of that year, Roy Emerson Stryker joined the staff of the Resettlement Administration as "Chief of the Historical Section," whose responsibility it was to direct economists, sociologists, statisticians, and photographers engaged in compiling information relevant to the Administration's charge. By the end of the year, Stryker had assembled a team of four photographers for the section: Walker Evans, Dorothea Lange, Carl Mydens, and Arthur Rothstein. While they are usually discussed as Farm Security Administration photographers, it was not until 1937, when the Resettlement Administration was absorbed into the Department of Agriculture, that the F.S.A. was officially organized. By that time, however, Stryker's team had already created some of the most poignant and classic images of the Great Depression.

If Dorothea Lange's famed *Migrant Mother* or her photograph of a farm laborer and his wife in their dilapidated car [fig. 76] documented the look of the American migrant poor after they had arrived in California—those displaced "Arkies" and "Okies" celebrated by John Steinbeck in his novel *The Grapes of Wrath* of 1939—Rothstein's picture of an Oklahoma farmer and his two sons depicted the oppressive poverty and adverse conditions from which these migrant laborers were escaping, the so-called "Dust Bowl" of the Southern Midwest.

It was in Cimarron County, in the middle of the Oklahoma Panhandle, that I found one of the farmers still on his land. . . . The buildings, barns and sheds were almost buried by drifts and in some places only the tops of the fenceposts could be seen. . . . While making my pictures I could hardly breathe because the dust was everywhere. It was so heavy in the air that the land and sky seemed to merge until there was no horizon. . . . Just as I was about to stop shooting, I saw the farmer and his two sons walk across the fields. As they pressed into the wind, the smallest child walked a few steps behind, his hands covering his eyes to protect them from the dust. I caught the three of them as they neared the shed.[1]

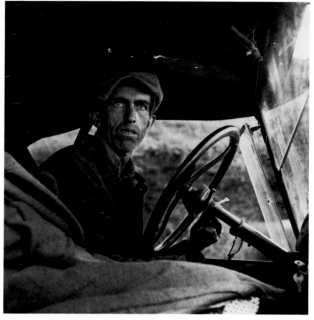

Fig. 76. Dorothea Lange, *Migratory Farm Laborer on the Pacific Coast, California*, gelatin silver print, 1936.

Perhaps because this image has been so often reproduced and become so much a part of the visual baggage of the Depression, or perhaps because there is a certain sense of theater to the scene, almost as if it were too perfect a *summa* of what we imagine the actual situation to have been, Rothstein's photograph no longer appears the result of neutral disinterestedness or of that clinical factuality we call social realism. That the image is dramatic and theatrically expressive, however, was an essential aspect to thirties' documentary photography as a means of penetrating journalistic interpretation. Rothstein's photograph functions much the same as did the finest of documentary films of the period, as described then by John Grierson, the Scottish filmmaker who coined the term "documentary" in 1926: "It gets behind the news, observes the factors of influence, and gives a perspective to events. . . . it has yet carried over from journalism . . . something of that bright and easy tradition of freeborn comment which the newspaper has won. . . ."[2]

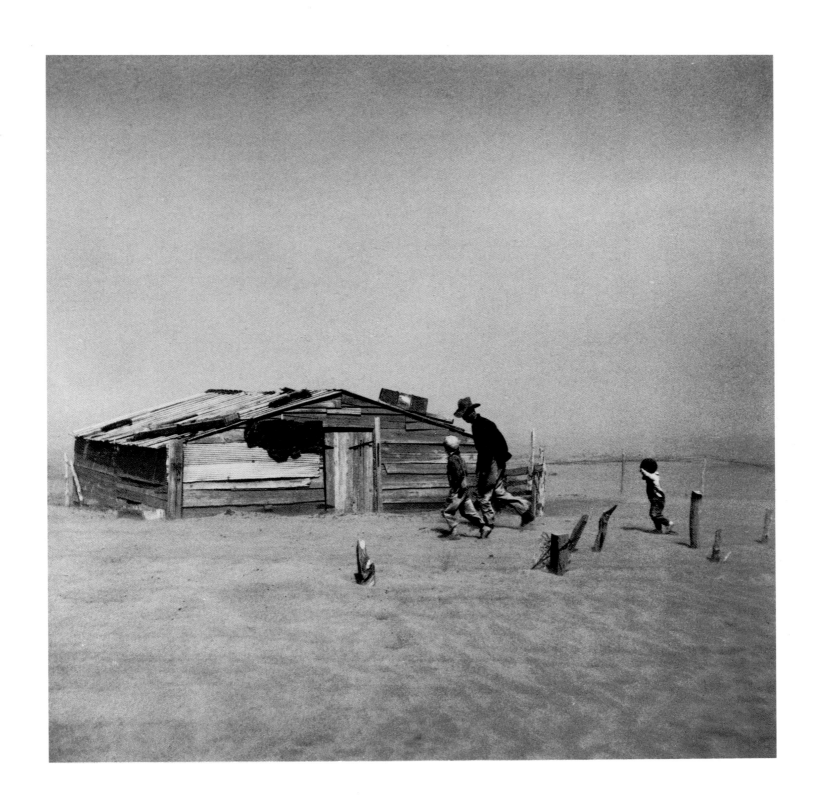

MARGARET BOURKE-WHITE

American · 1904–1971

Taxi Dancers, Fort Peck, Montana

1936 · Gelatin silver print · 37.8 × 49.6 cm.

The first issue of *Life* magazine, dated November 23, 1936, not only featured a photograph by Margaret Bourke-White on its cover, but hers was that issue's lead photographic essay. Prior to this, Bourke-White had worked in her own photographic studio in Cleveland, and in 1929 began photographing for Henry Luce's *Fortune* magazine. In 1930 and 1931, she documented the expanding industry of Russia in still photographs and, in 1932, in cinematography. For *Fortune*, in 1934, she reported on the severe drought in the Midwest that earned it the name Dust Bowl and attracted such photographers as Walker Evans and Arthur Rothstein in following years. In 1936, Bourke-White, Alfred Eisenstaedt, Thomas D. McAvoy, and Peter Stackpole constituted the original photographic staff of Luce's famed *Life* magazine, for which her first assignment was to document the construction of what was then the world's largest earthen dam, at Fort Peck, Montana.

As part of Franklin Roosevelt's New Deal program, begun in 1933, a series of dams were built in the Northwest, among them Grand Coulee Dam and Bonneville Dam along the Columbia River and the Fort Peck Dam on the Missouri. The undertaking was a monumental task of engineering, and Bourke-White's shot of the immense and brutal concrete piers of Fort Peck Dam, which appeared on *Life*'s first cover, was as optimistic a celebration of modern progress and industry as were her earlier photographs of the gargoyles atop the Chrysler Building in New York or of the world's largest blast furnace in Magnitogorsk in the U.S.S.R. Taken the same year as H. G. Wells's *The Shape of Things to Come*, her portrayals of the dam's piers or of workmen dwarfed by the vast scale of its diversion tunnels [fig. 77] attest to a fervid nationalism as much as to a trust in a future of technological prosperity, similar to those expressions of modern faith found in the "Century of Progress" exposition of 1934 and the New York World's Fair of 1939.

With the construction of these dams, a number of shanty towns sprung up around the sites with such names as "New Deal," "Square Deal," and "Delano Heights," honoring Roosevelt's program of economic relief during the Depression. Life in these towns contrasted sharply with the image of American poverty found in the photographs of migrant workers by Dorothea Lange and Dust Bowl farmers by Arthur Rothstein made the same year as Bourke-White's coverage of these towns. While not affluent by any means, these towns affirmed and Bourke-White's

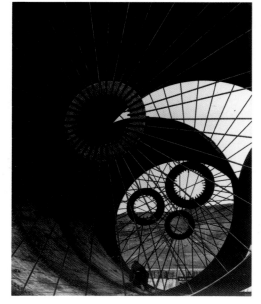

Fig. 77. Margaret Bourke-White, *Worker in Steel Liner of Diversion Tunnel, Fort Peck Dam, Montana*, gelatin silver print, 1936.

photographs validated the American work ethic. The printed captions in *Life* even romanticized that ethic in terms of the country's pioneer spirit.

The frontier has returned to the cow country. But not with cows. In the shanty towns which have grown up around the great U. S. work-relief projects at Fort Peck, Montana, there are neither long-horns nor lariets. But there is about everything else the West once knew with the exception of the two-gun shootings. . . . If the hombres aren't as tough as Billy the Kid they are tough enough—particularly on pay day. Even the dancing has the old Cheyenne flavor. These taxi-dancers with the chuffed and dusty shoes lope around with their fares in something half way between the old barroom stomp and the lackadaisical stroll of the college boys at Roseland. They will lope all night for a nickel a number. Pay is on the rebate system. The fare buys his lady a five cent beer for a dime. She drinks the beer and the management refunds the nickel. If she can hold sixty beers she makes three dollars—and frequently does. [1]

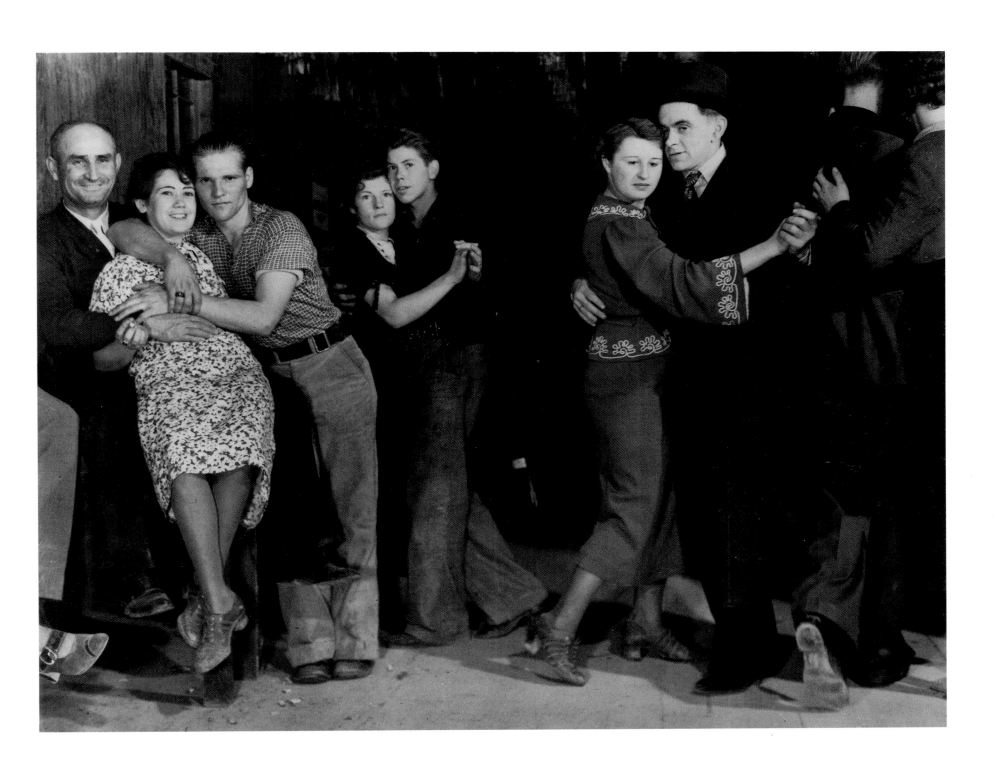

DOROTHEA LANGE

American · 1895–1965

Migrant Mother, Nipomo, California

1936/printed later · Gelatin silver print · 32.8 × 25.7 cm.

This picture has become the quintessential photographic portrayal of human abjection. More than that, it has taken on the investiture of the eternal abjectness of Motherhood—supportive while in fearful grief, stoic yet vulnerable, meant to suffer but not exactly certain of the reason. It is a profane correlative to the Madonna of the Passion, or perhaps a variation of the painter Edvard Munch's *Inheritance* of 1898 whose mother cradles her dying, syphilitic child, only the inevitable now is more broadly social and economic. Like the narrator's mother in Céline's *Journey to the End of the Night*, published two years before this picture was taken, "She had no doubt that poor people like her were born to suffer in every way, that that was their role on earth, and that if things had been going so badly of late, the cumulative faults of the poor must have a good deal to do with it. . . . giving them a chance to expiate their transgressions by suffering was a great kindness."[1]

The theme of human abjection has been portrayed photographically since the middle of the last century. Social realist images, if not possible in real life situations, could at least be feigned or staged, as Oscar Gustave Rejlander had done with his *Poor Jo* of around 1860, or John Thomson with his depiction of a derelict woman, *The Crawlers* of about 1876. Later, documentary photographers like Lewis Hine and Jacob Riis had recorded the misery and poor living conditions of the economically distressed in situ; and, during the Great Depression, the theme was as inherent to certain strata of the culture as it was the object of

much of the period's photographic documentation. Following the second World War, journalists like W. Eugene Smith created countless memorable images of human grief and anguish. Yet none, fictive or otherwise, can match Dorothea Lange's *Migrant Mother* of 1936 for its simplicity of means, its restrained pathos, and its mute autonomy of language.

Like Walker Evans and Arthur Rothstein, Lange was a member of Roy Stryker's photographic team charged with photographing the plight of the American farm worker for the "Historical Section" of Roosevelt's Resettlement Administration. In March of 1936, after completing a month of photographing the migratory farm labor of California, Lange chanced to make a final stop at a "Pea-Pickers Camp" near Nipomo. There, just after a rainstorm, she made five exposures in about ten minutes, all of the same subject, a thirty-two-year-old mother and four children who had been living in a primitive three-sided lean-to and feeding on peas dug from the frozen ground and birds killed by the children.[2] "There she sat in that lean-to tent with her children huddled around her, and seemed to know that my pictures might help her, and so she helped me. There was a sort of equality about it. The pea crop at Nipomo had frozen and there was no work for anybody."[3] As a result of the publication of two of her photographs, neither of which were this image, food was soon sent to the pea pickers of Nipomo by the Relief Administration.[4] According to Lange, no names were exchanged.

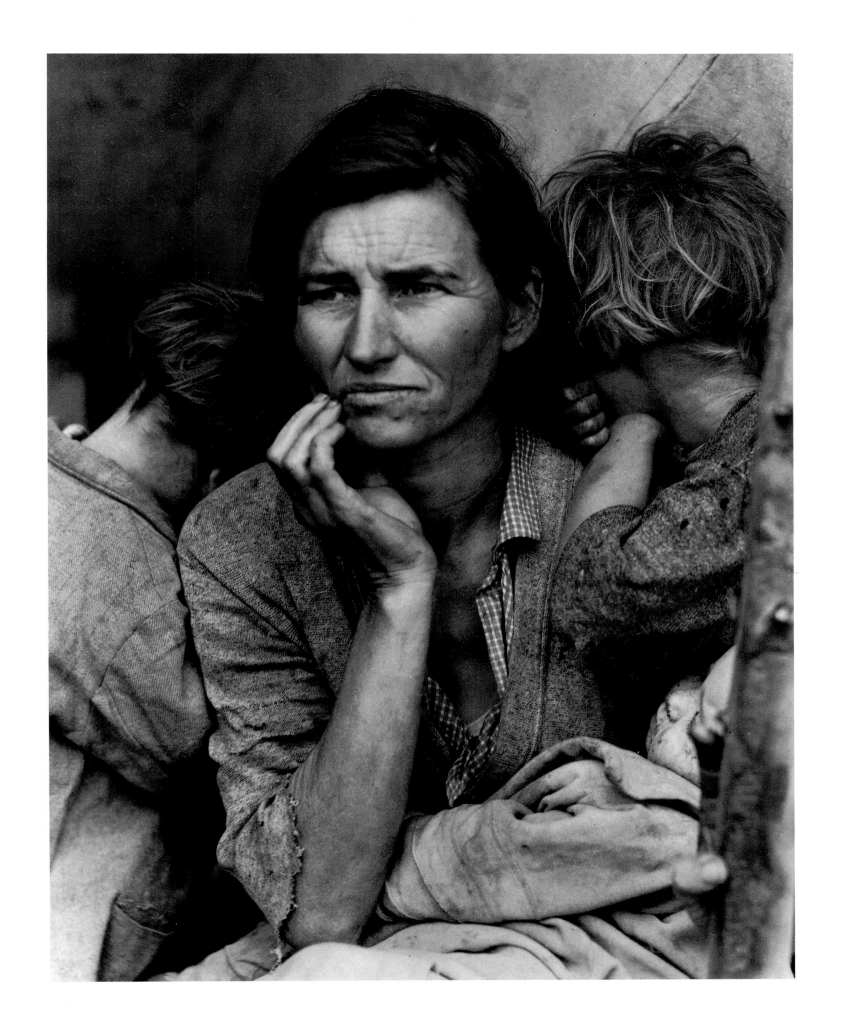

WALKER EVANS

American · 1903–1975

Floyd Burroughs and Family, Alabama

1936/printed later by James Dow · Gelatin silver print · 19.3 × 20.0 cm.

Perhaps the best description of Walker Evans's photographs is one written by John Szarkowski in 1971:

> Without doubt, Evans' pictures have enlarged our sense of the usable visual tradition, and have affected the way that we now see not only other photographs, but billboards, junkyards, postcards, gas stations, colloquial architecture, Main Streets, and walls of rooms. Nevertheless Evans' work is rooted in the photography of the earlier past, and constitutes a reaffirmation of what had been photography's central sense of purpose and aesthetic: the precise and lucid description of significant fact. . . . Evans at his best convinces us that we are seeing the dry bones of fact, presented without comment, almost without thought. [1]

And while the subjects listed here are limited to Evans's powerful documentation of America during the Great Depression of the thirties, the same would apply to the famous series of portraits he made in 1936. In these, families of Alabama sharecroppers are portrayed with all the patient factuality and willful completement found in Evans's views of architecture and interiors, walls of posters and roadside gas stations, Southern mansions and destitute stores [fig. 78].

In 1936, originating with a commission from *Fortune* magazine, Walker Evans and the writer James Agee embarked on a survey of Southern cotton tenancy; the piece was to be a "photographic and verbal record of the daily living of an 'average,' or 'representative,' family of white tenant farmers." [2] Neither artist suspected that the abandoned magazine article and resultant book, *Let Us Now Praise Famous Men*, would become the decade's classic example of investigative reporting. In a single book, published by Houghton Mifflin in 1941, both Agee and Evans defied every expectation about what constituted the documentary mode. Agee's prose was subjective, fulminating, and hectoring of his readers; his was essentially a political bias but one that did not remove itself from the fundamental humanity of the subjects. Evans's pictures, too, refused to pander to conventional expectations of what and how the Southern agrarian poor looked like. These were not figures illustrated from descriptions in an Erskine Caldwell novel, they were actual folks, not cartoons or stereotypes; in Evans's photographs they possessed the nobility and the look of existential humankind within a real world. They were not subjected to an expressionistic recording, playing to a sympathetic sensibility by showing them in struggle or abjection. Instead, Evans chose to portray his subjects in a completely moral fashion, honoring them with a human dignity,

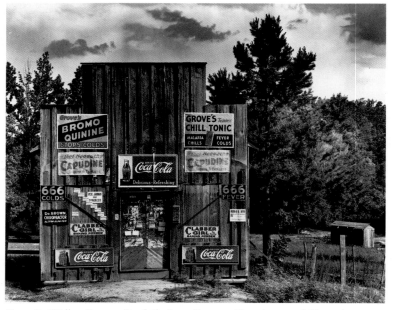

Fig. 78. Walker Evans, *Roadside Store Between Tuscaloosa and Greensboro, Alabama*, gelatin silver print, 1936. Museum purchase with National Endowment for the Arts support.

and accepting them fully into the complicity of the portrait. Szarkowski was correct; Evans's work is "rooted in the photography of the earlier past," for, in this and nearly all of his photographs, there is the unequivocal directness and clear economy of style that characterized the finest American daguerreotypes of the last century.

Evans photographed much like Agee wrote about these tenant farmers, whose actual names were changed for publication. The approach to their "art" was similar with both men, and may be characterized in part by one of Agee's comments concerning his involved objectivity as a writer.

> . . . I would do just as badly to simplify or eliminate myself from this picture as to simplify or invent character, places or atmospheres. A chain of truth did actually weave itself and run through: it is their texture that I want to represent, not betray, nor pretty up into art. The one deeply exciting thing to me about Gudger is that he is actual, he is living, at this instant. He is not some artist's or journalist's or propagandist's invention: he is a human being: and to what degree I am able it is my business to reproduce him as the human being he is; not just to amalgamate him into some invented, literary imitation of a human being. [3]

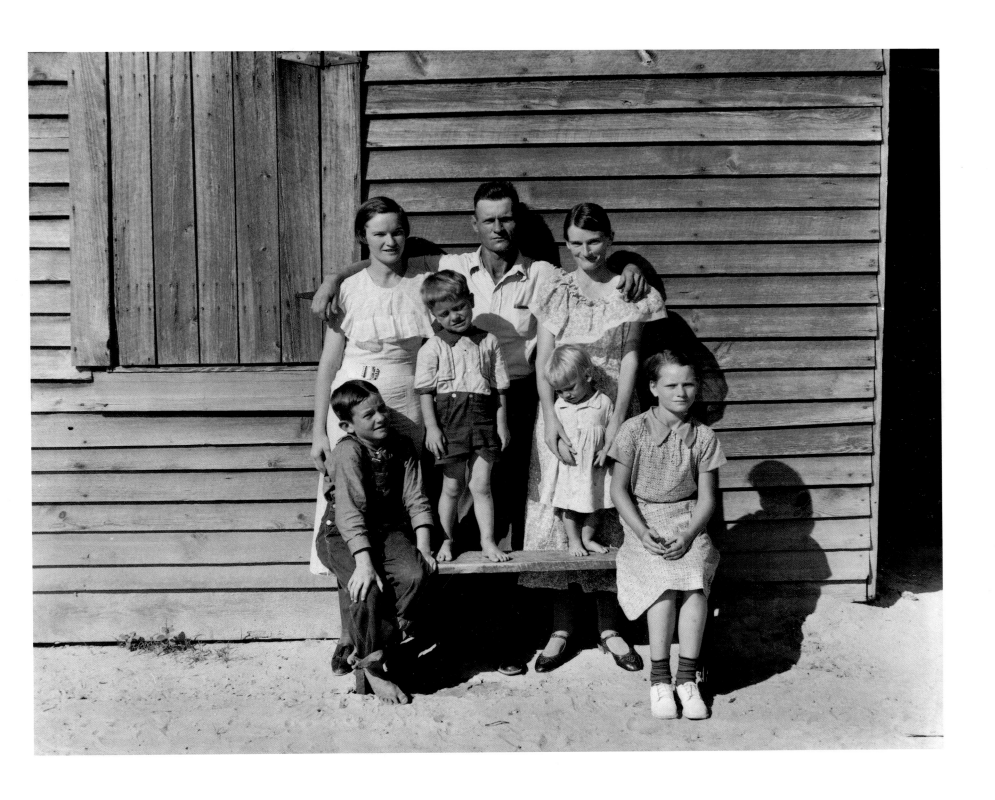

FRANCIS BRUGUIERE

American · 1879–1945

Rosalinde Fuller and Her Sister

ca. 1936–40 · Gelatin silver print, solarized · 23.1 × 17.0 cm.

The unusual character and extreme solarization of this print may at first appear disarmingly abstract and confused. Slowly, however, the features of two women are revealed, caught in the shimmering tonal opalescence and graphic orchestrations of lights and darks. Shortly before Francis Bruguière made this print he wrote about the technique used to produce these effects.

> The process, which was observed from the beginning of photography, termed "solarization," has been technically perfected by Man Ray. It is accomplished by exposing a fully developed negative or print to the light for a few seconds, and then continuing development and fixing. It is, as far as I know, the most promising process in the hands of the modern photographer. Here there is no hand work, the results being controlled by light and chemicals: there is what might be termed "legitimate" manipulation of the light. . . . The possibilities of the resultant image range from a slight to a complete transformation of the photographic image.[1]

Bruguière gave full credit for his inspiration to Man Ray, who, perhaps more than any other photographic artist of the century, established solarization as a creative tool for modern expression; but where Man Ray's solarizations of the twenties and thirties were restrained and nearly classical, Bruguière pushed the process until the image was almost completely deteriorated by the reversals of its tonal scale.

Born in San Francisco, Bruguière studied photography in New York with Frank Eugene, through whom he met Alfred Stieglitz and became an early member of the Photo-Secession. He began experimenting with multiple exposures and multiple printing around 1912, and utilized this technique to surprising ends in the documentation of theater productions and architecture during the twenties. Responding to certain trends in contemporary art, such as Kandinsky's nonobjective painting, American Synchromism of the teens, and the colored-light abstractions of Thomas Wilfred's "Clavilux" of the early twenties, Bruguière progressively worked toward greater abstraction in his photography and produced a series of what he called "designs in abstract forms of light" beginning around 1921 [fig. 79]. In works completely devoid of subjects except the modulation of light, Bruguière created the most formally abstract photographs after Alvin Langdon Coburn's *Vortographs* of 1917. These were for Bruguière a way of "apprehending light as an active symbol of consciousness."[2]

Bruguière photographed for *Harper's Bazaar*, *Vogue*, and *Vanity Fair* during the twenties, and continued in commercial photogra-

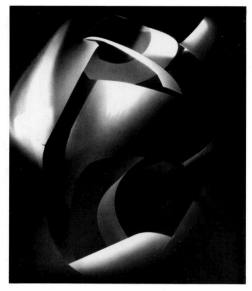

Fig. 79. Francis Bruguière, *Cut Paper Abstraction*, gelatin silver print, ca. 1925-27.

phy, throughout the thirties. He also experimented with the cinema after moving to London, and co-produced Britain's first abstract film, *Light Rhythms*, in 1930.[3] His commercial and personal work was relentlessly modern, drawing equally from both Cubist and Surrealist art. Bruguière was interested in Nietzsche's writings and in Jung's theories of "mandalaism," and many of his works provoke a sense of the oneiric and dreamlike, figures asleep or captured in irreal reverie as in this solarized print of Rosalinde Fuller, Bruguière's companion, and her sister. From Nietzsche's aphorisms, *Human, All-Too-Human* "The Logic of the Dream," Bruguière had copied the following lines.

> In our sleep and in our dreams we pass thru the whole thought of earlier humanity. I mean the same way man reasons in his dreams he reasoned in a waking state for many thousands of years. The first cause which occurred to his mind in reference to anything that needed explanation satisfied him and passed for truth. In the dream this atavistic relic of humanity manifests itself within us, for it is the foundation upon which the higher rational faculty developed and which is still developing in every individual. The dream carries us back to earlier stages of human culture and affords us a means of understanding it better.[4]

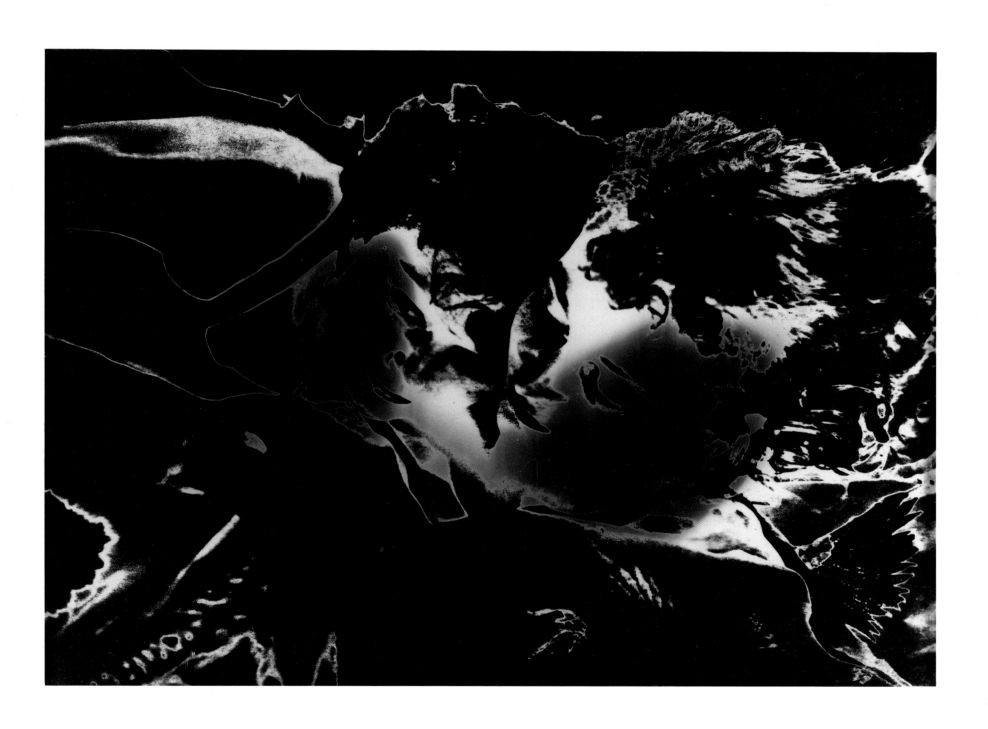

ANTON BRUEHL

American · b. Australia · 1900–1982

Marlene Dietrich

1937 · Dye transfer print · 33.4 × 25.6 cm.

The origins of "glamour" photography, as a sub-species of photographic portraiture, can be traced to a portrait of Mademoiselle Rachel, the most popular dramatic actress in Europe during the Second Empire, made by Charles Nègre in the autumn of 1853. One London newspaper wrote that this French actress "had conquered a large territory hitherto closed to the passions and sympathies of thousands, and given them access to it."[1] Reportedly Nègre's portrait sold over five hundred copies when published, an unprecedented number at the time. By 1880, Rachel had been supplanted by another international actress, and critic Arsène Houssaye could write, "Today, Mlle. Rachel is called Sarah Bernhardt."[2] With Bernhardt's success, photographers like Walery in Paris and Napoleon Sarony in New York found a large and receptive audience for her portraits.[3]

While its beginnings are firmly in the 19th century, "glamour" photography of celebrated stars and personalities entered what might be called its "golden age" only in the 1930s, when the motion picture industry advanced new celebrities yearly and when illustrated magazines could fill their pages with photographs. During the thirties, Hollywood "glamour" photography was dominated by a number of talented portraitists, including Clarence Bull, George Hurrell, and to some degree both Nickolas Muray and Edward Steichen. One of the most respected was the Australian-born photographer Anton Bruehl. Bruehl studied photography in America with the Pictorialist Clarence White

during the 1920s, and at the end of the decade his photographs were included in the German exhibition of avant-garde photography "*Film und Foto*," held in Stuttgart in 1929. In 1932, along with Fernand Bourges, a technical specialist in color photography at Condé Nast publications, Bruehl developed a process of color separation photography that, when reproduced in the pages of *Vogue* or *Vanity Fair* and according to an advertisement in *Vogue*, resulted in "the compelling beauty of a painting and the fidelity of a blueprint."[4] In both black-and-white and in color, Bruehl's advertising and portraiture of the late twenties and thirties, was resolutely "*moderne*"—dynamically composed, severely graphic, and expressionistically theatric. Sharp contrasts, deep blacks, and saturated colors frequently served to underscore gestures of physical tension and psychological stress.

Bruehl's portrait of the German actress Marlene Dietrich appeared on six pages of *Cinema Arts* in September, 1937, the third issue of the magazine. The purpose was to demonstrate the stages of printing color photographs by offset lithography and how various combinations of the colored inks looked during printing, such as red with yellow, or blue and black with yellow. The final page was given to the completed reproduction, entitled "Four-Color Dietrich." The brief editorial text claimed simply that, "When the world's greatest color photographer meets the world's most photographic face, something exciting is bound to happen. . . . We spell it 'Art.'"[5]

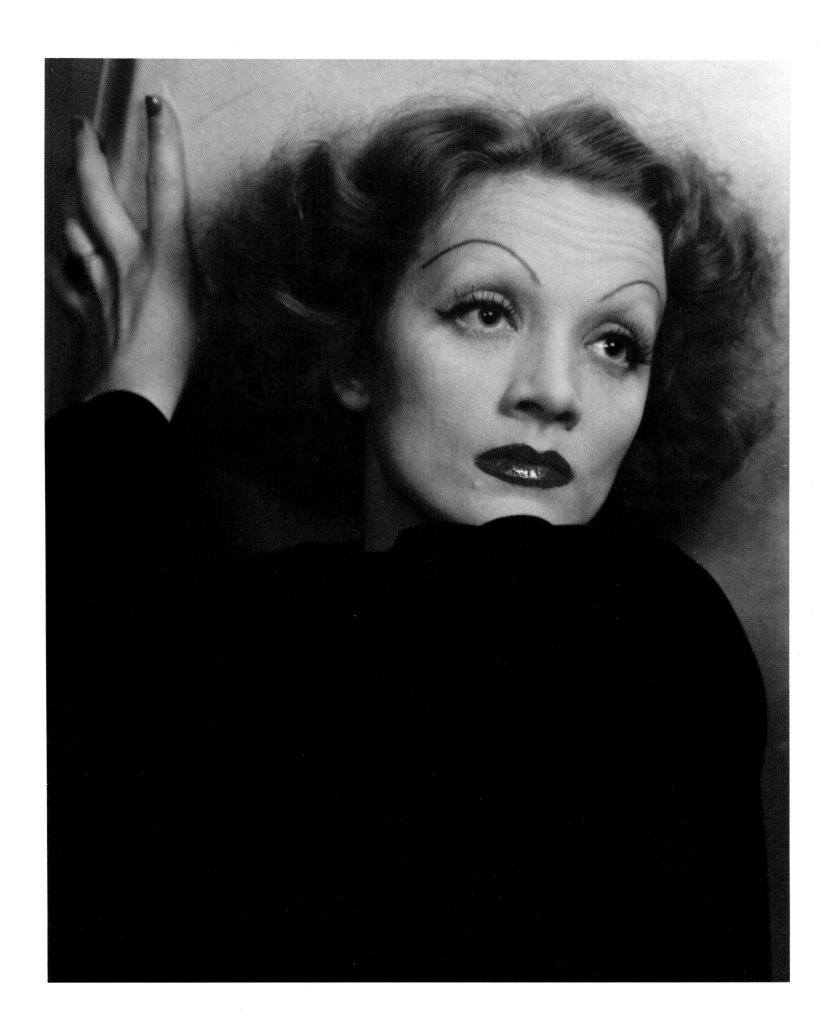

HORST P. HORST

German · 1906–

"From Paris—The New Detolle Corset with Back Lacing"

1939/printed later · Gelatin silver print · 24.5 × 19.8 cm.

The corset is one of those few garments that have taken on the function of a nearly universal symbol; in fact, it may well be the most persistent and, because of that, the most potent sexual symbol in women's fashion. According to the historian David Kunzle, "the corset gave in the past as it still does, vestigially, in the present not merely physical support, but positive physical and erotic pleasure."[1] Depending on one's political attitudes, the corset may either signify human repression or freedom of expression; on both sides, however, the sexual message is paramount.

A tight corset sexualizes the body not simply by thrusting the bosom and hips into prominence, but by showing how it must feel. The sight of discomfort voluntarily endured for the sake of an acute but obscure satisfaction is very disturbing. . . . Among other things, extreme tightness seems to suggest a sexual readiness deliberately prolonged, an erotic tension stretched to the breaking point. Similarly, the display of self-inflicted sexual pain seems to invite sexual cruelty.[2]

When published in *Vogue* in 1939, Horst's consummately surrealistic panegyric to the corset was accompanied by copy that quite openly alluded to sexual bondage while validating the corset as part of a stylish, art historical tradition. "Paris puts you back in laced corsets—and here they are. Detolle made the extreme, back-lacing corset . . . to bind you in for the Velasquez silhouette. This corset is specifically for evening."[3] An article of fashion singularly devoted to physical extremes, the corset is depicted by Horst with full "implausible theatricality,"[4] a still from a dream sequence in which the model appears as a faceless classical torso, without arms or legs, and bathed in that irreal, single-point lighting dear to Surrealists adopting the example of De Chirico. As in a dream, especially one fraught with psychosexual imagery, the mannequin is coolly and tirelessly an object of vision alone, ambiguously and casually placed atop a shelf. Following Roland Barthes, this image is a romantic, "poetic apparition" in which "life receives the guarantee of Art, of a noble art sufficiently rhetorical to let it be understood that it is acting out beauty or dreams."[5]

This particular corset was never mass-produced because of the economic situation of the early war years. Originally designed in pink satin by Mainbocher (Main Bocher), fashion artist and editor of French *Vogue*, it has been characterized as having been the "mainstay of the 'New Look'."[6]

308

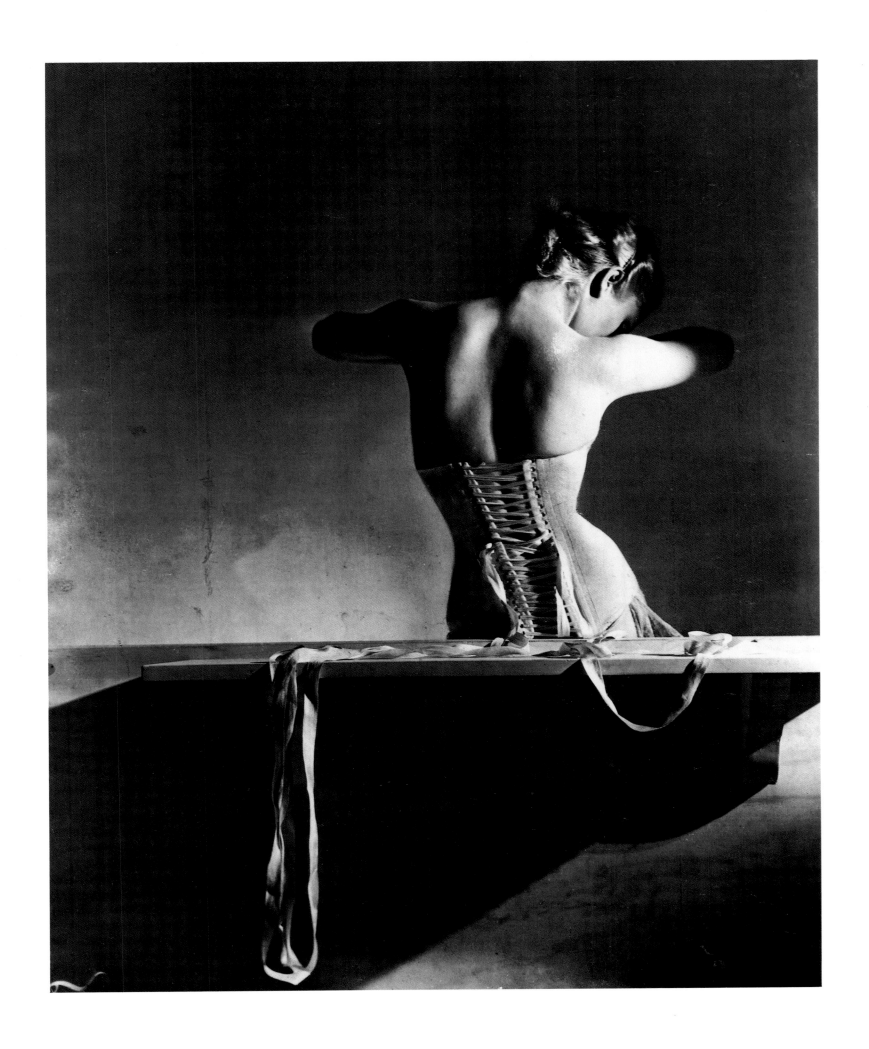

A DYNAMICS OF PLURALISM: MATTERS OF THE HEART AND EYE · 1940-1980

The private photograph, almost meaningless to a stranger, is thought of as if it were the materialization of that glimpse through the window which looked across history towards the timeless. . . . It is only possible to *itemize* the things seen, for if they touch the heart, they do so essentially through the eye.
 —John Berger, "In Opposition to History, In Defiance to Time," 1980

 The sample
One sees is not to be taken as
Merely that, but as everything as it
May be imagined outside time—not as a gesture
But as all, in the refined, assimilable state.
 —John Ashbery, "Self-Portrait in a Convex Mirror," 1975

The division of the perceived universe into parts and wholes is convenient and may be necessary, but no necessity determines how it shall be done.
 —Gregory Bateson, *Mind and Nature*, 1979

Understand this: *All pictures are faked*. As soon as you have the concept of a picture there is no limit to falsification.
 —William S. Burroughs, *The Place of Dead Roads*, 1983

WITH A CENTURY or more behind it, and with an unprecedented range of functional options and alternative styles open to it, photography has become a central force within our culture. For the last four decades we have lived with photography in a way that our ancestors never even suspected; our knowledge of the world and the solar system is derived chiefly from pictures; information is gathered, distributed, and validated by means of photography; and our social landscape is chiefly made up of images. The photograph has been aestheticized, politicalized, conceptualized, invested in, and critically deconstructed. Most time-honored roles of the pictorial arts have been appropriated by camera images. Nearly everyone owns at least one camera, and what previously required at least a modicum of training is now taken for granted: exposures and focusing are automatic, prints process themselves in seconds, and color is more common than simple black and white photography.

Amid these functions and roles, options and alternatives, futuristic technologies and mass-marketed conveniences, and amid all the confusions of diverse stylistic advocacies and moral "camps," still photography continues to address fundamental human issues. Its artists can be journalists or documentarians, commercial or academic, formalists or expressionists, fabulists or poets. Even images made solely for scientific analysis have fascinated us by their unexpected pictorial beauty and the strange worlds they reveal. Amid the panoply of modernism, certain works may seem brash and antagonistic; some may appear as reprises of older imagery while others tease us by their newness; still others are serenely seductive by their obdurate beauty. In the end, the finest photographs confront and challenge us; they force us to understand and, at their best, affect what we see and what we feel.

BARBARA MORGAN

American · 1900–

Pure Energy and Neurotic Man

1941/1970 · Gelatin silver print, combination printing · 50.1 × 38.8 cm.

Barbara Morgan is perhaps best known for her vivid and now classical photographs of the dance, especially those she made of Merce Cunningham, Doris Humphrey, Valerie Bettis, and Martha Graham between 1935 and 1944 [fig. 80]. The exuberant and lyrical energy that Morgan captured stands as one of the most forceful testaments to human vitality ever created by the camera. Even more remarkable is the degree to which, as a photographic artist documenting the artistry of another art form, she was able to faithfully record and at the same time create fully realized and independent works of her own—canonical images not of particular dances (although they are that) but of human motive expression itself.

During the same period Morgan also pursued the photographic expression of more complex and psychological themes and emotions peculiar to modern man. "To survive in this complex activity," she wrote, "no one can have a one-tracked mind. We are rapidly getting many-tracked minds. It is this multiple mind that makes montage possible. Life today is chaotic, unless we organize it. . . . The chief function of montage is that of mirroring this complex life. The multiple form which expresses it must not be chaotic but instead it must be channelized until it makes sense."[1] Drawing on a rich tradition of photographic montage that included the pioneering work of László Moholy-Nagy, John Heartfield, as well as the example of modern abstract art, Morgan stylized a personal approach to the technique of combining various photographic images. Eschewing the cut-and-paste, collage approach favored by the Dadaists and the German and Russian Constructivists, she adopted the more cinematic form of "automatic photomontage," as identified by Moholy-Nagy.[2] Similar to mirrorings and reflections, the multiply exposed or printed image was, for Moholy-Nagy, a perfect means for modern expression, and for Morgan the predominant tool for visually grappling with the ideas of energy, time, and human psychology. According to Moholy-Nagy, "Mirroring means in this sense the changing aspects of vision, the sharpened identification of the inside and outside penetrations. With this instrument of thought many other phenomena (dreams, for example) can be explained as space-time articulations. In dreams there is a char-

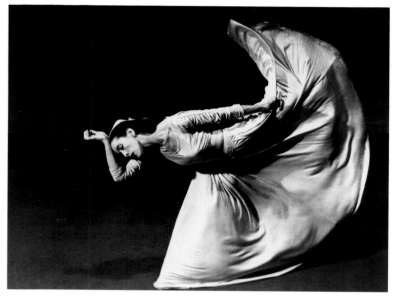

Fig. 80. Barbara Morgan, *Martha Graham, LETTER TO THE WORLD (Kick)*, gelatin silver print, 1944.

acteristic blending of independent events into a coherent whole. Super-imposition of photographs, as frequently seen in motion pictures, can be used as the visual representational form of dreams, and in this way, as a space-time synonym."[3]

Both Moholy-Nagy and Morgan utilized montage and its virtual freedom of pictorial combination for the examination of pathological themes. Around 1927, Moholy-Nagy constructed his famous "fotoplastik" *Jealousy*, which remains to this date rather enigmatic. Two years after the death of Sigmund Freud, and at the beginning of the American involvement in World War II, Morgan created this symbolic image of a realistic human hand in strained tension, either fending off or reaching toward a frenetic nucleus of unbridled light tracings set against a void of black. The montagist, Morgan cautioned, "should keep uppermost in his mind the fact that he is using a high voltage medium only because he has a high voltage experience to express."[4]

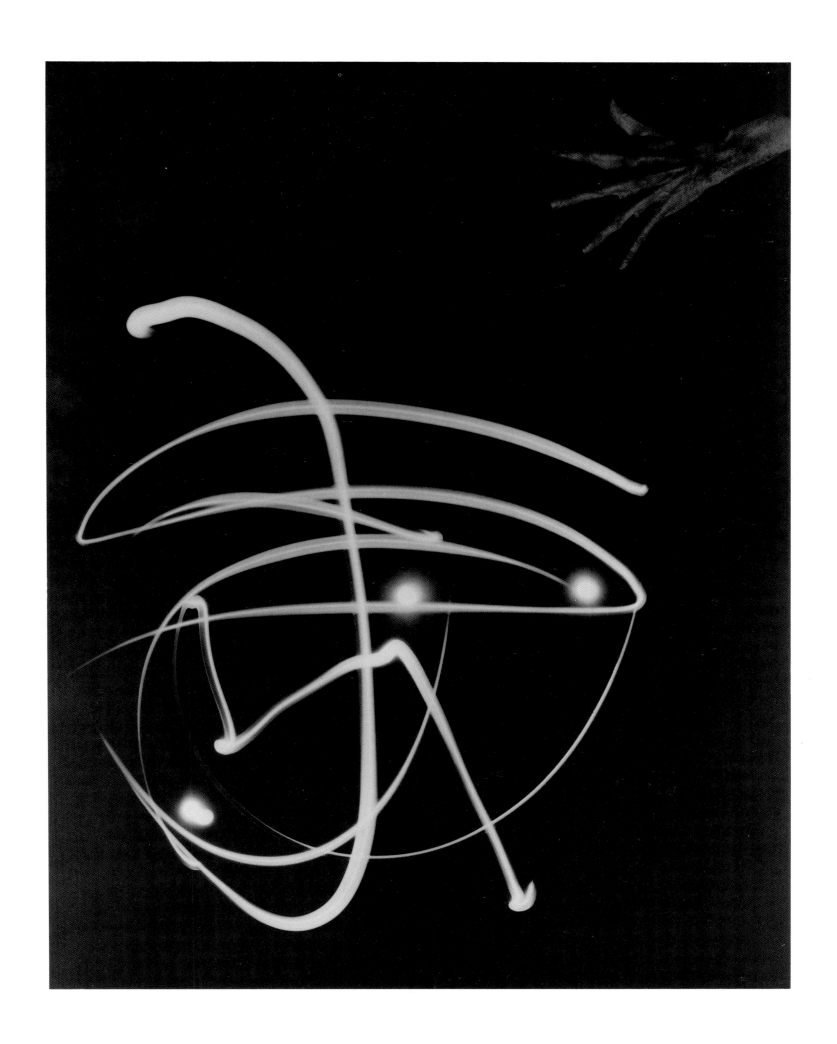

GEORGE PLATT LYNES

American · 1907–1955

George Balanchine

ca. 1941/1959 · Gelatin silver print, printed by Jenson Yow · 19.2 × 24.2 cm.

"I began to photograph with a mere hand Kodak," wrote George Platt Lynes in 1943, "prompted by the importance of certain of my friends such as Gertrude Stein and Marsden Hartley and Alexander Smallens and Tchelitchew; and the beauty of some others, such as Anna Duncan and Barbara Wescott and Joella Lloyd. Worldly greatness and good looks have, I suppose, served as the points of my compass in photography ever since."[1] The two phrases, "worldly greatness" and "good looks," summarize the majority of Lynes's photographic subjects. A truly self-taught photographer, Lynes began taking portraits of friends and social acquaintances in the mid-1920s, and by 1933 he had graduated to an 8 by 10 inch view camera and his own studio in New York, where he photographed the most important personalities of literature, the arts, dance, and society. Glamor in any form attracted Lynes, and his fashion photographs were published widely in *Town and Country*, *Harper's Bazaar*, and *Vogue*—images that merged his own tastes for imaginative compositions with those of the period's fascination with Surrealist settings, pictorial irony, and the fantastic. A contemporary of Cecil Beaton, Angus McBean, and Horst P. Horst, Lynes customarily staged his fashion plates (as well as his sensitive and evocative depictions of the dance and its performers) in an irreal spatial zone in which a strange course of figural behavior is played out. And, nowhere is the imagery of the dream and its psychosexual iconographies better addressed than in Lynes's series of male nudes and principally homo-erotic "Mythologies" of the late thirties. Like Wilhelm von Gloeden at the turn of the century, Lynes, too, vested many of his male nudes with a token vernacular of classical antiquity; except that where Von Gloeden's classicism was merely superficial, Lynes's was programmatically illustrative of characters from Ovid's *Metamorphoses*. During the 1940s, Lynes traded Ovid for Freud's *The Interpretation of Dreams*, with the result that his nudes are frequently depicted in multifigured engagements that border on psychodrama—scenes often implying torture and anxiety.

If Lynes was patently surrealistic in his fashion and nude pho-
tography, he was only a little less so in his stylish, and at times symbolic, portraiture. According to Lincoln Kirstein:

> . . . Lynes fixed the face of nearly every artist and writer and musician of importance in his epoch, in a unique attitude. He has seen their faces as a symbol of the particular quality of their essential talent, not as a melodramatic mask which reflects the corroboration of a public icon. . . . Lynes' faces remained private faces. Sometimes he used accessories in the manner of symbolic badges; sometimes an object found around the studio suggested itself as a good positive or negative complementary shape, but his decor never got into gadgetry, and although he took some of the best fashion pictures of his time, the portraits are never fashion plates. They are dandiacal and elegant, but they do not date. . . . Elegance is a moral virtue which distills the aristocracy of personal grace and individual gift.[2]

One of Lynes's finest portraits was of the master choreographer George Balanchine, smartly attired, herringbone sport coat cavalierly draped, and silk tie insouciantly thrown over the shoulder. Intently staring at something unseen behind him, Balanchine holds a claw hammer and hand drill in his hands, oblique signs perhaps of his role as carpenter of the dance. The intensity of pose and expression and the uncertain signification of these tools is rendered even more unnerving by the fact that the choreographer's right arm is in reality a piece of sculpture or studio prop. What Balanchine said about Lynes's dance photographs could easily be transferred to this portrait. "His photographs have several lives of their own: as a record, as portraiture, as social-history of the taste of an epoch, and as beauty. For Lynes' secret was his sense of plasticity, his genius for lighting figures in space so that his bodies seemed to exist in an actual aery ambience, akin to the three-dimensional vitality in sculpture."[3] Lynes transformed his subject into a strange, emblematic deity not unlike some ancient Egyptian statue, regal and stately but finally obscure.

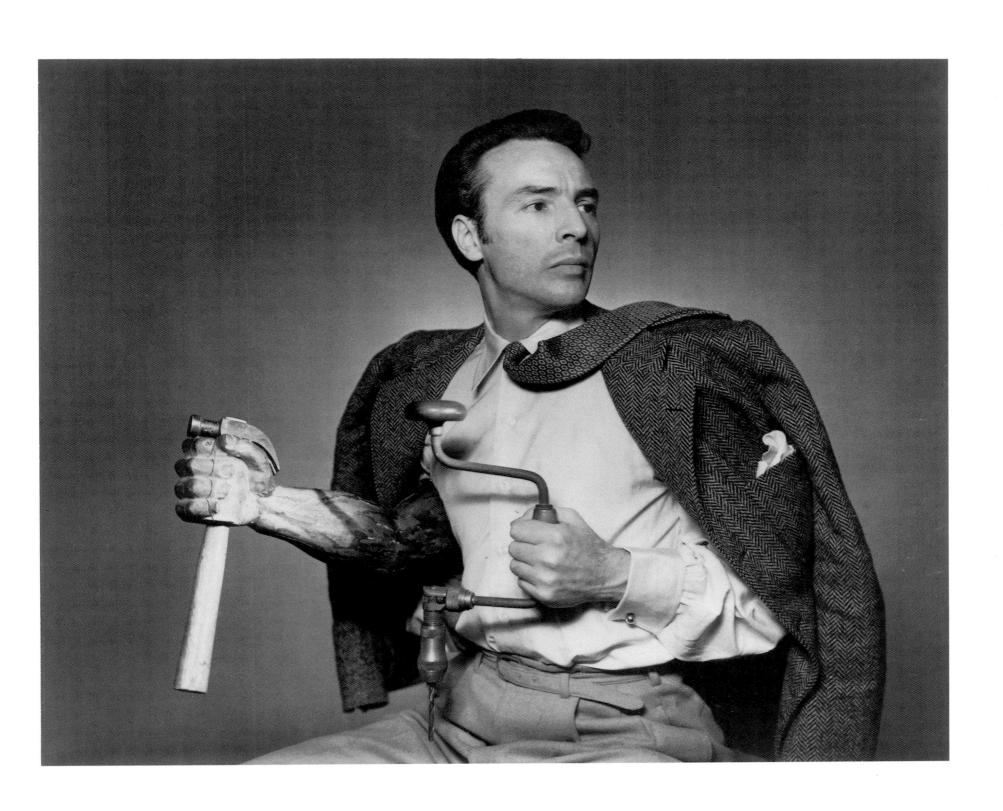

LISETTE MODEL [ELISE FELIC AMELIE SEYBERT MODEL]

American · b. Austria · 1906–1983

42nd. St.

ca. 1942 · Gelatin silver print · 27.5 × 34.2 cm.

The photography of Lisette Model mediates between Brassaï's nocturnal documentation of Paris during the early 1930s and Diane Arbus's portraiture of the late 1960s. Born in Vienna where she began her studies in music with Arnold Schönberg, she later moved to Paris, continued her musical training, and began painting. In 1937, with the war approaching, she taught herself photography and produced her first major series of pictures. Much as Brassaï had earlier captured the features and expressions of Parisian cafe-society, Model trained her camera on gamblers, vacationers, and common street people sunning themselves along the boardwalk of the *Promenade des Anglais* in Nice. But where Brassaï was furtive and candid, Model was confrontational to the point of risking intrusion; and where his photographs were intimate, hers had a grand, monumental scale exaggerated by the choice of an exceptionally low viewpoint. In 1938 she and her husband, Russian painter Evsa Model, settled in New York where, within two years, her work had been included in a group exhibition at the Museum of Modern Art and she had met Berenice Abbott, Ansel Adams, Paul Strand, and Edward Weston. From 1941 to 1953, Model free-lanced as a photographer for *Harper's Bazaar*, and from 1951 to her death she taught photography through the New School for Social Research and private workshops. Among her many students was Diane Arbus, who continued in Model's tradition of photographing alienated and marginal figures encountered on the streets and in the clubs of New York. Like Weegee, at about the same time, Model also discovered an urban picturesque in the subculture of the down-and-out in Bowery bars.

Model also delineated the multiplicity of transparent images occasioned by reflections seen in store windows along Fifth Avenue. Far different from the quiet doubling of subjects in vitrines photographed by Eugène Atget in the 1920s, Model's reflections are a visual parallel to urban dissonance and an analog of what Berenice Abbott called the "mumbo-jumbo of city madness."[1] Frenetic interpenetrations of mannequins, shadowy pedestrians, vehicles, buildings, and vistas vie, almost Futuristically, for simultaneity of space and attention, suggesting the pace and density of modern life.

Starting around 1942, Model also began to take close-ups of pedestrians' and dancers' feet—photographic hieroglyphics of anonymity and urban dynamics. Few photographers had ever created such supreme emblems of the urban tempo so economically nor summarized the faceless vectors of everyday action more mysteriously. Where Model's reflections were about city noise, her pictures of striding legs were about the constant, singular gestures of city crowds: its shoppers, businessmen, and unknown citizens. In his short story, "The Man of the Crowd," Edgar Allan Poe wrote of observing pedestrians in London. "At first my observations took an abstract and generalizing turn. I looked at the passengers in masses, and thought of them in their aggregate relations. Soon, however, I descended to details, and regarded with minute interest the innumerable varieties of figure, dress, air, gait, visage, and expression of countenance."[2] Following a single figure for the rest of the story, Poe's narrator concluded, "*He is the man of the crowd. It will be in vain to follow; for I shall learn no more of him, nor of his deeds.*"[3]

KENNETH HEDRICH

American · 1908–1972

Morton May Residence

1942/late 1940s · Gelatin silver print · 39.8 × 33.2 cm.

Established in 1929, the Chicago firm of Hedrich-Blessing continues to create some of the finest commercial architectural photographs of the 20th century. From nearly the firm's beginnings, Ken Hedrich, one of its founders, "challenged the documentary way of photographing a building," according to the architectural photographer Joseph Molitor. "[His] photographs had new and dramatic viewpoints and much bolder techniques, his prints had a sparkle and contrast unheard of at that time, and their impact on the viewer was great."[1] As opposed to prosaic documentation, Hedrich opted for an interpretive assault upon his subject—new angles of vision, dynamic points of view, theatrical night shots, and a patently graphic sense of pictorial organization. That Hedrich's business was based in Chicago was convenient, since so much of the history of modern American architecture has been showcased in that city; that Hedrich began to photograph just as modernism and futurism were beginning to have a serious influence on American architecture was invariably linked to his style. "No two architects are alike," says Bill Hedrich, younger brother to Ken and himself an architectural photographer. "You must interpret their buildings with your camera, but you must be truthful."[2] With the streamlined modern utopianism of the Chicago Century of Progress Exposition in 1933, and the cascading monoliths of Frank Lloyd Wright's "Fallingwater" of 1937 [fig. 81] as some of their commissions, it is hardly surprising that the firm's style responded in kind to the drama of their subjects.

This is not so much a record of the main staircase of the Morton May home in Ladue, Missouri, as it is an expressive distillation of a modernist interior by architect Samuel Marx. A

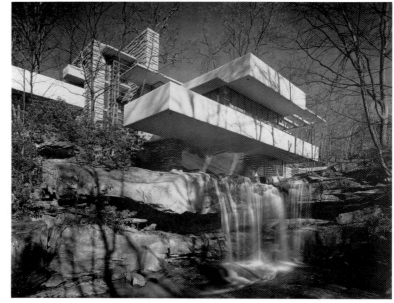

Fig. 81. Bill Hedrich, *Kaufmann Residence, "Fallingwater,"* gelatin silver print, 1937/1981. Gift of Hedrich-Blessing, Chicago.

languorous architectural gesture announcing streamlined forms and nontraditional materials, the staircase is given the grandly proportioned status of a glyph, a sculptured mark or symbol rising within the confines of clean regularity and order—a sensuous Art-Nouveau organicism posing the alternative to the interior's controlled and seductively lighted geometry.

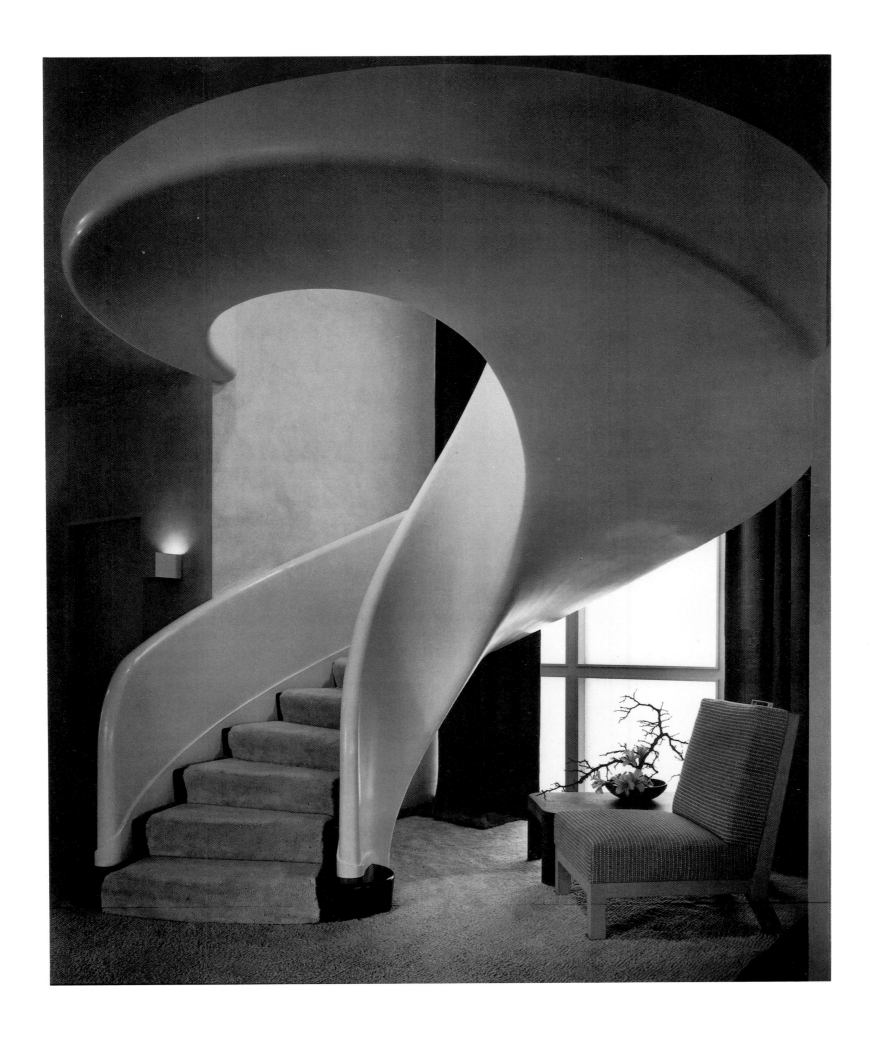

BILL BRANDT

British · 1904–1983

Belgravia, London

1951 · Gelatin silver print · 23.0 × 19.6 cm.

[The photographer] must have and keep in him something of the receptiveness of the child who looks at the world for the first time. . . . We are most of us too busy, too worried, too intent on proving ourselves right, too obsessed with ideas, to stand and stare. We look at a thing and think we have seen it. And yet what we see is often only what our prejudices tell us to expect to see, or what our past experiences tell us should be seen, or what our desires want to see. Very rarely are we able to free our minds of thoughts and emotions and just see for the simple pleasure of seeing. And so long as we fail to do this, so long will the essence of things be hidden from us. [1]

Both subtle and sometimes blatant flavors of French Surrealism entered British photography of the 1930s by a number of conduits. The principal route was through commercial photography, especially in the fashion work of Cecil Beaton and the theatrical portraiture of Angus McBean. While much of this photography was highly sophisticated, it frequently devolved into a stylish "chic," more fashionably absurd than serious. Bill Brandt, however, translated Surrealism's more profound attitudes about perception and the depiction of a psychologically charged worldview into a determinedly British style. Having worked with Man Ray in Paris in 1929–30, and having been impressed by the photographs of Brassaï, Eugène Atget, and the young Henri Cartier-Bresson, Brandt turned during the thirties to the social documentation of England and the British. On the surface, these early prints, rich in blacks and gritty charcoals, are typical *Picture Post* journalism, documenting the working classes, the housing projects, the affluent and their servants, and the industrial landscapes. Beneath that surface, however, there was a persistent and ominous sense of something slightly uneven or awry, a hint of foreboding, or a threatening, dark undercurrent [fig. 82]. It was the same mysterious black of troubling dreams and irrational nocturnal scenes that can be found in Paul Morand's and Brassaï's *Paris de nuit* of 1932, and which would later appeal

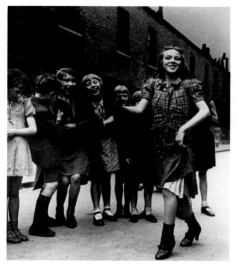

Fig. 82. Bill Brandt, *East End Girl Dancing the Lambeth Walk*, gelatin silver print, 1930s.

to Diane Arbus. "In Brassaï," Arbus claimed, "in Bill Brandt, there is the element of actual physical darkness and it's very thrilling to see darkness again." [2]

There is also much of a foreboding, dreamlike quality to Brandt's monumental nudes of the fifties. Gigantic icons, looming and solemn, beyond approach and seen in an atmosphere that is limpid and nearly aquatic, they are more fantastic than sensual. Where photographed by Brandt on the coast of Sussex, they become part of the rocky landscape and take on associations of primordial motherhood as do many of the reclining figures by Brandt's friend the sculptor Henry Moore. Indoors, however, there is something more secular about these nudes, something partial and, while not in the least salacious, a suggestion of the voyeuristic. With the exaggerated perspectives rendered by the pinhole camera Brandt used for this series, it is as though a glimpse was captured through a keyhole—a silent, stolen view that is disquietingly too close.

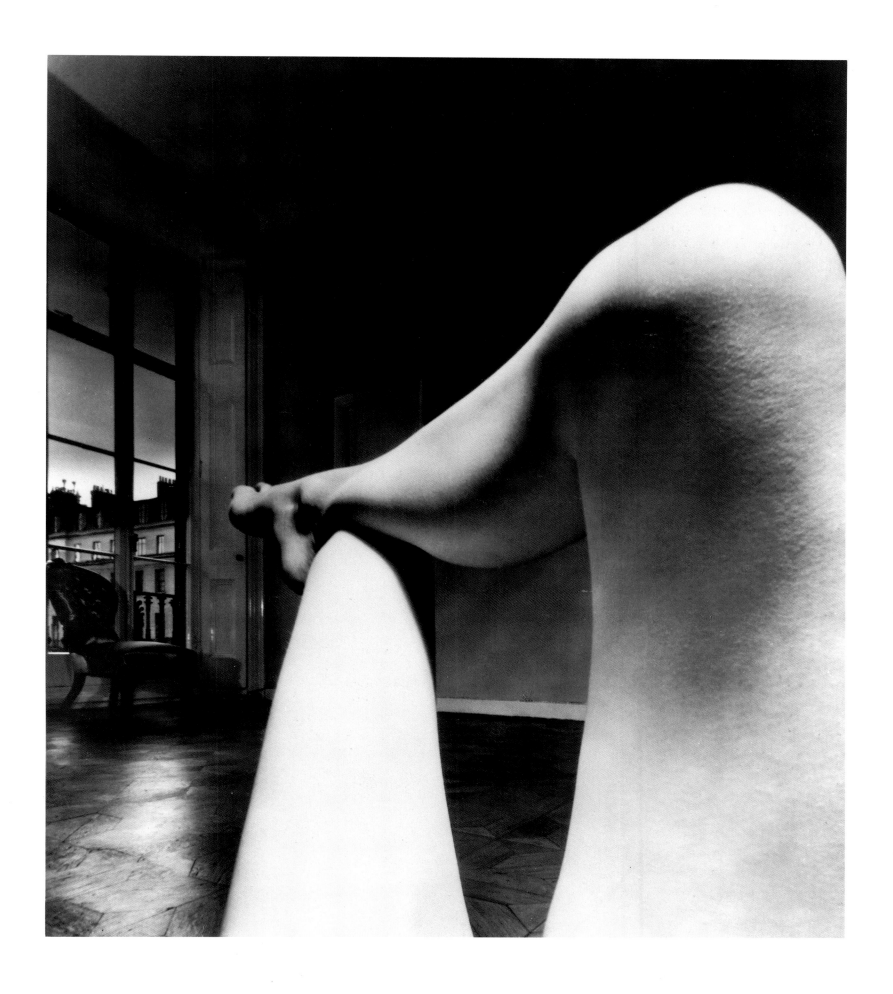

ANSEL EASTON ADAMS

American · 1902–1984

Pinnacles, Alabama Hills, Owens Valley, California

1945/1970 · Gelatin silver print · From Ansel Adams, *Portfolio V*, New York, 1970, no. 1. 39.5 × 48.3 cm.

"I am glad," wrote Ansel Adams in 1979, "that the artist can move through the wilderness taking nothing away from its inexhaustible spirit and bringing his vision-modulated fragments to all who come to see."[1] Two keys to the photographic art of Adams are summarized in this brief but encompassing statement: "spirit" and "vision-modulated." Primarily, each of Adams's prints is a genuflection before nature and that spirit, nearly transcendental, biding within—a respectful approach to the sanctity of life's fundamental energy and essential beauty as created by nature and viewed by man. Adams compelled his art to assume and express a purely American idealism—an idealism in which nature clearly revealed, ". . . that the dread universal essence, which is not wisdom, or love, or beauty, or power, but all in one, and each entirely, is that for which all things exist, and that by which they are; that spirit creates; that behind nature, throughout nature, spirit is present; one and not compound it does not act upon us from without, that is, in space and time, but spiritually, or through ourselves. . . ."[2] The portrayal of nature as experienced in these photographs is imperatively ethical, a reverential documentation whose entire fabric is one that demands devotion. More than elegant witnessings of natural grandeur, these prints are an active declaration of faith celebrated by perfection of vision modulated by an inordinately demanding perfection of craft.

In keeping with the American landscape tradition established in the last century, Adams's work can be compared to that of Carleton Watkins, Timothy O'Sullivan, and Eadweard Muybridge; there are unquestionable traces of Ruskinian naturalism and the 19th-century teleology of the American Thomas Starr King in both Adams's writings and his imagery. But where these earlier photographers were pressed into the service of recording a virtually unexplored landscape, one that had not as yet been marked by human "progress," Adams's mission, as it were, had been to preserve that very image of untouched nature after nearly a century of human involvement. And whereas the 19th-century photographer was satisfied in recording well his subject's appearance as a symbol of a divine force, Adams was far more concerned that the photographic print, the artistic image of nature, stand as a metaphor or immediate expression of that force. Adams wrote in 1944:

A great photograph is a full expression of what one feels about what is being photographed in the deepest sense, and is, thereby, a true expression of what one feels about life in its entirety. And the expression of what one feels should be set forth in terms of simple devotion to the medium—a statement of the utmost clarity and perfection possible under the conditions of creation and production. . . . My approach to photography is based on my belief in the vigor and values of the world of nature—in the aspects of grandeur and of the minutiae all about us. I believe in growing things, and in the things which have grown and died magnificently. I believe in people and in the simple aspects of human life, and in the relation of man to nature. I believe man must be free, both in spirit and society, that he must build strength into himself, affirming the "enormous beauty of the world" and acquiring the confidence to see and to express his vision. And I believe in photography as one means of expressing this affirmation, and of achieving an ultimate happiness and faith.[3]

FREDERICK SOMMER

American · b. Italy · 1905–

Arizona Landscape

1943 · Gelatin silver print · 19.4 × 24.3 cm.

It is the irony of Sommer's landscapes of 1943 that by excluding the sky and filling the picture with land—no foreground to speak of and certainly no real sense of distance, just ground—he was able to break from gravity's bonds and defy the land's assaultive dominance. This and the other pictures Sommer took of the Arizona desert are disorienting and enigmatic; they utterly fail at measurement, and measure is the sole means of positioning ourselves in relation to the world. Timothy O'Sullivan almost came close to this vision of the land during the last century, but he could not completely sever his bonds to sky and horizon. A few earlier photographers, lesser known, had chanced to take similar images, but those were flukes for the most part, done as simpleminded documentation of topography. Sommer's vista is endless, a geography without azimuth, an infinite terrain of perspectiveless expanse signifying a *domaine perdu* of the unconscious. It is a landscape sometimes encountered in dreams, without atmosphere and without duration.

> For years I looked at the Arizona landscape and it seemed almost a hopeless task. . . . It was just like a situation where everybody was in trouble. All those plants were dry and dead and dying. And, if they weren't, you could take them as a whole, in their totality. . . . And I said, "This is crazy, it doesn't make any sense." . . . It took three times of setting up before I photographed the thing. . . . What was the difference between the top of the picture and the bottom of it? It was all the same. But there was a difference. The only thing is that it was more subtle. . . . there's a great deal going on. Maybe this helped me to realize that I was also looking at details. These were enormous areas, but still there were details. . . . There's nothing happening in the sky and I decided, "No skies for me." Finally, there was no foreground, there was no middle distance, there was nothing. And, there was very little distinction between the plants and the rocks. Even the rocks were struggling. [1]

Raised in Brazil and trained in landscape architecture, Sommer first visited Arizona in 1931 while recuperating from tuberculosis, at which time he added photography to his music, painting, and drawing. Four years later, he settled permanently in Prescott, visited Stieglitz at his New York gallery, and soon after began a lifelong friendship with Edward Weston. In 1941, he met the Surrealist painter Max Ernst, who was to take up residence in Sedona, Arizona, a few years later. While Sommer denies being a Surrealist in the strictest sense, there are clear parallels between his themes and experimental attitudes and those found in Ernst's work. Assemblage and collage, icons of death and child ambassadors, inclusions of 19th-century engravings and strange objects metaphorically named are common to both artists. Similarly, where Ernst had developed the technique of *frottage*, a form of vague suggestive abstraction, Sommer created a form of synthetic photography by applying thick paint on cellophane as a negative from which to print equally suggestive images. Unlike Ernst, however, Sommer has created some of the most unsettling, nearly hallucinatory images by means of one of the principal mechanisms of modern, scientific positivism, the camera. Even his most relentlessly straight images, like this landscape, parallel what the painter Matta had written about Ernst. "The power to create hallucinations is the power to exalt existence. . . . The artist is the man who has survived the labyrinth. It is hard to imagine man ever finding happiness without employing his hallucinatory powers. . . . *To use hallucinations creatively, not to be enslaved by other men's hallucinations, as usually happens.*" [2]

MINOR WHITE

American · 1908–1976

Two Waves and Pitted Rock, Point Lobos

1952 · Gelatin silver print · From *Sequence 8*, no. 1 of final sequencing, 1968 · 18.2 × 23.2 cm.

The artistic genius of Minor White is not fully understood, perhaps simply because, like all great talents and thinkers, the implications of his teachings and his art have still to be sorted out and assimilated. Perhaps they never will be, completely. It is clear, however, that White was one of only a few photographers in the history of the medium who lived his art and through it sought to reveal the more profound mysteries of life and its experiences. His pictures are difficult only because they are simple, and in their simplicity there is a beauty that is all too rare in any art. His prints are exquisitely formal, but it is a formalism that transcends shape and substance. His writings are intellectually complicated and often esoteric only insofar as what they propound or meditate on are the very rudiments of self and poetic truth, questions so inordinately basic that they approach the primitive. And his example has been inherently moral, a guide to the sensibility of faith and a testament to spiritual vision.

Minor White was one of the extraordinary educators of photography in this century. Far more than just the "Zone System of Photography"—his text to the craft's mechanical perfection—his teachings led others into new and uncharted areas of pictorial expression in which the photograph stood as a function of understanding and not merely as an objective document. White first taught at the California School of Fine Arts, then at Rochester Institute of Technology, where he helped establish the graduate program in photography, and finally at Massachusetts Institute of Technology, where he remained on the faculty until his death.

White absorbed the idea of the "Equivalent" and the sense that an image could correspond to an inner state or feeling from Alfred Stieglitz, and he expanded it to encompass three levels of experience: the picture itself, what occurs in the viewer's mind when seeing the photograph, and the inner experience of the viewer when remembering the image.[1] Just as what was brought to the image was as important as the photograph itself, so too was the experience received from the photograph as vital a part of the art as what was recorded. "Exploring the depth and breadth of the words *Equivalent* and *Equivalence*," he wrote in 1966, "I have found a craftsmanship of feeling, a technique, an art, a psychology of feeling, and best of all, freedom from the tyranny of ecstasy."[2]

White further extended Stieglitz's notion of the Equivalent temporally, in the sense that a picture sequenced among others in a very specific way, whether in an exhibition or a book, took on a greater poetic association and, sometimes, meaning by the images on either side, or above and below it. This photograph, taken at Point Lobos, California, the last year White spent time photographing with Edward Weston, is the first image of what he named *Sequence 8*, which was finalized in 1968. About another image, but equally pertinent, White wrote, "While rocks were photographed, the subject of the sequence is not rocks; while symbols seem to appear, they are pointers to the significance. The meaning appears in the space between the images, in the mood they raise in the beholder. The flow of the sequence eddies in the river of his associations as he passes from picture to picture. The rocks and the photographs are only objects upon which significance is spread like sheets on the ground to dry."[3] In the "Memorable Fancy" engendered by *Sequence 8*, White also declared: "What must animate my pictures from now on, I want no name for. In need and even if not knowing how, I will call on IT. IT is not foreign to the city, nor to anyone. It is everywhere under the sun . . . for vision . . . for magic."[4]

ALBERT RENGER-PATZSCH

German · 1897–1966

Beech Forest

1936/1958 · Gelatin silver print · 28.1 × 38.3 cm.

Of all the strategies for artistic photography proposed during the 1920s, that which had the greatest impact and the farthest-ranging influences was based on the principles of *"neue Sachlich-keit"* (*New Objectivity*) as it was called in Germany or "straight photography" in America. It was what Albert Renger-Patzsch called "photographic photography." "The secret of a good photograph—which, like a work of art, can have aesthetic qualities—is its realism. . . . Let us therefore leave art to artists and endeavour to create, with the means peculiar to photography and without borrowing from art, photographs which will last because of their photographic qualities."[1] In America, of course, both Alfred Stieglitz and Paul Strand had pioneered this attitude well before the twenties, and Edward Weston and Ansel Adams would subscribe to obdurately straight photography throughout the decade and beyond. German artists, similarly disaffected with the romantic sentimentality of Romantic painting and Pictorialist photography and disenchanted with the intellectual gymnastics of abstract art, turned to a new Realism at about the same time. Painters like Christian Schad, Otto Dix, and George Grosz, and photographers like Karl Blossfeldt, August Sander, Renger-Patzsch, and to certain degrees László Moholy-Nagy and Helmar Lerski, opted for an art of logical structures, order, and precision.

Discussing the new photographic technologies and the new kind of imagery being produced by photographers, Gustaf Stotz, director of the seminal *"Film und Foto"* exhibition held in Stuttgart in 1929, a veritable international directory to modernist photography, wrote: "A new optic has developed. We see things differently now, without painterly intent in the impressionistic sense. Today things are important that earlier were hardly noticed: for example shoe lasts, gutters, spools of thread, fabrics, machines, etc. They interest us for their material substance, for the simple quality of the thing-in-itself; they interest us as means of creating space-form on surfaces. . . ."[2] A year before, in 1928, two books appeared in Germany that demonstrated the new objectivity in photography, Karl Blossfeldt's *Urformen der Kunst*, translated into English in 1932 with the title *Art Forms in Nature*, and Renger-Patzsch's *Die Welt ist schön* (*The World is Beautiful*). Blossfeldt's photographs showed "artistic" structures in nature revealed through macro- and microscopic photography. Renger-Patzsch's images were photographed through a "normal" lens, but arranged throughout the book in such a manner that photographs of plants, animals, and landscapes alternated with and were compared to those of factories, stacks of wood or ceramic tiles, rows of shoe trees, and industrial equipment. In the introduction to *Die Welt ist schön*, Carl Georg Heise commented on Renger-Patzsch's early "symbolic" landscapes with words that are equally applicable to those he made later in life.

A close-up of a single tree can . . . conjure up the same intensive atmosphere of sylvan nature as the picture of densely packed trunks. The fact that a fragment can symbolize the whole, and that enjoyment and empathy are mutually exalting when the imagination is forced to collaborate in the experience—this is an area in which landscape photography offers a multitude of possibilities. . . . And the fact that it is not merely an exaggerated stylization by the artist but also a sharpness of photographic seeing which conjures up the fantastic in everyday nature, this is proved again and again by Renger-Patzsch's camera.[3]

AARON SISKIND

American · 1903–

Martha's Vineyard

1954 · Gelatin silver print · 39.2 × 49.2 cm.

Few photographers in history have aimed their cameras at such unassuming subject matter and have come away with images as profoundly moving and metaphysical as Aaron Siskind's. In his photography, weathered walls, torn posters, a string of sea weed, bits of graffiti, and piles of rock assume Wagnerian proportions while testifying to the abject, existential thereness of things. They are abstract pictures, but their abstraction is one that is fundamental to the most pronounced, and therefore realistic, objectivity. It is in the close-up, the partial view, the detail of something larger and continuous, the isolation of particulars from the general, the enlargement and enhancement of incidentals that Siskind finds significance and poetry. It is also in the facts and their absence, the material and the void, the being and nonbeing as rendered so easily on photographic paper that Siskind finds the pictorial correlatives of life, the balancing of its forces, its vitality even when static, and its harmonies preserved so willfully within confusion and seeming desolation. The metaphors are obvious—sexual, priapic, anthropomorphic, gestures of faith, and the sacred—but so are the phenomenal subjects of Siskind's images, examined with such intense scrutiny and magnificent breadth that their specific realities become universal truths. One critic, as early as 1947, pointed to this aspect of Siskind's art and found certain parallels between it and Thomas Hardy's search for an essential realism, as when Hardy explained: "Nature is played out as a Beauty, but not as a mystery. . . . I don't want to see the original realities—as optical effects, that is. I want to see the deeper reality underlying the scenic, the expression of what are sometimes called 'abstract imaginings.' "[1] In Siskind's words:

> The business of making a photograph may be said in simple terms to consist of three elements: the objective world (whose permanent condition is change and disorder), the sheet of paper on which the picture will be realized, and the experience which brings them together. First, and emphatically, I accept the flat plane of the picture surface as the primary frame of reference of the picture. The experience itself may be described as one of total absorption in the object. But the object serves only a personal need and the requirements of the picture. Thus, rocks are sculptured forms; a section of common decorative iron-work, springing rhythmic shapes; fragments of paper sticking to a wall, a conversation piece. And these forms, totems, masks, figures, shapes, images must finally take their place in the tonal field of the picture and strictly conform to their space environment. The object has entered the picture, in a sense; it has been photographed directly. But it is often unrecognizable; for it has been removed from its usual context, disassociated from its customary neighbors and forced into new relationships.[2]

Siskind's work bears a strong and distinct resemblance to the paintings by the first generation of Abstract Expressionists in New York during the 1950s, especially those by his friend Franz Kline. Kline's broad painted gestures and calligraphic markings, his basic black and white spectrum, and his penchant for eliding background and foreground in the picture are similar to Siskind's formalism. At the same time, however, there are the issues of scale and intimacy, physical construction versus optical selection, and nonobjective imagery versus that which is stubbornly tied to a real world. In the words of the art critic Thomas Hess, ". . . beyond the controlling formalist issues, there remains another ten percent to be considered—the subject matter, the symbolizing magic, the evanescent nuances which give Siskind's oeuvre its particular flavor and peculiar timeliness. He may talk with History through his genius for shape and composition. He talks to us through our humanity—through his feel for the tragic."[3]

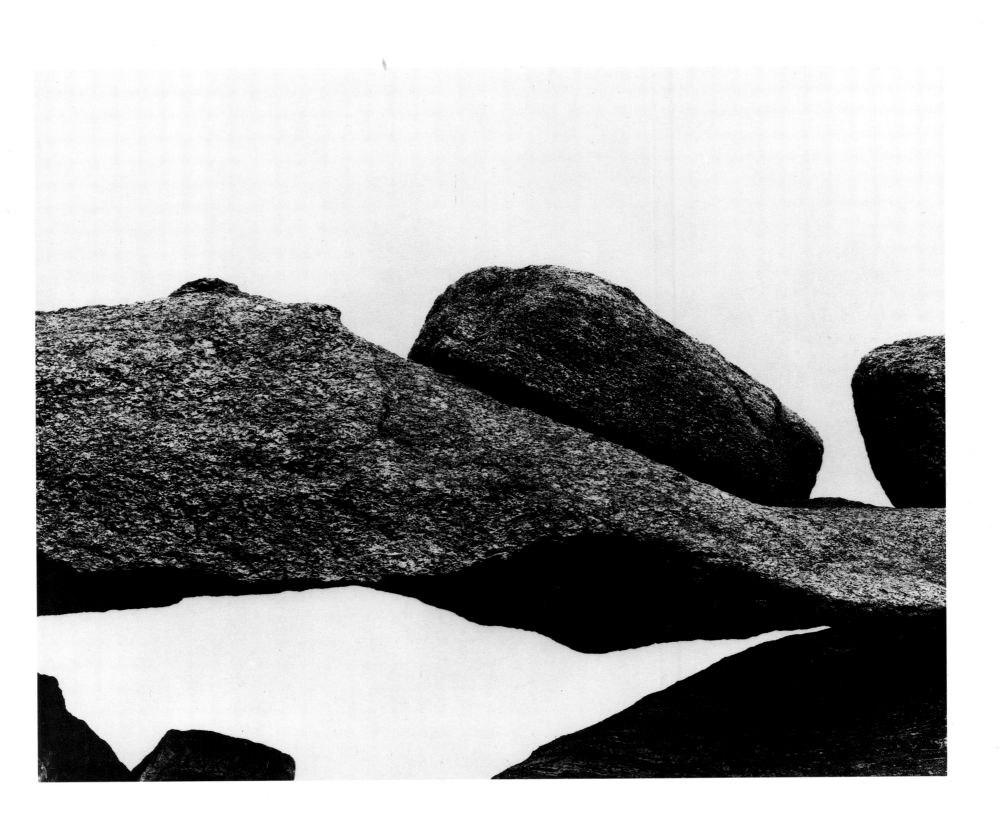

ELIOT FURNESS PORTER

American · 1901–

Lichen and Pine Needles

ca. 1960 · Dye transfer print · 27.3 × 20.3 cm.

In the first edition of his *Naturalistic Photography* of 1889, the British photographer Peter Henry Emerson wrote: "The student who would become a landscape photographer must go to the country and live there for long periods; for in no other way can he get any insight into the mystery of nature. . . . The fact of the matter is nature is full of pictures, and they are to be found in what appears to the uninitiated the most unlikely places."[1] More than four decades earlier, the writer Henry David Thoreau took up residence at Walden Pond for over two years as an experiment in social and natural philosophy, and he concluded that:

> We need the tonic of wildness,—to wade sometimes in marshes where the bittern and the meadow-hen lurk, and hear the booming of the snipe; to smell the whispering sedge where only some wilder and more solitary fowl builds her nest, and the mink crawls with its belly close to the ground. At the same time that we are earnest to explore and learn all things, we require that all things be mysterious and unexplorable, that land and sea be infinitely wild, unsurveyed and unfathomed by us because unfathomable. We can never have enough of Nature. . . . We need to witness our own limits transgressed, and some life pasturing freely where we never wander.[2]

Like Peter Henry Emerson, Eliot Porter was trained in medicine and turned to a career in landscape photography, but where the 19th-century photographer limited his work to platinum and photogravure prints, Porter has specialized in making his own color separation negatives and spectacular dye transfer prints of natural scenery. Porter first read Thoreau's *Walden* while spending summers with his family in Maine where he "found the tonic of wildness,"[3] and where he began to photograph the splendors of nature. Following an early exhibition of his work at Alfred Stieglitz's gallery An American Place in New York in 1939, Stieglitz wrote to Porter that "some of your photographs are the first I have ever seen which made me feel 'there is my own spirit.' "[4]

Porter's work rests securely within a tradition of photographic nature studies dating back to the middle of the last century and such photographers as Adalbert Cuvelier in France and Sir William Newton in Great Britain. In this century, his work stands alongside that of Ansel Adams, Paul Caponigro, and Edward Weston, but it differs considerably from these artists' pictures by its sense of serene and quiet intimacy and its joyous acceptance of those beauties found in the most unsuspectedly incidental details of nature. In the introduction to Porter's *In Wildness Is the Preservation of the World*, his first publication with the Sierra Club and the one in which this image appeared, the author Joseph Wood Krutch wrote, "Emmanuel Kant propounded the theory that the magic of art depends in large part upon the various means which it uses to isolate the thing represented from all ordinary desires and duties in such a way that the only reaction possible to it is pure contemplation. . . . It was thus that Thoreau wished to contemplate rather than use Nature, and it is thus that we can enjoy Porter's photographs."[5]

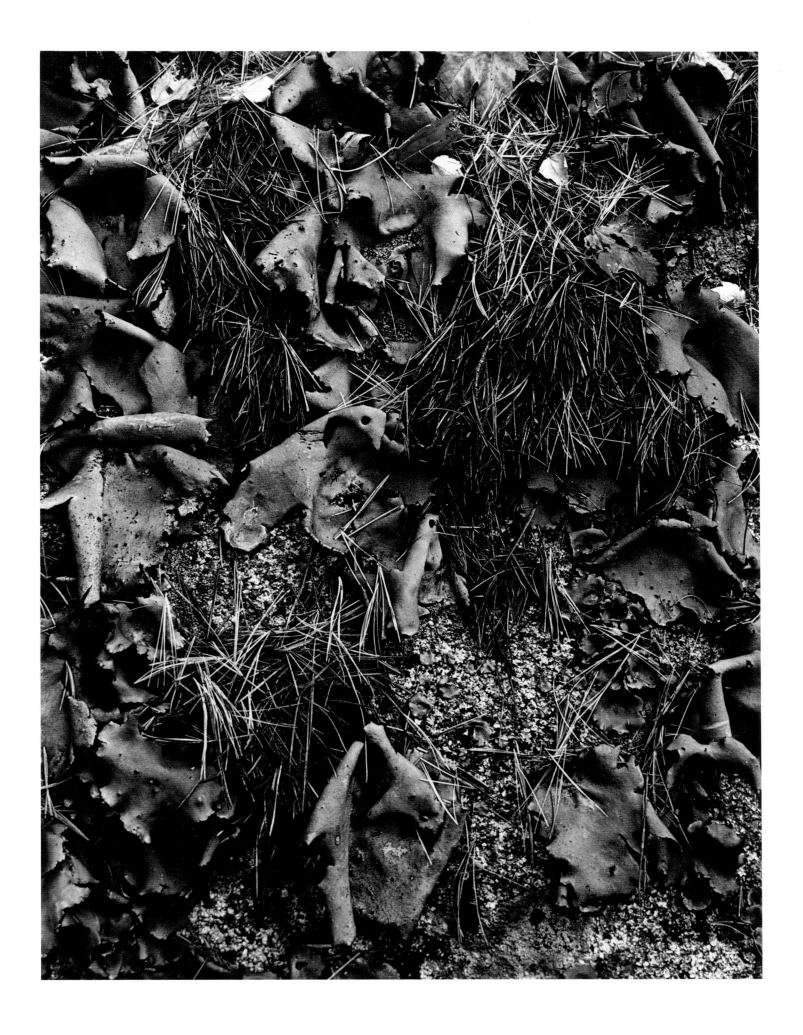

WYNN BULLOCK

American · 1902–1975

Child in the Forest

1951 · Gelatin silver print · 18.8 × 23.9 cm.

Undoubtedly one of the most remembered photographs of Edward Steichen's *The Family of Man* exhibition in 1955, Wynn Bullock's *A Child in the Forest* was the only photograph to be included on the same pages as Carl Sandburg's prologue to the show's illustrated book. As such it served as a pictorial testimonial to the poet's and the show's effusive sentimentality and the idea of universal humanism. It was the romantic symbol of birth and innocence, of communion with nature, and of the ultimate source of life. It spoke to a traditional Romantic pantheism not too far removed from that found in the early 19th-century paintings by the German artist Philipp Otto Runge [fig. 83] or the poetry of William Wordsworth. That the image was meant symbolically is clear not only from other of Bullock's photographs but from many of his statements. Born the same year as Ansel Adams, Bullock began photography after giving up a career as a concert tenor. He became an advocate of straight photography following early work with multiple exposures, double printing, and his own patented form of solarization. A student of semantics, Bullock remained throughout his career a profoundly philosophical photographer who sought to visually symbolize "reality in all of its four dimensions."[1] In an interview, he stated, "I think everything is mysterious. . . . To me everything in art is a symbol, it's never the thing. The photograph of a tree is not the tree, the painting of the person is not the person. The only thing that can change is the person and his power to create symbols. Once the symbol is created, it's not changed, except that the material gets older. The symbol, however, doesn't change. I believe that symbols are more important than the people. They have more power to influence the world than the people who create the symbols."[2]

His interests in music and the metaphysics of time led Bullock to fashion a photographic language that was as abstractly symbolic of four dimensions as it was realistically revealing of the beauties and grandeur of the natural world. This image of a child asleep within a pastoral setting might be seen, then, not as simply a celebration of youth in nature, but as a more complex poetic questioning, similar in ways to that posed by Wallace Stevens a year earlier in 1950.

There may be always a time of innocence.
There is never a place. Or if there is no time,
If it is not a thing of time, nor of place,

Existing in the idea of it, alone,
In the sense against calamity, it is not
Less real. For the oldest and coldest philosopher,

Fig. 83. Philipp Otto Runge, *The Child in the Meadow*, detail of the large version of *Morning*, oil on canvas, 1809. Courtesy of the Hamburger Kunsthalle, Hamburg.

There is or may be a time of innocence
As pure principle. Its nature is its end,
That it should be, and yet not be, a thing

That pinches the pity of the pitiful man,
Like a book at evening beautiful but untrue,
Like a book on rising beautiful and true.

It is like a thing of ether that exists
Almost as predicate. But it exists,
It exists, it is visible, it is, it is.

So, then, these lights are not a spell of light,
A saying out of a cloud, but innocence.
An innocence of the earth and no false sign

Or symbol of malice. That we partake thereof,
Lie down like children in this holiness,
As if, awake, we lay in the quiet of sleep,

As if the innocent mother sang in the dark
Of the room and on an accordion, half-heard,
Created the time and place in which we breathed. . . .[3]

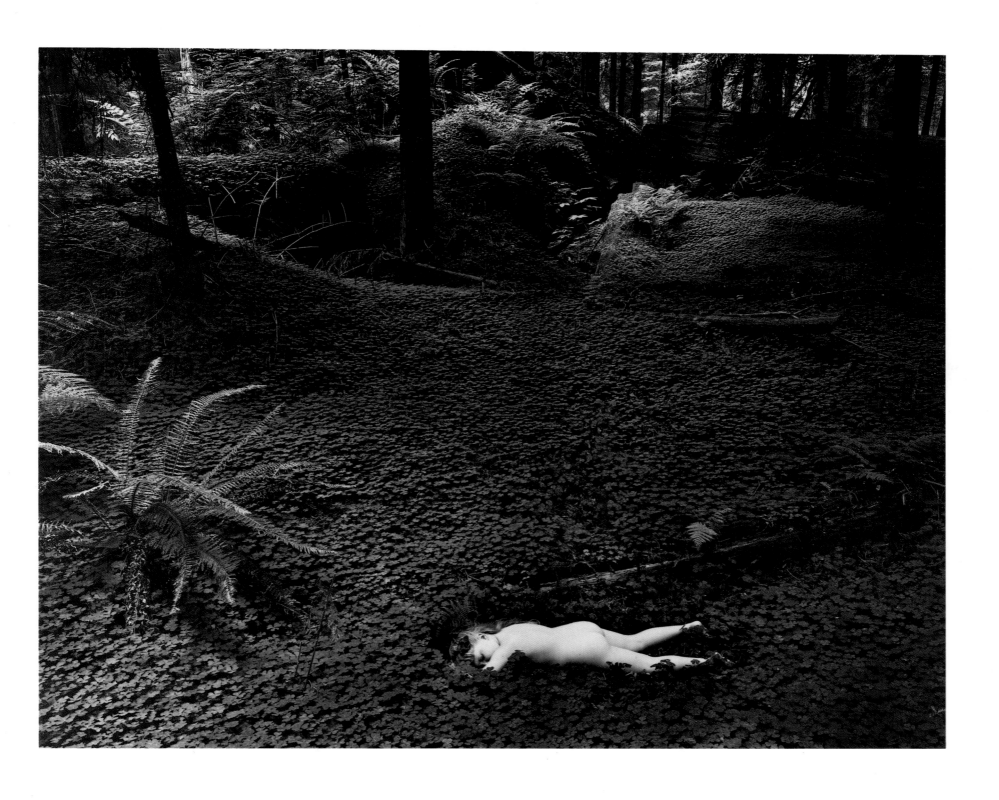

HARRY CALLAHAN

American · 1912–

Eleanor and Barbara, Chicago

1953 · Gelatin silver print · 19.5 × 24.3 cm.

Harry Callahan's photography has been one of the supreme examples of that simplest yet most difficult aim of photography: to see with precise clarity, sensitivity, and thoughtfulness. Observed with these qualities, the world is filled with appropriate subjects, and photographic beauty—exquisite, serene beauty—is the result. His images have a certain dispassionate coolness to them, a reserved, perfected formalism and intelligence bordering on what may be called classical. They are complementary to the images of Aaron Siskind, with whom he taught at both the Institute of Design in Chicago and the Rhode Island School of Design in Providence. Where Siskind's photography is romantic and expressive of a metaphysical *Sturm und Drang*, Callahan's is refined and quietly elegant. His is a vision of order and control, closed more than open, iconic far more than narrative, and rational above all else. But within his structured rationality there is also emotion, a feeling of inordinate pleasure in the just measure of form and light, of spaces and the subjects that inhabit them—whether those subjects are humble blades of grass, unassuming houses in Ireland or Mexico, towering skyscrapers in New York, or his wife and daughter.

It's the subject matter that counts. I'm interested in revealing the subject in a new way to intensify it. A photo is able to capture a moment that people can't always see. Wanting to see more makes you grow as a person and growing makes you want to show more of life around you. In each exploration or concern for the subject, I continue in the area for a great length of time, sometimes a couple of years. Working this way has been the result of my doing the photo series or groups. Many things I can't return to and many things I return to come out better. . . . I do believe strongly in photography and hope by following it intuitively that when the photographs are looked at they will touch the spirit in people.[1]

Eleanor and Barbara, Chicago, is but a single image from more than 150 photographs Callahan made of a subject he persisted in returning to, his wife Eleanor Knapp. Like Stieglitz before him, whose extended portrait of his wife Georgia O'Keeffe spanned nearly two decades, and like Emmet Gowin more recently, whose portrait of his wife and children is ongoing, Callahan's portrayal of Eleanor, often with their daughter Barbara, has been "part of our daily lives for 25 years," according to his wife.[2] Callahan has depicted this subject far more domestically than Stieglitz had, and far less tendentiously; and where Gowin's portraits are rather active and at times allegorical, Callahan's are individual expressions of stately calm and grandeur, similar to what artists at the end of the 18th century called the *beau ideal*. With what is perhaps his most familiar subject, his wife, as well as with his other subjects, Callahan has photographed the essential beauty of the everyday, the nuances of light and mood, the sensual economics of daily gestures, and unpretentious ideal forms set in harmonious space. Callahan is one of the few contemporary photographers about whom one could apply Goethe's words about the goal of the artist:

All that we see around us is but raw material. If it is rare enough for an artist, through instinct and taste, by practice and experiment, to reach the point of achieving the beautiful exterior of things, selecting the best from the good in front of him and producing at least a pleasing appearance, it is rarer still, especially in modern times, for an artist to penetrate into the depths of things as well as into the depths of his own soul, so as to produce in his works not only something light and superficially effective, but, as the rival of nature, something spiritually organic, and to give it a content and a form by which it appears both natural and beyond nature.[3]

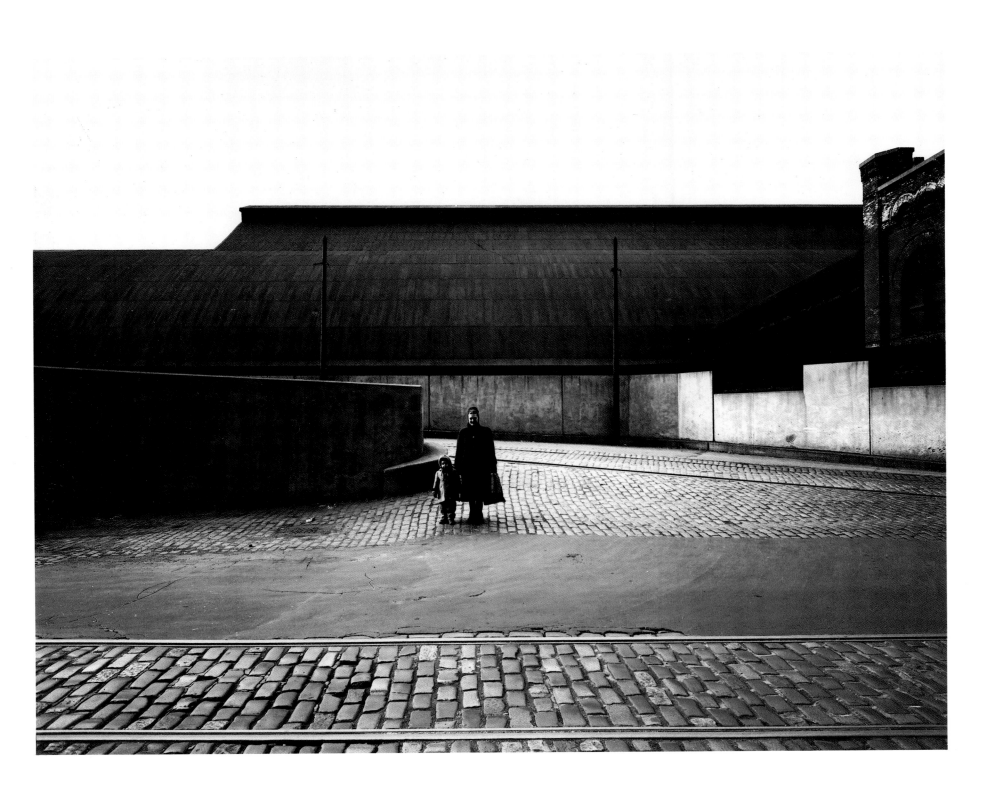

JOSEF SUDEK

Czechoslovakian · 1896–1976

A Walk in the Magic Garden

1954 · Gelatin silver print, toned · 8.7 × 28.3 cm.

At his Tuesday evening gatherings of friends, Josef Sudek would invariably greet his guests with the words, "There is music . . . and it plays on happily," which, according to his friend and biographer Sonja Bullaty, meant simply, "life's okay, no matter what."[1] The sense that there is a poetry (or "music") abstractly playing on about us, in spite of us, and that we would only need to look and listen carefully to discover it, is a perfect summary of this artist's vision. With only one arm (he lost his right one during the first World War), with rather antiquated camera equipment (this print was made using an 1894 Eastman Kodak panorama camera), and with undaunted faith in the integrity of his craft (he never enlarged a print after 1940 and refused to photograph in color since he personally would not have been able to develop the film), Sudek recorded his city of Prague in spirit not unlike the way Eugène Atget photographed Paris earlier in the century. Unlike Atget, however, Sudek was far less concerned with what might be called the "public" cityscape, there to be seen by any passerby and selected by the photographer; instead, Sudek felt more at home with a "private" urban scene, that fabric of small corners, misty graveyards, and chance views that, while certainly there, are only seen by the artist. So common, so utterly incidental are his subjects—a tiny opening in a lilac bush revealing a window-frame beyond, hanging wash seen through a window obscured by condensation, a suburban road just before dawn or a cobbled street at night, or the secret iconography of objects found in an apartment—that the profound mystery and lyricism of his photographs are even more marvelous. As he put it just before his death, "I believe that photography loves banal objects, and I love the life of objects."[2]

Like many other Czech photographers working in the 1920s, such as František Drtikol, Jaromir Funke, and Jaroslav Rössler, Sudek was influenced by the poetics of Surrealism and the irrational in art. This was the reason why both the Gothic architecture of Prague's St. Vitus Cathedral and the ornate decoration of Czech Baroque architecture intrigued him, and why his landscapes are either crepuscular or nocturnal. About the architect Otto Rothmayer, who was supervising the reconstruction of Prague Castle after the second World War, Sudek wrote, "Rothmayer was an artist who—like myself—had no great regard for the rationally definable."[3] The chairs in the architect's garden were pictured by Sudek in this panoramic photograph. At another moment, Sudek commented, "Everything around us, dead or alive, in the eyes of a crazy photographer mysteriously takes on many variations, so that a seemingly dead object comes to life through light or by its surrounding. And if the photographer has a bit of sense in his head maybe he is able to capture some of this—and I suppose that's lyricism."[4]

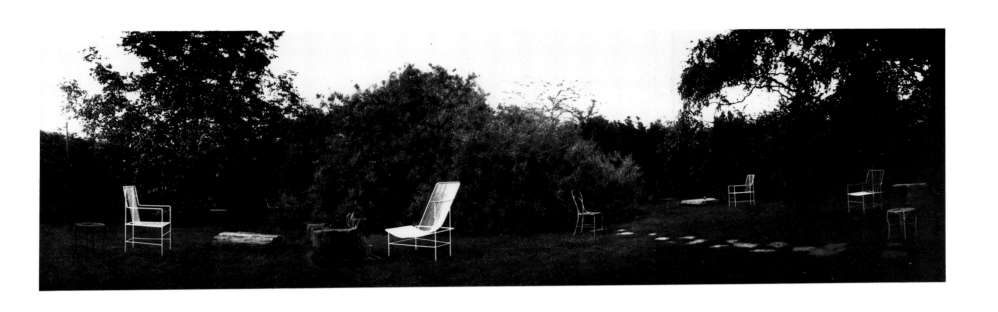

RALPH EUGENE MEATYARD

American · 1925–1972

Romance (N) from Ambrose Bierce, No. 3

1962 · Gelatin silver print · 17.7 × 18.7 cm.

There is a pronounced engagement with the magical and the mysterious in American Southern photography of this century. It is encountered in the work of Clarence John Laughlin, Jerry N. Uelsmann, Van Deren Coke, and Robert W. Fichter, to name only a few. It is an art made up of anecdotes, fictions, rural locutions, flirtations with the imagery of the bizarre and of death—a Southern Gothic kind of photography, equally at home with decaying mansions and creeping kudzu as it is with farmyard scenes, gardens, and honest, down-to-earth attitudes. But even the most prosaic of subjects can have here something of a disquieting quality to it, a hint that some fundamental mystery is being enacted before the camera. A mystery far more primal than obvious seems to be revealed in this image of a child's donning the grotesque mask of Ralph Eugene Meatyard's fictional character Lucybelle Crater. Meatyard's friend the writer and critic Jonathan Greene wrote of Lucybelle's mask: "Masks to hide, slide beyond. Not behind thee only, satanic soul-snatcher. They reveal (*click*) a narrative language. Gestures & looks unmistakable. And purer since we feel we are not really there because our faces are not in view. As if our bodies showed nothing. As if the masks were not man-made and the poses did not reveal their being."[1]

With all the homely and folkloristic elements garnered from his immediate surroundings, the whimsy of backyard make-believe, and the apparent ordinariness of the everyday snapshot, Meatyard's images speak directly and warmly to the heart while suggesting a deep mistrust for any certainty. Meatyard was a professional optician in Lexington, Kentucky. In many ways his photographs serve as a vision examination—one in which the security of what we see and trust is tested. Charming and modest, learned and "naive," funny and beautiful, there is also an edge of serious provocation in Meatyard's pictures. As he wrote:

> I work in several different groups of pictures which act on and with each other—ranging from several abstracted manners to a form for the surreal. I have been called a preacher—but, in reality, I'm more generally philosophical. I have never made an abstracted photograph without content. An educated background in Zen influences all of my photographs. It has been said that my work resembles, more closely than any photographer, "Le Douanier" Rousseau—working in a fairly isolated area and feeding mostly on myself—I feel that I am a "primitive" photographer.[2]

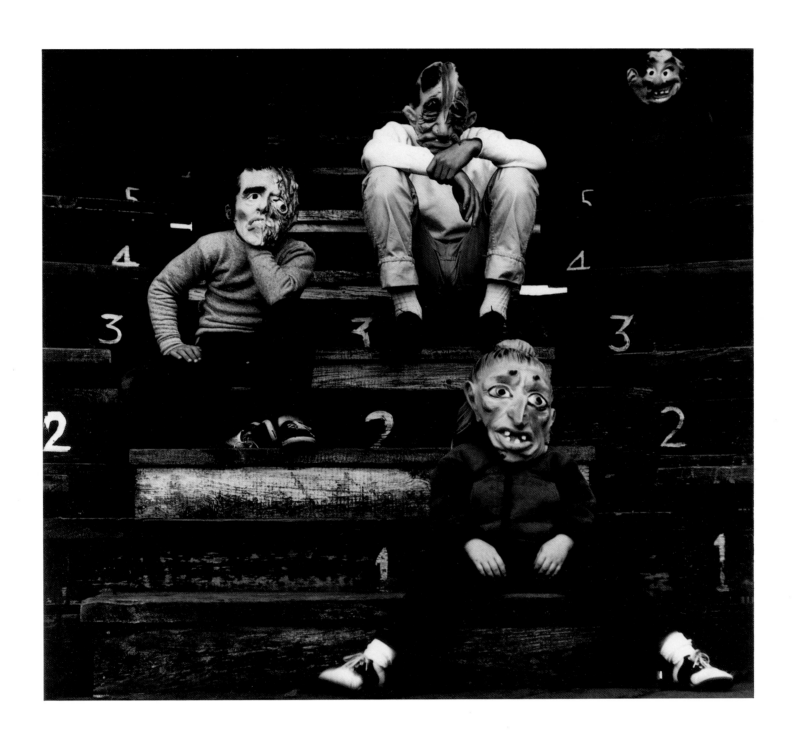

ANDRE KERTESZ

American · b. Hungary, 1894–

Flowers for Elizabeth, New York

1976 · Gelatin silver print · 24.1 × 34.7 cm.

André Kertész was born in Budapest and bought his first camera in 1912 while working as a clerk in the Budapest Stock Exchange. In 1925 he moved to Paris and soon adopted the 35mm Leica as his camera of choice. In 1936 he moved to New York, where he became an American citizen in 1944 and has lived ever since. Describing himself in 1930, he wrote:

> I am an amateur and intend to remain one my whole life long. I attribute to photography the task of recording the real nature of things, their interior, their life. The photographer's art is a continuous discovery which requires patience and time. A photograph draws its beauty from the truth with which it is marked. For this very reason I refuse all the tricks of the trade and professional virtuosity which could make me betray my canon. As soon as I find a subject which interests me, I leave it to the lens to record it truthfully. Look at the reporters and at the amateur photographers! They both have only one goal: to record a memory or a document. And that is pure photography.[1]

The year before his first solo exhibition at the Paris gallery Sacre du Printemps in 1927, Kertész photographed a corner of Piet Mondrian's studio and home [fig. 84]. While a record of the painter's apartment, the image is as well a lyrical testament to a tightly structured orchestration of space and form, light and shadow, planes and volumes; it is also one of the great sentimental photographs of the time. Set against the rectangles created by two door frames and various wall moldings, a table juts into the foreground carrying a vase with a single, opened flower in it. The relentless geometry of the picture is modulated, of course, by Mondrian's coat and hat at the left and by the sensuous parabola of the stair rail, but it is the flower (flowers having been a favorite subject of the painter at an earlier date) that gives this image its passion and humanism. It is a joyously human document rendered by an eye that is at once very sophisticated and innocently naive. In the catalogue to the show at Sacre du Printemps, the Dada poet Paul Dermée wrote:

> Eyes of a child whose every look is the first
> which see the Emperor naked when he is clothed in lies;
> which take fright at the canvas-draped phantoms haunting the quais of the Seine;
> which marvel at the all-new pictures that create, without malice, three chairs in the sun of the Luxembourg Garden, Mondrian's door opening onto the stairs, eyeglasses thrown on a table beside a pipe.
> No rearranging, no posing, no gimmicks, nor fakery.
> Your technique is as honest, as incorruptible, as your vision.
> In our home for the blind,
> Kertész is a Brother Seeing-Eye.[2]

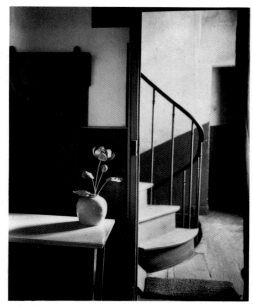

Fig. 84. André Kertész, *Chez Mondrian*, gelatin silver print, 1926/printed later.

A half-century later, Kertész made this photograph of another room's corner with floral elements. Like the former picture, this image is much more than a documented still life of common domestic objects, for by its title, *Flowers for Elizabeth*, it is clear that a memory and an emotion are being portrayed, a poignant, romantic poem to a loved one, Elizabeth Sali, whom Kertész married in 1933 and who was seriously ill at the time of this picture. It is a silent picture of remorse and feared loss, a quiet and bittersweet homage to the artist's companion for forty-four years. All is symbolic: the cut flowers of sentiment, the emptiness of the shirt draped over the chair, the photographer's glasses (his vision removed for the moment) and the magazine laid open to a page illustrating a naked odalisque portrayed asleep. The photograph is thus a romantic ceremony honoring the absence of the special other—a manifest private grieving, more modern and quite unlike the shared social grief depicted in that other great photograph about impending death and dying, H. P. Robinson's *Fading Away* of 1858. Writing about Western attitudes toward death, Philippe Ariès found that grief over the departed other was an essentially modern affect: " 'One person is absent and the whole world is empty.' The sense of the other now takes on a new primacy. . . . Today there is a tendency to regard romanticism as an aesthetic and bourgeois mode, without depth. We now know that it is a major objective fact of daily life, a profound transformation of man as a social being."[3]

WILLIAM EUGENE SMITH

American · 1918–1978

Death in a Spanish Village

1950/printed later · Gelatin silver print · From picture essay "A Spanish Village." 22.8 × 34.3 cm.

The photographic essay, in its strictest sense, first appeared in the pages of *Le Journal illustré*, a French newspaper, on September 5, 1886, when Paul Nadar documented a three day interview between his father Félix Nadar and Michel-Eugène Chevreul, the chemist and color theorist, who was then one hundred years old.[1] During the late 1920s and early 1930s, with the appearance in both Germany and Great Britain of illustrated newsmagazines such as the *Münchner Illustrierte Presse* and the *Weekly Illustrated*, and to some degree the French *Vu*, a new forum was established for the extended photographic coverage of single topics, locations, or events. Furthermore, where Nadar's photographic essay was made possible by the development of dry plate photography during the 1870s, the work of modern photojournalists like Felix Man and Erich Salomon was facilitated by the invention of miniature cameras, such as the Ermanox and the Leica during the mid-twenties, and of faster lenses and films. In 1936, the American picture magazine *Life* began publication and was followed by *Look* early the next year. The roster of great photojournalists who worked for *Life* between 1936 and 1972 included, among many others, Margaret Bourke-White, Alfred Eisenstaedt, Robert Capa, Larry Burrows, and W. Eugene Smith.

The April 9, 1951, issue of *Life* featured the pictorial essay "Spanish Village," a sequence of seventeen pictures documenting daily life in the small town of Deleitosa in Western Spain. According to historian William Johnson, "The protagonist of 'Spanish Village' is not any one individual, but a way of life made up of the acts of many individuals—a way of life still bound to hard physical labor and tied to the seasonal rhythms of growth and harvest. Smith represented a culture that was monolithic in its beliefs, loyalties, and traditions, and a society whose ceremonies were fleshed out with the weight of custom and driven by the force of faith."[2] While ninety-nine images from this series are catalogued in the W. Eugene Smith archive at the University of Arizona's Center for Creative Photography, only seventeen initially were published in *Life* in 1951 (issue no. 30, pp. 120-29). Public response was such that the magazine subsequently issued a promotional portfolio of eight previously unpublished images, without text or captions.[3]

For the most part, photojournalistic essays depend highly on the printed text (in the form of captions) for factual information, background, and, often, comprehension. According to the

Fig. 85. W. Eugene Smith, *The Thread Maker*, gelatin silver print, 1950.

standard text on photojournalism, "Aside from the photographic quality of the pictures, you may discover that the words under the pictures give them more meaning. It is the caption that keeps you moving from one picture to the next. It is very often the *caption* you remember when you think you are telling someone about a *picture* in a magazine."[4] The absolute genius of Smith's "Spanish Village" lies in the fact that the pictures are completely comprehensible without words; the name of the particular village of these scenes is unimportant since it is the essential truths of human life that Smith recorded, truths that are perfectly communicable by the photograph. If another picture from the series, *The Thread Maker* [fig. 85], could be characterized as a depiction of human labor and an image as "eternal as a drawing by Michelangelo of one of the Three Fates,"[5] this image of women mourning at the side of the corpse of an elderly man has distinct parallels with any number of Renaissance *Pietàs* or the three Marys mourning at the tomb of Christ. Words are unnecessary for meaning.

ROBERT LOUIS FRANK

American · b. Switzerland · 1924–

Parade, Hoboken, New Jersey

1955/printed later · Gelatin silver print · 33.4 × 49.8 cm.

It is ironic that Robert Frank's *The Americans*, the most important book of American photographs to appear between Walker Evans's *American Photographs* of 1938 and Lee Friedlander's *The American Monument* of 1976, was published in Paris one year before it was brought out here. It is equally fascinating that it was a Swiss photojournalist who documented this country while on a Guggenheim fellowship in 1955, and his book was the single most influential collection of images of the postwar era in terms of the impact it had on the next generation of American photographers. Compared to that other great photographic publication of the fifties, Steichen's *The Family of Man*, Frank's book was a critical and financial failure. Where Steichen, however, used the photographic image solely as platitudinous and propagandistic information testifying to "the universal elements and emotions in the everydayness of life—as a mirror of the essential oneness of mankind throughout the world,"[1] Frank used his camera to fashion an entirely new vision, one that was fresh, vital, gutsy, inspired, and to the heart. This was a new style of photography, later called "street photography" by some and "social landscape" photography by others. It was a photographic style whose influence can be later traced in the pictures of Lee Friedlander, Garry Winogrand, and even Diane Arbus. Its subjects belong to no hierarchy, its events are non-events, and the scenes are striking just because no one had ever bothered to photograph them before—utterly honest and revealing. According to Walker Evans, Frank "shows a high irony towards a nation that generally speaking has it not. . . ."[2]

Still maintaining what was basically a journalistic stance before his subject, Frank avoided the banal and the predictable and utterly spurned the sentimental. The America he recorded with his Leica was an America not seen on calendars, chamber of commerce promotions, or government information brochures. It was the America of mining towns and lonely bars, of Hollywood starlets and flamboyant gays in New York, of bootblacks in public latrines and preachers along the Mississippi, and of empty filling stations in Santa Fe and segregated trolleys in New Orleans. These were pictures of spectators and emptiness, sequenced visually rather than thematically. The spirit of the period and Frank's photography is summarized in the final picture of the sequence [fig. 86]. His old black Ford, one headlight shining, is parked on the shoulder of U.S. 90, somewhere in Texas; it is dusk, and his wife and their sleeping son are in the front seat; the left half of the car takes up most of the picture, the rest is parched dirt leading off into the far distance. Like the entire book, it is about the absolute core of the country, where nothing much but everything happens, where meanings are measured by transportation and the highway, where human identity

Fig. 86. Robert Frank, *U.S. 90, Texas*, gelatin silver print, 1955. Courtesy the artist and Houston Museum of Fine Arts.

is achieved by context, and where significance is often elided and immediate. It is a road picture, and it was appropriate that the writer of the introduction to the American edition was Jack Kerouac, whose novel *On the Road* appeared the same year as Frank was photographing the country. The tone of the novel ends the same as Frank's book of pictures.

So in America when the sun goes down and I sit on the old broken-down river pier watching the long, long skies over New Jersey and sense all that raw land that rolls in one unbelievable huge bulge over to the West Coast, and all that road going, all the people dreaming in the immensity of it, and in Iowa I know by now the children cry, and tonight the star'll be out, and don't you know that God is Pooh Bear? the evening star must be drooping and shedding her sparkler dims on the prairie, which is just before the coming of complete night that blesses the earth, darkens all rivers, cups the peaks and folds the final shore in, and nobody, nobody knows what's going to happen to anybody besides the forlorn rags of growing old. . . .[3]

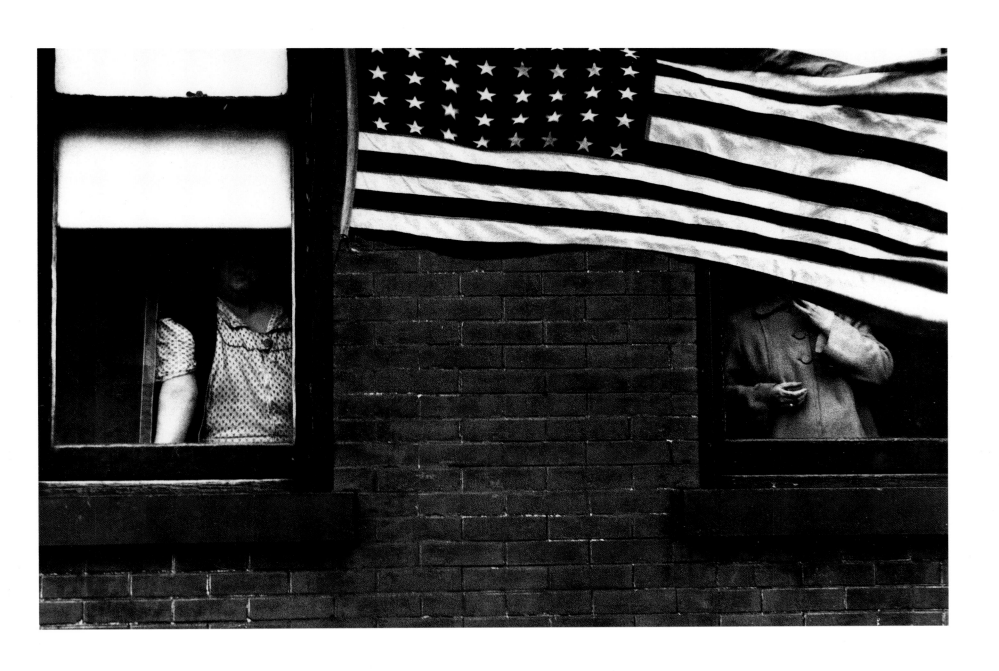

BRUCE DAVIDSON

American · 1933–

Two Youths, Coney Island

1958–59/1965 · Gelatin silver print · 18.9 × 12.2 cm.

Bruce Davidson is one of those photographers (a documentary essayist) whose images result from close, extended, and often threatening involvements with their subject. Perhaps the classic paradigm of this kind of photographer is Walker Evans, who may even have created the genre when he and James Agee lived with Southern tenant families while documenting their lives in 1936 for what was to become *Let Us Now Praise Famous Men.* W. Eugene Smith certainly had been familiar with this degree of involvement with his subjects, as had most every combat photographer in the second World War and Korea who stayed with a particular unit for any length of time. Although frequently compared to other photographers of the social landscape, Davidson's engagement with his subject is different. Where most, like Robert Frank and Lee Friedlander, have created extensive series on single subjects, their pictures have seldom been the direct result of that trust and complicity and understanding that comes from an intensive immersion into the lives and living conditions of those subjects.

Davidson, who was inspired to this kind of photography by W. Eugene Smith and who had joined Magnum Photos in 1958, summarized his method of participatory documentation when, in 1970, he wrote the introduction to his book *East 100th Street*, " 'What you call a ghetto, I call my home.' This was said to me when I first came to East Harlem, and during the two years that I photographed people of East 100th Street, it stayed with me.... I entered a life style, and, like the people who live on the block, I love and hate it and I keep going back."[1] Journalists like Hunter Thompson, Norman Mailer, and Gail Sheehy have understood this form of engagement for decades, as have the practitioners of the so-called "new journalism" who came to realize during the sixties that the mood, tone, and local flavor of a situation were both important to the narrative and not attainable from a single, synoptic interview.[2]

One of Davidson's earliest series in which he participated in the lives of his subjects was his essay on a gang of Brooklyn teenagers in 1958, which was published eventually in *Esquire* in June of the following year.

> In the late fifties, New York was plagued by youth gangs.... At first I went with a Youth Board worker to take pictures of their wounds from a gang war in front of their candy store hang-out. Later they let me go alone with them to Coney Island at night where they would lie under the boardwalk drinking beer. In the morning they would dance down the boardwalk together. A girl stopped to comb her hair at the cigarette-machine mirror. Then they took the long bus ride back to where they lived. In 1958, they were about seventeen and I was twenty-four. As we rode the bus, the sun burned in the windows. I held my Leica tight and released the silent shutter curtain the moment they looked alone. I force-developed the film to increase the harsh contrast that reflected the tension of their lives.[3]

The real version of *West Side Story*, as revealed by Davidson, is a lot more touching and a lot more sincere; whether or not there was a pack of cigarettes in the sleeve of the boy's tee-shirt, the ritualistic gesture of rolling the sleeve is as unquestionably authentic as the girl's pose while combing her hair—the validating details of everyday life.

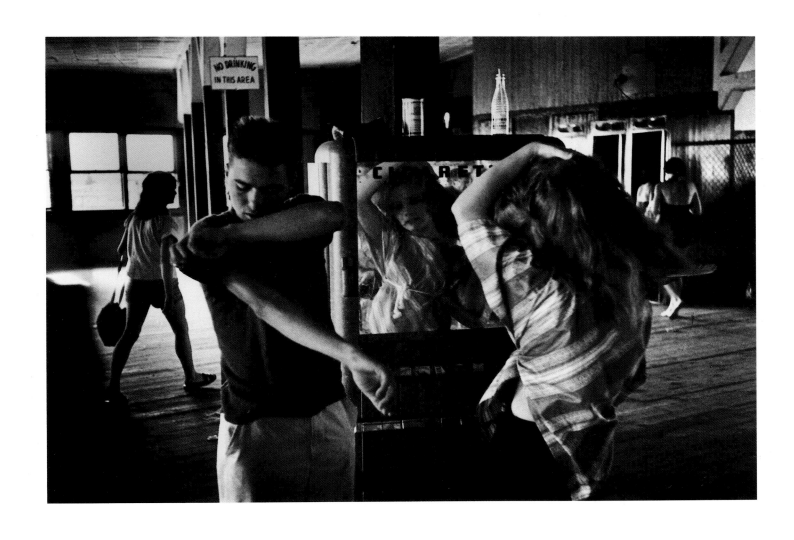

GARRY WINOGRAND

American · 1928–1984

Albuquerque, N.M.

1957 · Gelatin silver print · 22.7 × 34.0 cm.

That there was a decidedly new American photography, one rooted in the past but still strangely different, became quite apparent by the end of the 1960s. It was a photography of the incidental subject and mundane occurrence, of common people and popular icons, of urban streets and suburban backyards. It was a photography that raised the level of the everyday to an aesthetic level never dreamt of by the theorists of naturalism in the last century, a photography that assumed anything around us was appropriate for the photographic subject and, indeed, that the nominal subject could be the excuse for an artistic gesture of seeing and recording it. Documenting the social landscape, these images were both more and less than journalistic—more because their makers were as intent on rendering the look of our environment as on addressing the issues of how the camera defined that look, less because what was photographed was redolently eventless, its logic obtained by the act of photographing it. Three exhibitions affirmed this new photography, "Toward a Social Landscape" (George Eastman House, 1966), "12 Photographers of the American Social Landscape" (Poses Institute of Fine Arts, 1967), and "New Documents" (Museum of Modern Art, New York, 1967). In two, Garry Winogrand was featured.

For Winogrand and many others working in this vein, such as Bruce Davidson, Lee Friedlander, and Danny Lyon, the pictorial sources are manifold; and they can be argued to include Brassaï's and Bill Brandt's social realism of the thirties, Henri Cartier-Bresson's postwar "decisive moment," and, probably the most important, the brilliant example of *Les Americains* by Robert Frank, published in France in 1958 and here the following year. Like Frank's, Winogrand's style was tough, spontaneous, charged, and deliberate, but it recorded an experience, according to John Szarkowski, "more complex, subtle, and philosophically unresolved—more mysterious—than that described in Frank's work. The self-imposed limitation of Winogrand's art is symmetrical with its greatest strength: absolute fidelity to a photographic concept that is powerful, subtle, profound, and narrow, and dedicated solely to the exploration of stripped, essential camera vision."[1] There is a certain apparent irrationality about Winogrand's pictures, just as they seem to be completely unstructured, glorified snapshots. Yet there is also a very clear precision to his images, a definitiveness and authority that belie their casual appearance. Scalpeled from a far broader and temporal continuum, the brightly lighted infant, its shadowy parent and the toppled tricycle are forever caught on the apron to an empty carport at the very real edge of their social order, oblivious to the grandeur of the distant panorama.

Demanding a realistic art descriptive of the lives of common people, the British novelist George Eliot wrote in 1859: ". . . let Art always remind us of them; therefore let us always have men ready to give the loving pains of a life to the faithful representing of commonplace things—men who see beauty in these commonplace things, and delight in showing how kindly the light of heaven falls on them."[2] A century later, Winogrand defined his art of the commonplace far less effusively when he stated, "For me the true business of photography is to capture a bit of reality (whatever that is) on film . . . if, later, the reality means something to someone else, so much the better."[3]

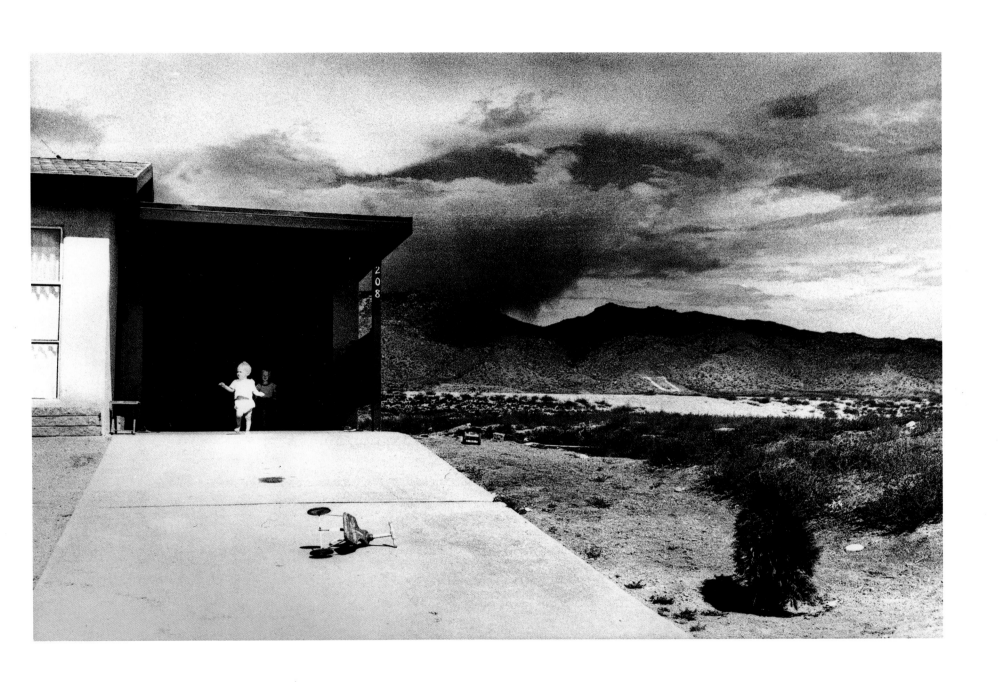

WILLIAM KLEIN

American · 1926–

Bikini, Moscow River

1959/printed later · Gelatin silver print · 36.7 × 49.3

William Klein, an American artist expatriated to Paris, is a painter and filmmaker who between 1954 and 1961 produced four books of photographs. In 1962, he gave up all but personal photography in order to spend time on his films, such as *Cassius le Grand* (*Float like a Butterfly, Sting like a Bee*) (1964–65), *Qui êtes-vous, Polly Maggoo?* (*Who Are You, Polly Maggoo?*) (1965–66), *Mr. Freedom* (1967–68), and *The Little Richard Story* (1979). Klein also has been a fashion photographer for Paris *Vogue*, a writer, and a designer. When they first appeared, his photographs failed to gain any serious critical acclaim in this country, nor have his films ever had more than very limited distribution here in contrast to Europe. Yet despite his lack of popular success in his own country, Klein is thoroughly American in style and attitude, and nowhere is this more apparent than in the comparison of his photographs to those of Robert Frank, a European photographer and cinematographer living in America.

During the fifties, both Frank and Klein formulated a modern style of photographic reportage that was not exactly as journalistic as was Weegee's or Margaret Bourke-White's (although there were similarities), and not precisely as documentary as Walker Evans's or Dorothea Lange's (even though there were correlations). Both photographers advanced the use of the Leica 35mm range-finder camera, which allowed them the flexibility and inconspicuousness to document street action. Neither minded that when enlarged the grain of the small negative would be a part of the print's final appearance. But where Frank was coolly precise in the images published in *The Americans* of 1959, Klein was, in *New York*[1] of 1956 and his other books, hot, violent, and passionate. Frank based much of his aesthetics on the example of Henri Cartier-Bresson, while Klein eschewed the latter's formalism for the frenetic moment and photographic confrontations with the energized flux of modern life. Where Frank was respectful of the medium and its potential for classical, timeless documents, Klein, with wanton disregard for tradition, used his Leica as an extension of his intuition, expressionistically capturing the action about him and accepting overexposures, eccentrically dynamic croppings, dissolving halations, and sudden perspective shifts. Frank positioned himself in the safety of middle distance from his subjects; Klein was in direct contact with them, close-in and wide-angled, on the street amid the jostling crowd. Even in the designs of their books, Frank's *The Americans* looks almost like a portfolio of fine prints next to Klein's *New York*, which attempts to pummel the viewer with combinations of images the way the New York *Daily News* saturated its readers with montages of shocking headlines. This was action, this was human interest at the pace of contemporary immediacy, and it was visually strong. Few photographers had ever incorporated the hand-held camera as a part of their psychological and physiological systems in as adroit and heartfelt a way as Klein had. Irreverent, honest and spontaneous, his photographs of New York, Tokyo, Rome, and Moscow (as in this print) are expressionistic and vital. In many ways, where Frank led to Lee Friedlander, Klein was the source, direct or not, for the work of Garry Winogrand and Mark Cohen.

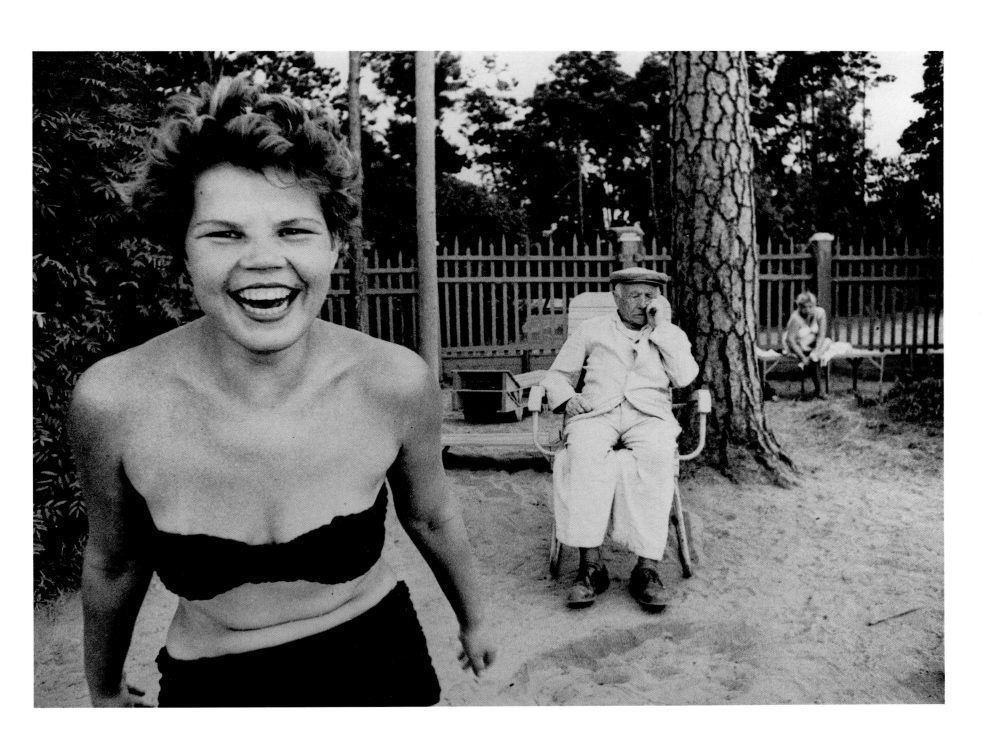

NICKOLAS MURAY

American · b. Hungary · 1892–1965

Marilyn Monroe—Actress

1952 · Color carbro print · 47.6 × 37.6 cm.

What Franz Hanfstaengl and Nadar had accomplished during the 1850s, what Bassano and Napoleon Sarony had done later in the century, and what Alvin Langdon Coburn had fashioned in 1913 and in 1922 was the use of the camera to record the faces and poses, the styles and fashions, in short, the look of those men and women of mark who defined the culture of their time. The achievement of these photographers went beyond simple portraits of famous individuals; rather, it was a matter of assembling a visual directory to the contemporary talent of their period. What previously had been attempted by engravings and mezzotints had by the end of the 19th century become a photographic tradition designed to capture the iconography of an era's creative genius. During the twenties and thirties of this century, that tradition, at least in America, fell to the camera work of a Hungarian emigré, Nickolas Muray, who, from his studio in Greenwich Village, was able to attract the most fashionable of the intellectual elite, the most celebrated of popular entertainers, and the more renowned of the "lost" and succeeding generation to sit before his camera. A skilled photo-technician, trained in Budapest and Berlin, and a photographer who opened his studio each Tuesday evening to the finest of New York talent, Muray photographed the likes of Humphrey Bogart, Clara Bow, Charlie Chaplin, Jean Cocteau, Marlene Dietrich, F. Scott Fitzgerald, Greta Garbo, Martha Graham, Jean Harlow, D. H. Lawrence, Sinclair Lewis, Claude Monet, Cole Porter, Paul Robeson, Babe Ruth, and Gloria Swanson [fig. 87]. And, although he is best known for his black and white portraiture done before the second World War, Muray was also an accomplished color photographer and carbro printer who continued in portraiture well into the fifties.

"Color," Muray claimed, "calls for a new way of looking at people, at things, *and a new way of looking at color.*"[1] His color photograph of seventeen models sporting beachwear in Miami became, when reproduced in the *Ladies' Home Journal* for June 1931, the first illustration from a color photograph to be published in an American mass-circulation magazine. In addition to still lifes for advertising, Muray furnished color portraits and domestic scenes for the covers of *McCall's Magazine*, *Modern Screen Magazine*, and *Time* during the forties and fifties. His later portrait subjects included the likes of Joan Crawford, Gloria de Haven, Jinx Falkenberg, Ava Gardner, Carole Lombard, Virginia Mayo, Edward Steichen, Elizabeth Taylor, and, of course, Marilyn Monroe.

Muray's *Marilyn Monroe—Actress*, while unquestionably not the most famous portrait of this star, is certainly one of the most

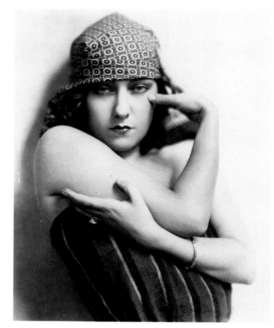

Fig. 87. Nickolas Muray, *Gloria Swanson*, gelatin silver print, ca. 1920s. Gift of the family of Nickolas Muray.

majestic and reverential. A languorous odalisque or some unspecified classical deity, Monroe poses in the style of countless Venuses and Olympias created by painters since the Renaissance. Bethroned, she postures with more than a hint of seductive allure. She is set apart atop a raised dais and by a cornucopia of fertile harvest that inhibits any potential approach while driving home the pictorial theme of abundance. This is not the actress camping or playing to the camera seen in so many photographs of her; it is a perfectly regal, officially sanctioned, historical portrait of the supreme sexual fantasy of the fifties, rendered in a manner directly transcribed from the *Beaux-Arts* of the 19th century. This picture is different in feeling from Muray's earlier portrait of Gloria Swanson, but then popular attitudes and the symbolism of sexual allure in the 1950s differed from those of the 1920s; Muray's portrait captured not the person but the idol, that cinematic ideal that Norman Mailer described: "She was one of the last of cinema's aristocrats. . . . Even down in the Eisenhower shank of the early Fifties she was already promising that a time was coming when sex would be easy and sweet, democratic provender for all. . . . She was a cornucopia. She excited dreams of honey for the horn."[2]

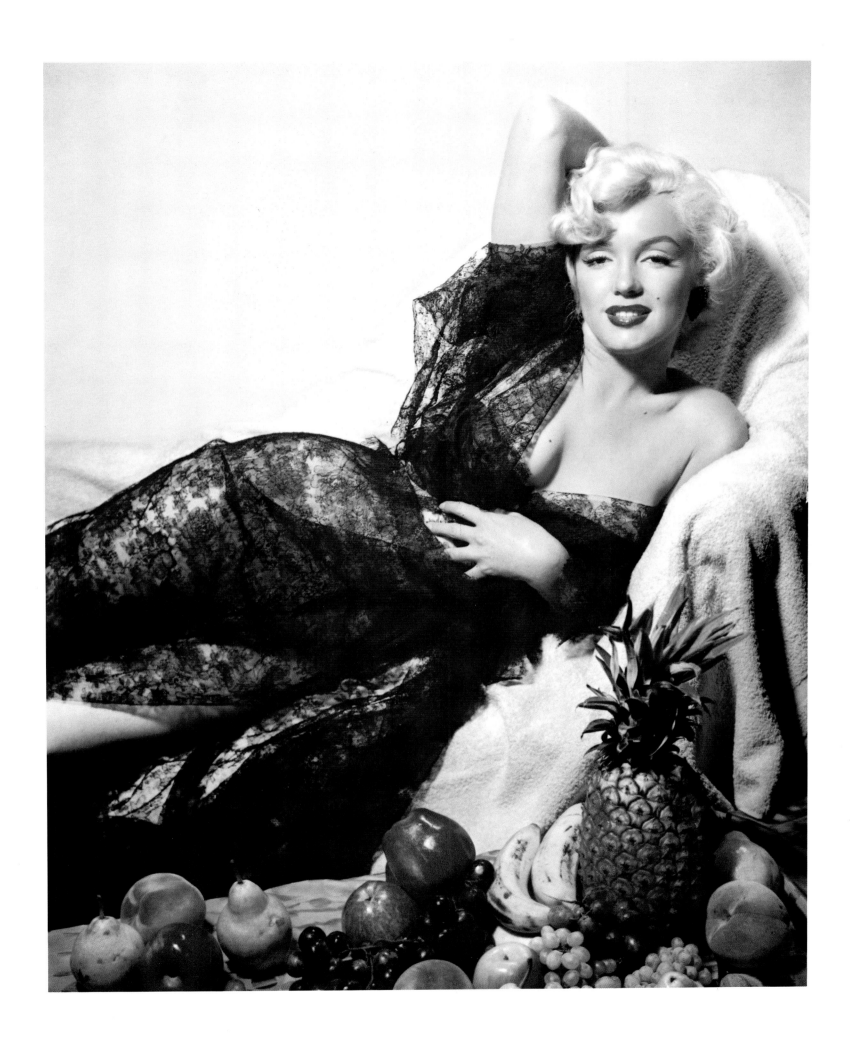

ARNOLD NEWMAN

American · 1918–

Alfried Krupp

1963/1983 · Dye transfer print · 48.3 × 33.3 cm.

About the nature of photographic portraiture, Arnold Newman has written:

> We must see our subjects through the camera and not through the eyes of one who thinks in terms of another medium. . . . The subject of a photographic portrait must be envisioned in terms of sharp lenses, fast emulsions, textures, light and realism. He must be thought of in terms of the twentieth century, of houses he lives in and places he works, in terms of the kind of light the windows in these places let through and by which we see him every day. We must think of him in the way he sits and the way he stands in everyday life, not just when he is before the camera. This is thinking in terms of photography. We are perhaps not consciously producing an art form, but in clear thinking, at least we are creating, not imitating.[1]

This traditionally based and functional attitude toward the aesthetics of photographic portraiture is evidenced in much of Newman's work, but perhaps never so fully than in his depiction of Alfried Krupp von Bohlen und Halbach (1907–1967).

For Newman, as for Brassaï and, to some degree, Lee Friedlander, the modern portrait is meant to acutely depict the personality of the sitter in an environment that is either his, and thus a reflection of his character, or another that has been adapted to fulfill that reflection by symbol or artifact. It is not simply the face or the physiognomy that carries the code to this personality but the integration of that figure and its countenance with surroundings that have been made personally meaningful. Thus, the environment, as it is merged with the figure, brings its details forward in resonance with the subject, alluding to it, supporting its psychological makeup, and completing the portrait's signification. Unlike the 19th-century official portrait photographer, such as Southworth and Hawes or Mayer and Pierson, who were tied for the most part to the controlled lighting and design of the studio, the official photographer of today can transport the studio to the subject.

The archaic and mythical grandeur of Newman's portrait suggests a thoroughly modern "hero," which the political scientist Marshall Berman likens to Goethe's Faust, the prototype of the modern developer.

> Deep night now seems to fall more
> deeply still, Yet inside me there shines a brilliant light;
> What
> I have thought I hasten to fulfill; The master's word alone has real might![2]

Photographed in one of his steel factories in Essen, West Germany, the figure of Alfried Krupp is so arranged, so controlled, and lighted in such a manner that likeness becomes comment. The most powerful head of Germany's armaments industry during the 1930s, a personal ally to Adolf Hitler, a convicted war criminal, Alfried Krupp is seen here only four years before his death and five before his family's business became a public company. The look is utterly theatrical and diabolic, an icon to strength and leadership, ruthlessness and determinacy. The harsh side-lighting, the crude steel forms framing the half-figure, and the acidic colors of the background, combined with Krupp's implacable stare and rigid deportment, are entirely in the service of this interpretation.

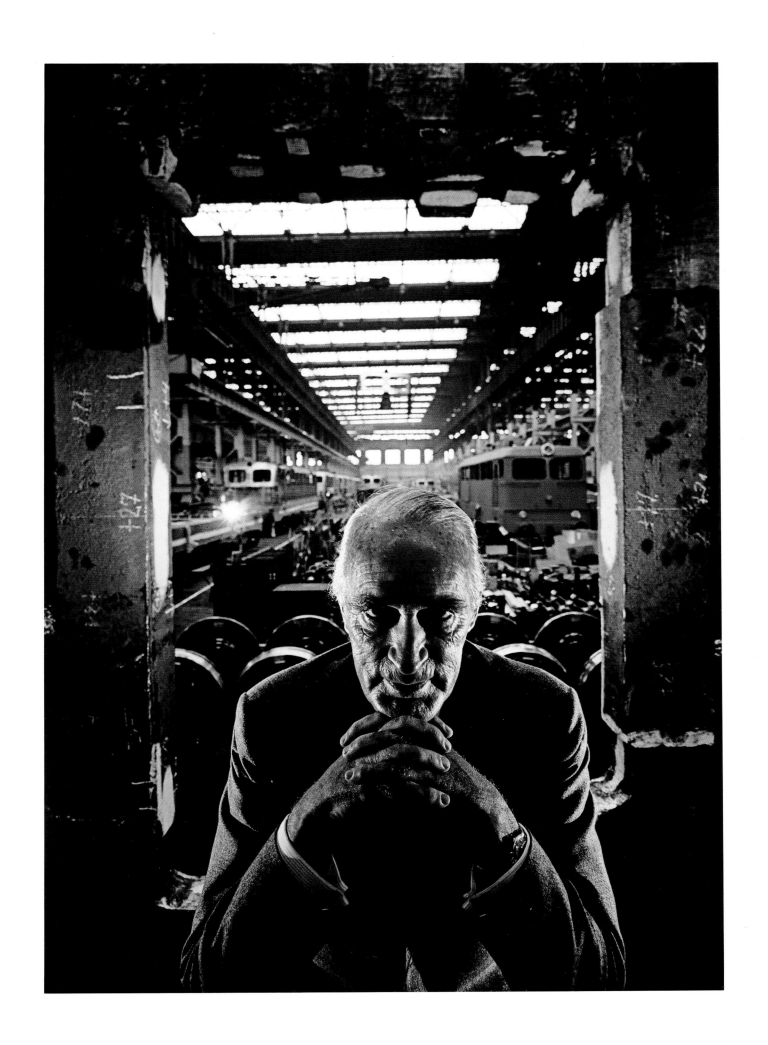

RICHARD AVEDON

American · 1923–

Igor Stravinsky, Composer, New York City, 11/2/69

1969 · Gelatin silver print · 24.4 × 59.4 cm.

My photographs don't go below the surface. They don't go below anything. They're readings of what's on the surface. I have great faith in surfaces. A good one is full of clues. But whenever I become absorbed in the beauty of a face, in the excellence of a single feature, I feel I've lost what's really there . . . been seduced by someone else's standard of beauty or by the sitter's own idea of the best in him. That's not usually the best. So each sitting becomes a contest. . . . I always prefer to work in the studio. It isolates people from their environment. They become in a sense . . . symbolic of themselves. [1]

Richard Avedon has monumentalized exactly that aspect of photographic portraiture most criticized since the earliest days of the medium—its factuality and disregard for idealization. When earlier photographers denounced conventional camera portraits as sterile, or when Julia Margaret Cameron called them mere "map-making and skeleton rendering of feature and form," they were in essence aspiring to free photography from what was seen as the tyrannies of objectivity and detail. [2] Avedon, in this century, embraces the relentless vision of the camera, its neutrality in the face of blemish or beauty, and that physiognomic "map-making" at which it is so facile. If the face is indeed the window to the human soul or character, then all its magnitude and solidity, its opacity and translucency must be delineated. In the strictest sense, these are likenesses rather than portraits; if any psychological reading or interpretation can be gained from them, it would be totally incidental to the picture. In fact, Avedon's portraits are quite unlike any others in photography; their nearest parallel may well be those supremely imperial late-Roman portraits in which the momentous lifelikeness of the subject gives rise to the very dimension and gravity of the portrait.

In 1970, Avedon spoke of depicting time in certain of his portraits: "Lately I've become interested in the passage of time within a photograph. I'd like to be able to do one long, long photograph that begins in one place and moves logically to another . . . in time and in event. I'm working on it." [3] But even then, as in the extended portrait of his dying father taken between 1969 and 1973, or here in the triptych of the composer Igor Stravinsky, each likeness was still an icon to a given, magnified instant. Each moment, each gesture is weighed slowly and heavily, so much so that the mere act of Stravinsky's raising his eyelids through three consecutive stages becomes a profound passion. The face as the chart of human emotion, or the portrait as an evocation of the sitter's poetic character is not what interests Avedon. Rather, it is the straightforward likeness, the appearance of the subject surgically fashioned for the camera with the complicity of the subject. It is not the interpretation of character that makes these portraits so captivating; it is the utter honesty of Avedon's art that persuades us of their justice.

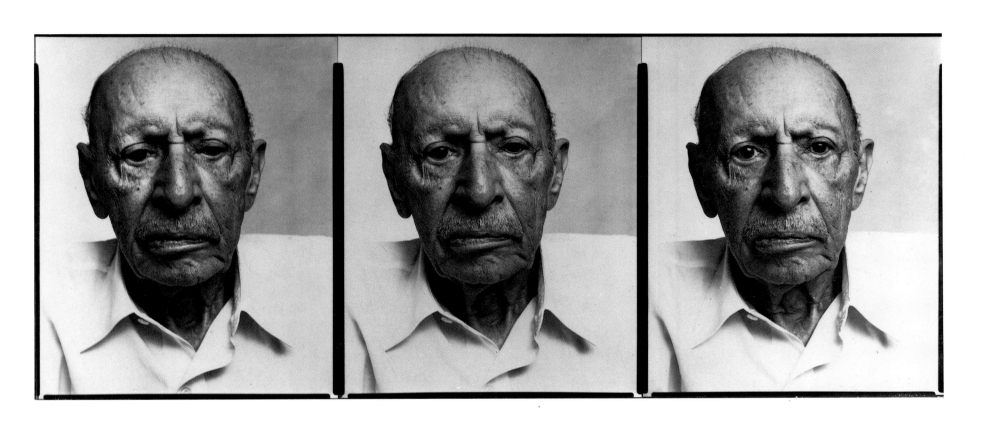

WALTER CHAPPELL

American · 1925–

Heart

1964 · Gelatin silver print · 24.0 × 19.1 cm.

Certain images depict for the sake of documentation; other images express through depiction some symbolic thought or feeling; and still others meditate upon the unseen and the spiritual through the object of their depiction. Nature seen is simply the natural world recorded by the camera, but even the most abjectly documentary of photographs may or may not have been made with certain hidden agendas of belief or values about what was recorded. There is ample evidence that 19th-century American landscape photographers such as Timothy O'Sullivan or William Henry Jackson often viewed the Western territories through the eyes of a transcendental idealism. Similarly, the "Equivalents" of Alfred Stieglitz are not about clouds but rather signs of correspondence between nature and a poetic or emotional state of mind. Nor are the landscape photographs of Minor White or Paul Caponigro merely eloquent renditions of a picturesque nature. For many American artists, especially since the second World War, the camera has been a tool for investigating and the photographic print a vehicle for addressing spiritual concerns, visions, or experiences decidedly transcendent of the material world. What is pictured is meant to reveal the immaterial or, if not to reveal, at least to mediate between the world of the perceived and the unseen. "I merely want," wrote Minor White, "to cause in others some degree of experience: shall we call it spirituality? identification? by using photographs as the excitant."[1]

Walter Chappell's photographs, according to the writer and photographer Ira Friedlander:

. . . are maps drawn for journeys to inaccessible places. . . . In various ways earth and flesh reflect each other, combine in contrast with one another and illuminate each other to produce maps to places in ourselves we rarely see clearly. Seeing the photographs through the eyes of the heart opens all visual barriers and carries the mind through the birth canal of experience to the ocean of total awareness. . . . Photographing in meditation, with sensitivity and knowledge, Walter Chappell seeks visual impressions of the human form to show its translucence and sometimes even its aura. Embodied in his work is the understanding that "He who realizes the truth of the body can then come to know the truth of the universe."[2]

Chappell's images are more than metaphoric or symbolic, they are, to use White's term, "excitants" by which the recognition of the unseen may occur. His pictures are about ultimate self-awareness witnessed through the form of things, and of which the Japanese novelist Yukio Mishima wrote:

For this type of self-awareness, the antinomy between seeing and existing is decisive, since it involves the question of how the core of the apple can be seen through the ordinary, red, opaque skin, and also how the eye that looks at that glossy red apple from the outside can penetrate into the apple and itself become the core. . . . The apple certainly exists, but to the core this existence as yet seems inadequate; if words cannot endorse it, then the only way to endorse it is with the eyes. Indeed, for the core the only sure mode of existence is to exist and to see at the same time.[3]

Chappell's work does not document the hidden secrets of life; rather, it reveals a mysterious and often morbid beauty of nature, a beauty made even more exquisite by its often brutal objectivity, and one that may suggest considerations of spiritual awareness.

EIKOH HOSOE

Japanese · 1933–

Kamaitachi, #11

1968 · Gelatin silver print · From Eikoh Hosoe, *Kamaitachi*, Tokyo, 1969, pl. 11 · 35.0 × 58.7 cm.

"Photography is the art of relating... two worlds," wrote Eikoh Hosoe. "It is the balance between the interior and the exterior. Human beings see things according to their past—their memory and their 'souvenirs.'"[1] Hosoe's photography examines that zone or arena in which those two worlds merge, in which phenomenal reality is not quite so certain nor so positive as it appears, and in which dreams and memories conflate with the material. Hosoe's photography has consistently centered on the notion of "private landscapes," and most frequently on that most private of all landscapes, the human body—the corpus of another persona. His figures are accessible to the degree that they are eloquently poetic delectations of flesh and muscle, of gesture and expression. The voyeuristic glance of the camera often focuses uncomfortably close or upon scenes of utterly personal reverie, witnessing the hidden "realm of the senses" exposed by the flesh [fig. 88]. The great Japanese poet and novelist Yukio Mishima, whose portrait was woven into *Killed by Roses*, wrote about his experience with Hosoe: "The world to which I was abducted under the spell of his lens was abnormal, warped, sarcastic, grotesque, savage, and promiscuous. . . . yet there was a clear undercurrent of lyricism murmuring gently through its unseen conduits. . . . The photographer has gazed clearly, with his own eyes, on unheard-of metamorphoses, and has testified to them."[2]

Hosoe's imagery is replete with very personal symbols and, at times, rather untranslatable narratives—narratives that pictorially yield only a portion of their significance. Yet a sense of the picture's meaning, an intuition into the artist's meaning, always rests on the surface, teasing with its unknowns and provoking by its implications. We might not fully grasp the story of *Kamaitachi*, but what affects us is the lyrical mystery lingering in the image and how forcefully that mystery captures and involves us.

Kamaitachi, or "Weasel's Sickles," translated literally from the Japanese, is a record of the memory I experienced during World War II when I was evacuated from Tokyo to the country village where my mother was born. I was twelve years old in 1944 when the American firebombing was the worst. . . . The dark, snowy country seemed to be full of

Fig. 88. Eikoh Hosoe, *Portrait of Yukio Mishima*, gelatin silver print, 1963, from Eikoh Hosoe, *Barakei* [formerly entitled *Killed by Roses*], Tokyo, 1963.

ghosts. In fact, there were ghosts. . . . Yuki-onna, or "Snow Woman," and Kamaitachi were among them. I picked the snow woman as not as terrible but on the contrary, as rather romantic. Kamaitachi, on the other hand, was something very awful. Kamaitachi is a small, invisible animal which attacks good people walking in the rice field lanes in the late springtime. A man who is attacked by Kamaitachi finds his arms or legs or some other part of his flesh sliced as if cut by a very sharp knife, but with no blood. In Japanese, *kama* means sickle and *itachi* means weasel. So Kamaitachi is an invisible weasel with very sharp teeth like a sickle. But no one has ever seen him. No one knows where or when he appears, only that he attacks people in the fields. I had the strange feeling, though, that I should never hate the land where my mother was born. If I hated it, I would hate my own mother. *Kamaitachi*, then, is a very personal record of my own memory from my boyhood, with all the complex feelings of love and hate from those days in the country.[3]

PAUL CAPONIGRO

American · 1932–

West Hartford, Connecticut

1959 · Gelatin silver print · From Paul Caponigro, *Portfolio One*, n.p., 1962, pl. 1. · 19.5 × 24.2 cm.

What about those images not thought out, but made with inner quiet? I am there, not only moving toward creation but toward realization. Knowledge and viewpoint are at the service of what, in me, wants to know. I feel my way. I know and direct up to a point and only so far as nature cooperates to carry out what I feel. We must be ready to use whatever in us is necessary to complete or manifest what we feel. [1]

In confronting the work of Paul Caponigro, one has the distinct urge to reconsider the traditional values of the photographic landscape. Like the typical landscape photographer of the last century, Caponigro approaches his subject with reverence, peace, and the absolute joy of nature's scenery. His pictures remind one of the arcadian splendors and beauties of the land, its forests, its solitary trees and raging streams, and its impressive geological formations. But Caponigro's work also brings to mind the consistency of photography throughout the last century and a half. There are no overt surprises in his work nor any esoteric positions of aestheticism, there is just—and this is quite special—a serene communion with the landscape, seen in all its details, exquisitely selected, and rendered with all the exactitude and tonal perfection that a silver print can achieve. These are the same landscapes that William Henry Jackson and Timothy O'Sullivan photographed in the 19th century; the oaks are similar to those pictured by Gustave Le Gray and Eugène Atget, and the views of Yosemite nearly identical to those depicted by Eadweard Muybridge and Carleton Watkins. Without a doubt, the same motivations that led Francis Frith to the ruins of Kar-

nak and Thebes and Ernest Edwards to the rock-cut Anchor Church near Derby during the 1850s brought Caponigro to the stone circles, arrangements, cairns, and dolmen of Scotland and Ireland in the 1960s and 1970s. Then as now, there is a certain mystery and majesty about the landscape, its relationship to man and his history, and its sense of a strange and daunting spiritualism.

For the photographic artist of the last century, the forms of nature and human pasts were inhabited with spirit, but where the form-directing beliefs of the earlier photographers were channeled through Ruskinian naturalism or Emersonian transcendentalism, those of Caponigro, like those of Minor White or Walter Chappell, are much more personally derived, filtered through various conduits of inner receptivity, such as medieval mysticism, Gurdjieff, and Zen, and individually transformed. According to Caponigro:

I work to attain a "state of heart," a gentle space offering inspirational substance that could purify one's vision. Photography, like music, must be born in the unmanifest world of spirit. . . . [A] meditative form of inaction has been my true realm of creative action. A dynamic and vital seeing is my aim. I do not necessarily visualize complete images, but rather, my intent is to sense an emotional shape or grasp some inner visitation. . . . Achieve the mystery of stillness, and you can experience a dynamic interaction with the life force that goes far beyond intellectual thought and touches the deepest wells of existence. [2]

BERNHARD BECHER and HILLA BECHER

German · 1931– German · 1934–

Winding Tower, 1920, "Dutemple," Valenciennes, Northern France

1967 · Gelatin silver print · From: Bernhard and Hilla Becher,
Industriebauten, Monchengladbach, 1968, portfolio of prints,
unn. · 19.4 × 15.4 cm.

The Bechers represent a blend of historian and artist, of factualist and idealist, of recorder and fabricator. In the words of French photographer Pierre Restany, these two artists, this couple, "together . . . form one camera, one eye. They cast one glance on the world, on a world which is dying and yet has not finished hatching us. The world of coal, blast-furnaces and slag-heaps, of cooling-towers, mines and drilling towers. . . . The functional architecture of the 1900s became sculpture, the tree as a symbol became the tree as an object. Such objective seeing is a major phenomenon of our times. . . . It is up to us to rediscover today in such a visual context the elements of a natural and modern vision."[1] That the Bechers have displayed an interest in picturing vernacular architecture, or, rather, engineered constructions, is not in itself surprising. Photographers since the middle of the last century have been called upon to document lighthouses, bridges, wharves, and mining operations. What is different is that the Bechers have created a transformational visual grammar along with their documentation of these structures. According to them, "Common to these objects is the fact that they were built without regard to proportion or ornament. Our special interest in this subject is that buildings serving the same function appear in manifold forms. We are attempting, with the help of photography, to categorize these forms and make them comparative."[2]

Nor is an artist's fascination with the material forms of technology and engineering especially new. A lengthy tradition of aestheticizing the engineered was firmly established earlier in the century, from Vladimir Tatlin's first version of the monument to the Third International of 1920, through Fernand Léger's manifesto *The Machine Aesthetic* of 1924, to Iakov Chernikhov's comprehensive treatise on constructivist-industrial architecture *The Construction of Architectural and Machine Forms* of 1931. In the constructivist, modernist tradition, the forms of the new technology were to be absorbed into the vocabulary of art, and through that absorption art would then become a vital part of life and culture. For the Bechers, however, the industrial forms they photograph are not visionary or especially modern. In fact, they have been most interested in the lime-kilns, mining elevators, blast furnaces, watertowers, etc., that are nearing their functional life spans and close to disappearing—structures that originally were built in the late 19th century or first decades of the 20th century. And while they may assemble their serial photographs of the same type of structure into larger montages, entitled *Morphologies*, the result is still a compendium of nearly lost architecture, intriguing in its strangeness and compelling in its mortality.

LEWIS BALTZ

American · 1945–

San Francisco, 1973

1973 · Gelatin silver print · 15.2 × 22.6 cm.

Sounding very much like Gustave Flaubert insofar as his aesthetic position is concerned, photographer Lewis Baltz wrote, "Whenever possible I use the camera at eye-level, not pointed up or down. I do this to make my photographs conform to the conventions of ordinary seeing. Ideally the photographer should be invisible and the medium transparent; at least I aspire to that level of objectivity. I want my work to be neutral and uninflected and free from esthetic or ideological posturing so that my photographs can be seen as factual statements about their subject rather than as an expression of my attitudes."[1] This sort of aesthetic disinterestedness is ultimately one of the cornerstones of modern art, from Flaubert and the painter Odilon Redon in the last century to Marcel Duchamp and August Sander in this century. Since nature and the external world had become, according to Redon in 1868, "the master and the one responsible for the effect it produces, the artist must above all be supple and submissive in front of it, obliterate the man so as to let the model shine, in a word—and this is a rare thing, difficult to acquire—he must have a great deal of talent without showing it."[2] It is a style easy to assimilate and simulate, but one that is perhaps almost impossible to bring off successfully. It is also a style that has certain resonances with minimalism and reductivism in modern art, a style of fundamentals and unique instances that bring home to us "the gravity, the stringency of art's demand that we should look at single objects for and in themselves."[3]

Yet photography on this order cannot divest itself of content nor ignore the fact that the camera must have a subject to record no matter in how severe and neutral a fashion. Baltz's subject is not only perfect in that the buildings and structures he records are so completely devoid of articulation or architectural expression that their very blandness corresponds to his artistic motive, but also in that these very buildings represent a sophisticated yet supremely unemotional modernity, which is achieved by their utter lack of affect as buildings. The subject here, as in much of Baltz's work, is precisely the new architectural symbolism of the corporate vision: the high-tech industrial park, the instantly developed resort community, unadulterated boxes on dehumanized sites. Architectural historian Reyner Banham has described this kind of building. "At its most nitty-grittily basic, it is the standard San Jose two-tone-avocado-with-racing-stripe tilt-up (so called because its plain concrete walls are cast flat on the ground and then tilted upright) that can currently be seen going up all over the valley, wherever energetic building entrepreneurs are trying to guess ahead of the coming demands for high-technology plants and high-quality warehousing."[4]

Unadorned as this architecture may be—from new, solemn black boxes of Silicon Valley to weathered stucco walls of overnight buildings only a few years old—Baltz capitalizes on its total lack of associative interest in order to document not only the architecture but an ironic abstraction of modern life.

ROBERT ADAMS

American · 1937–

Tract Houses

1974 · Gelatin silver print · 15.3 × 19.5 cm.

In the spirit of great landscape photographers of the 19th century like William Henry Jackson and Timothy O'Sullivan, who confronted views of an awesome and sublime nature from atop the Front Range or Pike's Peak, and nearly an exact century after Jackson, Robert Adams photographed the same Western American landscape. With the same sense of natural wonder and respect for the land, Adams addressed his views with patience, tact, and quiet deliberation. The panorama was breathtaking and its expanse magnificent; even the light was strangely beautiful. "The Front Range," wrote the artist in 1974, "is astonishing because it is overspread with light of such richness that banality is impossible."[1]

Between the time Jackson had begun documenting the region and the photographs of Robert Adams, Colorado had grown from a sparsely settled frontier territory that gained statehood in 1876 to a state whose population was 2,207,259 in 1970. Along with this growth, of course, came the signs of population and progress—houses and, especially since the second World War, housing developments. The virgin lands portrayed at times by the 19th-century photographer were no longer quite as virginal. Tract homes, suburban sprawl, and modern middle-income settlements had supplanted the small discrete towns and single cabins of the 1870s, and a view without the evidences of man became the exception. Without overly romanticizing the social effects of the past century upon the American landscape, Adams pictured the new landscape with acceptance, honesty, and civility. What else was really possible? According to him, ". . . we need to see the whole geography, natural and man-made, to experience a peace; all land, no matter what has happened to it, has over it a grace, an absolutely persistent beauty. . . . Even subdivisions, which we hate for the obscenity of the speculator's greed, are at certain times of day transformed to a dry, cold brilliance."[2]

It might be of interest to consider that while Adams and other American photographers like Joe Deal and Lewis Baltz were turning to the suburban landscape as a subject in which pictorial interest and even beauty could be discovered, the architect Robert Venturi was admonishing his profession against its blindly elitist rejection of the vernacular forms found in suburbia and for failing to discern, "architecture as symbol in space before form in space. To find our symbolism we must go to the suburban edges of the existing city that are symbolically rather than formalistically attractive and represent the aspirations of almost all Americans, including most low-income urban dwellers and most of the silent white majority."[3]

STEPHEN ERIC SHORE

American · 1947–

U. S. 1, Arundel, Maine

1974/1975 · Chromogenic development print · 19.5 × 24.6 cm.

There is an inherent and resolute romanticism to Stephen Shore's photography, and a certain wistful melancholy to his images of the mid-1970s. In part this has to do with the scenes he portrayed, and partly it is a factor of the light and color he used to record those scenes. Art critic Max Kozloff has written: "By any of the usual criteria of architectural interest or civic grace, they are grossly undistinguished vistas. Yet, though accepted in their very banality, they are often transfigured by a suavity of color or beauty of light that can be extremely assertive. . . . Shore nervelessly blinks the exquisite nuances glancing off unaffecting places with commanding visibility."[1] While the color and light may be assertive, Shore's unprepossessing scenes are utterly passive, as if nostalgic glimpses of forgotten childhood memories of place, locations so commandingly familiar once as to be easily glossed over by life's more impressive experiences— the unpeopled stages of unrecalled activities. Bathed in hard, brittle light and punctuated with details of such saturated color, these are less documentary than they are tableaux of revery and expectation, as in De Chirico's *pittura metafisica*.

Unlike the work of Walker Evans, who to some degree can be viewed as a model, Shore's pictures do not record the demographic facts of American regions [fig. 89]; rather, they confirm the presence of undefined neighborhoods and street corners. Writing in the same period, the poet Douglas Crase similarly attended to this topic.

Fig. 89. Walker Evans, *Roadside Houses for Miners, Vicinity Birmingham, Alabama*, gelatin silver print, 1935. Museum purchase with National Endowment for the Arts support.

> It has to be an act, almost a European thing
> Tricked out of its boundaries to appreciate
> What is sufficient if not just enough.
> And it probably must be the cat of behavior
> Trained, that will slip and step through
> Yet still accumulate rather than leave behind,
> Accumulate content out of the cracks
> Got through, imperial, empire on the sly.
> It will need to accumulate to persuade,
> By persuasion making a place for itself,
> Survived. Its rules are brief and it knows
> When it is tired, how far the border is
> And the distance it can cover in 24 hours.
> Knows, too, where neutral country may be found.
> In action it is the review of what it knows,
> A review of process and due possibility,
> Preceding its palace of results. A palace
> Where life had been possible, as it turns out.[2]

As in ordinary life, Shore's pictures accumulate content out of the cracks and persuade us of these places.

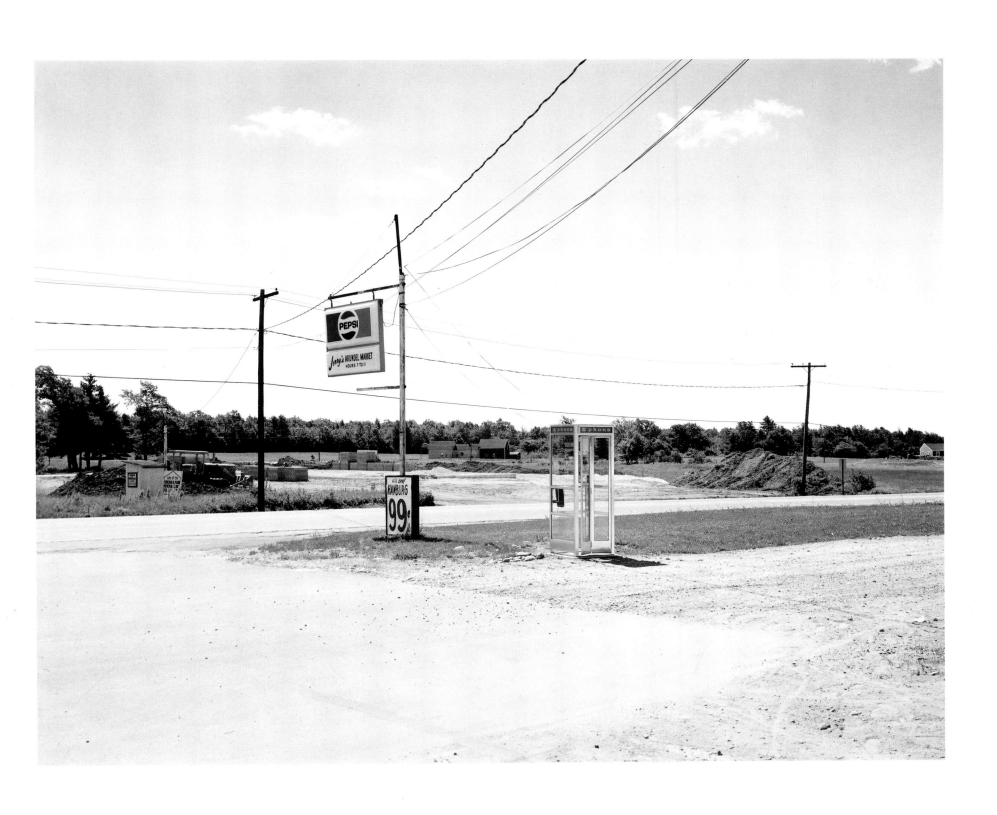

RAY K. METZKER

American · 1931–

Tales of Albuquerque

ca. 1973 · Gelatin silver prints, montaged · 43.9 × 38.3 cm.

The sources for Metzker's large mosaic montages of the late 1960s and early 1970s can be traced to a number of antecedents. Ultimately, the line meanders back to the series of photomontages made by the Belgian photomontagist Paul Citroen around 1922, in which a myriad of small, individual images of urban buildings were formatted into a flattened, overall pattern incorporating a loosely knit grid structure.[1] But where the Dadaists used the technique of montage in order to express the "chaotic, disorderly, and hectic characteristics of a big city,"[2] Metzker regularized the grid by repeating identical images of the same size so as to weave, as it were, a regular texture expressive of order and calm within a scintillating surface of graphically patterned lights and darks, planes and recessions.

The textural weavings of his photographic patterns suggest both the art of woven fiber as well as many of the design experiments in visual rhythm that were an important part of the curriculum of the German Bauhaus and its successor, the Institute of Design at Illinois Institute of Technology in Chicago, where Metzker studied under Harry Callahan during the 1950s. According to Gyorgy Kepes, who continued Moholy-Nagy's photography teachings at the Institute of Design, "Rhythm cannot be grasped as one isolated visual sensation. Its very meaning lies in the fact that it is an order of a greater temporal whole. The sparing of mental energies in judging the necessary physiological measures makes sense only in reference to the whole

building process of the image."[3] According to Kepes, rhythm could be simply planar and graphic, but it could also be "a regular change of sensation of spatial movements of colors and values; advancing, receding, expanding, contracting, moving up, down, left and right. . . . [and] of tension and repose, concentration and rarefaction, harmony and discord."[4] Metzker's mosaic constructions were highly sophisticated and elegant reformations of these artistic principles into strictly photographic terms.

This particular print, *Tales of Albuquerque*, was made toward the end of the artist's involvement with patterned mosaics, and represented a move toward a more calligraphic integration of the individual pieces. Instead of the predominantly dark images of shadowy urban scenes articulated with discrete areas of light, Metzker here reversed the order so that attenuated black shapes are choreographed across a broad white ground, each form doubly breaking its own individual drawn frame and connecting with others above and below. The resulting rhythm is more open, lively, and, in a way, more musical. In 1967, Metzker commented on this series of work: "Discontented with the single, fixed frame image. . . . my work has moved into something of the composite, of collected and related moments. . . . I employ methods of combination, repetition and superimposition. Where photography has been primarily a process of selection and extraction, I wish to investigate the possibilities of synthesis."[5]

FRANK W. GOHLKE

American · 1942–

Landscape—Grain Elevators and Lightning—La Mesa, Texas

1975 · Gelatin silver print · 35.0 × 35.0 cm.

Frank Gohlke is a photographer of the modern architectural environment, whose *Landscapes* consist of parking lots, suburban residential areas, and industrial buildings. Although frequently affiliated with that form of documentary photography called the "New Topographics," Frank Gohlke's images are not as much the product of a weightless, clinical, and undifferentiated approach to their subjects as at first they appear.[1] Where Lewis Baltz, the Bechers, and Nicholas Nixon strive for a description that is fundamentally analytical and transparent, Gohlke seeks out the nuances of topical light and incidental reflections that lend a certain sense of drama and mystery to what ordinarily would be rather prosaic. A bizarrely shaped water tower commands a hilltop, a bolt of lightning strikes somewhere down the highway, and long, raking shadows dominate the foreground of a suburban, Midwestern street corner, or an unseen shaft of light may brilliantly illuminate only the edge of a small *balcon* at early morning or late afternoon [fig. 90].

Ever since the 1920s, Midwestern grain elevators have symbolized the brutal elegance of modern architectural form, engineered for efficiency rather than designed for artistic expression. In France, the architect Le Corbusier published his *Vers une architecture* (*Towards a New Architecture*) in 1923, and began by countering "architecture" with the "engineer's aesthetic." He illustrated the first chapter with photographs of Canadian and American grain stores and elevators, and concluded: "Thus we have the American grain elevators and factories, the magnificent FIRST-FRUITS of the new age. THE AMERICAN ENGINEERS OVERWHELM WITH THEIR CALCULATIONS OUR EXPIRING ARCHITECTURE."[2] In 1924, the German Expressionist architect Eric Mendelsohn traveled to this country to study its indigenous, vernacular architecture, and he was similarly impressed with these functional constructions, a number of which he photographed for his *Amerika* of 1926.

In this print, Gohlke again addressed the aspect of these engineered structures insistently punctuating the flat landscape of

Fig. 90. Frank Gohlke, *Driveway, San Francisco*, gelatin silver print, ca. 1979. Museum purchase with National Endowment for the Arts support.

the Midwest. But here, and unlike their isolated glorification earlier in the century, these towers share in the natural theatrics of a passing storm, its watery reflections and unnerving lightning flash. The entire scene is charged with a certain poetics of humid, ozone-permeated stillness and eerie light effects. Like many of Gohlke's pictures, the topography is imbued with a sense of mystery far greater than that required by any analytical description of *topos*. Writing in 1927, the architect Eric Mendelsohn described this sort of tension: ". . . nothing appeals more readily to modern man than pictures. He wants to understand, but quickly, clearly, without a lot of furrowing of brows and mysticism. And with all this the world is mysterious as never before, impenetrable and full of daring possibilities."[3]

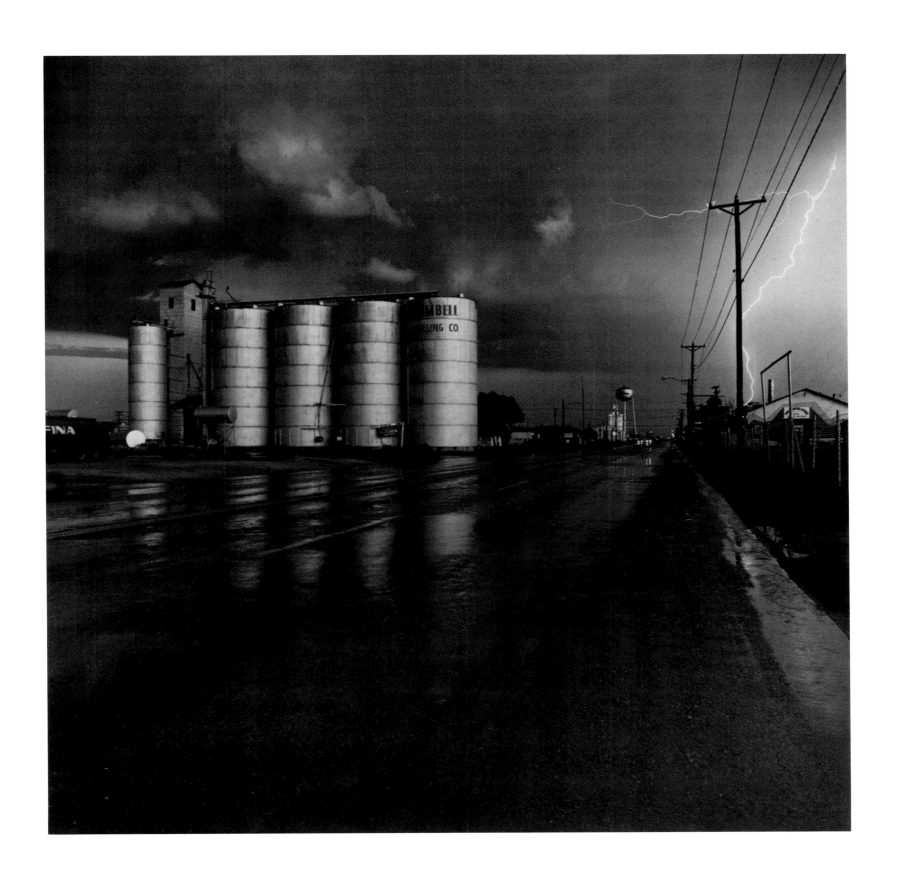

LEE FRIEDLANDER

American · 1934–

Monument at Shiloh, Two Views

1981 · Gelatin silver prints (diptych) · From Lee Friedlander, *Shiloh*, (portfolio), New York, 1981, nos. 12 and 13.
19.0 × 28.2 cm. (each)

There are certain places we imbue with special meanings. When these meanings are shared by more than passing interests or private significance, we appropriate the location and we demarcate it with boundaries, label it with signs, and let history and events continue around its perimeter. In short, we create a memorial, and we memorialize in order to remember. And, for the most part, we visit memorials to savor our recollections, whether they are sweet or bittersweet, either of a distant or near past. Memorials are similar to monuments, but more often memorials are larger both in scale and in what they allude to. Sometimes they even include subsidiary monuments, as in the National Park commemorating the Battle of Shiloh.

One of the bloodiest and more controversial engagements of the American Civil War, the battle occurred on April 6 and 7, 1862, and took its name from Shiloh Church near Pittsburg Landing, Tennessee, on the west bank of the Tennessee River. The Union armies, led by General Ulysses S. Grant, along with Generals Buell, McClernand, and McDowell, were engaged by Confederate forces led by Generals A. S. Johnston and Beauregard. In all, some 120,000 men were involved, and some 20,000 died, were wounded, or declared missing. It is said to have been only a technical victory for the North. In 1894, a tract of 3,702 acres was designated as a National Military Park.

In a case like Shiloh, the memorial is much more than the plaques and monuments that cite its particulars. The memorial is a complex of time past and present space. It is the land upon which soldiers fought, it is the landscape in which those that perished are buried, and it is the park articulated by the symbolic monuments that declare its meaning. All of this, and more, was eloquently rendered by Lee Friedlander, who, not content just to document tourist plaques and stacks of cannon balls, addressed the boundary lines between the artificial and the pastoral that make up this memorial. The result is much more than a record of the park; it is a sentimental and lyrically critical evocation of the natural place, the locus of a historic event. John Szarkowski aptly described the specific sort of photographic game played by Friedlander: "The point of the game is to know, love, and serve sight, and the basic strategic problem is to find a new kind of clarity within the prickly thickets of unordered sensation."[1]

Mathew Brady was at the first Battle of Bull Run, O'Sullivan photographed the grisly aftermath of Gettysburg, George Barnard followed Sherman's march through Georgia, and A. J. Russell documented Fredericksburg. In much the same spirit, Friedlander was also a Civil War photographer when he captured the traces and reminders of the conflict and romanticism of Shiloh's historic landscape. For the earlier photographers, the past they documented was only a few days or months old; for Friedlander, it was a past of nearly twelve decades. Still, it was the place that was important no matter the time because the then and now had become conflated. Photographically, *Shiloh*, the portfolio, is a celebration of recollection, a melancholy essay in overcast light and wistful tonalities, a pastoral of recollected bloodshed, and a revelation that, beneath the sculpture and within the forests, there is still the animated presence of the American past.

EDDIE ADAMS

American · 1933–

Saigon, 1968

1968/printed later · Gelatin silver print · 27.0 × 34.5 cm.

Only a handful of war photographs stand as canonical images of the historic events they are a part of. Most often, a series of images by a talented journalist will offer a studied and extended view of the atrocities, disasters, and death that are in large part the real war effort. The emotional power of W. Eugene Smith's photo-essays for *Life* on the battles of Saipan and Okinawa—in spite of many fine single images—rests in the cumulative effect of the more than 150 frames he shot in 1944 and 1945. A similar argument could be posed for Donald McCullin's shocking and wrenching reportage of more recent war scenes in the Congo, Londonderry, Vietnam, and Beirut. Periodically, however, a single image was made that did not require the amplification and continuity of the picture story or series. Timothy O'Sullivan's *A Harvest of Death* is such an image for the American Civil War, just as Robert Capa's *Death of a Loyalist Soldier* graphically symbolizes the Spanish Civil War of the late 1930s. Certain of these images have been fictive, camera events staged for the very act of their documentation; but the fact of their mythology does little to diminish the impact of O'Sullivan's portrayal of a field strewn with bloated dead bodies or of Joe Rosenthal's shot of U. S. Marines raising the American flag on Iwo Jima in 1945.[1] Others have been the result of the cameraman's being attentive to the action surrounding him and benefiting from a chance encounter with an extraordinary moment, the classic example of which might very well be this photograph by Eddie Adams during the Vietnam War.

The scene was the Cholon sector of Saigon immediately following a skirmish at An Quang Pagoda between the Viet Cong and the South Vietnamese. The official story has it that Brigadier General Nguyen Ngoc Loan, the South Vietnamese chief of police, being informed that the captured civilian was a Viet Cong lieutenant who had killed another police officer, pulled out his revolver and at point-blank range fired at the right side of the prisoner's head. His only reported comment afterwards was, "They killed many of my men and my people."[2] Adams recorded the assassination at the precise moment of the gunshot. Published widely, the powerful image was awarded a Pulitzer Prize in 1969.

Reacting to this image is a complex matter, both morally and politically, but it obtains memorability specifically because of its unprecedented timing. This is not a photograph of the moment before an accused is shot, nor is it the bloody aftermath; it is the exact instant of a homicide—calm, ordained, casual, and photographed. As the critic and novelist John Berger pointed out, "Today, what surrounds the individual life can change more quickly than the brief sequences of that life itself. The timeless has been abolished and history has become ephemerality. History no longer pays its respects to the dead: the dead are simply what it has passed through."[3]

It has become only incidental that the homicide might have had nothing to do with the war but rather with a personal vendetta, and that the victim might not have been a Viet Cong.[4]

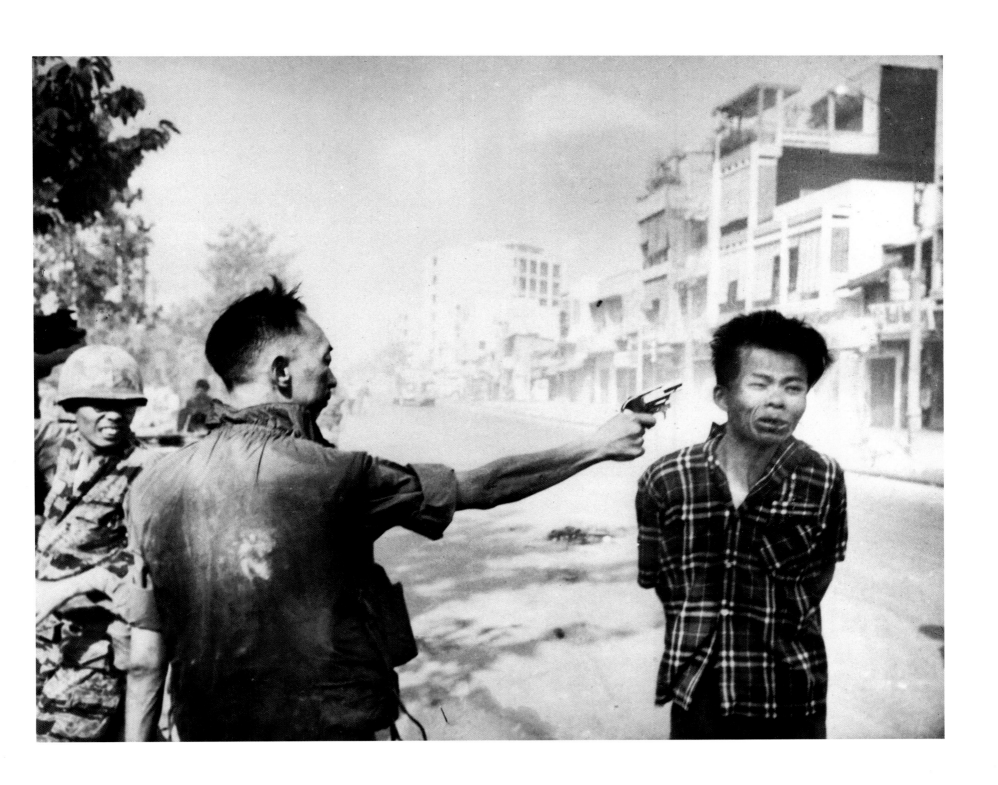

ROBERT WHITTEN FICHTER

American · 1939–

Female Figure and Lawn Chairs

ca. 1966 · Gelatin silver print · From series *Dianagrams*. 23.5 × 34.4 cm.

Robert W. Fichter is a thoroughly modern American artist, one who, with a blend of aggressive idealism and naive immediacy, has said with candor: "These photographs, drawings and writings are the acts of a desperate man, flawed and able to communicate less than a tenth of what he feels and imagines. I am a traditional American artist. I have constantly practiced to be able to perform without thought . . . to see the thing for all its implications . . . not to work toward a preset example . . . to try to move with the material both corporal and spiritual."[1] A Southern artist, his vision is primarily humorous and troubled— a wry humor often laced with pessimistic forebodings and serious anxieties. His style is disarming and provocative, expressionistic and symbolic, and like certain other Southern photographers of this century, such as Jerry Uelsmann, Clarence John Laughlin, and Ralph Eugene Meatyard, there is a firmly embedded "gothic" quality in his imagery. Fichter documents a darkly hermetic landscape, a peaceable kingdom often infiltrated by death and violence, a vernal pastoral sullied by deterioration and meanness and peopled by strange, disturbing "icons" of our present situation [fig. 91].

His is a romantic spirit at odds with his own capacities, frustrated by the limits of his variously chosen techniques for expression and with a need to get it all out as fast as possible. Whatever pictorial medium is at hand is serviceable to his art, whether drawing, painting, printmaking, photography, or computer-assisted renderings, and no medium is inviolate or proscribed from adulteration and manipulation. The only thing that matters is the direct, immediate fabrication of images that signal a profound impatience with the "embarassments of the human predicament"[2] and the formal rules of art. "Some times I'm in a mo zay ic mood, and sometimes I'm in a single frame mood. Sometimes I'm good and sometimes I'm terrible. Artists don't have to stay in 1 (one), singular mood all the time. Look at Paul Klee andhislineonawalk. Watch that line."[3] "Mo zay ic" or "single frame," it was the vision and the spirit that was important, not any superficial consistency.

In his early work, Fichter's imagery revolved around his restless travels and the premises of what a gelatin silver print could

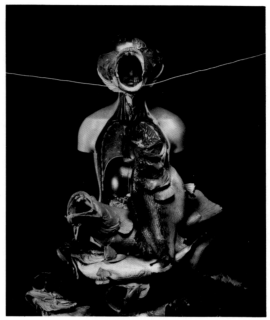

Fig. 91. Robert W. Fichter, *Medical Analysis*, Cibachrome print, 1982. Museum purchase, L. A. W. Fund.

look like and still be photographic. Real and fictive landscapes expanded and contracted in his photographs. Panoramas of solarized highway scenes alternated with visions constructed of multiple television images. And, more daringly, suburban or small-town urban backyard pastorals were captured by running the same roll of film repeatedly through a toylike "Diana" camera. Just enough of the original scene remained to show the sunbathing woman, her straw hat, blanket, and chairs. A woman resting in a garden, a bourgeois idyll similar to many painted by Pierre Bonnard earlier in the century, is, in Fichter's hands, reduced to a grainy, gritty, light-streaked, and blurred token of semblance and ritualized photographic essence. It is an image of tranquil domesticity, and an image threatened by the artist's very own act of recording it.

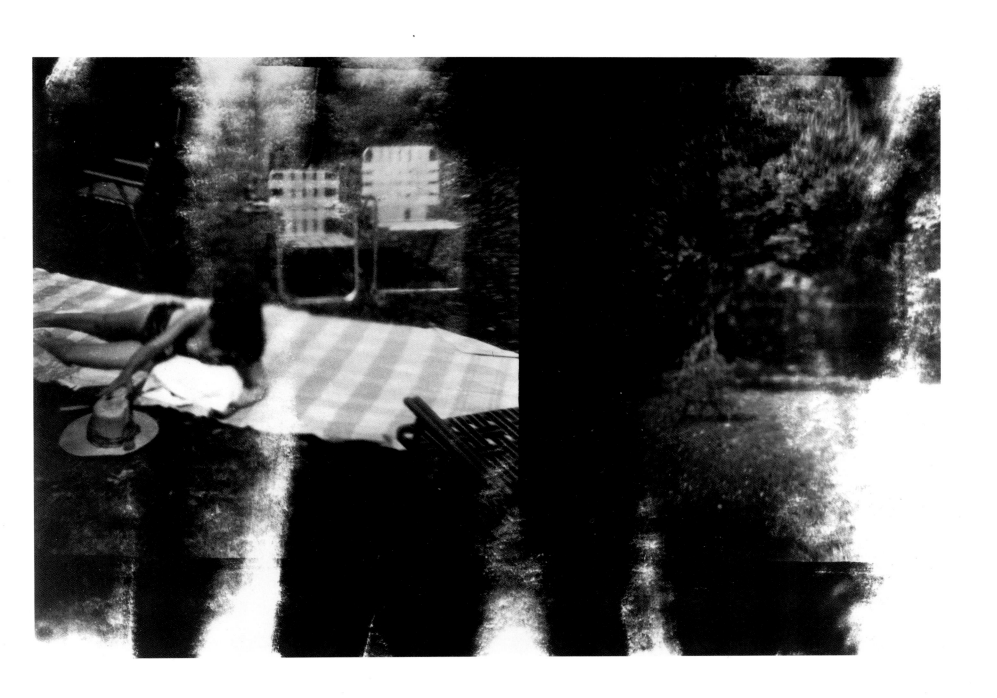

LES KRIMS

American · 1943–

Legless Man on Pedestal

1970 · Gelatin silver paper (Kodalith), toned · 11.9 × 17.0 cm.

Writing about H. P. Robinson's *Fading Away* of 1858, a 19th-century historian summed up the public response to that early image of a dying girl by saying "it attracted great attention and much difference of opinion was excited as to the propriety of photography being employed to delineate such a subject."[1] Much the same sentence could be written about the early work of Les Krims when it appeared in exhibitions and in periodicals in the late 1960s. Unlike Robinson, whose print was simply of a staged tableau portraying a rather private and sensitive scene, Krims took on the staging of subjects calculated to shock and disarm. From the very start, Krims's photographs were stilled images from a private theater of the absurd, grotesque dramas exquisitely directed and printed. At first, the subjects he photographed may have been found along the road or in city streets; progressively, he turned to the studio in order to create "fictions" for the camera, personal melodramas whose iconographies and narratives are frequently obscure, difficult, and irrational.

In the classic text of this century on the grotesque in photography, the California photographer William Mortensen wrote, "Boredom, with the prosaic material of the everyday world, with the smug limitations of his medium, leads the artist to seek new and more expressive forms. Often this search brings him to the grotesque. The photographer, bored to distraction by the banalities of realism and the imperious demands of the Machine [the camera], should find grateful release in the exaggerations of the grotesque."[2] Like Mortensen, Krims merges the grotesque with the sexual, the repulsive with the alluring, the documentary with the surreal, and the farcical with the tragic. His themes have included his naked mother preparing chicken soup, robotic costume contests, deer hunters and their dead game, naked women with various objects or food attached to their bodies, and jazz demonstrations surrounded by epic arrays of contemporary material culture. "I am not a historian," he wrote in 1970. "I create history. . . . It is possible to create any image one thinks of; this possibility, of course, is contingent on being able to think and create. The greatest potential source of photographic imagery is the mind."[3]

This early print is perhaps one of Krims's strongest images, portraying a legless man, discovered on a street in Buffalo, New York, who willingly posed for the photographer in his apartment during an afternoon "tea" of hot chocolate and cookies. It depicts a charade, a farce, but one that was guaranteed to disturb any conventional sense of decency and propriety. The feigned expression of anguish or hostility by the model is equally unnerving. Perhaps the greatest sense of outrage, however, comes not only from confronting an image of a victim of double amputation and social misfortune, but from attending to him atop a pedestal where his "anguish" or our discomfort cannot be easily dismissed. It is a troubling and alarming image, and it was one of four prints by Krims that provoked a viewer in Memphis, Tennessee, to kidnap the son of a university professor and ransom him for the removal of the pictures from exhibition.[4]

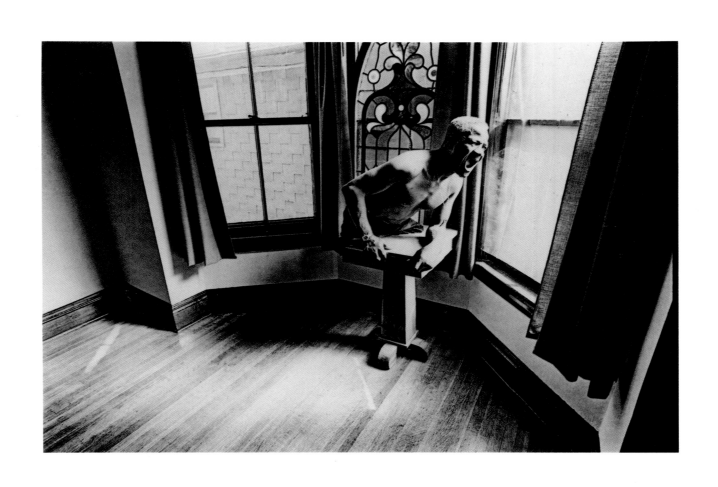

JUDY DATER

American · 1941–

Twinka

1970 · Gelatin silver print · 30.5 × 23.9 cm.

From a lengthy series of interpretive portraits of women done between 1965 and about 1973, Judy Dater's *Twinka* is somewhat anomalous. Instead of Dater's customarily romantic portrait, where the subject is found in a state of comfortable self-awareness and addressing the camera with confidence, *Twinka* here assaults the lens of the photographer with what may or may not be a fabricated gesture of estranged possession and an expression of intense emotionalism. Other images of the same model do not reveal this psychological element; more simply dressed or even nude, Twinka otherwise presents a far more conventional comportment or a healthy playfulness [fig. 92]. On the occasion of an exhibition of Dater's and Jack Welpott's portraits of women, in which this image was included, the two photographers wrote that the women portrayed in the photographs were "for the most part the free spirits among women."[1] Later, Dater described the circumstances of the session that resulted in this picture of Twinka clad in a diaphanous negligee and positioned in a hollow of a redwood tree: "I asked her to get [in] there, but I didn't tell her to put her hand up like that, and of course I didn't tell her to get that expression on her face, but I did ask her to hold it."[2] Just how much of the model's persona is revealed by Dater's print is unclear. It could just as easily be the product of an extravagant play as a sudden moment of photographic unmasking. Nor is this question even that relevant since what had been fashioned has taken on the gloss of an icon commemorating the passionate estrangement of a generation of women.

Where Anne Brigman concentrated on photographing nude female models entwined with cypresses along the California coast around 1910, her images were idyllic renditions of an almost theosophic pantheism in which the human form was vested with the same spirit and energy as nature. In *Twinka*, there is no joyous celebration of any spiritual unity with life. The figure is fetally secured within her natural confine, returning our confrontation with a mixture of protective fear and coiled tension. Especially given the context of this image's date and the

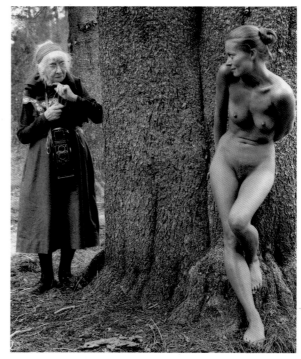

Fig. 92. Judy Dater, *Imogen and Twinka, Yosemite*, gelatin silver print, 1974. Courtesy the artist.

amount of active discourse devoted to the situation of the woman in modern Western society, *Twinka*, which carries a variant title of *Twinka, Insane*, suggests a visual counterpart to a passage by the writer Lara Jefferson. "There is nothing wrong with me—except I was born at least two thousand years too late. Ladies of Amazonian proportions and Berserker propensities have passed quite out of vogue and have no place in this too damned civilized world. . . . here I sit—mad as the hatter—with nothing to do but either become madder and madder or else recover enough of my sanity to be allowed to go back to the life which drove me mad."[3]

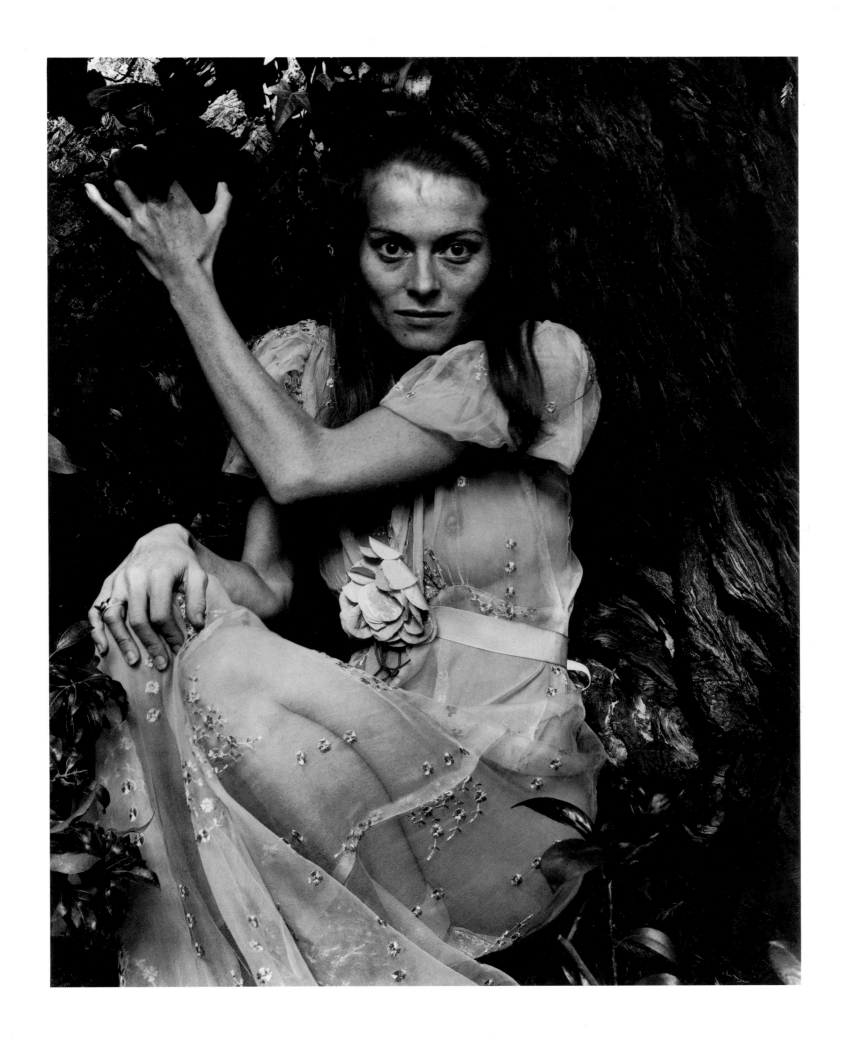

JERRY N. UELSMANN

American · 1934–

Nude and Rock Formation

1972 · Gelatin silver print, combination printing · 24.0 × 33.5 cm.

More than any other photographer of this century, Uelsmann has developed the expressive potentials of combination printing far beyond that imagined by the originators of this technique in the 1850s, Oscar Gustave Rejlander and Henry Peach Robinson. For the earlier artists, combination printing was a procedure for photographically rendering scenes or subjects that were beyond the means of the single lens and camera. With care and skill, any number of individual negatives could be used to print-out a final, composite image, and by so doing produce either a fully resolved naturalistic portrayal (such as the printing-in of an absent sky) or a completely imaginary scene from history or mythology. Rejlander, in his famed *The Two Ways of Life* of 1857, used approximately thirty negatives in printing the discrete parts of his allegorical tableau, much as a fresco painter builds up a painting in piecemeal fashion. Combination printing was also a means of creating a photographic art that was ideal and imaginative; no longer was the camera artist bound to a prosaic, material reality. According to H. P. Robinson, ". . . the scope of photography is wider than those who have only taken a simple portrait or landscape suppose. . . . We do not mean to assert that such subjects as Michael Angelo's Last Judgment, or Raphael's Transfiguration, for instance, have ever been done in photography; but it is not so much the fault of the art, as of the artists, that very elaborate pictures have not been successfully attempted."[1] In 1964, Uelsmann produced a combination print entitled *Self-portrait as Robinson & Rejlander*, as an homage to his 19th-century predecessors.

Where Raphael had depicted a convulsive scene from Christian history in his *Transfiguration*, Uelsmann has fabricated his own personal transformations, a visionary world of heterodox transfigurations in which impossible spaces, unlikely juxtapositions, and bizarre mergings occur with such precision and utter believability that questions of authenticity are simply muted. Boulders hover magically in the sky as do entire trees whose roots have been released from the ground; eyes naturally peer out from beneath the earth as easily as figures swim in sand or seed pods assume primal dimensions. It is a world of fantasy, but one in which the poetics of myth are more real than the laws of physics; for Uelsmann, it would seem, the notions of Newton and Descartes are more fictional than those of anthropologist Sir James George Frazer and psychologist Carl Jung. In Uelsmann's

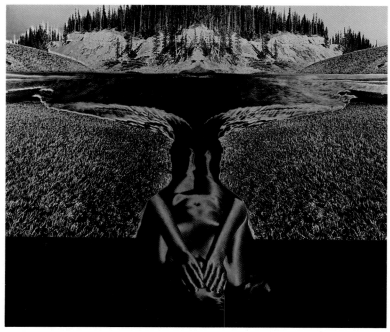

Fig. 93. Jerry N. Uelsmann, *Untitled*, gelatin silver print, solarized, 1972. Courtesy the artist.

photography, themes of fertility and birth, incarnation and animism, resurrection and atavism are celebrated as "psychic landscapes" in which spirit is revealed and the persona meets itself, as in his famous *Small Woods Where I Met Myself* of 1967.[2] Uelsmann's view of the singularity of spirit has been commented on by one critic. "His work suggests a concern for discovering what Erich Neumann phrased to be 'a breakthrough into the realm of essence,' an attainment of 'the image and likeness of a primal creative force, prior to the world and outside the world, which, though split from the very beginning into the polarity of nature and psyche, is in essence one undivided whole.' "[3]

This image of 1972, of a nude figure in negative floating above a doubled rock form, and its companion picture of a solarized nude submerged in a watery flow within a field of grass [fig. 93] suggest other polarities, such as Plato's Celestial and Vulgar Aphrodites or *Venus Coelestis* and *Venus Naturalis*, mother and daughter, perhaps, or the twins of primordial desire, the sacred and the profane.

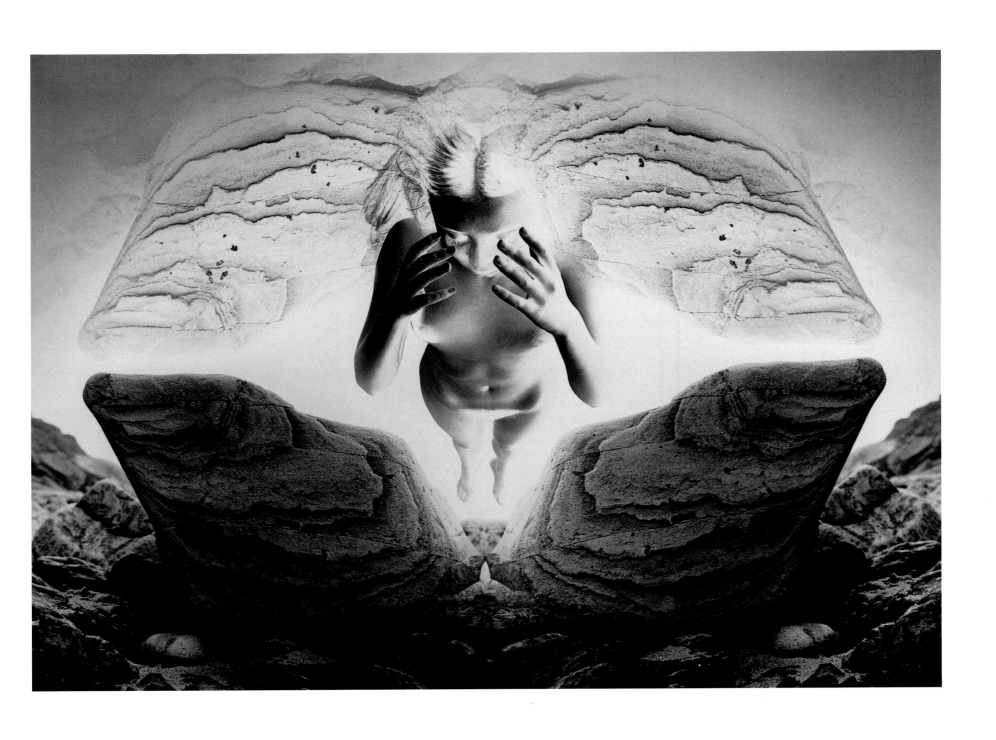

MARK COHEN

American · 1943–

Wilkes-Barre, Pennsylvania

1974 · Gelatin silver print · 30.0 × 45.0 cm.

In his commentary on William Klein's photograph of a young Moscow girl assertively thrusting herself toward the camera, the critic and historian John Szarkowski indicated that Klein and other photographers during the 1950s had "extended our sense of what might be meant by a clear photograph."[1] In 1982, another critic characterized the contemporary art of Mark Cohen by stating: "I like the hard-nosed, aggressive, edgy, raw, risky quality of Cohen's work. With him, art has to be willing to take its chances in a brawl. He knows that a photograph ain't art, anyhow, just an image, which is something cruder and more important."[2] Disregarding the rather specious contention about what Cohen knows about photographs, the points concerning the crudity of the photograph and the "aggressive," "raw" qualities of Cohen's work are important and they suggest a development of the photographic act that had been formulated earlier in the work of Klein.

Cohen, a professional photographer in Wilkes-Barre, Pennsylvania, has pursued his personal photography with an essentially political and active engagement with looking. His is not a candid, surreptitious, or detached observation; it is flagrantly intrusive and, by conventional standards, impolite. His pictures document just those subjects and portions of scenes that are encountered daily but that tend to be charged with a degree of social embarrassment—those sometimes furtive glances and frequent arrested focusings on details out of context or those sudden confrontations and too-close eye contacts with strangers on city streets. Sometimes, too, his encounters with children or teenagers have elicited an unsettling reversal of roles when, assaulting the camera by acting out or otherwise subverting the situation, his subjects refused to remain passive victims of the camera and challenged the photographer's assumed right to their image. Cohen's pictures are concerned, in part, with power: the power of the photographer to appropriate images by stealth or surprise and the ability of the subject to respond in kind.

Cohen consistently breaks the rules of photographic decorum by situating his camera and flash unit where they are not supposed to be or well inside the accepted limits of proximity designated by Western and other cultures for psychological or even sexual security. According to the fictional photographer in Kobo Abe's novel *The Box Man*, "We talk about romance, but this is after all merely aggressive instinct camouflaged with makeup and feathers. . . . the ultimate purpose lies in breaking down and disregarding the lines of demarcation of a given area. From my own experience the line in the case of humans seems to be located at a radius of about two and a half yards. . . . when you get through that line of demarcation you have already taken possession."[3]

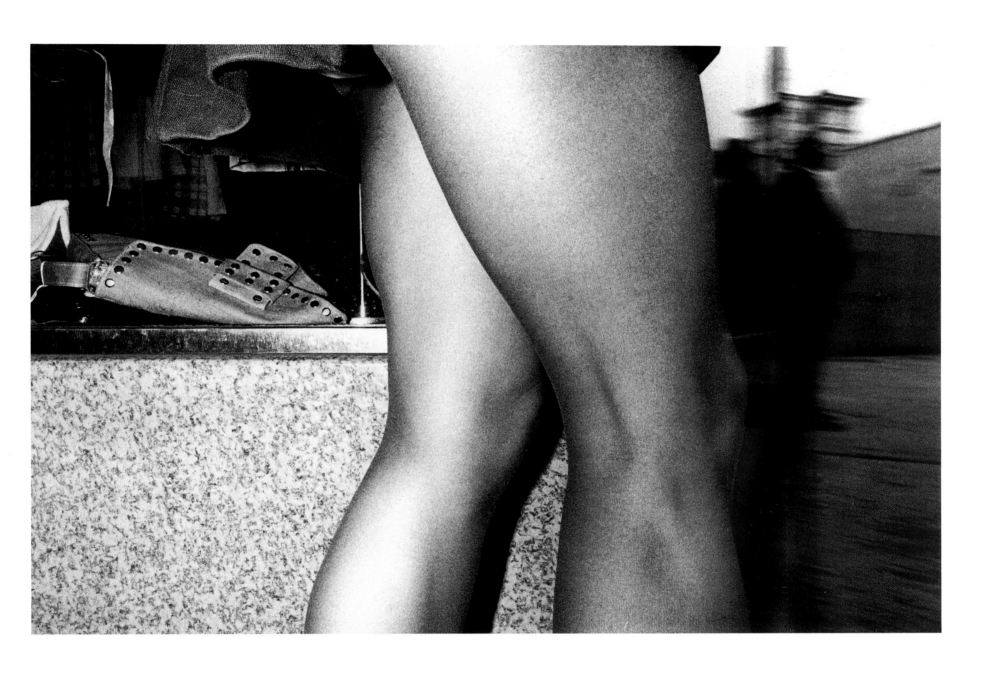

HIRO [YASUHIRO WAKABAYASHI]

American · b. China · 1930–

"Nail Shape '72 . . ."

1972/77 · Dye-transfer print · 51.3 × 39.7 cm.

Fashion concerns itself with details, and the photography of fash-
ion isolates and selects those details: a certain pattern or cut to
a garment, a specific length of hemline or a choice accessory, a
modish hair style or an unexpected application of makeup.
Clothing and cosmetics are active, integrated with daily life, and
articulated by movement; fashion and *maquillage* are static, sym-
bolic, and, more than anything else, the product of the fashion
photograph. Films and videotapes of fashion shows are as much
about the event as the clothes, whereas fashion photographs are
only about particular, stilled statements. Glamor photographs
serve as icons to complex dreams and desires, but the images in
fashion magazines more frequently serve as a handbook to the
constituents of style and allure. Writing about the signs and lan-
guage of fashion, the French critic Roland Barthes observed:
"Fashion does not evolve, it changes; its lexicon is new each
year, like that of a language which always keeps the same system
but suddenly and regularly changes the 'currency' of its words."[1]

Few contemporary photographers equal the technical mastery
and pictorial innovation of Hiro when it comes to rendering the
cultural ideals of luxury and exquisite materiality. Just as Edward
Weston discovered an equivalent sensuality in a broken piano or
a voluptuous nude female, Hiro reveals the serene elegance of
precision in the finest objects and details, whether an exotically
machined audio-turntable, a transparent wristwatch of diamonds
and rubies, or pajamas of richly printed silk. Hiro emphasizes
the object's or person's singularity and thus further isolates it
with an aura of preciousness by a variety of technical devices:
extreme close-ups, repeated stroboscopic flashes, multiple expo-
sures with colored lights, haloing by ultra-thin penlight tracings,
dramatic perspectives, and eerily foreign backdrops.

The subject of this print, published in *Harper's Bazaar* in
1972, is not immediately evident. Only the accompanying text
clarifies whether it was conceived to illustrate a feature on
makeup, beauty, or health: "Nail Shape '72: Exquisitely squared,
like the best Chippendale table with softly rounded sides by
Yvonne Sergent, nail specialist at Saks Fifth Avenue Beauty
Shop."[2] The mannequin's glistening lips and the presence of
what appear to be an aspirin and a capsule of the tranquilizer
Librium are merely backdrops to the fashionably decorated
fingernails.

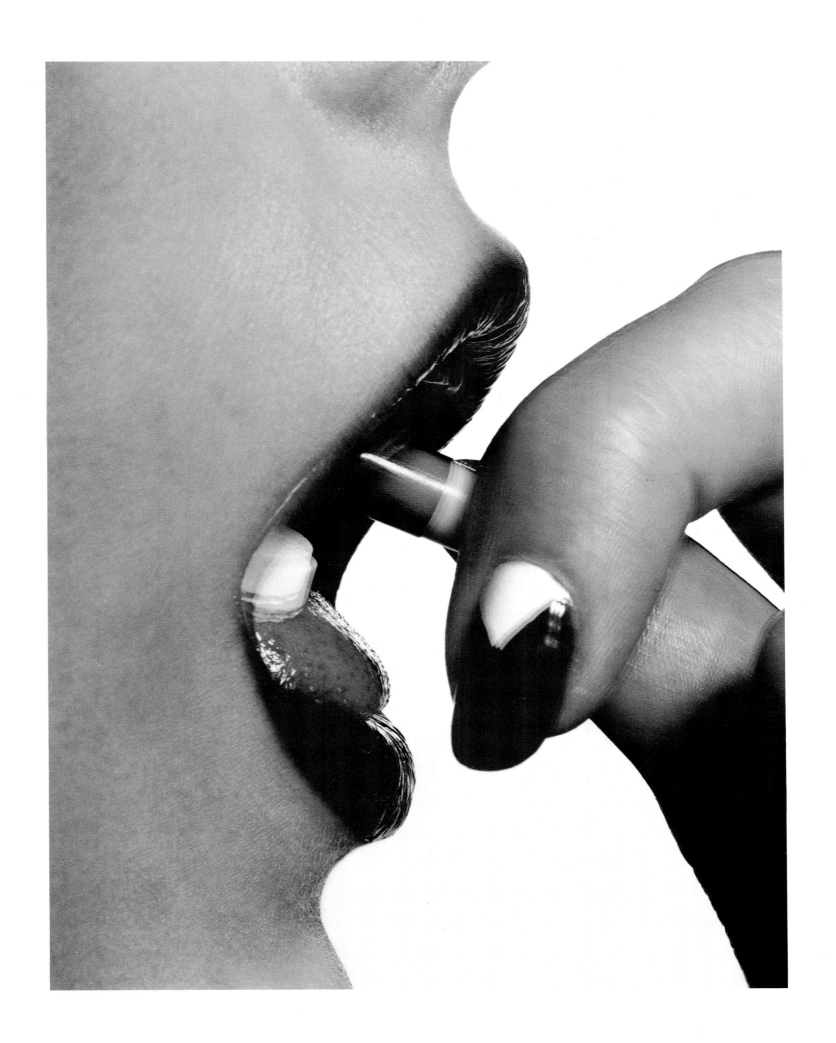

ROBERT HEINECKEN

American · 1931–

Cliche Vary/Fetishism

1974 · Photographic emulsion on canvas, pastel chalk · 106.7 × 106.7 cm.

When, in the early 1930s, the German Surrealist Hans Bellmer deconstructed female eroticism, he did so literally by disassembling and reassembling the parts of a physical mannequin of his own creation, and then photographing the articulated doll as if it were a vivified creature set in imaginary locales. Forty years later, Robert Heinecken also turned to the idea of manipulating the sexual image, but rather than suggestively deconstructing the physical model, he instead sought to establish a purely pictorial analogue to how the imagination manipulates that image. It seems obvious that any engagement with sexuality is principally a matter of compounded fantasies, complex desires, and simultaneous motivations, and that any sexual image is primarily one created in the mind of the onlooker. "Without thinking," said the narrator of J. G. Ballard's *Crash*, a novel purportedly read by Heinecken, "I visualized a series of imaginary pictures I might take of her: in various sexual acts. . . ."[1]

Heinecken began photographically rearranging parts of the female body around 1966, montaging and collaging them, gluing them onto wooden "puzzle" pieces that could be rearranged by the viewer into strange and often threatening possibilities, and overlapping them by multiple printing into images reminiscent of Francis Picabia's painted *Transparencies* of 1928 [fig. 94]. Around 1971, Heinecken began a series of works in which a number of modular canvases were coated with photographic emulsions, each bearing a close-up view of nude limbs and torsos, and each lined up side-by-side in a horizontal frame. In 1972, this series acquired the name *Le Voyeur/Robbe-Grillet* after the novel by Alain Robbe-Grillet in which the entire action transpires in the mind/memory of the protagonist. In 1974, the full, naked figure, gleaned from the commercial market for erotic images, regained the picture plane, but here too, in the *Cliche Vary* series, it was broken apart, fractured, rearranged, and multiplied. According to Heinecken:

Cliche Vary is a pun on the nineteenth century *cliche-verre process*. The first of this series is titled *Fetishism*. The use of the word *cliche* is meant to invoke the possibility that culturally misunderstood (or possibly understood)

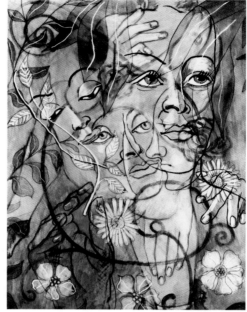

Fig. 94. Francis Picabia, *Hera*, tempera on cardboard, 1928, collection Gaston Kahn, Paris, photograph courtesy Editions du Seuil.

perversions, like fetishism, are really cliches. And so this picture is filled with what I consider cliches of fetishism: high heels, bondage, dildos, masks and all those things we accept as associated with fetishism. Yet fetishism may have little to do with these objects because very few of us understand that kind of fetishism, hence, the cliche.

These pieces are very carefully controlled in terms of positioning and color. Nothing occurs without consideration. As beautiful objects in their execution, this series gives one the sense that something has been artistically resolved; but like the puzzles, there is a tension and conflict. While one is drawn to respond to the beauty of these works, the subject matter often makes it difficult. It is in this dichotomy that I find the edge which most appeals to me.[2]

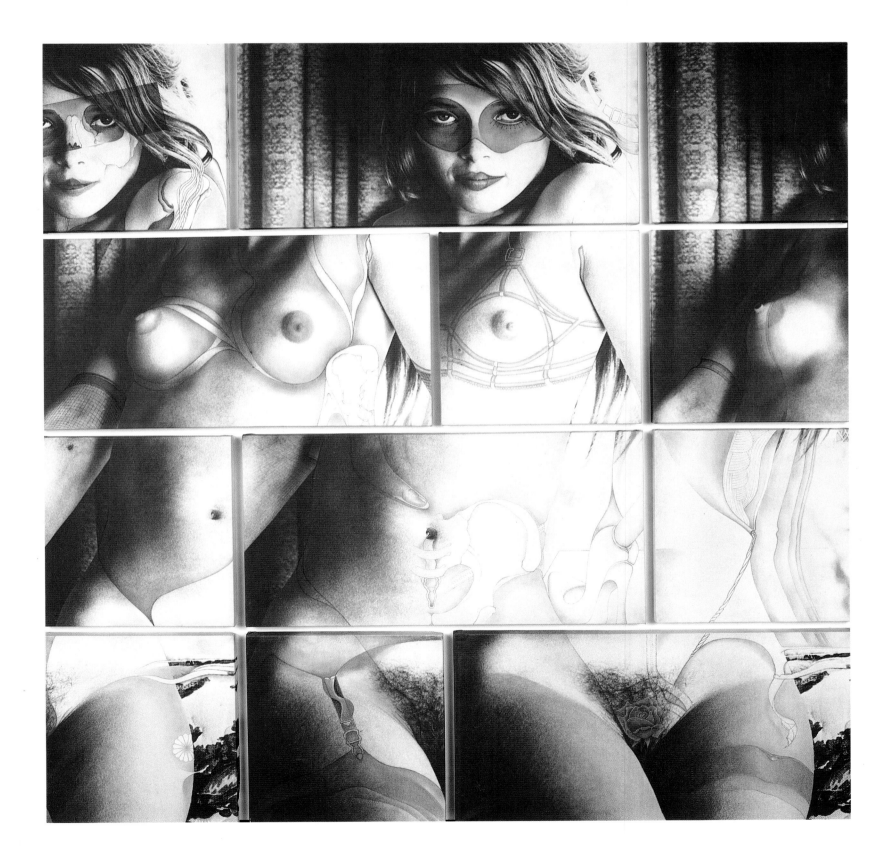

DIANE ARBUS

American · 1923–1971

Untitled (6) 1970–71

ca. 1971 · Gelatin silver print · 38.5 × 38.0 cm.

One feels an intense and deep *pathos* in the late work of Diane Arbus. It is about human limits and final reason, those fundamental questions of identity and truth, of self and other, of meaning and purpose. All of Arbus's mature photography leads to these last pictures, made at a home for retardates in Vineland, New Jersey. Of some of her very earliest, personal work, pictures which from the beginning examined the nature of those human mechanisms of personal identity, she wrote, "These are six singular people who appear like metaphors somewhere further out than we do, beckoned, not driven, invented by belief, author and hero of a real dream by which our own courage and cunning are tested and tried; so that we may wonder all over again what is veritable and inevitable and possible and what it is to become whoever we may be."[1] For close to ten years, Arbus pursued a reality at the edge of understanding, at that boundary between the human sign and what is signified.

Arbus photographed nudists, middle-class families, twins and triplets, elderly couples, strippers, midgets and giants, babies and senior citizens, patriots and transvestites—but it was never a matter of portraying social aberrants, the estranged, or freaks. Nor was Arbus interested in depicting the grotesquerie that can subsist within normalcy, as her mentor, Lisette Model, had done, or in fashioning a pictorial glossary of social types, as August Sander had attempted in Germany earlier in the century. Rather, Arbus was concerned with a compassionate decoding of the varied human persona and its expressive possibilities. By confronting the human extremes of the manifestly ordinary as well as the patently inordinate, her pictures suggest that self-comprehension may be not as dependable as we think nor as comfortable. Besides recording a likeness, the point of most portrait photography is to function as a chart to the hidden identity of the subject. Arbus's portraits, on the other hand, reveal little about the actual nature of her subjects; to a greater extent her pictures and their subjects are a challenge to our own definitions of self.

There is a certain darkness to most of Arbus's work, but nowhere is this more apparent than in her last pictures. Issues of what is conventional or not were completely dismissed, and in choosing individuals living at one of the extreme edges of the rational as her theme, Arbus transcended the particular for a far more universal inquiry into human nature. In an earlier picture of 1963, triplet girls neatly dressed and seated in their vividly patterned bedroom are depicted with clarity and order, the scene brightly lighted and balanced. In this print of three middle-aged retardates photographed out-of-doors and under gray skies, the controlled order of the picture, its careful pictorial balance, and the sense of confronting the subjects is totally gone. A bizarre choreography of address seems to be taking place before the artist's camera, a hieroglyphics of communication that we cannot begin to understand. But while strange there is also a warmth to the scene and these three women, and a simplicity of affectless behavior that impresses by its essential humanity. The *pathos* revealed is certainly not theirs; it is, if anything, ours. As one critic wrote, "Arbus' pictures are very difficult to stay out of. In fact, it seems to me, what disturbs people more than the subjects of these pictures, is the intensity of their power to dominate us, to literally stop us in mid-life and demand we ask ourselves who we are."[2]

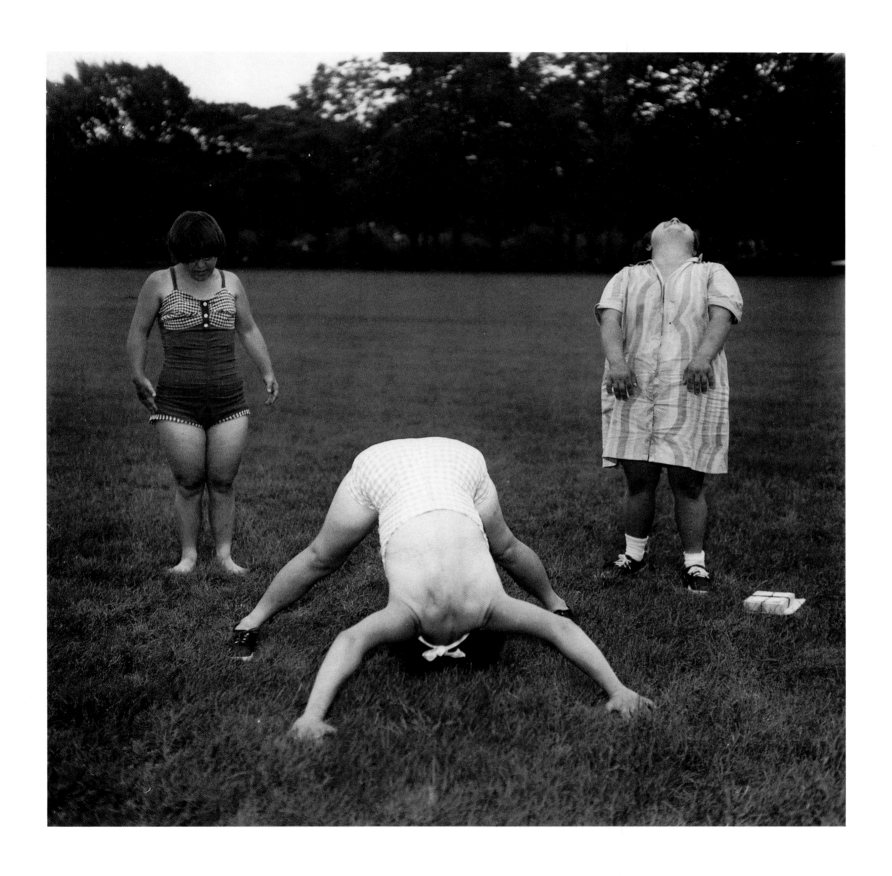

JOEL-PETER WITKIN

American • 1939–

I.D. Photograph from Purgatory: Two Women with Stomach Irritations

1982 • Gelatin silver print, toned • 71.0 × 71.4 cm.

Joel-Peter Witkin's photographs are, perhaps, some of the most unsettling and pathological camera images to be conceived. They shock, disturb, anger, and repel; they are horrific and nightmarish, and have been called perverse, pornographic, and grotesque. Their subjects are not easy nor are they especially meant to be—a cadaver opened in autopsy, a decapitated head sliced in half and posed in an autoerotic kiss, a hermaphrodite breast-feeding a dead fetus, eviscerated animals, an elephantine nude masturbating with vegetables, and violent acts of sadomasochism and human torture. These are the icons and narratives of an extreme imagination and pictorial cruelty, a bestiary of sorts, comprising the limits to which the dark side of the human soul can go. These are not, however, capricious tableaux, meant merely to shock and titillate, nor are the allusions to the history of art and classical mythology in them simply fashionable or chic. Witkin's reprises of Canova, Mantegna, Rodin, Rembrandt, and Francis Bacon, his references to Picasso's *Guernica* or to Mayer and Pierson's famous photograph of the Prince Imperial of around 1859, and his themes of Pygmalion and Galatea, the Birth of Venus, and the Christophanic legend all serve to establish the historical foundations of his art. Just as the exquisite surface manipulations of his prints suggest abraded, broken, and marred photographs from some uncertain past, his mythologies remind us of the fundamental moral imperative of art.

Witkin's figures are not the damned and lost souls from some contemporary psychopathic hell; rather, like the grotesques and monstrous figurations of medieval art, like Bruegel's "Seven Deadly Sins" or hyperrealistic tomb sculptures, they are graphic, visual remonstrations on the singularity of human limits. Like the tormented encountered among the levels of Dante's *Purgatorio*, and not that poet's *Inferno*, Witkin's creations enumerate the various purgations of the soul.

> Down there is a place not sad with torments, but
> with darkness alone, where the lamentations sound not as
> wailings, but as sighs.

> There do I abide with the innocent babes, bitten by the fangs
> of death, ere they were exempt from human sin. [1]

Following Dante, Witkin's Purgatory is also peopled by the three classes of less-than-perfect love: the excessive (carnality, gluttony, and avarice), the defective (sloth), and the perverted (anger, envy, and pride). Lacking in both Purgatories (Dante's epic and Witkin's imagery) are violence, incontinence, and fraud—for these there is true perdition. Present in both are various forms of love—after all, Witkin seems to be saying, even in its most abject state, the human soul is still capable of love. Witkin has charted a voyage through a contemporary Purgatory, a domain situated just beneath an impossible Garden of Eden, in which are found, as in the medieval version, Adam and Eve (Canto I), hermaphrodites (Canto XXVI), and the figures of Leah and Rachel (Matilda and Beatrice) (Canto XXVII), representing the opposition of active and contemplative life. It is a world also not too dissimilar from one described by the contemporary novelist J. G. Ballard:

> Traver's problem is how to come to terms with the violence
> that has pursued his life—not merely the violence of
> accident and bereavement, or the horrors of war, but the
> biomorphic horror of our own bodies, the awkward geometry
> of the postures we assume. . . . the real significance of these
> acts of violence lies elsewhere, in what we might term "the
> death of affect." Consider all our most real and tender
> pleasures—in the excitements of pain and mutilation; in sex
> as the perfect arena, like a culture-bed of sterile pus, for all
> the veronicas of our own perversions, in voyeurism and
> self-disgust, in our moral freedom to pursue our own
> psychopathologies as a game, and in our ever greater powers
> of abstractions. [2]

With photography Witkin addresses the same issue that Julia Kristeva has discerned in literature. "On close inspection, all literature is probably a version of the apocalypse that seems to me rooted, no matter what its socio-historical conditions might be, on the fragile border (borderline cases) where identities (subject/object, etc.) do not exist or only barely so—double, fuzzy, heterogeneous, animal, metamorphosed, altered, abject." [3]

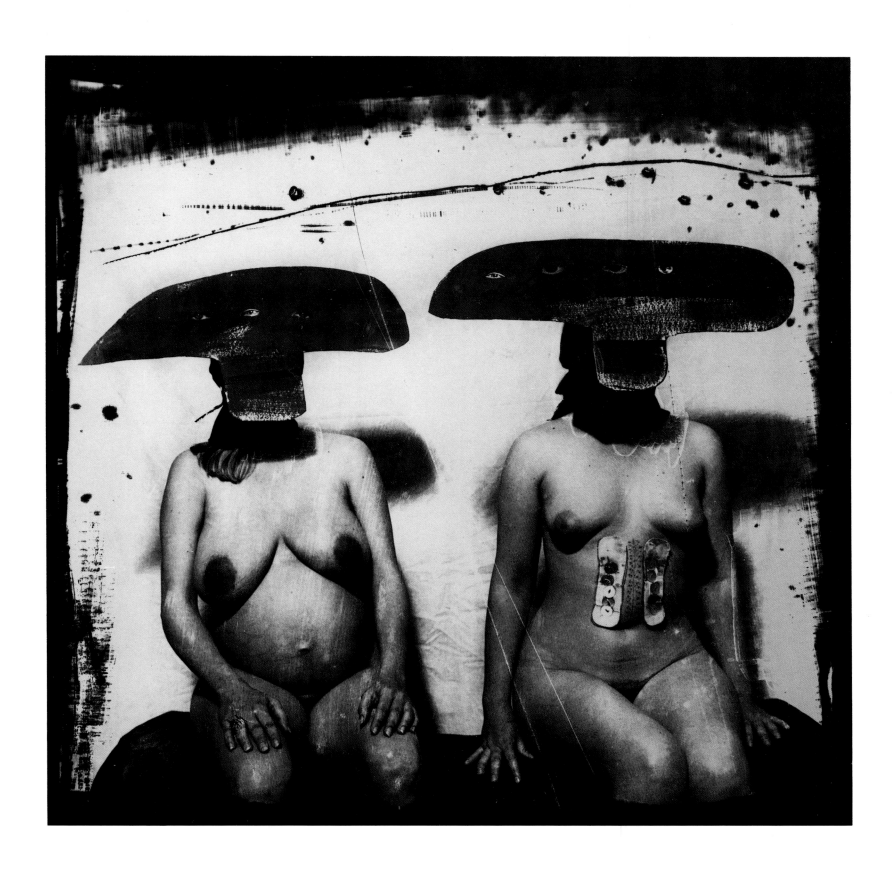

EILEEN COWIN

American · 1947–

Double Departure Scene

1981 · Chromogenic development print · From series "Family Docu-drama" · 47.7 × 59.9 cm.

In 1858, the British photographer Henry Peach Robinson fashioned a narrative photograph in which four figures enacted a personal, family tragedy—the dying moments of a young consumptive woman attended to by her grief-stricken parents and what may be a sister. Robinson probably was not the first to have used the camera for the fictional recreation of a melodramatic subject, but his photograph *Fading Away* was certainly successful enough in its time and throughout photographic history to have become, as it were, a standard by which to consider subsequent narrative photography. Playacting, psychodramatic fictions, dissimulations of self, and sexual acting out in front of the camera have been persistent, if not always valued, aspects of the photographic arts and, ever since the 1970s, a principal motivation in photographs by Les Krims, Ellen Brooks, Don Rodan, Bernard Faucon, Cindy Sherman, and Eileen Cowin.

Reviewing Cowin's first one-person exhibition in New York, the art critic Lucy Lippard wrote:

> Eileen Cowin's photographs are "original," as wholly created by the artist as any painting or performance. What she appropriates is a style—that of ads and movie stills—but she is more auteur than voyeur, retaining command over all aspects of the product. She scripts, directs, acts in, and photographs her "Family Docu-Drama" series, maybe because, like all of us, she wants more control over what happens in her own life. In other words,

Cowin reappropriates the "reality" that photography is supposed to reflect but not to engender.[1]

Cowin's fictions are stills from a make-believe domestic life enacted by her real-life family: herself, her husband and stepchildren, and, disarmingly, her twin sister. Molded around scenes of human tension and emotion, her pictures are suggestive of salience but elusively indefinite. That something is occurring is clear and it is dramatic, but exactly how to define the action is usually difficult. There are confrontations, gestures of supplication and antagonism, and facial expressions that are, if not histrionic, at least highly stylized—a mute, pictorial theater of ambiguity that is rather close to traditional melodrama. According to another critic, "The text of muteness is, then, pervasive in melodrama and central to the representation of its most important meanings. Gesture in all forms is a necessary complement and supplement to the word, tableau is a repeated device in the summary of meanings acted out, and the mute role is the virtuoso emblem of the possibilities of meaning engendered in the absence of the word."[2] In the same fashion as Robinson in 1858, Cowin draws upon the sentimental and emotionally charged in human relationships for her subjects; only where Robinson based his image on a stanza from Shelley's *Queen Mab*, Cowin turns to more familiar territory, television soap operas and their arsenal of confrontations, anguished and stressful anticipations, and moments of departure.

CINDY SHERMAN

American · 1954–

Untitled #85

1981 · Chromogenic development print · 61.0 × 121.3 cm.

Second only to representational likeness, the dissimulation of self has been a critical motive throughout the history of photographic portraiture. Some photographers like Gabriel Harrison, Julia Margaret Cameron, Man Ray, and William Wegman portrayed their subjects as fictive or historical characters. Others like David Wilkie Wynfield, F. Holland Day, and Lucas Samaras vested themselves in the costumes and appearances of fictional subjects, historical personalities, or unveiled alter-egos. Few if any photographers, however, adopted self-dissimulation as an entire artistic motive prior to Cindy Sherman. Portraying herself at first as vaguely identifiable figures from motion pictures of the 1950s, slightly suggestive of Doris Day, Sophia Loren, or Marilyn Monroe, Sherman evolved a style of self-portraiture that is as extensive and monumental as it is absorbed with the self as other. Her work progressively made fewer references to the cinema and assumed the narrative of vague psychological affects and uncertain moods. Retaining an interest in the near-camp associations of fifties' clothes, Sherman herself became the vehicle of nonspecific distress and melancholy and of arrested fears.

> I want that choked-up feeling in your throat which maybe comes from despair or tear-eyed sentimentality: conveying intangible emotions. A photograph should transcend itself, the image its medium, in order to have its own presence. These are pictures of emotions personified, entirely of themselves with their own presence—not of me. The issue of the identity of the model is no more interesting than the possible symbolism of any other detail. . . . I'm trying to make other people recognize something of themselves rather than me. [1]

Elsewhere, Sherman explained that, "I just wanted to see how transformed I could look. It was like painting in a way: staring at my face in a mirror, trying to figure out how to do something to this part of my face, how to shade another part." [2] Transformations of self into various characterizations is essentially the province of theater, but insofar as Sherman's art vests solely in her silent presentation of self in unordinary life she is closer in spirit to the self-transformations by Cornelius Drebbel during the 17th century. Using a fairly large-scaled camera obscura much like a magic lantern, Drebbel projected his own transformed likeness for the entertainment of friends. "I take my stand in a room and obviously no one is with me. First I change the appearance of my clothing in the eyes of all who see me. . . . I appear to be clad in satin of all colors, then in cloths of all colors, now cloth of gold and now cloth of silver, and I present myself as a king, adorned in diamonds and all sorts of precious stones, and then in a moment become a beggar, all my clothing in rags." [3] Where Drebbel was merely concerned with caprice and external disguise, Sherman manipulates a similar vocabulary of techniques in order to visually probe the stereotypes and language of human emotion.

VICTOR SCHRAGER

American · 1950–

Still Life with Vermeer's "Art of Painting"

1978 · Polacolor print · 62.5 × 52.4 cm.

Picturing pictures is by no means a novel strategy in art. Seventeenth-century Dutch painters frequently incorporated maps, engravings, other paintings, and illuminated manuscript pages in their opulent and compacted still lifes. American painters of the 19th century, artists like William M. Harnett and John Frederick Peto, specialized in recording *trompe l'oeil* still lifes in which photographic portraits, train tickets, paper money, and popular prints are seen pinned to flat boards as if the subject were merely a bulletin board of other images. In this century, both Picasso and Juan Gris included newspapers and other imagery in their Cubist works, either painted or physically collaged. And, of course, there were the explosive innovations of Dada and Bauhaus photomontage, such as in the work of Hannah Höch, Georges Hugnet, and Moholy-Nagy during the twenties and thirties, in which found images were reconstructed into new and often fantastic realities. Finally, advertising, so much a part of modern pictorial art ever since the late 1920s, has been a principal conduit for the representation of other pictorially representational images, ranging from photographs of opened magazines or piles of photographic prints to melanges of maps and illustrated packaging [fig. 95].

In discussing Vermeer's famous painting *The Art of Painting*, from about 1670 (a reproduction of which is seen in the lower left corner of Victor Schrager's photograph) the art historian Svetlana Alpers has shown particular interest in the map that Vermeer included in the scene's background and has argued that maps as well as paintings served 17th-century artists as means of describing the world around them.

> Mapmakers or publishers were referred to as "world describers" and their maps or atlases as the world described. Though the term was never, as far as I know, applied to a painting, there is good reason to do so. The aim of Dutch painters was to capture on a surface a great range of knowledge and information about the world. They too employed words with their images. Like the mappers, they made additive works that could not be taken in from a single viewing point. Theirs was not a window on the Italian model of art but rather, like a map, a surface on which is laid out an assemblage of the world. [1]

Not only has the amount of information about the world significantly increased since the late 17th century, but much of that

Fig. 95. Anonymous artist, advertisement for *B.Z.-Auto-Karte*, from Werner Gräff, *Es kommt der neue Fotograf!*, Berlin, 1929, illus. p. 119.

information has been disseminated in the form of pictures—countless lithographs, photomechanical prints, diagrams and maps, paintings and photographs. Victor Schrager's still lifes are precisely about this incredible layering of information and leveling of the types of descriptive imagery that constitute our daily lives.

Schrager's work is fundamentally concerned with intelligence and communication, and the methods by which knowledge is produced, translated, and transmitted. Language, both visual and literary, forms the basic mode of both intelligence and knowledge; thus, along with reproductions of Vermeer's painting and an Ingres nude, some *ukiyo-e* prints and a glamor photograph from a contemporary fashion magazine, there are pages from medieval manuscripts or books of hours, a photoengraving of the Rosetta stone with its parallel texts in three languages, and a guide to "Basic Punctuation." Like many photographers in the 19th century, such as Xavier Merieux, Schrager is fascinated with the sheer proliferation of informational content through pictures; Schrager is also concerned, however, with articulating the density and multiplicity of these pictures so that *his* photograph becomes a still life rich with graphic content and a description of the pleasures of reading.

IRVING PENN

American · 1917–

Still Life with Skull, Pitcher, and Medicine Bottle

1980/1981 · Platinum-palladium print · 23.3 × 49.2 cm.

Every still life is a moral image. Whether a simple record of material culture made for the sake of information or a more complexly assembled work of artistic expression, the still life is essentially an emblem that attests to life's vanity, the transience of things, and, inevitably, death. Still lifes are about duration, about time and its results, and as such are invariably melancholy reflections of what has passed. The history of art is filled with examples of skulls, dead game, cut flowers, harvested fruit, and material treasures, all rendered with acuity and reflective of the temporal nature of things. The still life is the ultimate depiction of materiality; it vests no spirit of life in those objects with which it is fundamentally concerned. Any meaning derived from its presentation rests both in the fact that what is pictured is no longer before us and in the recognition that it is in fact this absence that addresses us.

The still life is a *memento mori*, a reminder of the finiteness of material life, and an imprecation to consider what remains. By its very nature, the photograph renders the material appearance of things far more efficiently and in a far more detailed fashion than any other medium. Writing about Irving Penn's still lifes, the critic Rosalind Krauss stated, "Like the microscope, the camera is an instrument that increases the capacity of human vision, allowing man to see deeper and more accurately. The microscope led science into the heart of matter, to perceive the break-up of solids into smaller and smaller bits. The camera, as Penn proves, also can reveal the porousness of matter. But this porousness has to do with meaning, not science; the camera has become the tool and agent of Time in an attack against the seeming impermeability of beauty."[1] Yet there is a beauty in Penn's photographs of skulls, pitchers, sewing machines, Buddhist heads and bones, a cold perfection gleaned from his work in advertising and fashion photography.

The clinical austerity of these still lifes is strikingly similar to that found in the stereographic still lifes by the French daguerreotypist L. Jules Duboscq during the 1850s [fig. 96]. Unlike, however, the blatantly literal "text" of the earlier image with its tokens of genesis, death, time, and the hereafter, the

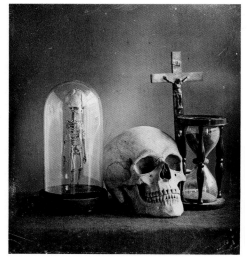

Fig. 96. L. Jules Duboscq, *Still Life with Skull, Skeleton, Crucifix and Hourglass*, daguerreotype (half-stereograph), ca. 1855.

casually associated objects in Penn's still life are uniquely devoid of narrative. Delicately balanced and aligned in a straight line, Penn's objects speak of a distinctly secular equivalence of things. That universal symbol of death, the human skull, here is only a visual counterpoint to the head of the Buddha, which seems more sculpture than religious icon, and carries the same weight as the ewer and the medicine bottle. But even these quite worldly artifacts, one feels, serve the same purpose as do skull and hourglass in older still lifes, for, according to art historian Colin Eisler, "Penn's prints are often essays on memory, graphic recollectings in tranquility. Celebrations of silence, they come close to art's need and purpose, the survival of death. . . . Penn's reflections, printed in precious metals, remain unveiled, revealing, not mourning. They accept and illuminate the passage of time, photography's exemplar of E. M. Forster's view: 'Death destroys a man but the idea of death saves him.' "[2]

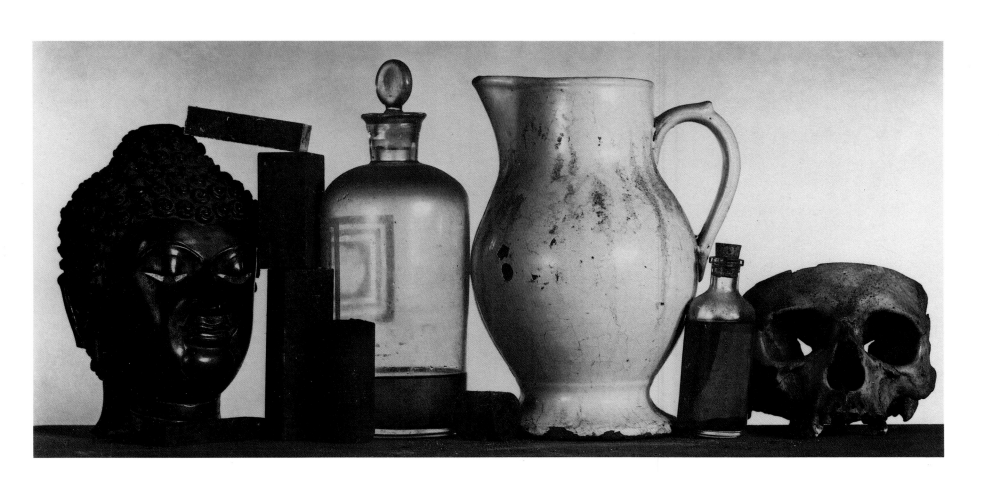

JAN GROOVER

American · 1943–

Untitled

1980 · Palladium-platinum print · 19.4 × 24.2 cm.

Jan Groover is a formalist artist, but one with such an advanced passionate eye that the highly intellectual basis of her art is quickly forgiven. In an article in *Artforum* published in 1973, she codified the photographic act into three essential categories. First, there was photography's fundamental "capacity to isolate phenomena from the rest of the world," and isolation itself, "has several forms: that of a time event, separating one specific part from the whole of a continuous act. . . . isolation which subtracts from the larger situation by angle of view, dependent upon distance from subject as well as on position in relation to subject; isolation which results from miniaturization; and lastly, that caused by the mechanical perception of the lens."[1] Second, there was photography's inherent ability to represent mimetically what was before the camera. "Due to the small size of most photographs, the events and things pictured are condensed, giving concise perception of appearances." Third, photography is constantly in the past tense. "A picture may have been accurate in its correspondence at one time, but may or may not be at the moment. Time has always been an issue of photography in the form of stop action, light changes, or has had the connotation of history." Photography is thus distinguished from any other pictorial mode by its inherent qualities of spatial selection (isolation), optically realistic representation (*mimesis*), and temporal determinacy (past tense).

Groover concluded her essay with cautionary remarks about constricting the definition of photography. "The significance of any of these characteristics inimitable to photography is conditioned by and dependent upon their usage within intentional contexts and not as a definition. The problem has never been one of defining photography's boundaries, because that implies that limits are conclusively discernible. The boundaries of a discipline are set, on the one hand, by its capacity or incapacity to continue to be useful or to make significant contributions, and on the other, by individuals who continue to perceive significant usage. The medium is the use." Six years later, Groover addressed these issues more simply. "In photography there is the

Fig. 97. Jan Groover, *Untitled*, (triptych), chromogenic development prints, 1977. Museum purchase, Intrepid Fund.

idea—endlessly, variable, but inevitably—that one is stuck with the real world. But if you are stuck with something, it certainly isn't the world, or the mechanics of the camera; simply, you are stuck with whatever your mind makes of things. The rules are yours, how else could it be?"[2]

Throughout her work during the 1970s, the most salient feature of Groover's pictures was the intelligence with which they were seen. It mattered little what the subject was, although for the most part they were of urban scenes. Much more impressive was the how of the seeing and not the what of the scene, although the majority are visually quite striking [fig. 97]. Each element of her triadic disposal of the medium was completely and elegantly realized in these works—the space, the realism, and the time—reminding one of an earlier comment, from another time, that "Whoever says art, says choice; whoever says choice says comparison, and supposes the idea of taste."[3] Since 1979, Groover has refined her vision even more in terms of still life arrangements, natural landscapes, and portraits; and she has abandoned color photography for the subtle tonalities of hand-made palladium-platinum paper stock. Her still lifes of prosaic kitchen wares, arranged, lighted, and viewed with utmost control, are unlike any others in photography. Seldom have such hard metallic objects of mundane identity been granted such serious consideration and passionate resonance when rendered by the human eye.

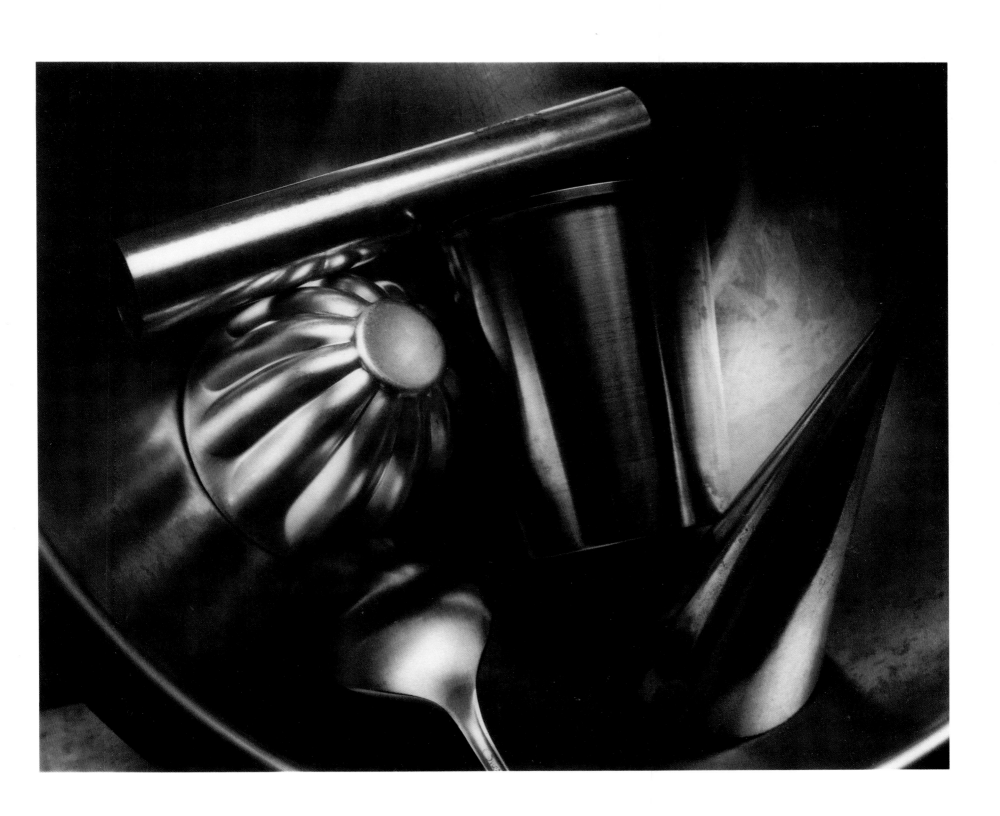

THOMAS FRANCIS BARROW

American · 1938–

Disjunctive Forms 2

1981 · Gelatin silver print, applied color · From "Spray Paint Series" · 40.5 × 50.5 cm.

Thomas Barrow is a photographer of material culture. But while he persists in having material culture attest to its own documentation, he does not document. Instead, Barrow conflates, montages, assembles, and along the way suggests and alludes to the significance of both his subjects and his art. His pictures are not silent records of things or landscapes, they are active pictorial discussions and fractured discourses on those things and landscapes. His images have to be listened to as well as perceived, in essence read as well as looked at, for they are also very much about the language of material experience and the overwhelming accretion of that experience in today's world. Barrow has been fascinated since the late 1960s with what might be called contemporary input; not merely the meaning of what is received, but the transformations of information caused by its transmission and collection. Like many artists of the sixties, artists like Robert Rauschenberg, Eduardo Paolozzi, and Richard Hamilton, Barrow adopted the forms and iconography of modern mass communications. The art critic Christopher Finch characterized this generation of artists. "To turn to the imagery projected by mass media was, for many young artists, simply to return to their native landscape. They were at ease with that world and it was natural for them to introduce it into their work. The necessity of translating mass media idioms into fine art terms again placed an emphasis upon the conscious manipulation of image as language."[1]

There is a richness to Barrow's imagery, and a density that is especially concerned with layered textures and vocabularies: magazine pages printed through so that both sides are revealed; lengthy exposures in front of a television screen that accumulate transient, unforeseen images; pages of trade catalogues coupled with suggestive texts found in newsprint and merged in Verifax; stenciled letter forms and textual patterns of printed diagrams blended into strident cacophonies of esoteric messages; vectors of popular science pointing to the obvious while, with perfect Heisenbergian uncertainty, transforming it into something bizarrely emblematic. Moreover, Barrow consistently manipulates these and other vocabularies in order to challenge and prod certain fundamental assumptions about the photographic medium—black and white images toned a pharmaceutical pink; series entitled "Pink Dualities" or "Pink Stuff" questioning the completeness of photographic information; denying the depth and transparency of the photographic print by physically scoring the negative; reprising the very beginnings of photography by documenting shelves of libraries, as William Henry Fox Talbot had done in the 1840s, and stressing the limits of content without words; applying encaustic to emphasize the edge of an image's separation from a seamless reality; and violating the print's silvered perfection by spraying it over with acrylic enamels and epoxy lacquers, as here.

In a statement published the same year this print was made, Barrow cited John Ashbery's comments on the French novelist Raymond Roussel. "The result in the case of each of his books is a gigantic dose of minutiae: to describe one is like trying to summarize the Manhattan telephone book. Moreover the force of his writing is felt only gradually; it proceeds from the accumulated weight of this mad wealth of particulars. A page or even a chapter of Roussel, fascinating as it may be, gives no idea of the final effect which is a question of density: the whole is more than the sum of its parts."[2]

NATIONAL AERONAUTICS AND SPACE ADMINISTRATION

American agency · est. 1958

Volcanic Activity on Io

1979 · Chromogenic development print from computer assisted montage of radio transmitted signals · 40.5 × 50.6 cm.

The first astronomical photographs were taken in the early 1850s, when John Adams Whipple made the first recorded daguerreotype of the moon in 1850 or 1851 and when Dr. Warren de la Rue successfully recorded the moon's image on a collodion negative in 1852. In 1868, British photographer William Lake Price wrote of the then expanding field of astronomical photography. "In undertaking this scientific speciality the photographer must make up his mind to surmount many obstacles by continuous perseverance, there being no hope of a successful result 'if he only dabbles in celestial photography in a desultory manner.' At the same time nothing can better repay the watchful nights spent over the subject, and the frequent discouragements from failures, than the interesting pictures which have been shown; the results of resolutely grappling with and overcoming opposing difficulties."[1] Lake Price was limited, obviously, to photographing the heavens from the surface of the earth, but he was already able to distinguish certain characteristics among the planets. "Of the planets, Jupiter seems to have the greatest actinic power, being within 1/4 to 1/6 that of the [earth's] moon. Saturn required twelve times longer exposure than Jupiter. In some of the largest telescopes hitherto used his diameter is only 1/37 of an inch in diameter."[2]

Slightly more than a century after this "grappling with and overcoming difficulties," the diameter of Jupiter as photographed by spacecrafts would extend beyond the photographic frames— images that would delineate meteorological details of the planet's surface as seen from a distance of only 1.1 million miles. After some three decades of astronomical photography from rockets and orbiting satellites (and eight years after Stanley Kubrick's motion picture 2001 fictively depicted Jupiter's surface) the twin spacecrafts Voyager 1 and Voyager 2 were launched from Florida in August and September, 1977, on a trajectory that would take them to Jupiter within two years, to photograph and obtain other scientific data from it and its neighbor Saturn, and continue beyond our solar system. By the end of 1978, Voyager 1 began to photograph the largest planet of our system at a range of 31 million miles, and by March 5, 1979, the spacecraft made its closest approach to the planet. The result of this "encounter" (as NASA calls it) was 16,500 photographs of Jupiter and its moons whereby "our knowledge of Jupiter had changed as profoundly as it did 369 years before, when Galileo Galilei first saw that Jupiter was circled by its own cluster of satellites."[3]

One of these moons, Io, proved to be not only the first planetary body beyond the earth on which there was volcanic activity but the single "most geologically active body known in the solar system."[4] In this image, shot on March 4, 1979, from a distance of 234,000 miles, a heart-shaped configuration from a volcanic plume named Pele was recorded; four months later, when Voyager 2 photographed the same area, its configuration had changed to an oval. From data supplied by the photographs, Pele's eruption measured about 175 miles above Io's surface and the total width of this volcano's plume was 620 miles. The principal gas venting from Pele and other volcanoes has been identified as sulphur dioxide. The size of Io is similar to that of the earth's moon, 2,257 miles in diameter, but its surface temperature is quite different, ranging from -99°F to +144°F.

Compared to Lake Price's 1/37 of an inch image of Jupiter, whose diameter is forty times that of Io, these unprecedented photographs are startlingly beautiful and contain far more information than dreamt of by him. Although technologically more sophisticated, they only demonstrate the logical extension of what the 19th-century photographer expected of photography when he wrote that, "already have the appearances of the firmament, of the photosphere of the sun, the minutiae of the planets, and of our satellite, been noted with unerring accuracy."[5]

PAUL ERIC BERGER

American · 1948–

Seattle Subtext—Photography

1981 · Gelatin silver print · 47.7 × 60.6 cm.

Nearly every photographic image transmits distinct data about what it records. During the last century, the single image demonstrated an inordinate facility in depicting factual information, and the album, especially one in which a single topic was serialized or sequenced, increased the measurable amount of content by a factor far more than simply the number of prints it contained. As illustrated books, magazines, and other forms of pictorial dissemination proliferated during this century, the single image, as a document, began to be submerged within a greater number of other images. While each of August Sander's portraits of German social types is a complete work in itself, its fuller signification is only gotten from its position within the total body of that artist's *Faces of the Time*; and much the same could be said about Eugène Atget's documentation of Paris. To Walter Benjamin's division of the value of the photographic image into its social function as a cult icon and its artistic merit as a work for exhibition,[1] a third category might prove clarifying, that of the photographic image as a unit within a greater grammar of pictorial information: a glyph so specific that its fundamental meaning is untenable without a general text or guiding caption. Again, according to Benjamin, "The camera will become smaller and smaller, more and more prepared to grasp fleeting, secret images whose shock will bring the mechanism of association in the viewer to a complete halt. At this point captions must begin to function, captions which understand the photography which turns all the relations of life into literature, and without which all photographic construction must remain bound in coincidences."[2] The joining of words to imagery, that subtle but forceful symbiosis of explication and amplification, admirably served photographers like W. Eugene Smith, Margaret Bourke-White, and Weegee during the illustrated press's golden age from the early 1930s through the 1970s. More recently,

video, electronically transmitted imagery, and computer generation of pictures have taken on the mantle of formulating the informational value of the photographic image.

More highly attuned to their medium's history and looking to Benjamin's essays as much for inspiration as for validation, a growing number of photographers during the last few decades have sought to integrate the very forms and contents of modern information systems within their art. Paul Berger is one who not only draws from current semiotic and linguistic studies for the sense of his photographs but also consolidates the actual imagery of contemporary electronic imagery, both pictorial and alphanumeric, with that of more expected and conventional photography. His work suggests, often with wry humor, the complicated mechanisms by which we read photographs and how we acquire any data from them at all. "Seattle Subtext is an imaginary and reordered magazine, a hypothetical alteration of the context and composition of all the 'information' that pours into ones [sic] home. By drawing on the conventions of 'layout,' it becomes possible to construct complex relationships among still photographs and television imagery, typeset captions and computer text. These relationships posit a personalized environment of great density and simultaneity in a format usually thought of as fixed when received—the magazine."[3] In this particular print from his *Seattle Subtext* series, marked *Photography*, he posits the most ordinary of snapshots along with its predictable legend of uncertainty ("Let's see . . . it's at a park . . . in France . . . no, in Italy . . . yeah, I think it's in Italy.") in direct confrontation to one of the more startlingly sophisticated new images, a "CAT" image taken from a satellite ("Satellite photo of farmer's dog at 10^8 magnification, near Urbana, Illinois."). No clue is given by the artist that the magnificently clear image of the dog was taken by Berger only a few feet off the ground.

Photography

Untitled no. 237 - "Let's see... it's at a park... in France... no, in Italy... yeah, I think it's in Italy..."

Il dit qu'il l'a prise... en France? (rire)... non, en Italie... Il se rappelle qu'il l'a prise dans un parc, en Italie...

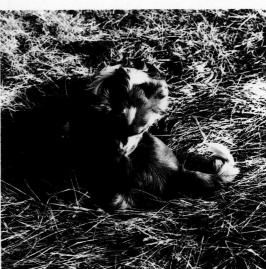

Satellite photo of farmer's dog at 10^8 magnification, near Urbana, Illinois

CAT scanning your dog from 21,000 miles in space.

BARBARA KASTEN

American · 1936–

Construct NYC-10

1983 · Cibachrome print · 74.8 × 95.2 cm.

Barbara Kasten's brilliantly saturated, coloristic photographs follow a 20th-century tradition, a historical chain of interest in the mathematics of form and the arrangements of machined precision. They are still lifes, of sorts, only instead of freshly killed game, fruit compotes, and peeled lemons, we are treated to the contemporary "spoils" of Euclidean geometries and the most primary of appreciations, form and color.

Kasten builds nearly room-sized assemblages, made of plastics and metals, glass and fabrics, lines and planes, volumes and coils, colors and textures. Sometimes, even, an architectural capital or inverted piano leg might appear, as a gesture to classical form. These, then, are the components of the measurable universe she documents. Her large-scaled, constructivist environments are a definite locus of her vision, completed works of art in themselves, awaiting still other transformations in the photographic print. They are theatrical sets and engineered sculptures within which the artist plays out her perceptions—constructions for their own sake as well as for a potential visual deconstruction. Kasten deconstructs by fracturing the entire scene into discrete selections, composed on her camera's ground glass. "I am painting with those elements I put into the frame of the image," she has said. [1]

Her pictorial constructions are formal caprices, reminiscent of a Bauhaus or Constructivist sensibility and recalling the art of El Lissitzky, Theo Van Doesburg, and Piet Mondrian as much as that of Sol LeWitt, DeWain Valentine, or Larry Bell. Her work also bears obvious connections with the earlier photography of László Moholy-Nagy, Florence Henri, and Paul Outerbridge, yet her shrill metallic surfaces, spatial gymnastics, and post-modern (if that term is still functional) colors are distinctly fresh. If there is a historicism in her work it is a retributive historicism, honoring a set of traditions while adapting them to the present. Kasten's images are largely in tune with a contemporary architectural culture, a culture that lists the Hotel Bonaventure, the Pacific Design Center, and "The China Club" on Melrose Avenue as some of its major monuments. If these sites are primarily located in Los Angeles, it might help explain the context in which Kasten had worked between 1973 and her move to New York in 1982 where Trump Tower was being constructed on Fifth Avenue. According to the art critic Peter Plagens:

> Formal Minimal sculpture was contagious in Southern California, whose taste for simple, regular, geometric solids in flat, straightforward colors (or none at all) emanated not from the dialects of short-term art history (as in New York), but from a physical demography dating more or less from World War II. Los Angeles's urban landscape consists of functional (or dreary), economical (or cheap) stucco boxes, and big-building architectural ornament of stainless steel, neon, and plastic (instead of granite, marble, or bronze). . . . In Southern California, Minimal sculpture could be more innocent, but also less final; whatever fining [sic] down was done, was only a stopping point on the path toward ethereal phenomenology. . . . [2]

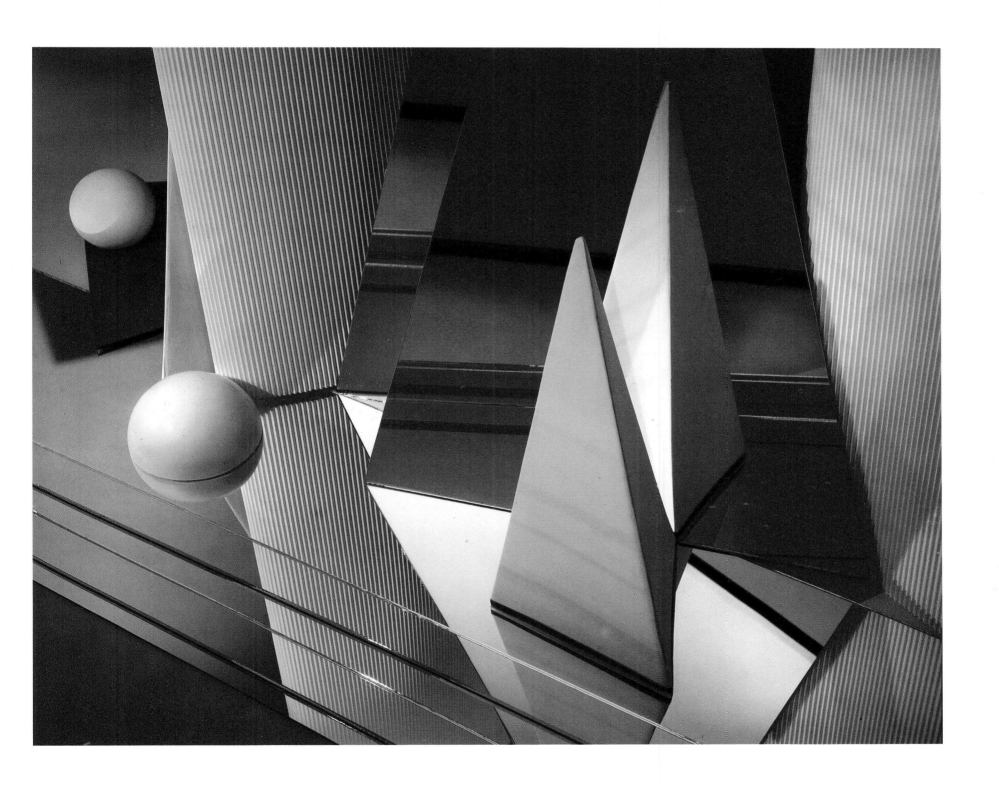

JOHN PFAHL

American · 1939–

Six Oranges, Buffalo, New York

1975 · Chromogenic development print · 18.9 × 22.9 cm.

There is one salient feature about John Pfahl's *Altered Landscapes*, and it has to do with the fact that, as objectively descriptive as they are, what they portray never existed except in the artist's ground glass. What is special, however, since photographs are so easily manipulated, is that there is absolutely no falsification or trickery involved. These prints are completely "factual," yet what facts are recorded are not really present except as an idea. Equally remarkable, what is pictured is not an esoteric effect or a phenomenon that could be documented only by abstracting or deconstructing normal notions of time or space, such as stop-motion photography or X-ray views of the invisible. Pfahl works entirely within the constraints of ordinary, straightforward photography of quite normal landscapes. In a way, his work is a continuation of the great American landscape tradition in photography. Like William Henry Jackson in the last century, Pfahl is interested in recording the natural scene and does not flinch from including signs of man's involvement with nature; however, where earlier photographs incorporated human alterations of the landscape as documentation, Pfahl manufactures his own temporary alterations as demonstration.

Engaging in problems of perspective and its equations of scale and distance, tensions between planarity and depth, and those between picture and nature, Pfahl constructively demonstrates the synthetic nature of our visual system and formulates a poetics of defied expectations. Like the painter René Magritte, he charms by depicting the flagrantly unexpected and the hauntingly unreal. It does not matter that the marks or objects Pfahl places in the landscape are not exactly where they appear to be—what matters is that very appearance and its denial by reason. By their identical size, we know that the six oranges in this print do not recede down the woodland path, but that is not what our eyes tell us. Were we to see these oranges with our two eyes, we would perceive them hanging in a flat plane perpendicular to the camera, but that, however, would be completely incidental. What is important is that, pictured by the single lens of the camera, they appear to be following the floor of the path into the recesses of three-dimensional space and that, despite what we may know to be true, we are convinced only of the opposite. In the land of binocular vision, such as ours, Pfahl's one-eyed camera reigns supreme and sees what we cannot, and while it is tempting to discuss Pfahl's work by seeking its verification in Renaissance theories of perspective and pictorial vision, that would be far too obvious. More than mechanical illustrations of a planimetric ordering of space, Pfahl's pictures are testaments to the wonder of vision, the seductive pleasures of looking, and the often ludicrous results of its conventions.

Writing about Pfahl's *Altered Landscapes*, the critic Anthony Bannon pointed to the pictorial poetry of these images. "What Pfahl obtains is nothing short of the image and the idea at the same time: both the rigorously intellectual and the lushly sublime. He offers an illusion of the real and the gesture of the abstraction, a rendition of the landscape and the articulation of a design, such that his pictures give us access to the world while demonstrating metaphors for its expression."[1]

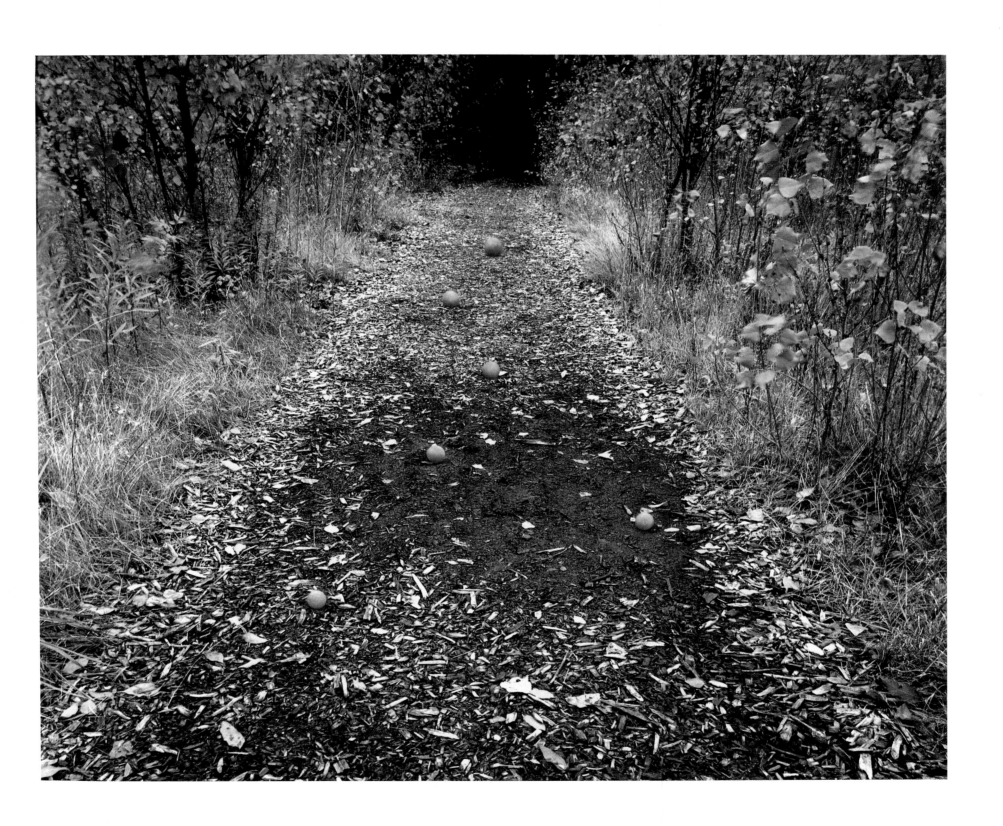

419

EMMET GOWIN

American · 1941–

Toutle River Valley. Mount Saint Helens.

1981/1983 · Gelatin silver print, split toned · 24.9 × 19.1 cm.

There are two aspects to the work of Emmet Gowin, one rooted firmly in the traditions of Southern domestic irony and gothic mystery and the other in the metaphysics of the sublime landscape. The earlier family genre scenes, especially those recording the likenesses of his wife Edith and their children Elijah and Isaac, bear a faint similarity of spirit to the photography of Ralph Eugene Meatyard; strange pantomimes, shrouded figures, and blurred gestures alternate with folkloristic sculpture, slaughtered hogs, and portentous fires—a personal iconography of life in the country, enacted in gardens, backyards, and darkened interiors and englobed in lenticular circles [fig. 98]. Like Meatyard, also, and like Harry Callahan, Gowin took his most immediate family as his principal theme, and with them their relatives and neighbors. More allusory at times than strictly illustrational, Gowin's figures frequently appear to be transformations of classical Renaissance myths. The children are rustic cherubs or putti; Edith is mother and madonna, Danae and Primavera, an odalisque or, perhaps here, a country Venus as if reprised from one of Titian's.

Around 1973, Gowin began to extend his photographic involvement beyond the immediate family and the vicinity of Danville, Virginia, and to devote more of his pictures to what he called "working landscapes." But, as in the earlier work, these landscape photographs were not as straightforward as they appeared; they too were allusory. According to photographic historian Peter C. Bunnell, "In all of this work there is the deeply spiritual allusion to God's presence. For Gowin, pictures are gateways to imagination but such travels of the spirit are not ones of pleasurable fantasy into the picturesque; rather there is always a certain hesitancy together with the excitement. Like all of us he is confronted with the acts of man and nature that are in every sense violent. To deal with this violence Gowin has come to understand that we must live imaginatively."[1] The most obvious source for Gowin's landscape style has been the work of Frederick Sommer, an artist Gowin particularly admires and one whose unqualified faith in the moral imperatives of the exquisitely seen and printed photograph can be best compared to Gowin's.

Gowin's landscapes, his views of Northern Italy, of Parkers

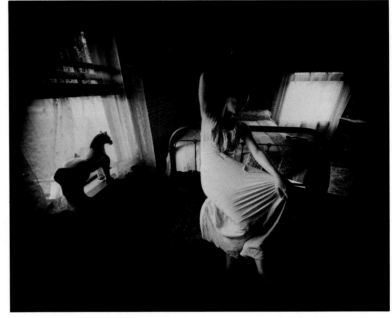

Fig. 98. Emmet Gowin, *Edith. Danville, Virginia*, gelatin silver print, 1971. Museum purchase with National Endowment for the Arts support.

Creek, Arizona, of the Canyon de Chelly, and especially those of Mount Saint Helens are far more than some of the most chillingly beautiful views rendered by a photographer. They are sublime, disorienting images where any normal logic of distance, scale, and position is exchanged for the "appearance of infinity," without which one would have "disorder only, without magnificence."[2] In their richly tonal nuances and nearly pathological detailing, Gowin's pictures, apart from their frequently being taken from an aerial vantage point, remind one of the finest 19th-century landscape photographs, say, by Carleton Watkins or Timothy O'Sullivan; but where they all demonstrate the reality of a place, Gowin's also register zones of human psychology and imagination, that state in which, according to Edmund Burke, "the mind is so entirely filled with its object, that it cannot entertain any other, nor by consequence reason on that object which employs it."[3]

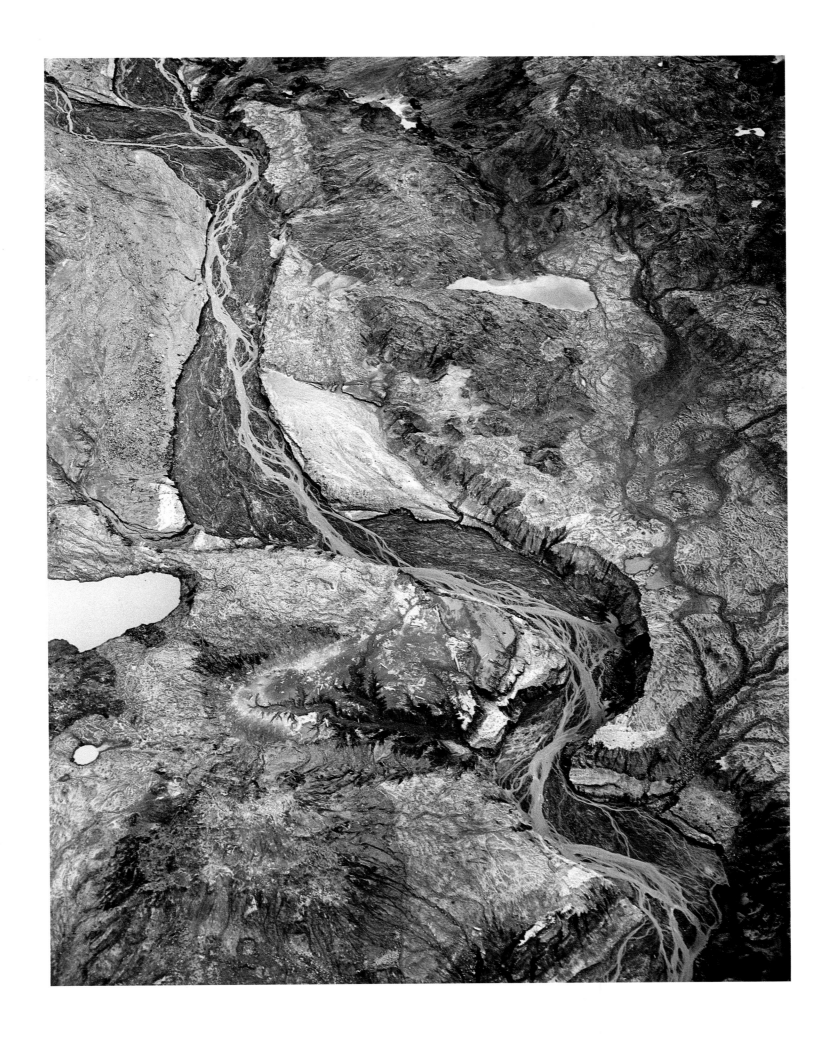

NOTES

INTRODUCTION

1. Roland Barthes, "The Photographic Message," in *Image—Music—Text,* trans. by Stephen Heath, New York, 1977, p. 31.

2. Philippe Burty, "Exposition de la Société française de photographie," *Gazette des Beaux-Arts,* II (1859), p. 216.

3. Svetlana Alpers, *The Art of Describing: Dutch Art in the Seventeenth Century,* Chicago, 1983, p. 41; cf. also Peter Galassi, *Before Photography: Painting and the Invention of Photography,* New York, 1981, p. 16.

4. Jules Janin, "Le Daguerotype," *L'Artiste,* II, 2 (27 January 1839), p. 148.

5. Cited with no further reference in Ruth Cherniss, "The Anti-Naturalists," in George Boas (ed.), *Courbet and the Naturalist Movement,* Baltimore, 1938, p. 87.

6. Anthony Burgess, "Modern Novels: The 99 Best," *The New York Times Book Review,* 5 February 1984, p. 36.

7. John White, *The Birth and Rebirth of Pictorial Space,* London, 1967, pp. 19–20.

8. Cited in Walter Cahn, *Masterpieces: Chapters on the History of an Idea,* Princeton, 1979, p. 104.

9. Kenneth Clark, *What is a Masterpiece?,* New York, 1981, p. 44.

10. For a fuller explanation of these concepts, cf. Erwin Panofsky, *Idea: A Concept in Art Theory,* Columbia, 1968, *passim.*

11. Max Kozloff, "Critical and Historical Problems of Photography," (1964), in *Renderings: Critical Essays on a Century of Modern Art,* New York, 1969, p. 292.

12. Jakob Rosenberg, *On Quality in Art: Criteria of Excellence, Past and Present,* New York and Princeton, 1967, p. 232.

13. William H. Gass, "Monumentality/Mentality," *Oppositions,* 25 (Fall 1982), p. 129.

CHAPTER 1

CHARLES-MARIE BOUTON

1. Helmut and Alison Gernsheim, *L. J. M. Daguerre: The History of the Diorama and the Daguerreotype,* New York, 1968, pp. 180-81.

2. Anonymous broadside, "Nomenclature des travaux artistiques de M. Bouton, Decoré au Musée de 1825 . . . ," Paris, 1825, in the museum's collection.

3. Gabriel Cromer, "L'Histoire de la Photographie et de ses précurseurs enseignée par l'image et l'objet d'époque. Première exposition: Daguerre artiste, et son Diorama," *Bulletin de la Société française de photographie,* XI, 3 (March 1924), p. 58.

4. Charles Gabet, *Dictionnaire des artistes de l'école française au XIXe siècle,* Paris, 1831, pp. 93-94.

5. Cf. Robert Rosenblum, entry for Daguerre, in Detroit Institute of Art, et al., *French Painting 1774-1830: The Age of Revolution,* Detroit and New York, 1975, cat. no. 25, pp. 355-56.

L. MARQUIER

1. Cf. Michael Twyman, *Lithography, 1800-1850,* London, 1970, pp. 252-53, pl. 158.

2. Cf. Bibliothèque Nationale, *Une invention du XIXe siècle: La photographie,* text by Bernard Marbot, Paris, 1976, cat. no. 310.

3. Charles Duplomb, *Histoire générale des ponts de Paris,* Paris, 1911, I, pp. 226-29.

4. Gustave Geffroy, *Charles Meryon,* Paris, 1926, pp. 68-70, pl. facing p. 124.

5. Charles Meryon to Paul Mantz, 4 June 1853, cited in G. Geffroy, *op. cit.,* p. 68.

ARMAND-HIPPOLYTE-LOUIS FIZEAU

1. Lerebours and Secretan, *Traité de photographie,* 5th ed., Paris, 1846, pp. 279-82.

2. N.-M. P. Lerebours, *A Treatise on Photography,* trans. by J. Egerton, London, 1843, pp. 124-25, note.

3. Lerebours and Secretan, *Traité de photographie, op. cit.,* p. 214.

LOUIS-JACQUES-MANDE DAGUERRE

1. Helmut and Alison Gernsheim, *L. J. M. Daguerre: The History of the Diorama and the Daguerreotype,* New York, 1968, pp. 192-94.

2. Cf. Raymond Lécuyer, *L'Histoire de la photographie,* Paris, 1945, p. 26, illus.; present whereabouts unknown.

3. H. and A. Gernsheim, *L. J. M. Daguerre . . . op. cit.,* p. 193; present whereabouts unknown.

4. Charles Baudelaire, *The Salon of 1846,* in *Art in Paris 1845-1862,* ed. and trans. by Jonathan Mayne, London, 1965, p. 81.

5. For Ingres, see Robert Rosenblum, *Jean-Auguste-Dominique Ingres,* New York, 1967, pls. 11 and 17; for Millet, see Robert L. Herbert, et al., *Jean-François Millet,* Paris, 1975, cat. no. 5; for Flandrin, see Musée du Luxembourg, *Hippolyte, Auguste et Paul Flandrin: Une fraternité picturale au XIXe siècle,* texts by Jacques Foucart, Bruno Foucart, et al., Paris, 1984, cat. no. 93.

JEAN-BAPTISTE SABATIER-BLOT

1. Gabriel Cromer, "Un photographe-artiste des premiers temps du daguerréotype, le miniaturiste SABATIER-BLOT," *Bulletin de la Société française de photographie*, 1 (January 1933), pp. 8-9.

2. J. Thierry, *Daguerréotypie*, Paris and Lyon, May 1847, pp. 86, 177.

ROBERT CORNELIUS

1. Hans Martin Boye, entry for "Analysis," in James Curtis Booth, *The Encyclopedia of Chemistry, Practical and Theoretical: Embracing Its Applications to the Arts of Metallurgy, Numerology, Geology, Medicine, and Pharmacy*, Philadelphia, 1850, p. 171, fig. 18.

UNIDENTIFIED PHOTOGRAPHER

1. Cf. Gail Buckland, *Fox Talbot and the Invention of Photography*, Boston, 1980, p. 86 ("The Ladder") and p. 155 ("The Broom"); and [Joseph-Marie] Lo Duca, *Bayard*, Paris, 1943, pls. vi, viii, x, and xvi.

WILLIAM HENRY FOX TALBOT

1. Cf. Beaumont Newhall, *Latent Image: The Discovery of Photography*, New York, 1967, esp. chaps. 7 and 13-16.

2. W. H. Fox Talbot, "Brief Historical Sketch of the Invention of the Art," *Pencil of Nature*, London, 1844-46, unp.

3. W. H. Fox Talbot, *loc. cit.*

4. John Walter, Jr., *Record of the Death Bed of C. M. W.*, London, 1844; published between January 24 and June 23 of that year.

5. W. H. Fox Talbot, "Lace," *The Pencil of Nature*, London, 1844-46, v, unp.

DAVID OCTAVIUS HILL and ROBERT ADAMSON

1. Letter from Brewster to Fox Talbot, 3 July 1843; cited in Colin Ford and Roy Strong, *An Early Victorian Album: The Hill/Adamson Collection*, London, 1974, p. 24.

2. Cited in *Ibid.*, p. 30.

3. Cf. *Ibid.*, p. 31.

4. The picture is entitled *The Morning After "He Greatly Daring Dined,"* see *ibid.*, p. 154.

ANTOINE-SAMUEL ADAM-SALOMON

1. Ernest Lacan, "Exposition photographique. Cinquième article," *La Lumière*, ix, 32 (6 June 1859), p. 125.

2. Cited in Marie-Renée Morin, et al., *Lamartine: Le poète et l'homme d'Etat*, exhibition catalogue, Paris, Bibliothèque Nationale, 1969, cat. no. 672.

3. Adam-Salomon, "A Word on Art in Photography," *The Year-Book of Photography, and Photographic News Almanac*, 1869, pp. 25-26.

4. P. H. Emerson, *Naturalistic Photography for Students of the Art*, London, 1889, p. iii.

5. H. P. Robinson, "Adam Salomon," *The Amateur Photographer*, ix, 236 (12 April 1889), p. 236.

SAMUEL LEON WALKER

1. Anon. "Obituary," *The Daily Press*, 27 April 1874, unp.

2. S. L. Walker, "S. L. Walker—Obituary. Written by Himself," 13 June 1872, unidentified newspaper clipping, family scrapbook.

3. Anon., "Death of S. L. Walker," *Poughkeepsie Journal and Eagle*, 27 April 1874, unp.

JEAN-GABRIEL EYNARD-LULLIN and JEAN RION

1. N. P. Lerebours, *A Treatise on Photography; Containing the Latest Discoveries and Improvements Appertaining the Daguerreotype*, trans. by J. Egerton, London, 1843, p. 25n.

2. Michel Auer, "Jean-Gabriel Eynard-Lullin, photographe," *Revue du Vieux Genève*, 3 (1973), p. 2.

FREDERIC MARTENS

1. Cf. Bernard Marbot in Bibliothèque Nationale, *Une invention du XIXe siècle: La photographie*, Paris, 1976, cat. no. 237.

2. Cf. Bernard Marbot, *loc. cit.*

3. Cf. Germain Bapst, *Essai sur l'histoire des panoramas et des dioramas*, Paris, 1891.

4. Honoré de Balzac, *Le Père Goriot*, Paris, (1834-35), 1966, p. 64.

WILLIAM SOUTHGATE PORTER

1. Cf. Hans Huth, *Nature and the American: Three Centuries of Changing Attitudes*, Berkeley and Los Angeles, 1957, pp. 59-60.

2. T. P. and D. C. Collins, *Fairmount Water Works*, daguerreotype-panorama in six horizontal half plates, ca. 1848, in the collection of the Franklin Institute, Philadelphia.

3. Letter to Beaumont Newhall from Carl Vitz, Librarian, Public Library of Cincinnati, Ohio, dated 15 November 1948; the author would like to thank Mr. Newhall for sharing this information with him.

4. Cf. Beaumont Newhall, *The Daguerreotype in America*, New York, 1961, pl. 32.

PLATT D. BABBITT

1. Cf., for instance, Beaumont Newhall, *The Daguerreotype in America*, New York, 1961, pl. 31; and F. and M. Rinhart, *The American Daguerreotype*, Athens, 1981, illus. p. 123.

2. Robert Hunter, Jr., *Quebec to Carolina in 1785-1786*, San Marino (Calif), 1943, pp. 98-99.

3. N.-M. P. Lerebours, *Excursions daguerriennes, vues et monuments les plus remarquables du globe*, Paris, 1841-42.

4. John Werge, *The Evolution of Photography*, London, 1890, p. 150.

5. Cf. Hans Huth, *Nature and the American: Three Centuries of Changing Attitudes*, Berkeley, 1957, p. 172.

BARON JEAN-BAPTISTE-LOUIS GROS

1. Baron Gros, *Quelques notes sur la photographie sur plaques métalliques*, Paris, 1850, p. 2.

2. [George Gordon Noel Byron], "Childe Harold's Pilgrimage; A Romaunt.", Canto II, verse 15, in *The Works of Lord Byron, Including the Suppressed Poems. Also a Sketch of His Life by J. W. Lake*, Philadelphia, 1852, p. 50.

GEORGE N. BARNARD

1. George N. Barnard, *Photographic Views of Sherman's Campaign, . . . From negatives taken in the field by Geo. N. Barnard, Official Photographer of the Military Div. of the Miss.*, New York, [1866].

2. G. N. Barnard, "Taste," *The Photographic and Fine Art Journal*, VIII, 5 (May 1855), p. 158.

3. G. N. Barnard, *Loc. cit.*

4. The author would like to thank Beaumont Newhall for bringing this reference to his attention.

5. Information supplied Beaumont Newhall by Richard Wright of the Onondaga Historical Society, May 1963.

6. Cf. Helmut Gernsheim, *The Origins of Photography*, New York, 1982, pl. 90; and Wilhelm Weimar, *Die Daguerreotypie in Hamburg, 1839-1860*, Hamburg, 1915, pl. 1.

E. DESPLANQUES

1. Cf. Isabelle Jammes, *Blanquart-Evrard et les origines de l'édition photographique française . . .* , Geneva and Paris, 1981, cat. no. 123, p. 170.

CHARLES NEGRE

1. James Borcoman, *Charles Nègre, 1820-1880*, Ottawa, 1976, p. 34.

2. Charles Nègre, "Le Midi de la France photographié," unpublished mss., ca. 1854, National Archives, Paris; reprinted in Réunion des Musées Nationaux, *Charles Nègre, Photographe, 1820-1880*, Arles and Paris, 1980, pp. 352-54.

3. Henri de Lacretelle, "Albums photographiques. No. 1 - M. Nègre," *La Lumière*, III, 7 (12 February 1853), p. 25.

MARCUS AURELIUS ROOT

1. M. A. Root, *The Camera and the Pencil . . .* , Philadelphia, 1864, p. xv.

2. M. A. Root, *op. cit.*, p. 143.

GABRIEL HARRISON

1. Cf. Virginia Chandler, "Gabriel Harrison," in H. R. Stiles, *History of Kings County*, New York, 1884, pp. 1151-58.

2. M. A. Root, *The Camera and the Pencil . . .* , Philadelphia, 1864, p. 143.

3. S. J. Burr, "Gabriel Harrison and the Daguerrean Art," *The Photographic Art-Journal*, I, 3 (March 1851), p. 175.

4. S. J. Burr, *loc. cit.*

5. Gabriel Harrison, letter to the Anthony Prize competition, *The Photographic Art-Journal*, IV, 3 (September 1852), p. 151; cited by Richard

Rudisill, *Mirror Image: The Influence of the Daguerreotype on American Society*, Albuquerque, 1971, p. 128.

6. Gabriel Harrison, letter to editor, *The Photographic Art-Journal*, I, 1 (January 1851), p. 64; cited in R. Rudisill, *op. cit., p. 182.*

UNIDENTIFIED PHOTOGRAPHER

1. Zelda P. Mackay, "Catalogue of the Daguerreotype Collection of Zelda P. Mackay . . . ," unp. mss., San Francisco, ca. 1930-68, no. 792.

UNIDENTIFIED PHOTOGRAPHER

1. Susan Sontag, *On Photography*, New York, 1977, pp. 8-9.

2. Zelda P. Mackay, "Catalogue of the Daguerreotype Collection of Zelda P. Mackay . . . ," unp. mss., San Francisco, ca. 1930-68, no. 574.

UNIDENTIFIED PHOTOGRAPHER

1. Hector Berlioz, *The Memoirs of Hector Berlioz*, trans. by David Cairns, London, 1970, p. 223.

2. Illustrated in John Rewald, *Post-Impressionism from Van Gogh to Gauguin*, New York, 1962, p. 420.

EUGENE PIOT

1. Cf. André Jammes and Eugenia Parry Janis, *The Art of French Calotype*, Princeton, 1983, p. 234.

2. Ernest Lacan, *Esquisses photographiques*, Paris, 1856, pp. 92-93.

MAXIME DU CAMP

1. Cited and trans. in Francis Steegmuller, *Flaubert in Egypt . . .* , Boston, 1972, p. 170.

2. Karl Baedeker, *Egypt and The Sudan*, 7th ed., Leipzig, 1914, p. 331.

3. Cf. Victor Chan, "Rebellion, Retribution, Resistance, and Redemption: Genesis and metamorphosis of a Romantic Giant Enigma," *Arts Magazine*, LVIII, 10 (Summer 1984), pp. 80-95.

4. Cited and trans. in Francis Steegmuller, *Flaubert in Egypt . . .* , *op. cit.*, p. 74.

5. Francis Wey, "Voyages héliographiques, Album d'Egypte de Maxime Du Camp," *La Lumière*, I, 32 (14 September 1851), p. 126.

6. Cited and trans. in Francis Steegmuller, *Flaubert in Egypt . . .* , *op. cit.*, pp. 101-2.

LINNEAUS TRIPE

1. Cf. Mark Haworth-Booth et al., *The Golden Age of British Photography, 1839-1900*, Millerton (NY), 1984, p. 105.

ALEXANDRE JEAN-PIERRE CLAUSEL

1. Cf. Philadelphia Museum of Art, et al., *The Second Empire: Art in France under Napoleon III*, Philadelphia, 1978, cat. no. VI-24, p. 271, illus.

2. Edward Wheelwright, "Recollections of Millet," *Atlantic Monthly*,

(September 1876), cited in Aaron Scharf, *Art and Photography*, Baltimore, 1969, p. 67.

3. Cf. Charles Blanc, *The Grammar of Painting and Engraving*, 3rd ed., trans. by Kate Newell Doggett, Chicago, 1879, pp. 209-18.

JEAN-LOUIS-HENRI LE SECQ DES TOURNELLES

1. E. P. Janis, entry for Le Secq in André Jammes and Eugenia Parry Janis, *The Art of French Calotype*, Princeton, 1983, p. 207.

2. Cf. Robert J. Bingham, *Photogenic Manipulation*, 9th ed., London, 1852, pp. 66-68.

3. Cf. E. P. Janis, in *The Art of French Calotype*, op. cit., p 209.

LOUIS-DESIRE BLANQUART-EVRARD

1. L.-D. Blanquart-Evrard, *Procédés employés pour obtenir les épreuves de photographie sur papier, presentés a l'Académie des Sciences*, Paris, 1847, cited and translated in Isabelle Jammes, "Louis-Désiré Blanquart-Evrard, 1802-1872," *Camera*, LVII, 12 (December 1978), p. 13.

2. Isabelle Jammes, *op. cit.*, p. 13.

3. Cf. Robert A. Sobieszek, "Photography and the Theory of Realism in the the Second Empire: A Reexamination of a Relationship," in Van Deren Coke (ed.), *One Hundred Years of Photographic History: Essays in Honor of Beaumont Newhall*, Albuquerque, 1975, pp. 145-59.

CHAPTER 2

GASPARD-FELIX TOURNACHON (called NADAR)

1. Cf. Philippe Neagu and Jean-Jacques Poulet-Allamagny, *Nadar*, Paris, 1979, I, pp. 58-62.

2. Philippe Busson, article in *Illustration*, March 1854, cited in P. Neagu and J.-J. Poulet-Allamagny, *Nadar, op. cit.*, pp. 30-31.

EDOUARD-DENIS BALDUS

1. Philippe Neagu and Françoise Heilbrun, "Baldus: paysages, architectures," *Photographies*, no. 1 (Spring 1983), p. 57.

2. A. Belloc, *Les Quatre branches de la photographie*, Paris, 1855, p.xxv.

3. Ernest Lacan, *Esquisses photographiques*, Paris, 1856, p. 80; Lacan was discussing Baldus's 1.3 meter long *Panorama du Mont-doré*, but the same language can with equal justice be applied to the artist's *Pavillon Turgot*.

ROGER FENTON

1. Review of the photographic exhibition, *Journal of the Photographic Society*, (21 May 1858), pp. 208-9; cited in Valerie Lloyd, "Roger Fenton and the Making of a Photographic Establishment," in Mark Haworth-Booth, et al., *The Golden Age of British Photography, 1839-1900*, Millerton (NY), 1984, p. 75.

2. Anon., "Photographs from Sebastopol," *The Art-Journal*, NS I (1 October 1855), p. 285.

3. A. H. Wall, "On Taking Picturesque Photographs," *The British Journal of Photography*, XIV, 364 (26 April 1867), p. 196.

J.-B. GUSTAVE LE GRAY

1. Cited and trans. in André Jammes and Eugenia Parry Janis, *The Art of French Calotype*, Princeton, 1983, p. 202.

2. Bibliothèque Nationale, *Une invention du XIXe siècle: La photographie*, text by Bernard Marbot, Paris, 1976, cat. no. 105, illus. p. 133.

3. Hamburg Kunsthalle, *Courbet und Deutschland*, Hamburg, 1978, cat. no. 288; the painting is presently in Nationalgalerie, Berlin.

4. M.-A. Gaudin, "1857-1858," *La Lumière*, VIII, 1 (2 January 1858), p. 1.

EDOUARD FIERLANTS

1. Fernand Khnopff, letter to Paul Schultze-Naumburg, 1899, cited in The Brooklyn Museum, *Belgian Art, 1880-1914*, Brooklyn, 1980, cat. no. 39, p. 111.

2. Charles Baudelaire, *Sur la Belgique*, in *Oeuvres complètes*, Paris, 1961, p. 1448.

ADOLPHE BRAUN

1. Cf. Odile Nouvel, entry for *The Garden of Armida*, in Philadelphia Museum of Art, et al., *The Second Empire: Art in France under Napoleon III*, Philadelphia, 1978, cat. no. 11-16, pp. 92-93.

2. A. T. L., "Utile application de la photographie aux beaux-arts et à l'industrie." *La Lumière*, IV, 45 (11 November 1854), p. 178.

3. Anon., "Extrait du *Journal des débats*, du 7 Décembre 1854," in [A. Braun], *Photographies de fleurs, à l'usage des fabriques de toiles peintes, papiers peints, soieries, porcelaines, etc.*, pamphlet of reprinted critical notices, n.p. [Dornach], n.d. [1855], p. 2.

ADOLPHE BILORDEAUX

1. See Bernard Marbot and Weston J. Naef, *After Daguerre: Masterworks of French Photography (1848-1900) from the Bibliothèque Nationale*, New York, 1980, illustrated, cat. no. 18

2. Joseph Rishel, entry for Fantin-Latour, in Philadelphia Museum of Art, et al., *The Second Empire: Art in France under Napoleon III*, Philadelphia, 1978, cat. no. VI-51, p. 299.

3. Cited and translated in B. Marbot and W. J. Naef, *After Daguerre . . .*, op. cit., cat. no. 18.

B. BRAQUEHAIS

1. Ernest Lacan, "Revue photographique: M. Le Comte Olympe Aguado," *La Lumière*, IV, 4 (28 January 1854), p. 15.

2. Ernest Lacan, "Revue Photographique: Etudes d'après nature," *La Lumière*, IV, 37 (16 September 1854), p. 147.

3. Ernest Lacan, "Revue photographique: Etudes d'après nature," op. cit. p. 147.

4. Cited and trans. in Albert Boime, *The Academy & French Painting in the Nineteenth Century*, New York, 1971, p. 28.

ADRIEN TOURNACHON

1. Ernest Lacan, "Exposition Universelle, Photographie," (11th article), *La Lumière*, VI, 3 (19 June 1856), p. 9.

2. André Jammes, "Duchenne de Boulogne, La Grimace provoquée et Nadar," *Gazette des Beaux-Arts*, XCII, 1319 (December 1978), pp. 215-20.

3. Ernest Lacan, "Revue de la quinzaine," *Le Moniteur de la photographie*, 3 (15 April 1861), pp. 17-18.

4. Ernest Lacan, "Exposition photographique de Bruxelles," (XII), *La Lumière*, VI, 48 (29 November 1856), p. 185.

ALBERT SANDS SOUTHWORTH and JOSIAH JOHNSON HAWES

1. Albert S. Southworth, "An Address," *The Philadelphia Photographer*, VIII, 94 (October 1871), pp. 320-21.

2. *Ibid.*, p. 321.

3. *Ibid.*, p. 321.

F. A. WENDEROTH

1. Bernard E. Jones, *Cassell's Cyclopaedia of Photography*, New York, 1911, p. 313.

2. Walter E. Woodbury, *The Encyclopaedic Dictionary of Photography*, New York, 1898, p. 254.

3. M. A. Root, *The Camera and the Pencil. . .*, Philadelphia, 1864, p. 305.

LEWIS CARROLL (REV. CHARLES LUTWIDGE DODGSON)

1. For the various poses of Xie Kitchin, see Helmut Gernsheim, *Lewis Carroll, Photographer*, New York, 1969, pls. 62 and 64; an album of Carroll's photographs in the Gernsheim Collection, University of Texas, Austin (No. [A] III in *ibid.*, pp. 101-2); and Morton N. Cohen, (ed.), *Lewis Carroll and the Kitchins*, New York, 1980, *passim*.

2. Cf. Stuart Dodgson Collingwood, *The Life and Letters of Lewis Carroll*, Toronto, n.d. (ca. 1898), p. 173.

3. Cited in H. Gernsheim, *op. cit.*, p. 71.

FRANZ HANFSTAENGL

1. Ernest Lacan, *Esquisses photographiques*, Paris, 1856, p. 146.

2. Helmut Gernsheim, "Franz Hanfstaengl," in Christian Diener and Graham Fulton-Smith (eds.), *Franz Hanfstaengl: Album der Zeitgenossen*, Munich, 1975, unp.

3. Steinheil's name is alternatively given as Karl August Steinheil.

4. Cf. Josef Maria Eder, *History of Photography*, trans. by Edward Epstean, New York, 1945, p. 775.

LEOPOLD ERNEST MAYER and PIERRE-LOUIS PIERSON

1. Nadar, *Quand j'étais photographe*, Paris, 1900, p. 197.

2. Mayer and Pierson, *La Photographie considerée comme art et comme industrie. . . .*, Paris, 1862, p. 97.

3. Mayer and Pierson, *op. cit.*, pp. 106-7.

4. Benezit, *Dictionnaire critique et documentaire des peintres, sculpteurs, dessinateurs et graveurs*, Paris, 1976, VII, p. 589.

LOUIS-AUGUSTE and AUGUSTE-ROSALIE BISSON

1. Théophile Gautier, "Le Chemin de fer," (1830) in *Fusains et eaux-fortes*, Paris, 1880, pp. 187-88.

2. Anon., "Nouvelle application de la photographie," *La Lumière*, IV, 38 (23 September 1854), p. 151.

3. For the locomotive, cf. L. Le Chatelle, et al., *Guide du mécanicien constructeur et conducteur de machines locomotives*, Paris, n.d. [ca. 1858], atlas volume, especially pl. 61, "Lyon v," dated 1857.

ROBERT HOWLETT

1. Contemporary article in *Quarterly Review*, cited in John Pudney, *Brunel and His World*, London, 1974, p. 95.

2. "The Leviathan Number," *The Illustrated Times*, VI, 146 (16 January 1858), p. 49.

3. *Ibid.*, p. 67.

AUGUSTE SALZMANN

1. L.-F.-J. Caignart de Saulcy, *Voyage autour de la Mer Morte et dans les terres bibliques*, Paris, 1852-54.

2. Cited and trans. in André Jammes and Eugenia Parry Janis, *The Art of French Calotype*, Princeton, 1983, p. 247.

3. Reprinted from *Le Constitutionnel* as "Exploration photographique de Jérusalem, par M. Auguste Salzmann," *Bulletin de la Société française de photographie*, 1 (March 1855), pp. 84-87.

4. Cited and trans. in André Jammes, "Commentary and Catalogue," *French Primitive Photography*, Philadelphia, 1969, unp.

GIOACCHINO ALTOBELLI and POMPEO MOLINS

1. [George Gordon Noel Byron], "Childe Harold's Pilgrimage; A Royaunt," Cantos CXXVIII-CXLIV, in *The Works of Lord Byron, Including the Suppressed Poems. Also a Sketch of His Life by J. W. Lake*, Philadelphia, 1852, pp. 80-81.

ROBERT MACPHERSON

1. Francis Wey, *Rome*, ed. by Maria Hornor Lansdale, Philadelphia, 1898, p. 196.

FRANCIS FRITH

1. Cf. Goupil-Fesquet, *Voyage d'Horace Vernet en Orient*, Brussels, 1844, II, pp. 7-8.

2. Francis Frith, "Early Morning at Wady Kardassy, Nubia," *Egypt and Palestine Photographed and Described by Francis Frith*, London, 1858-60, I, unp.

3. Francis Frith, "The Art of Photography," *The Art-Journal*, NS, V (1 March 1859), p. 72.

CLAUDE-JOSEPH-DESIRE CHARNAY

1. Cf. the engraved illustrations from Frederick Catherwood's daguerreotypes in John Lloyd Stephens, *Incidents of Travel in Yucatan*, New York, 1843.

2. Cited and trans. in Keith F. Davis, *Désiré Charnay: Expeditionary Photographer*, Albuquerque, 1981, p. 129.

3. Désiré Charnay, *Cités et ruines américaines...*, Paris, 1862–63, p. ii, trans. in Keith F. Davis, *op. cit.*, p. 16.

JAMES ROBERTSON

1. Editorial, *The Journal of the Photographic Society*, I, 15 (21 March 1854), p. 1.

2. Edmund Maynard to his mother, 10 September 1855, cited in Helmut and Alison Gernsheim (eds.), *Roger Fenton: Photographer of the Crimean War*, London, 1954, pp. 105-6.

FELICE BEATO

1. Kineo Kuwabara, "History of Photography in Japan: The First Pioneers," *Camerart*, IV, 2 (March-April 1961), p. 48.

2. Anon., "The London and Provincial Photographic Association," *The British Journal of Photography*, XXXIII, 1347 (26 February 1886), p. 136.

3. Anon., "At Mr. Hering's...," *Littell's Living Age*, LXXIV, 948 (2 August 1862), p. 220.

ANDREW JOSEPH RUSSELL

1. Walt Whitman, "An Army Corps on the March," in *Drum Taps*, (1865), in *Complete Poetry and Selected Prose*, ed. by James E. Miller, Jr., Boston, 1959, pp. 215-16.

2. Leo Marx, "Specimen Days," *The New York Times Book Review*, (21 November 1971), p. 7.

ALEXANDER HESLER

1. Alex. Hesler to Friend Ayres, a.l.s., 24 May 1895, cited in Ellen Manchester, "Alexander Hesler: Chicago Photographer," *Image*, XVI, 1 (March 1973), p. 10; the original letter is now in the collection of the Chicago Historical Society.

2. William Henry Herndon and Jesse Weik, *Herndon's Lincoln: The True Story of a Great Life*, (1889), cited in Charles Hamilton and Lloyd Ostendorf, *Lincoln in Photographs: An Album of Every Known Pose*, Norman (Okla.), 1963, p. 46.

3. Samuel R. Wells, *New Physiognomy; or, Signs of Character, as Manifested Through Temperament and External Forms and Especially in the "Human Face Divine,"* New York, 1869, p. 550, fig. 759. The photograph from which the engraving was made is now dated between late February and the end of June, 1861; cf. James Mellon (ed.), *The Face of Lincoln*, New York, 1979, cat. no. 26, pp. 88-89.

4. This political cartoon is illustrated in Stefan Lorant, *Lincoln: A Picture Story of His Life*, rev. ed., New York, 1969, pp. 108-9.

ALEXANDER GARDNER

1. Cf. Stefan Lorant, *Lincoln: A Picture Story of His Life*, rev. ed., New York, 1969, pp. 282-87.

2. Cf. *ibid.*, p. 283.

3. Cited in *ibid.*, p. 290.

ANDRE-ADOLPHE-EUGENE DISDERI

1. Nadar, *Quand j'étais photographe*, Paris, 1900, p. 211.

2. Champfleury, "La Légende du daguerréotype," in *Les bons contes font les bons amis*, Paris, 1864.

3. A.-A.-E. Disdéri, *L'Art de la photographie*, Paris, 1862, p. 273.

ANTOINE FRANCOIS JEAN CLAUDET

1. A. Claudet, "New Process for Equalizing the Definition of all the Planes of a Solid Figure Represented in a Photographic Picture," *The British Journal of Photography*, (31 August 1866), p. 415; cited in Linda Sevey, *The Question of Style in Daguerreotype and Calotype Portraits by Antoine Claudet*, unpublished thesis, Rochester Institute of Technology, 1977, pp. 51-52.

2. A. Claudet, "On a Means of Introducing Harmony and Artistic Effect in Photo-Graphic Portraits by Equalizing the Definition of the Various Planes of the Figure," *The British Journal of Photography*, (16 November 1866), p. 548.

FRANCOIS WILLEME

1. Théophile Gautier, *Photosculpture*, pamphlet reprinted from *Le Moniteur universel*, (4 January 1864), Paris, 1864, pp. 9-10.

ETIENNE CARJAT

1. Charles Baudelaire, "The Modern Public and Photography," *The Salon of 1859*, in *Art in Paris 1845-1862*, ed. and trans. by Jonathan Mayne, London, 1965, pp. 152-53.

2. Cited in Petite Palais, *Baudelaire*, Paris, 1969, cat. no. 703.

3. See Claude Pichois, *Album Baudelaire*, Paris, 1974, p. 268, illus. 384.

4. Cited in Jean Adhémar, "Carjat," *Gazette des beaux-arts*, LXXX, 1242-43 (July-August 1972), pp. 79-80.

5. Cf. Petit Palais, *Baudelaire*, Paris, 1969, cat. nos. 684, 686.

HENRY PEACH ROBINSON

1. H. P. Robinson, *Pictorial Effect in Photography*, London, 1869, p. 14.

2. Thos. H. Cummings, "H. P. Robinson," *Photo Era*, VII, 1 (July 1901), p. 1.

3. Cf. Susan Sontag, *Illness as Metaphor*, New York, 1978, pp. 20-36.

4. H. P. Robinson, *The Elements of a Pictorial Photograph*, London, 1896, p. 102.

5. The version of this print, entitled *She Never Told Her Love*, which carries this inscription on its line, is in the collection of the Royal Photographic Society, Bath. Robinson titled the picture simply *A Study* in 1896.

DAVID WILKIE WYNFIELD

1. Cited in Helmut Gernsheim, *Julia Margaret Cameron: Her Life and Photographic Work*, Millerton (NY), 1975, p. 35.

2. Cf. Svetlana Alpers, *The Art of Describing: Dutch Art in the Seventeenth Century*, Chicago, 1983, pp. 12-15.

JULIA MARGARET CAMERON

1. Helmut Gernsheim, *Julia Margaret Cameron...*, Millerton (NY), 1975, p. 74, illus.

2. Stanford University Museum of Art, "Mrs. Cameron's Photographs from the Life," Stanford, 1974, cat. no. 21, illus. (The Art Institute of Chicago).

3. H. Gernsheim, *op. cit.*, p. 149, illus.

4. Cf. Minneapolis Institute of Arts, *Victorian High Renaissance*, Minneapolis, 1978, cat. no. 13, pp. 68–69.

5. J. M. Cameron, "On a Portrait," *Macmillan's Magazine*, XXXIII (February 1876), p. 372; reprinted in Mike Weaver, *Julia Margaret Cameron, 1815-1879*, Southampton, 1984, p. 158.

6. Alfred Lord Tennyson, *The Idylls of the King*, lines 329-35, cited in Minneapolis Institute of Arts, *op. cit.*, p. 69.

7. Julia Margaret Cameron to Sir John Herschel, 31 December 1864, cited in H. Gernsheim, *op. cit.*, p. 14.

FRANCIS EDMOND CURREY

1. Hippolyte Taine, *Notes on England*, trans. by W. F. Rae, New York, 1872, p. 328; cited in Joseph Rishel, "Landseer and the Continent: The Artist in International Perspective," in Richard Ormond, et al., *Sir Edwin Landseer*, New York, 1981, p. 38.

2. Cf. R. & D. Colnaghi, *Photography: The First Eighty Years*, texts by Valerie Lloyd, London, 1976, cat. no. 134, illus.

3. Cf. Beaumont Newhall (ed.), *Photography: Essays and Images*, New York, 1980, p. 97, illus.

4. Cf. Bernard Marbot and Weston J. Naef, *After Daguerre: Masterworks of French Photography (1848-1900) from the Bibliothèque Nationale*, New York, 1980, cat. nos. 35, 77.

5. Cf. *The Photographic Album for the Year 1857*, London, 1857 for *Piscator No. 2*; also cf. Charles Millard, "Images of Nature: A Photo-Essay," in U. C. Knoepflmacher and G. B. Tennyson (eds.), *Nature and the Victorian Imagination*, Berkeley, 1977, p. 16, illus.

6. Thomas Hardy, *The Return of the Native*, New York, 1981, p. 262.

COUNT DE MONTIZON

1. Cited in Gail Buckland, *Reality Recorded...*, Greenwich (Conn.), 1974, p. 35.

2. John Berger, "Why Look at Animals," in *About Looking*, New York, 1980, p. 19.

3. Edmund Burke, *Philosophical Enquiry into the Origin of Our Ideas of the Sublime and Beautiful*, ed. by J. T. Boulton, New York, 1958, p. 66; cf. also Walter L. Creese, "Imagination in the Suburb," in U. C. Knoepflmacher and G. B. Tennyson (eds.), *Nature and the Victorian Imagination*, Berkeley, 1977, pp. 54-55.

UNIDENTIFIED PHOTOGRAPHER

1. Charles Darwin, *On the Origin of Species, by Means of Natural Selection; or the Preservation of Favored Races in the Struggle for Life*, London, 1860, p. 484.

2. Anon., reprinted in *Littell's Living Age*, LXVI, 848 (1 September 1860), p. 517.

3. A copy of Fenton's photograph is presently in the J. Paul Getty Museum, formerly in the collection of Sam Wagstaff; cf. Margarett Loke, "Collecting's Big Thrill is the Chase," *The New York Times Magazine*, 17 March 1985, p. 43.

UNIDENTIFIED PHOTOGRAPHER

1. Michael Riffaterre, "Descriptive Imagery," in *Yale French Studies*, issue entitled "Towards a Theory of Description," LXI (1981), p. 107.

2. Cf. also Roland Barthes, *L'Empire des signes*, Paris, 1970, *passim*.

ERNEST EDWARDS

1. John Ruskin, *Modern Painters*, London, 1856, IV, p. 325.

2. Cf. *op. cit.*, pl. 48, "Bank of Slaty Crystallines," facing p. 307.

UNIDENTIFIED PHOTOGRAPHER

1. William Lake Price, "On Composition and Chiaro-scuro—XI," *The Photographic News*, III, 86 (27 April 1860), p. 407.

VICTOR PREVOST

1. Cf. Eugenia Parry Janis, entry for Prevost, in André Jammes and Eugenia Parry Janis, *The Art of French Calotype*, Princeton, 1983, p. 236.

GEORGE WASHINGTON WILSON

1. Oliver Wendell Holmes, "The Stereoscope and the Stereograph," *The Atlantic Monthly*, 3 (June 1859), reprinted in Beaumont Newhall (ed.), *Photography: Essays & Images*, New York, 1980, pp. 56-57.

2. Roger Taylor, *George Washington Wilson: Artist & Photographer, 1823-93*, Aberdeen, 1981, p. 66.

3. Cf. *ibid.*, pp. 174-75.

4. Anon., "Sketches of Prominent Photographers. No. 8. George Washington Wilson," *The Photographer's Friend*, II (April 1872), pp. 48-49.

5. Cf. Roger Taylor, *op. cit.*, pl. 203, *Abbotsford, from the Tweed*, no. 358.

XAVIER MERIEUX

1. Felix Klee (ed.), *The Diaries of Paul Klee, 1898-1918*, Berkeley, 1964, no. 677, p. 185.

DELMAET and (EDOUARD?) DURANDELLE

1. Cited in Monika Steinhauser et al., *Petite encyclopédie illustrée de l'Opéra de Paris*, 2nd ed., Paris, 1978, p. 17.

2. Cf. Bernard Marbot and Weston J. Naef, *After Daguerre: Masterworks of French Photography (1848-1900) from the Bibliothèque Nationale*, New York, 1980, cat. nos. 50-51.

3. Cited in Marshall Berman, *All That Is Solid Melts into Air: The Experience of Modernity*, New York, 1982, p. 95.

PIALLAT

1. Lemercier, Lerebours, Barreswil, and Davanne, *Lithophotographie ou impressions obtenues sur pierre à l'aide de la photographie*, London and Paris, 1854; cf. also Bibliothèque Nationale, *Une invention du XIXe siècle: La photographie*, text by Bernard Marbot, Paris, 1976, cat. no. 277.

2. Cf. *Photographische Archiv*, III (1862), p. 243; cited in Wolfgang Baier, *Quellendarstellungen zur Geschichte der Fotografie*, Halle (Saale), 1964, pp. 291, 518.

3. Cf. Gabriel P. Weisberg, *The Realist Tradition: French Painting and Drawing, 1830-1900*, Cleveland, 1980, cat. no. 41, pp. 75-76.

EDOUARD (?) DURANDELLE

1. Cf. Eugenia Parry Janis, entry for Delmaet and Durandelle, in Philadelphia Museum of Art, et al., *The Second Empire: Art in France under Napoleon III*, Philadelphia, 1978, cat. no. VIII-10, pp. 409-10.

2. Cf. Eugenia W. Herbert, *The Artist and Social Reform: France and Belgium, 1885-1898*, New Haven, 1961, pp. 1-2, *passim*.

3. Cf. Félix-Paul Codaccioni, "De la prospérité impériale à la Belle Epoque (1851-1914)," in Louis Trenard (ed.), *Histoire des Pays-Bas Français*, Toulouse, 1972, pp. 421-52.

FELIX BONFILS

1. Félix Bonfils, *Catalogue des vues photographiques de l'Orient . . .* , Alais, 1876, p. 15, no. 239 in format 24/30; cf. also A. Guiragossian, *Catalogue général des vues photographiques de l'Orient . . .* , Beirut, n.d., p. 32, no. 397 in format 24/30; the differences in numbering are not unusual in various editions of 19th-century photographic trade catalogues.

2. Cited in Edward W. Said, *Orientalism*, New York, 1978, p. 108; for a critique of the Europocentrist view of the Orient, see *ibid.*, chaps. 1 and 4.

3. Cited and translated in Robert A. Sobieszek, "La Maison Bonfils," *American Photographer*, IV, 5 (November 1980), p. 54; also cf. Robert A. Sobieszek and Carney E. S. Gavin, *Remembrances of the Near East: The Photographs of Bonfils, 1867-1907*, exhibition catalogue, Rochester (IMP/GEH), 1980, unp.

LALA DEEN DAYAL [RAJA]

1. From Dayal's memoirs, cited in Clark Worswick, *Princely India: Photographs by Raja Deen Dayal, 1884-1910*, New York, 1980, p. 19.

2. *Ibid.*, p. 19.

3. Cf. *ibid.*, p. 30.

CARLETON E. WATKINS

1. H. T. Tuckerman, *Book of the Artist*, (1867), New York, 1966, p. 395, cited in Barbara Novak, "Grand Opera and the Small Still Voice," *Art in America*, LIX, 2 (March-April 1971), p. 67.

2. Cf. Peter Palmquist, *Carleton E. Watkins, Photographer of the American West*, Albuquerque, 1983, pp. 33-35.

3. Cf. Peter Palmquist, *op. cit.*, pl. 32; the print is in the collection of the Gilman Paper Company, New York.

TIMOTHY H. O'SULLIVAN

1. Cf. William A. Frassanito, *Gettysburg: A Journey in Time*, New York, 1975, pp. 226-29.

2. John Ruskin, *Modern Painters*, IV ("Of Mountain Beauty"), London, 1856 pp. 105-6.

EADWEARD J. MUYBRIDGE

1. Cited in Mary V. Jessup Hood and Robert Bartlett Haas, "Eadweard Muybridge's Yosemite Valley Photographs, 1867-1872," *California Historical Society Quarterly*, XLII, 1 (March 1963), p. 10.

2. Cited in *ibid.*, p. 11.

3. Cited in *ibid.*, p. 18.

WILLIAM HENRY JACKSON

1. William Henry Jackson, *Time Exposure*, New York, 1940, p. 186.

2. Cf. E. H. Gombrich, "The Renaissance Theory of Art and the Rise of Landscape," *Norm and Form: Studies in the Art of the Renaissance*, London, 1966, pp. 107-21.

3. Herman Melville, *Moby-Dick*, (New York, 1851); cited in Leo Marx, *The Machine in the Garden*, New York, 1967, pp. 294-95.

OSCAR GUSTAVE REJLANDER

1. Cf. Gillian Wagner, "A Man of Tender Violence," in National Portrait Gallery, *The Camera and Dr. Barnardo*, texts by Gillian Wagner and Valerie Lloyd, London, n.d. [1974], p. 4.

2. A. H. Wall, "On Taking Picturesque Photographs," *The British Journal of Photography*, XIV, 364 (26 April 1867), p. 195.

3. Cf. Edgar Yoxall Jones, *Father of Art Photography: Oscar Gustave Rejlander 1813-1875*, Newton Abbot, 1973, p. 27.

4. A. H. Wall, "Rejlander's Photographic Art Studies, Their Teachings and Suggestions," *The Photographic News*, XXX, 1466 (8 October 1886), p. 652; reprinted in Peter C. Bunnell, *The Photography of O. G. Rejlander*, New York, 1979, unp.

5. Charles Dickens, *Bleak House*, (London, 1853), Boston, 1965, p. 113.

JOHN THOMSON

1. John Thomson, "Proverbial Photographic Philosophy," *The British Journal Photographic Almanac, and Photographer's Daily Companion*, 1875, p. 128.

2. Adolphe Smith and John Thomson, "Preface," *Street Life in London*, London, 1877-78, p. [6].

3. *Ibid.*, p. 9.

4. *Loc. cit.*

THOMAS ANNAN

1. Cited in M. F. Harker, "Annans of Glasgow," *The British Journal of Photography*, CXX, 5909 (19 October 1973), p. 966.

HENRY DIXON

1. Rev. F. A. S. Marshall, *Photography: The Importance of Its Application in Preserving Pictorial Records of the National Monuments of History and Art*, London, 1855, p. 17; cited in Gertrude Mae Prescott, "Architectural Views of Old London," *The Library Chronicle of the University of Texas at Austin*, NS, 15 (1981), p. 27, n. 2.

CHAPTER 3

LOUIS DUCOS DU HAURON

1. Charles Cros, *Solution générale du problème de la photographie des couleurs*, Paris, 1869, p. 1; this pamphlet reprinted an article that first appeared in *Les Mondes*, 25 February 1869.

2. Cited in Bibliothèque Nationale, *Une invention du XIXe siècle: La photographie*, Paris, 1976, cat. no. 220, p. 61.

3. L. Ducos du Hauron, *Les couleurs en photographie: Solution du problème*, Paris, 1869, p. 7.

4. L. Ducos du Hauron, *Le Transformisme en photographie par le pouvoir de deux fentes*, Algiers, 1889.

PETER HENRY EMERSON

1. This connection is brilliantly established in Kenneth McConkey, "Rustic Naturalism in Britain," in Gabriel P. Weisberg (ed.), *The European Realist Tradition*, Bloomington, 1982, pp. 215-28.

2. London Stereoscopic & Photographic Co., *A Selection of Prize Pictures from the London Stereoscopic and Photographic Exhibition*, London, 1886, fol. 11r; a copy of this published album is in the museum's collection.

3. Cf. Robert L. Herbert, "City vs. Country: The Rural Image in French Painting from Millet to Gauguin," *Artforum*, VIII, 6 (February 1970), p. 51.

4. André Theuriet, *Rustic Life in France*, trans. by Helen B. Dole, New York, 1896, pp. 49-50.

5. Cited in Peter Turner and Richard Wood, *P. H. Emerson, Photographer of Norfolk*, Boston, 1974, p. 108.

ALFRED STIEGLITZ

1. Cited in Dorothy Norman, "Alfred Stieglitz, Introduction to an American Seer," *Aperture*, VIII, 1 (1960), p. 9.

2. Cf. Neil Leonard, "Alfred Stieglitz and Realism," *The Art Quarterly*, XXIX, 3-4 (1966), pp. 277-86; cf. also Edward Lucie-Smith and Celestine Dars, *Work and Struggle: The Painter as Witness*, New York, 1977, pls. 175, 181.

3. James Joyce, *Stephen Hero*, (ca. 1903), New York, 1963, pp. 211-13.

4. Cited in Charles Caffin, *Photography as a Fine Art*, New York, 1901, p. 36.

HILAIRE GERMAIN EDGAR DEGAS

1. Paul Valéry, *Degas Manet Morisot*, trans. by David Paul, New York, 1960, p. 40.

2. Daniel Halévy, *My Friend Degas*, trans. by Mina Curtiss, Middletown (Conn.), 1964, p. 83.

3. Jean Cocteau, *Secrèt professionnel*, cited in Luce Hoctin, "Degas photographe," *Oeil*, 65 (May 1960), p. 40.

4. Degas to Tasset, 17 August 1895, trans. in Beaumont Newhall, "Degas: Amateur Photographer," *Image*, V, 6 (June 1956), p. 126.

5. Emile Verhaeren, "Silhouettes d'artistes, Fernand Khnopff," *L'Art Moderne*, (12 September 1886), p. 290; cited and trans. in Francine-Claire Legrand, "The Symbolist Movement," in The Brooklyn Museum, *Belgian Art: 1880-1914*, Brooklyn, 1980, pp. 57-58.

JOSEF MARIA EDER and EDUARD VALENTA

1. Cited and trans. in Josef Maria Eder, *History of Photography*, trans. by Edward Epstean, New York, 1945, pp. 384-85.

2. Umberto Boccioni et al., *Futurist Painting: Technical Manifesto*, English version, London, 1912, in Umbro Apollonio (ed.), *Futurist Manifestos*, New York, 1973, p. 28.

3. László Moholy-Nagy, "Space-Time and the Photographer," *American Annual of Photography*, 1942, in Richard Kostelanetz (ed.), *Moholy-Nagy*, New York, 1970, p. 61.

ALFRED HORSLEY HINTON

1. Clive Holland, "Artistic Photography in Great Britain," *The Studio*, special summer number, *Art in Photography*, (1905), pp. GB 6-7.

2. A. Horsley Hinton, "Individuality—Some Suggestions for the Pictorial Worker," *The Photographic Times*, XXXI, 1 (January 1899), pp. 12-19; reprinted in Peter C. Bunnell, *A Photographic Vision: Pictorial Photography, 1889-1923*, Salt Lake City, 1980, p. 75.

3. A. Horsley Hinton, "Naturalism in Photography," *Camera Notes*, IV, 2 (October 1900), pp. 83-91; reprinted in P. Bunnell, *op. cit.*, p. 138.

ALEXANDER KEIGHLEY

1. J. Dudley Johnston, "The Art of Alexander Keighley, Hon. FRPS," *The American Annual of Photography—1949*, LXIII, Boston, 1948, p. 8.

2. Joseph T. Keiley, "The Linked Ring . . . ," *Camera Notes*, V, 2 (October 1901), p. 113.

3. J. Dudley Johnston, *loc. cit.*

F. HOLLAND DAY

1. Cf. Editorial, "Sacred Art and the Camera," *The Photogram*, VIII, 88 (April 1901), p. 91.

2. Cf. Estelle Jussim, *Slave to Beauty*, Boston, 1981, p. 122.

3. Frederick H. Evans, unpublished typescript, International Museum of Photography at George Eastman House; cited in Estelle Jussim, *op. cit.*, p. 127.

4. Cited in *ibid.*, p. 126.

5. Cf. Editorial, "Sacred Art and the Camera," *The Photogram*, VI, 64 (April 1899), pp. 97-99.

6. F. Holland Day, "Sacred Art and the Camera," *The Photogram*, VI, 62 (February 1899), p. 38.

7. Frederick H. Evans, letter to editors, *British Journal of Photography* (2 November 1900), pp. 702-3; cited in Estelle Jussim, *op. cit.*, pp. 133-34.

EMILE JOACHIM CONSTANT PUYO

1. C. Puyo, "Concerning the Use of Artificial Light Combined with Daylight," *The Photographic Times*, XXXI, 1 (January 1899), pp. 34-41.

2. C. Puyo, *op. cit.*, pp. 37-38, fig. D.

3. R. de la Sizeranne, *La Photographie est-elle une art?*, Paris, 1899, pp. 48-49, illus.

4. C. Puyo, "La Photographie d'intérieur," in Paul Bourgeois (ed.), *Esthétique de la photographie*, Paris, 1900, p. 48.

5. Jean Lorrain, "Pour Oscar Wilde," cited and trans. in Philippe Jullian, *Dreamers of Decadence*, trans. by Robert Baldick, New York, 1971, p. 244.

GUIDO REY

1. [E.J.] C. Puyo, "Le Passé source d'inspiration," *Le Revue de photographie*, II (1904), p. 8.

LEON ROBERT DEMACHY

1. Robert Demachy, "What Difference Is There Between a Good Photograph and an Artistic Photograph?" *Camera Notes*, III, 2 (October 1899), p. 48.

2. R. Demachy, *loc. cit.*

3. Alfred Maskell and Robert Demachy, *Le Procédé à la gomme bichromatée ou photo-aquateinte*, Paris, 1905, p. 82.

4. Anon., "M. Demachy's Pictures," *The Photographic Art Journal*, II, 16 (15 June 1902), p. 74.

5. Cited in Jean Pierrot, *The Decadent Imagination, 1880-1900*, trans. by Derek Coltman, Chicago, 1981, p. 87.

GERTRUDE STANTON KASEBIER

1. Arthur W. Dow, "Mrs. Gertrude Käsebier's Portrait Photographs, From a Painter's Point of View," *Camera Notes*, III, 1 (July 1899), p. 22.

2. J. T. K., "Mrs. Käsebier's Prints," *Camera Notes*, III, 1 (July 1899), p. 34.

3. Cited in Giles Edgerton [Mary Fanton Roberts], "Photography as an Emotional Art: A Study of the Work of Gertrude Käsebier," *The Craftsman*, XII, 1 (April 1907), p. 88; cf. also Barbara L. Michaels, "Rediscovering Gertrude Käsebier," *Image*, XIX, 2 (June 1976), pp. 20-32.

CLARENCE HUDSON WHITE

1. Paul Strand, "Photography," *Camera Work*, 49/50 (1917), p. 3

2. Cf. Minneapolis Institute of Arts, *Victorian High Renaissance*, Minneapolis, 1978, pp. 129-55.

3. The painting is in the collection of the Museum of Fine Arts, Boston; cf. Robert Rosenblum and H. W. Janson, *19th Century Art*, New York, 1984, pl. 303, p. 380.

SAMUEL J. CASTNER

1. George Santayana, "The Photograph and the Mental Image," in Vicki Goldberg (ed.), *Photography in Print: Writings from 1816 to the Present*, New York, 1981, pp. 259-60.

UNIDENTIFIED PHOTOGRAPHER

1. N. Gogol, "Nevsky Prospect," cited and translated in Marshall Berman, *All That Is Solid Melts into Air: the Experience of Modernity*, New York, 1982, p. 196.

FREDERICK H. EVANS

1. Frederick H. Evans, "Camera-Work in Cathedral Architecture," *Camera Work*, 4 (October 1903), p. 21.

2. In his *Journal* for 15 May 1835; cited in Geneviève Viollet-le-Duc, et al., *Le Voyage d'Italie d'Eugène Viollet-le-Duc, 1836-1837*, Florence, 1980, cat. no. 7, p. 40.

3. Frederick H. Evans, "Wells Cathedral," *Photography*, (18 July 1903), pp. 65-67; cited in Beaumont Newhall, *The History of Photography from 1839 to the Present*, rev. ed., New York, 1982, p. 151.

4. Cf. Gabriel Weisberg, et al., *Japonisme: Japanese Influence on French Art, 1854-1910*, Cleveland, 1975, cat. nos. 67a and 67b, p. 71.

CARL CHRISTIAN HEINRICH KUHN

1. A. Horsley Hinton, "Pictorial Photography in Austria and Germany," *The Studio*, special summer number, *Art in Photography*, (1905), p. G 7.

2. *Ibid.*, p. G 3.

3. Cf. Ronald J. Hill, "Kühn and Stieglitz," in Rudolf Kicken (ed.), *An Exhibition of One Hundred Photographs by Heinrich Kühn*, Cologne, 1981, pp. 67-73; also cf. Peter Galassi, "Heinrich Kühn 1866-1944," in Lunn Gallery, *Catalogue 6: Photo-Secession*, Washington, 1977, pp. 39-42; about 200 letters are conserved in the Stieglitz Archive, Beinecke Rare Book and Manuscript Library, Yale University, New Haven, Conn.

4. F. Matthies-Masuren, "Forward—'Secession,'" in *Secession. Offizieller Katalog der Internationalen Elite-Ausstellung Künstlerischer Photographien, München*, Munich, 1898, pp. ix-xvi; trans. in Peter C. Bunnell, *A Photographic Vision: Pictorial Photography, 1889-1923*, Salt Lake City, 1980, (pp. 91-93), p. 91.

5. *Ibid.*, p. 92.

6. Cited in F. Matthies-Masuren, "Hugo Henneberg—Heinrich Kühn—Hans Watzek," *Camera Work*, 13 (January 1906), p. 28.

7. Cf. Carle Schorske, *Fin-de-Siècle Vienna: Politics and Culture*, New York, 1981, p. 219.

ANNE W. BRIGMAN

1. Joseph T. Keiley, "The Buffalo Exhibition," *Camera Work*, 33 (1911), in Jonathan Green (ed.), *Camera Work: A Critical Anthology*, Millerton (NY), 1973, p. 210.

2. H. Snowdon Ward, "Work of the Year," *Photograms of the Year*, 1909, p. 93.

3. Thomas Bullfinch, *The Age of Fable, or Beauties of Mythology*, Philadelphia, 1898, p. 32.

4. Maurice Maeterlinck, *The Intelligence of Flowers*, trans. by Alexander Teixeira de Mattos, Toronto, 1907, pp. 178-79.

WILHELM VON GLOEDEN

1. Jean Pierrot, *The Decadent Imagination, 1880-1900*, trans. by Derek Coltman, Chicago, 1981, p. 143.

2. W. I. Lincoln Adams, *In Nature's Image: Chapters on Pictorial Photography*, 2nd ed., New York, 1898, pp. 65-66.

3. Roland Barthes, *Wilhelm von Gloeden . . .* , Naples, 1978, p. 12.

PAUL LEWIS ANDERSON

1. Henry R. Poore, *Pictorial Composition and the Critical Judgment of Pictures*, 11th ed., New York, 1903, p. 180.

2. Paul L. Anderson, *The Fine Art of Photography*, Philadelphia, 1919, pp. 20-21.

3. *Ibid.*, p. 24.

4. *Ibid.*, p. 90.

CHARLES SHEELER

1. Charles Sheeler, "Recent Photographs by Alfred Stieglitz," *The Arts*, 3 (May 1923), p. 345.

2. Cf. John Pultz and Catherine B. Scallen, *Cubism and American Photography, 1910-1930*, Williamstown (Mass.), 1981, p. 29 and *passim*.

3. Cf. William S. Lieberman (ed.), *Art of the Twenties*, New York, 1979, p. 133.

4. William Carlos Williams, "Introduction," [to *Charles Sheeler—Paintings—Drawings—Photographs* (1939)], in *Selected Essays of William Carlos Williams*, New York, 1954, pp. 232-33.

MORTON LIVINGSTON SCHAMBERG

1. William Henry Fox Talbot, "View of the Boulevards at Paris," *The Pencil of Nature*, London, 1844–46, pl. II, unp.

2. Harold Clurman, "Alfred Stieglitz and the Group Idea," in Waldo Frank, et al. (eds.), *America & Alfred Stieglitz: A Collective Portrait*, New York, 1934, p. 273.

3. M. de Zayas, [Comment], *291*, 7-8 (September-October 1915), [p. 1].

ALVIN LANGDON COBURN

1. Ezra Pound, "Vortographs," Appendix IV, in *Pavannes and Divisions*, 1918, an abridged version of his introduction to the London Camera Club catalogue of 1917, cited in Nancy Newhall (ed.), *A Portfolio of Sixteen Photographs by Alvin Langdon Coburn*, Rochester (NY), 1962, p. 14.

2. Alvin Langdon Coburn, "The Future of Pictorial Photography," *Photograms of the Year 1916*, reprinted in Beaumont Newhall (ed.), *Photography: Essays and Images*, New York, 1980, p. 205.

3. Ezra Pound to John Quinn (24 January 1917), *The Selected Letters of Ezra Pound, 1907-1941*, ed. by D. D. Paige, New York, 1971, p. 104.

FRANTISEK DRTIKOL

1. Cf. Rudolf Skopec, "František Drtikol," *Creative Camera*, 93 (March 1972), p. 518.

2. From *Les artistes d'aujourd'hui*, (February 1926), trans. in Daniela Mrázková, "František Drtikol," in Rudolf Kicken Galerie and Robert Miller Gallery, *Drtikol*, Cologne and New York, 1983, p. 8.

3. André Bréton, "Situation Surréaliste de l'objet," in *Manifestes du Surréalisme*, Paris, 1962, p. 305.

EDWARD HENRY WESTON

1. Edward Weston, "Photography—Not Pictorial," *Camera Craft*, XXXVII, 7 (July 1930), reprinted in Edward Weston, *On Photography*, ed. by Peter C. Bunnell, Salt Lake City, 1983, p. 59.

2. Edward Weston, "Statement," *Exhibition of Photographs/Edward Weston*, New York, 1932, reprinted in Edward Weston, *On Photography*, *op. cit.*, p. 70.

3. Edward Weston, "America and Photography," ms. for German text, "Amerika und Fotografie," in Gustav Stotz (ed.), *Internationale Ausstellung des Deutschen Werkbunds Film und Foto*, Stuttgart, 1929, reprinted in Edward Weston, *On Photography*, *op. cit.*, p. 56.

4. Cf. Ben Maddow, *Edward Weston: Fifty Years*, Millerton (NY), 1973, pp. 43-44.

5. Cf. *ibid.*, p. 40.

PAUL EVERARD OUTERBRIDGE, JR.

1. Cited in Graham Howe (ed.), *Paul Outerbridge, Jr: Photographs*, New York, 1980, p. 11.

2. William Carlos Williams, "Prologue to *Kora in Hell*," (1920), *Selected Essays of William Carlos Williams*, New York, 1954, p. 11.

JEAN-EUGENE-AUGUSTE ATGET

1. John Fraser, "Atget and the City," *The Cambridge Review*, III, 3 (Summer 1968), p. 201.

2. Ansel Adams in *The Fortnightly*, I, 5 (6 November 1931), p. 25, cited in John Szarkowski, "Atget and the Art of Photography," in John Szarkowski and Maria Morris Hambourg, *The Work of Atget*, I, *Old France*, New York, 1981, p. 24.

3. John Szarkowski, "Atget and the Art of Photography," *op. cit.*, p. 26.

4. Cf. Jean Leroy, "Atget et son temps, 1857-1927," *Terre d'images*, v/vi, 3 (1964), p. 369.

5. Paul Eluard, "Le Miroir d'un moment," *Capitale de la douleur*, (Paris, 1926), *Capitale de la douleur, suivi de l'amour la poésie*, Paris, 1964, p. 128.

EDWARD SHERIFF CURTIS

1. Sidney Allan [Pseud.], "E. S. Curtis, Photo Historian," *Wilson's Photographic Magazine*, xliv (August 1907), reprinted in Sadakichi Hartmann, *The Valiant Knights of Daguerre: Selected Critical Essays on Photography and Profiles of Photographic Pioneers*, ed. by Harry W. Lawton and George Knox, Berkeley and Los Angeles, 1978, pp. 267-70.

2. Caption for plate 634, in Edward S. Curtis, *The North American Indian . . .* , xviii (portfolio), Cambridge (Mass.), 1926, unp.

LASZLO MOHOLY-NAGY

1. Franz Roh, "mechanism and expression: the essence and value of photography," in Franz Roh and Jan Tschichold (eds.), *foto-auge*, Stuttgart, 1929, pp. 17-18.

2. László Moholy-Nagy, *Painting Photography Film*, trans. by Janet Seligmann, Cambridge, 1969, p. 113.

3. László Moholy-Nagy, *op. cit.*, p. 37.

4. László Moholy-Nagy, *Vision in Motion*, Chicago, (1947) 1961, p. 212.

ALEXANDER MIKHAILOVICH RODCHENKO

1. Cf. Alexander Rodchenko, "Rodchenko's System," trans. in J. E. Bowlt (ed.), *Russian Art of the Avant-Garde: Theory and Criticism, 1902-1934*, New York, 1976, p. 149.

2. Ossip Brik, "Photography Versus Painting," *Sovetskoi Foto*, 2 (1926), trans. in David Elliott (ed.), *Rodchenko and the Arts of Revolutionary Russia*, Oxford and New York, 1979, p. 91.

3. Ossip Mandelstam, "Tempest and Passion," *Rousskoe iskousstvo*, 1 (1923), reprinted in Centre Georges Pompidou, *Art et poésie russes, 1900-1930, textes choisis*, Paris, 1979, p. 174.

AUGUST SANDER

1. Alfred Döblin, "About Faces, Portraits and their Reality," *Antlitz der Zeit*, (1929), trans. in David Mellor (ed.), *Germany: The New Photography, 1927-33*, London, 1978, p. 58.

2. Alfred Döblin, *op. cit.*, p. 59.

3. Cf. Richard Pommer, "August Sander and the Cologne Progressives," *Art in America*, lxiv, 1 (January-February 1976), pp. 38-39; an important article for the understanding of Sander's work.

EDUARD [EDWARD] JEAN STEICHEN

1. Edward Steichen, *A Life in Photography*, New York, 1963, unp.

2. Alexander Liberman, "Steichen's Eye," *Vogue*, (1 August 1959), reprinted in The Museum of Modern Art, *Steichen the Photographer*, New York, 1961, p. 12.

HELMAR LERSKI
[ISRAEL SCHMUKLERSKI]

1. From *Der Kinematograph*, (19 July 1916), trans. in Ute Eskildsen and Jan-Christopher Horak, "Israel Schmuklerski/Helmar Lerski 1871-1956: Schauspieler, Fotograf und Filmer," in Museum Folkwang, *Helmar Lerski, Lichtbildner: Fotografien und Filme, 1910-1947*, Essen, 1982, p. 23.

2. Curt Glaser, "Introduction to Helmar Lerski," *Köpfe des Alltags*, in David Mellor (ed.), *Germany: The New Photography, 1927-33*, London, 1974, p. 63.

3. Kenneth Macpherson, "As Is," *Close Up*, (19 September 1931), trans. in *ibid.*, pp. 67-68.

IMOGEN CUNNINGHAM

1. Das Deutschen Werkbunds, *Film und Foto*, Stuttgart, 1929, p. 56.

2. John Paul Edwards, "Group f.64," *Camera Craft*, 42 (March 1935), p. 107.

3. *Ibid.*, p. 113.

4. Carl Georg Heise, [Preface to Albert Renger-Patzsch, *Die Welt ist schön*], trans. in David Mellor (ed.), *Germany: The New Photography, 1927-33*, London, 1978, p. 9.

ERICH SALOMON

1. Erich Salomon, *Berühmte Zeitgenossen in unbewachten Augenblicken*, Stuttgart, 1931, trans. in Beaumont and Nancy Newhall, *Masters of Photography*, New York, 1958, p. 134.

2. Walter Benjamin, "A Short History of Photography," trans. by Kingsley Shorter in David Mellor (ed.), *Germany—The New Photography, 1927-33*, London, 1978, p. 75.

ROBERT CAPA
[ANDREI FRIEDMANN]

1. Cf. Cecil Beaton and Gail Buckland, *The Magic Image: The Genius of Photography from 1839 to the Present Day*, Boston, 1975, p. 175. The photograph was originally published in the Sunday pictorial supplement, *Der Welt Spiegel*, to the newspaper *Berliner Tageblatt* on 11 December 1932; I am greatly indebted to Mr. Richard Whelan of New York for this information.

2. Cf. *ibid.*, p. 174.

3. Edmund Wilson, *To the Finland Station: A Study in the Writing and Acting of History*, (1940), New York, 1972, pp. 493-94.

LEWIS WICKES HINE

1. Elizabeth McCausland, "Two Exhibitions of a 'Photographic Season,'" *Springfield Sunday Union and Republican*, (8 January 1939), p. 6e.

2. Cf. William Stott, *Documentary Expression and Thirties America*, New York, pp. 8-12.

3. Lewis W. Hine, "Social Photography, How the Camera May Help in the Social Uplift," *Proceedings, National Conference of Charities and*

Corrections, (June 1909), in Alan Trachtenberg (ed.), *Classic Essays on Photography*, New Haven, 1980, p. 111.

4. Lewis W. Hine, *loc. cit.*

5. Cited in Judith Mara Gutman, *Lewis W. Hine and the American Social Conscience*, New York, 1967, p. 39.

6. Sheldon Cheney, *The New World of Architecture*, New York, 1930, p. 120.

BERENICE ABBOTT

1. Audrey McMahon, "Changing New York," in Berenice Abbott, *Changing New York*, New York, 1939, pp. vi-vii.

2. Elizabeth McCausland, "The Photography of Berenice Abbott," *Trend*, III (March-April 1935), reprinted in Marlborough Gallery and Lunn Gallery/Graphics International, *Berenice Abbott*, 1976, unp.

3. *Loc. cit.*

HENRI CARTIER-BRESSON

1. Henri Cartier-Bresson, [Introduction], *The Decisive Moment*, New York, 1952, unp.

2. Reyner Banham, "The New Brutalism," *Architectural Review*, CXVIII (December 1955), p. 358.

3. This is especially true in comparing Cartier-Bresson's unpublished project for a book of American images in 1947 with Frank's *The Americans* of 1959; see Henri Cartier-Bresson, "Coup d'Oeil Americain," texts by Lincoln Kirstein and Allan Porter, *Camera*, LV, 7 (July 1976), pp. 3-46; I would like to thank Lawrence Merrill for this reference.

BRASSAI [GYULA HALASZ]

1. Cited in Lawrence Durrell, [Introduction], *Brassaï*, New York, 1968, pp. 11-12.

2. Cited in *ibid.*, p. 13.

3. Joris-Karl Huysmans, *A rebours*, (1884), trans. by Robert Baldick, Baltimore, 1959, p. 175; cited in Theodore Reff, *Manet and Modern Paris*, Washington, 1982, p. 75.

CECIL WALTER HARDY BEATON

1. Cf. Thomas Barrow, "600 Faces By Beaton, 1928–69," *Aperture*, XV, 2 (Summer 1970), unp.

2. Nancy Hall-Duncan, *The History of Fashion Photography*, New York, 1979, p. 108.

3. Hilton Kramer, "The Dubious Art of Fashion Photography," *New York Times*, (28 December 1975), p. 28; cited in *ibid*, p. 108.

4. Cecil Beaton, "Introduction," in Victoria and Albert Museum, *Fashion: An Anthology by Cecil Beaton*, London, 1971, p. 7.

MAN RAY
[EMMANUEL RUDNITSKY (?)]

1. Man Ray, "The Age of Light," in James Thrall Soby, *Photographs by Man Ray: 105 Works, 1920-1934*, New York, 1979, unp.

2. Man Ray, "It Has Never Been My Object . . . ," (1945), in Arturo Schwarz (ed.), *Man Ray: 60 Years of Liberties*, Milan, 1971, p. 48.

3. Paul Eluard, "Man Ray," in James Thrall Soby, *op. cit.*, p. 24.

FLORENCE HENRI

1. Fernand Léger, "The Machine Aesthetic: Geometric Order and Truth," (1925), in Fernand Léger, *Functions of Painting*, ed. by Edward F. Fry, trans. by Alexandra Anderson, New York, p. 64.

2. László Moholy-Nagy, *The New Vision* (1928), in *The New Vision and Abstract of an Artist*, trans. by Daphne M. Hoffman, Chicago, 1947, pp. 38-39.

3. Waldemar George, "Photographie: Vision du monde," *Arts et métiers graphiques*, 16 (Photographie), (15 March 1930), pp. 138-40; two of Florence Henri's compositions appeared on p. 32 of this issue, one of which utilized a mirror reflection.

PAUL STRAND

1. Susan Sontag, "Freak Show," *The New York Review of Books*, XX, 18 (15 November 1973), p. 13, n. 1.; interestingly, this comment was omitted when this article appeared as part of her book, *On Photography*, New York, 1977, cf. p. 29.

2. [Alfred Stieglitz], "Our Illustrations," *Camera Work*, 49/50 (June 1917), p. 36.

3. Gustave Flaubert, *Extraits de la correspondance, ou Préface à la vie d'écrivain*, ed. by G. Bollème, Paris, 1963, no. 524, p. 188; trans. in George J. Becker, *Documents of Modern Literary Realism*, Princeton, 1963, pp. 94-95.

4. Cited in Calvin Tomkins, "Profiles: Look to the Things Around You," *New Yorker*, L, 30 (16 September 1974), p. 45.

5. Cited in Calvin Tomkins, *op. cit.*, p. 44.

VINICIO PALADINI

1. Cf. Giovanni Lista, "Paladini," in Musée d'art moderne, *Photographie futuriste italienne, 1911–1939*, Paris, 1981, p. 84.

2. Cf. Musée d'art moderne, et al., *Léger et l'Esprit moderne*, texts by Gladys C. Fabre, et al., Paris, 1982, pp. 321-27.

JOHN PAUL PENNEBAKER

1. A Century of Progress International Exposition, *Official Guide Book of the World's Fair of 1934*, Chicago, 1934, *passim*.

HANS BELLMER

1. Alain Robbe-Grillet, "A Voyeur in the Labyrinth," *Evergreen Review*, 43 (October 1966), p. 47; cited in Robert A. Sobieszek, "Addressing the Erotic: Reflections on the Nude Photograph," in Constance Sullivan (ed.), *Nude: Photographs, 1850-1980*, New York, 1980, p. 171.

2. Hans Bellmer, "La Poupée," *Cahiers d'Art*, (1936), reprinted in *Obliques, Bellmer*, special number, Paris, n.d. [1979], p. 65; cf. also Marcel Jean, *The History of Surrealist Painting*, trans. by Simon Watson Taylor, New York, 1960, p. 242, n. 1.

3. Cited in Timothy Baum, "Hans Bellmer," *G. Ray Hawkins Gallery Photo Bulletin*, IV, 8 (December 1981), [p. 4].

JOHN HEARTFIELD [HELMUT HERZFELD]

1. George Grosz, "Randzeichnungen zum Thema," *Blätter der Piscatorbühne*, Berlin, 1928; trans. in Peter Selz, "John Heartfield's Photomontages," in John Heartfield, *Photomontages of the Nazi Period*, New York, 1977, pp. 7-8.

2. Wieland Herzfelde, *John Heartfield: Leben und Werk*, Dresden, (1962), rev. ed. 1971, p. 24; trans. in *ibid.*, p. 11.

3. Louis Aragon, "John Heartfield et la beauté révolutionnaire," *Les Collages*, Paris, 1965, p. 81; this translation partially indebted to that in Peter Selz, *op. cit.*, p. 15.

LEJAREN A HILLER

1. Anon., "Glimpses of Men in the Public Eye," *Popular Science Monthly*, CXIV, 5 (May 1929), p. 131.

2. Arnold Sorvari, [Letter to the editor], *Camera Arts*, II, 1 (January-February 1972), pp. 8, 102.

3. Paul Benton or John H. Hewlett, "Plague and Prejudice," in Lejaren à Hiller, *Surgery Through the Ages, A Pictorial Chronical [sic]*, New York, 1944, p. 92.

GEORGES HUGNET

1. Cited in Georges Hugnet, "In the Light of Surrealism," in Alfred H. Barr, Jr. (ed.), *Fantastic Art, Dada, Surrealism*, New York, 1947, pp. 43-44.

2. Cited in Dawn Ades, *Dada and Surrealism Reviewed*, London, 1978, p. 289.

3. Georges Hugnet, *op cit.*, p. 51.

MANUEL ALVAREZ BRAVO

1. André Breton, "Souvenir du Mexique," *Minotaur*, VI, 12-13 (May 1939), p. 31.

2. *Ibid.*, p. 32.

3. A. D. Coleman, "Death in Many Forms," *The New York Times*, (18 July 1971), p. 14D.

4. Malcolm Lowry, *Under the Volcano*, New York, 1971, p. 253.

WEEGEE [ARTHUR FELLIG]

1. Weegee, *Weegee by Weegee: An Autobiography*, New York, 1961, cited in Louis Stettner, "Introduction," in Weegee, *Weegee*, New York, 1977, p. 11.

2. Cf. Colin L. Westerbeck, Jr., "Night Light: Brassaï and Weegee," *Artforum*, (December 1976); reprinted in Vicki Goldberg (ed.), *Photography in Print: Writings from 1816 to the Present*, New York, 1981, pp. 404-19.

3. Cf. John Coplans, "Weegee the Famous," *Art in America*, LXV, 5 (September-October 1977), p. 38.

ARTHUR ROTHSTEIN

1. Arthur Rothstein, "The Picture That Became a Campaign Issue," *Popular Photography*, (September 1961), cited in F. Jack Hurley, *Portrait of a Decade...*, Baton Rouge, 1972, p. 84.

2. Cited in Michael J. Arlen, "On the Trail of a 'Fine Careless Rapture,'" *The New Yorker*, (10 March 1980), p. 74.

MARGARET BOURKE-WHITE

1. Anon., "10,000 Montana Relief Workers Make Woopee on Saturday Night," *Life*, I, 1 (23 November 1936), p. 9.

DOROTHEA LANGE

1. Louis-Ferdinand Céline, *Journey to the End of the Night*, trans. by Ralph Manheim, New York, 1983, p. 80; for a parallel reading of this passage, cf. Julia Kristeva, *Powers of Horror: An Essay on Abjection*, trans. by Leon S. Roudiez, New York, 1982, p. 158.

2. Possibly six negatives; cf. Paul Taylor, [Text of lecture], in Eugenia Parry Janis and Wendy MacNeil (eds.), *Photography within the Humanities*, Danbury (NH), 1977, p. 38.

3. Dorothea Lange, "The Assignment I'll Never Forget," *Popular Photography*, XLVI (February 1960), reprinted in Beaumont Newhall (ed.), *Photography: Essays & Images*, New York, 1980, p. 264.

4. Cf. Paul Taylor, *op. cit.*, p. 41.

WALKER EVANS

1. John Szarkowski, "Introduction," in Walker Evans, *Walker Evans*, New York, 1971, pp. 17-18.

2. Cited in William Stott, *Documentary Expression and Thirties America*, London and New York, 1973, p. 261.

3. James Agee, *Let Us Now Praise Famous Men*, Boston, (1941) reedition 1960, p. 240.

FRANCIS BRUGUIERE

1. Francis Bruguière, "Creative Photography," *Modern Photography Annual*, 1935-36; reprinted in Nathan Lyons (ed.), *Photographers on Photography*, New York, 1966, p. 35.

2. Walter Chappell, "Francis Bruguière," *Art in America*, XLVII, 3 (Fall 1959), p. 59.

3. Cf. James L. Enyeart, *Bruguière: His Photographs and His Life*, New York, 1977, p. 158.

4. Cited in James L. Enyeart, *ibid.*, p. 52.

ANTON BRUEHL

1. Anon., "Mademoiselle Rachel," *Illustrated Times*, VIII (11 August 1855), p. 156.

2. Arsène Houssaye, *La Comédie française, 1680-1880*, Paris, 1880, p. 158.

3. Cf. fig. 70, entry for Cecil Beaton.

4. Cited in Joe Deal, "Anton Bruehl," *Image*, XIX, 2 (June 1976), p. 2.

5. Anon. in Anton Bruehl, "Dietrich by Bruehl," *Cinema Arts*, I, 3 (September 1937), p. 51.

HORST P. HORST

1. David Kunzle, *Fashion and Fetishism: A Social History of the Corset, Tight-Lacing, and Other Forms of Body-Sculpture in the West*, New York, 1982; cited in Anne Hollander, "A Tight Squeeze," *The New York Review of Books*, (4 March 1982), p. 21.

2. Anne Hollander, *op. cit.*, p. 21.

3. *Vogue*, (15 September 1939), p. 76; cited in Nancy Hall-Duncan, *The History of Fashion Photography*, New York, 1979, p. 64.

4. Kennedy Fraser, "Clothes as a Form of Magic: Photographing Style," *Vogue*, (September 1981), p. 431.

5. Roland Barthes, *The Fashion System*, trans. by Matthew Ward and Richard Howard, New York, 1983, p. 302.

6. In Scottish Arts Council and Victoria and Albert Museum, *Fashion, 1900-1939*, texts by Madge Garland, Valerie Lloyd, et al., London, 1975, cat. no. B245, p. 70.

CHAPTER 4

BARBARA MORGAN

1. Barbara Morgan, "Photomontage," in Willard D. Morgan and Henry M. Lester (eds.), *Miniature Camera Work*, New York, 1938, p. 145.

2. László Moholy-Nagy, "A New Instrument of Vision," *Telehor*, Brno, 1936, cited in Richard Kostelanetz (ed.), *Moholy-Nagy*, New York, 1970, p. 52.

3. László Moholy-Nagy, "Space-Time and the Photographer," *American Annual of Photography*, (1942), cited in *ibid.*, p. 63.

4. Barbara Morgan, *op. cit.*, p. 147.

GEORGE PLATT LYNES

1. George Platt Lynes, "Portraits Should Be Imaginative," *Minicam Photography*, VI, 6 (February 1943), p. [50].

2. Lincoln Kirstein, in The Art Institute of Chicago, *George Platt Lynes' Portraits, 1931-1952*, Chicago, 1960; reprinted in Jack Woody, *George Platt Lynes Photographs, 1931-1955*, Los Angeles, 1980, p. 79.

3. George Balanchine, [Statement], (1956), in Jack Woody, *op. cit.*, p. 105.

LISETTE MODEL
[ELISE FELIC AMELIE SEYBERT MODEL]

1. Berenice Abbott, "Introduction," in Lisette Model, *Lisette Model*, Millerton (NY), 1979, p. 9.

2. Edgar Allan Poe, "The Man of the Crowd," *The Complete Tales and Poems of Edgar Allan Poe*, New York, 1938, pp. 475-76.

3. *Ibid.*, p. 481.

KENNETH HEDRICH

1. Joseph W. Molitor, *Architectural Photography*, New York, 1976, p. 148.

2. P. Gapp, "The Exacting Business of Shooting Buildings," *Chicago Tribune Magazine*, (12 November 1978), p. 74.

BILL BRANDT

1. Bill Brandt, *Camera in London*, London and New York, 1948, pp. 14-15.

2. Cited in Patricia Bosworth, *Diane Arbus*, New York, 1984, p. 307.

ANSEL EASTON ADAMS

1. Ansel Adams, "Foreword," *Yosemite and the Range of Light*, Boston, 1979, p. 13.

2. Ralph Waldo Emerson, "Nature," in Brooks Atkinson (ed.), *The Selected Writings of Ralph Waldo Emerson*, New York, 1968, p. 35.

3. Ansel Adams, "A Personal Credo," *American Annual of Photography*, LVIII, (1944), in Nathan Lyons (ed.), *Photographers on Photography*, Englewood Cliffs (NJ), 1966, pp. 29-31.

FREDERICK SOMMER

1. Frederick Sommer, "Extemporaneous Talk," *Aperture* (1971), cited in Leland Rice, "Introduction," in The Art Museum and Galleries, California State University, *Frederick Sommer at Seventy-Five: A Retrospective*, Long Beach, 1980, pp. 9-13.

2. Matta, "Hellucinations," in Max Ernst, *Beyond Painting, and Other Writings by the Artist and His Friends*, New York, 1948, p. 194.

MINOR WHITE

1. Cf. Minor White, "Equivalence: The Perennial Trend," *PSA Journal*, XXIX, 7 (1963); reprinted in Nathan Lyons (ed.), *Photographers on Photography*, Englewood Cliffs (NJ), 1966, pp. 168-69.

2. Cited in Minor White, *Rites and Passages*, Millerton (NY), 1978, p. 87.

3. *Ibid.*, p. 12.

4. Minor White, *Mirrors/Messages/Manifestations*, New York, 1969, p. 81.

ALBERT RENGER-PATZSCH

1. Albert Renger-Patzsch, "Ziele," *Das Deutsche Lichtbild*, (1927), p. 18; trans. in Ute Eskildsen, "Photography and the Neue Sachlichkeit Movement," in David Mellor (ed.), *Germany: The New Photography, 1927-33*, London, 1978, p. 103.

2. Gustaf Stotz in *Das Kunstblatt*, (May 1929), trans. in Van Deren Coke, "Introduction," in San Francisco Museum of Modern Art, *Avant-Garde Photography in Germany, 1919-1939*, San Francisco, 1980, p. 18.

3. Carl Georg Heise, "Preface" to Albert Renger-Patzsch, *Die Welt ist schön*, (1928), trans. in David Mellor, *op. cit.*, pp. 10-11.

AARON SISKIND

1. Hilda Loveman Wilson, "The Camera's New Eye," *Mademoiselle*, (1947); cited in Carl Chiarenza, *Aaron Siskind: Pleasures and Terrors*, Boston, 1982, p. 74.

2. Aaron Siskind, "Statement," in Aaron Siskind, *Aaron Siskind: Photographer*, ed. by Nathan Lyons, Rochester (NY), 1965, p. 24.

3. Thomas B. Hess, "Introduction," in Aaron Siskind, *Places: Aaron Siskind Photographs*, New York, 1976, p. 11.

ELIOT FURNESS PORTER

1. Peter Henry Emerson, *Naturalistic Photography for Students of the Art*, London, 1889, pp. 245-47.

2. Henry David Thoreau, *Walden and Civil Disobedience*, ed. by Sherman Paul, Boston, 1957, pp. 216-17.

3. Eliot Porter, "Preface," *In Wildness Is the Preservation of the World*, San Francisco, 1962, p. 11.

4. Cited in Eliot Porter, *Summer Island: Penobscot Country*, ed. by David Brower, San Francisco, 1966, p. 74.

5. Joseph Wood Krutch, "Introduction," in Eliot Porter, *In Wildness Is the Preservation of the World*, op. cit., p. 15.

WYNN BULLOCK

1. Wynn Bullock, *Wynn Bullock*, texts by Barbara Bullock and Wynn Bullock, San Francisco, 1971, unp.

2. Interview with Wynn Bullock, in Paul Hill and Thomas Cooper, *Dialogue with Photography*, New York, 1979, p. 331.

3. Wallace Stevens, "The Auroras of Autumn," (1950), in *The Collected Poems of Wallace Stevens*, New York, 1954, pp. 418-19.

HARRY CALLAHAN

1. Harry Callahan, [Statement], *Photographs: Harry Callahan*, Santa Barbara, 1964, reprinted in Vicki Goldberg (ed.), *Photography in Print: Writings from 1816 to the Present*, New York, 1981, p. 421.

2. Cited in Valerie Brooks, "Harry Callahan's True Colors," *Artnews*, LXXXII, 8 (October 1983), p. 69.

3. J. W. von Goethe, "Introduction to the *Propylaen*," 1798, in *Goethe on Art*, trans. and ed. by John Gage, Berkeley and Los Angeles, p. 6.

JOSEF SUDEK

1. Cited in Sonja Bullaty, *Sudek*, New York, 1978, p. 16.

2. Josef Sudek, "Josef Sudek—A Self-Portrait," in Sonja Bullaty, op. cit., p. 26.

3. *Ibid.*, p. 26.

4. *Ibid.*, p. 27.

RALPH EUGENE MEATYARD

1. Jonathan Greene, "Paraface (for Gene's Lucybelle book)," in Jonathan Williams (ed.), *The Family Album of Lucybelle Crater*, Highlands (NC), 1974, p. 80.

2. Ralph Eugene Meatyard, [Statement], *Photographer's Choice*, 1 (Spring 1959); cited in Lee D. Witkin and Barbara London, *The Photograph Collector's Guide*, Boston, 1979, p. 190.

ANDRE KERTESZ

1. Cited in Anna Fárová (ed.), *André Kertész*, adapted by Robert Sagalyn, New York, 1966, pp. 7-8.

2. Paul Dermée, trans. by Nicolas-Olivier McGinley, cited in André Kertész, *André Kertész: Sixty Years of Photography, 1912-1972*, ed. by Nicolas Ducrot, New York, 1972, p. 5.

3. Philippe Ariès, *The Hour of Our Death*, trans. by Helen Weaver, New York, 1981, p. 472.

WILLIAM EUGENE SMITH

1. Cf. André Barret, *Nadar: 50 Photographies de ses illustrées contemporains*, Paris, 1975, pp. 132-33.

2. William S. Johnson (ed.), *W. Eugene Smith: Master of the Photographic Essay*, Millerton (NY), 1981, p. 44.

3. Cf. Beaumont Newhall, *The History of Photography from 1839 to the Present*, rev. ed., New York, 1982, p. 263.

4. John R. Whiting, *Photography Is a Language*, Chicago and New York, 1946, p. 98.

5. Nancy Newhall, "The Caption," *Aperture*, 1, (1952), p. 22.

ROBERT LOUIS FRANK

1. Edward Steichen, "Introduction," *The Family of Man*, New York, 1955, p. 4.

2. Walker Evans, in *U.S. Camera 1958*, cited in Beaumont Newhall, *The History of Photography from 1839 to the Present*, rev. ed., New York, 1982, p. 288.

3. Jack Kerouac, *On the Road*, New York, (1955), 1983, pp. 309-10.

BRUCE DAVIDSON

1. Bruce Davidson, [Statement], *East 100th Street*, Cambridge (Mass.), 1970, unp.

2. Tom Wolfe, "The Birth of 'The New Journalism'; Eyewitness Report by Tom Wolfe," *New York*, v, 7 (14 February 1972), Part 1, front cover, pp. 30-45.

3. Bruce Davidson, "Introduction," *Bruce Davidson: Photographs*, New York, 1978, p. 10.

GARRY WINOGRAND

1. John Szarkowski, *Mirrors and Windows: American Photography Since 1960*, New York, 1978, p. 24.

2. George Eliot, *Adam Bede*, (1859), in George J. Becker (ed.), *Documents of Modern Literary Realism*, Princeton, 1963, p.116.

3. Garry Winogrand, cited in Nathan Lyons, "Introduction," *Toward a Social Landscape*, New York and Rochester (NY), 1966, unp.

WILLIAM KLEIN

1. The full title of this work is *Life is Good & Good for You in New York: Trance Witness Revels.*

NICKOLAS MURAY

1. Cited in Robert A. Sobieszek, "Nickolas Muray (1892-1965)," in International Museum of Photography, *Nickolas Muray*, Rochester (NY), 1974, unp.

2. Norman Mailer, *Marilyn*, New York, 1973, p. 16.

ARNOLD NEWMAN

1. Cited in Robert A. Sobieszek, "Introduction," *One Mind's Eye: The Portraits and Other Photographs of Arnold Newman*, Boston, 1974, p. xvii.

2. Johann Wolfgang von Goethe, *Faust*, II, 11499 ff, cited in Marshall Berman, *All That Is Solid Melts Into Air: The Experience of Modernity*, New York, 1982, p. 71.

RICHARD AVEDON

1. Richard Avedon, [Statement], in Minneapolis Institute of Art, *Avedon*, Minneapolis, 1970, unp.

2. Julia Margaret Cameron, letter to Sir John Herschel, (31 December 1864), cited in Helmut Gernsheim, *Julia Margaret Cameron: Her Life and Photographic Work*, Millerton (NY), 1975, [p. 14].

3. Richard Avedon, *loc. cit.*

WALTER CHAPPELL

1. Minor White, "The Camera Mind and Eye," *Magazine of Art*, XLV, 1 (1952); reprinted in Nathan Lyons (ed.), *Photographers on Photography*, New York, 1966, p. 167.

2. Ira Friedlander, [Commentary], in Walter Chappell, "Opening of Doors," *Aperture*, 79 (1977), p. 20.

3. Yukio Mishima, *Sun and Steel*, trans. by John Bester, New York, 1970, pp. 64-65

EIKOH HOSOE

1. Cited in Anon., "Eikoh Hosoe," *Photo World*, II, 3 (March 1974), p. 96.

2. Yukio Mishima, "Preface," in Eikoh Hosoe, *Killed by Roses*, Tokyo, 1963, unp.; cf. also the revised edition, *Ordeal by Roses*, Tokyo, 1971. The work's Japanese title, *Barakei* is now used exclusively by the photographer.

3. Eikoh Hosoe, [Statement], in Rochester Institute of Technology, *Eikoh Hosoe: Photographs, 1960-1980*, ed. by Constance McCabe, Rochester (NY), 1982, unp.

PAUL CAPONIGRO

1. Paul Caponigro, *Paul Caponigro*, Millerton (NY), 1967, p. 20.

2. Paul Caponigro, "Preface," *The Wise Silence: Photographs by Paul Caponigro*, Boston, 1983, p. 10.

BERNARD BECHER and HILLA BECHER

1. Pierre Restany, "The Unique Eye of the Two Bechers," *Kunst-Zeitung*, 2 (January 1969), p. 2.

2. Bernhard and Hilla Becher, "Anonyme Skulpturen," *ibid.*, p. 2.

LEWIS BALTZ

1. Lewis Baltz, [Statement], in Carol di Grappa (ed.), *Landscape: Theory*, New York, 1980, p. 26.

2. Odilon Redon, *Le Salon de 1868*, cited and trans. in John Rewald, *The History of Impressionism*, New York, 1961, p. 188.

3. Richard Wollheim, "Minimal Art," *Arts Magazine*, (January 1965), in Gregory Battcock (ed.), *Minimal Art: A Critical Anthology*, New York, 1968, p. 399.

4. Reyner Banham, "The Architecture of Silicon Valley," *New West*, v, 19 (22 September 1980), p. 50.

ROBERT ADAMS

1. Robert Adams, "Introduction," *The New West: Landscapes Along the Colorado Front Range*, Boulder, 1974, reprinted in Thomas F. Barrow, et al. (eds.), *Reading into Photography: Selected Essays, 1959-1980*, Albuquerque, 1982, p. 50.

2. *Ibid.*, pp. 49-50.

3. Robert Venturi, et al., *Learning from Las Vegas: The Forgotten Symbolism of Architectural Form*, Cambridge (Mass.), (1972) 1977, p. 161.

STEPHEN ERIC SHORE

1. Max Kozloff, "The Coming to Age of Color," *Artforum*, XIII, 5 (January 1975), p. 35.

2. Douglas Crase, "Life in a Small Neighborhood," in *The Revisionist*, New York, 1981, p. 28.

RAY K. METZKER

1. Cf. Robert A. Sobieszek, "Composite Imagery and the Origins of Photomontage, Part II: The Formalist Strain," *Artforum*, XVII, 2 (October 1978), pp. 44-45.

2. Hans M. Wingler, *The Bauhaus: Weimar, Dessau, Berlin, Chicago*, Cambridge (Mass.) and London, 1969, p. 296.

3. Gyorgy Kepes, *Language of Vision*, (1944), Chicago, 1959, p. 53.

4. *Ibid.*, p. 54.

5. Ray K. Metzker, [Statement], *Aperture*, XIII, 2 (1967), unp.

FRANK W. GOHLKE

1. Cf. Joe Deal, [Statement], in International Museum of Photography at George Eastman House, *New Topographics: Photographs of a Man-altered Landscape*, Rochester (NY), 1975, pp. 6-7.

2. Le Corbusier, *Towards a New Architecture*, trans. by Frederick Etchells, New York, 1960, p. 33.

3. Letter to his wife (11 July 1927), in Oskar Beyer (ed.), *Eric Mendelsohn: Letters of an Architect*, trans. by Geoffrey Strachan, London, 1967, p. 96.

LEE FRIEDLANDER

1. John Szarkowski, *Looking at Photographs: 100 Pictures from the Collection of the Museum of Modern Art*, New York, 1973, p. 204.

EDDIE ADAMS

1. Cf. John Szarkowski, "Introduction," *From the Picture Press*, New York, 1973, p. 4.

2. Cited in Anon., "Moment of Truth," *American Photographer*, IV, 5 (November 1980), p. 34.

3. John Berger, "In Opposition to History, In Defiance of Time," *Village Voice*, (14 August 1980), p. 89.

4. Interview with Eddie Adams, *The Today Show*, 24 April 1985.

ROBERT WHITTEN FICHTER

1. Cited in Robert A. Sobieszek, *Robert Fichter, Photography and Other Questions*, Albuquerque (NM), 1983, p. 1.

2. Henry Holmes Smith, "Photography in Our Time: A Note on Some Prospects for the Seventh Decade," *Three Photographers*, Kalamazoo (IN), 1961, unp.

3. Robert W. Fichter, *Confessions of a Silver Addic! [sic]*, [Covington (KY)], [1979], unp.

LES KRIMS

1. W. Jerome Harrison, *A History of Photography*, New York, 1887, p. 87.

2. William Mortensen, "The Vampire," *Monsters and Madonnas*, San Francisco, 1936, unp.

3. Les Krims, [Letter to the editor], *Camera Mainichi*, 8 (August 1970), unp.

4. Cf. A. D. Coleman, "Four Photographs That Drove a Man to Crime," *The New York Times*, (11 April 1971), p. 38D.

JUDY DATER

1. Judy Dater and Jack Welpott, [Statement], cited in Robert A. Sobieszek, "Ms.: Portraits of Women by Judy Dater and Jack Welpott," *Image*, XVI, 1 (March 1973), p. 12.

2. Cited in Anne Tucker (ed.), *The Woman's Eye*, New York, 1973, p. 143.

3. Lara Jefferson, *These Are My Sisters*, Tulsa, 1948, cited in Phyllis Chesler, *Women & Madness*, New York, 1972, p. 4.

JERRY N. UELSMANN

1. Henry Peach Robinson and Capt. Abney, *The Art and Practice of Silver Printing*, New York, 1881, p. 74. The same passage is found in Robinson's *Pictorial Effect in Photography; Being Hints on Composition and Chiaroscuro for Photographers; to which is Added a Chapter on Combination Printing*, London, 1869, p. 191; only there, instead of the examples of Michelangelo and Raphael, the author cited a sentimental Victorian painting, Frederick Goodall's *The Swing*.

2. Illustrated in Jerry N. Uelsmann, *Silver Meditations*, Dobbs Ferry (NY), 1975, unp.; the phrase "psychic landscapes" is from Erich Neumann, cited in William E. Parker, "Uelsmann's Unitary Reality," *Aperture*, XIII, 3 (1967), unp., n. 26.

3. William E. Parker, *op. cit.*, unp.

MARK COHEN

1. John Szarkowski, *Looking at Photographs: 100 Pictures from the Collection of The Museum of Modern Art*, New York, 1973, p. 180.

2. Colin Westerbeck, Jr., "Mark Cohen," *Artforum*, XX, 5 (January 1982), p. 77.

3. Kobo Abe, *The Box Man*, trans. by E. Dale Saunders, New York, 1974, p. 99.

HIRO [YASUHIRO WAKABAYASHI]

1. Roland Barthes, *The Fashion System*, trans. by Matthew Ward and Richard Howard, New York, 1983, p. 215.

2. *Harper's Bazaar*, August 1972, p. 47.

ROBERT HEINECKEN

1. J. G. Ballard, *Crash*, New York, 1973, p. 100.

2. Robert Heinecken, "Adapted from a lecture . . . January 28, 1976," in James Enyeart (ed.), *Heinecken*, Carmel (NY), 1980, pp. 121, 127.

DIANE ARBUS

1. Diane Arbus, "The Full Circle," *Infinity*, XI, 2 (February 1962), p. 9.

2. Peter C. Bunnell, "Diane Arbus," *The Print Collector's Newsletter*, III, 6 (January-February 1973), p. 129.

JOEL-PETER WITKIN

1. *Purgatorio*, Canto VII, trans. by Thomas Okey, in Dante Alighieri, *The Divine Comedy*, New York, p. 231.

2. J. G. Ballard, *The Atrocity Exhibition*, London, 1969, p. 104.

3. Julia Kristeva, *Powers of Horror: An Essay on Abjection*, trans. by Leon S. Roudiez, New York, 1982, p. 207.

EILEEN COWIN

1. Lucy R. Lippard, "Cool Wave," *The Village Voice*, XXIX, 28 (10 July 1984), p. 69.

2. Peter Brooks, *The Melodramatic Imagination: Balzac, Henry James, Melodrama, and the Mode of Excess*, New Haven, 1976, p. 62.

CINDY SHERMAN

1. Cindy Sherman, [Statement], in Rudi H. Fuchs (ed.), *Documenta 7*, Kassel, n. d. [1982], p. 410.

2. Cited in Gerald Marzorati, "Imitation of Life," *Artnews*, LXXXII, 7 (September 1983), pp. 84-85.

3. Trans. in Rosalie L. Colie, *"Some Thankfulnesse to Constantine,"* The Hague, 1956, p. 97; cited in Svetlana Alpers, *The Art of Describing: Dutch Art in the Seventeenth Century*, Chicago, 1983, p. 13.

VICTOR SCHRAGER

1. Svetlana Alpers, *The Art of Describing: Dutch Art in the Seventeenth Century*, Chicago, 1983, p. 124.

IRVING PENN

1. Rosalind Krauss, "Irving Penn: Seeing Beyond the Shapes of Things," *Vogue*, (September 1982), p. 134.

2. Colin Eisler, "Penn's *Pensées*—Camera *Predicans*," in Marlborough Gallery, *Irving Penn: Recent Still Life*, New York, 1982, p. 6.

JAN GROOVER

1. Jan Groover, "The Medium Is the Use," *Artforum*, XII, 3 (November 1973), p. 79. The following citations appear on p. 80.

2. Jan Groover, [Statement], in Lee D. Witkin and Barbara London, *The Photograph Collector's Guide*, Boston, 1979, p.154.

3. Clement de Ris, 1853, cited with no further reference in Ruth Cherniss, "The Anti-Naturalists," in *Courbet and the Naturalist Movement*, ed. by George Boas, Baltimore, 1938, p. 87.

THOMAS FRANCIS BARROW

1. Christopher Finch, *Image as Language: Aspects of British Art, 1950-1968*, Baltimore, 1969, p. 14.

2. From Raymond Roussel, *How I Wrote Certain of My Books*, trans. by T. Winkfield, New York, 1977; cited in Thomas Barrow, [Statement], in Addison Gallery of American Art, *Photo Fact & Fiction*, ed. by Kelly Wise, Andover (Mass.), 1981, p. 12.

NATIONAL AERONAUTICS AND SPACE ADMINISTRATION

1. [William] Lake Price, *A Manual of Photographic Manipulation, Treating of the Practice of the Art; and Its Various Applications to Nature*, 2nd ed., London, 1868, p. 243.

2. *Ibid.*, p. 240.

3. National Aeronautics and Space Administration, Jet Propulsion Laboratory, *The Voyager Flights to Jupiter and Saturn*, Pasadena, 1982, p. 4.

4. *Ibid.*, p. 19.

5. [William] Lake Price, *op. cit.*, p. 2.

PAUL ERIC BERGER

1. Cf. Walter Benjamin, "The Work of Art in the Age of Mechanical Reproduction," (1936), in *Illuminations*, ed. by Hannah Arendt, New York, 1969, pp. 224-25.

2. Walter Benjamin, "A Short History of Photography," (1931), in Alan Trachtenberg, *Classic Essays on Photography*, New Haven (Conn.), 1980, p. 215.

3. Paul Berger, "Introduction," *Seattle Subtext*, Rochester (NY) and Seattle, 1984, unp.

BARBARA KASTEN

1. In conversation with the author, October 1981.

2. Peter Plagens, *Sunshine Muse: Contemporary Art on the West Coast*, New York, 1974, pp. 125-27.

JOHN PFAHL

1. Anthony Bannon, "John Pfahl's Picturesque Paradoxes," *Afterimage*, (February 1979), cited in William E. Parker, "Four Comments about a Distanced World with a Conclusion Prompted by John Pfahl's ALTERED LANDSCAPES Photographs," in John Pfahl, *Altered Landscapes*, (portfolio), New York, 1980. unp.

EMMET GOWIN

1. Peter C. Bunnell, "Introduction," in Corcoran Gallery of Art, *Emmet Gowin: Photographs, 1966-1983*, Washington, D.C., 1983, unp.

2. Edmund Burke, *A Philosophical Enquiry into the Origin of Our Ideas of the Sublime and Beautiful*, (1757), cited in Samuel H. Monk, *The Sublime: A Study of Critical Theories in XVIII-Century England*, Ann Arbor, 1960, p. 95.

3. *Ibid*, p. 92.

ALPHABETICAL CATALOG OF PHOTOGRAPHERS

BERENICE ABBOTT *p. 266*
American, 1898–
Horse Fountain, Lincoln Square, 1929
Gelatin silver print
16.2 × 22.3 cm.
Artist's stamp on verso.
Accession number 67:0006:1
Provenance: the artist.
Bibliography: Berenice Abbott, *Changing New York*, New York, 1939; David Vestal, et al., *Berenice Abbott, Photographs*, New York, 1970, illus., p. 105; Marlborough Gallery and Lunn Gallery/Graphics International, *Berenice Abbott*, text by Elizabeth McCausland, New York and Washington, 1976.

ANTOINE-SAMUEL ADAM-SALOMON *p. 34*
French, 1818–1881
[Profile of a Woman], ca. 1848
Daguerreotype
8.3 × 6.9 cm., sixth plate
Accession number 76:0168:96
Gift of Eastman Kodak Co.
Provenance: Eastman Historic Photographic Collection; Gabriel Cromer Collection; the family of Adam-Salomon.
Bibliography: Janet E. Buerger, "Adam-Salomon: Representational Illusionism and Art in Mid-Nineteenth Century Photography," unpublished mss. to lecture, College Art Association sessions, 1977; Bernard Marbot and Weston J. Naef, *After Daguerre: Masterworks of French Photography (1848–1900) from the Bibliothèque Nationale*, New York, 1980, cat. nos. 1, 2.

ANSEL EASTON ADAMS
p. 322
American, 1902–1984
Pinnacles, Alabama Hills, Owens Valley, California, 1945/1970
Gelatin silver print
From Ansel Adams, *Portfolio V*, New York, 1970, no. 1.
39.5 × 48.3 cm.
Signed on mount (l.r.).
Accession number 71:0040:1

Provenance: the artist.
Bibliography: Nancy Newhall, *Ansel Adams—The Eloquent Light*, San Francisco, 1963; Ansel Adams, *Yosemite and the Range of Light*, texts by Ansel Adams, Paul Brooks, and John Szarkowski, Boston, 1979; Ansel Adams, *The Portfolios of Ansel Adams*, text by John Szarkowski, Boston, 1981, illus., V / Plate 1.

EDDIE ADAMS *p. 380*
American, 1933–
[Saigon, 1968], 1968/printed later
Gelatin silver print
27.0 × 34.5 cm.
Accession number 84:0881:1
Museum purchase, L.A.W. Fund.
Provenance: Wide World Photos, New York.
Bibliography: The Associated Press, *The Instant It Happened*, ed. by Hal Buell and Saul Pett, New York, 1976, illus., p. 201; Anon., "Moment of Truth," *American Photography*, IV, 5 (November 1980), p. 34, illus.; Sheryle and John Leekley, *Moments: The Pulitzer Prize Photographs*, update ed., New York, 1982, illus., p. 69.

ROBERT ADAMS *p. 370*
American, 1937–
[Tract Houses], 1974
Gelatin silver print
15.3 × 19.5 cm.
Accession number 77:0148:4
Museum purchase with National Endowment for the Arts support.
Provenance: Castelli Graphics, New York; the artist.
Bibliography: Robert Adams, *The New West: Landscapes Along the Colorado Front Range*, texts by Robert Adams and John Szarkowski, Boulder, 1974; International Museum of Photography, *New Topographics: Photographs of a Man-altered Landscape*, text by William Jenkins, Rochester (NY), 1975; Robert Adams, *Beauty in Photography: Essays in Defense of Traditional Values*, Millerton (NY), 1981.

FRATELLI ALINARI *p. 112*
Italian, firm est. 1854
Florence: Lower Section of the First Door of the Baptistry, ca. 1856
Albumen print

32.5 × 42.2 cm.
Firm's blindstamp on mount (l.c.).
Accession number 76:020:16
Provenance: Wadsworth Library, Geneseo, NY; Mr. James Wadsworth; the firm (?).
Bibliography: Wladimiro Settimelli and Filippo Zevi, *Gli Alinari: Fotografi a Firenze, 1852–1920*, Florence, 1977; Piero Becchetti, *Fotografi e fotografia in Italia, 1839–1880*, Rome, 1978, p. 64 and *passim*.

GIOACCHINO ALTOBELLI and POMPEO MOLINS *p. 114*
Italian, partnership active Rome, ca. 1857–65
["Night" View of the Roman Colosseum], ca. 1860–65
Albumen print, combination printing
24.6 × 37.9 cm.
Firm's name stamped on mount (l.c.).
Accession number 76:020:3
Provenance: Wadsworth Library, Geneseo, NY; Mr. James Wadsworth; unknown.
Bibliography: Wendy Watson, *Images of Italy: Photography in the Nineteenth Century*, exhibition catalogue, South Hadley (Mass.), Mount Holyoke College Art Museum, 1980, pp. 8–12, illus.; Richard Pare et al., *Photography and Architecture: 1839–1939*, Montreal, 1982, p. 232.

MANUEL ALVAREZ BRAVO
p. 292
Mexican, 1902–
Murdered Worker, Tehuantepec, Chiapas, 1934
Gelatin silver print
19.3 × 23.8 cm.
Signed on verso.
Accession number 77:0744:15
Provenance: the artist.
Bibliography: André Breton, "Souvenir du Mexique," *Minotaur*, VI, 12–13 (May 1939), pp. 30–51, illus., p. 31; Fred R. Parker, *Manuel Alvarez Bravo*, Pasadena, 1971, cat. no. 7, illus., p. 21; Octavio Praz and Manuel Alvarez Bravo, *Instante y Revelacion*, Mexico City, 1982, illus., unp.

PAUL LEWIS ANDERSON
p. 230
American, 1880–1956

Branch Brook Park, 1911
Platinum print
20.1 × 14.8 cm.
Monogrammed and dated (l.l.).
Accession number 76:0315:70
Gift of Mrs. Raymond C. Collins.
Provenance: the family of the artist.
Bibliography: Paul L. Anderson, *Pictorial Photography, Its Principles and Practice*, Philadelphia, 1917; Paul L. Anderson, *The Fine Art of Photography*, Philadelphia, 1919; Susan E. Cohen, "Recent Acquisitions: Paul Lewis Anderson," *Image*, XXII, 2 (June 1979), pp. 15–20.

THOMAS ANNAN *p. 186*
Scottish, 1829–1887
Close No. 118, High Street, ca. 1868–77
Carbon print, combination printing or retouched negative
From Thomas Annan, *Photographs of the Old Closes, Streets, Etc., Taken 1868–1877*, Glasgow, 1878, pl. 6.
27.3 × 21.9 cm.
Accession number 75:054:6
Provenance: Private Collection, Chicago; unknown.
Bibliography: Margaret F. Harker, "Annans of Glasgow," *The British Journal of Photography*, CXX, 5908 (12 October 1973), pp. 932–35, and CXX, 5909 (19 October 1973), pp. 966–69; Anita Ventura Mozley, "Thomas Annan of Glasgow," *Image*, XX, 2 (June 1977), pp. 1–12; Thomas Annan, *Photographs of the Old Closes and Streets of Glasgow 1868/1877; with a Supplement of 18 Related Views*, text by Anita V. Mozley, New York, 1977, illus.

DIANE ARBUS *p. 396*
American, 1923–1971
Untitled (6) 1970–71, ca. 1971
Gelatin silver print
38.5 × 38.0 cm.
Signed by Doon Arbus with estate stamp on verso.
Accession number 84:0260:1
Museum purchase, Intrepid Fund.
Provenance: Sotheby Parke-Bernet, New York; the estate of the artist.
Bibliography: Diane Arbus, *Diane Arbus*, New York and Millerton (NY), 1972, illus., unp.; Patricia Bosworth,

Diane Arbus, New York, 1984; Doon Arbus and Marvin Israel (eds.), *Diane Arbus: Magazine Work*, texts by Diane Arbus, essay by Thomas W. Southall, Millerton (NY), 1984.

JEAN-EUGENE-AUGUSTE ATGET *p. 244*
French, 1857–1927
[*Coiffeur—Avenue Observatoire*], ca. 1926
Gelatin silver print, toned
18.0 × 22.4 cm.
Artist's stamp on verso.
Accession number 76:0118:18
Provenance: ex-collection Man Ray, Paris; the artist (?)
Bibliography: Arthur D. Trottenberg, *A Vision of Paris: The Photographs of Eugène Atget, The Words of Marcel Proust*, New York, 1963; Berenice Abbott, *The World of Atget*, New York, 1964; John Fraser, "Atget and the City," *The Cambridge Quarterly*, III, 3 (Summer 1968), pp. 199–233; John Szarkowski and Maria Morris Hambourg, *The Work of Atget*, 4 vols., New York, 1981–84.

RICHARD AVEDON *p. 358*
American, 1923–
Igor Stravinsky, Composer, New York City, 11/2/69, 1969
Gelatin silver print
24.4 × 59.4 cm.
Signed (l.l.) and dated (l.r.) on mount, artist's stamp on verso.
Accession number 76:0046:1
Museum purchase with National Endowment for the Arts support.
Provenance: the artist.
Bibliography: Minneapolis Institute of Art, *Avedon*, Minneapolis, 1970; Richard Avedon, *Portraits*, text by Harold Rosenberg, New York, 1976, illus., unp.

PLATT D. BABBITT *p. 44*
American, active Niagara Falls, 1854–ca. 1870
[*Tourists Viewing Niagara Falls from Prospect Point*], ca. 1855
Daguerreotype, applied color
16.5 × 21.6 cm., full plate
Artist's name cold stamped on preserver (l.r.).
Accession number 78:0608:1
Gift of Eastman Kodak Co.
Provenance: Eastman Historic Photographic Collection; Gabriel Cromer Collection; unknown.
Bibliography: Beaumont Newhall, *The Daguerreotype in America*, New York, 1961; Floyd Rinhart and Marion Rinhart, *The American Daguerreotype*, Athens (Ga.), 1981.

EDOUARD-DENIS BALDUS *p. 80*
French, b. Prussia, 1813–1882
Pavillon Turgot, Nouveau Louvre
ca. 1856
Albumen print
43.5 × 34.2 cm.
Artist's name stamped on image (l.r.).
Accession number 74:0050:26
Gift of Eastman Kodak Co.
Provenance: Eastman Historic Photographic Collection; Gabriel Cromer Collection; unknown.
Bibliography: Edouard Baldus, *Concours de photographie, mémoire déposé au secrétariat de la société d'encouragement pour l'industrie nationale*, Paris, 1852; Philippe Néagu and Françoise Heilbrun, "Baldus: paysages, architectures," *Photographies*, no. 1 (Spring 1983), pp. 56–77; Philippe Néagu, et al., *La Mission héliographique: Photographies de 1851*, 1980, pp. 32–49; Richard Pare, et al., *Photography and Architecture: 1839–1939*, Montreal, 1982, pp. 225–26.

LEWIS BALTZ *p. 368*
American, 1945–
San Francisco, 1973, 1973
Gelatin silver print
15.2 × 22.6 cm.
Accession number 74:0152:1
Museum purchase with National Endowment for the Arts support.
Provenance: Castelli Graphics, New York; the artist.
Bibliography: Lewis Baltz, *The New Industrial Parks near Irvine, California*, New York, 1974; Lewis Baltz, *Park City*, text by Gus Blaisdell, Albuquerque and New York, 1980; Lewis Baltz, [Statement], in Carol di Grappa (ed.), *Landscape: Theory*, New York, 1980, pp. 23–39.

GEORGE N. BARNARD *p. 48*
American, 1819–1902
[*Fire in the Ames Mills, Oswego, New York*], 1853
Daguerreotype, applied color
7.0 × 8.3 cm., sixth plate
Accession number 79:3107:2
Provenance: Anonymous gift.
Bibliography: George N. Barnard, "Taste," *The Photographic and Fine Art Journal*, VIII, 5 (May 1855), pp. 158–59; Richard Rudisill, *Mirror Image: The Influence of the Daguerreotype on American Society*, Albuquerque, 1971, illus., pl. 48; Beaumont Newhall, *The Daguerreotype in America*, New York, 1961.

THOMAS FRANCIS BARROW *p. 410*
American, 1938–
Disjunctive Forms 2, 1981

Gelatin silver print, applied color
From "Spray Paint Series."
40.5 × 50.5 cm.
Titled on mount.
Accession number 82:1770:1
Museum purchase, Intrepid Fund.
Provenance: Light Gallery, New York; the artist.
Bibliography: International Museum of Photography, *The Extended Document*, text by William Jenkins, Rochester (NY), 1975; Andy Grundberg and Julia Scully, "Currents: American Photography Today," *Modern Photography*, (April 1978), pp. 116–19, 139, 142, 147, 150; Thomas Barrow, [Statement], in Addison Gallery of American Art, *Photo Facts & Opinions*, ed. by Kelly Wise, Andover (Mass.), 1981, pp. 12–13.

FELICE BEATO *p. 124*
British, b. Italy, active 1855–ca. 1867
The Capture of Fort Taku in North China, 1860
Albumen print
25.5 × 32.5 cm.
Accession number 76:0134:5
Provenance: Sotheby Parke Bernet, NY; unknown.
Bibliography: Walter Chappell, "Robertson Beato & Co.: Camera Vision at Lucknow," *Image*, VII, 2 (February 1958), pp. 37–40; Sol Benjamin, "Views of Japan: Photographs by Felix Beato," *Aperture*, 90 (1983), pp. 28–39; Helmut Gernsheim, "Antonio Felicio Beato," *Nordisk Fotohistorisk Journal*, I, 1, (July 1977), pp. 11–17, illus.

CECIL WALTER HARDY BEATON *p. 272*
British, 1904–1980
Paula Gellibrand, Countess de Maury, ca. 1930/printed later
Gelatin silver print
44.9 × 35.4 cm.
Signed on mount (l.r.).
Accession number 73:0190:4
Provenance: Sonnabend Gallery, New York; the artist.
Bibliography: Cecil Beaton, *The Book of Beauty*, London, 1930; Cecil Beaton, *Images*, texts by Edith Sitwell and Christopher Isherwood, London, 1963; Cecil Beaton, *The Best of Beaton*, text by Truman Capote, London, 1968.

BERNHARD BECHER and HILLA BECHER *p. 366*
German, Bernhard: 1931–
German, Hilla: 1934–
Winding Tower, 1920, "Dutemple," Valenciennes, Northern France, 1967
Gelatin silver print

From Bernhard and Hilla Becher, *Industriebauten*, Monchengladbach, 1968, portfolio of prints, unn.
19.4 × 15.4 cm.
Artists' stamp on verso.
Accession number 71:0027:3
Provenance: Walter König, Cologne; the artists.
Bibliography: Bernhard and Hilla Becher, *Anonyme Skulpturen: eine Typologie technischer Bauten*, Dusseldorf, 1970; Bernhard and Hilla Becher, *Die Architektur der Forderund Wasserturme*, Munich, 1971.

HANS BELLMER *p. 284*
German, 1902–1975
[*The Doll*], ca. 1934
Gelatin silver print
From Hans Bellmer, *Die Puppe*, Carlsruhe, 1934.
7.8 × 11.6 cm.
Accession number 81:1421:1
Provenance: Prakapas Gallery, New York; unknown.
Bibliography: Hans Bellmer, *L'Anatomie de l'Image*, Paris, 1957; Centre National d'Art Contemporain, *Hans Bellmer, oeuvre gravé*, Paris, 1972; *Bellmer*, special number of *Obliques*, Paris, n.d. [1979], illus., p. 67; Alain Sayag, *Hans Bellmer: Photographien*, Munich, 1983, illus., pl. 22.

PAUL ERIC BERGER *p. 414*
American, 1948–
Seattle Subtext—Photography, 1981
Gelatin silver print
47.7 × 60.6 cm.
Signed and dated on verso (l.r.).
Accession number 84:0837:8
Museum purchase, L.A.W. Fund.
Provenance: Light Gallery New York; the artist.
Bibliography: Paul Berger, *Seattle Subtext*, Rochester (NY) and Seattle, 1984, illus.

ADOLPHE BILORDEAUX *p. 90*
French, active 1850s–1860s
[*Still Life with Musket and Shell*], ca. 1859
Albumen print
42.2 × 30.1 cm., domed
S/numbered in negative (l.r.), artist's name stamped on mount (l.r.).
Accession number 81:0976:2
Gift of Eastman Kodak Co.
Provenance: Eastman Historic Photographic Collection; Gabriel Cromer Collection; unknown.
Bibliography: André Jammes and Eugenia Parry Janis, *The Art of French Calotype*, Princeton, 1983, p. 151; Bernard Marbot and Weston J. Naef, *After Daguerre: Masterworks of French Photography (1848–1900) from*

the *Bibliothèque Nationale*, New York, 1980, cat. no. 18; Janet E. Buerger, *The Era of the French Calotype*, Rochester (NY), 1982, cat. nos. 242–43, illus.

LOUIS-AUGUSTE and AUGUSTE-ROSALIE BISSON *p. 106*
French, Louis-Auguste: 1814–1876
French, Auguste-Rosalie: 1826–1900
[*The locomotive, "La Vaux"*], ca. 1859
Albumen print
31.5 × 43.6 cm.
Artists' names stamped on mount and blindstamp (l.c.).
Accession number 81:1009:3
Gift of Eastman Kodak Co.
Provenance: Eastman Historic Photographic Collection; Gabriel Cromer Collection; unknown.
Bibliography: Bernard Marbot and Weston J. Naef, *After Daguerre: Masterworks of French Photography (1848–1900) from the Bibliothèque Nationale*, New York, 1980, cat. nos. 19–24; Janet E. Buerger, *The Era of the French Calotype*, Rochester (NY), 1982, cat. 167, illus.; Richard Pare, et al., *Photography and Architecture: 1839–1939*, Montreal, 1982, pp. 224–25.

LOUIS-DESIRE BLANQUART-EVRARD *p. 74*
French, 1802–1872
[*Peasant family at rest in front of a thatched shed*], 1853
Salted paper print
[From Blanquart-Evrard, *Etudes photographiques*, Lille, 1853, 2nd series, no. 204.]
18.0 × 23.3 cm.
Accession number 81:1100:3
Gift of Alden Scott Boyer.
Provenance: Alden Scott Boyer Collection; unknown.
Bibliography: L.-D. Blanquart-Evrard, *Traité de photographie sur papier*, Paris, 1851; Isabelle Jammes, *Blanquart-Evrard et les origines de l'édition photographique française: Catalogue raisonné des albums photographiques édités 1851–1855*, Geneva and Paris, 1981, illus.; Isabelle Jammes, "Louis-Desiré Blanquart-Evrard, 1802–1872," *Camera*, LVII, 12 (December 1978), pp. 4–44.

FELIX BONFILS *p. 170*
French, 1831–1885
Palmyra: A Sculptured Capital, Syria, ca. 1867–76
Albumen print
23.2 × 28.4 cm.

Inscription on negative: "239. Palmyre. Sculpture d'un chapiteau. Syrie," at lower edge; number on negative: "380."
Accession number 73:0074:6
Provenance: Daguerrian Era, Pawlet (VT); unknown.
Bibliography: Félix Bonfils, *Catalogue des vues photographiques de l'Orient. . . .*, Alais, 1876; Carney E. S. Gavin, "Bonfils and the Early Photography of the Near East," *Harvard Library Bulletin*, XXVI, 4 (October 1978), 442–70; Ritchie Thomas, "Bonfils & Son, Egypt, Greece and the Levant, 1876–1894," *History of Photography*, III, 1 (January 1979), pp. 33–46, illus.

MARGARET BOURKE-WHITE *p. 298*
American, 1904–1971
Taxi Dancers, Fort Peck, Montana, 1936
Gelatin silver print
37.8 × 49.6 cm.
Accession number 71:0155:55
Provenance: the artist via Beaumont Newhall.
Bibliography: Margaret Bourke-White, *Portrait of Myself*, New York, 1963; Theodore M. Brown, *Margaret Bourke-White: Photojournalist*, Ithaca (NY), 1972, illus., p. 59; Sean Callahan (ed.), *The Photographs of Margaret Bourke-White*, London, 1973, illus., p. 109; Jonathan Silverman, *For the World to See: The Life of Margaret Bourke-White*, New York, 1983, illus., p. 125.

CHARLES-MARIE BOUTON *p. 16*
French, 1781–1853
[*Vaulted Gothic Ruin*], ca. 1825
Watercolor and graphite on paper
22.2 × 32.3 cm.
Signed (u.l.).
Accession number 70:0194:1
Gift of Eastman Kodak Co.
Provenance: Eastman Historic Photographic Collection; Gabriel Cromer Collection; unknown.
Bibliography: Gabriel Cromer, "L'Histoire de la Photographie et de ses précurseurs enseignée par l'image et l'objet d'époque. Première exposition: Daguerre artiste, et son Diorama," *Bulletin de la Société française de photographie*, XI, 3 (March 1924), pp. 52–65; Georges Potonniée, *Daguerre, peintre et decorateur*, Paris, 1935; Helmut and Alison Gernsheim, *L. J. M. Daguerre: The History of the Diorama and the Daguerreotype*, New York, 1968.

BILL BRANDT *p. 320*
British, 1904–1983
Belgravia, London, 1951
Gelatin silver print
23.0 × 19.6 cm.
Accession number 77:0745:18
Provenance: the artist.
Bibliography: Bill Brandt, *Perspectives of Nudes*, text by Lawrence Durrell, London and New York, 1961, illus., p. 11; Bill Brandt, *Shadow of Light*, text by Cyril Connolly, London, 1966; rev. ed., text by Mark Haworth-Booth, London, and New York, 1977; Bill Brandt, *Bill Brandt: Nudes, 1945–1980*, text by Michael Hiley, Boston, 1980, illus., pl. 8.

B. BRAQUEHAIS *p. 92*
French, active 1850–1874
[*Academic Study with "Venus de Milo"*], ca. 1854
Albumen print
25.4 × 20.1 cm.
Artist blindstamp (l.l. and l.c.).
Accession number 80:0205:1
Gift of Eastman Kodak Co.
Provenance: Eastman Historic Photographic Collection; Gabriel Cromer Collection; unknown.
Bibliography: Ernest Lacan, "Revue photographique: Etudes d'après nature," *La Lumière*, IV, 37 (16 September 1854), p. 147; Bernard Marbot and Weston J. Naef, *After Daguerre: Masterworks of French Photography (1848–1900) from the Bibliothèque Nationale*, New York, 1980, cat. nos. 30, 31; Janet E. Buerger, *The Era of the French Calotype*, Rochester (NY), 1982, cat. no. 27, illus.

BRASSAI [GYULA HALASZ] *p. 270*
Hungarian, 1899–1984
Couple at the Bal des Quatre Saisons, Rue de Lappe, ca. 1932
Gelatin silver print
49.4 × 40.3 cm.
Accession number 77:0749:10
Provenance: the artist via Beaumont Newhall.
Bibliography: Paul Morand, *Paris de nuit*, Paris, [1933]; Museum of Modern Art, *Brassaï*, text by Lawrence Durrell, New York, 1968; Brassaï, *The Secret Paris of the 30's*, New York, 1976, illus., unp.; Brassaï, *The Artists of My Life*, trans. by Richard Miller, New York, 1982.

ADOLPHE BRAUN *p. 88*
French, 1812–1877
[*Still Life of Flowers*], ca. 1854–56
Albumen print
43.8 × 46.7 cm., rounded corners
Accession number 77:0033:13
Gift of Eastman Kodak Co.

Provenance: Eastman Historic Photographic Collection; Gabriel Cromer Collection; unknown.
Bibliography: Naomi Rosenblum, "Adolphe Braun: A 19th-Century Career in Photography," *History of Photography*, III, 4 (October 1979), pp. 357–72; Bernard Marbot and Weston J. Naef, *After Daguerre: Masterworks of French Photography (1848–1900) from the Bibliothèque Nationale*, New York, 1980, cat. no. 32; Janet E. Buerger, *The Era of the French Calotype*, Rochester (NY), 1982, cat. no. 233, illus.

ANNE W. BRIGMAN *p. 226*
American, 1869–1950
Invictus, ca. 1907–11
Gelatin silver print
24.5 × 18.8 cm.
Signed on mount (l.r.) and in negative (l.l.).
Accession number 81:1013:40
Gift of Willard M. Nott
Provenance: Willard M. Nott, Oakland; unknown.
Bibliography: Therese Thau Heyman, *Anne Brigman: Pictorial Photographer/Pagan/Member of the Photo-Secession*, Oakland, 1974; Weston J. Naef, *The Collection of Alfred Stieglitz: Fifty Pioneers of Modern Photography*, New York, 1978, pp. 278–85.

ANTON BRUEHL *p. 306*
American, b. Australia, 1900–1982
Marlene Dietrich, 1937
Dye transfer print
33.4 × 25.6 cm.
Accession number 76:0093:1
Gift of the artist.
Provenance: the artist.
Bibliography: Anton Bruehl, "Dietrich by Bruehl," *Cinema Arts*, (September 1937), pp. 51–57, illus., p. 57; Joe Deal, "Anton Bruehl," *Image*, XIX, 2 (June 1976), pp. 1–9, illus., p. 6.

FRANCIS BRUGUIERE *p. 304*
American, 1879–1945
[*Rosalinde Fuller and Her Sister*], ca. 1936–40
Gelatin silver print, solarized
23.1 × 17.0 cm.
Signed on verso of mount.
Accession number 81:1089:22
Provenance: Rosalinde Fuller, London; the artist.
Bibliography: Francis Bruguière, "Creative Photography," *Modern Photography Annual*, (1935–36), pp. 9–14; Walter Chappell, "Francis Bruguière," *Art in America*, XLVII, 3 (Fall 1959), pp. 56–59; James L. Enyeart, *Bruguière: His Photographs and His Life*, New York, 1977, illus., pl. 99.

WYNN BULLOCK *p. 334*
American, 1902–1975
Child in the Forest, 1951
Gelatin silver print
18.8 × 23.9 cm.
Signed and dated on verso (l.r.).
Accession number 70:0188:2
Provenance: the artist.
Bibliography: Wynn Bullock, *Wynn Bullock*, texts by Barbara Bullock and Wynn Bullock, San Francisco, 1971, illus., unp.; Wynn Bullock, *Wynn Bullock: Photography, A Way of Life*, ed. by Liliane DeCock, text by Barbara Bullock-Wilson, Dobbs Ferry (NY), 1973, illus., unn.; Wynn Bullock, *Wynn Bullock*, text by David Fuess, Millerton (NY), 1976, illus., pl. 49.

HARRY CALLAHAN *p. 336*
American, 1912–
Eleanor and Barbara, Chicago, 1953
Gelatin silver print
19.5 × 24.3 cm.
Accession number 81:1136:2
Provenance: the artist via Beaumont Newhall.
Bibliography: Harry Callahan, *Harry Callahan, Photographs*, ed. by Keith F. Davis, Kansas City, 1981, illus., cover; American Federation of Arts, *Harry Callahan*, text by Peter C. Bunnell, New York, 1978; Harry Callahan, *Eleanor*, New York, 1984, illus., p. 49.

JULIA MARGARET CAMERON *p. 144*
British, b. India, 1815–1879
Mrs. Herbert Duckworth, 1867
Albumen print
27.6 × 23.8 cm.
Autographed (l.r.) with Colnaghi blindstamp on mount (l.c.).
Accession number 81:1124:7
Provenance: Brussels Associates, NY; unknown.
Bibliography: Helmut Gernsheim, *Julia Margaret Cameron: Her Life and Photographic Work*, Millerton (NY), 1975; Mike Weaver, *Julia Margaret Cameron, 1815–1879*, Southampton and Boston, 1984.

ROBERT CAPA [ANDREI FRIEDMANN] *p. 262*
American, b. Hungary, 1913–1954
Leon Trotsky, Copenhagen, 1932
Gelatin silver print
22.6 × 34.1 cm.
Accession number 66:0080:5
Gift of Beaumont Newhall.
Provenance: Beaumont Newhall; the artist.
Bibliography: Robert Capa, *Slightly Out of Focus*, New York, 1947;

Magnum Photos, *Robert Capa: War Photographs*, New York, 1960.

PAUL CAPONIGRO *p. 364*
American, 1932–
West Hartford, Connecticut, 1959
Gelatin silver print
From Paul Caponigro, *Portfolio One*, n.p., 1962, pl. 1.
19.5 × 24.2 cm.
Signed on mount (l.r.).
Accession number 80:0212:2
Museum purchase with National Endowment for the Arts support.
Provenance: the artist.
Bibliography: Paul Caponigro, *Paul Caponigro*, Millerton (NY), 1967, illus., p. 21; The Photography Gallery, *Paul Caponigro, Photography: 25 Years*, text by Peter C. Bunnell, Philadelphia and La Jolla, 1981, illus., pl. 1; Paul Caponigro, *The Wise Silence: Photographs by Paul Caponigro*, text by Marianne Fulton, Boston, 1983, illus., pl. 19.

ETIENNE CARJAT *p. 138*
French, 1828–1906
Charles Baudelaire, 1861–62/1877
Woodburytype print
[From *Galerie contemporaine, litteraire, artistique*, sem. 1, series 1 (1878), unp.]
23.0 × 18.1 cm.
Mounted on sheet with letterpress title, author's and printer's names.
Accession number 83:0649:1
Gift of Eastman Kodak Co.
Provenance: Eastman Historic Photographic Collection; Gabriel Cromer Collection; unknown.
Bibliography: Jean Adhémar, "Carjat," *Gazette des beaux-arts*, LXXX, 1242–43 (July–August, 1972), pp. 71–81; Claude Pichois, *Album Baudelaire*, Paris, 1974, p. 214, illus. 305; Musée Carnavalet, *Etienne Carjat (1828–1906): Photographe*, texts by Philippe Néagu, et al., Paris, 1983, cat. no. 98; Claude Pichois and François Ruchon, *Iconographie de Charles Baudelaire*, Geneva, 1960, cat. no. 35.

LEWIS CARROLL [REV. CHARLES LUTWIDGE DODGSON] *p. 100*
British, 1832–1898
[Xie Kitchin with Violin], 1876
Albumen print
14.8 × 10.4 cm., cabinet card
Accession number 83:1546:1
Provenance: Stephen White Gallery, Beverly Hills; Christie's South Kensington Ltd., London; Henry Holiday; the artist.
Bibliography: Stuart Dodgson Collingwood, *The Life and Letters of Lewis Carroll*, Toronto, n.d. (ca. 1898); Helmut Gernsheim, *Lewis Carroll, Pho-*

tographer, New York, 1969; Morton N. Cohen, (ed.), *Lewis Carroll and the Kitchins*, New York, 1980.

HENRI CARTIER-BRESSON *p. 268*
French, 1908–
Hyères, France, 1932
Gelatin silver print
33.9 × 50.4 cm.
Accession number 77:0759:2
Provenance: the artist via Beaumont Newhall.
Bibliography: Henri Cartier-Bresson, *The Decisive Moment*, New York, 1952; Henri Cartier-Bresson, *Photographs*, texts by Lincoln Kirstein and Beaumont Newhall, New York, 1963; International Center of Photography, *Henri Cartier-Bresson: Photographer*, text by Yves Bonnefoy, Paris, 1975, illus., pl. 13.

SAMUEL J. CASTNER *p. 218*
American, 1843–1929
[Children on Lawn], ca. 1910–12
Platinum print
19.7 × 22.7 cm.
Artist's name inscribed on verso.
Accession number 77:0305:14
Gift of 3M Co., ex-collection Louis Walton Sipley.
Provenance: 3M Company, St. Paul; Louis Walton Sipley, The American Museum of Photography, Philadelphia; unknown.
Bibliography: Robert A. Sobieszek, et al., *An American Century of Photography, 1840–1940*, Lucerne (*Camera*), 1978, cat. no. 13, illus.

WALTER CHAPPELL *p. 360*
American, 1925–
[Heart], 1964
Gelatin silver print
24.0 × 19.1 cm.
Signed and dated on mount (l.r.).
Accession number 73:0034:2
Museum purchase with National Endowment for the Arts support.
Provenance: the artist.
Bibliography: Walter Chappell, Syl Labrot and Nathan Lyons, *Under the Sun*, New York, 1960; Walter Chappell, "Opening the Doors," text by Ira Friedlander, *Aperture*, 79 (1977), pp. 6–21.

CLAUDE-JOSEPH-DESIRE CHARNAY *p. 120*
French, 1828–1915
Chichén-Itzà: Main façade of the Nun's Palace, 1857–61
Albumen print
From Désiré Charnay, untitled album, [prototype (?) for *Cités et ruines américaines. Mitla, Palenqué, Izamal, Chichén-Itzà, Uxmal. Recueillies et*

photographiées par Désiré Charnay, avec un texte par Viollet-le-Duc . . . suivi du voyage et des documents de l'auteur, Paris, 1862–63], Paris, n.d. [ca. 1861].
34.4 × 43.5 cm.
Accession number 73:0199:14
Gift of Eastman Kodak Co.
Provenance: Eastman Historic Photographic Collection; Gabriel Cromer Collection; unknown.
Bibliography: Désiré Charnay, *Les Anciennes villes du Nouveau monde. Voyages d'explorations au Mexique et dans l'Amérique centrale, par Désiré Charnay, 1857–1882*, Paris, 1885; Keith F. Davis, *Désiré Charnay: Expeditionary Photographer*, Albuquerque, 1981, illus., pl. 20.

ANTOINE FRANÇOIS JEAN CLAUDET *p. 134*
British, b. France, 1797–1867
Mrs. Antoine Claudet, ca. 1860
Albumen print
25.5 × 20.0 cm.
Artist's name printed on mount.
Accession number 83:2129:3
Gift of Mr. H. H. Claudet and Mrs. Norman Gilchrist.
Provenance: The family of the artist.
Bibliography: Linda Vance Sevey, *The Question of Style in Daguerreotype and Calotype Portraits by Antoine Claudet*, unpublished thesis, Rochester Institute of Technology, 1977; Robert A. Sobieszek, *British Masters of the Albumen Print: A Selection of Mid-Nineteenth-Century Photography*, Chicago, 1976, cat. no. 1E9, illus.; Mark Haworth-Booth, et al., *The Golden Age of British Photography, 1839–1900*, Millerton (NY), 1984, p. 23 and *passim*.

ALEXANDRE JEAN-PIERRE CLAUSEL *p. 70*
French, 1802–1884
[Landscape, Probably Near Troyes], ca. 1855
Daguerreotype
17.0 × 21.3 cm., full plate
Label on verso: "Executés [*sic*] par Mr. Clausel, Artiste-Peintre et Photographe à Troyes (Aube), Rue de la Trinité, No. 12."
Accession number 76:0168:35
Gift of Eastman Kodak Co.
Provenance: Eastman Historic Photographic Collection; Gabriel Cromer Collection; unknown.
Bibliography: Beaumont Newhall, *The History of Photography*, 4th ed., New York, 1964, p. 24, illus.

ALVIN LANGDON COBURN *p. 236*
American, 1882–1966
[Vortograph of Ezra Pound], ca. 1917

Gelatin silver print
20.2 × 15.5 cm.
Accession number 67:0098:21
Gift of the artist.
Provenance: the artist.
Bibliography: Alvin Langdon
Coburn, *Photographer: An Autobiography*, ed. by Helmut and Alison Gernsheim, New York, 1966; Nancy Newhall (ed.), *A Portfolio of Sixteen Photographs by Alvin Langdon Coburn*, Rochester, 1962; William C. Wees, *Vorticism and the English Avant-Garde*, Toronto, 1972; Mike Weaver, *Alvin Langdon Coburn, 1882–1966: Men of Mark Centenary*, Bath, 1982, illus., pl. 2.

MARK COHEN *p. 390*
American, 1943–
[Wilkes-Barre, Pennsylvania], 1974
Gelatin silver print
30.0 × 45.0 cm.
Accession number 75:0059:2
Museum purchase with National Endowment for the Arts support.
Provenance: the artist.
Bibliography: John Szarkowski, *Mirrors and Windows: American Photography since 1960*, New York, 1978; Carol Squiers, "Mark Cohen: Recognized Moments," *Artforum*, XVI, 7 (March 1978), pp. 22–25; Colin L. Westerbeck, Jr., "Mark Cohen," *Artforum*, XX, 5 (January 1982), p. 77.

ROBERT CORNELIUS *p. 26*
American, 1809–1893
[Self Portrait with Laboratory Instruments], 1843
Daguerreotype
8.3 × 7.7 cm., sixth plate
Accession number 77:0242:3
Gift of 3M Co., ex-collection Louis Walton Sipley.
Provenance: 3M Company, St. Paul; Louis Walton Sipley, The American Museum of Photography, Philadelphia; Historical Society of Pennsylvania, Philadelphia; Martin Hans Boye; the artist.
Bibliography: Robert A. Sobieszek, et al., *An American Century of Photography, 1840–1940: Selections from the Sipley/3M Collection*, Lucerne (Camera), 1978, cat. no. 30c, illus., p. 8; William F. Stapp, et al., *Robert Cornelius: Portraits from the Dawn of Photography*, Washington, 1983, cat. no. 30, illus.

EILEEN COWIN *p. 400*
American, 1947–
Double Departure Scene, 1981
Chromogenic development print
From series "Family Docu-drama."
47.7 × 59.9 cm.
Signed and dated on verso (l.r.).

Accession number 84:0045:1
Museum purchase, L.A.W. Fund.
Provenance: H. F. Manes Gallery, New York; the artist.
Bibliography: University Art Museum, The University of New Mexico, *Self as Subject: Visual Diaries by 14 Photographers*, text by Dana Asbury, Albuquerque, 1983; Lucy R. Lippard, "Cool Wave," *The Village Voice*, XXIX, 28 (10 July 1984), p. 69.

IMOGEN CUNNINGHAM
p. 258
American, 1883–1976
Calla, 1929
Gelatin silver print
From series *Pflanzenformen*.
28.0 × 24.2 cm.
Signed on verso (l.r.).
Accession number 77:0760:63
Provenance: the artist.
Bibliography: George Craven, "Imogen Cunningham," *Aperture*, XI, 4 (1964), pp. 135–74; Stanford University, *Imogen Cunningham: Photographs 1921–1967*, text by Beaumont Newhall, Stanford, 1967; Imogen Cunningham, *Imogen Cunningham: Photographs*, text by Margery Mann, Seattle and London, 1970, rev. as *Imogen! Imogen Cunningham: Photographs 1910–1973*, Seattle and London, 1974.

FRANCIS EDMOND CURREY
p. 146
British, 1814–1886
The Heron, ca. 1865
Albumen print
20.3 × 14.5 cm.
Accession number 77:0689:144
Provenance: A. E. Marshall Collection, NY; unknown.
Bibliography: Robert A. Sobieszek, *British Masters of the Albumen Print: A Selection of Mid-Nineteenth-Century Victorian Photography*, Chicago, 1976, illus., 1F6; Beaumont Newhall, *The History of Photography*, 4th ed., New York, 1964, p. 64, illus.

EDWARD SHERIFF CURTIS
p. 246
American, 1868–1952
Placating the Spirit of a Slain Eagle—Assiniboin, 1926
Photogravure print, printed by John Andrew & Son, Boston
From Edward S. Curtis, *The North American Indian. . . .*, Cambridge (Mass.), 1907–30, XVIII, pl. 634.
39.5 × 29.2 cm. (image)
Printed on sheet with letterpress title, artist's and printer's names.
Accession number 74:0033:19
Provenance: Light Impressions, Rochester (NY); unknown.

Bibliography: Edward S. Curtis, *The North American Indian, Being a Series of Volumes Picturing and Describing the Indians of the United States and Alaska*, Cambridge (Mass.), 1907–30, illus., XVIII, pl. 634; Ralph W. Andrews, *Curtis' Western Indians*, New York, 1962, illus., p. 122; Edward S. Curtis, *The North American Indians*, text by Joseph Epes Brown, New York, 1972, illus., p. 34; Edward S. Curtis, *Portraits from North American Indian Life*, text by A. D. Coleman and T. C. McCluhan, New York, 1972.

LOUIS-JACQUES-MANDE DAGUERRE *p. 22*
French, 1787–1851
[Portrait of an Unidentified Painter], ca. 1842–43
Daguerreotype
10.5 × 8.3 cm., quarter plate
Signed (l.l.), inscribed into metal surface.
Accession number 76:0168:151
Gift of Eastman Kodak Co.
Provenance: Eastman Historic Photographic Collection; Gabriel Cromer Collection; unknown.
Bibliography: Louis-Jacques-Mandé Daguerre, *An Historical & descriptive account of the various processes of the daguerreotype & the diorama. . . .*, ed. by Beaumont Newhall, New York, 1971; Helmut and Alison Gernsheim, *L. J. M. Daguerre: The History of the Diorama and the Daguerreotype*, New York, 1968, illus., pl. 61; Helmut Gernsheim, *The Origins of Photography*, New York, 1982, illus., pl. 20.

JUDY DATER *p. 386*
American, 1941–
Twinka, 1970
Gelatin silver print
30.5 × 23.9 cm.
Signed on mount (l.r.).
Accession number 74:0220:1
Museum purchase with National Endowment for the Arts support.
Provenance: the artist.
Bibliography: Robert A. Sobieszek, "Ms.: Portraits of Women by Judy Dater and Jack Welpott," *Image*, XVI, 1 (March 1973), pp. 11–12; Anne Tucker (ed.), *The Woman's Eye*, New York, 1973, pp. 141–53, illus., p. 153 and cover; Judy Dater and Jack Welpott, *Women and Other Visions*, text by Henry Holmes Smith, Dobbs Ferry (NY), 1975, illus., pl. 52.

BRUCE DAVIDSON *p. 348*
American, 1933–
[Two Youths, Coney Island], 1958–59/1965
Gelatin silver print
18.9 × 12.2 cm.

Artist's stamp on verso.
Accession number 80:0244:32
Provenance: the artist.
Bibliography: International Museum of Photography at George Eastman House, *Toward a Social Landscape*, text by Nathan Lyons, Rochester (NY), 1966; Bruce Davidson, *East 100th Street*, Cambridge (Mass.), 1970; Bruce Davidson, *Bruce Davidson: Photographs*, New York, 1978, illus., pp. 38–39.

F. HOLLAND DAY *p. 206*
American, 1864–1933
The Seven Last Words. I. "Father, forgive them, they know not what they do." II. "To-day thou shalt be with Me in Paradise." III. "Woman, behold thy son; son, thy mother." IV. "My God! my God! why hast Thou forsaken me?" V. "I thirst." VI. "Into Thy hands I commend my spirit." VII. "It is finished.", 1898
Platinum prints (7), printed by Frederick Evans from copy negatives, 1912.
Captioned on mounts.
19.9 × 15.1, 20.0 × 15.2, 20.2 × 15.2, 20.1 × 15.3, 20.1 × 15.1, 20.2 × 15.1, 20.1 × 15.2 cm. (respectively, nos. 1–7)
Accession number 73:0027:1–7
Provenance: Witkin Gallery, New York; estate of Frederick H. Evans.
Bibliography: Wellesley College Museum, *The Photographic Work of F. Holland Day*, text by Ellen Fritz Clattenburg, Wellesley, 1975, cat. nos. 18–25; Weston J. Naef, *The Collection of Alfred Stieglitz: Fifty Pioneers of Modern Photography*, New York, 1978, cat. no. 197, illus.; Estelle Jussim, *Slave to Beauty: The Eccentric Life and Controversial Career of F. Holland Day, Photographer, Publisher, Aesthete*, Boston, 1981, pls. 19–25.

LALA DEEN DAYAL
[RAJA] *p. 172*
Indian, 1844–1910
Gold and Silver Guns—Baroda, ca. 1880s
Albumen print
19.4 × 26.9 cm.
Accession number 82:2736:44
Gift of University of Rochester.
Provenance: University of Rochester Library; unknown.
Bibliography: Ed Praus, "Lala Deen Dayal: 19th Century East Indian Photographer," *Image*, XVI, 4 (December 1973), pp. 7–15; Clark Worswick and Ainslie Embree, *The Last Empire: Photography in British India, 1855–1911*, Millerton (NY), 1976; Clark Worswick, *Princely India: Photographs by Raja Deen Dayal, 1884–1910*, New York, 1980; Judith Mara Gutman, *Through Indian Eyes*, New York, 1982.

HILAIRE GERMAIN EDGAR
DEGAS *p. 198*
French, 1834–1917
[*Portrait of Emile Verhaeren*],
ca. 1895
Gelatin silver print
11.0 × 7.9 cm. (irregular)
Accession number 80:0246:1
Provenance: Mme. Louette, Paris;
unknown.
Bibliography: Beaumont Newhall,
"Degas: Amateur Photographer,"
Image, v, 6 (June 1956), pp. 124–26,
illus.; Luce Hoctin, "Degas photo-
graphe," *Oeil*, 65 (May 1960), pp. 36–
43; Antoine Terrasse, *Degas et la pho-
tographie*, Paris, 1983.

DELMAET and DURANDELLE
p. 164
French, partnership active
1866–1888
[*Men on the Roof of the Paris Opera
Construction*], ca. 1866–70
Albumen print
27.0 × 38.3 cm.
Blindstamp on mount (l.c.); num-
bered in negative "186" (l.l.).
Accession number 80:0099:17
Gift of Eastman Kodak Co.
Provenance: Eastman Historic Photo-
graphic Collection; Gabriel Cromer
Collection; unknown.
Bibliography: Philadelphia Museum
of Art, et al., *The Second Empire: Art
in France under Napoleon III*, Philadel-
phia, 1978, cat. no. VIII–10, illus.

LEON ROBERT DEMACHY
p. 212
French, 1859–1936
[*The Young Votaress*], ca. 1905
Oil transfer print
15.1 × 8.9 cm.
Artist's monogram on print (l.l.).
Accession number 77:0213:2
Gift of 3M Co., ex-collection Louis
Walton Sipley.
Provenance: 3M Company, St. Paul;
Louis Walton Sipley, The American
Museum of Photography, Philadel-
phia; unknown.
Bibliography: Robert Demachy and C.
Puyo, *Les Procédés d'Art en Photogra-
phie*, Paris, 1906; Bill Jay, *Robert Dema-
chy, 1859–1936: Photographs and
Essays*, London, 1974; Romeo Marti-
nez, *Robert Demachy*, Paris, 1976.

E. DESPLANQUES *p. 50*
Belgian (?), active 1850s
The Grande Place at Oudenaarde,
1854
Salted paper print, printed by
Blanquart-Evrard
From L.-D. Blanquart-Evrard, *La Bel-
gique*, Lille, 1854, pl. 5.
34.3 × 44.8 cm.

Mounted on sheet with letterpress
title, photographer's and printer's
names.
Accession number 77:0033:16
Gift of Eastman Kodak Co.
Provenance: Eastman Historic Photo-
graphic Collection; Gabriel Cromer
Collection; unknown.
Bibliography: Isabelle Jammes,
*Blanquart-Evrard et les origines de l'édi-
tion photographique française: Cata-
logue raisonné des albums photograph-
iques édités 1851–1855*, Geneva
and Paris, 1981, cat. no. 122, p. 170,
illus.; André Jammes and Eugenia
Parry Janis, *The Art of French Calotype*,
Princeton, 1983, pp. 169–70.

ANDRE-ADOLPHE-EUGENE
DISDERI *p. 132*
French, 1819–1889
[*Portrait of Unidentified Woman*],
ca. 1860–65
Albumen print
19.8 × 23.7 cm., sheet of uncut
cartes-de-visite
Accession number 81:2348:9
Gift of Eastman Kodak Co.
Provenance: Eastman Historic Photo-
graphic Collection; Gabriel Cromer
Collection; unknown.
Bibliography: André-Adolphe-
Eugène Disdéri, *L'Art de la photogra-
phie*, Paris, 1862; Elizabeth Anne
McCauley, *A. A. E. Disdéri and the
Carte de Visite Portrait Photograph*, dis-
sertation (Yale University, 1980), Ann
Arbor, 1983; Elizabeth Anne
McCauley, *A. A. E. Disdéri and the
Carte de Visite Portrait Photograph*,
New Haven, 1985.

HENRY DIXON *p. 188*
British, 1820–1893
Little Dean's Yard, Westminster,
1882
From Society for Photographing
Relics of Old London, *Photographic
Relics of Old London*, London, 1886,
pl. 61.
Carbon print
18.0 × 22.5 cm.
Mounted on sheet with letterpress
title (l.l.).
Accession number 76:0048:61
Provenance: Christie, Manson and
Woods, London; unknown.
Bibliography: P. & D. Colnaghi &
Co., *Photography: the First Eighty Years*,
text by Valerie Lloyd, London, 1976,
cat. nos. 337–43, pp. 194–96; Rich-
ard Pare, et al., *Photography and Archi-
tecture, 1839–1939*, Montreal, 1982,
pp. 259–60; Gertrude Mae Prescott,
"Architectural Views of Old Lon-
don," *The Library Chronicle of the Uni-
versity of Texas at Austin*, NS, 15 (1981),
pp. 8–47.

FRANTISEK DRTIKOL *p. 238*
Czechoslovakian, 1883–1961
[*Portrait of an Unidentified Woman*],
1922
Gelatin silver print
26.8 × 16.1 cm.
Signed and dated on print (l.r.).
Accession number 72:0046:4
Provenance: Private Collection,
Prague; the artist.
Bibliography: A. Calavas, *Les Nus de
Drtikol*, Paris, 1929; Museum of Deco-
rative Arts, *František Drtikol*, text by
Anna Fárová, Prague, 1972; Rudolf
Kicken Galerie and Robert Miller
Gallery, *Drtikol*, texts by Anna Fárová
and Daniela Mrázková, Cologne and
New York, 1983.

MAXIME DU CAMP *p. 66*
French, 1822–1894
*Thebes, Gournah, Monolithic
Colossus of Amenhotep III*,
1850/1852
Salted paper print, printed by
Blanquart-Evrard
From Maxime Du Camp, *Egypte,
Nubie, Palestine et Syrie. Dessins photo-
graphiques recueillis pendant les années
1849, 1850 et 1851, accompagnés d'un
texte explicatif et precédé d'une introduc-
tion par Maxime Du Camp, Chargé
d'une mission archéologique par le Mini-
stère de l'Instruction Publique*, Paris,
1852, pl. 56.
19.6 × 16.1 cm.
Mounted on sheet with letterpress
title, author's and printer's names.
Accession number 79:0030:55
Gift of Eastman Kodak Co.
Provenance: Eastman Historic Photo-
graphic Collection; Gabriel Cromer
Collection; unknown.
Bibliography: André Jammes and
Eugenia Parry Janis, *The Art of French
Calotype*, Princeton, 1983,
pp. 172–76; Francis Steegmuller (ed.
and trans.), *Flaubert in Egypt: A Sensi-
bility on Tour*, Boston, 1972.

LOUIS DUCOS DU
HAURON *p. 192*
French, 1837–1920
[*Still Life with Rooster*],
ca. 1869–79
Tricolor carbro print (reproduced
from a Kodak Dye Transfer copy print
by Louis Condax, ca. 1950s)
20.8 × 21.7 cm. (irregular)
Accession number 82:1568:1
Provenance: Mme. Louette, Paris;
unknown.
Bibliography: L. Ducos du Hauron,
*Les Couleurs en photographie: Solution
du problème*, Paris, 1869; L. Ducos and
Alcide Ducos du Hauron, *Traité pra-
tique de photographie des couleurs: Sys-
teme d'héliochromie Louis Ducos du

Hauron*, Paris, 1878; Bibliothèque
Nationale, *Une invention du XIXe siècle:
La photographie*, text by Bernard
Marbot, Paris, 1976, cat. nos. 72,
221–25.

EDOUARD (?) DURANDELLE
p. 168
French, active 1860s–1880s
[*School for Infants*], ca. 1875–80
Albumen print
From series, *Eschger Ghesquière & Cie.
Fondaries & Laminoirs de Biache St.
Vaast (Pas-de-Calais)*.
41.7 × 53.2 cm.
Mounted on sheet with letterpress
title and name of photographer.
Accession number 78:0693:6
Provenance: Daniel Wolf Gallery,
New York; unknown.
Bibliography: Richard Pare, et al.,
*Photography and Architecture: 1839–
1949*, Montreal, 1982, p. 258.

JOSEF MARIA EDER and
EDUARD VALENTA *p. 200*
Austrian, J. M. Eder: 1855–1944
Austrian, E. Valenta: 1857–after
1929
Aesculapius Snake, 1896
Photogravure print from stereoscopic
negatives
From Josef Maria Eder and Eduard
Valenta, *Versuche über Photographie
mittelst der RONTGENschen*, Vienna,
1896, pl. 15.
27.0 × 21.7 cm.
Mounted on sheet with letterpress
title, artists' names, and process
identification.
Accession number 79:3352:2
Gift of Eastman Kodak Co.
Provenance: Eastman Historic Photo-
graphic Collection; Josef Maria Eder
Collection.
Bibliography: Josef Maria Eder,
Geschichte der Photographie, Halle
(Saale), 1932; Josef Maria Eder, *His-
tory of Photography*, trans. by Edward
Epstean, New York, 1945.

ERNEST EDWARDS *p. 154*
British, 1837–1903
"*Cleft in the Rock—Anchor
Church, Derby*," ca. 1860–65
Albumen print
22.6 × 18.6 cm.
Identification inscribed on
mount (r.).
Accession number 80:0264:2
Provenance: A. E. Marshall Collec-
tion; unknown.
Bibliography: Robert A. Sobieszek,
*British Masters of the Albumen Print: A
Selection of Mid-Nineteenth-Century
Victorian Photography*, Chicago, 1976,
illus., 1F12; P. & D. Colnaghi, *Photog-
raphy: The First Eighty Years*, text by

Valerie Lloyd, London, 1976, cat. nos. 156–59; Charles Millard, "Images of Nature: A Photo-Essay," in U. C. Knoepflmacher and G. B. Tennyson (eds.), *Nature and the Victorian Imagination*, Berkeley, 1977, p. 15, illus.

PETER HENRY EMERSON *p. 194*
British, b. Cuba, 1856–1936
A Stiff Pull, Suffolk, 1886
Photogravure print
From Peter Henry Emerson, *Pictures of East Anglian Life*, London, 1888, pl. 4.
20.7 × 28.6 cm.
Accession number 81:1295:4
Gift of Alden Scott Boyer.
Provenance: Alden Scott Boyer Collection; unknown.
Bibliography: Peter Henry Emerson, *Naturalistic Photography for Students of the Art*, London, 1889; Peter Turner and Richard Wood, *P. H. Emerson, Photographer of Norfolk*, Boston, 1974, illus., pl. 62; Nancy Newhall, *P. H. Emerson: The Fight for Photography as a Fine Art*, New York, 1975, illus., p. 189.

FREDERICK H. EVANS *p. 222*
British, 1853–1943
Wells Cathedral: Stairway to Chapter House [A Sea of Steps], 1903
Gelatin silver print
23.1 × 19.2 cm.
Titled by Evans on tissue beneath print; artist's monogram stamped on tissue.
Accession number 81:1198:97
Provenance: Gordon Conn; Evan Evans, London; the artist.
Bibliography: Beaumont Newhall, *Frederick H. Evans: Photographer of the Majesty, Light and Space of the Medieval Cathedrals of England and France*, Millerton (NY), 1973, unp.; James L. Enyeart and James L. Connelly, "The Romantic Chateau: Architectural Photographs by Frederick Evans," *The Register of the Museum of Art*, (University of Kansas), IV, 8 (Summer 1972), pp. 1–44; Weston J. Naef, *The Collection of Alfred Stieglitz: Fifty Pioneers of Modern Photography*, New York, 1978, pp. 358–62.

WALKER EVANS *p. 302*
American, 1903–1975
Floyd Burroughs and Family, Alabama, 1936/printed later by James Dow
Gelatin silver print
19.3 × 20.0 cm.
Accession number 72:0017:11
Provenance: James Dow.
Bibliography: Walker Evans, *American Photographs*, text by Lincoln

Kirstein, New York, 1938; James Agee and Walker Evans, *Let Us Now Praise Famous Men: Three Tenant Families*, Boston, 1941; Walker Evans, *Walker Evans*, text by John Szarkowski, New York, 1971, illus., p. 89; Da Capo Press, *Walker Evans, Photographs for the Farm Security Administration, 1935–1938*, text by Jerald C. Maddox, New York, 1975.

JEAN-GABRIEL EYNARD-LULLIN and JEAN RION *p. 38*
Swiss, J.-G. Eynard-Lullin: 1775–1863
Swiss (?), J. Rion: active, ca. 1840s–1850s
[M. Eynard, Griselda, Felix], ca. 1843–52
Daguerreotype
16.9 × 21.1 cm., full plate
Accession number: 73:009:2
Provenance: Michel Auer Collection; unknown.
Bibliography: Michel Auer, "Jean-Gabriel Eynard-Lullin, photographe," *Revue du Vieux Genève*, 3 (1973), pp. 1–4; Helmut Gernsheim, *The Origins of Photography*, New York, 1982, pp. 164–66, pls. 97–99.

ROGER FENTON *p. 82*
British, 1819–1869
Chatsworth, The Palace of the Peak, The Italian Garden, ca. 1858–60
Albumen print
34.1 × 43.9 cm.
Artist's name printed on mount; printed label with title on mount (l.r.).
Accession number 75:0123:2
Provenance: Sotheby Parke Bernet, NY; unknown.
Bibliography: John Hannavy, *Roger Fenton of Crimble Hall*, London, 1975; Richard Pare, et al., *Photography and Architecture, 1839–1939*, Montreal, 1982, pp. 222–23; Valerie Lloyd, "Roger Fenton and the Making of a Photographic Establishment," in Mark Haworth-Booth, et al., *The Golden Age of British Photography, 1839–1900*, Millerton (NY), 1984, pp. 70–81.

ROBERT WHITTEN FICHTER *p. 382*
American, 1939–
[Female Figure and Lawn Chairs], ca. 1966
Gelatin silver print
From series *Dianagrams*.
23.5 × 34.4 cm.
Accession number 67:0112:05
Provenance: the artist.
Bibliography: Robert W. Fichter, *Confessions of a Silver Addic!* [sic], [Covington (Ky.)], [1979]; Robert

A. Sobieszek, *Robert Fichter: Photography and Other Questions*, Albuquerque, 1983, cat. no. 12, illus., p. 16.

EDOUARD FIERLANTS *p. 86*
Belgian, 1819–1869
Hôpital St. Jean, ca. 1860–62
Albumen print, varnished (?)
27.0 × 36.3 cm.
Artist's name stamped on print (l.l.).
Accession number 70:0049:21
Gift of Eastman Kodak Co.
Provenance: Eastman Historic Photographic Collection; Gabriel Cromer Collection; unknown.
Bibliography: Claude Magelhaes and Laurent Roosens, *De fotokunst in Belgie 1839–1940*, Deurne-Antwerp, 1970; Janet E. Buerger, *The Era of the French Calotype*, Rochester (NY), 1982, cat. nos. 185–95, illus.; J. Van Roey, *Gefotografeerd door E. Fierlants (1860)*, Amsterdam, 1979.

ARMAND-HIPPOLYTE-LOUIS FIZEAU *p. 20*
French, 1819–1896
House Elevation, Rue St. Georges, by M. Renaud, ca. 1842
Photographic etching from daguerreotype
From Noël-Marie Paymal Lerebours, *Excursions daguerriennes: vues et monuments les plus remarquable du globe*, Paris, 1841–43, II, unnumbered plate.
14.2 × 19.1 cm. (image)
Mounted on sheet with letterpress title, artist's and printer's names.
Accession number 77:0033:8
Gift of Alden Scott Boyer.
Provenance: Alden Scott Boyer Collection; unknown.
Bibliography: Lerebours and Secretan, *Traité de photographie*, 5th ed., Paris, 1846, chap. XXX, pp. 210–15; N.-P. Lerebours, "Avis aux souscripteurs," in *Excursions daguerriennes: vues et monuments les plus remarquables du globe*, Paris, 1841–43, unp.; Bibliothèque Nationale, *Une invention du XIXe siècle: La photographie*, text by Bernard Marbot, Paris, 1976, cat. no. 275.

ROBERT LOUIS FRANK *p. 346*
American, b. Switzerland, 1924–
Parade, Hoboken, New Jersey, 1955/printed later
Gelatin silver print
33.4 × 49.8 cm.
Accession number 81:2251:01
Provenance: the artist via Beaumont Newhall.
Bibliography: Robert Frank, *Les Americains*, texts ed. by Alain Bosquet, Paris, 1958, illus., p. 7; Robert

Frank, *The Americans*, text by Jack Kerouac, New York, 1959, 2nd ed., Millerton (NY), 1978, illus., p. 12.

LEE FRIEDLANDER *p. 378*
American, 1934–
[Monument at Shiloh, Two Views], 1981
Gelatin silver prints (diptych)
From Lee Friedlander, *Shiloh*, (portfolio), New York, 1981, nos. 12 and 13.
19.0 × 28.2 cm. (each)
Accession number 81:3206:12, 13
Museum purchase with partial National Endowment for the Arts support and Intrepid Fund.
Provenance: Robert Freidus Gallery, New York; the artist.
Bibliography: Lee Friedlander, *The American Monument*, New York, 1976; Lee Friedlander, *Lee Friedlander Photographs*, New York, 1978.

FRANCIS FRITH *p. 118*
British, 1822–1898
The Pyramids of Sakkarah, from the North East, ca. 1858
Albumen print
From Francis Frith, *Egypt, Sinai and Jerusalem: A Series of Twenty Photographic Views by Francis Frith*, texts by Mrs. Poole and Reginald Stuart Poole, London, n.d. [ca. 1860], pl. 7.
38.2 × 47.5 cm.
Inscribed signature and plate number on negative (l.r.); mounted on sheet with letterpress title.
Accession number 79:0068:7
Provenance: Helmut Gernsheim Collection, London; Bridgewater Library; unknown.
Bibliography: Francis Frith, "The Art of Photography," *The Art Journal*, NS, V (1 March 1859), pp. 71–72; Deborah Bull and Donald Lorimer, *Up the Nile: A Photographic Excursion: Egypt 1839–1898*, New York, 1979; Julia van Haaften and Jon Manchip White, *Egypt and the Holy Land in Historic Photographs: 77 Views by Francis Frith*, New York, 1980; Louis Vaczek and Gail Buckland, *Travelers in Ancient Lands: A Portrait of the Middle East, 1839–1919*, Boston, 1981.

ALEXANDER GARDNER *p. 130*
American, b. Scotland, 1821–1882
"Lewis Payne [sic] Powell, Alias Lewis Payne, Who Attacked Hon. W. H. Seward," 1865
Albumen print
From album, *The Lincoln Conspiracy*, Boston, 1865, folio number 2082.
22.0 × 16.5 cm.
Accession number 72:0033:31

Provenance: Sotheby Parke Bernet, NY; Arnold A. Rand, Boston.
Bibliography: Josephine Cobb, "Alexander Gardner," *Image*, VII, 6 (June 1958), pp. 124–36; Theodore Roscoe, *The Web of Conspiracy*, Englewood Cliffs (NJ), 1959; Stefan Lorant, *Lincoln: A Picture Story of His Life*, rev. ed., New York, 1969; Alan Clark Miller, "New Acquisitions: A Gardner Album," *Image*, XV, 4 (December 1972), pp. 13–16.

FRANK W. GOHLKE *p. 376*
American, 1942–
[Landscape—Grain Elevators and Lightning—La Mesa, Texas], 1975
Gelatin silver print
35.0 × 35.0 cm.
Accession number 80:0780:3
Museum purchase with National Endowment for the Arts support.
Provenance: the artist.
Bibliography: International Museum of Photography at George Eastman House, *New Topographics: Photographs of a Man-altered Landscape*, text by William Jenkins, Rochester (NY), 1975; John Szarkowski, *Mirrors and Windows: American Photography Since 1960*, New York, 1978, illus., p. 148.

EMMET GOWIN *p. 420*
American, 1941–
Toutle River Valley. Mount Saint Helens., 1981/1983
Gelatin silver print, split toned
24.9 × 19.1 cm.
Signed and dated on verso.
Accession number 84:0837:1
Museum purchase, L.A.W. Fund.
Provenance: Light Gallery, New York; the artist.
Bibliography: Emmet Gowin, *Emmet Gowin: Photographs*, New York, 1976; Corcoran Gallery of Art, *Emmet Gowin: Photographs, 1966–1983*, text by Peter C. Bunnell, Washington, D.C., 1983.

JAN GROOVER *p. 408*
American, 1943–
Untitled, 1980
Palladium-platinum print
19.4 × 24.2 cm.
Signed and dated on mount (l.l.).
Accession number 83:0123:1
Museum purchase, Intrepid Fund.
Provenance: Daniel Wolf Gallery, New York; the artist.
Bibliography: Jan Groover, "The Medium Is the Use," *Artforum*, XII, 3 (November 1973), pp. 79–80; Neuberger Museum, *Jan Groover*, texts by Laurence Shopmaker and Alan Trachtenberg, Purchase (NY), 1983, illus., unp.

BARON JEAN-BAPTISTE-LOUIS GROS *p. 46*
French, 1793–1871
Monument of Lysicrates, Athens, 1850
Daguerreotype
10.8 × 17.2 cm., half plate, original frame
S/d on verso: "Monument de Lysicrates. Vulgairement appelé lanterne de Demosthenes athènes, Mai 1850. Baron Gros."
Accession number 69:0265:123
Gift of Eastman Kodak Co.
Provenance: Eastman Historic Photographic Collection; Gabriel Cromer Collection; unknown.
Bibliography: [Beaumont Newhall], "Index to Resources," *Image*, V, 7 (September 1956), p. 162; Bernard Marbot and Weston J. Naef, *After Daguerre: Masterworks of French Photography (1848–1900) from the Bibliothèque Nationale*, New York, 1980, cat. nos. 74, 75; Baron [J.-B.-L.] Gros, *Quelques notes sur la photographie sur plaques métalliques*, Paris, 1850.

FRANZ HANFSTAENGL
p. 102
German, 1804–1877
Carl August von Steinheil, ca. 1860
Albumen print
21.4 × 16.8 cm., octagonal
Artist's printed collophon on decorative mount; inscribed on mount in ink "C. A. Steinheil/geb: zu [unreadable] 12d Oktober 1801" (l. r.).
Accession number 78:0054:26
Acquired with funds provided by Alliance Tool and Die Corporation.
Provenance: Scott Elliot Gallery, NY; unknown.
Bibliography: Christian Diener and Graham Fulton-Smith (eds.), *Franz Hanfstaengl: Album der Zeitgenossen*, Munich, 1975; Robert A. Sobieszek, "Franz Hanfstaengl: Munich Portraits, 1853–1863," *Image*, XXI, 3 (September 1978), pp. 15–19; Heinz Gebhardt, *Franz Hanfstaengl: von der Lithographie zur Photographie*, Munich, 1984.

GABRIEL HARRISON *p. 56*
American, 1818–1902
The Infant Saviour Bearing the Cross, 1853
Daguerreotype
16.5 × 14.2 cm. (sight), full plate
Accession number 81:1660:1
Gift of Clara L. Harrison.
Provenance: the family of the artist.
Bibliography: Gabriel Harrison, "The Dignity of our Art," *The Photographic Art Journal*, III, 4 (April 1852), pp.

230–32; S. J. Burr, "Gabriel Harrison and the Daguerrean Art," *The Photographic Art Journal*, I, 3 (March 1851), pp. 169–77; Richard Rudisill, *Mirror Image: The Influence of the Daguerreotype on American Society*, Albuquerque, 1971, pp. 127–30, illus., pl. 43; Grant B. Romer, "Gabriel Harrison—The Poetic Daguerrian," *Image*, XXII, 3 (September 1979), pp. 8–18.

JOHN HEARTFIELD
[HELMUT HERZFELD] *p. 286*
German, 1891–1968
What the Angels of Christmas Have Become ["O du fröhliche, O du selige, gnadenbringende Zeit"], 1935
Rotogravure print, rephotographed montage with typography
From *AIZ*, 26 December 1935, p. 831.
38.3 × 26.6 cm.
Accession number 76:0076:29
Gift of Barbara Morgan.
Provenance: ex-collection Willard D. Morgan; unknown.
Bibliography: Wieland Herzfeld, *John Heartfield, Leben und Werk*, Dresden, 1962; Deutschen Academie der Künste and Württembergischen Kunstverein, *John Heartfield/George Grosz*, texts by Marina Schneede-Sczesny and Uwe M. Schneede, Stuttgart, 1969, cat. no. 71, illus., p. 48; Neue Gesellschaft für bildende Kunst, *John Heartfield*, ed. by Arbeitsgruppe Heartfield, Berlin, 1969, illus., p. 84; John Heartfield, *Photomontages of the Nazi Period*, texts by Peter Selz, Wieland Herzfeld, et al., New York, 1977.

KENNETH HEDRICH *p. 318*
American, 1908–1972
Morton May Residence, 1942/ late 1940s
Gelatin silver print
39.8 × 33.2 cm.
Signed "Hedrich-Blessing" on mount (l.l.).
Accession number 81:2330:1
Gift of 3M Co., ex-collection Louis Walton Sipley.
Provenance: 3M Company, St. Paul; Louis Walton Sipley, The American Museum of Photography, Philadelphia; unknown.
Bibliography: International Museum of Photography at George Eastman House, *Hedrich-Blessing: Architectural Photography, 1930–1981*, text by Robert A. Sobieszek, Rochester (NY), 1981, cat. no. 48, illus. (cover); Robert A. Sobieszek, *The Architectural Photography of Hedrich-Blessing*, New York, 1984, illus., p. 37.

ROBERT HEINECKEN *p. 394*
American, 1931–
Cliche Vary/Fetishism, 1974
Photographic emulsion on canvas, pastel chalk
106.7 × 106.7 cm.
Accession number 76:0012:1
Museum purchase with National Endowment for the Arts support.
Provenance: Light Gallery, NY; the artist.
Bibliography: James Enyeart (ed.), *Heinecken*, texts by Marvin Bell, et al., Carmel, 1980, illus., pl. 86.

FLORENCE HENRI *p. 276*
German, b. United States, 1895–1982
Composition No. 12, ca. 1930–32
Gelatin silver print
24.0 × 37.8 cm.
Titled on verso of print.
Accession number 78:0849:1
Provenance: the artist.
Bibliography: Florence Henri, *Aspekte der Photographie der 20er Jahre*, Munster, 1976; Van Deren Coke, *Avant Garde Photography in Germany, 1919–1939*, New York, 1982; Rencontres internationales de la photographie, *Bauhaus Photographie*, Arles, 1983.

ALEXANDER HESLER *p. 128*
American, b. Canada, 1823–1895
Portrait of Abraham Lincoln, 1860/1881
Albumen print, printed by George B. Ayres
19.0 × 14.0 cm.
Date of print blindstamped on print (u.l.).
Accession number 83:1865:1
Provenance: Anonymous gift.
Bibliography: Charles Hamilton and Lloyd Ostendorf, *Lincoln in Photographs: An Album of Every Known Pose*, Norman (Okla.), 1963, cat. no. 26, illus., pp. 46, 366; Stefan Lorant, *Lincoln: A Picture Story of His Life*, rev. ed., New York, 1969, cat. no. 22, illus., p. 315; Ellen Manchester, "Alexander Hesler: Chicago Photographer," *Image*, XVI, 1 (March 1973), pp. 7–10; James Mellon (ed.), *The Face of Lincoln*, New York, 1979, illus., p. 78 (also cf. illus., p. 10).

DAVID OCTAVIUS HILL and ROBERT ADAMSON *p. 32*
Scottish, D. O. Hill: 1802–1870
Scottish, R. Adamson: 1821–1848
Professor [James] Miller, ca. 1846
Salted paper print
11.9 × 14.0 cm.
Accession number 81:2396:87
Gift of Alden Scott Boyer.

Provenance: Alden Scott Boyer Collection; unknown.
Bibliography: The Scottish Arts Council, *David Octavius Hill and Robert Adamson*, text by Katherine Michaelson, Edinburgh, 1970; David Bruce, *Sun Pictures: the Hill-Adamson Calotypes*, London, 1973; Colin Ford and Roy Strong, *An Early Victorian Album: The Hill/Adamson Collection*, London, 1974.

LEJAREN A HILLER *p. 288*
American, 1880–1969
Etienne Gourmelen, ca. 1927–38
From series "Surgery Through the Ages."
Gelatin silver print, toned
45.6 × 37.5 cm.
Accession number 77:0081:12
Gift of 3M Co., ex-collection Louis Walton Sipley.
Provenance: 3M Company, St. Paul; Louis Walton Sipley, The American Museum of Photography, Philadelphia; unknown.
Bibliography: Lejaren à Hiller, *Surgery Through the Ages, A Pictorial Chronical* [sic], intro. by Iago Galdston, texts by Paul Benton and John H. Hewlett, New York, 1944, illus., p. 93; Focal Point Productions, *Lejaren à Hiller*, (slide set), text by Arnold Sorvari, Rochester, 1979, unp.

LEWIS WICKES HINE *p. 264*
American, 1874–1940
Icarus Atop Empire State Building, 1931
Gelatin silver print
18.8 × 6.3 cm.
Title in pencil and artist's stamp on verso.
Accession number 77:0165:69
The Lewis W. Hine Collection, gift of the Photo League.
Provenance: The Photo League, New York; the family of the artist.
Bibliography: Lewis W. Hine, *Men at Work*, New York, 1932; Judith Mara Gutman, *Lewis W. Hine and the American Social Conscience*, New York, 1967; Jonathan L. Doherty, *Lewis Wickes Hine's Interpretive Photography: The Six Early Projects*, Chicago, 1978; Walter Rosenblum, Naomi Rosenblum, and Alan Trachtenberg, *America & Lewis Hine: Photographs, 1904–1940*, Millerton (NY), 1977.

ALFRED HORSLEY HINTON *p. 202*
British, 1863–1906
Day's Awakening, 1896
Platinum print, toned (?)
49.8 × 29.2 cm.
Signed and dated (l.l.).
Accession number 77:0338:36

Gift of 3M Co., ex-collection Louis Walton Sipley.
Provenance: 3M Company, St. Paul; Louis Walton Sipley, The American Museum of Photography, Philadelphia; Photographic Society of Philadelphia; the artist.
Bibliography: Arts Council of Great Britain, *Pictorial Photography in Britain 1900–1920*, text by John Taylor, London, 1978; Weston J. Naef, *The Collection of Alfred Stieglitz: Fifty Pioneers of Modern Photography*, New York, 1978, pp. 382–84; Peter C. Bunnell (ed.), *A Photographic Vision: Pictorial Photography, 1889–1923*, Salt Lake City, 1980.

HIRO [YASUHIRO WAKABAYASHI] *p. 392*
American, b. China, 1930–
"Nail Shape '72 . . . ," 1972/77
Dye transfer print
51.3 × 39.7 cm.
Signed and dated with artist's stamp on verso.
Accession number 77:006:107
Provenance: the artist; courtesy *Harper's Bazaar*.
Bibliography: Anon., "Hiro," *Photo World*, II, 5 (May 1972), pp. 28–41, 94–96, illus.; Nancy Hall-Duncan, *The History of Fashion Photography*, New York, 1979, illus., p. 164; Owen Edwards, et al., *American Photographer*, special issue on Hiro, VIII, I (January 1982), illus., p. 47.

HORST P. HORST *p. 308*
German, 1906–
"From Paris—The New Detolle Corset with Back Lacing," 1939/printed later
Gelatin silver print
24.5 × 19.8 cm.
Signed on mat.
Accession number 77:0629:1
Provenance: Ileana Sonnebend Gallery, New York; the artist.
Bibliography: Horst P. Horst, *Salute to the Thirties*, text by Janet Flanner, New York, 1971; Joe Deal, "Horst on Fashion Photography," *Image*, XVIII, 3 (September 1975), pp. 1–11, illus., cover; Valentine Lawford, *Horst: His Works and His World*, New York, 1984, illus., p. 84.

EIKOH HOSOE *p. 362*
Japanese, 1933–
Kamaitachi #11, 1968
From Eikoh Hosoe, *Kamaitachi*, Tokyo, 1969, pl. 11.
Gelatin silver print
35.0 × 58.7 cm.
Signed and dated on verso.
Accession number 75:0119:4
Provenance: Light Gallery,

New York; the artist.
Bibliography: Eikoh Hosoe, *Kamaitachi*, text by Tatsumi Hijikata, Tokyo, 1969; John Szarkowski and Shojin Yamagishi (eds.), *New Japanese Photography*, New York, 1974; Rochester Institute of Technology, *Eikoh Hosoe: Photographs, 1960–1980*, ed. by Constance McCabe, Rochester (NY), 1982.

ROBERT HOWLETT *p. 108*
British, 1831–1858
Leviathan: View of the Bows, 1857
Albumen print
From album "The Leviathan," London, n.d. [ca. 1858], unn.
21.1 × 26.0 cm.
Inscribed date on negative, "Nov. 30, 57" (l.c.); artist's blindstamp on mount (u.l.).
Accession number 81:1647:53
Provenance: David Magee Book Shop, San Francisco; unknown.
Bibliography: L. T. C. Rolt, *Isambard Kingdom Brunel*, London, 1957; Robert A. Sobieszek, *British Masters of the Albumen Print: A Selection of Mid-Nineteenth-Century Victorian Photography*, Chicago, 1976, cat. no. 289, illus.; Mark Haworth-Booth, et al., *The Golden Age of British Photography, 1839–1900*, Millerton (NY), 1984, pp. 50, 61–65, illus. (variant).

GEORGES HUGNET *p. 290*
French, 1906–1974
["*The Double Life. . .*"], 1936
Photomechanical offset, rotogravure, typography
From Georges Hugnet, *La Septième face du dé, Poèmes—découpages*, Paris, 1936, insert to special edition.
28.7 × 21.0 cm.
Signed and dated on mount (l.r.).
Accession number 77:0848:23
Provenance: Image and the Myth Gallery, Los Angeles; the estate of the artist.
Bibliography: Georges Hugnet, *L'aventure Dada*, Paris, 1957; Robert A. Sobieszek, "Erotic Photomontages: Georges Hugnet's *La Septième face du dé*," *Dada/Surrealism*, 9 (1979), pp. 66–82, illus., p. 68; Zabriskie Gallery, *Georges Hugnet: Artist, Poet, Critic*, text by Pepe Karmel, New York and Paris, 1984.

WILLIAM HENRY JACKSON *p. 180*
American, 1843–1942
Mt. Sopris, From Junction of Rock Creek and Roaring Fork, after 1880
Albumen print, combination printing
From series "Colorado Midland Ry./Pike's Peak Route"

54.3 × 44.3 cm.
Number, title and artist's name inscribed on negative; mounted on board with lithographic title of series.
Accession number 81:2248:124
Gift of Harvard University.
Provenance: Dept. of Mineralogy, Harvard University; unknown.
Bibliography: William Henry Jackson, *Time Exposure*, New York, 1940; Beaumont Newhall and Diana E. Edkins, *William H. Jackson*, Fort Worth, 1974; Weston J. Naef, et al., *Era of Exploration: The Rise of Landscape Photography in the American West, 1860–1885*, Buffalo and New York, 1975, pp. 219–50.

GERTRUDE STANTON KASEBIER *p. 214*
American, 1852–1934
Portrait (Miss N.), ca. 1898
Platinum print
20.4 × 15.5 cm.
Signed on print (l.l.).
Accession number 70:0058:17
Gift of Mrs. Hermine M. Turner.
Provenance: Mrs. Hermine M. Turner, New York; the estate of the artist.
Bibliography: Anne Tucker, "Gertrude Käsebier," *The Woman's Eye*, New York, 1973, pp. 13–27; Peter C. Bunnell, "Gertrude Käsebier," *Arts in Virginia*, 16 (Fall 1975), pp. 2–15; Weston J. Naef, *The Collection of Alfred Stieglitz: Fifty Years of Modern Photography*, New York, 1978, pp. 387–93.

BARBARA KASTEN *p. 416*
American, 1936–
Construct NYC-10, 1983
Cibachrome print
74.8 × 95.2 cm.
Signed and dated on verso.
Accession number 84:0158:1
Museum purchase, L.A.W. Fund.
Provenance: John Weber Gallery, New York; the artist.
Bibliography: The Art Museum and Galleries, California State University, *Centric 2: Barbara Kasten, Installation/Photographs*, texts by Constance W. Glenn, Long Beach, 1982; Belinda Rathbone, "Barbara Kasten: Picture Apparatus," *Polaroid Close-Up*, XIV, 1 (April 1983), pp. 18-23; Barbara Kasten, *Constructs*, text by Estelle Jussim, Boston, 1985, illus. (variant), unp.

ALEXANDER KEIGHLEY *p. 204*
British, 1861–1947
Gathering the Flock, 1897
Carbon print, manipulated
31.6 × 49.1 cm.

Signed in pencil (l.l.).
Accession number 81:1417:1
Gift of C. F. Hutchison.
Provenance: C. F. Hutchison;
unknown.
Bibliography: "Die Galerie," *Alex. Keighley*, Vienna, n.d. [1936], illus., pl. 19; Pictorial Group of Royal Photographic Society, *Alexander Keighley: A Memorial*, London, ca. 1948; J. Dudley Johnston, "The Art of Alexander Keighley, Hon. FRPS," *The American Annual of Photography*—1949, LXIII, Boston, 1948, pp. 7–22; Cecil Beaton and Gail Buckland, *The Magic Image: The Genius of Photography from 1839 to the Present Day*, Boston, 1975, pp. 120–21.

ANDRE KERTESZ *p. 342*
American, b. Hungary, 1894–
Flowers for Elizabeth, New York, 1976
Gelatin silver print
24.1 × 34.7 cm.
Accession number 80:0806:4
Provenance: the artist.
Bibliography: André Kertész, *André Kertész: Sixty Years of Photography, 1912-1972*, ed. by Nicolas Ducrot, New York, 1972; André Kertész, *Distortions*, ed. by Nicolas Ducrot, text by Hilton Kramer, New York, 1976; André Kertész, *Kertész on Kertész*, text by Peter Adam, New York, 1985, illus., p. 112.

WILLIAM KLEIN *p. 352*
American, 1928–
Bikini, Moscow, 1959/printed later
Gelatin silver print
36.7 × 49.3
Accession number 69:0030:1
Provenance: the artist.
Bibliography: William Klein, *Moscow*, texts by William Klein and Harrison E. Salisbury, New York, 1964, illus., pp. 104–5; William Klein, *William Klein: Photographs, Etc.*, text by John Heilpern, Millerton (NY), 1981, illus., pp. 104–5; Max Kozloff, "William Klein and the Radioactive Fifties," *Artforum*, XIX, 9 (May 1981), pp. 34–41.

LES KRIMS *p. 384*
American, 1943–
[*Legless Man on Pedestal*], 1970
Gelatin silver paper (Kodalith), toned
11.9 × 17.0 cm.
Signed and artist's stamp on verso.
Accession number 83:2438:1
Gift of David Pond, Rochester.
Provenance: David Pond; the artist.
Bibliography: A. D. Coleman, *The Grotesque in Photography*, New York, 1977, illus., p. 89.

CARL CHRISTIAN HEINRICH KUHN *p. 224*
Austrian, 1866–1944
[*Hans Kühn and His Tutor*], 1902
Gum-bichromate print (brown)
73.3 × 55.0 cm.
Signed and dated (u.l.).
Accession number 71:0061:9
Provenance: Frau Lotte Kühn-Schönitzer; the artist.
Bibliography: Allan Porter, et al., *Camera*, special issue on Kühn, LVI, 6 (June 1977); Museum Folkwang, *Heinrich Kühn, 1866-1944*, texts by Ute Eskildsen, et al., Essen, 1978, cat. no. 32, illus., pl. 9; Rudolf Kicken (ed.), *An Exhibition of One Hundred Photographs by Heinrich Kühn*, texts by Elizabeth Pollock, et al., Cologne, 1981.

DOROTHEA LANGE *p. 300*
American, 1895–1965
Migrant Mother, Nipomo, California, 1936/printed later
Gelatin silver print
32.8 × 25.7 cm.
Accession number 76:0009:1
Gift of Arthur Rothstein.
Provenance: Arthur Rothstein; the artist.
Bibliography: Dorothea Lange and Paul Schuster Taylor, *An American Exodus: A Record of Human Erosion*, New York, 1939; The Museum of Modern Art, *Dorothea Lange*, text by George P. Elliott, New York, 1966, illus., p. 25; Dorothea Lange, "The Assignment I'll Never Forget," *Popular Photography*, XLVI (February 1960), pp. 42, 126, reprinted in Beaumont Newhall (ed.), *Photography: Essays & Images*, New York, 1980, pp. 262–65, illus., p. 265; Dorothea Lange, *Dorothea Lange: Photographs of a Lifetime*, texts by Robert Coles and Therese Heyman, Millerton (NY), 1982, illus., p. 77.

J.-B. GUSTAVE LE GRAY *p. 84*
French, 1820–1882
[*Seascape*], ca. 1857
Albumen print, combination printing
34.8 × 41.5 cm.
Artist's name stamped on print (l.r.); artist's blindstamp on mount (l.c.).
Accession number 82:1589:1
Gift of Eastman Kodak Co.
Provenance: Eastman Historic Photographic Collection; Gabriel Cromer Collection; unknown.
Bibliography: Gustave Le Gray, *Photographie. Traité nouveau théorique et pratique des procédés et manipulations sur papier-sec, humide et sur verre au collodion, à l'albumine.*, Edition nouveau, Paris, 1854; Bernard Marbot and Wes-

ton J. Naef, *After Daguerre: Masterworks of French Photography (1848–1900) from the Bibliothèque Nationale*, New York, 1980, cat. nos. 79–84; André Jammes and Eugenia Parry Janis, *The Art of French Calotype*, Princeton, 1983, pp. 200–205.

JEAN-LOUIS-HENRI LE SECQ DES TOURNELLES *p. 72*
French, 1818–1882
[*Farmyard Scene, Near St.-Leu-d'Esserent*], ca. 1852
Cyanotype print
21.7 × 32.2 cm.
Accession number 81:1465:7
Provenance: E. Weil, London; unknown.
Bibliography: Gabriel Cromer, "Un photographe-artiste des milieu du XIX siècle, le peintre, Henri Le Secq," *Bulletin de la Société française de photographie*, 10 (October 1930), pp. 287–95; André Jammes and Eugenia Parry Janis, *The Art of French Calotype*, Princeton, 1983, esp. pp. 206–10; Janet E. Buerger, *The Era of the French Calotype*, Rochester (NY), 1982, cat. nos. 40–61, illus., cover; Eugenia Parry Janis, entry for Le Secq, in Philadelphia Museum of Art, et al., *The Second Empire: Art in France under Napoleon III*, Philadelphia, 1978, cat. no. VIII-19, pp. 417–18, illus.

HELMAR LERSKI [ISRAEL SCHMUKLERSKI] *p. 256*
German, 1871–1956
[*German Housekeeper*], ca. 1928–31
Gelatin silver print
28.6 × 23.1 cm.
Artist's stamp on verso.
Accession number 81:1289:3
Provenance: Anneliese Lerski, Zurich; the artist.
Bibliography: Helmar Lerski, *Köpfe des Alltags: Unbekannte Menschen*, Berlin, 1931; [Beaumont Newhall], "Helmar Lerski," *Image*, X, 2 (February 1961), pp. 5–7, illus.; Curt Glaser, "Introduction to Helmar Lerski, *Köpfe des Alltags*," in David Mellor (ed.), *Germany: The New Photography, 1927–33*, London, 1974, pp. 60–64; Museum Folkwang, *Helmar Lerski, Lichtbildner: Fotografien und Film, 1910–1947*, texts by Ute Eskildsen and Jan-Christopher Horak, Essen, 1982; Helmar Lerski, *Verwandlungen durch Licht*, ed. by Ute Eskildsen, Zurich, 1982.

GEORGE PLATT LYNES *p. 314*
American, 1907–1955
George Balanchine, ca. 1941/1959
Gelatin silver print, printed by Jenson Yow

19.2 × 24.2 cm.
Accession number 78:0517:1
Provenance: The Art Institute of Chicago.
Bibliography: The Art Institute of Chicago, *George Platt Lynes' Portraits, 1931–1952*, text by Lincoln Kirstein, Chicago, 1960, cat. no. 20; Institute of Contemporary Art, *George Platt Lynes, Photographic Visions*, text by Stephen Prokopoff, Boston, 1980; Jack Woody, *George Platt Lynes: Photographs, 1931–1955*, Los Angeles, 1980.

ROBERT MACPHERSON *p. 116*
Scottish, 1811–1872
Rome: Pines, Villa Pamphili-Doria, ca. 1856–65
Albumen print
40.0 × 30.1 cm.
Photographer's blindstamp on mount (l.c.).
Accession number 82:1970:6
Provenance: Wadsworth Library, Geneseo (NY); Mr. James Wadsworth; unknown.
Bibliography: Wendy Watson, *Images of Italy: Photography in the Nineteenth Century*, exhibition catalogue, South Hadley (Mass.), Mount Holyoke College Art Museum, 1980, pp. 34–40; Richard Pare, et al., *Photography and Architecture: 1839–1949*, Montreal, 1982, p. 234.

MAN RAY [EMMANUEL RUDNITSKY (?)] *p. 274*
French, b. United States, 1890–1976
[*Nude*], 1931
Gelatin silver print, solarized
23.0 × 29.7 cm.
Signed and dated on print (l.l.).
Accession number 81:1662:1
Provenance: the artist.
Bibliography: James Thrall Soby, *Photographs by Man Ray Paris 1920 Paris 1934*, Hartford (Conn.), 1934, illus.; reprinted as *Photographs by Man Ray: 105 Works, 1920–1934*, New York, 1979, illus., p. 35; Man Ray, *Self Portrait*, Boston, 1963; Centre National d'Art et de Culture Georges Pompidou, *Man Ray Photographe*, texts by Man Ray, Jean-Hubert Martin, and Herbert Molderings, Paris, 1981.

L. MARQUIER *p. 18*
French, active 1830s
The Notre-Dame Pumphouse, ca. 1839
Lithograph, printed by Desportes
20.2 × 14.0 cm. (image)
Printed on sheet with lined borders, title, photographer's, lithographer's, and printer's names.

Accession number 80:0447:1
Gift of Eastman Kodak Co.
Provenance: Eastman Historic Photographic Collection; Gabriel Cromer Collection; unknown.
Bibliography: Beaumont Newhall and Robert Doty, "The Value of Photography to the Artist, 1839," *Image*, XI, 6 (1962), pp. 25–28, illus.

FREDERIC MARTENS *p. 40*
French, b. Germany, ca. 1809–1875
[*Panorama of Paris*], ca. 1844–45
Daguerreotype
10.0 × 37.0 cm., panoramic plate
Accession number 76:0168:136
Gift of Eastman Kodak Co.
Provenance: Eastman Historic Photographic Collection; Gabriel Cromer Collection; unknown.
Bibliography: M.-A. Gaudin, "Photographie des glaciers des Alps par M. Martens," *La Lumière*, IV, 15 (15 April 1854), pp. 58–59; Bibliothèque Nationale, *Une invention du XIXe siècle: La photographie*, text by Bernard Marbot, Paris, 1976, cat. no. 237; André Jammes and Eugenia Parry Janis, *The Art of French Calotype*, Princeton, 1983, pp. 213–14.

LEOPOLD ERNEST MAYER and PIERRE-LOUIS PIERSON *p. 104*
French, firm active 1855–64
French, Louis Pierson: 1822–1913
[*Portrait of Napoleon III*], ca. 1860
Albumen print
32.5 × 24.2 cm.
Accession number 81:1638:1
Provenance: A. E. Marshall Collection, NY; unknown.
Bibliography: Mayer and Pierson, *La Photographie considerée comme art et comme industrie; Histoire de sa découverte, ses progrès, ses applications—son avenir*, Paris, 1862; Eugenia Parry Janis, entry for Mayer & Pierson, in Philadelphia Museum of Art, et al., *The Second Empire: Art in France under Napoleon III*, Philadelphia, 1978, cat. no. VIII-23, pp. 420–23; Pierre Tyl, "Mayer et Pierson," I. and II., *Prestige de la photographie*, 6 (April 1979), pp. 5–31, and 7 (August 1979), pp. 36–63.

RALPH EUGENE MEATYARD *p. 340*
American, 1925–1972
Romance (N) from Ambrose Bierce, No. 3, 1962
Gelatin silver print
17.7 × 18.7 cm.
Signed and artist's stamp on verso.
Accession number 80:0467:1
Gift of Eastman Kodak Co.

Provenance: Eastman Kodak Company, Rochester; the artist.
Bibliography: James Baker Hall, *Ralph Eugene Meatyard*, Millerton (NY), 1974; Jonathan Williams (ed.), *The Family Album of Lucybelle Crater*, Highlands (NC), 1974; Center for the Visual Arts, Illinois State University, *Ralph Eugene Meatyard: A Retrospective*, text by Van Deren Coke, Normal, 1976.

XAVIER MERIEUX *p. 162*
French, active 1860s
[*Photographic Trade Card*], ca. 1865
Albumen print
8.8 × 5.7 cm., carte-de-visite
Photographer's collophon on verso.
Accession number 80:0474:1
Gift of Eastman Kodak Co.
Provenance: Eastman Historic Photographic Collection; Gabriel Cromer Collection; unknown.
Bibliography: Robert A. Sobieszek, "Composite Imagery, 1850–1935: The Early History of Photomontage," checklist of exhibition, Rochester, IMP/GEH, 1979, cat. no. 1.

RAY K. METZKER *p. 374*
American, 1931–
Tales of Albuquerque, ca. 1973
Gelatin silver prints, montaged
43.9 × 38.3 cm.
Accession number 83:0033:1
Museum purchase, Intrepid Fund.
Provenance: Laurence Miller Gallery, New York; the artist.
Bibliography: Milwaukee Art Center, *Bennett, Steichen, Metzker: The Wisconsin Heritage in Photography*, Milwaukee, 1970; Peter C. Bunnell, "Ray Metzker," *The Print Collector's Newsletter*, IX (January/February 1979), pp. 177–79; Anne Wilkes Tucker, *Unknown Territory: Photographs by Ray K. Metzker*, comments by Ray K. Metzker, Millerton (NY) and Houston, 1984.

LISETTE MODEL [ELISE FELIC AMELIE SEYBERT MODEL] *p. 316*
American, b. Austria, 1906–1983
42nd. St., ca. 1942
Gelatin silver print
27.5 × 34.2 cm.
Signed and stamped on verso.
Accession number 84:0157:2
Museum purchase, Intrepid Fund.
Provenance: Sander Gallery, New York; estate of the artist.
Bibliography: Sander Gallery, *Model Photographs*, Washington, D.C., 1976; Allan Porter (ed.), "Lisette Model," *Camera*, texts by Lisette Model and Berenice Abbott, LVI, 12

(December 1977), (entire issue); Lisette Model, *Lisette Model*, text by Berenice Abbott, Millerton (NY), 1979.

LASZLO MOHOLY-NAGY *p. 248*
Hungarian, 1895–1946
The Structure of the World, 1927
Photomechanical offset, rotogravure, pencil
64.9 × 49.2 cm.
Titled and dated (l.l.), signed (l.r.).
Accession number 81:2163:51
Provenance: Mrs. Sibyl Moholy-Nagy; the artist.
Bibliography: László Moholy-Nagy, *Malerei Photographie Film*, Munich, 1925; trans. by Janet Seligmann as *Painting, Photography, Film*, Cambridge, 1969; László Moholy-Nagy, *Vision and Motion*, Chicago, (1947) 1961, illus., p. 213; László Moholy-Nagy, *Moholy-Nagy*, ed. by Richard Kostelanetz, New York, 1970, illus., pl. 20; Andreas Haus, *Moholy-Nagy: Photographs and Photograms*, trans. by Frederic Samson, New York, 1980, illus., fig. 32, p. 37; Bronx Museum of the Arts, *Moholy-Nagy, Fotoplastiks: The Bauhaus Years*, texts by Philip Verre and Julie Saul, New York, 1983, cat. no. 38; Wellesley College Museum, *Moholy-Nagy: Photography and Film in Weimar Germany*, text by Eleanor M. Hight, Wellesley, Mass., 1985.

COUNT DE MONTIZON *p. 148*
French, active England, 1850s
The Hippopotamus at the Zoological Gardens, Regent's Park, ca. 1854
Albumen (or albumenized salt) print
From *Photographic Album for the Year 1855. Contributions from the Members of the Photographic Club.*, London, 1855.
11.1 × 12.7 cm.
Accession number 77:0742:4
Gift of Mr. H. H. Claudet and Mrs. Norman Gilchrist.
Provenance: Mr. H. H. Claudet, Calgary; unknown.
Bibliography: Robert A. Sobieszek, *British Masters of the Albumen Print: A Selection of Mid-Nineteenth-Century Victorian Photography*, Chicago, 1976, illus., 2D11; Gail Buckland, *Reality Recorded: Early Documentary Photography*, Greenwich (Conn.), 1974, p. 35, illus.; Sam Wagstaff, *A Book of Photographs from the Collection of Sam Wagstaff*, New York, 1978, p. 29, illus.

BARBARA MORGAN *p. 312*
American, 1900–
Pure Energy and Neurotic Man,

1941/1970
Gelatin silver print, combination printing
50.1 × 38.8 cm.
Signed and dated on mount (l.r.).
Accession number 71:0024:7
Provenance: the artist.
Bibliography: Barbara Morgan, "Photomontage," in Willard D. Morgan and Henry M. Lester (eds.), *Miniature Camera Work*, New York, 1938, pp. 145–66; Barbara Morgan, *Barbara Morgan*, text by Peter C. Bunnell, Hastings-on-Hudson (NY), 1972, illus., p. 117; Anne Tucker, *The Woman's Eye*, New York, 1973, pp. 93–107; Barbara Morgan, *Barbara Morgan: Photomontage*, Dobbs Ferry (NY), 1982, illus., cover.

NICKOLAS MURAY *p. 354*
American, b. Hungary, 1892–1965
Marilyn Monroe—Actress, 1952
Color carbro print
47.6 × 37.6 cm.
Signed and dated on mount (l.r.).
Accession number 74:0100:1
Gift of Michael Brooke Muray, Nickolas Christopher Muray, and Gustav Schwab.
Provenance: the family of the artist; the artist.
Bibliography: Nickolas Muray and Paul Gallico, *The Revealing Eye*, New York, 1967; International Museum of Photography, *Nickolas Muray*, text by Robert A. Sobieszek, 1974; Nickolas Muray, *Muray's Celebrity Portraits of the Twenties and Thirties*, text by Marianne Fulton Margolis, New York and Rochester (NY), 1978.

EADWEARD J. MUYBRIDGE *p. 178*
American, b. England, 1830–1904
Mount Hoffmann, Sierra Nevada Mountain, from Lake Tenaya, 1872
Albumen print, combination printing
43.2 × 55.1 cm.
Letterpress label with title, artist's name, and publisher's name on mount (l.c.).
Accession number 81:2377:11
Gift of Harvard University.
Provenance: Dept. of Mineralogy, Harvard University; unknown.
Bibliography: Stanford University, *Eadweard Muybridge: The Stanford Years, 1872–1882*, texts by Anita Ventura Mozley, et al., Stanford, 1972; Weston J. Naef, et al., *Era of Exploration: The Rise of Landscape Photography in the American West, 1860–1885*, Buffalo and New York, 1975, pp. 167–200; Robert Bartlett Haas, *Muybridge, Man in Motion*, Berkeley, 1976.

NADAR [GASPARD-FELIX TOURNACHON] p. 78
French, 1820–1910
The Nadar Pantheon, 1854
Lithographic print, printed by Lemercier, Paris
72.0 × 94.5 cm. (image)
S/d "Nadar 1854" with the inscription "qui a été fièrement content quand c'a été fini!" ["who was pridefully content when this was finished!"] (l.l.) on the printing stone.
Accession number 81:0023:1
Gift of Eastman Kodak Co.
Provenance: Eastman Historic Photographic Collection; Gabriel Cromer Collection; unknown.
Bibliography: Nadar, *Quand j'étais photographe*, Paris, n.d. [1900]; Philippe Néagu and Jean-Jacques Poulet-Allamagny (eds.), *Nadar*, Paris, 1979, II, pp. 891–909, illus.; Jean Prinet and Antoinette Dilasser, *Nadar*, Paris, 1966; André Barret, *Nadar*, Paris, 1975, illus.; Roger Greaves, *Nadar, ou le paradox vital*, Paris, 1980.

NATIONAL AERONAUTICS AND SPACE ADMINISTRATION p. 412
American agency, est. 1958
[*Volcanic Activity on Io*], 1979
Chromogenic development print from computer assisted montage of radio transmitted signals
40.5 × 50.6 cm.
Accession number 79:2913:10
Gift of Jet Propulsion Laboratory, California Institute of Technology, Pasadena.
Provenance: Jet Propulsion Laboratory, California Institute of Technology, Pasadena; Voyager 1 Spacecraft.
Bibliography: Beaumont Newhall, *Airborne Camera: The World from the Air and Outer Space*, New York, 1969; National Aeronautics and Space Administration, Jet Propulsion Laboratory, *The Voyager Flights to Jupiter and Saturn*, Pasadena, 1982, illus., p. 18.

CHARLES NEGRE p. 52
French, 1820–1880
Arles: Porte des Châtaignes, 1852
Salted paper print
23.3 × 32.0 cm.
Artist's initials inscribed in negative (l.r.).
Accession number 80:0521:1
Gift of Eastman Kodak Co.
Provenance: Eastman Historic Photographic Collection; Gabriel Cromer Collection; unknown.
Bibliography: André Jammes, *Charles Nègre, photographe, 1820–1880*, Paris, 1963; James Borcoman, *Charles Nègre, 1820–1880*, Ottawa, 1976, cat. no.

62, illus.; Réunion des Musées Nationaux, *Charles Nègre, Photographe, 1820–1880*, texts by Françoise Heilbrun and Philippe Néagu, Arles and Paris, 1980, cat. no. 63, illus.

ARNOLD NEWMAN p. 356
American, 1918–
Alfried Krupp, 1963/1983
Dye transfer print
48.3 × 33.3 cm.
Signed (l.l.) and dated (l.r.) on mount.
Accession number 84:0180:6
Gift of the Lila Acheson Wallace Fund.
Provenance: the artist.
Bibliography: Arnold Newman, *One Mind's Eye: The Portraits and Other Photographs of Arnold Newman*, texts by Beaumont Newhall and Robert A. Sobieszek, Boston, 1974, illus., pl. 141; Gruppo Editoriale Fabbri, *Arnold Newman*, series "I grandi Fotografi," text by Robert A. Sobieszek, Milan, 1983, illus., p. 35; William Manchester, *The Arms of Krupp, 1587–1968*, New York, 1968.

TIMOTHY H. O'SULLIVAN p. 176
American, b. Ireland (?), ca. 1840–1882
Wall in the Grand Cañon, Colorado River, 1871
Albumen print
From U.S. Army, Corps of Engineers, *Photographs Showing Landscapes, Geological and other Features, of Portions of the Western Territory of the United States, Obtained in Connection with Geographical and Geological Explorations and Surveys West of the 100th Meridian, Seasons of 1871, 1872 and 1873. 1st Lieut. Geo. M. Wheeler, Corps of Engineers, U.S. Army, In Charge*, n.p. [Washington], n.d. [ca. 1875], pl. 11.
27.6 × 20.3 cm.
Mounted on sheet with letterpress title, artist's name and number.
Accession number 79:0014:10
Provenance: Philip Medicus; unknown.
Bibliography: Beaumont and Nancy Newhall, *T. H. O'Sullivan, Photographer*, Rochester, 1966, illus., pl. 25; Weston J. Naef, et al., *Era of Exploration: The Rise of Landscape Photography in the American West, 1860–1885*, Buffalo and New York, 1975, pp. 125–66, illus., pl. 54; Joel Snyder, *American Frontiers: The Photographs of Timothy H. O'Sullivan, 1867–1874*, Philadelphia, 1981.

PAUL EVERARD OUTERBRIDGE, JR. p. 242
American, 1896–1958
Piano, 1924

Platinum print
11.5 × 8.9 cm.
Signed and dated on verso of mount (l.r.).
Accession number 70:0375:1
Gift of the artist.
Provenance: the artist.
Bibliography: Paul Outerbridge, Jr., *Photographing in Color*, New York, 1940; John Szarkowski, *Looking at Photographs*, New York, 1973, pp. 80–81, illus.; Graham Howe (ed.), *Paul Outerbridge Jr: Photographs*, New York, 1980, illus., p. 48; Elaine Dines (ed.), *Paul Outerbridge, A Singular Aesthetic*, Laguna Beach, 1981, illus., p. 87.

VINICIO PALADINI p. 280
Italian, b. Russia, 1902–1971
[*Olympic Games*] ca. 1933–34
Gelatin silver print, watercolor, construction paper on board
From series *Olympic Games*.
30.0 × 19.0 cm.
Accession number 82:2857:4
Museum purchase, Alvin Langdon Coburn Memorial Fund.
Provenance: Sotheby Parke Bernet, New York; Giovanni Lista, Paris; the artist.
Bibliography: Giovanni Lista, *Futurismo e Fotografia*, Milan, 1979; Giovanni Lista, *Vinicio Paladini, dal futurismo all'immaginismo*, Milan, 1981; Musée d'art moderne, *Photographie futuriste italienne, 1911–1939*, text by Giovanni Lista, Paris, 1981, cat. no. 86, illus., p. 93.

IRVING PENN p. 406
American, 1917–
Still Life with Skull, Pitcher and Medicine Bottle, 1980/1981
Platinum-palladium print
23.3 × 49.2 cm.
Artist's stamp on verso.
Accession number 83:0126:1
Museum purchase, Intrepid Fund.
Provenance: Marlborough Gallery, New York; the artist.
Bibliography: Irving Penn, *Worlds in a Small Room*, New York, 1974; Marlborough Gallery, *Irving Penn: Recent Still Life*, text by Colin Eisler, New York, 1982, cat. no. 23, illus., p. 25; John Szarkowski, *Irving Penn*, New York, 1984.

JOHN PAUL PENNEBAKER p. 282
American, active 1930s
Chicago World's Fair, 1933/34
Fresson prints, composite triptych
34.1 × 56.9 cm. (ensemble)
Signed on mount (l.r.).
Accession number 77:0345:1
Gift of 3M Co., ex-collection Louis Walton Sipley.

Provenance: 3M Company, St. Paul; Louis Walton Sipley, The American Museum of Photography, Philadelphia; unknown.
Bibliography: Robert A. Sobieszek, et al., *An American Century of Photography, 1840–1940*, Lucerne (Camera), 1978, cat. no. 144, illus., p. 35.

JOHN PFAHL p. 418
American, 1939–
Six Oranges, Buffalo, New York, 1975
Chromogenic development print
18.9 × 22.9 cm.
Accession number 77:0119:2
Provenance: Collection of Robert Freidus, New York; the artist.
Bibliography: John Pfahl, *Altered Landscapes*, (portfolio), text by William E. Parker, New York, 1980; John Pfahl, *Altered Landscapes: The Photographs of John Pfahl*, (Untitled 26), text by Peter C. Bunnell, Carmel, 1981; illus., p. 31.

PIALLAT p. 166
French, active 1860s (?)
Warehouse of Edmond Ganneron, Specialist in Agricultural Equipment, ca. 1865–70
Photolithographic print, plate by Rodier, printed by Bertauts
35.4 × 46.2 cm.
Printed on sheet with letterpress title, photographer's, photolithographer's and printer's names.
Accession number 69:0165:1
Gift of Eastman Kodak Co.
Provenance: Eastman Historic Photographic Collection; Gabriel Cromer Collection; unknown.
Bibliography: André Jammes and Robert A. Sobieszek, *French Primitive Photography*, New York and Philadelphia, 1970, cat. no. 226, illus.

EUGENE PIOT p. 64
French, 1812–1891
The Acropolis of Athens, the Pandroseion, 1852
Salted paper print
32.7 × 22.6 cm.
Mounted on sheet with letterpress title, artist's name, and date.
Accession number 82:1564:1
Museum purchase, Lila Acheson Wallace Fund.
Provenance: Steven White Gallery, Los Angeles; unknown.
Bibliography: Bernard Marbot and Weston J. Naef, *After Daguerre: Masterworks of French Photography (1848–1900) from the Bibliothèque Nationale*, New York, 1980, cat. no. 125; Janet E. Buerger, *The Era of the French Calotype*, Rochester (NY), 1982, cat. no.

204, illus.; André Jammes and Eugenia Parry Janis, *The Art of French Calotype*, Princeton, 1983, pp. 234–35.

ELIOT FURNESS PORTER
p. 332
American, 1901–
[*Lichen and Pine Needles*],
ca. 1960
Dye transfer print
27.3 × 20.3 cm.
Artist's stamp on verso.
Accession number 81:1505:24
Provenance: the artist.
Bibliography: Eliot Porter, *In Wildness Is the Preservation of the World*, texts by Henry David Thoreau and Joseph Wood Krutch, San Francisco, 1962, illus., p. 129; Eliot Porter, *Intimate Landscapes: Photographs by Eliot Porter*, text by Weston J. Naef, New York, 1979.

WILLIAM SOUTHGATE
PORTER *p. 42*
American, 1822–1889
Fair Mount, 1848
Daguerreotypes
36.7 × 99.8 cm.(ensemble), 8 half plates (trimmed) in original mount, with applied color
Lettered on original mount.
"Daguerreotyped by W. S. Porter. Philaeelphia [*sic*], May 22d 1848." (l.c.).
Accession number 77:0503:1–8
Gift of 3M Co., ex-collection Louis Walton Sipley.
Provenance: 3M Company, St. Paul; Louis Walton Sipley, The American Museum of Photography, Philadelphia; unknown.
Bibliography: Beaumont Newhall, *The Daguerreotype in America*, New York, 1961, p. 151; Robert A. Sobieszek, et al., *An American Century of Photography, 1840–1940*, Lucerne (*Camera*), 1978, cat. no. 146.

VICTOR PREVOST *p. 158*
French, 1820–1881
Part of the Lion Bridge on Equestrian Road, August 17th., 1862
Albumen print
From Presentation portfolio, ("To A. H. Green Esq." from V. Prevost), *Central Park, New York*, 1862, pl. 5.
13.5 × 13.5 cm.
Signed in negative (l.l.).
Accession number 76:0031:6
Provenance: House of Antiques, Montreal.
Bibliography: W. I. Scandlin, "Victor Prevost, Photographer, Artist, Chemist," *Photo Era*, VII, 4 (October 1901), pp. 126–31; Robert A. Sobieszek, et al., *Acquisitions 1973–1980*, Rochester (NY), 1981, cat. no. 214; André

Jammes and Eugenia Parry Janis, *The Art of French Calotype*, Princeton, 1983, pp. 236–37.

EMILE-JOACHIM-CONSTANT
PUYO *p. 208*
French, 1857–1933
Gorgon's Head, ca. 1898
Brown gum bichromate print
20.3 × 15.2 cm.
Artist's monogram embossed on print (l.l.).
Accession number 83:2344:1
Provenance: Sotheby Parke Bernet, New York; unknown.
Bibliography: R. Demachy and C. Puyo, *Les Procédés d'art en photographie*, Paris, 1906; C. Puyo, "La Photographie synthétique," *La Revue de photographie*, II (1904), pp. 105–10, 137–44, 181–83; Robert de la Sizeranne, *La Photographie est-elle un art?*, Paris, 1899, illus., p. 49; Yves Aubry, *Puyo et la Revolte Pictorialiste*, (extract from ZOOM, no. 93), Paris, 1982, illus., unp.

OSCAR GUSTAVE
REJLANDER *p. 182*
British, b. Sweden, 1813–1875
Poor Jo, ca. 1860
Albumen print
20.2 × 14.9 cm.
Signed on mount (l.r.).
Accession number 84:0081:1
Museum purchase, Miller-Plummer Fund.
Provenance: Jane Corkin Gallery, Toronto; unknown.
Bibliography: Peter C. Bunnell (ed.), *The Photography of O. G. Rejlander*, New York, 1979, illus.; Edgar Yoxall Jones, *Father of Art Photography: O. G. Rejlander, 1813–1875*, Newton Abbot, 1973, illus., p. 79; Stephanie Laine Spencer, *O. G. Rejlander—Art Photographer*, dissertation (University of Michigan, 1981), Ann Arbor, 1983, illus., fig. 68.

ALBERT RENGER-PATZSCH
p. 328
German, 1897–1966
Beech Forest, 1936/1958
Gelatin silver print
28.1 × 38.3 cm.
Signed and dated on verso.
Accession number 80:0546:19
Provenance: the artist.
Bibliography: Albert Renger-Patzsch, *Die Welt ist schön*, text by Carl Georg Heise, Munich, 1928; Albert Renger-Patzsch, *Bilder aus der Landschaft zwischen Ruhr und Mohne*, text by Helene Henze, Belecke (Möhne), 1957, illus., unp.; Rheinisches Landesmuseum, *Industrielandschaft, Industriearchitektur, Industrieprodukt:*

Fotografien 1925–1960 von Albert Renger-Patzsch, Bonn, 1977; Galerie Schurmann & Kicken, *Albert Renger-Patzsch: 100 Photographs*, texts by Fritz Kempe, et al., Cologne and Boston, 1979.

GUIDO REY *p. 210*
Italian, active 1890s–1920s
[*Seated Woman with Lilies*],
ca. 1899
Platinum print
14.6 × 18.7 cm.
Accession number 84:0176:1
Museum purchase, Miller-Plummer Fund.
Provenance: Tom Jacobson, San Diego; unknown.
Bibliography: [E. J.] C. Puyo, "Le Passe source d'inspiration," *La Revue de photographie*, II (1904), pp. 1–8

JAMES ROBERTSON *p. 122*
British, active 1852–1865
Interior of the Redan After the Assault (The Barracks Battery), 1855
From James Robertson, *Athenes-Constantinople-Sebastopol*, Constantinople [?], ca. 1855, unn.
Albumenized salted paper print [?]
23.8 × 30.2 cm.
Artist's name inscribed on negative (l.l.); on sheet with lithographic artist's name.
Accession number 79:0001:45
Gift of Eastman Kodak Co.
Provenance: Eastman Historic Photographic Collection; Gabriel Cromer Collection; unknown.
Bibliography: Helmut and Alison Gernsheim (eds.), *Roger Fenton: Photographer of the Crimean War*, London, 1954, illus., pl. 83; Marie Therese and André Jammes, "The First War Photographs," *Camera*, XLIII, 1 (1964), pp. 2–4; B. A. and H. K. Henisch, "Robertson of Constantinople," *Image*, XVII, 3 (September 1974), pp. 1–11; P. & D. Colnaghi, *Photography: The First Eighty Years*, text by Valerie Lloyd, London, 1976, cat. nos. 59–71, pp. 43–46.

HENRY PEACH
ROBINSON
p. 140
British, 1830–1901
Fading Away, 1858
Albumen print, combination print from 5 negatives
24.2 × 39.2 cm.
S/d on mount (l.r.); titled on mount (l.c.); inscription of lines from Shelley on mount (l.l.).
Accession number 76:0116:1
Gift of Alden Scott Boyer.
Provenance: Alden Scott Boyer Col-

lection, Chicago; unknown.
Bibliography: Henry Peach Robinson, *Pictorial Effect in Photography*, London, 1869; Anon., "The Photographic Exhibition at the Crystal Palace" (Second Notice), *The Photographic News*, I, 4 (October 1, 1858), pp. 40–41; Alan Vertrees, "The Picture Making of Henry Peach Robinson," in Dave Oliphant and Thomas Zigal (eds.), *Perspectives on Photography*, Austin, 1982, pp. 78–101, illus.

ALEXANDER MIKHAILOVICH
RODCHENKO *p. 250*
Russian, 1891–1956
Portrait of the Writer Nicolai Asseev, 1927
Gelatin silver print
15.6 × 22.5 cm.
Artist's stamp on verso of print.
Accession number 70:0087:2
Provenance: Caio Garrubha; unknown.
Bibliography: Evelyn Weiss (ed.), *Alexander Rodtschenko: Fotografien 1920–1938*, Cologne, 1978; David Elliott (ed.), *Alexander Rodchenko 1891–1956*, Oxford and New York, 1979; Alexander Lavrentjev, *Rodchenko Photography*, trans. by John William Gabriel, New York, 1982; illus., pl. 30.

MARCUS AURELIUS ROOT
p. 54
American, 1808–1888
Self Portrait, ca. 1850–55
Daguerreotype
11.8 × 8.8 cm. (sight), half plate, in vintage frame
Accession number 77:0259:9
Gift of 3M Co., ex-collection Louis Walton Sipley.
Provenance: 3M Company, St. Paul; Louis Walton Sipley, The American Museum of Photography; unknown.
Bibliography: M. A. Root, *The Camera and the Pencil; or the Heliographic Art. . . .*, Philadelphia, 1864; Robert A. Sobieszek, et al., *An American Century of Photography, 1840–1940: Selections from the Sipley/3M Collection*, Lucerne (*Camera*), 1978, cat. no. 157; Richard Rudisill, *Mirror Image: The Influence of the Daguerreotype on American Society*, Albuquerque, 1971, pp. 182–86, and *passim*.

ARTHUR ROTHSTEIN *p. 296*
American, 1915–
Dust Storm, Cimarron County, Oklahoma, 1936/printed later
Gelatin silver print
19.1 × 19.2 cm.
Accession number 73:0086:1
Anonymous gift.

Provenance: Private collection; unknown.

Bibliography: Arthur Rothstein, *Look at Us, Let's See, Here We Are. . . .*, text by William Saroyan, New York, 1967, illus., p. 25; F. Jack Hurley, *Portrait of a Decade: Roy Stryker and the Development of Documentary Photography in the Thirties*, Baton Rouge, 1972, illus., p. 85; Arthur Rothstein, *Words and Pictures*, New York, 1979, illus., p. 38.

ANDREW JOSEPH RUSSELL *p. 126*
American, 1830–1902
Rebel Caisson Destroyed by Federal Shells, 1863
Albumen print
24.4 × 33.2 cm.
Accession number 83:2161:1
Provenance: Philip Medicus; unknown.
Bibliography: Weston J. Naef, et al., *Era of Exploration: The Rise of Landscape Photography in the American West, 1860–1885*, Buffalo and New York, 1975, pp. 201–18; The David and Alfred Smart Gallery, The University of Chicago, *The Documentary Photograph as a Work of Art*, texts by Joel Snyder, et al., Chicago, 1976, cat. no. 145, illus.; Sam Wagstaff, *A Book of Photographs*, New York, 1978, p. 38, illus.

JEAN-BAPTISTE SABATIER-BLOT *p. 24*
French, 1801–1881
Mme. Sabatier, ca. 1844
Daguerreotype
10.7 × 8.3 cm., quarter plate
Platemark: "SB".
Accession number 76:0168:160
Gift of Eastman Kodak Co.
Provenance: Eastman Historic Photographic Collection; Gabriel Cromer Collection; the family of Sabatier-Blot.
Bibliography: Gabriel Cromer, "Un photographe-artiste des premiers temps du daguerreotype, le miniaturiste SABATIER-BLOT," *Bulletin de la Société française de photographie*, 1 (January 1933), pp. 6–11; J. Thierry, *Daguerréotypie*, Paris and Lyon, May 1847, pp. 86, 177; J. Thierry, *ibid.*, 2nd ed., November 1847, p. 187; Jean Clay, *Romanticism*, New York, 1981, p. 19, illus.

ERICH SALOMON *p. 260*
German, 1886–1944
Balcony, League of Nations, Geneva, 1930/ca. 1958
Gelatin silver print
19.2 × 24.5 cm.
Stamped on verso "Peter Hunter

Press Features."
Accession number 81:1926:3
Provenance: Peter Hunter-Salomon, Amsterdam; the artist.
Bibliography: Erich Salomon, *Berühmte Zeitgenossen in unbewachten Augenblicken*, Stuttgart, 1931; Beaumont and Nancy Newhall, *Masters of Photography*, New York, 1958, pp. 134–39, illus.; Peter Hunter-Salomon, *Erich Salomon: Portrait of an Age*, New York, 1967.

AUGUSTE SALZMANN *p. 110*
French, 1824–1872
Temple Wall: Triple Roman Portal, 1855/1856
Salted paper print, printed by Blanquart-Evrard
From Auguste Salzmann, *Jerusalem. Etude et reproduction photographique des monuments de la ville sainté, depuis l'époque judaïque jusqu'à nos jours*, Paris, 1856.
22.3 × 45.7 cm.
Mounted on sheet with letterpress title, artist's and printer's names.
Accession number 79:2893:1
Provenance: Van Deren Coke, Albuquerque; unknown.
Bibliography: Robert A. Sobieszek, "Aug. Salzmann, Phot.," *Image*, IV, 5/6, pp. 24–26; Isabelle Jammes, *Blanquart-Evrard et les origines de l'édition photographique française: Catalogue raisonné des albums photographiques édités 1851–1855*, Geneva and Paris, 1981, pp. 92–103; Abigail Solomon-Godeau, "A Photographer in Jerusalem, 1855: Auguste Salzmann and His Times," *October*, 18 (Fall 1981), pp. 90–107.

AUGUST SANDER *p. 252*
German, 1876–1964
Young Sport Pilot, 1925
Gelatin silver print
20.5 × 14.6 cm.
Signed and dated on mount (l.r.), artist's stamp on verso.
Accession number 78:0100:2
Provenance: the family of the artist; the artist.
Bibliography: August Sander, *Antlitz der Zeit*, text by Alfred Döblin, Munich, 1929; August Sander, *Menschen ohne Maske*, texts by Golo Mann and Gunther Sander, Luzern and Frankfurt/M, 1971, illus., pl. 206; Ulrich Keller, *August Sander: Menschen des 20. Jahrhunderts: Portraitphotographien, 1892–1952*, Munich, 1980, illus., pl. 88.

MORTON LIVINGSTON SCHAMBERG *p. 234*
American, 1881–1918
[City Rooftops], 1916

Gelatin silver print
22.8 × 15.2 cm.
Accession number 73:0079:1
Provenance: Robert Schoelkopf Gallery, New York; unknown.
Bibliography: Van Deren Coke, "The Cubist Photographs of Paul Strand and Morton Schamberg," *One Hundred Years of Photographic History: Essays in Honor of Beaumont Newhall*, Albuquerque, 1975, pp. 36–42; John Pultz and Catherine B. Scallen, *Cubism and American Photography, 1910–1930*, Williamstown (Mass.), 1981, cat. no. 37; Karen Tsujimoto, *Images of America: Precisionist Painting and Modern Photography*, San Francisco, 1982.

VICTOR SCHRAGER *p. 404*
American, 1950–
[Still Life with Vermeer's "Art of Painting"], 1978
Polacolor print
62.5 × 52.4 cm.
Accession number 81:2349:1
Museum purchase with National Endowment for the Arts support.
Provenance: Robert Freidus Gallery, New York; the artist.
Bibliography: Robert A. Sobieszek, "Mythological Structures and Du Hauron's Rooster," in Florida School of the Arts, *Cultural Artifacts*, Palatka, 1979, unp.; Ben Lifson, "Boxed-In," *The Village Voice*, (3 December 1979), p. 93; Jorgensen Gallery, The University of Connecticut, *Victor Schrager: Photography*, Storrs, 1980.

CHARLES SHEELER *p. 232*
American, 1883–1965
[Bucks County House, Interior Detail], ca. 1914–17
Gelatin silver print
24.2 × 16.2 cm.
Signed on verso (l.r.).
Accession number 81:1758:22
Provenance: the artist.
Bibliography: Constance Rourke, *Charles Sheeler: Artist in the American Tradition*, New York, 1938; National Collection of Fine Arts, Smithsonian Institution, *Charles Sheeler*, texts by Martin Friedman, Bartlett Hayes, Charles Millard, Washington, 1968, cat. no. 11, illus., p. 83; Weston J. Naef, *The Collection of Alfred Stieglitz: Fifty Pioneers of Modern Photography*, New York, 1978, 437–40, cat. no. 448, pl. 90.

CINDY SHERMAN *p. 402*
American, 1954–
Untitled #85, 1981
Chromogenic development print
61.0 × 121.3 cm.
Accession number 83:1576:1

Museum purchase, L.A.W. Fund.
Provenance: Metro Pictures, New York; the artist.
Bibliography: Peter Schjeldahl, "Shermanettes," *Art in America*, LXX, 3 (March 1982), pp. 110–11; Stedelijk Museum, *Cindy Sherman*, text by Els Barents, Amsterdam, 1982, illus., pl. 50; Gerald Marzorati, "Imitation of Life," *Artnews*, LXXXII, 7 (September 1983), pp. 79–87; Cindy Sherman, *Cindy Sherman*, texts by Peter Schjeldahl and I. Mitchell Danoff, New York, 1984, illus., pl. 50.

STEPHEN ERIC SHORE *p. 372*
American, 1947–
U.S. 1, Arundel, Maine, 1974/1975
Chromogenic development print
19.5 × 24.6 cm.
Accession number 77:0022:4
Gift of the artist.
Provenance: the artist.
Bibliography: Max Kozloff, "The Coming of Age of Color," *Artforum*, XIII, 5 (January 1975), pp. 30–35; International Museum of Photography, *New Topographics*, text by William Jenkins, Rochester (NY), 1975, cat. unn.

AARON SISKIND *p. 330*
American, 1903–
Martha's Vineyard, 1954
Gelatin silver print
39.2 × 49.2 cm.
Accession number 72:0078:2
Provenance: the artist.
Bibliography: Aaron Siskind, *Aaron Siskind: Photographs*, text by Harold Rosenberg, New York, 1959; Aaron Siskind, *Aaron Siskind: Photographer*, ed. by Nathan Lyons, texts by Nathan Lyons, et al., Rochester (NY), 1965, illus., [p. 26]; Carl Chiarenza, *Aaron Siskind: Pleasures and Terrors*, Boston, 1982.

WILLIAM EUGENE SMITH *p. 344*
American, 1918–1978
Death in a Spanish Village, 1950/printed later
From picture essay "A Spanish Village," *Life*, 9 April 1951.
Gelatin silver print
22.8 × 34.3 cm.
Artist's stamps on verso.
Accession number 81:1936:1
Provenance: the artist.
Bibliography: W. Eugene Smith, *W. Eugene Smith: His Photographs and Notes*, text by Lincoln Kirstein, Millerton (NY), 1969, illus., unp.; William S. Johnson (ed.), *W. Eugene Smith: Master of the Photographic Essay*, New York, 1981, no. 13:073, illus., p. 80.

FREDERICK SOMMER *p. 324*
American, b. Italy, 1905–
Arizona Landscape, 1943
Gelatin silver print
19.4 × 24.3 cm.
Accession number 71:0112:3
Provenance: the artist.
Bibliography: Philadelphia College of Art, *Frederick Sommer*, text by Gerald Nordland, Philadelphia, 1968; The Art Museum and Galleries, California State University, *Frederick Sommer at Seventy-Five: A Retrospective*, ed. by Constance W. Glenn and Jane K. Bledsoe, Long Beach, 1980, cat. no. 4, illus., p. 48; Frederick Sommer, *Sommer: Words/Images*, Tucson, 1984, illus., pl. 29.

ALBERT SANDS
SOUTHWORTH and JOSIAH
JOHNSON HAWES *p. 96*
American, A. S. Southworth:
1811–1894
American, J. J. Hawes:
1808–1901
[*Group Portrait of Unidentified Women*], ca. 1856
Daguerreotype
16.5 × 21.6 cm., full plate
Hallmarks: star (u.r.), "40" (l.r.).
Accession number 74:0193:502
Provenance: Holman's Print Shop, Boston; the family of Josiah Johnson Hawes.
Bibliography: Richard Rudisill, *Mirror Image: The Influence of the Daguerreotype on American Society*, Albuquerque, 1971, illus., pl. 145; Robert A. Sobieszek and Odette M. Appel, *The Spirit of Fact: The Daguerreotypes of Southworth & Hawes, 1843–1862*, Boston and Rochester, 1976, cat. no. 96; illus., p. 112; Robert A. Sobieszek, "Albert Sands Southworth and Josiah Johnson Hawes," *Camera*, LV, 12 (December 1976), pp. 4–13, 34–37.

EDUARD [EDWARD] JEAN
STEICHEN *p. 254*
American, b. Luxembourg,
1879–1973
Greta Garbo, Hollywood, 1928
Gelatin silver print
42.2 × 33.9 cm.
Accession number 79:2176:2
Bequest of Edward Steichen by direction of Joanna T. Steichen.
Provenance: the estate of the artist.
Bibliography: Edward Steichen, *A Life in Photography*, New York, 1963, illus., pl. 125; The Museum of Modern Art, *Steichen the Photographer*, texts by Carl Sandburg, et al., New York, 1961, illus., p. 49; Dennis Longwell, *Steichen: The Master Prints, 1895–1914*, New York, 1978.

ALFRED STIEGLITZ *p. 196*
American, 1864–1946
The Terminal (New York), 1893/(?)
Gelatin silver on glass (lantern slide)
6.5 × 7.5 cm. (image), on glass
8.2 × 8.1 cm.
Accession number 83:0660:18
Gift of Georgia O'Keeffe.
Provenance: the estate of the artist.
Bibliography: Museum of Fine Arts, *Alfred Stieglitz: Photographer*, text by Doris Bry, Boston, 1965, illus., pl. 2; Dorothy Norman, *Alfred Stieglitz: An American Seer*, New York, 1973, illus., pl. IV; National Gallery of Art, *Alfred Stieglitz: Photographs and Writings*, texts by Sarah Greenough and Juan Hamilton, Washington, 1983, cat. nos. 21, 22; Sue Davidson Lowe, *Stieglitz: A Memoir/Biography*, New York, 1983.

PAUL STRAND *p. 278*
American, 1890–1976
Women of Santa Ana, Michocan, Mexico, 1933
Gelatin silver print
19.3 × 24.2 cm.
Accession number 81:2031:8
Provenance: the artist.
Bibliography: Paul Strand, *Photographs of Mexico*, text by Leo Hurwitz, (portfolio), New York, 1940; reissued as *The Mexican Portfolio*, text by David Alfaro Siqueiros, New York, 1967, pl. 4; Paul Strand, *Paul Strand: A Retrospective Monograph*, 2 vols., Millerton (NY), 1971, 1972; Paul Strand, *Paul Strand: Sixty Years of Photographs*, text by Calvin Tomkins, Millerton (NY), 1976.

JOSEF SUDEK *p. 338*
Czechoslovakian, 1896–1976
A Walk in the Magic Garden, 1954
Gelatin silver print, toned
8.7 × 28.3 cm.
Signed on mount (l.r.).
Accession number 72:0284:2
Provenance: the artist.
Bibliography: Vitezslav Nezval, *Praha—Josef Sudek*, Prague, 1948; Josef Sudek, *Praha Panoramaticka*, poem by Jaroslav Seifert, Prague, 1959; Sonja Bullaty, *Sudek*, New York, 1978, illus., pl. 25.

WILLIAM HENRY FOX
TALBOT *p. 30*
British, 1800–1877
Lace, ca. 1845
Salted paper print
23.0 × 18.8 cm. (irregular)
Accession number 81:2836:1
Gift of Dr. Walter Clark.
Provenance: Dr. Walter Clark, Pittsford (NY); unknown.
Bibliography: Beaumont Newhall, "Introduction," in William Henry

Fox Talbot, *The Pencil of Nature*, (reprint), New York, 1968, unp.; H. J. P. Arnold, *William Henry Fox Talbot: Pioneer of Photography and Man of Science*, London, 1977; Gail Buckland, *Fox Talbot and the Invention of Photography*, Boston, 1980.

JOHN THOMSON *p. 184*
British, 1837–1921
London Nomades, ca. 1876
Woodburytype print
From John Thomson and Adolphe Smith, *Street Life in London*, London, 1877–78, pl. 1.
11.0 × 8.6 cm.
Mounted on board with lithographic title and border.
Accession number 81:2141:6
Gift of Alden Scott Boyer.
Provenance: Alden Scott Boyer Collection; unknown.
Bibliography: Robert Doty, "Street Life in London," *Image*, VI, 10 (December 1957), pp. 240–45; Mark Haworth-Booth, et al., *The Golden Age of British Photography, 1839–1900*, Millerton (NY), 1984, pp. 142–43; Stephen White, *John Thomson: Victorian Photographer*, in preparation.

ADRIEN TOURNACHON
p. 94
French, 1825–1903
Alphonse de Lamartine, 1856
Albumen print (?), applied color
57.0 × 45.0 cm.
Accession number 83:0659:1
Gift of Eastman Kodak Co.
Provenance: Eastman Historic Photographic Collection; Gabriel Cromer Collection; unknown.
Bibliography: Bernard Marbot and Weston J. Naef, *After Daguerre: Masterworks of French Photography (1848–1900) from the Bibliothèque Nationale*, New York, 1980, cat. nos. 148, 149; Janet E. Buerger, *The Era of the French Calotype*, exhibition catalogue, Rochester (NY), IMP/GEH, 1982, cat. nos. 226–31.

LINNEAUS TRIPE *p. 68*
British, 1822–1902
Approach to the Temple at Trivady, 1856–57
Salted paper print
From Linneaus Tripe, *Photographic Views in Tanjore and Trivady*, Madras, 1858, pl. 23.
29.0 × 37.5 cm.
Accession number 78:0446:1
Provenance: Robert Hershkowitz, Ltd., London; unknown.
Bibliography: Clark Worswick and Ainslie Embree, *The Last Empire: Photography in British India, 1855–1911*, Millerton (NY), 1976; Mark

Haworth-Booth, et al., *The Golden Age of British Photography, 1839–1900*, Millerton (NY), 1984; Hans P. Kraus, Jr., *Catalogue One: Sun Pictures, Early British Photographs on Paper*, New York, 1984, cat. no. 42, illus. (with different title).

JERRY N. UELSMANN *p. 388*
American, 1934–
[*Nude and Rock Formation*], 1972
Gelatin silver print, combination printing
24.0 × 33.5 cm.
Signed on mount (l.r.).
Accession number 73:0051:3
Provenance: the artist.
Bibliography: William E. Parker, "Uelsmann's Unitary Reality," *Aperture*, XIII, 3 (1967), unp.; Jerry N. Uelsmann, *Jerry N. Uelsmann*, texts by Peter C. Bunnell and Russell Edson, New York, 1970; John L. Ward, *The Criticism of Photography as Art: The Photographs of Jerry Uelsmann*, Gainesville, 1970; Jerry N. Uelsmann, *Silver Meditations*, text by Peter C. Bunnell, Dobbs Ferry (NY), 1975, illus., unp; Jerry N. Uelsmann, *Jerry N. Uelsmann, Twenty-five Years: A Retrospective*, text by James L. Enyeart, Boston, 1982.

UNIDENTIFIED
PHOTOGRAPHER *p. 28*
French, active 1840s
[*Man Seated in Front of Garden Wall*], ca. 1845–50
Daguerreotype
16.5 × 21.7 cm., full plate
Accession number 76:0168:10
Gift of Eastman Kodak Co.
Provenance: Eastman Historic Photographic Collection; Gabriel Cromer Collection; unknown.
Bibliography: Beaumont Newhall, *The History of Photography*, New York, 1964, p. 23, illus.

UNIDENTIFIED
PHOTOGRAPHER *p. 58*
American, active 1850s
[*Quaker Sisters*], 1853
Daguerreotype, applied color
6.9 × 8.2 cm., oval, sixth plate
Accession number 69:201:4
Provenance: Zelda P. Mackay Collection; unknown.
Bibliography: Beaumont Newhall, *The Daguerreotype in America*, New York, 1961, pl. 27.

UNIDENTIFIED
PHOTOGRAPHER *p. 60*
American, active 1850s
[*Portrait of a Male Hunter*], ca. 1855–60
Ambrotype

8.3 × 6.9 cm., sixth plate
Accession number 69:0205:13
Provenance: Zelda P. Mackay Collection; Dorothy Manning Payne, Niles, Mich.; unknown.
Bibliography: N. G. Burgess, *The Photograph Manual; A Practical Treatise, Containing the Cartes de Visite Process, and the Method of Taking Stereoscopic Pictures*, New York, 1863, pt. II, "The Ambrotype Manual," pp. 123–90; Robert Taft, *Photography and the American Scene*, New York, 1938, chap. 7, "The Ambrotype," pp.123–37.

UNIDENTIFIED
PHOTOGRAPHER p. 62
French, active 1850s
[*Street Flutists*], ca. 1852
Daguerreotype, applied color
8.7 × 16.8 cm., stereograph
Accession number 76:0168:156
Gift of Alden Scott Boyer.
Provenance: Alden Scott Boyer Collection; unknown.

UNIDENTIFIED
PHOTOGRAPHER p. 156
British, active 1860s (?)
Windsor Park—Virginia Waters, ca. 1865
Albumen print
21.2 × 25.6 cm. (oval)
Titled on mount in pencil.
Accession number 77:0689:157
Provenance: A. E. Marshall Collection, NY; unknown.
Bibliography: Robert A. Sobieszek, *British Masters of the Albumen Print: A Selection of Mid-Nineteenth-Century Victorian Photography*, Chicago, 1976, cat. no. 3C11, illus.

UNIDENTIFIED
PHOTOGRAPHER p. 152
British, active 1860s (?)
[*Japanese Samurai*], ca. late 1860s
Albumen print
19.4 × 13.3 cm.
Accession number 77:0689:72
Provenance: A. E. Marshall Collection, NY; unknown.
Bibliography: Robert A. Sobieszek, *British Masters of the Albumen Print: A Selection of Mid-Nineteenth Century Victorian Photography*, Chicago, 1976, cat. no. 3A7, illus.

UNIDENTIFIED
PHOTOGRAPHER p. 150
British (?), active 1870s
"*Col. Michael, Military Secretary to Government, with Bones of the Leg of the Australian Dinornis*," ca. 1872
Albumen print
From album *Indian Photographs*,

Madras, n.d. [ca. 1872].
22.9 × 17.3 cm.
Mounted on sheet with hand-written caption beneath.
Accession number 79:0032:52
Provenance: Brentano's, Chicago; unknown.

UNIDENTIFIED
PHOTOGRAPHER
[DAZIARO (?)] p. 220
Russian (?), active late 19th century
[*View of Moscow*], ca. late 19th century
Albumen print, applied color
20.5 × 26.5 cm.
Accession number 73:0102:1
Provenance: Siembab Gallery, Boston; unknown.

WILHELM VON GLOEDEN
p. 228
German, 1856–1931
[*A Boy and a Child with Vases of Roses*], 1913
Albumen print
39.8 × 29.1 cm.
Signed and dated (u.r.).
Accession number 67:0027:1
Gift of Mrs. J. J. Conmey.
Provenance: Mrs. J. J. Conmey, Rochester (NY); unknown.
Bibliography: Baron de Gloeden, *Taormina: Debut de siècle*, text by Jean-Claude Lemagny, Paris, 1975; Charles Leslie, *Wilhelm von Gloeden, Photographer: A Brief Introduction to His Life and Work*, New York, 1977; Roland Barthes, *Wilhelm von Gloeden: Interventi di Joseph Beuys, Michelangelo Pistoletto, Andy Warhol*, Naples, 1978; Kunsthalle Basel, *Wilhelm von Gloeden (1856–1931)*, texts by Ekkehard Hieronimus and Gert Schiff, Basel, 1979; Galleria del Levante, *Wilhelm von Gloeden Photograph*, texts by Italo Mussa and Wilhelm von Gloeden, Munich, 1979, illus., p. 37.

SAMUEL LEON WALKER
p. 36
American, 1802–1874
[*The Artist's Daughter*], ca. 1847–54
Daguerreotype
10.7 × 9.4 cm., quarter plate
Accession number 78:0150:4
Provenance: Lynn Maillet, NY; private collection, San Juan Capistrano; the family of the artist.
Bibliography: Robert A. Sobieszek, "Samuel Walker," *American Photographer*, IX, 3 (September 1982), pp. 80–84, illus.

CARLETON E. WATKINS
p. 174
American, 1829–1916
Cape Horn, Columbia River, Oregon, 1867
Albumen print, combination printing
52.3 × 40.4 cm.
Accession number 73:0142:1
Provenance: Anonymous gift.
Bibliography: Weston J. Naef, et al., *Era of Exploration: The Rise of Landscape Photography in the American West, 1860–1885*, Buffalo and New York, 1975; James Alinder (ed.), *Carleton E. Watkins: Photographs of the Columbia River and Oregon*, Carmel, 1979; Peter E. Palmquist, *Carleton E. Watkins, Photographer of the American West*, Albuquerque, 1983, illus., pl. 32.

WEEGEE [ARTHUR FELLIG]
p. 294
American, b. Austria-Hungary, 1899–1968
"*Booked on suspicion of killing a policeman*," 1939
Gelatin silver print
34.5 × 27.1 cm.
Accession number 84:0157:3
Museum purchase, Intrepid Fund.
Provenance: Sander Gallery, New York; unknown.
Bibliography: Weegee, *Naked City*, New York, 1945; Weegee, *Weegee by Weegee: An Autobiography*, New York, 1961; Weegee, *Weegee*, ed. and text by Louis Stettner, New York, 1977, illus., p. 76; John Coplans, "Weegee the Famous," *Art in America*, LXV, 5 (September–October 1977), pp. 37–41, illus. (variant), p. 38.

F. A. WENDEROTH p. 98
American, active 1860s
[*The Artist's Daughter*], ca. 1855
Ivorytype, applied color
54.7 × 42.1 cm., domed, original frame
Accession number 81:2053:01
Provenance: Mr. and Mrs. F. Wenderoth Saunders, Wiscasset, Mass.; the family of the artist.
Bibliography: Marcus Aurelius Root, *The Camera and the Pencil*, Philadelphia, 1864, pp. 305–6; Anon., "F. Wenderoth," *Photographic News*, XVIII, 775 (11 July 1873), p. 326.

EDWARD HENRY WESTON
p. 240
American, 1886–1958
Ruth Shaw, 1922
Gelatin silver print
18.8 × 24.0 cm.
Signed and dated on verso of mount (l.r.).
Accession number 66:0070:3

Provenance: the artist.
Bibliography: Edward Weston, *The Art of Edward Weston*, ed. by Merle Armitage, New York, 1932; Edward Weston, *The Daybooks of Edward Weston*, 2 vols., Rochester (NY), 1961, 1966; Edward Weston, *Edward Weston, Photographer: The Flame of Recognition*, Rochester (NY), 1965; Ben Maddow, *Edward Weston: Fifty Years*, Millerton (NY), 1973, illus., p. 43.

CLARENCE HUDSON WHITE
p. 216
American, 1871–1925
The Ring Toss, 1899
Platinum print
19.9 × 15.2 cm.
Signed (l.r.).
Accession number 81:2132:3
Provenance: Anonymous gift.
Bibliography: Charles Caffin, *Photography as a Fine Art*, New York, 1901, pp. 113–39; Delaware Art Museum, *Symbolism of Light: The Photography of Clarence H. White*, texts by Maynard P. White, Jr., Cathleen A. Branciaroli, and William Innes Homer, Wilmington, 1977; Weston J. Naef, *The Collection of Alfred Stieglitz: Fifty Pioneers of Modern Photography*, New York, 1978, pp. 481–95; cat. no. 551, illus., p. 487.

MINOR WHITE p. 326
American, 1908–1976
Two Waves and Pitted Rock, Point Lobos, 1952
From *Sequence 8*, no. 1 of final sequencing, 1968.
Gelatin silver print
18.2 × 23.2 cm.
Signed in pencil on verso of mount.
Accession number 66:0041:2
Gift of Nathan Lyons.
Provenance: Nathan Lyons, Rochester (NY); the artist.
Bibliography: Minor White, *Mirrors/Messages/Manifestations*, New York, 1969, 2nd ed., Millerton (NY), 1982, illus., p. 71; Minor White, *Rites & Passages*, texts by Minor White and James Baker Hall, Millerton (NY), 1978.

FRANÇOIS WILLEME p. 136
French, 1830–1905
[*The Artist's Brother*], ca. 1859–61
Bronze relief
9.0 × 6.0 × 1.4 cm., on base 10.9 × 8.9 cm.
Accession number 77:0033:17
Gift of Eastman Kodak Co.
Provenance: Eastman Historic Photographic Collection; Gabriel Cromer Collection; the family of the artist.
Bibliography: Gabriel Cromer, "Histoire de la photographie et de ses pré-

curseurs enseignée par l'image et l'objet d'époque. Deuxième exposition: François Willème, inventeur de la photosculpture," *Bulletin de la Société Française de Photographie*, XI (June 1924), pp. 134–45; Robert A. Sobieszek, "Sculpture as the Sum of Its Profiles: François Willème and Photosculpture in France, 1859–1868," *The Art Bulletin*, LXII, 4 (December 1980), pp. 617–30.

GEORGE WASHINGTON
WILSON *p. 160*
Scottish, 1823–1893
Abbotsford, from the Tweed
[3 Views], ca. 1856–ca. 1863
(and after ?)
Albumen prints (3)
7.6 × 6.9 (l.) and 7.5 × 6.7 (r.);
7.7 × 7.8 (l.) and 7.7 × 7.1 (r.);
7.9 × 7.4 (l.) and 8.0 × 7.3 (r.) cm.;
stereographs.

Mounted on stereographic cards with letterpress on verso.
Accession numbers 81:1581:1; 81:8700:64; 81:8700:65
Provenance: Fred Lightfoot Collection; unknown.
Bibliography: George Washington Wilson, *A Practical Guide to Collodion Process in Photography*, London, 1855; Roger Taylor, *George Washington Wilson: Artist and Photographer 1823–93*, Aberdeen, 1981.

GARRY WINOGRAND *p. 350*
American, 1928–1984
[*Albuquerque, N.M.*], 1957
Gelatin silver print
22.7 × 34.0 cm.
Accession number 66:0058:7
Provenance: the artist.
Bibliography: Nathan Lyons (ed.), *Toward a Social Landscape*, New York and Rochester (NY), 1966, illus., pl.

50; University of New Mexico Art Museum, *Peculiar to Photography*, text by Henri Man Barendse, Albuquerque, 1976; John Szarkowski, *Mirrors and Windows: American Photography since 1960*, New York, 1978, illus., p. 92.

JOEL-PETER WITKIN *p. 398*
American, 1939–
I. D. Photograph from Purgatory: Two Women with Stomach Irritations, 1982
Gelatin silver print, toned
71.0 × 71.4 cm.
Signed and dated on verso.
Accession number 84:0513:1
Museum purchase, L. A. W. Fund
Provenance: Pace/MacGill Gallery, New York; the artist.
Bibliography: Stedelijk Museum, *Joel Peter Witkin*, text by Els Barents, Amsterdam, 1983; Max Kozloff, "Contention Between Two Critics

About a Disagreeable Beauty," *Artforum*, XXII, 6 (February 1984), pp. 45–53, illus., p. 48.

DAVID WILKIE WYNFIELD
p. 142
British, 1837–1887
[*Self Portrait in Renaissance Costume*], ca. 1860–65
Albumen print
21.0 × 16.0 cm.
Accession number 76:0115:4
Provenance: Sotheby Parke Bernet, New York; unknown.
Bibliography: Margaret A. K. Garner, "David Wynfield, Painter and Photographer," *Apollo*, (February 1973), pp. 158–59; P. & D. Colnaghi, *Photography: The First Eighty Years*, text by Valerie Lloyd, London, 1976, cat. no. 161, illus.; Mark Haworth-Booth (ed.), et al., *The Golden Age of British Photography: 1839–1900*, Millerton (NY), 1984, p. 120, illus., cat. nos. 130–31.

ACKNOWLEDGMENTS

After nearly two decades of direct involvement with the George Eastman House photographic print collections (including three leaves of absence of different durations), it would be impossible for me to thank all those people, colleagues on the staff and associates elsewhere, who have helped me appreciate and begin to understand the unparalleled riches and density of this collection. With the exception of General Oscar N. Solbert, the museum's first director, I have been privileged to work for and with every other director, including Beaumont Newhall, the foremost American photographic historian of our time and truly the guiding spirit of the print collection, Van Deren Coke, Robert J. Doherty, and Robert A. Mayer, who clearly saw the need for this publication and allowed me the time to write it. Over the years, various curators, historians, educators, and photographers who were part of the museum's staff have shared with me their own special insights and personal knowledge concerning this strange and enchanting art form. Undoubtedly, many of their ideas have found a way into this volume and will be recognized by their originators, to whom I extend my heartfelt thanks and apologies for not always recalling my sources. Other ideas have been utterly corrupted by time or by my particular failure to comprehend them from the start; for these and any errors of fact or omission I claim full responsibility.

Members of the present staff of the museum have been exceptional in their support of this project; without their energies and fervent belief in the importance and value of the collections this work would not have been possible. To the Development Office and especially Susan Kramarsky; Andrew Eskind, Director of Interdepartmental Services; Ann McCabe and James Conlin of the Registrar's Office; Del Zogg, Pat Byrne, and Karen Chase of the cataloguing staff; Linda McCausland and Barbara Puorro Galasso of the Darkroom; Rick Hock, James Via, and Carolyn Zaft of the Exhibitions Department; Grant Romer, Director of Conservation, and his staff; Janet E. Buerger, Associate Curator, and Marianne Fulton, Assistant Curator, of the Department of Photographic Collections—to these and others I owe much. Especial thanks must be given to Joan Pedzich and David Wooters of the Archives for their unstinting efforts in facilitating my selection of two hundred images from a collection of more than five hundred thousand; to Rachel Stuhlman, Rebecca Simmons, and Gail McClain of the Library for making available all that I needed by way of pertinent literature; and to Joanne Lukitsch and Heather Alberts, curatorial assistants in the Department of Photographic Collections, for their selfless devotion to accuracy in researching these two hundred prints. Our secretary, Carole Kosloski, is to be commended for her success at managing the various forms that the manuscript took over the course of its composition.

My gratitude is extended to those many photographers who answered my often frantic and, sometimes I would imagine, confused enquiries concerning their pictures and aesthetics; and to those photographers, collectors, dealers, and institutions who were so helpful in providing the reproductions by which points otherwise inadequately made by my texts could be illustrated. I would like also to thank Beaumont Newhall again for his early guidance and continuing example, Peter C. Bunnell of Princeton University for his unswerving faith, Dr. Walter Clark for his prescience and tenacity, John Weber and Joyce Nereaux for their necessary *divertimenti*, Lawrence Merrill for the willing and ready access to his library, Joseph P. Holt, Jr., for his technical help with word processing, Ben Lifson for his critically insightful reading of the manuscript, and Walton Rawls, my editor, for his patient and exacting shepherding of my words.

To the IBM Corporation, which believed in the value of bringing the treasures of the museum's print collection to a far broader audience than ever before, to the Andrew W. Mellon Foundation, and to the National Endowment for the Arts for their additional support of this project, our most sincere thanks and gratitude.

Finally, thanks are totally insufficient to express what is owed my wife, Sonja Flavin, for her constant and vital support throughout the entire project and, in the words of John Ashbery, for the loving manner with which she kept before me:

> —the normal way things are done,
> Like the concentric growing up of days
> Around a life: correctly, if you think about it.

To her this book is dedicated.

R.A.S.

466